Writing for Visual Media

Fourth Edition

Anthony Friedmann

Focal Press
Taylor & Francis Group

NEW YORK AND LONDON

First published 2001 by Focal Press

This edition published 2014
by Focal Press

70 Blanchard Road, Suite 402, Burlington, MA 01803
and by Focal Press
2 Park Square, Milton Park, Abingdon, Oxon OX14 4RN

Focal Press is an imprint of the Taylor & Francis Group, an informa business

Library of Congress Cataloging-in-Publication Data
Friedmann, Anthony.
 Writing for visual media / Anthony Friedmann. — Fourth edition.
 pages cm
 Includes bibliographical references and index.
 1. Mass media—Authorship. 2. Visual communication. I. Title.
 P96.A86F75 2014
 808′.066302—dc23
 2013030017

ISBN: 978-0-415-71794-6 (hbk)
ISBN: 978-0-415-81585-7 (pbk)
ISBN: 978-1-315-86781-6 (ebk)

Typeset in ITC Stone Serif
By Apex CoVantage, LLC

Contents

Acknowledgments

Authors of this kind of book are almost always indebted to others for advice, help, and corrections. I want to thank Daniel Tibbets, Senior Vice President at Bunim-Murray Productions in Hollywood, formerly Vice-President and Studio Chief at GoTV Networks, for information and material that enabled me to understand the development of mobile media formats in which he pioneered. His new work in second screen production continues to innovate in a fast moving industry, which we are trying to explain even as it changes. Without this contact, many phone conversations, and emails, Chapter 14 would be less authentic and be less up to date.

Since I use *Writing for Visual Media* to teach introductory courses in scriptwriting, I learn a lot from students and their struggle to master visual writing. They have sometimes shown me by their honest mistakes the shortcomings of certain passages that needed either more or clearer explanation.

I am particularly grateful for the support and detailed feedback given me by Kathryn Morrissey, my editor at Focal Press, without whose suggestions, many good revisions, and new features might not have come to pass.

Praise

"Worth its weight in gold . . . ! It doesn't get any better than this: Here we have a master teacher—Anthony Friedman, bringing 21 years of writing, producing and directing experience to bear writing the third edition of this very impressive text . . . An impressive book that delivers what it promises . . . an essential purchase for anyone interested in writing for the visual media."

R. Neil Scott, Author, Former Professor & User Services
Librarian at Middle Tennessee State University (MTSU)

"An engaging textbook that trains, entertains and concentrates on contemporary writing issues in an accessible way. This book delivers a treasure trove of valuable, well-written information aspiring writers can use to familiarize themselves with the challenges of visual media."

Jared Castle, marketing and public relations consultant, writer

"A comprehensive, well-structured, and well-written introduction to writing for electronic and digital screens wherever they might be found."

Nathaniel Kohn, University of Georgia

". . . a critical text that is accessible for students. This textbook provides comprehensive examples and exercises to push students to engage with real-world examples that will be needed once they become professionals. Broken down into five parts, this book allows lecturers to focus on critical concepts either in order, or in smaller chunks. The section on Interactive and Mobile Media is a welcome addition to a mediated world that is going global with the use of a Smartphone!"

Dr. Ann Luce, University of Portsmouth, UK

"Anthony Friedman is a master at his craft for writing for a variety of media. He is also a master when it comes to explaining his methods to the average lay man. I thought the book was brilliantly put together . . . I feel this book is well worth the purchase price, and the time spent reading."

Stephanie Manley, editor of CopyKat.com

"If my journalism students could only have three textbooks during their journalism academic career, I'd be pleased to know that "Writing for Visual Media" was one of them. From producing PSAs to defining target audiences to writing for interactive and mobile media, and finally, marketing oneself in this ever-changing media landscape, this text has the tools that journalism and new media students need now and tomorrow."

Deidra Jackson, Instructor of Journalism, University of
Mississippi Meek School of Journalism and New Media

Preface to the Fourth Edition

Once again, it is time for a new edition thanks to those readers and writers who have expressed confidence in the content of this book by buying the third edition and to those instructors who adopted it as a textbook. It has always been the author's ambition to bridge the world of a pure textbook and a trade book about writing that would appeal to all writers and would-be writers everywhere who are not already experienced professionals in media writing. Even professionals might benefit from a refresher or from looking at a different kind of visual writing than the one they know. Although some elements like exercises concede to the needs of instructors and students, the style and approach are not exclusively academic. Sometimes the academic gets in the way of learning.

A new edition is a kind of reprieve. You see mistakes; you see opportunities not only to improve the prose, even though it seemed to read alright before, but also to re-order the exposition of ideas within chapters to achieve greater intelligibility as well as develop new ideas. Reviewers invited by the publisher to comment on the previous edition often oblige me to re-examine my approach, sometimes leading to changes but sometimes confirming for me that I needed to stick to the convictions that underlie the book and that inspired me to write it in the first place. With each successive edition, I have been encouraged to preserve most of the content and the order of many chapters, retaining the approach that presumably accounts for the relative success of previous editions. At the same time, I have been keen to find new ways of getting certain ideas across and embarrassed to find passages that could be considerably improved in clarity and style.

The order in which key ideas are transmitted matters to the success of the transmission and the consequent assimilation of those ideas. One way is better than another even though, in the end, a writer must assimilate them all and possess an integrated understanding of the whole. Hence the new order of chapters in the third edition has been preserved, although internally chapters benefit from some rearrangement of the contents and headings. Some sections and headings have been moved between chapters where, on critical examination, they seemed to belong. Discussing the method of analysis, brainstorming, and thinking that precedes actual script writing now comes earlier than explaining the problem of describing sight and sound and the necessary stages of script development. I decided to rewrite Chapter 8 and move the list of genres that cluttered up the chapter to an Appendix. This allows for a deeper, more complete discussion of storytelling and dramatic theory together with an analysis of films that illustrate story structures. I have also expanded some other chapters and dealt with new developments in media and their impact on writing.

Every instructor structuring a writing course around this book will have an individual approach, and no doubt no order or exposition will suit everyone. The convenience of the linear layout of books is that users can edit and re-order the sequence of chapters to their own preference although I do make a strong plea to try it my way.

The website had errors, which have been corrected. Perhaps more important, the interactive content has been expanded to include more video clips, links, and scripts. The website will be updated regularly. It is difficult, impossible, or simply too expensive to get rights to entertainment video clips, which explains why I continue to use examples of films and television for which I already have rich materials when more contemporary production might be more desirable. Publishers insist that the author pay for the rights. Sorry, I can't afford them. I believe that film, television, and video should, like print media, be subject to the "fair use" provision of copyright law. However, publishers do not seem prepared to pioneer and defend this in a court of law. So I have to rely on scraps, trailers, and whatever can be found on websites and on YouTube.

With the passing of time, examples from many ads and PSAs inevitably become dated. Some of these I need and want to retain because they are either classic or because I have the scripts and video clips for the website and face restrictions of copyright for material that is desirable in an ideal world but unobtainable in a real one. I have updated many examples and references where possible, thanks again mainly to YouTube, which has flourished to become a major resource for all since the last edition.

Some readers didn't like the printing of key terms in bold throughout chapters that was introduced in the third edition. The problem is that we do not know how many did like that change. I believe identifying key terms helps readers. Bolding them for every occurrence in the chapter produced clutter. By way of compromise, we have kept the list of key terms at the beginning of every chapter and removed the printing of those terms in bold in the body of the chapter. These terms form part of the glossary and are still set apart from other terminology by bold type so as to make them more readily identifiable and accessible. Key terms are specific to a chapter as far as possible. This does not exclude repetition where useful and germane to the chapter heading.

Although the premise of the book that is expressed in its title must control the content, the audio component of the visual medium remains largely unchanged from the third edition. Since we have to describe both sight and sound in visual media, writing for the voice is a component of visual writing even though audio is heard not seen. Nevertheless, it supports the visual. Writing for radio, which is sound only, receives some attention particularly in connection with writing PSAs. This cognate discipline that we can explore to help us define more clearly what is meant by visual writing therefore remains unchanged from the third edition. However, audio values as a component of the PSA sound track receive more attention.

The argument of the premise of the book is that writing broadcast news is not visual writing equivalent to other forms of scriptwriting. Despite the clear argument in the Introduction, some continue to object to the exclusion of broadcast journalism. Some curricula are organized in such a way that media writing includes broadcast journalism and are taught from a foundation in journalism that sets it apart from other forms of writing for media. Such a foundation course is broader and served by another kind of textbook with a different premise. Several good textbooks of this kind exist and take a different approach. Likewise, copywriting is yet another writing discipline that is only treated in the context of the visual writing that is demanded by ads and PSAs. Such writing is strongly visual and rich in visual metaphor and needs to be included.

Another misunderstanding that some users have relates to writing for the internet. This is not a book about new journalism just as it is not a book about broadcast journalism. Although writers creating web content often rely on still images, video clips, and perhaps even audio clips, they are not visual writers as such. Web pages or blogs consist mostly of text meant to be read not to be produced. Although the style changes from print, there is no visual writing as such. If video of any length is going to be produced, the video segment depends on the methods expounded in this book. Video clips or stills do not generally need scripting as separate elements. They are short unedited clips or plucked out of archives. In addition, the visual experience of a website, its design, its look,

and functionality result from graphic design. Writing concepts and treatment for websites that might precede graphic design are, however, grist for our mill. In this context, writing for the web for the purpose of this book means conceptualizing functionality, look, and navigation, not writing the text that is read in blocks or in sidebars. That is prose exposition.

The chapter devoted to writing for mobile media platforms, which was new to the third edition, reflects the way digital media and mobile platforms have evolved over the intervening years and changed how content is created and written to account for the second screen experience and the emergence of new formats that encompass multiple media distribution.

I have realized, partly in retrospect, that this is not just a book about how to write for visual media; it is also by turns, a reflection about the history, evolution, and origins of a medium and the kind of writing on which it depends. Media writers have to understand the forces that are changing the very media they write for. Nowhere is this more critical than for new mobile media platforms. This is not just a writing manual. It is also a book about the economic, production, and social contexts in which writing for visual media occurs.

I do believe this is a better book, a better website, and will reward its readers.

anthony.friedmann@gmail.com
Lake Conroe, Texas

What's on the Companion Website?

This text is designed to work in tandem with a website. Interactive online media provide us with a new opportunity, hitherto impossible to achieve in a writing textbook, to link script blueprint and resultant image in the visual medium in which it is produced. Reading a screenplay or PSA script and connecting them to finished, produced media closes a gap in most people's imagination. This should help everyone grasp how visual writing works by seeing this critical link. Although the printed book contains some examples of scripts, the website provides many more and also more complete scripts.

An interactive visual glossary of script vocabulary for camera shots and movements enables the reader to see live action or still media that correspond to the term and hear audio that corresponds to the audio terminology. This in fact was the germinal idea for a companion CD-ROM that was bound into the first edition.

There are many links to useful websites about scriptwriting, movies, television, games, and social media. All this and more would be impossible to include in a standalone printed book.

HOW IT WORKS

Throughout the text words and phrases have been highlighted in bold against a background whenever the website contains supplementary material to consult. This is a prompt to the reader to open the website and explore the content cognate to the chapter being read. In the e-book, this should be an active hyperlink and allow immediate access in another tab. Many URLs cited in the printed text become active links in the e-book avoiding the tedium of typing the URL into the browser.

In previous editions, many footnotes and other references mentioned the web address for imdb.com inviting the reader to look for background information about a film. Everybody in this field knows this website and with a few exceptions, we have now adopted a policy of assuming that any reader who needs production information or to watch a trailer can and will consult that website if need be.

The companion website provides an interactive menu that corresponds to the chapters of the book. The interactive navigation is modeled on the chapter outline so that all the links for a given chapter are accessible under the heading for that chapter. All supplementary materials referenced in the printed text can be accessed via this menu. There are also other options for interactive navigation that follow useful themes or topics so that readers can consult the website content independently of the chapter navigation:

- many corporate, and feature film scripts
- storyboards

- video clips of scenes produced from many script examples
- an interactive glossary of camera shots, movements and transitions
- links to relevant websites

Over time, some URLs become invalid because the World Wide Web is a changing environment in which many websites are not permanent or undergo revision. The companion website will undergo revision from time to time to supplement material or remove links that are no longer active, typically when the book is reprinted. New content and new links will be added to the website during the life of this edition so that the site can be consulted continuously for material that may not be flagged in the text.

Readers should understand that the website contains material, especially video clips that can take several minutes to download depending on the speed of the Internet connection, the clock speed of the computer processor being used, and the available RAM. The URL of the companion website is: www.focalpress.com/cw/friedmann.

SUPPORT AND SUPPLEMENTARY MATERIALS FOR INSTRUCTORS

Materials such as tests, lesson plans, and a syllabus are provided on the Focal Press website for this book. Instructors are required to complete an online form to request access.

Introduction

THE PURPOSE

Although this book is intended mainly for students in colleges and universities who are taking introductory courses in writing scripts for media, it is also meant for all writers navigating the transition from writing for the printed page to writing for visual media. It assumes that the reader begins with minimal understanding of the nature of writing for visual media. The mechanisms for creating video content and setting it before an audience is open to all in the era of YouTube. Many people can shoot digital video, whether on a portable point-and-shoot camera or on a cell phone. You can even make money uploading videos because Google will pay you for viewers' impressions. The greater the number of impressions, the larger the audience for their contextual advertising! These videos, however, are rarely scripted. If you want to be the next **Jenna Marbles** and live off self-shot viral videos, you probably do not need this book. This comment is not meant in any way to belittle these witty and stylish mini-productions that have a large audience. However, if you wish to earn a living as a writer of commercial media content, you have to investigate how it's done and learn some craft skills.

Most beginners have had a large number of experiences viewing visual media: films, television, and video. They probably contemplate the originating creative act that lies behind such programs without much idea of how it's done. They may not understand visual thinking, or if they do, they don't know how to set it down. They don't know formats. In short, they don't quite know where or how to start. This book is designed to get the beginner started. It is not intended to make fully fledged professionals out of beginners, but it does deal with every type of media writing, and it does cover all the material a beginner will need to write viable scripts in the main media formats.

Other books dedicated to specific genres offer more exhaustive and more specialized information about how to work at a professional level writing for film, television, corporate video, or interactive media. Broadcast journalism for current affairs and sports is another discipline that is well covered in more specialized works. A selected bibliography at the end of this book lists many of these more advanced books that focus more narrowly on writing for a single medium; the bibliography also includes more general works and the sources quoted or referenced in this book.

THE PREMISE OF THIS BOOK

This book is based on the premise that the fundamental challenge of writing for visual media arises from learning to think and write visually, that a script is a plan for production, and that visual media are identifiably different from print media. Granted, the production medium of television is visual,

the production script refers to B-roll, and investigative reporting demands visual input. Although broadcast journalism overlaps visual writing in some of its forms, journalists have concerns about sources, objectivity, and editorial issues that predominate. Shaping a news story delivered to a teleprompter does not really require visual writing. If anything it is writing for the ear. Even though a news script might make allowance for B-roll and story packages, those inserts are not written as scripts but captured on location by recording events. News production, however, does not need visual metaphor and is principally made up of and controlled by the concept of talking heads reading from a teleprompter. That still sets apart this kind of writing, which must apply the disciplines of journalism; this leads in another direction. However, for the sake of comprehensiveness and contrast, we include the script format for broadcast studio production in Chapter 4, in the appendix, and on the companion website (**www.focalpress.com/cw/friedmann**).

Although writing for the audio track has been part of the job of scriptwriting since sound was added to motion pictures some 90 years ago, writing for the ear alone concerns only words that are to be heard rather than words that describe a visual experience on screen. Our focus is a body of technique that is concerned with writing for audiovisual media that are based on sequencing images. Writing for radio, with the exception of a show like *Prairie Home Companion* on National Public Radio, usually consists of writing radio ads, which are a form of copywriting and, therefore, guided by advertising concerns, or it is news and involves the journalistic issues already mentioned. Therefore, writing purely for radio is limited to radio public service announcements (PSAs) as an adjunct to visual PSAs. However, in context, writing dialogue, voice-over narration, and other audio concerns are given the importance they deserve.

This is not just a book about how to write for visual media: it is not just a writing manual; it is also by turns, a reflection about the history, evolution, and origins of this kind of writing; it is also a book about the technological, economic, production, and social contexts in which writing for visual media occurs. Media writers have to understand the forces that are changing the very media they write for. Nowhere is this more critical than for new mobile media platforms and the sudden emergence of the second screen dimension in television storytelling. Finally, the question of how to earn a living by writing for media raises ethical, esthetic, and creative conflicts that are inescapable. Understanding this difficult relationship between art and commerce, always in the background, is examined in detail in the last chapter.

OBJECTIVES

To become good at your craft, sooner or later you need to specialize. You need to hone and refine your writing skills for the way in which a particular medium is used. This does not mean you can never cross over from one form to another, but if you are going to make a living writing for a visual medium, you will have to be good enough in at least one area to compete with the *pros* already practicing the craft. That is a few stages away.

To get there from here you need to learn:

- How visual media communicate
- Visual thinking
- Visual writing
- Scriptwriting terminology
- The recognized script format for each visual medium
- A method to get from brain static to a coherent idea for any media script
- The role of the writer in media industries

SECONDARY OBJECTIVES

Even if you don't end up writing for a living, you may find yourself in a job that requires you to read, interpret, evaluate, buy, or review scripts. Whether in preproduction, production, or postproduction, there are dozens of activities that require you to be able to evaluate the written plan that is the script. You need to be able to construe the final product from words and ideas on a page. Some of the jobs that require you to do this are producer, director, casting director, cinematographer, story editor, literary agent, studio and TV executive, film and video editor, and actor. Other positions in the visual communications industry might also require that you be able to read a script and deduce what it will cost to make a product that an audience will see. In addition to the people who have to evaluate and buy or reject scripts, these positions include art director, set designer, talent agent, casting director, lighting director, and sound designer. Virtually anyone who has a role in bringing a script to the screen needs to be able to read the blueprint from which a program is made.

Before production, the script is the movie or the project or the PSA. The logic of project development and the economics of production dictate the importance of the script. If you work in the visual media industry, you will need to be able to follow the way a script translates into narrative images that communicate to an audience, and to read the coded set of instructions that a script embodies. The script is cheap to produce compared to producing the script.

THE BASIC IDEA OF A SCRIPT

When composers want someone else to play their music, they must write it down as notes in a form that other musicians can read, decode, and then turn back into music. This problem has been solved in the music world by inventing the musical score with a clear set of rules for the symbols which designate the length of the note, the pitch, the loudness, and rhythm that should be reproduced. Even composers who don't write music need arrangers to write it out for them because most music involves groups of musicians playing different instruments simultaneously. There is always a barrier between the music score and the auditory experience of hearing the music. You can't hear the score just by reading it unless you are a trained musician. Even then, you need to play the notes to understand what the composer intended and create a musical experience for a wide audience, most of whom cannot read music or play an instrument.

Likewise, you can't see a film or video by looking at the script. If you are a trained director or editor who knows how to read a script, you can visualize in your mind's eye what is intended, just as a musician can hear in his mind's ear what the music should sound like. You can translate a static page into a sequence of images flowing in a time line. Today's nonlinear video editors display programs in a graphic time line, which is a kind of storyboard metaphor for the content of a program. In the end, the production process is needed to make the script into images that are accessible to all viewers even though they cannot read a script, frame a shot, or edit a sequence to make narrative sense.

Like all analogies, this one breaks down. Musical scores are used over and over again for numberless performances, whereas a script is used only once. So another useful analogy is the blueprint, the drawings an architect makes for a builder or contractor to erect a building. After the building is finished, the blueprint has little interest except perhaps for maintenance or repair. The person who buys a house or who lives in it might not be able to read the architect's plans any more than the audience at a concert is able to read music or an audience for a film is able to read a script. The home dweller hardly thinks about the plans of the house, even though this person may have strong views about how successful the building is to inhabit. If you like living in the space, then that is a measure of the building's success even though you do not necessarily know how to design a house.

Likewise, if you watch a TV series, enjoy a movie, or understand a corporate message, you don't think about the scripts on which they are based. You get an audiovisual, intellectual, and emotional experience. You laugh, cry, reflect, or go into a rewarding imaginative or mental space. So a script has little value except as a blueprint to make something. Think of it this way: you couldn't sell many scripts of *Star Wars* or *Jurassic Park* (or your favorite movie), but you can sell a lot of tickets to see the movie made from it—millions of tickets in fact.

META-WRITING

I introduced the term *meta-writing* in the second edition of this book to clarify and explain how visual writing works. The process of visual writing is elusive because it originates in the imagination before writing happens. Writing of any kind arises in the mind in some pre-verbal phase that seeks words to embody an idea. Languages are many, and the writing process is not confined to any particular language. Anyone who knows another language well can be faced with a dilemma of which language accommodates the idea. I am fluent in French and have written scripts, stories, and letters in that language. I have come to realize that visual thinking is independent of what language I am using to write the script down. Writing does not originate simply in words although words might enable the process. Writing for visual media involves yet another complexity, namely that the language used to describe the visual idea is not what the audience itself experiences. The language we use as visual writers is a referent for images or a construct of images that underlies the produced result and accounts for how and why it works. The term meta-writing refers to that *ur*-writing or pre-writing activity of the creative imagination. It is expressed as a concept, a premise, or some pre-script document that then has to evolve through further elaboration in a treatment into a set of written instructions that eventually become part of the script itself. That script is sustained by a vision that the audience grasps visually and not through words. So the audience is really responding to what is in effect the meta-writing.

We can verify this by an analysis of some **CSX television commercials**. One of them consists of a montage of brief shots of all kinds of people breathing in. We then see another montage of the same people breathing out and swimmers racing. It incorporates the following text intercut with images:

> CSX trains move one ton of freight 436 miles on 1 gallon of fuel.
> Less fuel = less emissions.
> Good news for anyone who breathes.

The final tag line completes an idea that can only be assimilated visually. If you see this television ad, you understand it and know what it means. If you try to express your understanding in words, you might have difficulty. Expressed in words, something is lost. Let's try and then view **the ad online**.

We live in a gaseous atmosphere just as fish live in water. That atmosphere is being altered by human activity burning fossil fuels and changing the gaseous makeup of that atmosphere. This same activity also emits pollutants which contaminate the environment and impact the health of the human organism that must breathe that gas polluted with carcinogens and other particulate matter detrimental to the respiratory system. Reducing that pollution benefits

everyone who breathes, indeed every animal that breathes (a shot of a dog exhaling is included). So if we can get trucks off the road and do the same job of transporting goods by rail, which uses fossil fuel energy more efficiently, we all benefit. We are a railroad. We understand this. Every year, our train operations reduce the amount of CO_2 being pumped into the air by over 6.5 million tons. It would take 152 million tree seedlings 10 years to absorb that much carbon. We want you to appreciate how important our older technology is for the survival of the planet and its life forms—you. Although railroads are old transportation technology, they are the energy and environmental solution for tomorrow.

Expressed in words, the idea is lengthy and somewhat clumsy; expressed visually, it is elegant and can be accomplished in 30 seconds. The human brain can process images 60,000 times faster than text. It is primordial and in our genes. Nevertheless, text is still immensely valuable. It either backs up or completes the visual idea. The tag line for the campaign completes the idea in words: "How tomorrow moves™".

The transmission of a visual idea cannot take place without live action images, which have to be produced. The audience then experiences the meta-writing as images. The audience gets the idea that started the whole process. This is why understanding how you do meta-writing is so important to visual writing. It happens before you write, but you have to find words to explain it to someone else so that it can be produced. Learning how to do this entails more than the traditional writing skills. It is less dependent on facility with language or descriptive wording than a capacity to think in images. This is what meta-writing means for visual media.

THE LEARNING TASK

Your job right now is to begin to understand how you put this plan, this score, or this blueprint for a movie together. Whether it is a PSA (public service announcement), a corporate communication, or a feature film, you have to figure out the process. You have to learn in what forms media industries communicate, buy, sell, and produce their ideas. You have to try it out before your next month's rent is at stake.

The most difficult part of writing is the constant revision. We have to rewrite and revise until we get it right. Writers whose work you watch on TV and in the movie theater have spent a long time studying how it's done. One day, I was explaining this to a communications student who played on the college basketball team. I asked him what the coach had him do in basketball practice. His eyes lit up and he described some of the shooting drills. Then I asked him what he thought the equivalent drills would be for a writer. He wasn't so sure and did not understand that a similar degree of practice is the foundation for successful writing. Since we are comparing writing to basketball, consider this quote from Michael Jordan: "I've missed more than 9,000 shots in my career. I've lost almost 300 games. Twenty-six times, I've been trusted to take the game winning shot and missed. I've failed over and over and over again in my life. And that is why I succeed."

If you have to shoot thousands of baskets so as to be confident about sinking a foul shot, let's think about what it takes to get to be good enough to score consistently in a competitive writing game. Some people will put in a lot of time practicing basketball because they love the game. Scriptwriters keep writing because they love the medium and they love to create. Isn't it the same idea? Practice, practice, practice! Don't give up! Don't get discouraged when your ideas don't work out right away, and, above all, enjoy the creative act, even if you don't make points every time!

A complex topic such as visual writing has an evident linear arrangement that is implied in a table of contents with numbered chapters. That is dictated by the structure of the medium. Another paradigm that can explain this assembly of ideas is a wheel: It has a center, a circumference, and spokes. You can begin almost anywhere and get to the center.

CONCLUSION

This book is about learning the fundamentals of scriptwriting. It is designed to take you from nowhere to somewhere, from no experience and no knowledge to a basic level of competence and knowledge of what the issues of scriptwriting are. It gives you a chance to explore your visual imagination and try out your powers of invention. My fervent wish is that readers will find an improved route to understanding the process of writing, acquire a better understanding of the different types of visual writing, and finally see how to get on the path to doing their own writing. Later, you can confront the full range of writing issues particular to each genre in each medium by taking more advanced media writing courses dedicated to specific media formats, or by reading more advanced texts, or by further self-directed writing experience. In the end, you learn, not by reading alone, not by thinking alone, and not by talking about doing it, but by doing it. "Just do it!" as the Nike ad used to say.

Just write!

PART 1

Defining the Problem

Many people, including readers of this book, have confidence in their basic ability to write but are unsure of how they should apply it to writing a script. To know how to write for visual media, it is important to understand how such writing differs from the writing most of us have learned to do until now. To change these habits and learn how to write a script, we need to see the specific problems that this different kind of writing solves. Above all, we need some kind of method to solve those problems. The first part of this book is devoted to a logical and pragmatic analysis of the reasons why scripts are written a certain way. If you understand the problem, you will understand the solution. This part also introduces you to a basic process of thinking, a method of devising content, and a method of writing in stages or steps.

Writing is a peculiar business. It is at once an intensely private act whose intention is to become public. If it works well, the writer disappears and the writing itself has a life of its own. This is true for all writing, but it has a particular importance for scriptwriting and writing for media because the words constitute instructions to others to do something and create content in another medium, which is essentially visual. So you could say that the writing doesn't count; yet it does in ways that are critical for the final product if perplexing in the process.

I had always thought of myself as a pretty good writer, and I liked writing before I ever wrote a script. Many of you might feel the same way. I started writing scripts to have something to shoot in film school. After all, I could hardly hire a professional scriptwriter, and people around me were too busy doing their own projects to help out with mine. Besides, I wanted to write my own scripts. A lot of you are probably students in media production and will have to invent content for production projects. We all learn the hard way, by trial and error. The following chapters are intended to minimize those errors. Although there is a considerable body of craft to learn, this part of the book is about what a writer should understand before dealing with specific visual media, their formats, and writing screen directions. Let's begin.

CHAPTER 1

Describing One Medium through Another

The essential problem of writing for visual media comes from the difference between print as a medium, or words on a page, and the medium of moving images. You have to describe an audiovisual medium that plays in real time by using a written text that is stuck on a page and frozen in time. So a description in words on a page of what is to be seen on a screen has limited or no value until it is translated into that moving picture medium itself.

WRITING NOT TO BE READ BUT TO BE MADE

The fundamental premise of scriptwriting is that you are writing words that are not to be read but to be made. This does not mean that a script is not read by producers, directors, and others who must decide whether to put resources into producing it. It means that the audience generally doesn't read the script. By contrast, a novelist or a poet or a journalist writes what a reader reads. I am now writing what my readers will experience directly as written language. But this is not so for a scriptwriter! Just as the musical score is a set of instructions to musicians and an architectural blueprint is a set of instructions to builders, a script is a set of instructions to a production crew to make a film, a video, or a television program. Only the ideas, scenes, and dialogue that are written down get made. This is the first principle to keep in mind. Whatever your vision, whatever your idea, whatever you want to see on the screen, you must describe in language so that a team of technicians and visual image workers can understand and translate it into moving images and sound. They can't shoot what you don't write, or worse, they might shoot something different if you did not write clearly, or worse still, improvise something that you didn't write.

A script is fundamental to the process of making a movie, video, or any type of visual program. It is the basis for production. From it flows a huge number of production decisions, consequences, and actions. The first of these is cost. Every stroke of the pen (or every keystroke) implies a production

cost to bring it to reality on the screen. Although the techniques of filmmaking and special effects are seemingly without boundaries these days, extravagant ideas incur extravagant cost. A writer must keep in mind that a production budget is written with every word by virtue of the visual ideas contained in the script, whether that script is for a feature film or a training video. A script writer can reach an audience only by visualizing and writing potential scenes for directors and producers to shoot and edit. The finished work often reflects a multitude of creative choices and alterations unspecified by the writer—in an ideal world, the inspired interpretation of a director or editor.

WRITING, PRODUCING, AND DIRECTING

It is often said that a good script can be ruined by bad producing and bad directing but good producing and good directing cannot save a bad script. Producers and directors have more recognizable roles in the process because production is visible and material. Sometimes, the writer's role is combined with that of either producer or director. Some writers can direct, and some directors can write. Writing and producing can also be combined. If you study program credits, you will see some of these dual roles and combined responsibilities. Some individuals attempt triple responsibilities. Among the Academy Award nominees for 1998, James Cameron had writer, director, and producer credits for *Titanic* (1998). He combined these roles again for *Avatar* (2009). Quentin Tarantino usually writes the scripts he directs. The Coen brothers have written and directed many very successful films, such as *Fargo* (1996), which won an Academy Award for best original screenplay, and *No Country for Old Men* (2007), which won for best adapted screenplay. They also directed these films.

As a rule, audiences pay little attention to the scriptwriter and often don't recognize the producer or director. Audiences identify with the actors they see on screen. However, they do so only because the writer has created the story that the audience wants to hear, the characters that it believes in, and the words that it accepts as those characters' speech. A film or a television series gets made because a producer, a director, and sometimes key acting talent respond to the potential of the script idea. The script expresses the primary imaginative vision that can become a successful program or film.

The writer's work is somewhat isolated because the writer is the originator, with no one else to lean on. Others are waiting for the scriptwriter to deliver before they can do their work. However, strong collaboration can occur between the original writer and the producers and directors, and sometimes with co-writers. The scriptwriter's work is less isolated than that of the traditional novelist, poet, or biographer because those writers write their words to be read directly by the audience. They do not need any intermediary, except perhaps a publisher, whereas a scriptwriter is never read directly by the audience and needs a team of skilled technicians as intermediaries and a risky investment of millions of dollars to create a result visible on screen.

In the entertainment world, the viewing audience is usually much larger than the reading audience for a book. It is a measure of the media age we now live in that visual media are so predominant in our imaginations. In fact, the very word *audience* is a carryover from another age when audiences listened. The word derives from the Latin *audio,* meaning "I hear." Perhaps we should invent a new word, *vidience,* from the Latin *video,* meaning "I see." Printed media no longer have the monopoly they have enjoyed for 500 years, since the Gutenberg era and the invention of the printing press. With the invention of the motion picture camera/projector by Louis Lumière in 1895 and the movie projector by Thomas A. Edison in 1896,[1] a visual medium was born—one that, with its electronic derivatives, has probably displaced the print medium as a primary form of entertainment and now rivals it as a form of communication. Audiences today are primarily viewing audiences.

1 The Edison company demonstrated the Kinetoscope in the United States in 1891, which enabled one person at a time to view moving pictures. In 1896, Edison brought out the Vitascope projector.

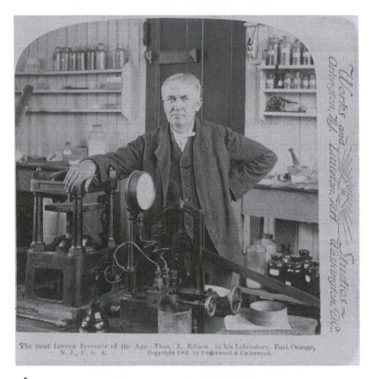

→ **Figure 1.1** Edison in his laboratory.

Since the invention of the motion picture on film, these visual media have multiplied in type and nature so that a range of visual communication types now exists that requires scriptwriting of many different kinds. After movies came television and a dozen different types of program requiring a variety of writing talents. From television came portable television or video, programs recorded on a single camera and edited to be distributed on videotape rather than broadcast. Other exhibition media based on microchip technology synchronizing slide projectors led to extravagant multi-image and multimedia projections for business meetings, museums, and exhibitions. This led to video walls that involve composing images across banks of nine or twelve TV screens. New combinations of video and computer technology have led to the creation of interactive multimedia both for entertainment and instruction published on CD-ROMs, DVDs, and websites.

Scriptwriters are indispensable to all these visual media. Their craft and art lie behind every program. Every time you watch a program on television, see a movie, or watch a corporate communication, remind yourself that it began as a script—as words on a page. Don't walk out of the

Auteur Theory

The French *Nouvelle Vague*, or New Wave school of French movie directors that emerged soon after World War II and famously expounded their theory in the journal *Cahiers du Cinéma*, argued that the director is the *auteur*, or author of a film. It is a strongly held view with which I disagree. After writing, directing, and producing feature film, corporate film and video, and interactive multimedia, I have found that narrative or structure and fundamental visual meaning are overwhelmingly established in the script phase. If you also direct your own script, you may take the liberty of altering your script on the floor or on location, but that is a temporary change of hats. Directors may develop a style of shooting that confers visual qualities on the work. They also cast and draw performance out of actors. They translate the script into visuals by commanding the production craft skills. Both writers and directors are indispensable. Filmmaking or production requires direction. However, in the final analysis, everything begins with a script as the first cause. That compels me to side with the writer as *auteur*. This debate underlines our point about writing that is not to be read but to be made.

movies or switch the television channel when the credits roll—look for the scriptwriting credit! According to the Writers Guild agreement with the producers of movies, in both the United States and the United Kingdom, the script credit must come immediately before the director's, which is always the last credit. Is the director or the scriptwriter the author of a film? Keep this question in mind as you read on.

MOVING FROM BEING A VIEWER TO BEING A CREATOR

In the transformation from a beginner into a competent scriptwriter, most of us begin with the experience of being in the audience. We grow up going to the movies and watching television. A complete media experience written, produced, and edited is presented to us for our enjoyment. We are conditioned to be passive consumers of these images. We learn to interpret them. We do not think in depth about how they were created, although some viewers might have had a mild curiosity about the creative process. We just enjoy watching.

You begin to be a scriptwriter when you start to think about how the story got invented, who wrote the dialogue, who decided what the voiceover should say, whether they could have been better or different. It is a change of mindset. A member of the audience decides to get up and cross over to the other side and become a creator. The writer creates for an audience. A writer has to know what it is like to be in the audience, but no one in the audience has to know what it is to be a writer. This transition in awareness and in point of view must take place before you can function successfully as a scriptwriter. The following chapters are designed to engender that transition. It will take time. You are an apprentice to a craft. Where do you begin? Because you are writing in one medium for another, you have to change the way you have been used to writing, which was meant to be read by an audience, and instead write so that your writing works as a set of instructions for a production team.

THE PRODUCER AND DIRECTOR CANNOT READ YOUR MIND

Everything begins in your mind, in your imagination. Unless you write down what you see and hear, no one else knows about it. Beginning writers sometimes forget this. Unless the script contains a clear description of your vision from beginning to end, with no gaps, your vision will not reach the screen. The production people who make the script into screen images cannot read your mind. Rule number one: Do not hand over your scriptwriting prerogative and responsibility to the director or actor, or anyone else whose job it is to translate your script into a program. Too often they will take it and do something other than what you intended. If you leave blanks, they will fill in those blanks from their own perspectives. They have to—it is their professional responsibility. There are no empty frames in movies or television.

INSTRUCTIONS TO THE PRODUCTION CREW

Consider the differences between the following sentences:

A man is sitting in a car watching the entrance to a building . . .

and

An undercover agent, unshaven and tired after a long vigil, sits in an unmarked car, watching the entrance to a run-down apartment building through binoculars.

To shoot the first statement leaves a number of decisions to the director and art director: What type of car? What year? Is it period? What street? What else is in the shot? Crowd? Extras? Day? Night? What is the man doing in the car? Does he drive up? Time has to be allowed to set up the shot and rehearse. Permits are required to shoot in the street. These details may not be critical to your scene, but writers have to think all the time about what they should specify and what they can leave up to the good judgment of the production people, mainly the director. As a general rule, be specific. However, to provide answers to all these questions would result in an unusable script, encumbered with unnecessary and unacceptable production detail.

There is a prevailing sentiment in the industry that everyone wants to get the script right before proceeding with production. To change a script involves work and expense, but a lot less than reshooting. Until there is agreement about this crucial document, it is difficult to advance the project. So rewriting is almost unavoidable. The script becomes the common denominator of a production to which everybody refers. Production people use the script to make budgets, schedules, and sets; select a cast; and choose locations.

WHAT IS THE ROLE OF A SCRIPTWRITER?

Because scripts are indispensable to production, writers are indispensable to the producers in the industry. This would seem to put writers in a powerful position. In practice, though, the scriptwriter seems to be the least valued contributor and the most abused.[2] Once a writer delivers a script and is paid, the power to shape the end result wanes rapidly or even ceases. The producer and the director take control of the process. That is why the script must express a convincing vision and be a clear plan. Successful collaboration between a writer and a director is the basis for good films and television programs. The producer's role is to bring about such collaboration and make it possible by finding financial backing.

The "Script" Writer Is a New Kind of Writer

The invention of the motion picture brought about the need for a new kind of writer. In the early days of silent film, one- and two-reelers could be shot without scripts. The first writing job was to write the title cards and dialogue cards that were intercut with action scenes from time to time. More complex stories and longer films needed a scenario (the precursor of the treatment of today) that was written down by writers who could visualize and write action continuity. Scenario, photoplay, photo-drama, now replaced by screenplay or script, were all new terms to describe this kind of writing. The new visual medium required a new kind of writing that described what was to be made visible on the screen. This new kind of writing had to describe the visual content of the frame or shot. It had to describe sequences of shots that would make narrative sense. It had to be a document that could be used as a plan for production. It required visual writing. It required screenwriting. Seeing how early scriptwriters invented techniques and ways of writing for the screen tells us a lot about the problem.

2 "In terms of authority, screenwriters rank somewhere between the man who guards the studio gate and the man who runs the studio (this week)." William Goldman, *Adventures in the Screen Trade* (New York: Warner Books, 1983), p. xii.

Many of the early writers for the new medium were women. Anita Loos (*Gentlemen Prefer Blondes*) wrote for D.W. Griffith and the Biograph Company. Margaret Turnbull, Beulah Marie Dix, and Marion Fairfax wrote for Famous Players-Lasky.[3] Literary writers of novels and plays were recruited by William C. de Mille to dignify the vulgar reputation of movies, with sometimes disastrous results because writers despised the medium and their main reason for condescending to write for the movies was the money.[4] From today's perspective, it is clear that few people really knew how to do this kind of writing. By the 1920s, the idea of writing for the movies had taken hold, and many phony writing schools were advertising to the public: "No physical exertion required—invalids can succeed. Learn in five day's time. Start to write immediately."[5] Very quickly the need for visual writing that translated to the screen and for writing that anticipated practical production realities led to a new writing profession.[6] In the 1930s, after the advent of sound, the Academy of Motion Picture Arts and Sciences set about finding a standard form for the screenplay.

Everyone who tries to write for the moving picture medium and its derivatives goes through a personal evolution, somewhat as the industry did. You learn about the problem of composing for a visual medium and struggle with finding a form in which to express it. You do not have to reinvent the wheel, just understand why the wheel was invented. Your job is to learn the conventions of the form and layout of a script that the industry has worked out by trial and error. If you do not follow these conventions, you set up barriers to having your work understood and accepted.

WHAT IS VISUAL WRITING?

Everybody has heard the old adage that a picture is worth a thousand words. Visual writing means making images stand for words. For example, a clock face tells you that time is passing. In the classic Western *High Noon* (1952), the characters frequently look at the clock, and the audience sees a cutaway of the clock because the time left before the noon train is a powerful plot element. An outlaw recently released from prison and sworn to revenge is arriving on the noon train. The former marshal who put him in prison, just married and now in a dispute with his Quaker wife before they have even left on their honeymoon, desperately tries to recruit a posse but finally has to confront his enemy alone. Although visual writing for the screen involves description, it is not necessarily descriptive prose with a lot of adjectives. The clock in *High Noon* could be described in two words— CUTAWAY clock. The art director picks the clock to fit the period. We don't need to describe it and say whether it has roman numerals or a pendulum. The clock is a visual idea that communicates the importance of time in the plot and communicates tension and worry in the audience by means of a visual image alone. It is a functional visual idea. An image communicates both by logical deduction and emotional implication. A visual medium makes demands on both by using signs, symbols, and icons. You can tell the bad guys from the good guys in a Western without subtitles. The style of their hats, gun belt, clothes, and facial hair all let the audience know how to understand the character.

3 Kevin Brownlow, *The Parade's Gone By* (New York: Alfred A. Knopf, 1969), p. 270.

4 Ibid, p. 275.

5 One hopelessly inept literary writer, Edward Knoblock, wrote in a script: "Words fail to describe the scene that follows." Brownlow, p. 276.

6 Brownlow, p. 278.

Visual writing means writing and thinking with images that the audience will see rather than words they will read.[7]

How do you write with visual ideas as opposed to writing visually descriptive prose? We are all familiar with descriptive prose:

> In the late summer of that year we lived in a village that looked across the river and the plain to the mountains. In the bed of the river there were pebbles and boulders, dry and white in the sun, and the water was clear and swiftly moving and blue in the channels. The troops went by the house and down the road and the dust they raised powdered the leaves of the trees. The trunks of the trees were too dusty and the leaves fell early that year and we saw the troops marching along the road and the dust rising and leaves, stirred by the breeze, falling and the soldiers marching and afterward the road bare and white except for the leaves.
>
> The plain was rich with crops; there were many orchards of fruit trees and beyond the plain the mountains were brown and bare. There was fighting in the mountains and at night we could see the flashes from the artillery. In the dark it was like summer lightning, but the nights were cool and there was not the feeling of a storm coming.[8]

This visually descriptive opening to Ernest Hemingway's *A Farewell to Arms* is, no doubt, admirable prose fiction. However, it would not work for a film script. The freedom of the novelist to assemble impressions and condense impressions over time (written in the past tense) into a mood or atmosphere that is the setting for characters and action is hard to duplicate in film or television. It is barely conceivable that a moviemaker would reproduce all of these visual images, even in a montage. A scriptwriter cannot assume the freedom that a novelist has. A lot of descriptive imagery is irrelevant to the visual medium. If the nights are cold, saying so in the script does not translate onto the screen; to do so with a line of dialogue would be heavy handed. You have to show someone shivering or putting on a sweater—all very costly in screen time unless critical to the story.

The omniscient narrator is another novelistic device that is hard to duplicate in a screenplay, unless you create a voiceover narrator. In a novel, the narration is verbalized. In a screenplay, it must disappear. Whether you are adapting an existing work or writing an original script, the imaginative challenge is to select a key setting and a key image. Do we choose the flashes of artillery at night? That would be quite demanding to shoot. A script can't deal with the simile of comparing the shell bursts to summer lightning. Do we choose the soldiers marching by raising dust with the crops, orchards, and mountains in the background? This is probably more concise cinematically and requires the right location. If we describe it too closely, the location search becomes impossible. Do we need to see the stream and the pebbles? Do we need to see the dust on the leaves? It is unrealistic for the writer to impose this kind of detail on the production. The director will resist when faced with the concrete task of choosing a location and a camera angle.

Essentially, the script writer has to introduce action. This is true not only for movies and television but also for corporate and instructional programs. The description that sets the scene is usually subordinate to character and action. The art is to combine them. Six pages on and some time later, Hemingway gets to a street scene with characters and interaction. On the seventh page, the first dialogue interchange between the narrator, a priest, Lieutenant Rinaldi, and a captain occurs in the mess hall. Two pages of

7 "Writing for films was a new craft, having little to do with established literary forms. An elegant turn of phrase was of no use in a silent-movie script (unless it appeared as an intertitle). The plot and the visual ideas were what mattered." Eileen Bowser, "The Transformation of Cinema 1907–1915," in *History of the American Cinema*, vol. 2, ed. Charles Harpole (New York: Charles Scribner's Sons, 1990).

8 Ernest Hemingway, *A Farewell to Arms* (New York: Charles Scribner's Sons, 1957), p. 3.

dialogue in which the mood of war is introduced could easily take 5 or 10 minutes of screen time and a lot of money to create with lead actors, a crowd, sets, props, costumes, and locations. Yet by the end of Hemingway's Chapter 2, we barely have a title sequence for a movie. Good novel! Bad script!

A scriptwriter has to invent a visual sequence that condenses background and action in such a way as to advance a story. This could be achieved by a number of devices:

Solution 1: Create an observer. A character could be riding a bike down the road with the scene in the background and the column of soldiers in the foreground. He arrives in the village. The street scene is established. Cut to the mess hall. It is also a visual linking device.

Solution 2: Create a montage. We see quick cuts from artillery flashes in the night. Cut to a column of soldiers marching past. Quick cut to ambulance. Cut to civilians hiding from gunfire. Cut to ripe fruit in an orchard. Cut to Lieutenant Rinaldi in the mess hall.

Solution 3: Use audio to add value to the scene. Interior, night, mess hall, Lieutenant Rinaldi, a captain, and a priest in terse conversation with an American. Between phrases, the sound effect of an artillery exchange rattles the glass faintly from the shock wave of an explosion. Flashes of nearby artillery illuminate the faces near the windows.

Some screenwriters invent scenes in their adaptations that are not in the original work, or even change the plot, often to our great annoyance. Is it laziness? Is it legitimate adaptation? Sometimes what works in a novel doesn't work on screen. A novel can be hundreds of pages long. A feature film is 120-odd pages of script for 100 minutes of screen time, give or take. As we saw earlier, there are plenty of ways to achieve the necessary economy of action. This linking and condensing of actions is visual writing. We might be better off calling it writing with visual ideas. It works by narrating through a sequence of images. The scriptwriter has to think in terms of physical action because everything in a screenplay is seen on the screen. The scriptwriter's job is to describe action as the camera sees it.

When screenwriter Ben Hecht adapted Hemingway's novel for the movie of 1957, he adopted a narrative voiceover technique.[9] Lieutenant Frederic Henry sets the background of the story of the war as we see him return from leave. He walks past a military column of pack mules and a company of Italian troops against a backdrop of the village of Orsino and evidence of war damage. He gets a wave from a girl from the window of a brothel over a local bar before he enters the ambulance pool adjoining the hospital. Now we meet characters, and dialogue between them moves the plot along.

In the final analysis, the solution to adapting Hemingway may be to cut out this opening and start deeper into the story. At this point, you might decide you'd rather be a novelist. On the assumption that you are still open to scriptwriting as an option, let's proceed.

META-WRITING

So the first understanding of visual writing means writing for the media result, providing a description of what the audience will experience. There is another aspect to visual writing called meta-writing discussed in the Introduction. This writing, or perhaps this thinking (sometimes an unwritten concept), often determines the structure of media content. However, it is not necessarily the plot itself, nor the story; it is the visual idea that makes the content work for a given medium. It can be a dramatic conflict for a story, but it can also be the visual idea that makes a billboard work or a

9 Ben Hecht wrote a screenplay for the movie version of *A Farewell to Arms* (1957). There was also an earlier production in 1932 starring Gary Cooper and Helen Hayes.

television commercial succeed. Often it requires a visual metaphor that carries the theme. It is usually embodied in the written creative concept.

To understand this concept better, let's illustrate meta-writing. *Titanic!* As soon as you say the word, you conjure up a major shipwreck, tragic loss of life, survivors—all things that you can see. The love story in the film is a storyline and plot that is superimposed on the meta-writing. *Jurassic Park!* The genetic reconstruction of dinosaurs in an island theme park is a visual idea. The characters and the storyline are superimposed on it and make the environment dramatic.

Meta-writing also has great importance in corporate communications, which often depend on finding a visual correlative for an abstract idea-change, for instance. Although change itself is an abstract idea, it can be understood through visual metaphors such as weather, a river, a speeded-up growth sequence of a plant, or speeded-up sequence of decay. The companion website for this book has a clip for an **EMC Corporation video** on management of information flows. It is made comprehensible emotionally and intellectually by images of water in motion, such as waves, rivers, and waterfalls. So, meta-writing is that writing or thinking that enables the writing of the key concept.

WHERE DO WE GO FROM HERE?

We are ready to look at some of the specific problems of setting down the writer's vision—namely, describing images and sound for production. We will learn how to do so in incremental steps. One way is to reverse engineer a scene from a movie or a television program. From your experience of seeing a scene, turn your role around and try to describe what a production crew would need to know to remake that scene. Even though you don't yet know how to write scripts, trying to do so introduces you to the essential problem. This will start you thinking about how you describe things and how you lay out this information on a page.

A good way to approach this task is to find a movie with a published script and study the way the visuals on screen relate to the script. A word to the wise, however: published scripts are usually postproduction scripts. They are transcribed from the finished movie for distribution, dubbing foreign language versions, and publicity purposes. A postproduction script seldom corresponds word-for-word with the production script, and it is usually written by a person other than the scriptwriter.

DIFFERENCES COMPARED TO NOVELS AND STAGE PLAYS

Another way to isolate the special nature of scriptwriting is to compare it to playwriting. Stage plays do not usually describe action in detail. Stage directors and designers have greater latitude to decide on the details of staging and the blocking. Stage plays assume a constant point of view based on the proscenium stage with a consistent sight line. In contrast, the scriptwriter has to be concerned with physical action and a specific point of view anywhere within a 360-degree compass. Action must be described as it is framed by a camera lens and by a camera movement. The words spoken by characters, the dramatic dialogue, although part of the script, do not present a visual writing problem except perhaps when dialogue stops the action (see a discussion of this issue in Chapter 9).

Plays are not always visual and depend heavily on dialogue. Novels describe emotions. Visual media have to show emotions. So a script is not a novel, though it may be adapted from a novel. It is not a play, though it is sometimes adapted from a play and becomes a screenplay. It is a unique form. A screenplay and many shorter scripts can be original, not based on a source work. Although visual writing means thinking in terms of images rather than describing visual things, visual writing also means leaving out obvious and unnecessary scenes, no matter how visual. The scriptwriter has

to construct visual meaning out of sequences of images, whether he is communicating a corporate message or adapting Hemingway. A writer can also write or compose directly for the visual medium.[10] Such original visual writing for the screen means inventing scenes in your mind's eye that, when strung together in sequence, tell a story.

WRITING WITH DIALOGUE

Colin Welland wrote an original script, *Chariots of Fire*, produced by David Puttnam, about two British runners, Eric Liddell and Harold Abrahams, who competed in the Olympic Games of 1924. *Chariots of Fire* won the Academy Award for best picture in 1982. Here is the scene of a college race in which we meet Abrahams, a main character. Welland introduces the theme of running and competition and establishes the social setting and the social class of the characters in this Cambridge University setting:[11]

```
EXT. TRINITY COURT MID-DAY

                         ROBIN
         Mr. Abrahams—your position please!

HAROLD MOVE FORWARD. A HUSH DESCENDS ON THE COURT. THE CROWD CRANE
THEIR NECKS AS HAROLD TOES THE LINE TO FIND THE BEST GRIP.

                         ROBIN
                 (addressing the throng)
         Owing to the absence of any other
         challenger, Mr. Abrahams will run alone.

A VOICE CUTS IN

                         VOICE
         Not so Mr. Starter!

ALL HEADS TURN—TO SEE, HURRYING THROUGH THE CROWD, HIS COAT THROWN
OVER HIS SHOULDER, ANDY LINDSEY. CROOKED IN HIS ARM IS AN UNOPENED
BOTTLE OF CHAMPAGNE. HAROLD IS AS AMAZED AS THE REST. ANDY TOSSES
HIS COAT TO THE OPEN MOUTHED AUBREY AND THE BOTTLE TO HARRY. HE'S
RESPLENDENT IN ETON RUNNING STRIPE.

                         ROBIN
         Your name and college if you please sir.

                         ANDY
         Lindsey. I race beside my friend
         here. We challenge in the name of
         Repton, Eton and Caius.

CHEERS AGAIN.
```

10 See Paul Schrader's screenplay for *Taxi Driver* (London: Faber and Faber, 1990), and his other writings.

11 Unpublished script of *Chariots of Fire* (1982), written by Colin Welland.

The dialogue, although natural to the characters, advances the plot. The description is necessary to the action. It also sets up an action scene, which creates interest and anticipation for the audience.

WRITING WITHOUT DIALOGUE

Consider the opening of *Bartleby*,[12] a contemporary adaptation of the story *Bartleby, the Scrivener*, by Herman Melville. The images establish an urban setting and the anonymity, alienation, and isolation of the main character.

INT. TUBE TRAIN—DAY

BARTLEBY is sitting next to the window in silhouette. Light rain streaks past the window as the train flashes past London suburbs. The train plunges underground.

 FADE IN MUSIC
 CUT TO:

INT. TUBE STATION—DAY

A train arrives in the station and stops. People pour out across the platform. In the middle, we catch a glimpse of BARTLEBY.

 CUT TO:

INT. TUBE ESCALATOR—DAY

Side shot from parallel escalator descending of BARTLEBY riding up the escalator. He is motionless. The background moves by.

 CUT TO:

INT. TUBE ESCALATOR—DAY

LS of BARTLEBY, one of a line of people riding up escalator. MS BARTLEBY. He is motionless. Most of them are looking straight ahead. BARTLEBY looks towards camera as it descends past him.

 CUT TO:

INT. TUBE STATION—DAY

CAMERA TRACKS and PANS past a long bank of 24 hour lockers coming upon BARTLEBY putting a bag into a locker at chest height.

 DISSOLVE TO:

12 Bartleby, unpublished screenplay, Pantheon Film Productions Ltd., distributed by Corinth Films, New York. See www.focalpress.com/cw/friedmann for complete version.

This visual sequence without dialogue is the cinematic equivalent of novelistic description. Cinematic description is often implied by the setting, crowd, action, and movement of the camera. All good scriptwriters try to write with images and show action.

Some scriptwriting is down to earth. Here is a description of a shipping sequence from a corporate video:

```
MONTAGE OF 55-foot Truck and trailer backing up to a loading bay,
hand signals between driver and bay. Forklift loads the Truck.
Securing for the journey. Shutting the trailer door.
```

This is not inspired prose. It just describes essential action. What it looks like on screen will be decided by the director on location, by the placement of the camera, and by the chance availability of certain trucks and forklifts. Scriptwriting is primarily an art of organizing images and describing action to tell a story or communicate a message.

CONCLUSION

In this chapter, we have looked at how you adapt existing material and invent original writing for a visual medium. Starting with an examination of something familiar, a novel, reveals some of the ways that scriptwriting is different from writing prose. A later chapter deals with more of these issues. There are many other kinds of scriptwriting. Some have particular page formats governed by production methods such as multicamera live production. All scriptwriting involves clear description of action. A hundred years of development since the beginning of motion pictures have led to techniques of writing and a specific camera and audio vocabulary to help do the job. You need to learn these recognized conventions for describing certain recurring visual frames. This subject requires a chapter of its own (see Chapter 4).

EXERCISES

1. Write a description of a short scene from a TV series or a movie so that another production crew could recreate that same scene. Invent your own way of writing a one-page script.
2. Look at a video of a film with a published script and read the script while you study the video. Start by using a silent film, say, a Charlie Chaplin film such as *Gold Rush*. Here are a few movie titles for which you can find a postproduction script: *Citizen Kane, Casablanca, Taxi Driver,* and *The Piano Player.*
3. Select a scene from a play. Try Shakespeare, George Bernard Shaw, and Henrik Ibsen. Identify what would not be clear in the scene for film production. What do you have to add to make a film or television sequence? Can you use all the dialogue? Do not write a script; instead, write an analysis of what would have to change or be added to adapt the scene to film.
4. Write a present-time action description for the opening chapter of Hemingway's *A Farewell to Arms*. Decide how to condense the action. Make a list of shots describing visuals only. Set yourself an objective of no more than three minutes of screen time.
5. Write a present-time action description of the opening of a movie adaptation of J.D. Salinger's *The Catcher in the Rye*. Make a list of shots describing visuals only. Decide what screen time will work.
6. Compare a book you have read with the movie based on it. See if you can identify a key scene in the movie that wasn't in the book. Analyze why the screenwriter chose to add the scene to the

movie. Also look for a scene in the book that wasn't in the movie. Analyze why the screenwriter chose to not include the scene. Find a scene that is in both the book and the movie and examine how the adaptation worked.

7. As an exercise in visual writing, try to create an image or a one-shot scene that communicates primary emotional situations: anger, fear, humor, curiosity, conflict, danger, deceit, hope, or fatigue. The challenge is to show it without words and without literal-minded solutions, such as a close-up of an angry face as a representation of anger.

A Seven-Step Method for Developing a Creative Concept

Key Terms

analytic steps

axiom

behavioral objective

communication objective

communication problem

communication strategy

content

copy platform

creative concept

demographics

ethos, an appeal to ethical values

first-person plural

first-person singular

Friedmann's first law of media communication

Friedmann's second law of media communication

informational objective

logos, an appeal to reason and argument

meta-writing

motivational objective

pathos, an appeal to emotion

present tense

psychographics

public policy problem

seven-step method

target audience

which medium?

Knowing how to describe visuals, sound, and action so that a production team can understand your intentions is the essential task of a scriptwriter. However, knowing this does not help you come up with a program idea or construct a script. How scripts get started is often a mystery to the beginner. One thing is certain—you do not just start describing scenes and immediately write a first draft script. That is a recipe for failure. Scriptwriting is preceded by a great deal of thinking. Once you have done the right thinking, the writing follows. A strong creative concept is the foundation of successful scriptwriting. We now need to outline the steps needed to develop a creative concept.

In the last chapter, we discussed scriptwriting more in the context of entertainment. Now we will look at more utilitarian writing applied to advertising and corporate communications, mainly because the method we are going to outline is more easily applied to this kind of visual writing. The visual media of the twenty-first century are sophisticated communications tools. From their roots in photography and film, they continue to evolve in electronic form with dazzling innovations. To succeed in writing for these new media, we need to see how the choice of the medium and its application result from a thinking process. It is the quality of this thinking process that determines the quality of the writing and the effectiveness of the communication. As discussed in Chapter 1, meta-writing is

the thinking beneath, or behind, the actual writing that supports the visual idea. And let's be clear; this thinking is often written out for the benefit of the writer, the producer, or the client. If you watch a film or video, or even if you read a script, you do not see all of the analytic and conceptual thinking on which it is based. This is the part of the iceberg that is unseen below the surface.

Let's start with an axiom. An *axiom* is an undisputed given from which argument or investigation can proceed. Our axiom states that every program is a response to a communication problem. If there were no need to show, tell, or explain something to an audience, if there were no need to attract, entertain, seduce, delight, or distract an audience, there would be no reason to make a program and, therefore, no need to write a script. Common sense tells us that any program addresses and solves some kind of communication need. Before we can start any job, we have to identify and define this particular communications need. Going through this analysis is not only essential but highly creative. Moreover, it is a method that will always prepare you for any writing job. As you learn your scriptwriting craft, follow the seven-step process described in this chapter. When you are experienced and a proven scriptwriter, you can adopt your own way of defining a solution to a communications problem.

STEP 1: DEFINE THE COMMUNICATION PROBLEM

Most of this method is logic and common sense. The first shorthand question to answer is: "What need?" Sometimes, you will come across the term *needs analysis*, referring to the investigation that discovers a communication problem. Basic communication means that someone (a person or corporate entity) expresses a thought, idea, or message that is delivered via some kind of medium—speech, print, video, interactive multimedia—to a receiver. The message can be designed and sent but not necessarily received or, if received, not necessarily understood. We all experience unsuccessful communication both as senders and receivers. Talking or writing to your friends, family, or strangers, although it could be important, is easy to do and doesn't cost you anything except a telephone call or a postage stamp. Creating, sending, and receiving a public service announcement (PSA), a corporate public relations video, or a training video is a very expensive exercise. Doing it haphazardly or improvising as you go is too risky. Professionals have developed ways of tipping the odds in favor of success by careful analysis and thought about the nature of any given communication problem.

Defining the communication need or problem is the first step. Collaboration is needed between the scriptwriter and the producer or between the writer and a client. When you write for clients, you do so not for your own personal expression or artistic reasons, but to help the client communicate an idea. Until you know what the communication problem is, you cannot begin. Until writer and client define the problem, the enterprise is fraught with hazard. You risk misunderstanding, multiple revisions, wasted money, and, in the end, an unsuccessful result. The seven-step method discussed here is particularly successful for scriptwriting commissioned by corporate clients.

Think of it this way: unless you can identify an audience that needs to know, understand, or perceive something that you, the communicator, want them to grasp, there is no basis for a script or a program. Simply put, you do not know what to say, to whom you are telling it, and why you should demand an audience's attention. Too often, corporate clients decide to make a video or create a website without thinking through what precise problem it will solve. It is important to grasp this basic point: you must think for your client because your client may not have thought through the communication problem . A client can ask an architect to design a bad building without realizing it. A client can ask a producer to produce a bad video without knowing that it will be ineffective. Architects can design buildings that do not solve the problem that led to the need for the building, and producers can make videos that do not solve the communication problem.

Let us illustrate this with some examples. First, we will go through the analysis of the communication problem so as to define the media need. Then we will see how to write the problem down in an acceptable and convincing way. Such a document is an intelligent form of insurance for the writer as well as for the producer or client.

IVY COLLEGE: AN ADMISSIONS VIDEO

Most college students have seen a video made by a college or university to recruit students. There are hundreds of them. Now there are DVDs and videos on websites that provide an interactive opportunity for prospective students to get information. Because many can identify strongly with this particular audience, put yourself in the recruitment video creator's shoes and think about the communications problem for the academic institution. The institution has to think about the needs of the student. What information will satisfy the high school senior's need for facts about the courses, curricula, dorm life, campus environment, sports, or recreational facilities? Is it just a need for information? Doesn't the institution want to project itself to a certain kind of student to differentiate itself from other institutions? Does it want any student at any price? Is there something special about the institution and its traditions? What role should the video play in the whole process of recruitment that involves print media, applications, phone calls, campus visits, and counseling?

How can we define the communications problem? The students who might want to apply to Ivy College don't know enough about the institution to enable them to make a decision to apply or perhaps to make an inquiry about applying. They might not know where it is, what it looks like, what the courses are like, what the other students are like, whether it matches a special interest or requirement. They might not know that Ivy College has a strong program in, say, cellular biology. They might not know things the college wants them to know, or they might want to know things that the college doesn't want them to know.

The question then arises, "What is the objective of the video?" After your audience has seen it, what do you want them to think, feel, or do? Three questions quickly come into play that are closely interrelated: (1) What is the nature of the communication problem you want to solve?; (2) Who is your audience?; and (3) How can you define the successful outcome of that communication, namely, the objective?

Now that several issues are on the table, you have to be able to state clearly what each one is. This means being able to write them down for someone else to read and evaluate. The beginning scriptwriter is typically impatient and wants to get started on the actual writing, and thus may be tempted to brush off the questions that this chapter addresses. Whatever you do, resist the temptation to shortcut the analytic thinking that precedes writing. At the outset of a scriptwriting job, all is promise, all is possible, and you have a great deal of freedom to invent. With each step, the script becomes more and more specific, and has to deliver on the easy promises of the concept you put forward at the beginning. These analytic steps ensure that you stay succinct and on target.

AMERICAN EXPRESS: AMERICAN TRAVEL IN EUROPE

American Express has an interest in the success of European hotels and restaurants that accept its card. American Express is sometimes perceived as an agent taking a percentage of revenue rather than as a contributor to the travel and tourism industry. Its market research indicates that the pattern of American tourism is changing and that the European tourist industry is in danger of losing its market share.

What is the communications problem? It is complex. First, there is a need to communicate information. The client knows something the audience doesn't know. If we tell that audience what we know, they will see a business problem in a different light. They will also change their perception of the client from a passive intermediary to a contributor and a partner. So the second communications problem is to shift perception or attitude. You can measure the success or failure of the speech, publication, or video by verifying the transfer of information and noting any change of attitude.

Next you must ask: who is the audience and what is their current mentality? Unless you can answer these questions, you cannot ever design a successful communication. Even when you answer the question of who the audience is, you still don't know what the content should be nor how you will persuade the audience to see your point of view. If you define your communication problem clearly, at least you can start thinking about the other problems with some hope of success.

In this case, the target audience is European travel professionals such as hotel management staff, restaurateurs, and tourist authorities (but not the general public). Research shows that this audience is somewhat complacent. They think the tourists will keep coming because it is a law of nature, like the migration of elk across the tundra. They are ignorant of American trends and tastes and unaware of competitive destinations. (See the complete script of **American Travel in Europe** on the companion website.)

Let's look at another communications problem.

PSA FOR BATTERED WOMEN

A shelter for battered women wants to make a PSA to reach women who need a refuge from abuse. Although at first glance, the solution to this communication problem may seem obvious, it's not. You know that your target audience is battered women. The beginner may think the solution for this PSA would be to simply tell them about the safe house, including its location. However, there are a dozen different messages that serve different communication needs. Some are purely informational, such as location and contact information for women victims who don't know about it. Your PSA tells them. Communication problem solved! Job done!

But there are also women who are abused who are in denial. Some are in real physical danger. Others may be sliding into a pattern that will lead to abuse. Some have children; some don't. Some are educated; some aren't. Some are afraid and confused; some are aware of the abuse but powerless to overcome their problems.

Suddenly, we realize that a good PSA for one type of battered woman would be unsuccessful for another. A meaningful message for one would be of limited interest to another. The communication problem has to be defined very precisely to accomplish a meaningful objective. One problem might be informational; another might be motivational. You have to get your audience to think and go on thinking. Another problem you might want to solve could be defined by behavior—you want your audience to pick up the phone and call the number you publicize in the PSA. In fact, all media communication can be summed up as a combination of informational, motivational, or behavioral objectives. The mix or proportion of one to the other is infinitely variable. Sometimes one is dominant, sometimes another.

You have almost certainly seen PSAs that address the issues of drugs, smoking, or drinking and driving. All of them involve complex decisions about what communication problem is in play. What is certain is that the problem varies with the target audience. Hence, the objective varies with both. It is like an equation in algebra. If you change the value of one unknown, you get a different answer.

SHELL GAS INTERNATIONAL

An oil company has invented a process that can turn natural gas into lubrication oils at an economical cost. Huge reserves of natural gas exist in both developed and undeveloped countries that are practically worthless because there is no nearby market for the gas; however, there is a market for lubrication products because they have higher value and can be delivered to market at less cost. The decision to buy the process, make the investment, and enter into a joint venture would be made by a handful of people in the world—oil ministers and senior geologists or advisors. The countries involved number about a dozen.

The target audience for this video is going to be about 25 people, 50 at most in the entire world. Contrast that with the audience for a college recruitment video or an exercise video that shows you how to get six-pack abs. How different are the communication problems? How different are the target audiences? How different are the objectives of each video? Until you define the answers to the key questions, you don't stand a chance of writing a successful script. Your interest may be in writing for entertainment media. Although the problems are slightly different, you still need to be able to answer a variant of the same questions. For instance, you need to know who your primary audience is—children, thirty-somethings, women, or youth. Your objective could be to make them laugh or cry. You might intend to write drama, comedy, or documentary. For television you might be writing a game show or a children's adventure or an animated cartoon. All of these have different premises and, therefore, demand different kinds of thinking.

In summary, defining a communication problem is a "needs" analysis of a communication deficiency of some kind. Somebody or some group needs to know something that they don't now know. Having established what it is, you can follow the steps to find a media solution that will tell them what they need to know. Ask yourself why the program should be made. It must solve a communication problem that you must identify clearly. Sometimes people confuse the communication problem with another larger problem that lies behind the immediate reason for making the program. This could be a social problem or a marketing problem, which is the reason for the need for communication. However, the communication problem is not the social problem or the public policy problem. For example, smoking is a public health problem. The objective of public policy is to stop people, especially young people, from getting addicted to nicotine. The communication problem, however, is not to stop people smoking. It is to increase awareness, change attitude, or motivate a change of behavior. It is an incremental step deploying media in a public policy objective. The communication problem is not the same as the public policy problem. Understanding this distinction is critically important yet overlooked or misunderstood by so many.

An antismoking **PSA** might address a specific communication problem, which is that teenage smokers are unaware or dismissive of the health hazard of smoking. They've heard it all before. They dismiss the warnings and believe they are immortal. Getting through this specific problem of denial is the communication problem. Behind it lies a larger social, and public health, problem: persuading teenagers to stop smoking, or not to start in the first place. Beginners often and easily confuse the marketing problem or the social problem with the communication problem. Someone who says the communication problem is the need to show that drinking and driving do not go together is stating an objective, not a problem—not stating the problem but the solution.

Take another topic! What is the communication problem that lies behind a college recruitment video? The person who answers, "The communication problem is to show high school students, mostly seniors, how to apply to college through a video," has not found the problem. The problem is better stated by asking, "What do those who are unsure about the application process to college need to know in order to apply successfully?" Or, "Many high school students are insecure about the

college application process and do not know how to go about applying." That states a problem for which there is a possible media solution.

You can see that several different PSAs could be made from the same generalized premise in each case. Smoking is a social problem or a health problem; domestic abuse is a social problem; college recruitment is a marketing problem. But within these, there are multiple communication problems that will be specific to the programs, define your PSA, and lead to clear ideas about the target audience and the objective.

Understanding what communication problem lies behind a media project is so critical to getting the script right that you should not proceed until you have achieved clarity about exactly what problem you are trying to solve. Once again, let us emphasize that many people confuse the public policy problem or the marketing problem with the media communication problem. We must remember that the role of a media piece, whether a PSA or TV ad or even a corporate video, is often particular and subordinate to a larger communication problem. In almost every case of scripting an ad or a PSA, there is a subtle and critical distinction between the campaign and marketing objective and the objective of the particular piece of media. Even when you are selling a good or a service, the communication problem is almost never to sell the product but to change an awareness that creates the context for selling. If a product solves a problem of daily living or satisfies a need, then the change of understanding, perception, or awareness creates the condition for a sale to take place. All media solutions solve problems that are a subset of a global campaign objective. Get this right and your thinking or meta-writing will fall into place.

STEP 2: DEFINE THE TARGET AUDIENCE

The shorthand question to answer is "to whom?" From the previous examples, you can see it is impossible to talk about any communication problem without bumping into the question who is the target audience? If you change the audience, you change the communication problem, and hence, the objective. We can illustrate this by referring to the 50-year-long campaign against smoking. Beginners frequently make the mistake of stating that the communication problem of the antismoking PSA is to get people to stop smoking. It almost never is. The public policy objective of the whole campaign surely is, but any campaign involves multiple media strategies such as lobbying for changes in legislation; it often takes years. The television PSA has to be focused on some subset of the problem. If you want to warn smokers of the dangers of smoking, you will write a completely different script if you are addressing adolescents or high school students compared to adults or veteran smokers. Getting someone to stop a 20-year-old habit is a different communication task than discouraging a young person from starting. For instance, where adolescents are the target audience, the communication problem could be more accurately and precisely stated—adolescents are not aware how addictive cigarettes are and that smoking to claim maturity and independence is dangerous. Now switch the target to veteran smokers. The communication problem of the PSA, not the public policy campaign, is that addicted smokers do not realize that even though they may have been smoking for years and damaged their health, there is a huge health benefit from quitting that can prolong life and the quality of life.

To illustrate how much the target audience changes the communication problem and the objective, let's play with the variables. It is Valentine's Day. The message is "I love you." You have had an argument with your boyfriend or girlfriend. You want to make up. Suddenly, the message takes on a different weight. How you will communicate suddenly becomes very important. Sincerity is crucial. But some kinds of sincerity are better than others. How the message is delivered is critical.

Try another variation. The target audience for your "I love you" message is your mother on Mother's Day, or your grandmother on her 90th birthday. Does that color the problem differently and suggest a completely different objective? Or your audience is someone to whom you are expressing this feeling for the first time. You have never uttered these words to this person before. Does that feel different? You get the point. Every time you vary the target audience, you change the communication problem and the kind of strategy that is going to make it succeed.

Information Overload

In our day and age, the amount of information presented to us through print media, radio, TV, and, now, the Internet is overwhelming—and that is before you consider deeper levels of information that you can search out in libraries, archives, or online. We all have to limit our intake in order to process it. Thinking about the rate at which an audience can absorb information is key.

➜ Figure 2.1 The Target Metaphor.

You will hear the terms *target audience, primary target audience, secondary target audience*, even *tertiary target audience*. What do these terms mean? The term *target* in this context is a metaphor. You shoot at a target. The idea is to aim at and hit the bull's-eye. Hitting concentric rings on the target near the bull's-eye is less desirable but useful nevertheless, and scores points. Even with the exhaustive research that advertisers do to market products, a certain averaging of audience characteristics is necessary. Dominant factors have to govern your approach. You have probably heard someone say "you can fool some of the people all of the time, and all of the people some of the time, but you cannot fool all of the people all of the time."[1] You can never have a hundred percent of your audience. So you make your judgment and hope that you bracket the largest and most important part of your audience. The others are called the *secondary* target audience. You want them, but you are not going to jeopardize gaining the key target audience to get them. You know that you might lose some of the secondary audience, but the success of your communication does not depend on them.

Take the Ivy College recruitment video discussed earlier. What if your target audience is nontraditional or returning students? What if your video is for a graduate program? Consider an extreme case. What if your audience is openly hostile? A company takes over another company and intends to rationalize the operation leading to layoffs, relocation, and changes in job titles. You are not going to construct the same video as if you were addressing company personnel about pensions or safety issues

1 "You can fool some of the people all of the time, and all of the people some of the time, but you cannot fool all of the people all of the time." Abraham Lincoln, 16th president of the United States (attributed).

in the workplace. You have to address the deep distrust the audience will bring to the company's message. In general, awareness of what the audience thinks, feels, knows, understands, does for a living, does for recreation, and so on could change everything. Their educational level, income, gender, age, marital status, political views, or consumer preferences could flip your approach one way or the other.

Most beginners tend to be too vague about their target audience. Here's an example of a student attempt at defining the audience for a college admissions video:

> My target audience consists of males and females who are interested in attending a small, diverse college in a town on the outskirts of Boston that offers a wide variety of majors.

This is too vague and mixes the statement up with objectives about "majors." In fact, some of the audience might not know they are interested in a small college or in the geographical location. The point is that we want to define who they are. Male and female is clear. They must be high school seniors or graduates. Are they all American, or are there also international students? Income might be a factor for private college tuition. Location is part of the content or the strategy of persuasion rather than a definition of the identity of the audience.

There are two words you need to know about that refer to techniques of measuring and identifying the characteristics of audiences. They are demographics and psychographics. For most scriptwriting, you need to think about both.

DEMOGRAPHICS

Trying to identify the common characteristics of a group of people so that you can define them as a target audience is a professional preoccupation of advertisers, public relations practitioners, pollsters, marketers, television ratings researchers, and more. Millions of dollars are spent on audience research and market research to identify the profile of a buyer or a viewer. Just because you don't have a large budget to commission such research does not mean you can ignore demographics when you try to define who your audience is. You can, and should, do some amateur demographics. A lot of it is common sense.

Let's put down the major characteristics that delimit the nature of a person and categorize him or her as part of one grouping or another.

Age

The age of your target audience will determine both the vocabulary and the devices that will be most effective. You would not use a stuffed animal or a dinosaur character to explain company pensions, but you might use them to warn young children about the dangers of crossing the road. The college admissions video has a fairly well-defined target age. Many other projects do not have well-defined age targets.

Gender

If you could identify a majority female audience, you might opt for a different approach than if it were a majority male audience. You can see this in TV advertising for products with a gender bias such as shampoos, hygiene products, or perfume. A PSA targeting battered women is easier to write because the gender of the target audience is more likely to be women. However, you could write a PSA targeted at male abusers also, trying to increase awareness of destructive behavior. The approach would have to be entirely different. Yet again, women also abuse men although it is less well known,

largely because men do not want to admit it. This would entail a complete rethink of the way to approach the PSA message.

Race and Ethnic Origin

The sociology of race and ethnic origins tells us that groups have identities. There are common cultural assumptions and values that might aid or hinder communicating with these groups. The United States is home to numerous subcultures that might respond differently to certain nuances in language, music, or style. A good example is the campaign by the Milk Marketing Board with the well-known tag line "Got milk?" Translate this into Spanish and you get "Are you lactating?" If your audience is international, the possibilities for cross-cultural misunderstanding are considerable. The most obvious way this could affect your message design is in casting. You might want the actors in your production to be representative of a minority group. A recent TV recruitment commercial for the U.S. Army showed an African American youth with his mother. He says that it is time for him to be the man now. Interestingly, this ad implies that we are seeing a stereotyped single parent family presumed to be prevalent in this demographic. Moreover, the ad is clearly pitched at a disadvantaged racial and economic demographic. The target is race.

When Wal-Mart started doing business in Germany, the greeters who approach shoppers at the entrance to Wal-Mart (the smiley face) offended Germans, who complained to management about being approached and harassed by strangers. In the United States, people are more familiar and personal with strangers than in Europe. American sales personnel and telephone marketers call you by your first name, which Europeans consider a breach of etiquette that is offensive. There are regional differences in the United States. This is often exploited in advertising food that is regional, for instance. A Southern accent might sell the barbecued spare ribs or the sauce better than a Boston accent, which might give a New England clam chowder an identity.

Education

The educational level of an audience governs the vocabulary you can use, the general knowledge you can assume, and the kind of argument that will be readily understood. When writing a corporate video for Shell that is aimed at decision makers in petroleum-producing countries, you can assume a certain level of language and concept, but you have to know the difference between an audience of geologists and an audience of ministers or high-level civil servants who are not scientists. The larger the audience, the lower the educational denominator is likely to be until you reach a national average.

A pharmaceutical company making a video about a new cholesterol-lowering drug aimed at cardiologists has a very high educational demographic. If the video is aimed, however, at the eventual users of that same cholesterol-lowering drug, the demographics change. The patients, who are likely to use the drug, cut across the educational demographic and would be less educated and knowledgeable than the doctors who prescribe to them.

Income

Advertisers have studied socioeconomic classes intensively so that they can define their characteristics. You may have heard of the letter classifications that designate income, with "A" being those people with the highest disposable income. Income is usually associated with professional occupations. Wealth might correlate with a political bias toward conservative views. You want to advertise expensive cars, perfume, and cognac to the group of people who have the disposable income to afford the product.

In the final analysis, most audiences are defined by complex variables. Whatever you can do to narrow down the classification of your audience's cultural preferences, disposable income, or cultural attitudes will help. Advertising and public relations practitioners maintain large departments devoted to audience research and demographics.

PSYCHOGRAPHICS

A concern with psychographics means worrying about what is going through the mind of your target audience. So just as you can classify the social and cultural characteristics of a person, you can also identify attitudes and mental outlook or state of mind. A person's attitude might overwhelm the demographics for certain messages. Most people are driven by emotions to a greater or lesser degree. How they feel governs how they act and how they respond. Visual media such as film, video, and television communicate emotionally. For one reason, they show the human face and figure with all the body language and nonverbal communication that people intuitively understand. They tell stories that invite emotional responses. They use visual images that signify emotions or engender strong emotional responses. An image of an explosion or a plane crash provokes awe, fear, and fascination. Think of an image of a hydrogen bomb going off with its signature mushroom cloud, or the dark vortex of a tornado touching down. These images compel attention.

Think about the ways that audiences can be "turned off." The very phrase is a metaphor. A knob or a button on a radio or television set or remote control gives the user the power to interrupt the transmission or switch to another channel. Even if you were strapped to a chair and left in front of a television with your eyelids taped open, your attention could wander or even switch off entirely. We all have a "turn off" function in the brain, and we have filters that screen out what we don't want to hear. If you are distracted by an argument in your living room, you will not hear an advertising message. If you are intent on reading a personal e-mail or playing a video game, you will not hear what someone says to you. We have the capacity to pay attention selectively to what is important to us at the moment because of instinctual, primal fight or flight responses: "In complex vertebrates, including humans, the amygdalae perform primary roles in the formation and storage of memories associated with emotional events" (Wikipedia, Amygdala). Emotional appeal plays a significant part of media content, especially advertising.

Corporate television and video often play to captive audiences. Unless the program designers give thought to the psychographics, they will lose the audience because of the "turn-off" switch in their brains. A client once argued to me that his internal corporate audience of middle managers was paid to watch the program we were making, and he therefore rejected my imaginative ideas to motivate them. This person did not understand psychographics. Audience response involves passive assent at a minimum. A stronger posture would be neutral consent. Even more positive would be getting the audience to actively seek and participate in the experience of the program in a way that involves a level of enjoyment.

Students sometimes tell me that a certain subject is boring to write about. My reply is always that there are no boring subjects, only boring writers. As a scriptwriter, I believe, and you must believe, that there is always a way to reach an audience. This is especially true for corporate communications.

Safety is a huge problem that costs corporate America millions of dollars. Companies are strongly motivated to reduce insurance premiums and lost workdays by communicating safe work practices. This subject probably sounds boring to you, but if you are a good scriptwriter, you can find a way to make the topic watchable. The point is not whether you would choose to view a safety video on how to use ladders at home on a Saturday night and invite your friends. Nevertheless, in the right context,

at the right moment, many outwardly uninteresting subjects become relevant to what you need to know in your job or in your life.

Video Arts is a company that has made millions out of videos on management training often written around a comic character played by John Cleese, the Monty Python actor. The videos are often funny and clever. The audience swallows the message with the comedy and remembers it. Delivered as a straight message, the audience might reject that which it willingly accepts when presented with humor. This is applied psychographics.

Emotions are complex, volatile, and difficult to categorize. For these reasons, psychographics is an art rather than a science. You don't have to be a psychologist or psychic to make use of psychographics in your writing. Once again, a great deal is commonsense deduction. You can analyze your audience's psychographics by putting yourself in its shoes. You can investigate your own feelings and attitudes to extrapolate what is likely to be shared by another. You have to be self-aware and self-analytical. Your own strong preferences might not represent the masses. Your taste in music, whether it's Mozart or Marilyn Manson, Handel or heavy metal, seems right to your ear, but it may turn off a large segment of your audience.

This, incidentally, makes it difficult to choose music for a sound track. Surprising successes can result from daring choices. For example, *2001: A Space Odyssey*, Stanley Kubrick's classic film, made a huge audience listen to and appreciate a modern classical composer, Richard Strauss. This mass audience probably didn't know the name of the composer or the name of the composition, *Thus Spake Zarathustra*, or that it was played by the Berlin Philharmonic conducted by Herbert Von Karajan, but they responded to the music. Now most people instantly recognize the theme. The theme was imitated and copied and jazzed up and played on different instruments. Millions hummed it. Another example was the huge jump in sales of a Mozart piano concerto (No. 21, C major, K. 467), whose slow movement was used in the sound track of a Swedish film, *Elvira Madigan* (1967). People who would normally never listen to or buy a recording of Mozart were sending this record off the charts because the director made them experience the lyrical and romantic feeling of the music. All this is to remind you that you have to use intuition. Sometimes you have to go beyond the obvious, the conventional, and the predictable to tap into the receptivity of an audience.

What are the main psychological issues that make up a person's mind? They are things you know about already.

Emotion

We all have moods and sensations that are colored by emotions that range from down or depressed, sad and anxious, to happy, elated, playful, or wild. Individuals have emotions; groups have emotions; and crowds react with emotions. Most rock concerts are exercises in crowd mood creation. Emotions are tricky and volatile, especially when crowds are involved. An audience is sometimes a crowd and sometimes a large number of individuals in a serial response to a program. Think of a book that has sold a million copies. The audience is large, but each one of that million encountered the book individually. They do not all gather in a stadium for a mass reading, whereas the audience for a movie made from the book is a different entity still sits together and experience the same moments together, perhaps laugh together or cry together. Even a television audience is a simultaneous mass audience of single viewers or small groups of viewers. Even though movie and television content is distributed digitally across many platforms for individual viewing, social media build second screen dimensions that bring individuals together as a virtual group audience. We will discuss this in Chapter 14.

As a scriptwriter, you have to deal with emotions, with the anticipated emotional response of your audience. It is almost always important to communicate emotionally to an audience in the

visual media as well as by reason and logic. The mixture varies with the nature of the communication. Dramatic narrative tends to work through emotional communication, whereas documentary or training videos lean on logical argument. Getting battered women to use a shelter probably requires reaching the audience through emotion rather than reason. The selling of Shell's natural gas conversion process, in contrast, should be based primarily on logic and rational exposition.

Attitude

An audience frequently has a particular attitude that will color their impressions about any given topic. For example, consider these different audiences:

- After the Rodney King beating by four Los Angeles police officers, you have to write a police PR video about police and community relations in the inner city. Simply put, your audience is going to be hostile. You cannot make a move without dealing with the open distrust and skepticism that will block their hearing what you want to convey.
- After a school shooting with dozens of innocent victims, you want to oppose greater gun control and make a second amendment argument for assault rifles with 100 round magazines when the population at large is in shock.
- A company has undergone a merger. People are fearful of losing their jobs, their seniority, or their pensions, and they are distrustful of their employer.

In all three situations, you cannot proceed without taking into account the attitude or psychographics of the particular audience and the context of your communication.

The opposite condition can arise. Audiences can be receptive as well as hostile. Let's say you are writing a recruiting video for an elite volunteer military unit such as the Marine Corps or the Green Berets. You are probably preaching to the converted. If they are watching, it's because they are already thinking about joining the military. You don't have to break down mistrust, skepticism, or hostility. You do not design the message to turn pacifists into warriors.

Yet other audiences are neutral or indifferent. They do not bring a strong predisposition, negative or positive, to the table. You have to wake them up or arouse interest or curiosity by your images and your creative ideas. It seems constructive for a scriptwriter to think carefully about whether his audience falls into one or other of these categories—receptive, hostile, or indifferent.

The importance of psychographics cannot be emphasized enough. The attitude, outlook, and mental receptivity of your audience are critical. I have read too often the dismissive and lazy statement of beginners that this PSA or this program includes all ages, all genders. The broader the message, the less effective it will be. Let me introduce Friedmann's first law of media communication. It states that the effectiveness of a message varies in inverse proportion to the size and breadth of its audience. That means that as an audience increases in size, the chances of including every member of the audience in your communication falls off or decreases proportionately. It is easy to grasp the psychographic and demographic of an audience of one. If the audience doubles, the effectiveness is going to be halved. If multiplied a hundred times, it is going to be one hundredth as effective. The relationship is not mathematically precise because as the size of the number increases some changes are barely noticeable.

Friedmann's second law of media communication is that the simplicity of the message must be in inverse proportion to the size of the audience: the larger the audience, the greater the need to simplify the content to reach the lowest common denominator of any given audience. An extreme example is a Stop sign. An Exit sign is another. The only audiences excluded from this message are children who cannot read. Even they might get the meaning from the color red. That's why a message for an

audience of one is the most effective. It is addressed to you and you alone. Every increase in the size of the audience reduces to some degree the effectiveness of the message. We all practice this principle every day. If we are talking to one person, we think and speak differently to when we have to talk to a group. Teaching an individual is easier than teaching 20, 40, or 100. The congruence of an audience of one with its message must generally break down. That is why all junk mail tries to personalize a letter by using your name in the text. It creates the illusion of an audience of one. Clearly, the way to overcome the decay in effectiveness of the message or communication to a mass audience is to find the common denominator so that you reduce the fraction to get as near to one as possible. Attention to the demographics and psychographics moves you in that direction. Clearly some messages can be more effective when matched to an audience demographic and psychographic than when watered down for all. Take drinking and driving. A teenage or college audience has a completely different psychographic than a general audience. The first audience basically considers itself bullet proof, immune to death, disease, and misfortune.

The best way to test yourself is to ask whether you can describe that audience profile. Can you say who is not part of that audience? Can you carry your defined audience through the program? Can you connect it to the communication problem? You are now answering the question "to whom?" So now you've got a shorthand guide—what for, and to whom? Next we need to answer the question "why?" Answering "why?" means you can define the objective for the video or program.

STEP 3: DEFINE THE OBJECTIVE

The communication objective is closely associated with the communication problem. One states the problem, the other states the outcome. So if teenagers do not appreciate or understand the health hazards of smoking, which is the problem, the objective is to change their perception of smoking. The shorthand questions to answer are "why?" and "what for?" In military terms, an objective would be to capture a position or to win the battle. The larger objective is always to win the war. The objective is usually easy to see. The hard part is knowing how to obtain it. The same is true of scriptwriting. In business terms, an objective would be to achieve a 10 percent increase in sales or a 5 percent decrease in costs. These objectives are clear. The hard part is how to achieve them. Likewise with scriptwriting!

A TV program, film, or video must have an objective that is clear. It is the net result that you are working to achieve at the end of the viewing—the message. It is what the audience is left with as a general effect. A lot of programs are meant to entertain. That is too general. Entertainment can mean many things. Comedy is designed to make the audience laugh; drama, to make the audience worry; romance, to make the audience fantasize; horror, to make the audience fearful; and so on.

Many programs do not have an entertainment objective. The primary objective could be to impart information. That is not to say they are not watchable or entertaining. Lots of programs try to give you facts and figures, for example, about products, countries, health issues, the environment, or the life of an animal species. You assimilate information from the program that you did not possess before watching the program. You may have had other experiences during the program, but taken as a whole, your main acquisition is that you know something or understand something you didn't know or understand before. The objective of the program was to convey information. What is the primary objective of your script concept? An informational objective appeals to the reasoning side of the brain.

Another common way to design a visual communication is to think about shifting the audience's attitude or point of view. Information might also be part of the package, but the primary net result you desire is to get the audience to see things differently. For example, you can communicate a mountain of facts about the dangers of smoking—how many people die of smoking-related diseases, a list of the negative consequences of smoking. A thinking person might draw conclusions. Almost anyone

can draw the conclusion that smoking involves a serious risk to health. Nevertheless, many of those people will dismiss the communication and not change their thinking, let alone their behavior.

So facts and information alone won't work. You have to get the audience to acknowledge the facts and infer consequences for an individual's health. A nicotine addict has already been bombarded with facts. So try another approach! Turn facts and figures into graphic images that will disturb the audience. Make use of drama and imagination to get the audience watching! Let the audience draw its own conclusion.

How would you respond? Not with your head! Images bring your emotions into play. You are forced to see something commonplace in a smoker's daily life in a different context. If you are a smoker, you might be disturbed. You might start seeing your habit differently. Your attitude could shift. If the shift is strong enough, it could be described as motivating. The word *motivate* comes from the Latin root meaning "to move," and so does the word *emotion*. If emotions are affected in a coherent and sequenced fashion, the result is motivation—a motivational objective. Most advertising depends on visual stimulation of the emotions to shift attitudes. This is sometimes known as the *soft sell*. The challenge is to create a sequence of images that compel the viewers by their responses to lead themselves involuntarily into a position from which they cannot go back.

Apply this to more complex problems. You have to make a 15-minute video that communicates safe handling of materials in an industry or explains how to drive defensively. Or you have to make a 10-minute video that persuades the audience to recycle. In this communication problem, your objective is slightly different. The difference is that you not only want to motivate the audience, you also want to activate them. You want them to do something—to put their bottles and cans and plastics into receptacles for collection. This is the most demanding objective because you want to change their behavior. A lot of marketing videos (not TV commercials, as you will see in a later chapter) try to do just that. We have now defined an action objective, commonly called a behavioral objective.

Let's revisit our examples. For the anti-smoking campaign, the objective is to make high school teenagers think twice about getting addicted to nicotine. For the women's shelter PSA, the objective is to encourage battered women to seek counseling and assistance. For American Express, the objective is to get European travel professionals to think about their tourist product for American tourists and whether it corresponds to what those customers are looking for. For the college application video, the objective is to get a high school graduate or senior to call admissions and ask for an application. For the Valentine's Day "I love you" message, the objective is to get your estranged girlfriend or boyfriend to let bygones be bygones and come back to you.

In every case, you can make a definite and specific statement about the successful outcome of the communication. Until you can do that, you will never write a successful script to solve the communication problem because you haven't thought about what you are trying to achieve.

One way of defining an objective is a change of knowledge, perception, or awareness. Once you have learned that Santa Claus doesn't exist, you cannot go back to a state of consciousness in which you believed in Santa Claus. Your childhood is in some sense over. Similarly, once you know something about smoking or using drugs, you cannot restore your mind to a previous state when you did not have that knowledge or awareness like we can restore a computer to a state before a virus infection or before some undesirable alteration of its operating system. If you can achieve that change of consciousness in an audience, you have succeeded in putting in place the foundation for all subsequent thinking and, eventually, action. So the motivational awareness induced by an antismoking PSA is the prerequisite for the action of a change of behavior—quitting. In other words, your behavioral objective is engendered by the motivational even though it is not directly targeted.

We now have three clear steps for developing your creative concept: (1) Define the problem; (2) Define the audience; (3) Define the desired result or objective you are working toward. Completing these three steps does not finish the job because you have yet to answer the question "how?" In other words, how are you going to solve the communications problem, reach the audience, and achieve the objective?

STEP 4: DEFINE THE STRATEGY

The shorthand question to answer is "how?" To write a successful script that solves the communication problem, we need to figure out how to achieve the objective, reach the target audience, and suggest the content that leads to effective communication. This is a moment of creative challenge. If you want an audience to think, feel, or act in a certain way, you have to have a communication strategy. A military commander plans to pound the enemy position with artillery, then divide his forces into two groups who will attack from different directions. A marketing executive has a plan to increase sales by offering an incentive such as a 2-for-1 sale or a free baseball glove with every full tank of gas. How are you, the scriptwriter, going to achieve your objective?

Attention Span

How long does it take you to change the TV channel if something doesn't catch your interest? You have been pampered all your life with a multitude of choices. If you don't like something, you switch to another channel, or you switch off the TV. Now you are on the other side of the game. You have to hold your audience by the pacing, content, and imagination of your script. They have the remote control. Andy Warhol, the controversial American artist, made *Sleep* (1963), a 5 hour and 21 minute film of the poet John Giorno sleeping. Needless to say, it did not have a large box office. Two of the nine people who attended the premiere left during the first hour (Wikipedia, Sleep (film)).[2]

Think about how network news programs try to keep you interested with little previews and announcements about what's up next. They use good-looking anchors who smile at you through the lens and seduce you into staying with them. How many times do you hear the line "Don't go away?" You can't give frequent-flyer miles to your audience for watching. So how can scriptwriters get the job done? They think up strategic ways to hold the attention of the audience while they deliver the message. For example, they use humor, a story, suspense, shock, intrigue, unique footage, a testimonial, or a case history. Everyone will listen to a joke. If the joke has a clever point, your audience will get the message while they laugh or chuckle.

Many ads use humor. One ad that captured my attention even though I am not a dog owner shows a dog and a man sitting in front of one another. The dog is training the man to balance a piece of cheese on his nose and on command flip it in the air and eat it. Reversing the roles of dog and man and having the dog talk captures people's attention with a smile. You will remember that brand of dog food.

Communication strategy involves getting the audience's attention by humor or shock so that you can deliver a packet of information or an idea. We can draw on an understanding that was articulated by Aristotle in his *Rhetoric* over 2,400 years ago. You can sum up strategy by noting that it almost always relies on pathos, an appeal to emotion; or on logos, an appeal to reason and argument; or on ethos, an appeal to ethical values.

STEP 5: DEFINE THE CONTENT

The shorthand version of defining the content is to ask the question "what?" What are we going to see and hear on the screen? What is the program going to be about? What happens in the story or narrative of the program? Clearly, the content cannot be defined first. You may well

2 An 8-hour version (1964) shown in Los Angeles caused a near riot. It was a rebellious stunt by an outrageous artist.

argue that you can define the communications problem, the target audience, and the objective in almost any order. However, they must all be defined before you can designate content. In fact, you really need to have some kind of strategy or creative device to make it all work before you fill in content.

Content is what you see. Content is what your program is about. It is the objective matter or substance of the piece. When a program is shot, the camera has to be placed in front of something to capture its image. The script has to describe what is going to be in front of the camera. How it serves the communication objective may not be apparent from shot to shot.

We can illustrate this by revisiting the several script ideas we have discussed throughout this chapter. In the college recruitment video, the content could be described by a list of the things we are going to shoot: classrooms and teachers, dorm life with students, sports and extracurricular activities. From this list, you can quickly see that content does not often define what is unique about a program. This list could cover hundreds of recruitment videos, if not all of them. What makes one different from another is the strategy and the creative concept. In the natural gas video, we have to show the process. In this case, we could shoot a pilot plant and show the process working. In the American Express video, the content relies on testimonials and shots of the type of tourist setting that market research shows is appeals to American tourists.

STEP 6: DEFINE THE APPROPRIATE MEDIUM

The shorthand question to answer is "which medium?" All media have particular qualities and peculiarities that give them strengths and weaknesses. What works for film on a large screen projected in a darkened room might not work on a 21-inch TV screen. The intimacy of the television image would not work on a 40-foot movie screen. Dense information that should be presented in the form of graphs works in a slide show but not on video. Training benefits from interactive self-paced learning, which works better on a DVD or a website module. In short, the concept we devise has to work for the medium, or we have to pick the medium that will work for the concept. We have to write so as to exploit the special advantages and qualities of the medium.

Interviews work well on television and video. Action and long shots work better in film. Corporate clients frequently ask for communication objectives to be put into a video that clash with the medium. For instance, a detailed instruction about how to install a piece of equipment is better done in print. An audience is not able to take in written instructions on a TV screen. They won't remember them. In print, you can look at a page as long as you need to and refer back to it whenever you like. If the communication has a long shelf life, an interactive CD-ROM would work better than linear video programming and possibly better than print. A small TV screen won't work at an exhibition or a trade show. You need something that commands attention visually. A video wall of nine or twelve programmable TV screens does the job.

What makes a PSA for television different from a PSA for radio, for instance? A student of mine wrote a PSA on domestic abuse that, although conceived for video, worked successfully as a pure audio script. It was only secondarily a visual script. The creative idea is a sequence of spoken statements that compels an audience to think. The message is carried in the spoken voice-over more than in the images. Although it also works with visuals, the test is to take the images away and see if it works. A visual concept and visual writing relies on a sequence of visual images: Although the images have been visualized, you can hear this script. It relies heavily on the spoken commentary. You can easily imagine this as a successful radio commercial. Visual ideas work best in a visual medium.

```
INT. BEDROOM—DAY

CAMERA PANS ACROSS A SMALL
BEDROOM, PAUSING BRIEFLY TO
SHOW THE BROKEN GLASS AND
SHATTERED TABLE STREWN ACROSS
THE HARDWOOD FLOOR. BROKEN
PICTURE FRAME HOLDING A PHOTO
OF A MAN AND WOMAN KISSING.

CUT TO WINDOW WITH RAIN
FALLING AGAINST THE GLASS.

PAN DOWN TO WOMAN SITTING ON
THE FLOOR HOLDING HER KNEES
TO HER CHEST, SHAKING.

SUPER TEXT: HOTLINE 800
NUMBER.
```

```
MALE V.O.
A woman is beaten every fifteen
seconds.

FEMALE V.O.
Which means … every minute,
four … women are beaten, …
every hour 240 … women are
beaten … and every day 960 …
women are beaten … and every
week, 6,720 … women are beaten.

MALE V.O.
What did you do last week?
```

This PSA is not essentially a visual communication. It works perfectly well as an audio only message. You need to ask yourself whether your idea is visual. But print, billboards, and posters can be visual. The question to answer is why this idea will succeed and come alive uniquely in the video or/television medium as opposed to putting it on a billboard or print ad, or creating a website. So if it is going to be for television, ask what are the values that make that medium work. First, there's color. Do you use color? Then there's motion. Do you exploit the moving picture medium, or are you running a slide show on television? Do you use emotion? Do you have stunning graphics or animation or special effects? The fewer of these elements present in your concept, the less likely it is to be an effective television commercial or PSA! At this point you could ask whether you should be working in another medium. Some campaigns use several media and vary the concept to suit the medium. Although the Milk Marketing Board *Got Milk?* campaign has been seen on television, it probably works best as a billboard because you can convey the essence of its visual idea in a still—the milk moustache on a celebrity—that can be read in a matter of seconds as you drive by. The visual idea is so strong that you could take away the text and the audience would still understand the idea even though they are there to reinforce one another.

STEP 7: CREATE THE CONCEPT

The seventh step is to create the concept. You are thinking: "That's enough. Let's get started. I've done my homework." Not yet! Before you take the seventh and final step, you should answer these questions in writing so that they are crystal clear. You may get impatient with this method and resist going through this analytic prewriting process. Rest assured that any problem that shows up in your script concept will be traceable to your prewriting process. Addressing these six questions is the most important realization that you can have at this point. It will enable you to generate creative ideas. Now the hidden process of writing comes out into the light. This arc of ideas that lie behind the

creative concept is meta-writing. This writing is the creative thinking that will be embodied in the final production document.

Before we go to the final step, let's review the sequence of analytic thinking. The order of analysis is ideally as follows:

1. Define the communication problem (What need?)
2. Define the target audience (To whom?)
3. Define the objective (Why?)
4. Define the strategy (How?)
5. Define the content (What?)
6. Define the appropriate medium (Which medium?)

The seventh step is the seed of your script. Let's call it the creative concept or, if you want, just the concept. This is the first visible step of the scriptwriting process. In a professional assignment, you may not write out all of the thinking you did to answer the six questions although it is common practice to write out some response to a client's communication problem. I like to set down my thinking for all scriptwriting assignments that are not entertainment so that my client will buy into the thinking that lies behind my creative idea. So now you are going to explain in writing to your client, producer, or director what the key idea is, what the approach is, and how you will use the specific medium to make the communication work. This creative idea or creative concept will solve the communication problem, reach the target audience, achieve the communication objective, embody the communication strategy, provide the content of the program, and show how it will work in the chosen medium.

To some extent, almost anyone can go through the six steps and get to reasonable answers to each of the questions. In the advertising world, this is commonly referred to as a *copy platform*. The copy platform format is slightly different from the visual media format because it will involve a product and a summary of its benefit or selling points; however, the rationale is the same: think through the communication before writing copy. And so finally we come to the creative embodiment of all this preparatory work. The seventh step—devising a creative concept or device that will translate all the answers to the six questions into a working script—is different. It is a creative task, not an analytic task. It is the work of a scriptwriter's imagination. This is the source of freshness, originality, clarity, and visual intelligence that makes a program compelling or pleasurable to watch. This creative task is hard to explain and perhaps harder still to teach. This is the imaginative talent that you get paid for.

From this concept your script will grow or die. Until you have a convincing concept or proposal that addresses all of the issues expounded in this chapter, you shouldn't continue. No professional would. You might pull it off for one assignment because the topic is congenial to you. Don't let yourself rely on luck. You will be digging the grave of your scriptwriting career. Succeeding in this business is about consistent results, producing again and again whether you are inspired or not. It is about becoming a pro. Confidence comes with practice and experience.

We have kept up a running discussion of several communication problems. Now we can float some creative concepts for them. Just in case you are unsure of what creative concept means, let's clarify. Everything we've discussed so far—the "need," "who," "why," "how," "what content," and "which medium" issues—still doesn't give us images or actions to describe from scene to scene or a way of approaching a topic. The trick is to come up with creative ideas that encapsulate all of the definitions for a particular medium. One of these ideas will translate into a living, breathing visual idea that will make a script.

SEVEN-STEP QUESTIONNAIRE

Many people do not honestly and effectively answer the seven questions. They mix up issues belonging to each area and end up with a less than clear reasoning for a strong creative concept. So here are some of the questions you use to double-check whether you are genuinely answering the primary questions of the seven steps:

Step 1: What Need?

1. Have you stated a problem for the potential target audience in terms of something they do not understand, don't know, don't want to know, or could not know until you tell them with your video or other communication?
2. Have you made the common mistake of substituting for a communication problem a social problem or a public policy problem?

Step 2: Who?

1. Have you stated all the demographic characteristics of your audience? Have you evaded the question by making a lazy, general statement?
2. Have you addressed the all-important issue off psychographics?
3. Have you asked yourself what the mental and emotional state of your audience is?

Step 3: Why?

1. Have you stated an communication objective that is informational, motivational, and behavioral, or some combination of those?
2. Can you see that the objective is the reverse side of the coin of the communication problem?
3. Could you have put the objective down as the problem and ended up repeating the objective in the third step?

Step 4: How?

1. Does your idea achieve the objective?

2. Does your idea get the attention of the target audience defined in step 2?
3. Does your idea get past the defenses of the target audience defined in step 2?
4. Is your idea visual, a visual metaphor, and one that completes itself in the audience's imagination?

Step 5: What?

1. Is the content about the objective?
2. Is the content, action, or activity something that uses the visual medium?
3. Does this description of the content preempt and take away from the creative concept?

Step 6: Which Medium?

1. Is the idea dependent on visual qualities that are unique to the moving picture medium?
2. Have you relied on talking heads or voice commentary to a degree that misuses the medium?
3. What is visually unique about this idea that means that this cannot be produced in print, on radio, or for a billboard, poster, or any other static medium?

Step 7: What Is the Creative Concept?

1. Does your creative concept test out against all the questions for the six prior steps?
2. Are you writing down the driving creative idea?
3. Are you summarizing the content and, in effect, writing a treatment before time?
4. Are you pestering the client/producer with camera directions that don't belong?

Some ideas sound great but don't work out in practice; so you have to test them. If you are writing a college recruitment video, how are you going to avoid the predictable shots of campus buildings with voice-over superlatives extolling the praises of the place? You're creative. You wake up one morning with a brainstorm. You'll do the college recruitment as a Broadway musical. You can see it now—a chorus of coeds singing and dancing instead of a boring voice-over. It's entertainment. The audience will keep watching. It's creative, but somehow it's not right. The idiom doesn't suit the target audience. Ignore the fact that it will quadruple the production costs. The problem is that the creative concept runs away with the communication objective. The concept doesn't serve the objective. Maybe you could use a team of cheerleaders that relates to college life. Better! You lie in bed wondering how you're going to crack this one. Suddenly, you jump up, hit the word processor, and type out your idea. Use your own experience to show the audience what a typical day is like, perhaps with a bit of embellishment to work in all the points you want to make. So this will be . . . a day in the life of an Ivy College student. That gives you a concept that provides the content, the structure, and the objective. It will give the target audience a character to identify with. Any leftover points could be carried by a commentary voice-over.

Most beginners make the mistake of thinking their first idea is the only idea and the one to work with. You should put down at least three different creative concepts for the job, test them out, and then pick the best. So we still have one to go. What would be another way to get at this objective? How about a student who comes on campus and, through a series of interviews, which we carefully craft to reveal the information we know to be necessary, finds out everything about Ivy College?

How do you choose between them? One way is by pitching them to a client, or the class, or your instructor. Another is by your feel for how well the concept will play out through the detail of the content. There are usually trade-offs. Interviews may be good, but scripting them makes them sound stilted and false. On the other hand, how do you know that you'll get what you want if you film unscripted interviews? There's a risk. If you define the six questions with integrity and try out creative concepts, you will isolate a creative concept that works.

The communication problem for American Express was to convey the fruits of its market research to its target audience so that audience would shift its erroneous perception of American tourists in Europe. The research defined categories of travelers such as Grey Panthers, Business Travelers, and Adventurers. They all had different ideas about what they wanted to find in Europe. It was apparent to the writer that the audience of European tourist professionals was complacent and needed to be persuaded by undeniable evidence to change their point of view. In this case, interviewing dozens of each category in unscripted video recordings at an airport yielded enough evidence to corroborate the published market research. It was expensive and risky, but it paid off. That's the nature of a creative business. It involves risk. That's part of what makes it exciting to be a scriptwriter—to have an idea and see it working in a finished program.

We also mentioned the oil company with the process to convert natural gas to lubrication oils. A hundred million dollars (more in today's money) had been spent over 10 years in research. A pilot plant had been built in Amsterdam to prove it worked. Here the problem was to get scientific and technical information into a form that would be comprehensible and convincing to the small audience of decision makers. The creative concept that worked was governed by the fact that there was a lot of archive footage that had to be used. The solution was to tell a story—a news story. So the script was built around a current affairs format with an actor playing an investigative reporter talking to the camera and taking the audience through the story. It enabled the stock footage to be bracketed with an explanation. It made the patented process sound like a suspense story. It gave a structure and a variety to difficult material. It became an investigative documentary that took the audience to the conclusion, which was essentially the selling proposition.

How about a creative concept for a Valentine's Day message? This is to get your imagination going. Don't send a card. It's predictable and conventional. You telephone your girlfriend. You say, "Look out the window up at the sky!" A Microlite is flying around trailing a banner that reads, "I love you, Mary Jane. Will you marry me?" Outside your budget? Go to the exercises at the end of this chapter and try out some of your ideas.

To finish, let us bring it all together and write a document that sets all these issues down. Sometimes, you need to do this for a client as a first step. Sometimes you need to do this for yourself to prepare for your concept. There is no fixed format or industry-wide convention for doing this. A simple solution is to use the headings we have used in this chapter.

A word of warning before we write it out! Write in the present tense! Never use the future tense in media writing! If you use the future or the conditional, you put off the prospect of the PSA, ad, or corporate video being real before you've even begun. By using the future tense, you introduce into the mind of your reader that (the future always being uncertain) this may not happen. You appear to the reader to have less conviction about what you are proposing than if you write as if it is happening now. You can see it, and you want your reader to see it as if it already exists. Another verbal giveaway in writing and verbal pitching in meetings is to use the word *hopefully*. That instantly communicates to your immediate audience, client or producer, that you do not really believe in your idea and that you are not sure that it works. Until you can arrive at that state of conviction and convey it in your writing and presentation, you should not begin.

Another fatal error is to use the first-person singular. As soon as you write *my* PSA, or *my* idea, or *my* video, you instantly create a tension. First of all, it is not yours. You are being paid to create something for someone else. You are putting your creative talent at the service of your client. It is theirs. They are paying for it. By attaching your person to the communication, you create a psychological problem. If someone wants to criticize your work, your ideas, or your thinking, it becomes personal. That critic has to confront you or attack and criticize you by implication because you have identified yourself with the product. Consider now what happens if you employ the first-person plural. As soon as you write or say "we," you include your client. You put both of you on the same side, on the same team. Thus, any criticism, modification, or difference of opinion becomes the group thinking through a problem to find a collective and collaborative solution.

A CONCEPT FOR AN ANTISMOKING PSA

All antismoking PSAs face the problem of having to convince addicts to quit. We need to get past their defenses and their denial. All the facts about health hazards are already out there. We have to make them real and emotionally affecting. In Massachusetts, there have been a number of effective antismoking campaigns. One had a billboard the exact size of a room with the dimensions shown and a punch line: "Second-hand smoke spreads like cancer." The image and the punch line conspire to make you think. The smoke that fills a room when anyone smokes in it obliges everyone else to smoke. So the spreading smoke is also spreading cancer. Another billboard referred to the number of toxic substances in a cigarette with a tag line saying that it would be illegal to dispose of them in a garbage dump (but in your lungs is okay?). Another has a simple statistic: "Last year smoking killed 470,000 people." A recent television campaign against smoking breaks down this number into how many people die each day. The creative visual shows crews piling that number of body bags in a city street. By making the audience see the number as a heap of body bags in a street, the creators turn a dull statistic into a graphic image and make the audience think.

Now let's follow a seven-step analysis to generate a creative concept for a PSA concerning texting while driving—a universal problem which every reader can recognize and comprehend. When the previous edition of this book was prepared, this public policy concern was not really on the radar screen although calling while driving was clearly a form of distracted driving. Now cell phones with texting and Internet capability are pretty much universal, and studies have shown that texting while driving greatly increases the chance of getting in an accident . The Ad Council has produced several ads for what will probably be a long campaign like the drunken driving campaign. Each one has a slightly different approach. One creates a dramatic story with a shock strategy and is an appeal to emotion. One uses a celebrity approach involving a NASCAR driver to point out the risks and compares texting other insanely risky things you wouldn't dream of doing. Another makes use of the statistic about how long texting distracts a driver from paying attention to the road: *How far does a car travel in 5 seconds at 55 mph?*

Seven-Step Analysis for Creating a Texting While Driving PSA

The Communication Problem

Young adults and teenagers do not realize or understand how distracted driving increases the risk of an auto accident. If you are texting while driving, you are not attentive to the road. Texting is particularly addictive and demands looking away from the road for an average time of 5 seconds. Many teenagers do not realize how serious the risk is to themselves and other drivers. They may have some information, but their understanding of the danger is not fully conscious. The delay in a texting driver's response to an emergency is longer than for a drunk driver. Even though most states now have laws and penalties for texting while driving, people are so addicted to this form of instant communication; they continue to take huge risks.

Audience

Our target audience is primarily young adults and teenagers with a secondary audience of older drivers.

Demographics: Our focus is an age group between 16 and 25, sometimes not well educated, but this is not dependent on their vocabulary or sophisticated knowledge but rather their immaturity. We may have to consider targeting the younger or older end of this audience as the primary target because the psychographic is different.

Psychographics: Younger audiences think they are so slick with a phone that they can multitask and control a car while texting, no problem. They are immune to rational argument and in denial of risks. They dismiss legal warnings. The audience will not accept a lecture and is not really impressed by statistics. They are responsive to images of their own lives. We have to show them in a scene that matches a plausible lifestyle for them so that they can think—that could be me.

The Objective

The objective is in part informational, to convey further facts about the hazards of texting while driving. It is also strongly motivational so as to shift the attitude of the target audience and make them start thinking and start worrying. The objective to haunt them with troubling images that won't go away. It is only through the motivational shift that the possibility of an indirect behavioral outcome can occur.

The Strategy

We want to show how trivial most messages are for which drivers take enormous risks. We create suspense with slow motion that goes with a countdown that corresponds to the 5 second distraction and shows how far a car travels at given speeds. We want to plant a shock image in the mind of the viewer that will be so plausible and realistic that it will be remembered when that person is behind the wheel with a cell phone.

The Content

An attractive young man and young woman are in separate vehicles texting one another in alternate shots obviously emotionally excited and distracted. We see close up text messages, driver reactions, hair raising external traffic conditions with near accidents; the scene ends with an accident. The texts themselves could enhance the tension of the narrative. For instance, the last text reads "I miss you," and then the screen goes black.

The Medium

Our message is primarily visual. The message needs close-ups and depends on slow motion and dramatic editing that is available with video. It could not be conveyed as well by audio, only for radio, or for a static medium such as a billboard. The medium necessary to convey this message is television. This idea exploits the visual potential of video and television.

The Concept

The creative concept is: *If you could text one last message, what would it be?* The slo-mo crash is agonizing. The cell phone flies out of the window and comes to rest on the road. A close-up of the text not sent is in the text composition box: "I miss you." Possible last lines could be variations of: "If you text and drive, what will your last message be? Hit or miss? Your choice! Don't text and drive. It didn't work for him/her. Text and let die."

From the concept you can pitch the solution to the communication problem to the client. Once it is agreed, you can elaborate the concept as a *treatment* that narrates in chronological order what happens on screen . . . to be continued!

CONCLUSION

This chapter explains the essential scriptwriting problems. You have seen how important it is to think before you write. Thinking through the communication problem with the seven-step method outlined in this chapter will enable you to generate content. You can ask and answer seven questions to analyze any communication problem. However, these questions must be answered honestly and rigorously. This capacity to break down a communication problem and come up with creative solutions is an essential part of the job of scriptwriter, especially in the world of corporate communications, which includes advertising, public relations, sales, training, and corporate videos, either stand alone or uploaded to websites, or interactive modules. If you can become proficient at coming up with creative solutions, you will bring an invaluable skill to any media enterprise and to businesses large and small that need professional help to solve a whole range of communication problems.

EXERCISES

1. You are going to send a Valentine's Day message. You will not use the words "I love you." Using the seven-step method, come up with five creative concepts for five different audiences. Let the changing target audience modify your communication objective and your strategy. The message does not have to be sent as a video. The question of which medium to use is important. For example, a dozen red roses with a card could be your creative concept. Unchain your imagination.

2. Your job is to devise a creative concept for an antismoking PSA using the seven-step method. Come up with five creative concepts for these different target audiences: pregnant women, preteens, college students, and adult addicts.

3. Devise a creative concept for a PSA to counter bullying, hazing, or other forms of abuse in schools and colleges.

4. Your assignment is to devise a creative concept for a safety video about (a) carbon monoxide hazards in the home, (b) ladder safety, or (c) pedestrian rules for children under age 7.

5. Your assignment is to devise a creative concept to launch a new product to a company sales force: a new car, a new can opener, or a holiday package. Could this be a website?

6. Your assignment is to write a creative concept for a video to get people to recycle. How do you define the target audience?

Describing Sight and Sound

Key Terms

angle of acceptance	graphics	script format
audio writing	INT.(interior)	scriptwriting software
camera angles	marked-up script	sequence
camera directions	master scene script	shooting script
camera movements	montage	shot
character generator	multimedia time continuum	slug line
character names		sound cues
commentary	music	sound effect
computer graphic imaging (CGI)	music bed	specialized kind of writing
	music bridge	storyboard
day/night	music cues	sync
depth of field	music sting	transitions
dialogue	rack focus	visual writing
dual-column format	scene	voice narration
EXT.(exterior)	scene heading	writing for audio

Writing a script, simply put, involves describing what the eye sees through the camera lens and what the ear hears on the audio track. It sounds easy enough. The problem is, as we found in the first chapter, knowing what to leave out. When you try to write a script for the first time, you usually end up describing too much or not thinking concretely about what is visible within the frame. You must describe the essential visual event that happens in front of the camera, but without preempting the basic production responsibilities of the director. Describing what the camera sees means understanding the basic technique of shooting and what separates one shot from another. To communicate your intentions (and a script is nothing but a set of intentions that others depend on), you must let go of some habits that have been drilled into you for writing expository prose.

DESCRIBING TIME AND PLACE

Consider this example. Look out of the window and describe what you see. First write it as prose. It might go something like this:

> It was a drizzly fall day outside. Leaves had collected in the gutters and created wet skid traps on the asphalt. The wind was stripping the last few leaves clinging to the branches. A car went past with a screaming fan belt. A jogger slapped through the soggy leaves exhaling rhythmic puffs of vapor and disappeared around the corner. The phone rang. Alessandra turned to answer it. Tears made rivulets of mascara down her cheeks.

This is descriptive prose for an essay or a novel, not Hemingway, but the problem is similar. The events are brought together as an assembly of impressions without reference to order in time or place. To describe a scene is not the same as visualizing the sequence of images on a screen and then describing it so that a production crew can shoot it. The camera is like a robot. It sees only what it is in front of it. Anything not in front of it cannot be admitted to the description of the scene. What the camera sees and records is always in the present. Therefore, the description of what the camera sees is always in the present tense—always.

Human vision scans a scene. The eyes move; the head moves; and the angle of acceptance of the human eye is very wide. Most important of all, the eye is connected to a brain that selects and interprets the visual information delivered by the optical nerve. The brain can assemble and arrange impressions in any number of ways. A camera interposes an artificial eye between the scene and the eye of the audience. That is what makes the medium an art. The audience only gets to see what the camera lens frames, which issues from the scripted scene. The artificial image on an emulsion (film) or an electronic scan (lines, pixels) are visual experiences separate from reality, just like an artist's canvas is a visual experience apart from the reality that inspires it.

So let's take the same scene and explore how it would work to write it as a script. Always ask the question, what does the camera see? To answer this question, think about where the camera will be set up physically and in which specific direction it will point. The camera always expresses a point

The Slug Line The three letter abbreviation INT. (meaning interior) conveys essential production information. The scene in question must be shot with some artificial light mixed with daylight from the window. This presents a lighting problem of mixed color temperatures, which tells the videographer or cinematographer to bring gels for the lighting instruments or gels for the windows. It also allows for two possible solutions for the setting. Either it has to be a real location that the location manager and art director or production designer must find, or it can be built as a set with a green screen for the window that shows the exterior view when shooting in that direction. Every interior has implications for lighting and location and, therefore, cost.

The three letter abbreviation EXT. (meaning exterior) also conveys essential production information. The director, art director, and the location manager have to find an appropriate location that fulfills both artistic and practical criteria. That location search costs money. It has to be fitted into a shooting schedule. A production manager will start trying to group locations to minimize travel time and cost. The lighting cameraman or director of photography has to think whether the scene can be shot using available light or whether it needs fill light with HMI lights or arc lights that match daylight color temperature. If so, these lights will need power from a generator truck and gaffers to run and rig the lights.

A writer does not have to think specifically about these things because they are utterly remote from

of view. Therefore, you must use it. Although the director has the final decision about these matters, the scriptwriter describes the possibilities.

the narrative process. A writer simply has to know that the slug line is a condensed and effective way to convey certain essential information about each scene.

Your first decision as a scriptwriter is to imagine whether to shoot the scene from the interior looking out or whether the scene is predominantly an exterior. You express this with an abbreviation: INT.(interior) or EXT.(exterior). The director, the camera crew, and anyone working on the shoot know the practical implications of this abbreviation. The next piece of essential information is to describe where the action is taking place. This can be a word or two, such as STREET or LIVING ROOM. Next you have to decide what time it is, day or night. Again, your decision has implications for lighting and production. You write DAY/NIGHT. Occasionally, you can specify a particular time, such as dawn or sunset. You now have three critical pieces of information necessary to every scene in a script that tell a production crew a great deal about what they have to do and what they have to plan for. These three pieces of information are arranged in a well-recognized sequence called a scene heading or a slug line, for example:

```
INT. LIVING ROOM—DAY
```

DESCRIBING ACTION

So far so good! Your next job is to describe some action or object or person that you want to be seen within the camera frame. Now you need to think about how large or how small this frame is and about what is in the foreground and background.

The description could go like this:

```
INT. LIVING ROOM—DAY

We see a figure in silhouette against a window. Through the window,
we see a suburban street lined with trees. Leaves are falling. It
is windy and raining. A car drives past, with a screaming fan belt.
A jogger runs past. His breath is visible. A telephone rings. The
figure turns toward camera. There are tears on her face.
```

This could be enough. What has changed from the written prose we looked at earlier? The description is in the present tense. Descriptions of action in scripts are always in the present tense, as if we are seeing everything in front of us right now playing on a movie or TV screen. Another difference is that most descriptive adjectives and poetic embellishments are removed. Reduce the description to simple, short statements of action! Sometimes it is permissible to write in incomplete sentence fragments that would usually get red ink corrections in composition classes. Try this:

```
INT. LIVING ROOM—DAY

LS with figure in silhouette in foreground against a window. In
background through the window a suburban street with trees. Leaves
are falling. It is windy and raining. A car up and past. SFX a
screaming fan belt. A jogger runs past. His breath is visible. SFX
telephone ring. The figure turns. We see ALESSANDRA's face in CU,
tears running down her face.
```

This is probably enough. It could be shot as one shot by racking focus (see definition in the next section, "Describing the Camera Frame or the Shot"), or it could be broken down into two different shots, one interior and one exterior. Also, specifying a CU (see definition in the next section, "Describing the Camera Frame or the Shot") or deciding what size of shot should frame the figure is optional and must not be overdone.

Try another version with an exterior:

```
EXT. STREET—DAY

LOW ANGLE of a woman at a window. REVERSE ANGLE of the street—
leaves are falling. It is windy and raining. A car up and past. SFX
a screaming fan belt. A jogger runs past. We see the steam of his
breath. The figure turns away from the window.
```

Now we have to visualize a different shot, which involves a different camera setup, which requires two separate shots produced separately. Each will be shot on a different slate clapped at the front of shot. The scriptwriter has to decide which the primary view is going to be. A script written the first way might inspire a director to cover the scene with an exterior and an interior. In fact, a director might shoot close-ups of the runner, or cutaways of the leaves, or a long shot of the window, none of which are specifically written into the script. The scene breaks down into two setups and two camera angles in the director's shooting script. The scriptwriter writes one scene which carries the action and the story.

```
INT. LIVING ROOM—DAY

The street scene of the previous shot in the background. The phone
rings. ALESSANDRA, in silhouette against a window, turns to the
camera and reveals a tear-stained face. She answers the phone.
```

Deciding which way to play the scene is a director's prerogative, but, before production, the scriptwriter is all powerful. In reality, once the script is turned over to production, the writer's power wanes, as we learned in the previous chapter, and the director assumes control. The interior version is cheaper to produce because it involves only one setup. The interior/exterior combination is visually more interesting and introduces more dramatic complexity. It takes more time to do two setups: one interior and one exterior under different lighting conditions and, therefore, more money.

DESCRIBING THE CAMERA FRAME OR THE SHOT

You may have picked up other features of scriptwriting style in these examples. CHARACTER NAMES and CAMERA ANGLES are usually typed in uppercase. Most important of all is the specialized language that describes the way a lens produces an image, often written as an abbreviation such as CU. Because this is not a book about production, the details of camera work are not covered in an exhaustive way; however, the following commonly used terms and abbreviations—and their meanings—must become part of your working vocabulary. The companion website provides an **interactive glossary** of live-action video or stills to illustrate every type of shot.

Although you should know these terms and although they will be needed from time to time to convey what your vision is, you should be careful not to pepper your script with minute camera directions. Too much directing of the script by trying to choose camera frames clutters up the script and encumbers the director. The director has to make a decision based on the real scene in front of the camera on the day of shooting. I have shot many of my own scripts and had to abandon visions of how it was supposed to be because the lens would not accommodate the idea. The performance of lenses is governed by the laws of optics, which limit what directors can do. The principal limitation is in the way foreground and background can be contained in focus in what is called the *depth of field*. This could be a weakness of the interior version discussed earlier. The figure and the exterior scene will not both be in focus. As the figure turns, the camera crew will have to rack focus to feature the face. All of these problems of execution are the province of the director and his crew. A rule of thumb might be to give a camera direction only when it is indispensable to the visual idea on which your scene rests. Otherwise, leave it to the common sense of the director.

Standard Camera Angles

VLS	VERY LONG SHOT: A very long shot has no precise definition other than that it should include the whole human figure from head to foot, all of the action, and a good view of the background.
LS	LONG SHOT: A long shot should include the whole human figure from head to foot so that this figure (or figures, if more than one) is featured rather than the background.
MS	MEDIUM SHOT: A medium shot, like all of these shots, is defined with reference to the inclusion or exclusion of parts of the human body. So a medium shot usually frames just below the waist. Keeping the hands in is one way to visualize the shot. It is definitely well above the knees.
CU	CLOSE-UP: A close-up frames the head and shoulders leaving room above the head. A close-up captures facial expression or the detailed characteristics of an inanimate object.
2 SHOT	TWO-SHOT: Although this is not an abbreviation, it is a common term that describes two people in close-up or medium shot. The wide-screen format (2.75:1 ratio) of the movie screen and the new high-definition television (HDTV) format (16:9 ratio) make good use of this frame.
BCU or ECU	BIG CLOSE-UP/ EXTREME CLOSE-UP: A big close-up or extreme close-up frames the head so that the top of frame clips the forehead or hairline and the bottom of the frame clips the neck.
WIDE ANGLE	This term is somewhat loose. It generally means a long shot or an establishing shot that shows the whole scene. It refers to a shorter focal length lens.
OTS	OVER-THE-SHOULDER: This shot, as the name implies, frames two figures so that one is partially in the frame in a quarter back view to one side while the other is featured in a three-quarter front view. This shot is usually matched to a reverse angle of the same figures so that the values are reversed.

REVERSE ANGLE	A reverse angle is one of a typical pairing of two matched shots with converging eye lines. They can be medium shots, close-ups, or over-the-shoulder shots, and are shot from two separate camera setups.
LOW ANGLE	A low angle means pointing the camera lens up at the subject, whether an object or a person.
HIGH ANGLE	A high angle means pointing the camera lens down at the subject, whether an object or a person.
RACK FOCUS	Racking focus, also known as pulling focus, refers to a deliberate change of focus executed by twisting the focus ring on the barrel of a lens during the shot. This technique is typically used to shift attention from one character to another when they are speaking and the depth-of-field is insufficient to hold both in focus at the same time. It is commonly used in television drama and movies.

Describing Camera Movement

You need to learn the terms that describe camera movements. Camera movements change the size or perspective of a frame, the angle of view, or a combination of these. (See the companion website for live-action video of each camera movement.)

Standard Camera Movements

PAN	Panorama is the most common movement of the camera. A pan can move from left to right or vice versa, sweeping across a scene to give a panoramic view. The most common use of this camera movement is to follow a moving figure or object while the camera platform remains stationary.
TILT	A tilt is a movement of the camera platform to angle up or angle down in a continuous movement along a vertical axis. It is useful for following movement. Panning and tilting are often combined in one movement to follow motion in two dimensions.
TRACK	A track refers to the continuous movement of the camera platform in one direction, usually alongside a moving figure. This is accomplished by putting the camera on a dolly that runs on tracks or by handholding the camera while walking alongside the action. Professionals often use a gyroscopic Steadycam mount. This enables the camera operator to maintain a constant frame around a moving object or person and to track movement without camera shake. A camera platform can also be mounted on a vehicle or any other moving object. Tracking was an early innovation in camera movement in silent movie days.
DOLLY	A dolly shot is similar to a tracking shot in that the camera platform moves, but it moves toward or away from the subject so that the frame size gets larger or smaller. A similar but different effect is obtained with a zoom lens.

ZOOM	A zoom is an optical effect created by changing the focal length during a shot with a specially designed lens that has a variable focal length. The effect makes the frame larger or smaller like a dolly shot. The important difference is that a dolly shot maintains the focal length and depth of field throughout the shot as the camera moves nearer or farther away. The zoom uses an optical effect without moving the camera to change from a wide-angle lens to a telephoto lens so that it appears to the viewer that the subject is closer or farther away. The depth of field changes as the focal length changes.
CRANE	A crane shot is made by raising or lowering a camera platform, usually with a crane or boom. It can also be achieved with a helicopter-mounted camera, at great expense. In a low-budget production, a smaller-scale crane effect can be done by bending and straightening the knees while handholding the camera.

DESCRIBING GRAPHICS AND EFFECTS

In contemporary television and video, a significant proportion of program content, especially commercials, is generated by computer imaging software output to video. This includes titles, 2-D and 3-D animation, and computer-generated optical effects that produce layers of video. **Graphics** and live action can be combined to create almost anything imaginable, including images that defy logic and natural laws. Metallic insects, hybrid creatures, science fiction worlds, a face metamorphosing into a different face or object (known as *morphing*)—all of these images can be created without using a lens or light-sensitive medium to record a real-world scene. Therefore, the scene heading has no meaning when describing a **computer-generated graphic**. A useful convention to adopt in place of the slug line is a heading: GRAPHICS or CGI (computer graphic imaging). This graphics slug line announces to all production people that this scene does not have to be shot but must be scheduled for postproduction by the editor or by a graphic artist.

If you need a graphic image or graphic animation in your script, you need to describe it as you see it. If it is a 3-D animation, you can resort to the conventional frame descriptions to visualize the scene. For example:

```
CU spaceship, seen from a low angle, filling the screen.
```

A title is created either in a character generator or as part of CGI. It is created in postproduction and needs to be identified by another slug line separate from a shot or a scene. You can indicate this by a simple slug: TITLE or CG.

DESCRIBING TRANSITIONS BETWEEN SHOTS

Transitions between shots are predominantly decided by the director and the editor. Although all scripts begin with FADE IN FROM BLACK and often designate a DISSOLVE or a MIX in place of a CUT, it would be inappropriate for a writer to try to pin down the director or editor at every transition between scenes. As with other camera directions, sparing use for specific cinematic reasons will command attention, whereas overuse will irritate postproduction people who will probably ignore most of them. Let's take a look at the terminology used to describe transitions between scenes (see also the **companion website**).

Standard Transitions

CUT	The most basic and indispensable transition on which modern visual editing relies is the cut. In the early days of film, movies were short, sometimes consisting of one shot that lasted for a few minutes. Modern motion picture editing was born when directors shot more than one angle so that the rhythm and pace of a scene could be controlled in the way shots were edited. Some scriptwriters write in a transition in uppercase at the end of every scene: CUT TO. Some scripts are written with the understanding that any transition is automatically a cut unless some other transition is specified. D.W. Griffith, the silent film director, is usually credited with the invention of editing innovations based on cutting shots together. His techniques are still in use today—for example, cutting to a close-up for emphasis and cutting away to a detail of a scene which is out of continuity.
CUTAWAY	A cutaway is a shot of some detail within the scene, something like a clock or a telephone that is not part of the continuity of action, or a cutaway of, say, the feet of a runner. An editor can cut away to it without concern for its match to the previous or the following shot. Experienced directors always shoot plenty of cutaways to solve continuity problems in the editing phase. For the writer, the use of the cutaway would be to emphasize the dramatic or narrative importance of an object. As mentioned in Chapter 1, the classic Western *High Noon*, scripted by Carl Foreman, cuts away to a clock as a dramatic device. The audience knows that the bad guy will be arriving on the noon train to take revenge on the marshal who put him away. The visual of the clock increases the narrative tension for the audience because movie premise equates the elapsed time of the movie to clock time. This is a good example of a scripted cutaway. Some cutaways, however, are created by directors and editors.
DISSOLVE/MIX TO	In film production, anything other than a cut has to be created in the optical printer from A- and B-roll offsets. The editor marks up the film so that the lab technician can move the printer from the outgoing shot on the A-roll to the incoming shot on the B-roll. In video, the mix is made with a fader bar that diminishes input from one video source as a second is added. In video, the term MIX TO is preferred.
SUPER	In the middle of a dissolve when 50 percent of the printer light or video source comes from each picture, a temporary effect called a *superimposition* is produced. This effect is now created digitally within nonlinear editors. A superimposition is simply the mix or dissolve mixed into the midprinter light or midfader position and then out. Beginners often go to unnecessary lengths to describe the way titles superimpose on picture or a background. A sentence can be reduced to "SUPER TITLES over black," "SUPER TITLES over LS of street" or "SUPER flashback action over CU of face."

FADE IN FROM BLACK	All programs begin with this effect, which is simply a mix or dissolve from black to picture. Sometimes you might write in this effect to mark a break in time or sections of a program.
FADE OUT TO BLACK	All programs end with this effect, which is a mix or dissolve from picture to black, the opposite of the fade in from black. Logically, these two fade effects go in pairs.
WIPE	A wipe is the effect of an incoming image pushing off the outgoing image. A wipe is more commonly a video effect. Every switcher has a number of standard wipe patterns. The most obvious are a horizontal and a vertical wipe in which the two are images are separated by a moving line that bisects the screen. The other basic patterns are circle wipes and rectangle wipes in which the incoming image grows from a point in the middle of the outgoing picture as an expanding shape. The corner wipe is a variation. The incoming picture starts as a rectangle entering from any corner of the screen. Once again, a scriptwriter should think very carefully before writing in such detailed transitions. It is better to leave postproduction decisions to the director and editor.
DVE	Transitions between shots have become so numerous, because of the advent of digital video effects (DVEs) in computer-based editors and mixers, that it would be impossible to list the dozens of different patterns and effects. Once again, this is the province of postproduction unless you have a strong reason to incorporate a specific visual effect into your script.

DESCRIBING SOUND

The sound track is an enormously vital part of any program. There are basically three ways that sound works to intensify the visual image. The most obvious element is voice. The human voice is our most important means of communication. Speech or dialogue is commonly recorded in sync with the image of people when they talk. So the words we write for sound track, the manner of delivery, and even the gender of the voice all contribute to the final result. If you listen to any sound track carefully, you will hear more than just the synchronized sound that was part of the scene when it was shot. Most dramas involve two other elements that are not part of the camera recording. Voice can be recorded over the picture in the form of commentary both in documentaries and narrative entertainment.

The second kind of sound that we use is the sound effect, either in sync with something on screen, or as a pure effect, natural or artificial. If we see an explosion, we expect to hear the sound effect. If we see a dog barking, we expect to hear it. Then there are ambient sounds that complete a picture or an impression of time and place without sync. An example would be a scene in the country reinforced by the sound of birdsong or a city scene given greater realism by the distant sound of sirens and traffic.

Lastly, the makers of theatrical films, documentaries, and corporate and advertising programs well understand the emotional impact of music on a scene. The right music can lift a scene that, in

visual terms, is quite ordinary. Cutting footage to music allows the musical beat to reinforce a visual expectation.

So visual writing has to include audio writing. You have to think about sound sometimes when you are writing visuals. The three elements of a sound track have to be mixed together in postproduction in what has become an elaborate and demanding multitrack mix. Both music and sound effects (often created by Foley artists in a special studio) are usually added later in postproduction. Scriptwriters do not normally describe every aspect of this multitrack mix. Audio recordists, directors, and mixers make production decisions as to how to produce the sound track of your scene. The exceptions are when you want to emphasize the specific dramatic, comic, or informational use of sound effects. So we mention specific sound effects or music cues only when the production team might otherwise leave them out or because they have special significance. If a character hears footsteps approaching or hears a door opening off screen, the sound effects have dramatic significance and, therefore, could be written into the script.

If you are an editor or have been involved in editing film or video, you likely have discovered how ordinary shots can be transformed by music or sound effects or how cutting a montage to a beat can transform ordinary and mundane shots into something visually interesting. Sound alters the viewer's experience of images, which is why sound cues are aesthetically and technically part of the scripting language we need to learn.

Writers need to know as much about production as possible, but they also need to know when not to intrude on the work of production and postproduction personnel. Only a limited number of detailed decisions in making and finishing a program can be incorporated at a given moment in the production. It is unnecessary and silly to give instructions that cannot be used.

Here are the abbreviations you should learn when working with sound directions:

Sound Directions

SFX	This is a convenient abbreviation for SOUND EFFECTS. Instead of describing a thunderstorm and the sound of thunder at length, it is sufficient to write SFX thunder. In postproduction, whoever assumes responsibility for the audio tracks will pull a stock effect from a bank of effects on a DVD or from an audiotape. A sound effect is anything other than speech or music.
MUSIC	A music track is created independently of camera production. Music videos begin with a defined sound track. Other programs have music added in postproduction to fit the dialogue, sound effects, and mood. The writer does not usually pick music or decide where music is necessary. The exception is when the music is integral to the idea or in a short script such as a public service announcement (PSA), in which detailed conception might include ideas for music. If you do write in music cues, there is a correct way to do it, by using the following terms.
FADE IN	Almost all audio events are faded in and faded out to avoid a click as the playback head picks up a snap cut to music or effects at full level. This also permits us to use music cues that do not necessarily correspond to the beginning and end of a piece.
FADE OUT	This is the audio cue that most people forget to use. They fade in music or effect and then forget to indicate where the audio event ends. Mixing multitrack sound depends on fading in and out of different tracks. The fade out diminishes the loudness of the sound

	down to zero over an interval, short or long, according to taste so that it avoids an abrupt cutoff and does not shock the ear or draw attention to itself. Many commercial recordings of popular music are faded out at the end, whereas classical music has a specific ending to the composition, the loudness of which is controlled by the performer. Library music that is sold by needle time for specific synchronization rights for designated territories is generally recorded without fades so that the audio mixer of a program can make the decisions about the length of fades. This music is recorded in convenient lengths of 30 and 60 seconds. Some pieces are longer with variations on the same basic theme so that the piece can be reprised at different moments on the sound track. Also, pre-recorded small music bridges, riffs, and teasers are available off the shelf for editors and audio mixers to use.
FADE UP	A fade up is a change of level in an audio event that needs to be featured again after being faded under. Music tracks need constant fading under and up to clear dialogue. A writer seldom needs this kind of cue.
FADE UNDER	Fading under an audio event such as music is necessary when you want the event to continue but not compete with a new event that will mix from another track, typically dialogue or commentary. You should understand that audio mixers and editors largely make these types of decisions. Nevertheless, you should know these terms for the rare occasion when you need to specify an important audio idea in your script.
SEGUE TO	This term means to cross-fade two audio events. It is the audio equivalent of the video mix. You do not need to write this into the audio side of a script every time you use a MIX TO (see above) transition. All involved understand that one goes with the other.

VOICE NARRATION AND DIALOGUE

Since sound was added to picture in the 1930s, dialogue and voice narration have assumed a significant role in moving picture media. One of the particular skills that a writer needs to bring to the writing of a script is the ability to write dialogue and voice narration. The obvious point is that language written to be read on the printed page has a subtly different ring to it than language meant to be spoken sound on an audio track. Whereas spoken language in a voice-over commentary works better in short sentences that are readily understood, in printed media, longer and more complex sentences can have value. Printed sentences can be reread, but spoken language on the sound track of a program must communicate effectively right away because the viewer usually has no opportunity for a second hearing.

Spoken language is often more colloquial than written language, which is usually more formal. Spoken language allows contractions, shortcuts, and even sentence fragments that are inappropriate in print. This is particularly true of dialogue. If you are creating a character, the lines that a character speaks must be credible and plausible. A rap artist does not talk like a senator. A construction worker doesn't talk like a college professor. Whatever kind of character is on screen, his or her dialogue should come across as natural and believable.

Decorum, a basic principle of oratory given in the Greek philosopher Aristotle's and the Roman senator Cicero's classical treatises on rhetoric, means that language must be appropriate to the

occasion, the person, and the subject matter. Thus, dialogue follows the rules of classical rhetoric and should match the character, setting, and dramatic context of your scene. Not all spoken language is necessarily casual and colloquial. Great moments in history have been marked by spoken language. Every American student has been referred to **Abraham Lincoln's Gettysburg Address** as an example of a clear, eloquent, and succinct statement. It was written to be spoken; yet, it is formal, stylized, and not at all colloquial. It has decorum. It uses language appropriate to the time, place, and occasion of a public ceremony, of memorial. In our time, we seem to have lost some of this awareness about how to use language appropriately and effectively. In this context, consider the challenge for Tony Kushner when writing the script for Steven **Spielberg's *Lincoln*** (2012). Lincoln was not always making speeches. He was also garrulous and full of folksy anecdotes.

Whatever you write for the sound track, whether dialogue or commentary, you should always test it out by reading it aloud, or better still by asking someone else to read it back to you. Wildlife documentaries are particularly prone to bad commentaries. They are frequently intrusive, cute, or, worse still, monotonous.

Language destined for the sound track should:

- Be clear
- Complement the image
- Match the character or subject matter
- Be pronounceable
- Be suitable for the target audience

Voice-over commentary must fit the picture in two particular ways. First, if the duration of the words spoken extends the picture beyond its intrinsic visual value, then the visual becomes wallpaper. Put it this way: are we watching the picture just so that more words can be spoken? If so, the video becomes an illustrated lecture, a kind of moving picture slide show. If the visual narrative expressed through images is strong, however, those images can communicate meaning with less propping up by words. A strong way to use commentary is to set up an expectation of visual exposition by providing key themes illustrated by images. We could introduce a series of related images of suspension bridges by making a statement about the engineering: "All suspension bridges are held up by cables, which translate the weight to the load-bearing tower." Then you can stop talking and show a montage of bridges in long shot and close-up that illustrate your point. Commentary should cue the audience, not bludgeon it into submission with verbal information. There is a further discussion of writing for commentary and voice-over for documentary in Chapter 7.

Format for Radio

Although this book is concerned with writing for visual media, writing for audio is inevitably part of the writing task for an audiovisual medium. As a footnote to these issues, it seems useful to look at a script dedicated to radio and audio only. Whereas radio used to produce drama, soap operas, and series, it now consists of music, news, and talk, with a few exceptions like Garrison Keillor's Prairie Home Companion on National Public Radio. In effect, the only real audio scripting that is left to do on radio is for the advertisements on commercial stations. Both ads and public service announcements (PSAs) for radio have to be written. To communicate to production sound engineers and voice artists, there has to be a workable convention for these instructions and a page format to accommodate them. Because radio is a linear medium that unfolds in time and is strictly timed, the script needs to show clearly both the sequence of audio events and the relation of simultaneous events. Sound

effects have to be described so that they can be recorded or taken from a sound library of prerecorded effects. Likewise the use of music must be clear in the script. Clearly, music, sound effects, and speech cannot all be recorded or rather mixed together at the same level or amplitude. The audio/radio script has to show the approximate relation in loudness of one element to another.

Music cues have a language of their own that indicates the function of the music and therefore is a guide to the type of music sought as well as how it should fade in and out.

A music bed is a longer piece of music that goes under dialogue and sound effects or segues to that dialogue or effect. Music can be part of an imagined scene such as the background of a car radio or a band in a parade that is not featured.

A music bridge, as the term suggests, is played or laid in a multitrack mix to link scenes or to mark a change of place, time, or action.

A music sting is a short prominent musical phrase or note that is used to underline a line of dialogue or a dramatic moment. We see this use in film and television, especially in suspense and horror films.

Let's imagine an audio script for a radio PSA about drinking and driving. Note that character names and music and sound effects cues are in uppercase. Dialogue and speech is in lowercase. Audio events are generally numbered. Transitions and cues are important.

1. SOUND FX: INTERIOR CAR SOUND OF MOTOR AND EXTERIOR TRAFFIC
2. MUSIC BED CAR RADIO—HEAVY METAL FADE UNDER.
3. COLLEGE STUDENT 1 What a great party!
4. COLLEGE STUDENT 2 I'm wasted.
5. COLLEGE STUDENT 1 Are you all right to drive?
6. COLLEGE STUDENT 2 Hell yes.
7. COLLEGE STUDENT 1 (PANICKED) Look out!
8. MUSIC BED SEGUE TO
9. SOUND FX: SCREECH OF BRAKES THEN CAR CRASH
10. SOUND FX: AMBULANCE SIREN
11. ANNCR: If you drink and drive, death could be the chaser.
12. MUSIC STING ORGAN CHORD

FINDING A FORMAT FOR THE PAGE

The last problem to solve for the beginning scriptwriter is to determine the accepted way of laying out a script on the page. You must respect well-established conventions. They have evolved by trial and error for specific reasons. In a professional setting, using the right script format is crucial. Not sticking to the standard conventions of format proclaims your ignorance of the business you are trying to break into. Your script will probably also be harder to read if you don't follow the accepted conventions. Fortunately, computer software makes this part of the job easy. Most word processing applications can be formatted with macros to create any script layout. Dedicated scriptwriting software is also available. Some of the specialized software such as Movie Magic Screenwriter also plugs into budgeting and scheduling software that saves time and money for producers. In the professional world, you must get to know some of these systems.[1]

1 Visit www.writersstore.com to see the range of formatting and story development software. This is also useful source for books, seminars, and courses on writing.

MASTER SCENE SCRIPT

Two broad types of script formats or page layouts are in common use. The first, called a **master scene script**, reads down the page and is close to a theatrical script in that way (see the example in the appendix). The master scene script is written according to a plan that includes a slug line or scene heading for every scene. In fact, if any information in your slug line no longer applies to the action you are describing—that is, if the time and place have changed—you must start another scene with a new slug line. The scenes are not numbered. Character names are typed in uppercase, as are camera directions. Dialogue is centered, indented, and separated from the description of action, which is set to run margin to margin. This format is used for feature film and TV film and usually anything that involves characters and lines of dialogue. TV series and serials are written in variants of this script format. Some series adopt the convention of putting dialogue in uppercase. Some series have idiosyncrasies in their script formats that spec writers should learn.

```
FADE IN:

INT. SEMINAR ROOM—DAY

A group of people eager to learn the secrets of the Master Scene
Script format are sitting around a seminar table. A projector shows
the text being created.

                         INSTRUCTOR
                    (smiling)
               The film industry has a standard
               format for screenplays that
               everyone follows.

                         EAGER LEARNER
               What are the margins?

                         INSTRUCTOR
               Good question! Left, 1.5 inches.
               Right, 1.0 inches. Top, 1.0 inches
               to the body, 0.5 inches to the
               number. Bottom, 0.5 to 1.5 inches,
               depending on the position of the
               page break.

The instructor shows an example on the projector.

                         SECOND EAGER LEARNER
               I get it. Scene headers stay
               attached to action description, and
               a line of dialogue would be pushed
               to the next page.
                                                          CUT TO:
```

```
EXT. CAMPUS—DAY

The sun is shining. Everyone is sitting on the grass having a
picnic lunch.

                                                   DISSOLVE TO:

INT. SEMINAR ROOM—AFTERNOON

The eager learners are taking notes while the instructor explains
more format issues.

                           INSTRUCTOR
                 Let's talk fonts. Always Courier,
                 12 point, 10 pitch. That is the
                 industry standard.

                                                     FADE OUT:
```

DUAL-COLUMN FORMAT

A **dual-column format** is the other main type of script format. It has to be read from left to right because audio and visual elements are separated into two columns (see a sample dual-column script in the appendix). The description of everything that is seen on screen is placed in the left-hand column. The description of everything that is heard on the sound track is placed in the right-hand column. Each scene therefore consists of a pair of descriptions. For anyone involved in production, this is an ideal arrangement because it accommodates production techniques. For a reader, it is awkward to integrate what you read in left and right columns and then move down to the next pair.

What we are discovering is the difficulty of describing visual media in a print medium. That is the nature of the problem. Remember the analogy of the blueprint. An architect or designer has to represent a three-dimensional object in two dimensions on the page. Likewise, we, as scriptwriters, have to represent a multimedia time continuum in writing. Writing is a 4,000-year-old technology that is still indispensable for many forms of communication, and the printed page is a 500-year-old technology that is still an immensely successful medium. However, writing and printing do not do justice to audiovisual media. Writers have written prose for as long as language and alphabets have existed. Playwrights have written for theatre since the fifth century BC in Athens. Scriptwriting is new and arose in response to the invention of a historically new medium of moving pictures. A script is, in effect, a specialized kind of writing, just as a blueprint is a specialized kind of drawing. Ideally, a script would need to be a kind of musical score, a visual representation, and a verbal description combined. There is a suggestion of this in the documents that describe interactive media, as we shall see in a later chapter in Part 4.

In the end, each format—that is, each way of organizing the page—has its advantages and disadvantages. A master scene script has to combine visual and audio descriptions. In production, these have to be disentangled. Because such scripts are usually driven by dialogue, the main audio event is read in alternation with the description of action, so the reader has to assimilate them and integrate in alternation going down the page. In the dual-column script, the problem is presented in a different way to favor production and requires the reader to assimilate pairs of audio and visual elements while parsing down the page.

FADE IN:

INT. SEMINAR ROOM—DAY

A GROUP OF PEOPLE EAGER TO LEARN THE SECRETS OF THE DUAL-COLUMN FORMAT ARE SITTING AROUND A SEMINAR TABLE. A PROJECTOR SHOWS THE TEXT BEING CREATED.

INSTRUCTOR: (smiling) The industry has a standard layout for dual-column scripts, used for corporate, documentary, and public service announcements.

THE COMPUTER PAGE IS PROJECTED ONTO A SCREEN.

EAGER LEARNER: Why is the action in caps?

THE GROUP TAKES NOTES

INSTRUCTOR: It doesn't have to be. I have seen the reverse where spoken dialogue is in caps and action is in lower case.

SECOND EAGER LEARNER: Can we choose?

INSTRUCTOR: I advise putting speech into upper and lower case because it is easier to read. Action description can also be in lower case.

CUT TO:

EXT. CAMPUS—DAY

EAGER LEARNER: What font do we use?

THE GROUP IS SITTING ON THE GRASS HAVING A PICNIC LUNCH.

INSTRUCTOR: I use Courier New 12 point, but outside the entertainment industry, the rules are less rigid.

FADE MUSIC UP AND UNDER

INSTRUCTOR: The most important point about the dual-column format is that the columns should be equal in width and action and speech should be related by horizontal position opposite one another. Audio cues should be in caps.

CUT TO:

FADE MUSIC UP AND OUT

STORYBOARD

Meanwhile, the best answer that the industry has devised to represent the moving picture media is known as a **storyboard**. It was developed by art departments in advertising agencies to get over the problem of clients reading and interpreting scripts visually by supplying them with sequential

drawings of key frames. It is similar to the problem of understanding blueprints. Architects visualize the result for nontechnical clients with models and sketches. TV ads and PSAs are almost always rendered as storyboards before going into production. Some directors storyboard dramatic scripts, especially sequences involving special effects. A scriptwriter might not be a good artist and, although capable of writing excellent scripts, might not be capable of drawing. An artist who can sketch the key frames probably has no scriptwriting skills. So creation of a storyboard generally requires collaboration. It is a good idea to sketch a storyboard for certain sequences even if your drawing consists of crude stick figures. It helps you to visualize what you are trying to describe in scripting language.

New computer software has transformed traditional roles by creating libraries of characters and backgrounds with powerful routines that can vary camera angles, size objects, and change perspectives. Text can be imported into caption areas. This allows almost anyone to create a storyboard. The more film and television rely on sophisticated computer-generated effects, the more important storyboarding will become. There is already a trend to create program content directly with images in an imaging medium that sequences frames. StoryBoard Artist, a program developed by PowerProduction Software, will even let you add sound files to the frame. The storyboard as produced by such computer software is halfway to an animated movie.

TV Studio Multi-Camera Script

Live television scripts, whether for news or for other programs that are intended to be shot in a television studio with a **multicamera** method and switched live in the control room, require a slightly different formatting of the script. Because news emphasizes the news anchor reading from a teleprompter, it only makes sense to adopt a two- or three-column format with the right-hand column for the audio. The visuals are either medium shots or closeups of the presenters. This can be indicated in the next column to the left and can identify which camera will take it. Most television news is put together from standard setups with very little camera movement. The cameras are increasingly robotic with one operator. The other elements are B-roll from tape VTR, or CG, still store, or live feed. These are produced separately and can be incorporated into the left-hand visual column for cueing. They would have to be produced independently beforehand. For more elaborate productions involving sets and movement of talent, a rehearsal would enable the floor and the control room to anticipate the camera moves from a rundown sheet and a shot list separated out for each camera to follow. Prerecorded video and music cues would be marked.

A television script really takes shape as a production script. Switching live means you must have precise cues for picture and sound. Whereas editing footage shot on a single camera in postproduction allows edit decisions to be made on the basis of a marked-up postproduction script. This marked-up script is produced by the script supervisor to show the relationship of multiple takes and angles shot out of script order that cover a scene identified by their unique slate numbers and logged and digitized in bins. Here, another level of information is superimposed on the master scene script to show what is covered and what is not for any given take. The marked-up script is strictly for production and postproduction, and no part of a writer's work.

A television drama might be written as a master scene script and then turned into a dual-column script for production if it were going to be shot live in a studio. A script for live multi-camera production is best written as a dual-column script to enable ample camera directions in the left-hand column. The master scene script layout would fight with the conceptual thinking about assigning cameras to action because it reads down the page. The dual-column shows the relationship of camera and shot to dialogue or to-camera speech. For this type of production, more camera direction is required. Later, a director can mark up the script with actual camera assignments during a camera rehearsal and produce a shot list for each camera. The production must be rehearsed from such a

script and is closer to a shooting script for single camera production. Directors write their own shooting scripts (see ***American Travel in Europe*** on the companion website); they are not the province of scriptwriters. Once again, we are straying into the realm of shooting and production scripts that involve directorial talent.

FADE IN:	
CG title	MUSIC INTRO FADE UP AND UNDER
SEMINAR SET	
WIDE SHOT of instructor and learners	
Instructor to camera	INSTRUCTOR:(smiling) The industry has a standard layout for dual-column scripts, used for corporate, documentary, and public service announcements.
	EAGER LEARNER: Why is the action in caps?
WIDE ANGLE of seminar table	INSTRUCTOR VO: It doesn't have to be. I have seen the reverse where spoken dialogue is in caps and action is in lower case.
STILL STORE script pageCU	SECOND EAGER LEARNER: Can we choose?
Eager Learner taking notes.	
WIDE ANGLE of the group	INSTRUCTOR: I advise putting speech into upper and lower case because it is easier to read. Action description can also be in lower case.
MS of InstructorCU Eager Learner	EAGER LEARNER: What font do we use?
LS Instructor	INSTRUCTOR: I use Courier New 12 point, but outside the entertainment industry, the rules are less rigid. The most important point about the dual-column format is that the columns should be equal in width and action and speech should be related by horizontal position opposite one another.

NEWS ANCHOR SCRIPT FORMAT

News scripts primarily show text to be entered into a teleprompter and then read by one or more anchors from the teleprompter. The only visual writing involves designating which anchor reads what portion of the text and which camera takes the shot. It is a production document and part of the writing necessary for one aspect of television production. In fact, it is more like a production script. Nevertheless, it has to be written prior to production.

```
ON CAMERA: SHERRY                     DRIVERS BETTER KEEP THEIR EYES
                                      PEELED. NEW 55-MILE-AN-HOUR
                                      SPEED-LIMIT SIGNS ARE GOING UP...
                                      TO KEEP OUR POLLUTION DOWN.
                                      W-B 39'S KATIE McCALL TELLS US
                                      ABOUT THE CHANGES.

TAKE VTR
:17 SUPER: JANELLE GBUR               SOT 1:38
DEPT. OF TRANSPORTATION
:32 SUPER: KATIE MC CALL
REPORTING
:40 SUPER: MIKE STAFFORD
HARRIS COUNTY ATTORNEY
1:38 TAPE OUT
                                      1:38 STD OUT CUE
```

CONCLUSION

After reading this chapter, you know the professional terminology of sight and sound and should have a complete repertoire of scriptwriting terms and conventions that enable you to deal with the detailed problems of describing sight, sound, and transitions. You should consult the interactive **glossary on the website** to reinforce this understanding visually. You now have the building blocks of script-writing. We have defined the problem of describing a moving picture medium in words on a page and shown how a scriptwriting convention has evolved to solve many of those problems. We have illustrated many different types of visual media formats. You now know what a script looks like. Scripts have special formats and use technical shorthand for many descriptive tasks. This kind of writing is unique to the new media that evolved throughout the twentieth century. You need to try them out in small-scale exercises. Then the larger issues of devising script concepts and content and of writing scripts for specific program formats can be brought into perspective in the next chapter.

EXERCISES

1. Write a camera description of yourself getting up and having breakfast. Use the camera vocabulary you have learned from this chapter. Think about what you would describe and what you would leave out. Don't worry about format at this point.

2. Watch a simple real-life scene, such as people having an argument, a cop giving a driver a ticket, or action in the street, on a bus, or in a restaurant. Now describe what a camera would see. What would appear on a screen if it were a movie? Describe it as you want to see it on the screen.

3. Listen to an auditory event or experience that involves more than one type of sound, namely, voice, sound effects, and, if possible, music. For example, listen to a restaurant scene or a scene in nature. Write an audio-only script using the terminology you learned in this chapter. You can add your own music to your scene.

4. Write a scene that comes from your imagination, describing both visual and audio elements. Don't be concerned about format. Just confront the problem of describing what you want to be shot.

5. Record or listen to a conversation in a cafeteria or a bus and transcribe it. Rewrite it to remove all the chaff and incoherence.

6. Take a piece of written prose and edit it for commentary.

7. Listen to a documentary sound track without looking at the picture. Watch a documentary without the sound track. Write an evaluation of the program structure based on each.

8. Take a short scene from a short story or novel and adapt it for the screen. How do you want to lay it out on the page? Choose a master scene script format or a dual-column format. (See the appendix.)

9. Choose a short scene from a short story or novel and make a storyboard for it.

CHAPTER 4

The Stages of Script Development

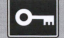 **Key Terms**

background research and investigation

beat sheet

brainstorming

camera plot

closed questions

concept

content

creative concept

dialogue

double-barreled questions

final draft

first-draft script

follow-up questions

format

funnel technique

hypothetical questions

index cards

inverted funnel

leading questions

location research

logline

open questions

outline

picture researchers

pitching/pitch

process

revision

scene outline

script

scriptwriting software

self-assessment questions

shooting script

subject matter experts (SMEs)

treatment

tunnel technique

visual metaphor

voice narration

voice-overs/voice-over commentary

Scriptwriting is a process. We can break the scriptwriting process down into well-recognized stages the most important of which are written whereas others are preparation for that writing. The written stages are so well recognized that they have names that are also reflected in the contractual agreements that usually govern professional writing of this kind. It begins with gathering information, thinking, analyzing, and questioning, which leads to devising a creative concept. This visual idea then needs to be developed through some kind of outline or treatment and then be scripted in a format appropriate to the medium concerned. This script format lays out a set of descriptive instructions in a special language about what is to be seen on the screen and heard on the sound track.

Let us outline this process by stages. Some of these stages may change places in the sequence depending on the nature of the writing job:

- Background research and investigation
- Developing a creative concept

- Pitching or verbal presentation
- Concept
- Treatment
- First draft
- Revision
- Final draft

BACKGROUND RESEARCH AND INVESTIGATION

Part of the process of scriptwriting often involves background research and investigation of the subject matter before you define the objective or outline the content. Experience tells you when you need to get information. Sometimes it is at the beginning of the creative thinking process. Sometimes it is in the middle. Research could be necessary to define the target audience. Consider a public service announcement (PSA) on smoking. Although you have general ideas about the effects of smoking on health, you do not have facts and figures. Research enables you to say with conviction how many Americans die annually from smoking-related diseases. If you are devising a PSA about domestic abuse, you need statistical facts and possibly psychological background before you can think about what is relevant, let alone make an assertion about the topic. Before you can say it, you need to know it. So research is gathering information that enables you to be authoritative and specific about the subject.

Even entertainment concepts require research. An imaginary story is often set in a time period or has a background. To make a story more believable, you need authentic detail embedded in the scenes. If your story concerns airline pilots, you need to know how they talk and what their world is like. To write a scene that involves cockpit talk, dialogue has to be credible and realistic. To write an episode of *ER* or any other hospital drama, you have to describe medical procedures and use meaningful dialogue between characters who are doctors. If you want to appreciate the research that might precede writing an original screenplay, read about William Goldman's research before writing *Butch Cassidy and the Sundance Kid* (1969).[1]

Research can be undertaken in any of several well-proven ways. You can consult encyclopedias, visit a library, or search the Internet. You have probably used a library catalog for a research paper. Research for scriptwriting is not much different. Everyone finds a particular style or method that works for him or her. Index cards are effective because they enable you to shuffle and reorder the material, and they help you to find the right sequence for ideas. Some **scripting software**, such as Movie Magic Screenwriter, has an electronic index card system that allows you to do it all on computer.

If you are working on a documentary project, background information about your topic is necessary to construct a meaningful narrative and to write a voice-over commentary. Researching a project for visual media is different from term paper or essay research because you not only need a factual background, you also need images—old photos, engravings, artifacts, and locations. Every scene in the script must be represented by an image. Suppose your script is historical. A good example would be the Civil War documentary by Ken Burns. You cannot interview Civil War veterans, but you can interview historians who are knowledgeable about the Civil War. You can film locations of some Civil

1 William Goldman, *Adventures in the Screen Trade* (New York: Warner Books, 1984).

War battlefields. Location research is critical to this kind of project. You can shoot existing images such as photos, engravings, and paintings. All of these images have to be found. A number of picture libraries sell the use of pictures from their collections, including the Library of Congress, which has a huge collection of Civil War photos that are in the public domain. Finding the right picture is a specialized task. There are people called picture researchers who make a living doing this particular kind of research.

Beginners will often propose short projects and pick documentaries about big topics such as HIV/AIDS or drug addiction. Most people find that their knowledge is very general and that the archive of available images is limited. Choosing such a project means doing research. A student of mine wanted to make a video about stress and how to combat it in college life. To do so, you need definitions of stress, statistics, and reliable information about diet and exercise. One of the issues was healthy diet and exercise. You need to make statements about diet in the voice-over commentary that are true and authoritative. All of these requirements lead to research. Obviously, research takes time and sometimes money if you have to travel to research a location or visit a specialized museum or library.

Before you can order a copy of an image or the text of particular statistics, you have to find them. The emergence of the World Wide Web has made research easier both for getting information and finding images. Clearly, picture libraries and photo agencies will become prime users of the web because they can show their product, sell it, and even deliver it online in one of the picture file formats, such as GIF or JPEG. Photo libraries that used to involve physical research and handling are now digitized and sell pictures as digitized files ready to download. Users of archive or library content can study low resolution images before buying rights and can manipulate digitized images in a program like Adobe Photoshop or a video editor on a desktop. It also simplifies the task of searching a collection for the image you want.[2] This is now particularly relevant to production of websites and video for DVDs.

Another example of research is collecting background information about a product or a process for a corporate program. To write about the client's product, you may need to read manuals and brochures and interview people in the company who are knowledgeable about the product. These people are sometimes known as subject matter experts (SMEs). This is particularly true if the content is technical. You have to learn enough about the subject to be able to make decisions about what is relevant or interesting to the designated target audience. For example, if you are writing about pacemakers, you have to pick the brains of a cardiologist. This means you have to know how to get to the right people and how to formulate the right questions. In a corporate context, your client usually guides you to many of the contacts you need. Before interviewing an expert, you should prepare a plan of investigation and a list of questions.

At what stage do you do your research? Some kind of investigation is usually necessary to get going and to stimulate your thinking; so that logically precedes everything else. Research could also come later in response to your need to know about specific things in order to make accurate statements. At a later stage, you may need to do audience research. If your production has a commercial purpose, it is quite possible that questionnaires, surveys, or focus groups would be called for. Then when you have defined your objective, communication problem, and target audience, you might have to research background information in order to devise your content. You might see a specific need for expert knowledge at this point.

2 Look up a photo archive such Getty Images at http://gettyimages.com.

For a PSA on smoking, you know you want to make a dramatic statement about how many people die each year from smoking-related diseases in America. You might want to compare it to another figure such as how many people die in automobile accidents or how many Americans died in the war in Vietnam. Comparing statistics would be a good way to put an issue in perspective for the audience. A statement that makes the audience realize that smoking kills more people every year than all those who died in Vietnam can have lasting impact. It makes the audience think. The populace would not accept American war casualties of that order every year without huge political consequences. Yet, for some reason, the lingering deaths of hundreds of thousands of people from all sorts of smoking-related diseases are acceptable. Our attitudes shift based on our knowledge and awareness.

If you are working on a PSA about texting and driving, you need to know how many accidents this practice causes, how long the average text messages takes to compose, and what distance a car travels at a given speed. Breaking distances are not proportional to speed but increase geometrically. Reaction time for braking or any other maneuver likewise increases geometrically with speed. Although you may know these things in general to be true, you have to make specific and accurate statements.

To get information about smoking-related deaths or drunk driving deaths, you might look at government statistics. These are published annually in reference works that are available online and in public libraries.[3] The Vietnam War statistic is historical fact and an extremely effective way to make a comparison to deaths from smoking. 420,000 Americans died last year (this changes) from smoking-related diseases; that is more than eight times the number of American casualties in the whole Vietnam War. Do you want to be one of them?"[4] "Roughly 48 percent of all traffic deaths in the United States are caused by drivers under the influence of alcohol" is a stronger statement than some generality about the dangers of drunk driving. You need a fact to reinforce a good punch line, such as "If you drink and drive, death could be the chaser."

Investigation and research overlaps with journalism. The difference is that research for visual writing is not just about verifying facts; it is about finding pictures and getting visual information from which you can construct a script. Knowing facts or background information does not tell you how to construct a script or persuade or entertain an audience. The same kind of information could be the basis for an article by a journalist or a book by an author.

Interviewing

People are another source of information. Some people are experts in their field. If they speak with authority, you might want to use them directly on camera as part of your program. Sometimes you need the point of view of the man in the street or you need to interview someone who represents a certain class of people, such as people with disabilities or post-traumatic stress syndrome. For documentaries and corporate programs, you need to find subject matter experts, people who have extraordinary knowledge based on a lifetime of research or direct personal experience. Because these interviews are often once-only opportunities, you need to prepare intelligent questions and

3 Statistical Abstract of the United States, published annually by the U.S. Department of Commerce, Economics and Statistics Administration, Bureau of the Census. Figures for 1990 are documented in *Substance Abuse: The Nation's Number One Health Problem* (Princeton, NJ: Institute for Health Policy, Brandeis University for the Robert Wood Johnson Foundation, October 1993). Alcohol-related deaths are also documented.

4 A total of 47,072 U.S. servicemen were killed in combat in Vietnam. This and other facts about the conflict can be found on the PBS website, www.pbs.org/wgbh/pages/frontline/shows.

have follow-up questions. There are a number of classic concepts for structuring an interview. There are a number of types of questions, each with a different purpose and usefulness in the interview process:

1. Open questions allow the interviewee to volunteer information, to express opinions, and to warm up: *What is the most exciting aspect of your job? How did you get interested in the reproductive life of sub-Saharan scarab beetles? Or, what do you like to do in your spare time?* Questions that ask who, what, when, where, why, or how typically lead to open questions.

2. Closed questions generally have a limited choice of answers. Do you like caviar? The answer can only be *yes* or *no*. Logically, it could also be *I don't know* if, for example, the person you are interviewing hasn't tasted it. In legal cross-examination and police interviewing, closed questions enable the questioner to pin down the facts. *Did you see the victim on the night of . . . ?* Closed questions can be hostile or threatening. In documentary investigation, the result might be refusal to answer or go into detail on controversial matters.

3. Double-barreled questions ask two or more questions in combination: *Why have you asked for political asylum, and what will you do if you get it, and if not, how will that change your view of this country?* The subject will tend to answer the questions he wants to answer and ignore those that might be awkward or revealing. Being interviewed puts people under pressure. Sometimes they forget one of the questions. Experienced interviewers avoid overloading the subject with multiple questions.

4. Leading questions imply an intent and can involve logical entrapment: *When did you stop beating your wife?* The answer involves an implicit confession. They can be positive: *Is the fact that your brother was imprisoned by the regime the only reason you decided to work for Amnesty International?* The interviewer prefaces the question with information based on research. These questions lead the interviewee to reveal more information or motivation.

5. Hypothetical questions ask someone to imagine a situation or choice that has not yet occurred or may never occur and to describe how they would respond. The answer reveals the character and mentality of the subject. The interviewer describes a situation to the subject and then asks what he or she would do. Such questions often involve ethical issues: *If you knew a terrorist had information that could save hundreds of lives, would you use torture to get that information? If your brother or sister needed a kidney to survive, would you donate one of yours?*

6. Self-assessment questions ask people to offer judgments or evaluations of themselves and their conduct. Political candidates get asked this kind of question all the time: *Why should you be elected president of the United Sates?* Or it could be in retrospect: *When you chose medical research as a career, did you ever think you might regret not becoming a professional actor?* These difficult questions hand the interviewee an opportunity that can be exploited—by a glib politician, for instance. They may bring a disadvantage to interviewing someone who is shy or inarticulate.

Capturing the opinion of people on camera is a universal documentary technique. News reports often do vox pops to reflect the views of the man on the street. An unrehearsed interview cannot be scripted although the questions can and should be written down ahead of time. To interview successfully, you should follow the well-established methods for constructing an interview. An interview needs to have an objective and a purpose. Why are you doing the interview, and what do you want to achieve through the interview?

The structure of the interview also matters. Do you start with a general question that is open so that the respondent can choose the scope of the answer? Sometimes, interviewers use this approach to put the subject at ease. This is called the *funnel technique*. You start wide and narrow down the questioning to finish with close questioning of a focused kind. Sometimes an aggressive interviewer will

start deceptively with open questions and work the subject down to difficult, embarrassing, closed questions that go for the jugular.

Let's imagine you are doing a documentary on terrorism. You have obtained a blindfold interview with a high-level, practicing terrorist. At the broad end of the funnel, you might ask: *What made you become a terrorist?* At the narrow end you can ask specific closed questions or detailed questions: *Were you involved in the planning of the 9/11 attacks?* If you were to invert the process, you would start with a specific closed question that might establish the point of departure: *Are you holding the three journalists hostage?* This could lead to broader questions that create a free-ranging discussion about terrorism, world politics, and values. This interviewing technique is known as the *inverted funnel*.

Lastly, there is the *tunnel technique*, which avoids the narrowing or broadening strategy but combines both and simply pursues a logical, consistent line of questioning. For instance, you are interviewing a cardiologist about pacemakers for a pharmaceutical-sponsored documentary about heart disease. For this you need instruction and explanation. You need to structure the interview to get the information you need. If you ask, *what is the most important advance in treating heart disease?*, your question may be too broad because there are so many types of heart disease. A better question might be: *What is the most important development in pacemakers over the last decade?* You must do your research and inform yourself ahead of time.

Follow-up questions, often improvised, can make a difference to what you find out when the person you are interviewing unpredictably opens up a topic or reveals a fact that the interviewer did not think to ask. If you have not done your pre-interview research, you will have difficulty asking good follow-up questions. Regardless of whether an interview is with a subject matter expert or a celebrity personality, preparation makes the difference. Although the answers can only be paraphrased in anticipation, the questions can be carefully written to provide a good structure from which it is easy to depart when the interview demands it.

An interview can be conducted by telephone and by e-mail, as well as in person. Whatever the method, it is also critical to record the interview accurately with an audio or video recording device. Sometimes, you discover that the interviewee is interesting enough to write an interview into the program and use what you have recorded.

Location Research

For film and video production, location research is very important. Unless you have the budget to create artificial interiors in a studio set, you have to find a setting in which to shoot. For exteriors, you have no choice. You are obliged to find a location. If you want a seashore with a sandy beach, you or your producer must go and find it. If you want historical buildings, you have to find a town or a street that fits the period. Rather than write and create locations searches, it often makes sense to research the locations first because they give you ideas for visuals. This is particularly true for corporate programs. Because the story or message usually has little visual information, you have to make it visual. Abstract ideas become concrete when you stand in a manufacturing plant or see the surroundings. Location research can make the difference for a writer. Visual writers need visual ideas. You get visual ideas by being in the environment of your topic. This is important to remember when negotiating a writing fee. Including an allowance for travel time, research time, and related travel expenses is important.

Writers of scripts still have to make the transition to the visual medium concerned. This is why the seven-step method discussed in Chapter 2 is so useful. To write a script, you have to think in the medium itself. This process starts with the loose, wide-ranging activity of creative sketching and digging for ideas. It is popularly called *brainstorming*.

BRAINSTORMING AND FREEING YOUR IMAGINATION

You can't write a script with just facts or information. You have to write with visual ideas that structure the narrative. These ideas may allude to facts or information, or they may even embody that information. Getting a script going depends on your imagination and, more specifically, on your visual imagination. There isn't a surefire method for stimulating this process that works for everyone. By trial and error, you learn what helps you think visually and creatively about the medium. Nevertheless, we can enumerate several techniques.

Brainstorming usually means just writing down all your ideas as they come to you without constraint or formality. It means stirring up your imagination by free association and by doodling. Making lists, drawing diagrams, and sketching images in storyboard sequences usually does the trick. The most important element of this process is to feel free to think or visualize whatever comes to mind. Very little should be rejected at this stage. By its very nature, this kind of writing produces more material than you will finally need or use; therefore, it leads to a necessary selection or editing process.

Sooner or later you need to make some kind of outline. One good way to work on your program is to outline it by listing key sequences or key images. You can use index cards, which allow you to shuffle the order to experiment with finding the most logical or the most meaningful order. Logic is not the only way to communicate, though. Sometimes, visual communication works best by being an emotional communication, such as showing a shocking image that disturbs the viewer. Visual exposition is not the same as writing essays in English composition. For example, there is no good verbal equivalent for a kaleidoscopic montage. And above all, you need visual metaphors both for individual scenes and structural organization. On the website there is **a video** about managing information flows that uses water, in all its forms and movement, to **explain metaphorically an abstract problem** of capturing, finding, using, and managing digital information.

CONCEPT

The first formal document you create in the scriptwriting process is called a *concept* or a *creative concept* (see step 7 of the seven-step method in Chapter 2). The concept outlines the key ideas and basic vision of the script content. This document is written in conventional prose. There is no special format for it. It does not provide any details of plot or content, nor does it include dialogue or voice narration. It is primarily an idea in a nutshell from which the script in all its detail will grow. A concept is written to persuade a key decision maker, such as a producer, director, or client that the project idea is on track and should go forward to the next stage. Very often the concept is presented verbally at meetings, which has come to be known as *pitching*. This is a baseball metaphor, which implies that you are trying to get an idea across the plate into the strike zone. In the entertainment world, the concept has a short form known as the *logline*. A logline is a written phrase or sentence that encapsulates the essence of the premise. It is part of the script development process of the entertainment world and will be discussed in greater detail in chapters devoted to that kind of scriptwriting.

The importance of a concept for the writer is that the vision of the script is clearly expressed and clearly understood. Like a sketch that precedes a painting or a model that precedes a sculpture or a drawing that precedes a building, a concept shows others the scope and potential of what the final result will be. The writer needs to know that whoever pays for the work gets what he wants. A scriptwriter is ultimately writing something that is validated by someone else wanting to collaborate to realize that expressed vision. That collaboration may take the form of money invested by a backer or

a producer; it may take the form of creative consent invested by a director or an actor; it may take the form of client consent to proceed with the vision.

It is difficult to characterize a concept because it has no fixed length and no fixed form. It just has to convince, persuade, and embody the seed of the script to come. Generally, the concept can be stated in a paragraph or a page at the most, depending on the length of the program. It is important for the writer to get reactions and for the producer to give reactions before significant effort goes into the next stage, the treatment. A concept for a PSA on the dangers of texting and driving might look like this.

A Concept for a PSA: Texting and Driving

We want to drive home the message by posing the question if you could text one last message, what would it be? We alternate between two drivers texting one another. We see one in an agonizing slow motion crash. The cell phone flies out of the car and comes to rest on the road. A close-up of the text not sent is in the text composition box: I miss you. Possible punch lines could be variations of: If you text and drive, what will your last message be? Text and let die.

Pitching

Most beginning writers don't know much about pitching. Pitching is talking, not writing. It is part of the communicating and selling of ideas in both the entertainment and the corporate communication industries. You have to be able to talk your ideas as well as write them down. To make a living as a writer, you often have to sell your ideas in meetings. It is a notorious part of the entertainment business that decisions to develop projects are often based on short pitches. The art of pitching is difficult to master. We discuss it in greater depth in Chapter 15. The Robert Altman movie *The Player* (1992) contains a number of scenes of pitching story ideas to producers and studio executives that gives you insight into how this works in the entertainment industry.

Pitching is not restricted to entertainment writing. When you write for a corporate client or a producer of corporate programs, you spend a lot of time in meetings and briefings in which you have to present your ideas succinctly and clearly to win the job. Even though the concept has been written down, you usually have to present it verbally in a meeting with the client. A good pitch should capture the essential idea in a nutshell and tease the listeners so that they are motivated to read what you have written. You should never read your concept to clients. If you do, then when they read it, they experience an anticlimax. This is because you read it for them, and there is nothing new. Thinking on your feet and communicating ideas orally is part of the writing business whether in entertainment or corporate communications.

Treatment

After the concept comes the treatment. Both of these terms are universally used and understood. A scriptwriter must know what they are and how to write them. Writing the treatment involves expanding the concept to reveal the complete structure of the program with the basic content or storyline arranged in the order that will prevail in the final script. A treatment is about structure and the arrangement of scenes. The narrative order must be clear. All the principal characters should be introduced. All the principal themes and points of exposition in a factual or corporate program should be laid out. Although this document is still written in normal prose, it can introduce key moments of voice narration or dramatic dialogue. Some writers base the treatment on a scene outline. In television series, the scene outline is known as a *beat sheet* and can substitute for a treatment. A treatment is

always written in the present tense—always. It is a prose description of the action and not yet a script. It is not appropriate to describe camera angles in abundance or shot concepts. Do not "ZOOM," because it is a difficult shot to shoot and an awkward shot to edit. An occasional CLOSE UP or CUT TO might contribute to clarity. However, the treatment is not a production document and therefore not filled with technical instructions. It must communicate clearly to nonproduction people.

A Treatment for a PSA: Texting While Driving

We see a young college age woman driving a convertible obviously happy and excited. We see a young man driving and texting. We see the cell phone in close-up both sender and receiver. The exchange is banal. The woman texts back for about five seconds. Begin slow motion. Suddenly she looks up in panic and horror and tries to seize control of the vehicle, swerve to avoid a pedestrian, and then collides with an oncoming car head on at an intersection. The cell phone flies out of the car. We hear the horrifying sound of the crash of metal on metal and breaking glass and a scream slowed down. We cut to a close-up of the phone on the road finishing its spin. We read the last message not yet sent: I MISS YOU. Over a scene of carnage we superimpose the punch line: DO YOU HAVE A LAST TEXT MESSAGE? A TEXTING DRIVER IS 23 TIMES MORE LIKELY TO GET INTO A CRASH THAN A NON-TEXTING DRIVER. TEXT AND LET DIE.

SHOT, SCENE, AND SEQUENCE

Now that we know the nuts and bolts of describing sight and sound in an individual shot, we need to think about how those shots go together to make scenes and how scenes go together to make sequences. In dramatic writing, there is a larger structural unit carried over from theatrical writing called an *act*. This is used in television scripts (see the templates in **Movie Magic Screenwriter**) and is usually implicit in screenplays. Chapter 8 discusses large-scale story structure that gives a script shape, rhythm, pace, and meaning.

A shot is the minimal element of the moving picture medium. It begins when the camera is switched on and ends when the camera is switched off. The beginning and ending can be adjusted in length in an edit suite, but that is all. Theoretically an edited shot could be one frame long, but it would not then have movement. It could only work as part of a montage. To make an analogy to language, a shot would correspond to a word. Then a scene would be like an assembly of words that put in a meaningful grammatical syntax make a sentence. Lastly, a series of sentences arranged as a meaningful exposition to make a paragraph would correspond to a sequence.

Let's go back to our developing PSA, Texting While Driving. What would be an example of a shot? Remember a shot is what is recorded in the interval between a camera being turned on and off. So a basic shot could be a Medium Shot of a happy-go-lucky attractive young woman sitting behind the wheel of her Mustang convertible. This shot could be taken from many positions such as a Low Angle from the passenger seat, or a quarter back view of her head from the back seat showing the steering wheel and the road.

A scene in Texting While Driving would be a series of shots cut together which would show her driving, looking at her cell phone, reading a text, texting a reply, and finally reacting in horror at the oncoming accident. A scene has to be shot in continuity so that the action is repeated from all the camera angles that contribute to the scene. How they are cut together and whether they are edited in a continuous order is an editing decision.

A sequence in Texting While Driving would add to the scene above another scene that might include say a shot of the road, the car driving past, and a shot of pedestrians at a crossing, the crash, the close-up of the cell phone on the road all intercut. The shape and order of the sequence is

suggested by the scriptwriting but ultimately determined by the director and editor in postproduction. It should be said that a 30-second PSA is itself really a sequence. So it is perhaps not the best example but allows us to follow the development of this one idea.

FIRST-DRAFT SCRIPT

The name of this document is fairly self-explanatory. The first-draft script is the initial attempt to transpose the content of the treatment into a screenplay or script format appropriate to the medium. This is the crossover from prose writing to scriptwriting in which all the special conventions of camera and scene description are used. The layout of the page serves the special job of communicating action, camera angles, and audio to a production team. It is the idea of the program formulated as a blueprint for production. The producer, the client, and the director get their first chance to read a total account for every scene from beginning to end. Until now the program idea has existed incompletely as a promise of things to come. Now it has to work in every scene with little or nothing left to chance for actors, directors, and anyone involved with production. Only now do we write a script, which has to communicate to production personnel. In order to do this, we have to know the specialized terminology for describing sight and sound, which is explained in the previous chapter. Now let's take a shot at a first-draft script Texting While Driving.

A FIRST-DRAFT SCRIPT FOR A PSA: TEXTING WHILE DRIVING

1. INT. CAR – DAY	
Establishing shot of a young, attractive woman at the wheel of a Red Mustang convertible. She is happy and listening to upbeat music on the car music system. She beeps the horn at an annoying driver.	FADE UP MUSIC AND CAR SFX
CUT TO	
2. EXT. ROAD – DAY	
The Red Mustang comes up and passes the camera.	MUSIC
CUT TO	
3. INT. CAR – DAY	
We see a good-looking young man in another car driving and texting with both thumbs while he steers with his knees. He sends a message.	SFX CAR INTERIOR
CUT TO	

4. INT. MUSTANG - DAY

Her cell phone on the passenger
seat signals a text delivery.
She looks down and back to the
road. Show cell phone screen.
We see a kind of conflict in
her face. She is desperate to
check the message but is also
conscious of the need to watch
the road while driving.

SFX CAR INTERIOR, MUSIC, WIND,
AND CELL PHONE TEXT MESSAGE
SIGNAL

 CUT TO

5. EXT. INTERSECTION - DAY

We see a red stop sign
approaching with some
pedestrians crossing

SFX ROAD

 CUT TO

6. INT. MUSTANG - DAY

The girl is smiling and texting
with one hand on the wheel.

MUSIC

 CUT TO

7. EXT. ROAD - DAY

We see another car approaching
the intersection at right
angles on the green light.

SFX INTERSECTION NOISE

 CUT TO

8. INT. MUSTANG - DAY

The girl suddenly looks back at
the road with a look of terror
and slams on the brakes.

MUSIC, SFX SCREECHING TIRES

 CUT TO

9. EXT. INTERSECTION - DAY

A pedestrian leaps to avoid the
Mustang. The car approaching
on the green light is on a
collision course. Just before
they collide.

SFX OF EXTERIOR CUT MUSIC

 CUT TO

10. INT. CAR – DAY	SFX SICKENING CRASH OF METAL AND GLASS
The young man looks at his cell phone wondering why there is no reply.	
11. EXT. ROAD – DAY	SFX CELL PHONE TONE
CU of the girl's cell phone spinning on the road. It stops. The screen of the unsent message reads: I MISS YOU. FREEZE FRAME.	
CUT TO	
CG LOWER THIRDS	
Text SUPERS over the freeze frame: A TEXTING DRIVER IS 23 TIMES MORE LIKELY TO GET INTO A CRASH THAN A NON-TEXTING DRIVER. NAME OF SPONSORING ORGANIZATION	V.O. A TEXTING DRIVER IS 23 TIMES MORE LIKELY TO GET INTO A CRASH THAN A NON-TEXTING DRIVER.

REVISION

Every stage of the scriptwriting process involves readers and critics. Most writers are paid to write by a producer or corporate client who is entitled to ask for changes at each stage of the process. This is normal and proper. The writer's skill in conceiving visual sequences is a valued skill. It requires a lot of work and a special talent. Although writers write their own scripts on spec (without being commissioned), eventually any script has to be read and understood by an enabler such as a producer, a director, or an actor. Anyone who is going to lend energy or resources to bring a script into production has views and will want to modify the script in some way. This means revision.

Revision is the hardest part of a writer's job because it means being self-critical. It means throwing out ideas or changing them after you have invested time and energy to make them work. Sometimes you have to give up ideas you believe in. You have to trust that the process will work out in the long run. If you cannot prevail in vigorous debate at a meeting and get all your ideas accepted, you have to accommodate alternatives. Willingness to revise and the capacity to make revisions mark the most successful and professional writers. You have to learn to see revision as an opportunity to make your work better. You have to develop a thick skin. If you are oversensitive to criticism, you will have a hard time. You must learn to see writing as collaborative and to see your writing as a creative service rather than personal expression.

There are different levels of revision. Revision does not mean correcting spelling or grammar. This should be corrected before submission. It means throwing out unneeded material. It means adding new scenes. It means changing the order of scenes. In an extreme case, it could mean abandoning a concept and starting again. However, the custom and practice in this industry, which is reflected in contracts, allows you to demand more money for rewriting something that had been accepted at an earlier stage. You can see the need for these stages of the process that have developed over the years. People change their minds. By submitting work in stages, you gain acceptance for your work before

you invest time and energy in the next stage, knowing that each stage is more laborious. If your client or producer demands something that overturns a previously accepted stage of the process, you should be paid to do the work again. This is unusual, but it does happen. In the entertainment industry, this often means paying off one writer and bringing in another. The stages of the process are important to the success of the scriptwriting enterprise because they support the creative development of ideas in a methodical way, and they provide a comprehensible system for the business arrangement that accompanies writing work.

FINAL-DRAFT SCRIPT

The *final draft* is another self-explanatory term. It is the final document that incorporates all the revisions and input of the client or producer and all the improvements and finishing touches that a scriptwriter gives to the writing job even when not explicitly asked for. Scriptwriters, like all writers, look at their work with a critical eye and seek constant improvement. This document should mark the end of the writer's task and the completion of any contractual arrangement.

Let's revise Texting While Driving. The final draft of Texting While Driving is not what we started out with. Changes are indicated in italics.

A FINAL-DRAFT SCRIPT FOR A PSA: TEXTING WHILE DRIVING

1. INT. CAR - DAY	
Establishing shot of a young, attractive woman at the wheel of a Red Mustang convertible. She is happy and listening to upbeat music on the car music system. She beeps the horn at an annoying driver.	FADE UP MUSIC AND CAR SFX
CUT TO	
2. EXT. ROAD - DAY	
The Red Mustang comes up and passes the camera.	MUSIC *OUT*
CUT TO	
3. INT. CAR - DAY	
We see a good-looking young man in another car driving and texting with both thumbs while he steers with his knees. He sends a message.	SFX CAR INTERIOR
CUT TO	

4. INT. MUSTANG - DAY	SFX CAR INTERIOR, MUSIC, WIND, AND CELL PHONE TEXT MESSAGE SIGNAL
Her cell phone on the passenger seat signals a text delivery. She looks down and back to the road. Show cell phone screen. ***We see a kind of conflict in her face. She is desperate to check the message but is also conscious of the need to watch the road while driving.***	
CUT TO	
5. ***INT. CAR POV*** – DAY	SFX ***CAR*** ~~ROAD~~
We see a red stop sign approaching with some pedestrians crossing	
CUT TO	
6. INT. MUSTANG - DAY	MUSIC
The girl ***gives in to temptation; checks the message and*** is ***now*** smiling and texting with one hand on the wheel.	
CUT TO	
7. EXT. ROAD - DAY	SFX INTERSECTION NOISE
We see another car approaching the intersection at right angles on the green light.	
CUT TO	
8. INT. MUSTANG - DAY	MUSIC, SFX SCREECHING TIRES
The girl suddenly looks back at the road with a look of terror and slams on the brakes.	
CUT TO	
9. EXT. INTERSECTION - DAY	SFX OF EXTERIOR ***HARD*** CUT MUSIC ***OUT***
A pedestrian leaps to avoid the Mustang. The car approaching on the green light is on a collision course. Just before they collide.	
CUT TO	

10. INT. CAR - DAY	
The young man **who has arrived at the destination,** looks at his cell phone wondering why there is no reply. **He sends an impatient message, which we see: WHERE R U?**	**HARD CUT TO** SFX SICKENING CRASH OF METAL AND GLASS.
11. EXT. INTERSECTION - DAY	
The pedestrian mother and child are lying in the road dead or injured.	**CAR MUSIC UP**
12. EXT. ROAD - DAY	
CU of the girl's cell phone spinning on the road. It stops. The screen of the unsent message reads: I MISS YOU. FREEZE FRAME.	SFX CELL PHONE TONE **RECEIVING MESSAGE.**
CUT TO	**CROSSFADE CAR MUSIC TO V.O.**
13. CG LOWER THIRDS	
Text SUPERS over the freeze frame: A TEXTING DRIVER IS 23 TIMES MORE LIKELY TO GET INTO A CRASH THAN A NON-TEXTING DRIVER.	V.O. A texting driver is 23 times more likely to get into a crash than a non-texting driver.
NAME OF SPONSORING ORGANIZATION	

The changes made clarify the intent of the scriptwriter. In scene 4, the description of her behavior needed a little clarification to understand the situation. In scene 5, the slug line was inaccurate because if you are shooting the approaching red light, you are using the car as a tracking platform and seeing it from the POV (point of view) of the driver. In fact, you could write this slug line as: EXT. POV DRIVER—DAY. Therefore, the sound effects in the shot are in the car and not exterior.

In scene 6, adding a little more to the description of behavior helps. The idea of a transition between scenes 9 and 10 was to have a shock hard cut on the sound track so that the audience imagines the crash via the audio while seeing the young man who has not arrived and is somewhere else at the same instance in time expecting her or a message. So the sound cues needed alteration. Explaining that he made it to the destination needed clarification. He was more outrageous in texting than she. If we have him send a message, which we see on his screen, we know what the message is coming in to her cell phone spinning on the road in scene 12. Scene 11 is added to enlarge the message to say that texting while driving does not just endanger the guilty but also the innocent. Now you have to renumber the scenes. In scene 12, the audio transition

from the upbeat music still playing on the crashed Mustang sound system provides a kind of ironic commentary. The idea of the close-up of the cell phone displaying her last banal message for which the driver died is reinforced by our knowing that a message has been delivered, which she will never read.

The last scene of graphics and titles had no number. During revision, I thought why not have the pedestrian accident be the disastrous outcome? This makes the point that others suffer the consequences of texting and driving. However, it then seemed that we could have both. The more important points to communicate in the script are the trivial, banal messages for which people risk their lives and those of others. I guess I kind of fell in love with the shot of the cell phone spinning on the road mechanically continuing to function without the owner. Cell phones survive but the texting drivers may not although the boyfriend gets away with his outrageous texting. Now you can see that revision involves both technical corrections and further development of the idea.

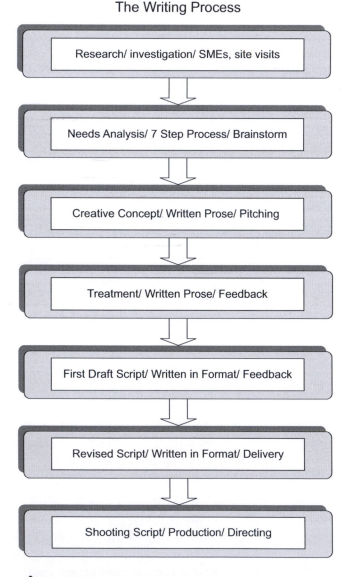

The Writing Process

Research/ investigation/ SMEs, site visits

Needs Analysis/ 7 Step Process/ Brainstorm

Creative Concept/ Written Prose/ Pitching

Treatment/ Written Prose/ Feedback

First Draft Script/ Written in Format/ Feedback

Revised Script/ Written in Format/ Delivery

Shooting Script/ Production/ Directing

➜ **Figure 4.1** The writing process.

SHOOTING SCRIPT

You have probably heard the term *shooting script*. What is the difference between a script and a shooting script? The simplest way to distinguish them is to say that the scriptwriter writes the script and the director writes the **shooting script**. The shooting script translates the script into a production document concerned with detailed camera angles usually based on location surveys and a camera plot. It breaks down the script into shots and camera setups. It represents the director's technical conception of how to shoot the program. A scriptwriter cannot write a shooting script unless that writer is also the director. It is inappropriate and irritating to a director when a scriptwriter tries to direct from the script by peppering it with camera angles and camera directions. The director is responsible for the execution of the vision set down in the script. That means choosing locations, production resources, and camera angles. It also means editing.

If you now break down the Texting While Driving script and turn it into a shooting script it might involve the following shots and camera set-up. We will not break down the whole script but a couple of illustrative scenes to show the difference. The first scene is inside the car and establishes one character. The scriptwriter describes action and writes dialogue. The director has to think about how to shoot in a moving car, or from a tracking vehicle driving along side. There are all sorts of car mounts for cameras. He could mount one on the hood seeing the driver from the front, maybe getting the cool effect of moving reflections of the surround scene in the windshield. There will have to be a shot inside the car probably low angle of the girl, especially to show her terror at the oncoming hazard. You would need a high angle close-up of the cell phone. Another shot could be from the back seat quarter back of her head also showing the road ahead. You could also have a tracking camera vehicle behind the car shooting her car and the road ahead. The director has a limited budget and schedule. Whereas the scriptwriter is thinking in terms of what we want to be seen on screen in the desired order and therefore describes the finished edited result, the director has to think how certain camera set-ups can be used as cover across several scenes. For example, all the tracking shots mounted on both the car and a tracking vehicle would be shot from the beginning to the end of the entire action. Another set would be a high angle of the cell phone on the road. A director would probably take a wide angle establishing shot of the intersection for the whole action. There would mediums shots and long shots of the pedestrian dodging and falling down injured. There would also be a panning shot of the Mustang coming up and past a fixed camera position on the road. So the director is going to make a list of those shots that cover the same action to allow for editing choices and pacing of the final product. Also actors and stunt drivers create the whole action from beginning to end, not the fragments that end up as shots in the final edit. The take away from this is very important: scriptwriters and directors think differently and have a different job.

CONCLUSION

We have learned that scriptwriting is a process. It has well-defined stages that have evolved with good reason to favor the development of quality results. We know what these stages are called and what they look like. Good scripts require conceptual invention, visual writing, and technical command of the medium. We have followed the development of a PSA about Text While Driving. The chapters that follow show you how to solve communication problems through script development and this newly acquired visual language so that a production team can execute your vision and produce finished, viewable product. We have studied the problem on a small scale. We will see that media content breaks down into genres that present slightly different challenges of both scale and nature.

Although we have a body of core techniques, we have to learn how to apply them to different kinds of media content in the remaining chapters.

EXERCISES

1. Conduct interviews of people you know to collect information for a piece on a controversial subject such as stem cell research, abortion, or gay marriage. Use an audio recorder or a camera.
2. Ask another writer to critique your work and write down that writer's comments. See if you can revise your script based on the critique.
3. Write a critique of a treatment or a script written by someone else.
4. Write a concept, treatment, and first-draft script for a PSA on smoking, drug addiction, or domestic violence.
5. Take a commercial product that you know and write a television ad for it.
6. Try writing a PSA relying solely on visuals with no commentary.
7. Try writing a radio PSA which relies solely on sound.

PART 2

Solving Communication Problems with Visual Media

In the beginning, television was simultaneously a production medium and a live distribution medium. Its production technique was matched to the necessity to broadcast live over the airwaves. After the invention of videotape recording and the evolution of postproduction video editing, television could be produced with single cameras by non-broadcast companies as well as by the broadcast behemoths. The television signal can be produced outside the studio, recorded, and edited on videotape. We can call this video. Television is now a distribution medium as well as a production medium. Let's not confuse the distribution medium with the production medium. Television programs can be delivered to the end user by broadcast radio signal, by satellite, and by cable. To these channels add podcasting via Internet web pages and mobile platforms. Other methods of program distribution include exhibition in movie theaters, on DVD and Blu-Ray release, and by streaming across the web (e.g., Netflix, Amazon, and Hulu).

A program delivered via a given medium might not be produced in that medium. For example, a feature film shot on film or even a series shot on film produced mainly for television can also be exhibited in a movie theater and broadcast, or cable-cast, or delivered by satellite transmission or on any digital media platform. A television quiz show or a news program would probably be restricted to over the air, on cable, or streaming to the web. A documentary could be delivered via any of the media mentioned. Multiple-camera studio production, the traditional and original television production technique, is different from single-camera video production, even if the final product is shown on television. The script is a production document, not a distribution document. Therefore, the writer must think in terms of the producing medium, not the distributing medium. Knowing that you can see documentaries on television does not help you write them. Knowing that you can see a feature film on television does not help you write one. Writing for television is different to writing for the big screen. And writing for mobile platforms and websites, we will find out, requires yet another approach.

The logical progression of our learning process is to apply what we know to specific media formats. Many of them have special requirements. Many of them have preferred formats that the industry has adopted. Each type of program has a definable characteristic that we need to learn about and practice writing. Although these formats are all visual media, the writer has to think about them in different ways.

In this section, we explore how to solve communication problems that are principally informational, promotional, instructional, and persuasive. This includes solutions to corporate communications needs and commercial messages, as well as factual documentary and educational content.

CHAPTER 5

Ads and PSAs: Copywriting for Visual Media

Advertising was established in radio (before television) and for film programs in movie houses. You still see local and national ads in some movie theaters before the program starts. The principle of selling time for commercial messages shown between programming grew up with visual media. A format suitable for television was developed to deliver short effective visual commercial messages in breaks during and between programs. The airtime was sold to advertisers to generate operating revenue and profit for the television companies. This is now the principal business model for visual media that are free to the viewer.

Television provides access to the majority of homes and, therefore, to the largest audience; however, it now competes with digital signage on websites and real-time advertising offered by browsers. This alters the relationship of advertising to content and to media channels that sell around that content. It allows advertisers to assign value to media rather than publishers, who can no longer control the price even though they can control the quality of the content and the audience on a given site.[1] Before broadcast television, few people had dealt with the pressure to communicate product or commercial information in the rapid, attention-getting way that television advertising requires. Although television and cable advertising are still alive and well, they now compete more and more with digital

1 See Tanzina Vega, "The New Algorithm of Web Marketing," *New York Times*, November 15, 2012.

signage on the web. Airtime was, and still is, very expensive to buy. Because television is the most expensive advertising medium, it has driven the writers and producers of commercials to refine their techniques so as to deliver a complete message in a short amount of time. The cost of this time on air far exceeds the cost of producing the message itself.

The short TV ad has become a kind of twentieth-century art form with a constantly evolving style. It has attracted much writing and directing talent from around the world, drawn partly by the money and partly by the opportunity to graduate to longer forms in the entertainment sector. Ads are special because they are so short—usually well under a minute and as short as 15 seconds. Everyone has seen them, which is not so true for some other formats.

Almost all television viewers have seen public service announcements (PSAs), which are messages that are broadcast for the public good. Sponsoring non-profit organizations sometimes pay for PSAs, but they are usually furnished to broadcasters to fill any unsold time in the commercial breaks. This is one way in which television stations help the community to which they broadcast and fulfill a public service obligation of their Federal Communications Commission (FCC) license to broadcast over public airwaves. Of course, PSAs usually run late at night or in other less commercially desirable time slots. Not everyone has the stamina to write a feature film script, but anyone can take a shot at writing a 30- or 60-second PSA. So it is a good way to start.

COPYWRITING VERSUS SCRIPTWRITING

Let us distinguish between copywriting and scriptwriting. Copywriting includes print, billboard, transportation signage, and media writing. National advertising campaigns on television are devised and produced by advertising agencies retained by the client company. Learning about this kind of writing and the business of advertising and public relations usually takes place in a specific track and specialized courses in communications programs. Although visual writing is involved in some kinds of copywriting, there are so many other issues involved in copywriting that it is better to leave those dedicated issues aside and understand the nature of the visual writing of ads and PSAs that happens to be part of copywriting.

Television ads and trailers for programming are also written for small markets in the broadcasting world. Local clients cannot afford an advertising agency. Somebody has to write these ads for the TV or radio station's clients. It could be a staff member, part of a unit that sells the station's time, or it could be a freelance writer or a local ad agency. We need to keep in mind that these kinds of local ads are made on small budgets by the television station, sometimes at cost, because their profit comes from selling airtime. The stations often have spare production capacity—a studio, cameras, a camera crew, and an editing facility. This means that the ad must be written without slick effects or expensive motion graphics, without travel to expensive locations, and without expensive talent. Local car dealer ads are a typical example. This brings us back to the perennial challenge that every scriptwriter faces: to write creatively and invent original visuals within a tight budget framework. The same holds true for local PSAs, sponsored by organizations with a limited budget to spend on production.

PSAs offer an excellent training ground for beginning scriptwriters. They are short and complete miniscripts. They require all the disciplines of scriptwriting. You might choose one of the common public service issues, such as smoking, domestic violence, education, drugs, drinking and driving, or texting and driving. Working on a PSA allows you to test-drive your creative imagination. If you are enrolled in a related production course, you might be able to make your PSA into video. You can also take a familiar product and try to devise a TV spot for it. However, a lot of ads rely on specialized production companies to get pack shots or create computer-generated effects that might be difficult to duplicate in a college production setup. For example, food shots are often enhanced with substances that look better than the real thing. Is it milk or watered-down glue that they are pouring into that

bowl of cereal? Another good exercise is to write and produce an anti-ad. You can satirize and expose the false logic of many ads exposing the shallow strategy of communication. A PSA that ran a couple of years ago takes the message of the coal industry that it has enough energy to power America for years to come, generating well-paying jobs and alluding to a new clean coal technology, and exposes the distortion of fact and logic in the ad. A presenter invites you to look at the new clean coal technology. You go through a door to an empty landscape. There is **no clean coal** technology.

Another one has a family using a can of *clean coal* to create a cleaner atmosphere in the home. The black dust coming from the spray can of *clean coal* dirties everything and has them coughing. The presenter exposes the patent deception in the idea of clean coal—an oxymoron. What we are learning here as writers also enhances our media literacy or understanding of how media communication works.

CLIENT NEEDS AND PRIORITIES

The PSA and the TV ad are works commissioned by a client. The client needs a solution to a communication problem that the writer must provide. We alluded to this discipline of the professional writer in Chapters 2 and 3. You often write for someone who represents the interests of an organization or a corporation. An entertainment script, however, is different from commissioned works because neither the producer nor the writer can know for sure what a good script is until it is produced, shown to an audience, and validated by box office or audience ratings. Commissioned programming doesn't have an audience measurement expressed in terms of box office revenue. Successful communication can only be measured by quantifying audience responses as changes in sales or behavior.

Advertisers expect to measure the effect of an ad in increased sales; otherwise, there is no business sense in spending money on ads. Some television spots do not sell a product but serve corporate publicity or other public relations objectives to create awareness of a brand or corporate identity. **BP** has spent millions in damage control for the Deepwater Horizon oil spill that polluted the Gulf of Mexico in 2010 and created a gigantic public relations problem for its corporate identity. It recently pleaded guilty to a number of violations and agreed to pay fines totaling in excess of $4 billion. It is still running ads to burnish its corporate image and show that it is investing millions in clean up and compensation and prove that the environmental damage caused by the spill has been overcome.

CSX, a railroad, has a long-running campaign of print, web, and television ads directed at the general public. Although the general public is not their direct client, the ads are intended to showcase CSX as a socially conscious, environmentally friendly business that carries freight with minimal carbon emissions. The campaign's slogan—How Tomorrow Moves—is the punch line that caps off a powerful visual narrative that makes us appreciate a freight train's fuel efficiency: rail can move a ton of freight 400 miles on one gallon of fuel. There is a selling proposition that rail freight competes with other forms of transportation, in particular trucking. However, the main message is that CSX is a green company that is aware of global warming caused by fuel combustion and that rail is environmentally friendly and therefore "how tomorrow moves." The message is company wide, as you can see on their website (**www.csx.com**).

It is much more difficult to garner information that positively proves the effectiveness of these non-marketing PSAs because they do not necessarily impact sales. A PSA often aims to change people's awareness and, eventually, their behavior. A good example would be the Ad Council's campaign, launched in 1983, against drinking and driving, sponsored by the U.S. Department of Transportation/National Highway Traffic Safety Administration. The slogan for the campaign was "Friends Don't Let Friends Drive Drunk." Changes in behavior are much more difficult to achieve than changes in the buying choices of the public. However, by 1998—15 years after the beginning of the campaign—alcohol-related accident fatalities had declined to a historic low. Now we have a new road safety hazard because of texting and driving and even cell phone calling and driving. This problem hardly

existed when the last edition of this book was published. Accidents and deaths from texting are overtaking **driving while drunk statistics**.

Writing for clients is often challenging and exciting precisely because you are given a communication problem and have to devise a solution. The seven-step method explained in Chapter 2 is an excellent way to approach this challenge. The process of analysis is really important for writing PSAs. Although you do not now have a client, you must practice script writing as if you had to satisfy a client's needs. Your creative ideas must work for a client, not just for you. This is not self-expression like some other forms of artistic writing. One of the constraints of this kind of writing is that the client fixes the length. Because the resulting product is transmitted in commercial breaks, its length must be exact to the second, as that is how airtime is bought and sold. Although the film or video editor will have to cut the piece to the frame to fit the given length, the writer has to be conscious of the pace and potential narrative that will fit the designated length.

THE 15-, 20-, AND 30-SECOND MINISCRIPTS

Ads in the form of 15-, 20-, or 30-second miniscripts are almost a new popular art form, born of the television age and the need to compress visual messages into very short, very expensive time slots. The style and tempo of these ads continues to evolve at a furious rate. The style of camera work, directing, and editing has influenced longer form narrative because a whole population has been educated from infancy to read the language of film rapidly. Shots are shorter and narrative more compressed. Some companies produce nothing but TV commercials, just as some directors spend their whole careers making these minimovies. From their ranks have come a number of feature film directors such as Ridley Scott, Hugh Hudson, and Alan Parker.

Some TV commercials for national campaigns of major brands, based on millions of dollars worth of airtime, have very high budgets. The per minute cost exceeds that of half-hour documentaries and some television episodes, and these miniproductions are often shot on 35-mm film with production crews that sometimes rival those for a small feature film. In major markets, there are companies that do nothing but shoot television commercials. The local market spot for a car dealer or furniture store, however, is usually low budget. Clearly the national campaigns are developed by advertising agencies whose copywriters develop the ads in collaboration with creative directors, art directors, and account executives. The copywriter is not a full-range scriptwriter and also usually has to write print media ads. Although this book primarily serves the interests of scriptwriters, the visual thinking that underlies billboards and transport ads relates to both copywriting and scriptwriting.

VISUAL WRITING

Some visual writing for television commercials is relatively simple. It relies on what is commonly called *show and tell*. We see a demonstration of a product and hear a voice-over explaining its benefits. The ad is a straight selling proposition. The communication is more or less literal. The script would have a description of the action on one side of the page and a voice-over explanation on the other side. There is no visual metaphor, but media writing, particularly television advertising, often needs a different kind of writing that describes a visual idea that is not literal. This is like another layer of writing.

In previous chapters we established how media writing is a different kind of writing than prose exposition. The words describe a scene or a shot which is going to be produced as a moving image. This visual idea is not in the words themselves but in what they allude to in another medium. That approach will work for the literal show and tell message. However, there is another degree or another level of

media communication that involves visual metaphor and a structural concept which does not exist in an individual shot or scene but in the assembly of images that, taken together, mean much more. The individual scene descriptions, which are instructions for production personnel, contribute to a visual idea that transcends the screen moment and rests on many of those moments put together, hence meta-writing. It is an idea that informs and governs the whole, not just the written detail of within the script, called meta-writing in previous chapters. There is a difference between visual meta-writing and the literal writing found on a page of script for a visual medium, whether in the minidrama of an ad or a full-length feature film. The dialogue, which is an integral part of the writing and exposition, is not itself visual writing but a necessary component of it. Radio ads need dialogue writing but not a visual idea. So visual writing is the creative visual idea that informs the whole as well as the description of specific images or shots. It needs what we call a visual metaphor. Let's look at some examples.

A few years ago, an ad by AOL tried to explain spam by comparing two sandwiches, one protected from spam and the other one smothered in ketchup, mayonnaise, and relish, making it inedible. That kind of organizing visual metaphor is often the key to successful visual communication. More recently, in a series of ads for Red Bull, we see an even purer form of visual metaphor; a propeller-driven aircraft flying an air rodeo obstacle course in Monument Valley in the Arizona desert and performing outrageous maneuvers ending with a vertical stall, allowing the plane to fall out of the sky into a dive. We get a close-up of the pilot happy and exhilarated. His line is: "Welcome to my world." There is no voice-over, no computer graphics or text on screen, and no identification of the product as a drink. Red Bull sponsors air races, rodeos, Formula 1 motor racing, and other extreme sports all over the world. So what is the visual communication here? As with many other Red Bull ads, there is a visual metaphor at work—the images of extreme sports represent skill, daring, and exceptional performance. The audience sees this, perceives this, and, without a verbal explanation, makes the connection between the high achievers and the qualities and benefits of this energy drink—the world of Red Bull. The stunt flyer demonstrates the implied effect of the product.

In an ad for Doritos, a young woman is hails a taxi while munching Doritos. When she looks at another car, the scene inside lights up and changes color; everywhere she looks there is a Doritos transformation. It ends with her stepping out of the taxi and striding past the bouncer of a chic club. Again, there are no words, and there is no text except for the name of the product. The script writer is trying to find an *objective correlative* or a visual metaphor for taste.

The audience extrapolates the meaning by a mental interpretation through the visual, not the auditory, cortex. Even though text or printed language is read through the eyes, it takes time to read and understand. The human brain processes images 60,000 times faster than text. So visual metaphor can make an image meaningful in the moment, but visual metaphor is also the organizing metaphor underlying narrative structures. This metaphorical thinking in images is meta-writing. Together they constitute visual writing.

> An *objective correlative* is a term of literary critical theory advanced by the poet T.S. Eliot. An objective correlative meant that an image in all its complexity stands for a meaning that is understood visually, whether in poetry or a TV commercial. The transfer of meaning is hard to achieve, but when it works it is stunning and engages the audience. This is another way of describing visual metaphor.

DEVICES TO CAPTURE AUDIENCE ATTENTION

Most of you have engaged in the subtle war between the viewer and the television advertiser. Hands up, everyone who has hit the mute button during the ads, or gone to the bathroom, or gone to the fridge, or made a telephone call during the commercial break! This nullifies the advertiser's effort and

expense. Sometimes, either by accident or by choice, we find TV commercials entertaining or fun to watch. The challenge is clear. The advertiser has a lot of resistance to overcome and must capture audience attention. Now you are on the other side of the box, tube, now flat screen. You have to be creative and capture the audience's attention in spite of itself so that it pays attention to your message. Your device has to work for others—millions of others. Measured by your own viewing behavior, no audience will give you any quarter. You live or die in seconds.

What are some of the ways you have noticed writers of these miniscripts hooking the audience so that it will pay attention to the message? You can recognize definite strategies such as humor, shock, suspense, minidrama, testimonial, special graphic effect, music, and, of course, sexual innuendo. These strategies are more elaborately developed in commercial advertising because for-profit companies have the dollars to spend on high-end production values. PSAs cannot command the same resources. They are made on lower budgets or created through the pro bono work of advertising agencies and production personnel. Working with a low budget is a creative challenge. Production dollars don't automatically buy creative and effective communication. Some of the most ingenious ads and PSAs are both cheap and effective.

Here's a good example of a low-budget local ad for a car wash, shot on a table top in a studio with a few props.[2] There is one camera angle. There is a toy car sitting on a dinner plate with a flat infinity background of colored backdrop paper. Several hands come into frame from the top of screen with different salt shakers and proceed to shake salt over the car. The speeded-up match dissolves show the salt gradually covering the car, and then as it is blown away the car disappears leaving four wheels. The voice-over says something like—

Everybody likes a little salt on what they eat, but do you know what salt likes to eat—cars, which is worth remembering because every winter several million tons of very hungry salt get dumped on the roads around here. So if you've been on the roads lately, get your car into a car wash before your car gets eaten right out from under you.

The client was the **New England Car Wash Association**. Clearly, this would only be meaningful to someone who has lived in New England or a similar geographical area where rock salt is scattered over roads every time it snows. It does not have to explain how rust corrodes the body work of cars. The audience knows that.

What are the virtues of this low-cost ad? It is simple, creative, original and has one basic idea. Its message is clear. It also engages the audience by relying on its intelligence, imagination, and thinking process to extrapolate the meaning from the visual. The audience contributes to the message. This is a key point. We want to build on it to cement our understanding of how strategies of engagement make strong successful ads. There are many, and they all rely on some clever way of engaging the audience. Carry this idea forward!

Other types of commercial messages such as the hard sell, marketing specific products (unique collections of songs compiled on CDs not found in stores, or kitchen gadgets, glues, cleaners) also work; they require you to pick up the phone now and order for only $19.95. But wait! If you order in the next 10 minutes, we'll not only give you two widgets for the price of one but a bonus gift of widget oil. That's a $99 value for only $19.95, shipping and handling not included. Clearly these kinds of ad with a unique selling proposition of a specific product whose virtues and effectiveness can be demonstrated on screen are effective. Otherwise, advertisers wouldn't keep doing them. And who has not at one time or another picked up the phone or at least been strongly intrigued by the gadget? Not available in stores, remember!

Consider how a PSA about a public policy issue such as gambling works. In this case, the Massachusetts Council on Compulsive Gambling needs to communicate to a population that suffers

2 The producer and local market is unknown to the author. It was viewed on a videotape, "How to Make a Creative Television Commercial," produced years ago by The Television Bureau of Advertising.

the destructive consequences of this kind of addictive behavior. How do you solve the communication problem? Let's apply the seven-step method we learned in Chapter 2. This is a more elaborate equivalent of a copy platform in the advertising world. From account executive to creative director to copywriter and art department—each party involved in creating the PSA needs to have a common understanding written down that defines the communication problem. Agencies develop their own ways of defining the communication problem by identifying the product, the medium, the product's benefits and selling points, and the creative strategy. Our approach is more thorough and more universal in its potential application because it's not limited to advertising.

CASE HISTORY: Using the Seven-Step Method to Create a Gambling PSA

1. Define the Communication Problem

The population of compulsive gamblers includes gamblers who are isolated by their problem and do not see that they are not alone. They do not fully comprehend the consequences of their addiction or are unable to do anything about it. The Massachusetts Council on Compulsive Gambling does not have a handy database of compulsive gamblers and cannot easily reach isolated individuals who need help to tell them about a confidential help line. The council wants to reach out to a hidden population.

2. Define the Target Audience

The *target audience* demographic is difficult because it cuts across age, gender, and social class. The audience has to be identified by a behavior pattern. Many gamblers, like alcoholics, don't want to acknowledge their problem. The psychographic of the audience is the critical determinant; this audience is probably resistant. Many in this audience will have ways of dismissing the message. They are probably in denial, maybe believing they have everything under control or, like all addicts, that they can quit any time.

3. Define the Objective

The gambling PSA alerts compulsive gamblers and those who know them to the addictive behavior and communicates an 800 number to call for help. An informational goal includes letting gamblers know that gambling is a common social problem. A motivational objective is to get gamblers to think about their problem and move them closer to changing their behavior. The highest goal is a behavioral objective: gamblers will stop gambling, or they will at least call the 800 number.

4. Define the Strategy

The audience has to recognize its problem in the powerful images shown in the PSA. The PSA must get their attention and get to their hidden thoughts and awaken a secret and buried wish that all those losses due to gambling could be reversed, undone, or at least stopped. We use a strongly visual device that is emotional rather than logical because compulsive gambling is an emotional and psychological weakness, not a logical choice. We show acts of gambling as if time were running backwards by running the video backwards.

5. Define the Content

Recognizable scenes of gambling dominate the 30-second PSA (Figure 5.1). A montage is shown of close-up shots of rolling dice, cards being shuffled and dealt, scratch card numbers being revealed, but in reverse. This is accompanied by a voice-over (Figure 5.2).

6. Define the Appropriate Medium

This PSA is uniquely conceived for a visual medium because its essential visual idea is impossible in any other medium. Time appears to run backwards when video plays in reverse, suggesting that the addiction can be undone. This is an effect unique to the moving picture medium and video in particular. Television lends itself to emotional appeal and motivational messages.

7. Define the Concept and Creative Idea

The effective creative concept is to use a strongly visual device to make the emotional connection to the audience by turning back the clock. Footage of gambling action is run backwards while a voice-over articulates the wish that time could be turned back and losses undone. Who would not want to undo past mistakes? The visual effect of seeing the fantasy realized compels attention. Again, this device of reversing time and showing action undoing itself is a visual effect unique to the medium. The voice-over drives home the message of how these images relate to a buried wish to escape compulsive gambling. The message is: you are not alone; more than 2 million Americans are in the same boat. There is an 800 number help line to call. We finish with an invitation to call and talk.

You see that the seven-step method breaks down the problem and identifies the solution in very precise ways that allow all concerned to see where the project is going. You can now see the storyboard and see the PSA as it was produced on the accompanying website. (**Gambling PSA**)

→ **Figure 5.1** Storyboard for "Turning Back the Clock," a PSA on gambling sponsored by the Massachusetts Council on Compulsive Gambling. (Storyboard by permission of Pontes/Buckley Advertising.)

MASSACHUSETTS COUNCIL ON COMPULSIVE GAMBLING

Turning Back the Clock (30 second TV Spot)
Written by Jerold Gelfand

Note: All action takes place in reverse. In addition voice-overs alternation male and female voice (possibly overlapping) with the final words "my life" simultaneously spoken (staggered) by several of the characters.

VIDEO	AUDIO
CUTAWAY A clock going backwards in fast motion with an optical jerking effect	VO: I want to go back to a time when life had promise . . .
INT. HOME OFFICE-NIGHT Tight shot of man at home office desk full of papers, envelopes, bills, booklets as well as a light and a drink. With pen in hand, he slams both hands down and sweeps the contents of desk onto the floor then clutches his hands to his forehead cradling his head in pain. 4 seconds	VO: . . . to a time when giving up wasn't an option to a time before running away seemed to be the only answer
INT. PAWNSHOP-DAY Tight shot at pawnshop counter where customer is giving up a watch (with clasp) for cash. 4 seconds	VO: . . . and before family heirlooms were sold for cash.
MONTAGE Gambling situations shown backwards (i.e., tights shots of cards being undealt, dice jumping back into person's hand, person unfilling-in lottery ticket numbers, person unscratching scratch ticket. FADE TO BLACK 5 seconds	VO: . . . back to a time when gambling didn't control my life. SFX crowd noises then "sucking" sound on fade to black.
FADE IN TEXT Over two million Americans suffer with problem gambling. 3 seconds	VO: Do you need help turning your life around?
FADE IN TEXT You're not alone! 2 seconds	VO: Call us and let's talk about it.
FADE IN TEXT Massachusetts Council on Compulsive Gambling 1 800 426-1234 We're in the Yellow Pages	

→ **Figure 5.2** Script for "Turning Back the Clock."

```
Client: The New England Home for Little Wanderers
Agency: Boston ITVA PSA Committee
Title : Family Portrait
Medium: 30 second television spot
```

VIDEO	AUDIO
The visual look is cold, monochromatic blue.	(MUSIC-increasing tension.) (SFX-The pulse of a racing heart.)
FADE UP ON . . . EXT. ALLEY. DAY. (4 seconds)An urban alley in a poor part of town. Garbage and debris litter the ground.	(Over this sound, we hear a series of DESPERATE VOICES.)
From a low angle, we look up at a tough,angry thirteen-year-old BOY. A CIGARETTE is jammed into the corner of his mouth. He walks through the alley with anger and attitude, kicking at the trash and smashing his book bag against the wall.	WOMAN'S VOICE (VO) (angry, frustrated, desperate, rising in pitch, losing control) (slight echo) "The school called again. What am I going to do with you?!"
The image in the alley is interrupted by a FLASH CUT (1 second)(Full color.) A happy family PORTRAIT. A single mother and the thirteen-year-old boy. He's dressed neatly in a tie. A jagged CRACK slices across the glass.	(SFX-Glass cracking.) (1 second)
CUT TO . . . INT. ROOM. NIGHT. (4 seconds) A young BOY, six or seven, huddles against a wall, terror and pain in his eyes. Behind him, we see the SILHOUETTES of a man hitting a woman.	(SFX-Woman crying. Struggling. Bottle breaking.) FATHER'S VOICE (VO)(angry, drunk, slurred speech)(SFX-SLAP.) "Don't you <u>ever</u> turn away (SLAP) from <u>me</u> when I'm talking!" (SLAP)
FLASH CUT (1 second) The family PORTRAIT. Father, mother, sister, and the young boy. A jagged CRACK slices across the glass.	(SFX-Glass cracking.)

→ **Figure 5.3** Script for "Family Portrait," a PSA for the New England Home for Little Wanderers. (Reproduced courtesy of Peter Cutler.)

CUT TO . . .
EXT. ALLEY. NIGHT.
(4 seconds) A young GIRL,
eight or nine.Tight on her
face. She cringes at her
disturbing memories. We move
in closer and closer until
all we see are her haunted,
tear-stained eyes.

FAMILY PORTRAIT
The young girl in happier
times with her mother and
father. As if struck from
behind, the family portrait
SHATTERS into
a million pieces.

Jagged pieces of the portrait
explode toward the camera in
slow motion.

(FULL COLOR)
As the shattered pieces of
the family portrait float
toward us, we DISSOLVE to
the LOGO—
**The New England Home
for Little Wanderers**

DISSOLVE to the phone
number—1-888-The Home over
a soft focus background of
rich, spring time, green
grass and deep blue sky.

In the background behind the
phone number, we see a tiny
CHILD'S HAND reach up into
the frame. A large MAN'S HAND
reaches down and holds it
tenderly.
Fade up the tag line—
**Children Families
Futures**

FADE TO BLACK

➡ **Figure 5.3** (Continued)

YOUNG GIRL'S VOICE(VO)
(pleading) (slight echo)
"Please don't. Please don't
touch me there. Daddy, I'm
scared."

(MUSIC stops and is replaced
by the sound of shattering
glass.)

NARRATOR (VO)
For some children—and some
families—life is a
shatteringexperience.
(MUSIC—brighter, hopeful)

NARRATOR (VO)
We help put the pieces
together again.

NARRATOR (VO)
To find out how you can help,
call 1-888-The Home.

For people who really need a
helping hand.

FADE OUT MUSIC

MORE ON ADS AND PSAs

In the short form of the television commercial, visual communication is critical. It enables a great many ideas to be compressed into seconds. Doing this requires visual thinking and visual writing. A PSA produced for the New England Home for Little Wanderers (Figure 5.3) puts a 30-second story together that evokes a dysfunctional home and domestic abuse. The visual metaphor, which also works for the sound track, is breaking glass. The shattering of a child's life, his family, and his future is captured by this single image.

Another excellent example of this type of condensed communication is the corporate TV spot for First Union (subsequently taken over by another bank). Let's understand the context. Banking is regulated by state and federal laws and agencies. Formerly, banks were not allowed to have inter-state branches, could not sell insurance, could not be stockbrokers, could not be investment bankers, could not run mutual funds, and so on. Now, after the Financial Services Modernization Act passed by Congress in 1999 repealing the 1933 Glass–Steagall Act, banks can combine financial services in these different areas and compete with other financial institutions. This deregulation has led to merg-ers and fundamental changes in the banking industry. The communication problem is that most people don't know how to tell one bank from another and don't understand the changes that are taking place in the financial world. Explaining financial matters to the consumer is difficult because most people are confused by financial products and intimidated by financial institutions. Companies large and small, using different institutions for different financial services, find themselves having to rethink their relationships and having to use new financial products such as derivatives to manage risk or so-called junk bonds to raise capital. As we now know, deregulation has also led to the housing bubble, an economic collapse, and government bailouts.

The objective of the First Union commercial is to get consumers and potential customers to grasp the changes in the banking system and see First Union as an island of security in a dangerous world and as the new solution to banking—one-stop shopping for all of their financial needs. The strategy is to show the financial world as a surrealistic nightmare, then to confront the problem, and then to have First Union provide the solution. The metaphor chosen is that First Union is a mountain. This visual image is backed up by the voice-over, which in a series of ads ends with a variation on the state-ment ". . . come to the mountain called First Union. Or if you prefer, the mountain will come to you."

It is axiomatic that the impact of the message here must be visual, not verbal. To do this requires images at the cutting edge—alpha channel effects, and computer-generated images that capture the audience's attention as well as set up and condense the message. In each of the ads, there is a visual narrative that makes sense on its own but is complemented by the verbal narrative, which functions on another level. The impact of the visual narrative is emotional, whereas the impact of the verbal narrative is rational. Scripts of this kind almost always have to be storyboarded. Look at storyboards and view the video results for two First Union ads on the companion website.

The storyboard is 19 pages long for a 30-second commercial. With two or three key frames per page, the pace of visual flow is pushed to the limit. A dorsal fin cuts through water with the financial wreckage of dollar bills and financial paper floating on it. The water is the runoff from a storm—a storm sewer that floods corporate boardrooms. In contrast, the voice-over is measured and minimal-ist: "In the financial world . . . the one requirement . . . for long-term survival . . . is to keep on the move. It is not a world for the hesitant or the timid."

What more effective way to suggest corporate merger than to show two skyscrapers crashing together or whole buildings being moved on huge caterpillar tracks? Such a visual metaphor exploits (then) cutting-edge computer imaging techniques. A scriptwriter could not put the image down on the page without some understanding of the techniques that are available. As recently as the 1990s, the

technology needed to make this TV commercial did not exist. It is extremely difficult to tell how these state-of-the-art TV commercials were made. They are a spin-off from the revolutionary CGI invented by George Lucas's company Industrial Light and Magic that enabled Steven Spielberg's *Jurassic Park* (1993). Visual writing creates content that flows from contemporary production techniques. Hence, visual writers must understand the repertoire of techniques available to the producer. Composite 3-D animation, graphics, and live action take the writer to the limits of verbal description—hence, the reliance on storyboards.

We should step back and reflect on the underlying principles of persuasion. Aristotle (Figure 5.4) mapped out the basic techniques of persuasion in his theory of rhetoric. They involve an appeal to reason (*logos*), an appeal to emotion (*pathos*), or an appeal to ethical values (*ethos*). Although there is a connection between what you learn in basic writing courses about argument and the techniques of visual persuasion, persuasion is not accomplished by words alone. Images have a vocabulary and a grammar. Many devices and strategies are available for hooking audiences and planting the message.

→ **Figure 5.4** Head of Aristotle, Louvre.

It is like the strategy of the flower in nature: show bright colors, give off powerful perfume, and produce sweet nectar, and bees and other insects will be attracted by the color and aromas and feed on the nectar while coating themselves with pollen, which they will carry to the next flower so as to fertilize the plant. The clever message maker creates seductive qualities that attract the viewer, who carries away the message whether he likes it or not, just as the bee carries the pollen away. Behind any visual communication, there is an argument that rests on a strategy of engagement. What follows is an informal survey of strategies of exposition that a scriptwriter can use to engage their audience and communicate in visual media.

Humor

Most people are attracted by humor. If you watch an evening's ads on television, you will find about half of them use some kind of comic device. Either the characters in the ad are funny in their behavior (a man behaves like a dog and his dog like a man, tossing the man treats for clever behavior), or the spoken lines have an amusing or clever turn. Comic conception can be expressed in visual graphics. Cats, dogs, and babies can be made to talk. **E-trade** has a baby in a high chair talking about stock strategies in an adult voice. It shocks and is funny at the same time.

Animation can create cute M&M's characters or the Pillsbury Doughboy. Morphing can change the expression of people's faces or distort them for effect. Much of the humor we see is a form of exaggeration. Slapstick, popular in the silent film days, continues to work in ads. Examples include dogs running away with toilet paper or a man's absurd physical struggles with equipment or materials. Dogs may behave like human beings or speak their thoughts, such as the dog requesting "bacon—want bacon" in an ad for Beggin' Strips. A pampered dog rides in a chauffeured Rolls Royce in an ad for Cottonelle toilet paper.

Using humor in an ad carries a risk. The risk is not being funny enough for your audience. Bad jokes can be a turn-off. Many corporate clients are nervous about humor as a device because they worry that their company or their product might not be taken seriously. Nevertheless, humor is an effective way to disarm hostility and skepticism in a target audience. It appeals to both emotion and logic. Capital One has a campaign built around the punch line, "What's in your wallet?" Improbable situations involve a gang of Vikings acting like gangbusters in department stores and gas stations, smashing things and behaving like, well, marauding Vikings who can't get to you because you have the Capital One credit card in your wallet. Sprint has a crowd of network users, all available on your Sprint network, which follows you around. The abstract idea of a network is made concrete and funny by seeing all the people on it in the shot. The come-on to look and listen is the humor. Fun relieves tedium. Jokes or gags often work on a logical principle by challenging that same logic. The logic of the argument is sometimes false or simple minded. Mocking your own ad with a wink is a disarming way of getting the audience to accept flawed logic. If you can get audiences to smile, they will probably listen to your message.

The Chick-fil-A campaign is funny and witty. Funny is not always witty. Witty is not always funny. Like most clever commercials, the visuals confuse you at first. They challenge you, creating a space that draws you into the communication. A herd of struggling cows who can't spell is trying to compose a message. Why cows? Cows trying to promote chicken? What the hell is this? Then you see their sign **Eat Mor Chickin**. You are hooked because you get the message: Don't eat us! Eat chickens! This campaign is also notable because it is a coordinated campaign with a brilliant roadside billboard message in which the cows are putting up those same billboards. It is truly visual communication. Notice in some ads there is no audio except moos! There is text: "eat mor chikin." Sometimes there is a tag line voiced over. The humor integrates the visual, textual, and aural.

Geico has adopted a tiny green lizard as a presenter for its auto insurance products. The voice of the lizard is a London Cockney who even uses English colloquialisms such as "free pie and chips," obscure to most Americans who do not know what this means (a greasy meat pie with French fries) or understand the accent or the other quirky phrases. There are even obscure references to the English television naturalist Sir David Attenborough, who plays cat and mouse trying to observe the gecko. The cute Geico gecko has become viral. The ads are now an ongoing saga. In one of the latest, we see the lizard in an edit suite asking for a better take, which is actually a worse take of lizard ham acting. In effect, the talking lizard is also a kind of *shock* device. You don't expect lizards to talk, and you particularly don't expect them to talk Cockney.

Animation

Animation does not only mean cartoon characters, although there are plenty of them in advertising: the Pillsbury Doughboy, the M&M characters, the scrubbing bubbles happy to clean your toilet or your shower, the Mucinex phlegm and nasal congestion characters, various sleeping pill fairies, and so on. The strategy seems to be cognate to humor. It is easy to be amusing with exaggerated, or cute characters. It is notable how often this artifice is used in ads targeted to an adult audience, like for Alka Seltzer. Children? Yes! However, an adult like me is often repelled by the characters and their cute and overproduced voice character. Somebody must like them. Animation also helps to personify something and explain how a process or a pharmaceutical product works.

In the case of scrubbing bubbles, you can see a transition between what we could call character animation and explanatory animation. You cannot easily show the cleaning power of a product that attacks germs without showing the germs. So we animate the germs and then show how this army of happy little worker bubbles takes out the bacteria and stains in the bathroom. We are halfway to diagrammatic animation that is not about characters but explains something abstract or microscopic. For example, an antacid coats the stomach lining, and changes in color seem to show how effectively the product works. Or an anti-cholesterol drug takes away plaque buildup in the arteries. Or toothpaste foams, swirls, and gets under the gums and whitens teeth. Animation represents how the product works, and you understand it better. Essentially, you could not shoot a live action shot that would capture the same visual. Animation makes it believable You remember because animation provides an explanation, even though over-simplified. Now I believe; now I want some. In a more prosaic way, animation diagrams are useful devices for exposition and explanation in documentaries, especially science documentaries. Concepts in astronomy, biology, or physics, such as gravity, the movement of planets, and the anatomy of animals, cannot be illustrated by live action and cannot be explained fully with words alone.

Shock

Shocking an audience is a way of getting its attention. Shock can take many forms. It can be violent, such as explosions. It can be funny (like talking geckos or dogs, or the E-trade baby in the high chair who talks finance with the voice and knowledge of an adult dubbed over baby body language. Whatever you do to shock, you have to follow your own act. You have to use the attention you get to good effect. Many people are good at getting attention but not so good at holding it. Consider streakers at games. Taking your clothes off and running out into the middle of the field pursued by police officers and officials will get the attention of the whole stadium, but then what? You can be outrageous, surprise the audience, or do something unexpected, but if all the audience remembers is the device and not the message, you have failed. It is easy to shock but hard to fold it into an effective message.

The Ad Council has a simple but effective message about **texting while driving**, which combines information with a shock technique. A girl is driving and texting her friends she is on the way. While sending this message, she fails to see a slower moving vehicle ahead. After cutting to black for the crash, we replay the texting, see a timer superimposed, and hear the voice-over explain that 5 seconds is the average time your eyes are off the road while texting. "Stop the texts! Stop the wrecks!" is the tag line on screen.

Suspense

Suspense offers a different way of getting an audience's attention. Shocking images often lead into suspense, as in the texting while driving ad we just discussed. Suspense makes the audience hold its breath until it knows the outcome. Suspense, like shock, is easy to start and hard to finish. The revelation at the end must justify the wait. Have you ever felt short-changed by a suspense movie that doesn't have a satisfying ending? There are various kinds of visual suspense that work well in ads. For example, what's going to happen to the truck attached to the bungee cord falling off a bridge? Comic suspense can involve a balancing act (a waiter carrying a loaded tray), a juggling act, or a character in a predicament. An AT&T ad has a pair of lovers exchanging pictures on a cell phone. His final picture is of him in the same place she is, and he has found her on a park bench. There is a bit of suspense about where we are going with these characters; there is also some humor or witty exploitation of the picture-capturing and messaging capability of cell phones. Suspense often involves drama.

Drama

Can you tell a story in 20 seconds? Television commercials have got it down to an art. Quick cuts minimize the visual information and allow minidramas, mini–love stories, and miniplots to unfold. Ads for Brink's Home Security show a woman at home alone who gets off the phone as we see two burglars peeping through the window. She puts on her ear phones to listen to music while working out on the treadmill. The burglars break in; the alarm goes off; the woman is frightened; the phone rings because Brink's is monitoring the alarm. She picks up the phone and gets the reassurance that a Brink's agent is radioed to go to her aid even though the burglars have fled, scared off by the alarm. So this is a story told in the form of a minidrama that illustrates the role and value of the product. These dramas can become little miniseries so that audiences become intrigued about the next episode. The Geico commercials, both of the lizard and the caveman, create serial dimensions that the audience understands. Meanwhile, their message gets exposure. A credit card gets a character out of a scrape, like in an Indiana Jones adventure. Someone has a splitting headache or a migraine. An important life event, such as a key assignment at work, or a wedding, or a date, is barely manageable. A friend urges the person to take the brand name painkiller. The crisis is averted, and it's smiles all round. The strategy is to mime little dramas typical of life and organize a happy ending dependent on use of the product.

Children

Children, babies, and animals are always good for pathos. People respond to cute kids and cute animals. Temporarily, they stop using their brains and respond emotionally. Children aren't only used for breakfast cereal. E-Trade gets your attention with a child in a highchair who discusses investing in an adult voice dubbed over the child's mouth movements. **Michelin** achieved one of the cleverest and most effective uses of a baby ever in a television commercial some years ago. On screen are four

tread marks from Michelin tires on a flat color background. The commentary makes the point that the main safety features of any car are the four points of contact with the road: "There's a lot riding on your tires." There is a match dissolve to a baby sitting on the ground in the middle. Viewers are forced to use visual logic to put together two ideas. The picture is static but the viewer can translate it into motion and braking. You want to protect the most vulnerable passenger any of us will carry—a helpless baby. This is the advertising equivalent of the car sticker BABY ON BOARD. The tire tread of your four wheels is your only contact with the road in all emergency situations. Your choice of tires is a factor in that safety. The sell is just the brand name on screen. The visual logic goes something like this: (vulnerable baby, standing for our indisputable wish for safety) + (choice of tire is your choice of tread contact with the road) = (brand name Michelin). It is elegant, simple, and brilliant as a piece of visual communication. A variation was to put a baby inside a Michelin tire smiling and gurgling happily. Again, the economy of the visual imagery forces the audience to understand the message through visual logic. This is a picture truly worth a thousand words. Effective visual imagery works through nonverbal communication. Michelin's ad is meta-writing at its best, resulting in stunning visual metaphor. Simplicity is also a virtue in Michelin's highly creative and inexpensive ad. Such visual writing is not limited to advertising. It is essential to powerful dramatic writing for the screen.

Let's go back to the E-trade talking baby. It works in another way indirectly. There is a kind of embedded analogy in the form of visual metaphor, which is another level of the ad. You get caught up in the humor. That gets your attention by a reversal of expectations. Normally, adults condescend to children and consider that they are not yet smart enough to understand the world. In this ad, the baby in the high chair or crib is smart to understand a complex world of investing, and the adult is not so smart. What does this say to the audience, even if it cannot articulate the idea we are analyzing? It's child's play. Investing with E-trade and its array of online investment tools makes investing easy and accessible—child's play. This is the correlative idea, the analogy embedded in the visual metaphor. Nowhere is this thought expressed in the script. It is embedded in the meta-writing, or the creative thinking that lies behind the actual script. Most successful ads or, indeed, any visual communication rely on unwritten creative thinking or meta-writing.

Serial Storytelling

This brings us to another common, important technique, which is to create a character or a premise that can be repeated from ad to ad. You have built characters to whom the audience relates, such as the E-trade baby. Now you can play variations and create new situations and new opportunities to engage the audience with the evolving character. The E-trade baby gets bolder and more outrageous. The copy relies on the character rather than the product or service but a strong and lasting association is built in the audience's imagination. The same technique got going with **Capital One ads** also using the baby in a high chair who doesn't want more money and undermines Jimmy Fallon's attempt to persuade her with the message. Then there's the gang of marauding Vikings who are inserted into ever changing locales behaving outrageously, always ending the punch line, "What's in your wallet?" We also see the same technique in Capital One ads that feature Alec Baldwin riding on a luggage conveyor making a point about frequent flier "miles you can use."

Testimonial

There are two types of testimonials: real and fake. Another way to categorize them would be to contrast a celebrity testimonial with a simulated testimonial. If you can find a well-known personality to endorse your product, you get the attention of your audience. The public will give you the time

of day because of the famous name. AT&T had a series running for its wireless Internet service that used champion athletes to play a competitive challenge with the AT&T guy; he has wireless Internet, whereas they do not. The celebrities, whether the tennis player Andrew Roddick or the Olympic gold medalist swimmer Michael Phelps, say nothing but look on in dismay as they are put at a huge disadvantage because they do not have the AT&T service. Cosmetics, perfumes, and beauty products often use actresses as poster girls for their products. Gillette used Tiger Woods. Sleep Number beds used Lindsay Wagner. Andie MacDowell is the model and advocate for L'Oréal hair color and cosmetics. As these ad campaigns go off air, you will find others that exemplify the same principle. Tommy Lee Jones opens an ad for Ameritrade retirement funds and then continues as the voice-over through the rest of the ad. Alec Baldwin's character in the Capital One ads, although relying on celebrity recognition, is not true testimonial. Celebrity testimonial is when a celebrity explicitly advocates for the product, and celebrity association is when a company uses a known celebrity to play a role in an ad. Include Jimmy Fallon's appearance in Capital One ads in this latter category!

Simulated testimonial is broadcast on television every day in ads for painkillers and cold remedies. We have become inured to them, but they must work well enough because advertisers keep using them. A white-coated actor playing a doctor, speaking earnestly into camera, affirms the effectiveness of a drug. An anonymous but professional-looking man or woman, usually walking along in a tracking shot and speaking into the camera, tells you with fake sincerity how one painkiller is prescribed by more doctors than any other. The presenter mimics the role of a news reporter, expert, or anchor. Many ads for feminine hygiene products rely on simulated and acted testimonials by a suitably cast representative woman talking about relief from menstrual cramps or migraine headaches or dry skin.

The beer commercial for **Dos Equis** involves another example of simulated testimonial. The fictional famous character, a high-achieving, well-connected adventurer and man of the world, surrounded by beautiful admiring women, addresses the camera and explains that when he is thirsty he always drinks Don Equis; he ends with the catchy phrase that has kind of gone viral: "Stay thirsty my friends!" By transference you are drinking his lifestyle.

Real testimonials also have a place in this repertoire of strategies. Despite years of feminist revolt, stereotyped housewives testify that a given laundry detergent washes whiter than another or that a household cleaner cleans "cleaner" or an old mop is rejected by a woman who makes love to her new and better mop. Or submitted to a double-blind test, they just happen to pick the load of laundry that was washed with the advertised product. Some years ago, AT&T ran a series of ads that were based on the real, spontaneous testimonials of people on the street saying that they preferred AT&T long-distance service. As the production company was filming, the lawyers were vetting the content and ruling whether or not the statements could be used. People in the shots used were paid and had to sign a waiver permitting use of the testimonial. This last example is an unscripted documentary technique. Most of the others are scripted ideas. Most of these devices can be used in longer corporate videos, as we shall see in the next chapter.

Special Effects

Today, many of the images we see on screen are computer generated. The 1999 prequel of the Star Wars trilogy, *The Phantom Menace*, is rumored to contain at least 80 percent computer-animated images despite the presence of live actors. Industrial Light and Magic, the company founded by George Lucas, has been responsible for many of the extraordinary computer-generated special effects in theatrical films, such as *Jurassic Park*. Now there are so many software toolkits on PCs and Macs that can create stunning graphics and animation that contemporary scriptwriters can fantasize scenes almost without limitation other than the skill of the animator.

A good example is the First Union ads that make skyscrapers merge and collapse, creating a visual metaphor for corporate merger. The camera wanders in a surrealistic, computer-generated fantasy world, a futuristic urban landscape reminiscent of *Blade Runner* (1982), suggesting the predicament of the consumer trying to deal with the world of financial services. It is a visual statement about the alarming uncertainty of the financial world.

How many ways can you shoot a car? Low angle to enhance its power! High angle to show it in a landscape! Mounted on the car to show the front wheel up close turning! Inside to show the dashboard dials! An exterior of speed across the Bonneville Salt Flats! Since all ads for cars are going to reduce to the same basic idea of transportation, comfort, and movement, you need something to set it apart from the competition. The Cadillac ATS road holding is shown in rugged terrain and difficult roads or racing over the Grand Prix Formula I circuit in Monaco or the Nürburgring. It is no longer the comfortable land yacht of yesteryear, but a full-blown, high-powered sports car that competes with the legendary European Grand Turismo sports cars—the Aston Martins and the Maseratis.

Sooner or later car ads have to use visual metaphors to vaunt the qualities of the car beyond simple transportation. Modern computer-generated imagery (CGI) has increased the range of visual metaphor because its ideas are purely visual and haves no verbal equivalent. Cars are made to do things that defy gravity and the laws of physics. Acura sells the aspiration of the engine. We see a competitive swimmer gulping air cresting through the water and the image morphs into a car and then the engine. A voice-over talks about the breathing engine. Infiniti aerodynamic design is expressed through the image of a competitive diver flying through the air and then entering the water with minimum splash in slow motion. He then morphs into the car breasting the air. There are also interesting ways of using animated artwork to elaborate an idea. A recent ad for Dodge Dart has a fantastic plot that takes you through drawing, designing, manufacturing, and testing a new car on speeded-up motion with a fantasy time machine to say that it is ahead of its time: How to Make the Most Hi-Tech Car.

Cars are assembled or exploded in a spectacular animated sequence that shows all the parts coming together to form a stunning new model. As a rule, these special effects are ways of getting attention by challenging visual norms and defying reality. Once again, the device has to serve the message or the audience will remember the effect and not the message.

Selling financial services also requires graphics and fantasy effects. T. Rowe Price has a series of shimmering line drawings morphing into different scenes of commodities and commerce while a voice-over assures that this bank and investment firm is on top of worldwide financial factors. Fidelity has a green pathway that leads through various home and work scenes to deliver the investor to the security of Fidelity investment. Likewise, insurance companies have to resort to visual metaphors such as Traveler's red umbrella, which shields you from the metaphorical rainy day.

Sexual Innuendo

Sexual innuendo is probably the oldest technique of all. At the outset, every new medium has exploited erotic interest, whether it be the early moving image peep shows (Edison's Kinetoscope, then the rival Mutograph), interactive CD-ROMs (*Virtual Valerie*), or the Internet, which was swamped with pornographic websites that opened without warning on your desktop and multiplied into others as you closed one. In the advertising world, sex sells. Is there an ad for perfume or aftershave that doesn't imply that the product will attract the opposite sex like flies? The same goes for most fashion advertising. Beer, alcohol, and soft drinks usually rely on the hoary proposition that consuming them makes you look so cool that members of the opposite sex will fall into your arms. A strong seductive technique of persuasion is the look straight into the lens. Another familiar technique is the big close-up

of lips or the framing of some a woman's face with batting eyelashes, pursed lips, or come-hither eyes. Somebody has to write this stuff into a script. What we see, however, is the finished ad, which has been produced and directed. The director has interpreted the script and talent has interpreted the role, but the intention is clear: get the audience's attention by appealing to sexual interest—sex sells.

As I'm writing this paragraph, the television is on. An ad comes on for an herbal shampoo. A woman whose car has broken down is stopped at a gas station. She asks the mechanic under the hood where she can freshen up. He throws her a key. In the washroom, she washes her hair (fat chance!). Pack shot! As she washes, she starts to cry, "Yes, yes, yes." The scene dissolves to brushing out her dry, bouncing hair as she emerges from the restroom. The "yes, yes" becomes louder. The mechanic looks up and bangs his head on the hood. The radiator spurts steam. Get the allusion? She asks if the car is ready. He says it will be a little while longer. Pack shot with a title: Herbal Essence—A totally organic experience. Get the pun? Notice the rip-off of the film *When Harry Met Sally* (1989), in which Meg Ryan simulates an orgasm in a restaurant. A woman at a nearby table tells the waitress she wants "to have what she's having." Somebody wrote the Herbal Essence ad with a sexual strategy in mind. The shampoo confers sexual power on the woman who uses it. Many other ads have followed in the same vein. This tradition has continued for years and traveled around the world. In the French version, a woman leaves a trail of clothes on the floor. We find her in the shower. She applies Herbal Essence and has the climax. A middle-aged couple watches the ad on television. The grandma says she wants the same shampoo as the woman in the ad. The original allusion is still going strong.

Or we find a young man spraying Axe deodorant or body spray on himself brings a thousand young women in red bikinis pounding out of the surf to get him and another few hundred in yellow bikinis rappelling down the cliff above the beach. They converge on him, but we never see the ending, which is left to our imagination. This is relatively tame compared to some of the European scripts for the same product, which are readily available on YouTube. The Axe deodorant and men's fragrance absolutely depends of the idea that a product confers irresistible allure for the opposite sex. These illogical assumptions of transference are repeated over and over again: look at this guy who is wearing product X becomes an involuntary chick magnet; if you wear or apply product X, you will become that magnet. Don't ask me to explain why so many audiences, generation after generation, product after product, fall for the flawed logic of this deduction. Evidently they do, probably because of the insecurity of most people about their attractiveness and appeal to the opposite sex, which remains a fundamental biological behavior, embedded in genes. The exaggeration can also work as a kind of self-mocking humor.

An ad now off air with Kate Walsh riding in her Cadillac argues that the real question is, "when you turn your car on, does it return the favor?" More recently the Italian Fiat Abarth, a high-performance compact car, has been introduced to America through the Italian company's acquisition of Chrysler. We see a man on a sidewalk staring at a woman who is bent down adjusting her stocking revealing a stunning figure. The woman straightens up and walks over to the man and slaps him and then caresses his head, grabs his tie, speaking terms of endearment in Italian and kisses him. The man is completely lost and uncomprehending. Then we reverse the angle and see that he has been staring at the Fiat car, which by association with the Italian woman is spirited, sexy, foreign, and different. A statement is made through visual metaphor that the audience understands without words or explanation.

RECRUITING THE AUDIENCE AS A CHARACTER

One common and effective way to use the television medium is to recruit the audience as a character. Television and video work well in close up. When talent looks straight into the lens and addresses the audience, a direct connection to the viewer is made. The artifice of the camera creates a psychological

effect that approximates someone speaking to you personally. Many spots are written so that a character speaks confidentially to the audience. It is the exact opposite of the fictional film technique, which depends on the actors never looking into the lens. In fact, the illusion of the film story would be instantly destroyed. Exceptions are certain comedies that deliberately use the technique of an aside to the audience, which derived from the theatrical device of a character speaking to the audience, used frequently in Shakespearean and Restoration comedy. Ads frequently use asides and often rely on a to-the-lens address. Examples are Jimmy Fallon and Alec Baldwin in the Capital One commercials.

ENGAGING THE AUDIENCE AS VISUAL THINKER

Perhaps the most sophisticated way of engaging the audience is to make it put two and two to together, make it think through a logical progression of thought. Now that sounds like the antithesis of visual metaphor and visual communication. In a way, this is the ultimate prize. If you can set the audience up with visual sequences that lead to the understanding of a proposition that is a logical deduction, then you have engaged the intelligence of the audience to make a statement to themselves that you, the copywriter, cannot make so effectively. There are examples above (including the low-budget car wash ad to combat salt corrosion). Perhaps we should call this visual logic, which is a component of visual metaphor. If you saw the following examples on television, so much the better!

CSX has run a brilliant campaign that relies consistently on visual metaphors, but there are two examples that are particularly noteworthy. The first shows a succession of images of people breathing in—a runner, someone undergoing a physical examination by a doctor with a stethoscope, a singer, swimmers, and so on. As usual, the images speak immediately and trump the verbal description of them. The first half of the ad is the inhale. The second half is the exhale shot for all the same characters—in the doctor's office, the opera singer, etc. The voice over says, "Good news for everyone who breathes."

The competition swimmers in an alien environment turn their heads in the crawl to take a breath. The quick cuts of these key moments in a montage add up to a portrait of humans as breathers. Without breath, there is no life. The punch line is the campaign theme: CSX TRAINS CARRY ONE TON OF FREIGHT 400 MILES ON ONE GALLON OF FUEL.[3] The audience of its own volition fills in the missing middle of the argument, which written long hand goes: breathing oxygen is essential to all life and all its activities, which is an indisputable premise; if air pollution is an environmental hazard that affects human health and well-being, then railroads and CSX are good for the environment and good for you and me. So the message is environmental. By wit and charm, the TV spot traps you by your visual response to assent to the proposition. You are enchanted with the sequence of shots, which involve wit and suspense, because you do not know what their significance is until the end; you accept their conclusion because you put the distributed middle in the argument, which has been expounded by visual messages.

This type of appeal takes risks. The audience might not get it and not complete the ad in their brain. A personal favorite, as I have found out from getting students to interpret the ad, is about global warming and was produced for the Environmental Defense Fund. The ad shows as New York subway grating which allows air and noise from each passing train to escape. This air inflates a paper balloon model of a polar bear and cub. Cars pass; onlookers are transfixed; a little girl runs up with

3 In reality, the figure is between **400 and 500**. See www.csx.com/index.cfm/about-csx/projects-and-partnerships/fuel-efficiency/.

excitement. As the train passes and the escaping air subsides, the polar bears collapse in a surprisingly realistic slow death as they deflate and die. There is no commentary and no tag line to read. It is extreme visual communication because it only works if the audience participates with a series of deductions that derive from the visual images. Most people know about the proclaimed threat to polar bears from global warming. So the puzzle is why are they inflating (coming to life) and collapsing (dying out)? **Global warming** is caused by the release of carbon dioxide byproducts of consuming the sun's energy store a hundred million years ago or so in fossil fuels. So it's like releasing the sun's energy for millions of years at the same time. If you take the subway or ride a bicycle or walk, you reduce carbon emissions and save the polar bear. If you drive cars, you add to the problem. The extinction of polar bears is just a byproduct of the icecap melting, which is in turn evidence of global warming. This complex train of thought is compressed in a visual sequence, which has to be decoded. The audience's mental gratification doing just this turbo-charges the PSA. Some won't get it. Hence the risk! What do you think? Is the risk worth taking? Does this strategy pay dividends? See the **Polar Bear ad** on the web and decide!

Patterns That Engage the Visual Cortex

We have already pointed out that the human brain processes images 60,000 times faster than it processes text (i.e., reading and understanding words in a phrase or a sentence). This capability is probably bred in our genes over millions of years and related to the fight-or-flight response of the brain. We react to what we see, especially something that moves, which could have meant life or death. Now it serves for driving a car. Most ads and even entertainment narratives rely on this visual processing. That is why writing for visual media means writing in images not words. Yes, we use words, but to describe a visual image. How we connect those visual images tells the story and reaches the audience in a primordial way. This is another way to understand the idea of metawriting.

A more recent ad in the CSX campaign called Nature's Fireworks employs a strategy of visual engagement. The ad is almost all visuals and little voice-over. We see a series of stunning shots of the natural world, both animal and vegetable—salmon leaping up a falls, springbok deer jumping, flowers opening. Pretty quickly you realize that each image, although not connected in time or space, exhibits a similar movement or shape. They reinforce one another and make something random thematic so that our brains recognize the pattern and begin to get in step with the idea. It is similar to our brains seeing a series of dots as a line, a shape, or a visual pattern. Throughout the montage there is a sound effect of firecrackers or fireworks. A couple is watching the night sky and sees meteors and fireworks. The punch line is: Nature is amazing. Let's keep it that way. The seduction of the ad lies in the way disparate images of nature have been made to resemble one another in shape, form, and movement. Now we are primed to follow the thought through that if we want to preserve nature in all its wonder, we must do something about the environment. The argument is that **CSX**, by moving freight with minimal carbon emissions, is doing just that. We assent; we approve; we embrace the message.[4]

Another highly creative concept involves an attention-getting sequence of shots with a similar movement, in this case, tracking or zooming across lines of objects in industry ending with railroad tracks and the CSX train. We are looking at tubes in a freight yard. We zoom through and dissolve into a track, down a row of supermarket carts. Always with a forward movement, we track or zoom through a production line of bottles, rows of agriculture; this visual movement builds the theme of

4 "CSX Corporation announced that the company earned a place on the Carbon Disclosure Project (CDP) S&P 500 Carbon Disclosure Leadership Index (CDLI) for the third consecutive year, and for the first time is recognized on the CDP Global 500 Carbon Disclosure Leadership Index" (www.csx.com).

"forward," which we recognize through the thematic similarity of shot. The visual cortex is engaged once again, getting us to recognize a common theme of parallel lines and forward movement. We end with a final dissolve into a tracking shot on a train emerging from a tunnel, and then the reveal of the **CSX** locomotive. The shots are accompanied by a sound effect of a train moving over rails, thus preparing for the denouement of the suspense device. We are engaged but we don't know where we are going and then we burst out of the tunnel and the sound track coincides with the image. The voice-over explains that CSX moves goods and helps to keep the economy moving "forward." The verbal cue reinforces the visual cues.

These creative ideas and the meta-writing behind the CSX commercials involve a basic visual psychology of human vision that makes an association between similar shapes and movements. As we pointed out at the beginning, one simple idea makes the message clear, but we add the device of recruiting the audience's brain to complete the message inside the viewer's brain, recruiting the curiosity and intelligence of the viewer. They set you up. You did it. It is elegant communication.

Delta has a television commercial that we will call "Up." It consists of a series of shots to do with airline travel that all involve an upward action or an upward camera movement, either a crane shot or a tilt. The montage sustains this upward theme until the last image, which is an airliner emerging from the clouds in a climb. Perhaps it is too obvious to explain what the audience intuitively understands, but the copywriter looking for a visual technique to convey the message is in a different position. Once you see it, it's easy; finding the concept involves understanding how the medium works and doing the meta-writing. The word *up*, a mere preposition, has a visual correlative. Although it connotes direction and the phenomenon of flight, it also expresses an idea of improvement, or getting better. The meta-writing is to translate this into a visual idea that works within the chosen medium, in this case film. Now you could have a still in a print ad showing the airliner emerging from the clouds and write copy that would express some of the ideas, but it would not be as effective. This short TV commercial works because the visual imagination of the viewer is engaged by a series of shots that independently do not mean that much but arranged in a sequence as a montage describing some keys moments of traveling by air, brings you to a conclusion that is determined by the concept. All airlines fly planes; all air travelers experience these sights and actions, but the *up* movement of the shots within the shot establishes a visual idea that is repeated and elaborated from shot to shot in pans and crane shots that engage the eye, that make you listen to the punch line about Delta as a superior airline, concluding with the last shot in which the plane is moving up but the camera remains still to underline the visual idea. So, you remember Delta in association with a visual experience.

Notice that all three of these examples in scripting and storyboarding rely on an editing device of montage that makes one shot relate to the other either by similarity of shape in the adjacent image or similarity of movement, or, in the Delta ad, a similarity, even repetition of a camera movement, crane, or tilt to reinforce the meaning of the word *up*" Up is a preposition that indicates the direction that is the key preposition of flight, the core business of an airline, but it also conveys that idea of improvement—going higher with all its connotations of getter better. The linked images engage the visual imagination so that the proposition of the tag line and commentary enhances the images, validates them, and then reinforces the message. This meta-writing that relies on visual metaphor is the epitome of visual writing. It is hard to explain but easy to see. It is hard to write, but easy to understand. This is true across all visual media, whether still or live action, whether commercial message or narrative entertainment.

This is the visual writing equivalent of an advertising jingle that through a certain amount of repetition embeds itself in your brain and plays by itself. You can't get it out of your head. In communication theory, this is explained as the hypodermic needle, or the involuntary impregnation of something in your mind. The visual idea is an engagement of the visual imagination to suggest a

conclusion and therefore is earned and owned by the viewer. The viewer contributes to the result. For that reason, the message is more effective. Most effective ads rely on this visual meta-writing.

WRITING FOR AUDIO

The scope of this book, signaled by its title, identifies visual writing as a different and special kind of writing that is the key to writing for visual media. If you observe carefully how many ads work, counter to our principal argument, the concept can arise from a writer's aural imagination. The visual media, after all, also rely on an audio component. The sound track, whether voice, music, or sound effects, is an integral part of the audience's experience. Language can be the hook for engagement with the audience. Audio word play—catching the ear first—is sometimes more effective than catching the eye with visuals. The question is delicate. If you do not think and write visually in a visual medium, you are essentially writing a radio commercial. What if an audio concept can cue the visual or enhance the visual? This technique needs to be explored with the proviso that if you write an audio track first and then illustrate, you are not using the potential of a visual medium. You are not practicing visual writing.

Tag lines, slogans, punch lines, and lead lines seed the audience's curiosity about the visuals or wrap up the message delivered by the visual metaphor. Audio word play can catch the ear first, or images can catch the eye first. Visual writing is paradoxically of necessity also audio writing. How they work together is critical. Whereas in dramatic writing, the dialogue of characters recorded as sync sound is taken for granted, in ads and PSAs, voice and words often have a specific value both apart from and complementary to the visuals. Many ads and PSAs have a punch line or a tag line that can stitch the message together without a visual metaphor, such as FRIENDS DON'T LET FRIENDS DRIVE DRUNK. It is the conclusion of a visual exposition or a visual metaphor. Lastly, humor is very often verbal. Without language, comedy would become purely slapstick and many ads would be unintelligible. Let's look at a borderline case. BASF, a chemical company, has an ad running which doesn't sell a product but sells the brand or achieves a PR goal of detoxifying the bad association with chemical pollution. The sequence of images illustrates by visual metaphor an abstract idea of molecules combining and changing physical properties to yield socially useful and technologically appealing products: a class of school kids hold up signs with all the chemical symbols of the periodic table of elements. By rearranging molecules, billiard balls scatter; housing insulation is improved; bandages love the water. A series of images explain that chemistry changes and rearranges, which leads us to their tag line: WE DON'T JUST MAKE CHEMICALS, WE CREATE CHEMISTRY. There are many clever and provocative images, but the structure and meaning of the ad is dependent on the voice-over. If you view it mute, it won't make much sense. That is one test for whether an ad is dependent on language.

Verbal humor is sometimes witty, sometimes goofy, and sometimes not so funny. Yet another Geico ad has two fellows on a stage strumming a Banjo and a ukulele. Afterward, we see a tedious (for me) scene of a witch flying around a factory on broom sticks, they ask how happy are people who save money on their car insurance with Geico: "How happy are they Jimmy?" Answer: "Happy as witch in a broom factory." Then we get the voice-over tag line: 15 MINUTES COULD SAVE YOU 15 PERCENT OR MORE ON CAR INSURANCE. This is the unifying message of all the Geico campaigns, playing on the symmetry of 15 percent and 15 minutes. Geico has had the caveman ads, the gecko ads, the simile ads about how happy the people who switch are, and the humorous logic ads in which children's nursery rhymes are used for effect, in which a serious announcer asks the audience how likely is that you will save money by switching to Geico then asking did the little piggy cry *weee weee* all the way home. The question has only one answer that leads to several somewhat asinine literal proofs depicting the answer. As

an aside, you have to wonder how much money these ad campaigns, sometimes running simultaneously, reduce the savings the company can offer. I haven't switched yet. Have you?

One characteristic of language is playfulness. Rhyme is mnemonic because the repetition of the combination of vowel and consonant sound makes a pattern of the brain. The insurance company Nationwide has jingle that links up all its adds—"Nationwide is on your side." It helps you remember a selling point through audio values—rhyme and jingle. The current campaign has another audio cue that reinforces a visual idea. The voice-over explains how good **Nationwide** drivers are because of "vanishing deductibles." The phrase becomes the cue for underlining the point with a visual effect of cars vaporizing and disappearing. There is a touch of humor when we see a worried Dad looking out the window at boy languishing against a convertible that his daughter is rushing out meet when—*pouff*—the car vanishes and the boy vanishes.

Music can be a lead in or a commentary on the visuals. It's Christmas 2012, **Hershey's kisses** are arranged in a pattern of a Christmas tree. They are like Christmas decorations. The music, played on the sound track without words is "We wish you a merry Christmas, we wish you a merry Christmas, we wish you a merry Christmas and a Happy New Year," played on bells or triangles, perhaps a synthesizer. The tune speaks—no words are necessary. With each note, a Hershey's kiss moves up and down in sync with the notes. The simple stop frame animation complements the music. The punch line is text mentioning Hershey's kisses in lower thirds on screen: HAPPY HOLIDAYS FROM HERSHEY'S KISSES! This is simple, creative, original, and unique. Job done! The brand is well known. We just need a new way to engage the audience's attention. The music is an integral part of the concept. It is a rare instance of music being written into a script/ storyboard by the copywriter. One can imagine the idea began with the music. Voice commentary is not needed.

The current ad for **Kit Kat** relies on a series of sound effects: the sound of unwrapping the candy, of breaking off a section, and of biting in to it with a sound of pleasurable appreciation—*mmm*. This sequence of sounds is played over and over again in a kind of 1–2–3 syncopated rhythm but in sync with multiple scenes people carrying out those actions until at the end, the picture of a building like the Empire State Building lights up in a 1-2-3 cuts. There is a product shot of a shelf of Kit Kat candy on display or there is a banner that unfurls from a building: KIT KAT BREAK TIME ANY TIME. There is no commentary whatsoever. The audio effect links the montage of images together of different people pleasurably discovering the fun of snapping off a piece of the chocolate and the sensation of tasting it shown in their facial expressions and making a little sound of pleasure. This illustrates how the sound track can be a fundamental part of the concept.

Advertising food products is a challenge. Most are predictable, whether for restaurant chains or packaged food products. The typical strategy is to show the food in glorious close-up colors and in slow motion. Another is to show someone, usually a woman, getting extreme pleasure from the taste sensation of chocolate, soups, or breakfast cereal. Another food product, Pringles, uses the sound of crunching one of their chips to evoke the sensation of eating them. Seeing someone eat or drink a product and then swoon over the taste sensation is rather literal and not very effective use of the medium because it is so literal.

Voice commentary that lives on the sound track and is written and recorded separately from any filming is often needed and demands a consciously different kind of writing. First and foremost, the language and sentence structure must be speakable out loud. The succinct expression of short sentences makes it easier for the audience to follow and condenses the ideas so that the commentary takes less screen time. Because the words have no sync with images, if the words outlive the available images or extend beyond the time value of the images on screen, a commentary-driven piece results, which is dominated by relentless and ultimately tedious spoken narrative. The visual narrative gets smothered and suppressed. Voice has to be subordinate to the image; it is complementary,

supportive, and highlights and underlines meaning. The CSX commercials discussed above marry the two narratives very well.

RADIO: WORDS WITHOUT PICTURES

We understand more about the role of voice when we contemplate how voice works in the pure audio medium of radio. A lot of radio advertising consists of verbal pitches and a music bed without much visual metaphor. Radio spots often cram words in a limited time slot by accelerated delivery. Voice in video or film should not compete with picture or substitute for picture. In radio, the sound effects often conjure up visuals or work to draw in the visual imagination. If you hear the sound of a car crash followed by police and ambulance sirens, you have a generic image of a scene. The sound effects have visual correlatives that the audience understands, even if listeners do not visualize. The sound effects are connected to a visual reality. Their value is visual in an audio medium.

The Ad Council produced a radio ad to combat **texting while driving** that involves three techniques at once. First, a voice describes improbably dangerous things you would never think of doing, which conjures up visuals. Then another voiceover commentary, delivered by a NASCAR driver draws the conclusion that you would not dream of texting in these dangerous situations; so why would you text and drive. This is, of course, celebrity advocacy.

INFOMERCIALS

The infomercial is a relatively new television format that has grown up with the emergence of cable television channels. It offers another way for a channel to make money. Companies or enterprises pay for the time at a cheaper rate than that which makes money for the cable channels selling spots in programming. You've all seen them. They masquerade as interview or talk shows in which a guest or guests are talking to a presenter about a product or service. Infomercials sell anything from real estate schemes and get-rich-quick seminars ("I guarantee you will make money out of my scheme") to exercise devices, cosmetics, and diet plans. They are periodically interrupted with buying breaks in which the 800 number comes on screen with images of the credit cards that can be used to purchase the service or product. Although some of this dialogue can be improvised, as in a talk or interview show, the format itself has to be scripted. There is little need for visual writing in this genre. Infomercials are mostly studio based and produced as a multi-camera productions.

VIDEO NEWS RELEASES

The video news release is another result of the proliferation of television channels. It is the video equivalent of a press release in print. Companies create a professionally produced news story about a certain product, and distribute the story free to TV stations in the hope that it will be inserted into the news. Many smaller markets are short on material and find that a professionally produced story about a new pharmaceutical drug embedded in a story about scientific research into cancer fits nicely into a science-reporting category. The fact that this particular manufacturer's new drug is featured as part of the story is acceptable if it is not too blatantly promoted. It is not advertising. It is a new form of publicity planted in news-like stories. A lot of this type of writing is given to journalists because it resembles journalistic writing. It mimics the objectivity of the news story and utilizes the same techniques of to-camera presenters and documentary footage. It is faux news that masquerades as news and deceives audiences.

BILLBOARDS AND TRANSPORTATION ADS

Billboards are a form of visual communication for commercial purposes that have evolved with the increase in consumer ownership of automobiles. Of course, people riding on surface public transportation also see city billboards, as do pedestrians. Large surfaces such as the sides of buildings become canvases for outdoor ads, which have developed a style and technique appropriate to the medium. The primary determinant of how a billboard works is its method of delivery. Delivery of the message depends on drive-by duration. You do not see a crowd gathering around billboards, as the dominant audience of billboards is the motorist or passenger of a motor vehicle. The sight line from the billboard to the viewer exists for a matter of seconds, as the vehicle drives by.

This fundamental context for reading billboards and posters leads to several logical axioms about billboard copywriting:

- The message has to be comprehensible within seconds.
- There has to be a strong visual idea behind the billboard.
- Text takes too long to read and has to be limited to large phrases.
- The visual idea should work independently of text.
- Messages use strategies of humor and shock, just like TV ads.
- Successful campaigns become series (GOT MILK?).

The billboard illustrates very well the difference between informational, motivational, and behavioral objectives. Clearly, information that is mainly text dependent has a limited place. Although behavioral objectives can work and billboards can deliver 800 numbers to act on, the primary objective is going to be motivational. Billboards are interesting examples of visual communication because of the severe constraints imposed on their content, which must be read in an instant. Their message has to achieve an extreme economy in audience capture and communication.

In 1999, the Outdoor Advertising Association of America commissioned a study to measure motorists' response to outdoor advertising using special ShopperVision eyeglasses that document the actual seeing experience from a passenger's perspective.[5] The study showed that the following elements are important and register with an audience, as follows, in descending order of importance:

- Bright/cheerful colors: 30 percent
- Uniqueness (movement/extensions): 26 percent
- The color yellow: 18 percent
- Catchy/clever/cute/humorous: 14 percent
- Personal relevance: 14 percent
- Familiarity/repeat exposure: 12 percent
- Product illustration: 12 percent

If a campaign deploys more than one medium, like the GOT MILK? campaign, it allows billboard design to trade on the print ads and exploit the familiarity and repetition. A print ad can use more text because readers can study the page. In the billboard, the image predominates. The milk moustache becomes the main visual idea, coupled with celebrity. Two strategies are combined. First, there is repeat exposure across media, which helps. The humor is important. All kinds of celebrities are, in

5 See www.oaaa.org.

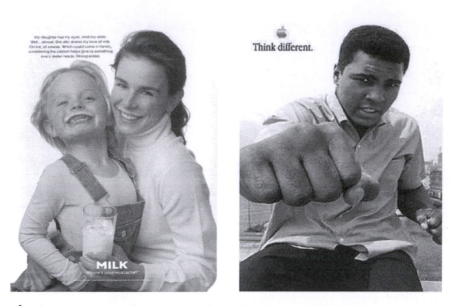

→ **Figure** 5.5 An advertisement from the "Got Milk?" campaign. (right) Muhammad Ali in Apple's "Think Different" ad campaign.

a sense, brought down to the level of you and me. The visual makes a great common denominator. The image of the milk moustache makes a wordless statement.

Apple's classic THINK DIFFERENT campaign used celebrity value in its print ads and billboards. However, Apple's celebrities were not like the GOT MILK? celebrities because they were, more often than not, historical celebrities. They were creative geniuses, usually unconventional, not necessarily beautiful. Because they did not follow convention or the crowd, they were innovators, inventors, thinkers, scientists, and artists. The visual statement is, "Here is a genius or a talented person who changed human history." Many were not Mac users because it hadn't been invented in their time; nevertheless, the association implies that if given the choice, creative geniuses like Einstein would choose Macs; this idea is communicated visually. Buying and using a Mac links you by association to genius and originality. This kind of visual elision between thoughts that compresses a syllogism into a single glance has to rank high as visual communication. It is more than just a picture; it is a train of thought. Of course, the text, THINK DIFFERENT, is itself a verbal embodiment of the picture. One is a clue to the other. *Think* is a verb in the imperative mood. Adjectives (*different*) do not modify verbs (despite the vernacular misuse of the language in phrases such as "I did good"). The correct expression would be, "Think differently!", but the grammatical mistake underlines the message that Macs are made for the unconventional mind.

Although visual writing generally relies on narrative, this narrative needs key moments and key images that compress the meaning into a single glance. Most good films have such moments. Even corporate communications, as we have seen, depend on this visual poetic device, which is the equivalent of a figure of speech. It is called metonymy. Apple's Mac stands for originality, for creators, for those who think differently than the crowd. The viewer is a character or a player in the ad. A key component of the ad is the viewer's recognition or the viewer supplying a missing link. It is the visual compression of a statement: if you know who Maria Callas (a famous opera singer and artist) is, you are part of a certain elite. If you recognize Einstein or Bob Dylan, you are part of that elite that thinks "different." That elite uses Macs. It is part of the same world. You could argue that while the GOT MILK? is inclusive, the THINK DIFFERENT campaign is exclusive. The one is for the many; the other is for the few.

Driving into or out of Boston on the Mass Pike, you see a number of billboards. The one that most merits our attention was dedicated to gun control. It was not a normal billboard, but the side of

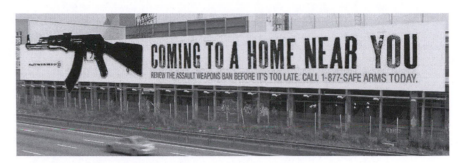

→ **Figure 5.6** Billboard on the Massachusetts Turnpike.

a long building. The ad consisted of a statement in large letters, "Bullets Leave Holes." At the end of this phrase, there are a series of frontal shots of kids. One of them was an outlined blank hole where a child was. The verbal cleverness in the double entendre on "holes" matches the visual image and gives it value. The billboard messages contract and compress verbal and visual meaning once again in apposite ways. Later it became a warning about assault rifles.

Another example of ingenious visual communication found in downtown Boston concerned an antismoking campaign. The billboard was the approximate size of a room with the dimensions marked on the billboard. The text message was: "Secondhand smoke spreads like cancer." The double meaning of "spreads" anchors the visual idea that is instantaneously understood—the way cigarette smoke diffuses throughout a room is a potential cause of cancer for nonsmokers in the room. The image is the smoke, which is the cancer spreading. The power of this idea is that the audience fills in the blank billboard with the visual—a room with furniture and a smoke haze. The audience has been co-opted to create its own visual. This is a very effective strategy because each viewer has an individual personal image, which is more powerful than a generic image that the advertiser might try to create.

The billboard and signage industry is the domain of the copywriter rather than the scriptwriter. The copywriter works closely with a creative director or a graphic designer so that the message in words is as concise as possible to complement the visual. The text stripped out would probably mean very little unless it were a company slogan or motto with an independent existence. However, there is little writing that precedes the design in the form of concept or needs analysis because agencies probably use an artist or graphic designer to draw roughs and then pitch the concept verbally at a creative meeting. Once again we see that meta-writing or visual thinking underlies the creative idea.

So we see that visual writing is critical to an advertising copywriter's arsenal. It applies to transportation posters and to full-page print ads, which often work like posters with a key phrase that unlocks an image. The visual has to be strong to attract the reader, flipping through pages of ads to get to the articles in a magazine, to pause. Messages that use a kind of informational and motivational sandwich are very effective, and the technique involves essentially the same mode of imagination that informs the work of the scriptwriter. The kind of writing we are trying to develop—compressed, elided, visual—is common to copywriters in an advertising world or scriptwriters in a corporate or entertainment world.

ADVERTISING ON THE WORLD WIDE WEB

In 1996, there was little or no advertising on the Internet. In 2014, advertising is a problem. There now exists a battery of new ways to reach audiences by inserting messages into web interaction, from animated messages in banners to popups, to click mapping that tracks the browser. There is a new form of digital signage that puts contextual messages on the desktop of web users, via the Internet

Service Provider or Internet portal that relate to their browsing choices. Writing web copy has to reflect a new medium and how it functions. The question arises whether this is visual writing or writing in a visual medium. A website is a visual experience but a lot of its content is text to be read. That text may be hyperlinked and include audiovisual material, but that is not essentially visual writing as I am defining it. True, you have to modify your writing style but you are not writing visuals that then have to be produced. The visual elements are also more the province of graphic designers.

Advertising on the web has many advantages. It is cheap to produce and can be updated quickly and easily compared to print and television. We see banner ads, sometimes animated, and pre-roll video. The online editions of *The Boston Globe, The Washington Post,* and others frequently interpose a full-screen pre-roll ad in front of the reader's chosen hyperlink. All web-based ads can get the viewer to respond by providing interactive cues to click on something that is fun, instructive, or logical and that will produce a result, answer a question, or show a product. The links allow the ad to occupy very little real estate on the desktop, but it connects to client web pages where an unlimited amount of detail can satisfy any level of consumer curiosity. The traffic can be measured by clicks and hits on websites, a much more precise measure than ratings on television or circulation of print media. For television or print media, there is no way of measuring of how many viewers see or read your ad other than the ratings and audience share, but web impressions and clicks can be counted.

Banner ads condense even further the visual language of ads and PSAs. They resemble billboards online but with the addition of animation. Once they advance beyond plain text and graphics, they begin to call on metaphor, which appeals to that faculty of the audience that can engage in visual reasoning. Metaphor is a kind of reasoning. If we say something is a two-edged sword, we mean that it can cut in two ways, one of which may be disadvantageous. CSX has an extensive multimedia campaign to advocate rail freight as an efficient and environmentally friendly mode of transport. The banner shows a landscape with a line of trees in the background. Superimposed on it is the signature outline of the CSX freight car. Inside the freight car graphics is a succession of phrases: 2,000 POUNDS OF FREIGHT; 1 GALLON OF FUEL; 423 MILES. Then the graphics freight car moves across the banner. The visual argument conveys in seconds that this mode of transportation is green and good for the environment. It has a feature unique to digital signage—a hyperlink to a website that invites a response with the text button LEARN MORE.

Web portals are businesses that need to build significant value for customers. Their objective is to get people in front of their content. To do this, they have to personalize sites, browsers, and portals to flatter the user. Search engines, formerly simple utilitarian tools, are evolving so that searching becomes embedded in other activities, such as downloading music, viewing pictures, reading articles, and collecting information. The new generation of search engines learns your interests and habits.[6] Association of products and services with personalized search engines will provide more efficient advertising. You can see this strategy working by using the Google search engine. Product placement increasingly provides a click-through link that takes you to a website where you can buy the product. Paid-for click advertising has become a major source of revenue.

Copywriting for the web has changed because advertising is structural and contextual. More important than the text or design of the message is the algorithm that tracks the browsing and presents an ad in the context of the web page content. The function of advertising, which is to deliver a message about a product or service to an audience that potentially needs or wants it, is served by delivering the surfer to the relevant site. The message is triggered based on embedded intelligence in the browser gathered from the way you use your browser rather than offered to an audience for

6 This is the vision of Jerry Yang, cofounder of Yahoo!, expressed in a television interview with Charlie Rose on PBS television in March 2005.

response. You don't need to respond to a particular message because your responses, at least your range of responses, are already known. You see ads that correspond to your interests.

Now new algorithms enable digital advertisers to target and bid for individual consumers with programmatic buying that gets advertisers to bid electronically in real time, based on impressions. It is probably related to computer trading in the stock market that enables big funds to buy and sell in fractions of a second whenever there is a profitable opportunity. So when the consumer is clicking on pages that define him as a desirable target, then the advertiser bids for access to the page in a fraction of a second. These systems "target individual consumers rather than the aggregate audience publishers serve up. In the world of 'programmatic buying' technologies, context matters less than tracking those consumers wherever they go." This is why certain ads follow you wherever you go.[7] "Context still matters and so does placement, . . . but it's only one element."[8]

As advertising on the Internet increases in quantity and interactive complexity, copywriters and creative directors have to comprehend interactivity and conceptualize campaigns that integrate with Internet services and interactive content on websites and interactive entertainment media. Interactive television will allow the future viewer to click on items in the picture, which may be put there by product placement, and take the viewer to an online boutique where a purchase can be made. We discuss these methods in Part 4.

From our point of view, although this kind of digital advertising is a form of visual communication, it is accomplished without really strong visual writing. The ads rely largely on text and graphics. Sometimes, we see stills or even video clips but it does not require the kind of visual writing that is unique to the moving picture media. It can all be handled by a print copywriter. The message has to be short and instantaneously appealing.

SOCIAL MEDIA

Social media have become indispensable. No corporation, no business, no independent freelancer, nobody, in short, can function in today's world without a presence in social media. Facebook, which was originally a site for connecting up with people, has been co-opted by business and corporations. The marketing of brands, of identity, of products, of external public relations depends on a presence in social media. We now have a kind of guerilla marketing craft that creates content for, and links between, social media platforms. Brands and product marketing now makes social media indispensable. Once again, although this is becoming a huge part of marketing and advertising, it does not call on genuine visual writing so much as text and graphics. It is visual composition but belongs to graphic design.

SCRIPT FORMATS

Applying visual writing techniques to commercial messages involves the whole gamut of devices and strategies that are available to the medium of moving pictures, whether video or film. Advertising

7 See Vega, "The New Algorithm of Web Marketing":

About 10 percent of the display ads that consumers see online have been sold through programmatic bidding channels, according to Walter Knapp, the executive vice president of platform revenue and operations at Federated Media, one of the world's largest digital advertising networks. Advertisers like Nike, Comcast, Progressive and Procter & Gamble are now using the programmatic buying, and luxury advertisers are starting to follow. According to data from Forrester Research, all ads traded on exchanges, as programmatic ads are, increased more than 17.5 percent to about 629 billion impressions (the number of times an ad appears) in 2012, from 535 billion in 2011.

8 Ibid.

and promotional budgets often allow writers and producers to exploit all the special effects and technology of the medium. The most adaptable format for the writer is the **dual-column format** (see Appendix). It is much easier to communicate precise, split-second timing of shots, effects, and voice-overs by lining up numbered shots in parallel so that the producer knows exactly what to shoot and the editor knows exactly what to edit. For clients who may not be able to read the dual-column format easily, storyboards serve the important function of visualizing the key frames for the client so that the image can be related to voice and effects. The storyboard, however, does not describe all of the detail of the shot as well as the dual-column script can. Camera movement has to be described, as do transitions and effects. The dual-column script is sort of like the architect's blueprint, whereas the storyboard is somewhat like the architect's sketch of what a building will look like. The client needs the sketch; the builder needs the blueprint.

CONCLUSION

Ads and PSAs are highly concentrated miniscripts that embody many of the techniques of longer form entertainment scripts. They rely on visual communication and require strong visual writing. They are an excellent training ground for beginning writers. It is not difficult to see that many ads and PSAs combine more than one of the strategies discussed. You can be sexy and funny. Special effects can be a means of creating humor. Mix and match! It works. Some of these strategies are carried over to digital signage and web advertising although an evolving technology of tracking and measuring eyeballs and browsing is changing the way advertisers engage audiences in the new digital ecosystem.

Television is a powerful medium, and it is not surprising that commercial organizations quickly worked out ways, helped by public relations practitioners, of establishing a presence and making use of the power of the medium in ways other than paid television advertising. Many of the techniques discussed in this chapter apply to longer forms of video communication that corporations and organizations need in order to promote, sell, or market products and services. They are also used for training, education, and self-help. The chapters that follow will look at these applications.

EXERCISES

1. Watch PSAs on television and analyze how they work by using the seven-step method, as outlined in Chapter 2. In other words, reverse-engineer the ad.
2. Call up a local advertising agency or a local public service organization and ask what public service announcements the agency is working on and offer to write one.
3. Pick out an advertisement or PSA that really holds your attention. Analyze how it works. What is the creative strategy that keeps you watching and therefore being exposed to the message?
4. Write a storyboard of an existing commercial or PSA. Try out the software program Storyboard Artist.
5. Pick one of the strategies or devices described in this chapter and use it to write a TV spot or a PSA. For example, use a shock effect in a PSA on drug or alcohol abuse, use sexuality to sell a healthy diet, or use humor to promote racial tolerance and diversity tolerance.
6. Write an infomercial for the business idea of an on-campus laundry service.
7. Write a video news release for a new birth control drug in the context of research into human reproduction.
8. Work out a digital signage banner. Describe how it works.

CHAPTER 6

Corporate Communications: Selling, Telling, Training, and Promoting

Key Terms

ADDIE model

asynchronous

authoring software

business theater

case history

cost benefit

documentary (educational, historical, investigative)

dramatization

dual-column format

focus group

formative evaluation

graphics

how-to videos

humor

instructional design

Instructional Systems Design (ISD)

interactive multimedia

interviewing

jobs

Learning Management Systems (LMS)

linear

narrative argument

nonlinear

on-camera anchor

SCORM

show-and-tell

story of a day

subject matter experts (SMEs)

summative evaluation

synchronous

task

technical writer

testimonials

treatment

visual metaphor

visual seduction

voice-overs/voice commentary

vox pops

Corporations, nonprofit organizations, government departments, and businesses large and small often use a visual medium like video to communicate important information and ideas to both internal and external audiences. Before video, they used film. Corporate use of visual media started early, although infrequently, in the days of silent film. Armour & Company, the Chicago meatpackers, used the Polyscope Company to make a promotional film about their stockyards to counter the negative publicity brought about by Upton Sinclair's novel *The Jungle* (1906), which exposed the less-than-desirable practices of the meatpacking industry.[1]

Today, making video and television for corporate clients, often called the non-broadcast industry, is a huge business, larger even than the more visible broadcast television industry. The general public

1 Charles Masser, "The Emergence of Cinema: The American Screen to 1907," in *History of the American Cinema*, vol. 1, ed. Charles Harpole (New York: Charles Scribner's Sons, 1990), p. 476.

sees very little of the output of the non-broadcast producers for the simple reason that the target audience for these videos is rarely the general public, and the videos are seldom seen on cable or broadcast networks. You may get to see an industrial or commercial video as a customer of a service or a purchaser of a product. Many of these productions serve business to business communications. Most people do not know about the vast number of writers, producers, and directors who make their livings creating these videos for corporate clients. Many of these creative talents migrated from the broadcasting and entertainment worlds. Some of them work in both.

The modern age of mass telecommunications really began with the telegraph, the telephone, and the radio. The modern age of mass visual communication began with photography and motion picture. A new era began in 1924, when sound was linked to pictures for the first talkie. Though not widely known, the first time sound was synchronized with film was for a classic public relations use—a 1924 informational tour of Western Electric's Hawthorn plant, hosted by the company's vice-president.[2] This is a good example, right at the beginning of corporate use of visual media, of how companies will sometimes be at the forefront of new technologies and new techniques that enhance visual communication. Live action picture with synchronized sound adds an element of realism that later turned film, news, and then television into a compelling mass medium now accessible across many digital platforms.

VIDEO, PRINT MEDIA, AND INTERACTIVE MEDIA

The world of corporate communications is dynamic and in a state of constant evolution. Once, 16-mm film was the only production medium for visual communication. In the 1970s, Sony's industrial U-matic videocassette format (1966) was joined by the domestic half-inch formats, of which only JVC's VHS format survives. Video recording and portable video recorders liberated television from the exclusive province of broadcasters and studio production. Location and production costs came within the budget of corporate departments. Then the convergence of video and computers in a digital domain led to a form of production that allowed multiple media to coexist in digital form on a computer hard drive. Then programs could be made to be menu driven and nonlinear. Linear program content runs from beginning to end in a predetermined order and period of time that the viewer must follow, whereas nonlinear media allow random access determined by the user. Video has been subordinated to an interactive multimedia world. This interactive multimedia experience could be stored on a CD-ROM or DVD and could also exist as a complex cluster of web pages at a site on the World Wide Web.

Finally, we must remember that traditional print media are still valid and unbeatable for certain kinds of communication. A great deal of information is more easily accessed and absorbed by using the old Gutenberg technology (i.e., the printed word). What we have now is a repertoire of communication media and communication methods, each of which has advantages and disadvantages. The choice of medium has to be matched to the communication problem.

VIDEO AS A CORPORATE COMMUNICATIONS TOOL

Although film and video are both linear media, there are differences between them. Video production is quicker to produce and thus more responsive to urgent business needs. The final product can be distributed on DVD or streamed over the web. It can be played by anyone on

2 See the website of the Media Communication Association International, an organization of media professionals who work in this area, at www.mcai.org/articles/mediapro.shtml.

equipment that is readily available. The screen size and, hence, the audience size is limited, but that has not inhibited its growth and popularity as a medium for corporate communicators. For large audiences, more than one projection screen or large video projection screens or more than one monitor can be provided. Another reason for the success of video is its use of the familiar idiom of television, an idiom that every member of the population understands. Everybody is educated in the language of the television screen from an early age. Therefore, corporate producers can exploit the devices and styles of television programming to get their messages across.

Film vs. Video Film negative is exposed to light and processed in a laboratory and then printed to positive. Its postproduction time is longer and less versatile in terms of effects and transitions. Film produces a better quality image, but it needs a special darkened room with a projection booth, a projector, and a projectionist to give an audience the full experience. Modern digital high-definition video can match 16-mm quality, and film is rarely used as a corporate medium. However, music videos, TV commercials, and high-end corporate production is shot on film and postproduced on video. Film is still an excellent medium for its contrast range and color reproduction.

The television screen on which the messages are delivered is an intimate and personal medium because only small groups can view it, sometimes a single individual at a time. Video and television make good use of close-ups and communicate the body language of human expression, particularly the face, very effectively. Hence, video communicates emotion effectively. Another advantage of video is that you can get instant playback, both when you shoot it and when you view a finished program, merely by rewinding the tape, or increasingly by random access to a hard disk or hard drive that stores the footage. Now video has incorporated most of the stunning special effects that can be created with graphics tools developed for computers. Both computer-generated graphics and live-action video images can be manipulated electronically in extraordinary ways by postproduction tools that digitize the video image and married to live action footage. This is well illustrated by the TV spots for the former **First Union Bank commercials** for which the preproduction storyboards are also available to understand the genesis of such high-end visuals.

Corporate video has often innovated ahead of broadcast television because corporate producers were free to use new formats and tools initially not admitted to the realm of the broadcast signal by the guardian engineers who ruled NTSC broadcast standards. Corporate producers have always experimented with new devices and formats that would make their work easier, cheaper, or more effective regardless of whether it met broadcast standards. Video can embody film, television, photography, computer graphics, and music. It is a linear experience starting at a specific frame and ending after a specific duration of time. This has advantages. We are used to it. Video is versatile and offers a range of narrative techniques and styles that we need to study, master, and learn to write. However, video has a disadvantage; it is not interactive and does not allow for user input. Interactive communication and how to write for it is discussed more fully in Part 4. Although stand alone video is not as dominant as it once was, professionally produced corporate video as a component of websites is thriving. Watchable videos, not necessarily about products or services, are now a way for corporate websites to engage website users consistent with contemporary marketing philosophy.

CORPORATE TELEVISION

The television medium, originally the exclusive province of public broadcasters with FCC licenses, was reinvented in private networks to serve business communication needs. This non-broadcast world, largely invisible to the general public, constitutes a large industry with a turnover in billions of

dollars that employs a large number of professionals. Corporate television, although not held to the same technical standards as the public broadcasters, uses much of the same equipment and, for the most part, is produced to the same standards. Some large corporations ran their own closed-circuit television channels. They acquired studios, equipment, crews, and creative staff to produce daily programming, distributed by cable or satellite to its branches and offices around the country or around the world. Now it can be streamed across a corporate website to both internal and external audiences at a lower cost. It is easier for employees to log on to a website and view the footage, interviews, or corporate announcements. The only real difference is that someone would have to log on to receive a message that would formerly be narrowcast at a given time for all to see.

Companies spend money on television or video programming because they get value for it. The efficient functioning of a business depends on successful communication, a great deal of which is visual or personal and more effective on television. Television and webcasts bring the internal corporate audience together. It therefore has an internal public relations potential that is incalculable. Think of the difference between seeing a CEO explain a takeover crisis or a major policy change compared to reading a memo about it! Think of the advantage of being able to communicate to employees in a visual medium that is understood by all! Product launches, training, company news, and company benefits can all be streamed on the corporate website.

Some international corporations have a business turnover as large as small countries. Many large geographically dispersed corporations, like FedEx, maintain private television networks to communicate with their workforce or sales force. Others have their own production studios and postproduction facilities. They are largely self-sufficient producers of their own video needs. As such, they are like a production company within the corporation that employs writers, producers, directors, graphic artists, editors, and the supporting personnel to produce a large number of videos or programs each year. The management decision to invest in the equipment and overhead to produce in house would only be triggered by a large and ongoing need for visual communication within the company. In any major commercial center, companies can find specialized production companies to make their videos for them. Some companies do both. They make some productions in house and contract out others. Many buy services from freelance creative talent such as directors and, in particular, writers. It is probably true to say that most scriptwriters are freelance although a few staff positions exist within these corporate studios. Modern practice is to concentrate on the core business and contract out the visual communication problem to specialist vendors.

One way to see the size of the industry that services corporate video production needs is to look at the Yellow Pages for your city under "video producer." You will see that most companies listed, other than the producers of wedding videos, produce commissioned audiovisual work for clients. Writers have an essential role in creating content for training and instruction. Managers and employees with communication roles in their work need to think and write visually to make more effective presentations

TRAINING, INSTRUCTION, AND EDUCATION

Business, government, and military all have vast training needs. Ever since television escaped from the broadcast television studio, when Sony introduced a portable format in the form of 3/4-inch U-matic cassettes, organizations have seized on video to create standardized training modules. A visual medium lends itself to showing how to do things and to explaining procedures and behavior. In fact, many products are now sold with video manuals as well as printed manuals. Video is an instructional tool for education and industry. Broadcast and cable television abound in how-to-do-it shows about home maintenance, auto maintenance, cooking, gardening, and so on. With the dissemination of the VHS format and the consumer VCR, now superseded by DVD players, either stand

alone or as a read/write drive in a computer, many different types of training and how-to-do-it videos are sold or rented to the general public, ranging from aerobic exercise tapes and learning modules to do-it-yourself videos. Once again, website delivery of video is more economical and more accessible than publishing DVDs. Here again is a vast market that needs writers, producers, and directors.

EDUCATIONAL/ INSTRUCTIONAL USE OF VIDEO

The advent of video in cheap portable formats opened up a vast educational video market. The simplest application was to record live lectures. Videos containing extraordinary images, archival material, or interviews, which are scripted and shot with an organized structure, offered valuable extensions to the classroom lecture technique and standard textbooks tradition-

> **Origins of Interactive Media**
>
> In the 1980s, attempts were made to make videotape interactive. The linear tape medium did not lend itself easily to this function because the time required to spool backwards and forwards to different sections of the tape took too long. With the advent of laser disks—first the 12-inch format (LaserDiscs), then the CD-ROM, and now the DVD—a real marriage between computers and audiovisual media became possible. Programs can be designed to be interactive so that the user input is part of the program concept. This nonlinear interactive structure lends itself perfectly to training needs. Self-paced learning can accommodate all learners. It allows tracking of performance and effective testing. That same interactivity is now accessible online. What used to be exclusively linear video now becomes a component of multimedia that demands a different kind of conceptualizing and writing. Further discussion of writing for interactive media can be found in Part 4.

ally used for teaching. Most students have seen this kind of educational documentary during their careers. Technically, this kind of content can be uploaded to courses online, but copyright issues sometimes restrict this. Educational libraries have significant video collections, a lot of it originated on old tape formats and is now distributed on DVDs and websites. The only difference between a television documentary and an educational documentary is probably length (because there is no scheduled slot to fit into) and subject matter. Television documentaries have to appeal to a general viewing audience. Educational documentaries can presume some background knowledge and can be more specialized.

From grade school through college, students need to acquire information, learn methods, and absorb subject matter from lectures. Overhead projectors are still a popular presentation tool for some educators despite more sophisticated LMS (Learning Management Systems) software. Now computer presentation software such as PowerPoint allows bulleted points and headings to be spiced up with graphic objects, audio, and video. The computer has basically subsumed the role of a slide projector when coupled to an LED projector. Slides can be stored as picture files and called up as needed. Now video capture tools allow instructors and designers of online courses to create video lectures, slide shows, and demonstrations. Computer software designed to facilitate distance learning, interactive learning, and blended learning has multiplied and introduced wikis and chat rooms so that learners can interact and learn from one another. Instructors can manage courses from the desktop and upload prerecorded video and provide hyperlinks to material on YouTube or other sites. Video remains an indispensable component of this mix.

Education from grade school through to college is undergoing a rapid and radical shift from traditional classroom lectures and face time to a curriculum that relies on flipped learning. More learning is pushed online to free up classroom time to work on individual learning difficulties and applying

what is absorbed online. Access to educational content has moved to the cloud and to mobile platforms such as tablets, net books, and smartphones. School budgets are spent on mobile platforms and institutions incorporate BYOD (bring your own device) at all levels of education to engage students and improve learning. Corporations are following suit moving away from company controlled desktops. Most courses in higher education are now taught with some kind of blended learning combining in-class contact hours with asynchronous delivery of learning content via a website using **specialized teaching and learning applications** such as Blackboard, Delta e-College, Adobe Captivate, Creative Suite, and other applications to create engaging learning experiences. The professionally produced educational video, rented or sold, is probably in decline and being replaced by content uploaded to e-learning websites. Publishers of textbooks often create online courses and ancillary materials with strong visual content to accompany books. This book will be published as an e-book integrated with a website accessible to readers of the print version.

Technical Writing

Industry is not concerned with grades but knowledge. What do you actually know? If you want employees to follow a lockout safety procedures working in say a refinery or on an oil rig, you must get them to reach a knowledge level that is effective. Consequences of serious grade inflation and passing someone who does not really know the subject would lead to blowing up your refinery or serious accidents with loss of life. An assured standard of knowledge then implies a verifiable process or method. In turn this leads to a study and definition of the learning process, which has now been codified and with which technical writers of training material have to be familiar. Instructional design is a specialized field that is an offshoot of visual writing, or vice versa. It depends on critical thinking and logical structure that could involve visual writing as a component but must achieve a measurable outcome. Analysis of the learning objective and technical accuracy must trump visual metaphor and visual seduction although metaphors can be strong instructional tools as can dramatized scenarios.

Today's companies need trainers, instructional designers, and technical writers who can serve their never-ending training needs. In every field, technology and the constant evolution of ideas means that existing employees need to be retrained and their knowledge and skills upgraded. Companies also need to train new hires who may have an inadequate education or who need knowledge about the company's products, history, policies, and benefits. Such training needs are ongoing. There is an overlap between the methods that can be applied to corporate training and can be applied to education. Training could be called a form of adult education, which is not part of a 4-year degree although it could be required for certification.

Developing instructional material for industry originates with the needs of the Department of Defense. With military technology and weaponry, a standardized model builds confidence in the results. This need gave rise to the ADDIE model, initially developed by Florida State University to provide a foundation for instructional design for military inter-service training and assure results for each job.[3] This generic framework for trainers and instructional designers has five phases: analysis, design, development, implementation, and evaluation. Instructional Systems Design (ISD) and Learning Management Systems (LMS) are usually built on this guideline, which has continued to evolve and spawn variations and modifications.

The seven-step method developed in this book serves as a kind of ADDIE model for visual writing and has some steps in common because each is a logical breakdown of a process. In the analysis

3 See http://en.wikipedia.org/wiki/ADDIE_Model.

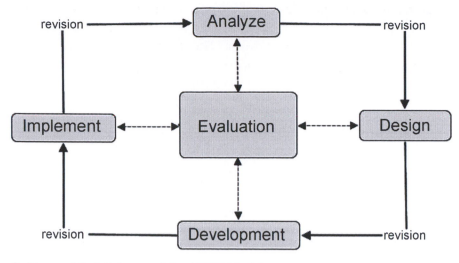

→ **Figure 6.1** A Schema of the ADDIE Model.

phase, the instructional problem has to be clarified (our step 1); the target audience has to be defined (our step 2); the objective must be determined (our step 3). More questions have to be answered that we ask in a different order. In the design phase, you must identify the strategy that will achieve the goal and desired outcome. In the development phase, you must identify and design the content (our step 4 and 5). In the implementation phase, you have to define the method of delivery, which could include more than one medium and come up with the concept or actual design (our step 6 and 7). Our seven steps do not include scriptwriting and production, which is part of the implementation phase. The evaluation phase, which is after production and not part of the seven steps, consists of formative and summative evaluation.

Formative Evaluation

Finding out whether a writer's idea for a corporate video is right or wrong can be an expensive business. Training and instructional programs are different because the desired end result can be closely defined and then tested or measured. Therefore, the content can be evaluated in a controlled way. Evaluation becomes a crucial part of the writing process. Evaluation comes in two kinds: formative and summative. It is also true, however, that many corporate productions go forward without formal evaluations, which can add to the cost. Clients and producers feel confident about being able to design the right content by through discussion and critical thinking.

Formative evaluation is a process that takes place before committing resources and time to a project. The word *formative* suggests that it is part of the forming or shaping process. There are a number of techniques, both formal and informal, that you can apply to your writing. It is easy to record interviews of a representative audience; it is not easy to interpret the results without some kind of tabulation. More accessible may be to make up a questionnaire for a sample of your target audience and use its answers to guide you to the content of the program. The trick here is to ask the right questions, which might need some research, and then will have to be tabulated to provide a profile of your audience. If you want to make a video about parallel parking, you would want a cross-section of your viewers to reveal what they find difficult about it, what their fears are, how they learned to do it, and what they think would be useful to see in a video. The more important the outcome, the more elaborate you would want the formative evaluation to be, which as usual boils down to resources and cost.

Summative Evaluation

Summative is a word that derives from a Latin root. The word *sum*, or "total," is related. The "summation" of arguments at the end of a trial is similarly derived. So we understand that this summative evaluation takes place at the end of the process of communication to see whether the message worked as planned. The process tries to verify whether the objectives defined at the outset were met and whether the target audience is effectively receiving the intended message. This can involve questionnaires, testing, and observation.

Formative and summative evaluations work in tandem. What you find out in the first evaluation becomes the basis for the second. Sometimes, they can be used independently and also serve a purpose. Normally, though, one leads to the other. If you ask formative questions about parallel parking to define what you would show in your video, you would then want to ask the audience whether they understood how to parallel park after viewing the video or test them by questionnaire, or observation. The message sent is not always the message received, hence the elaborate exercise to test whether your intention is working as planned. For a production company and its client, success or failure has commercial consequences. Formative and summative evaluation is a sort of insurance policy. You might think of a carpentry analogy. You measure your wood before cutting it. You check the result afterwards to see if it is right before assembly. Media communication is an inexact science. Any way of stacking the odds in your favor to achieve a successful result is highly desirable. Numerous techniques have been developed in the advertising and public relations industries to ensure the success of campaigns for specific publics. Formative and summative evaluations rest on many techniques that work equally well to assess training needs.

FOCUS GROUPS

A focus group is a handpicked group of people who represent a cross section of your target audience and who have agreed to participate in the evaluation process. This might involve questionnaires, meetings, and discussions with a view to collecting detailed responses about a product, a service, or the effectiveness of the message. Most formative and summative evaluation works best with focus groups. It is advantageous to measure hypothetical responses and actual responses with the same group of people. It would not be hard to do an evaluation exercise with a focus group in a college environment.

QUESTIONNAIRES

Questionnaires can be used on their own without a focus group to conduct formative or summative evaluations. A good questionnaire provides an efficient way to collect information about the audience and its attitudes. In an informal way, every writer asks and answers questions about the target audience. A formal questionnaire, however, needs to be designed to elicit specific results and eliminate faulty assumptions. At the high end, this requires specialized skills. The use of polls and research into public attitudes on given issues is a professional field. Advertisers are more likely to do extensive audience research and polling to verify the assumptions on which a communication will rest. Where money is involved all parties need to know that the product works.

Once, everyone depended on a couple of video formats and players, then CDs and DVDs for distribution. Now, distribution is likely to be online, which raises a number of issues such as different operating systems (OS): Windows, Mac, Linux, and Unix. Will your program play as designed on all operating systems? On top of that, despite universal languages for the World Wide Web, there are

numerous incompatible video players, incompatible still picture displays, and numerous audio formats. Many people are familiar with the frustration that video authored in Adobe's Flash player will not play in Apple's QuickTime player and vice versa. For example, the first two editions of this book had accompanying DVDs that were authored on Macromedia (now Adobe) Director. Even though care was taken to make the interactivity work on both Mac and Windows platforms, it seemed almost impossible to avoid some errors, mostly to do with fonts that were not available on both platforms. This meant that some text within boxes would not fit and either spoil the graphic design or not be legible within the box. There are numerous authoring software systems for picture, interactivity and audio that have a proprietary coding but can export files in some other formats. How do you ensure that your training product and its component media, graphics, and interactivity will be universally accessible? Although writers need not be directly concerned with coding, many job descriptions for trainers and instructional designers want candidates to be familiar with ADDIE, SCORM, or specific e-learning software to which the company is committed.

SCORM

SCORM stands for Sharable Content Object Reference Model. It is a set of technical standards for e-learning software products that is the de facto standard for assuring that e-learning content from one Learning Management System will communicate with another. It is similar to industry standards for DVDs or the HD television signal that assures that a DVD or Blu-ray player will read any DVD manufactured to the agreed standard, or any television set will receive the broadcast signal. Before SCORM, many Learning Management Systems were incompatible. This need for interoperable LMS content solved by ADL, a research group sponsored by the United States Department of Defense (DoD) which saw that some existing standards solved part of the problem. It tells developers how to use these existing standards. If you are a writer, you do not need to know as much about this as an instructional designer.

TYPICAL CORPORATE COMMUNICATION PROBLEMS

To understand the business of corporate media, you need to look at some of the communication problems that corporations and organizations face for which media can become a solution. For example, when I bought an early model cellular phone, Bell Atlantic, then Nynex, now Verizon supplied a video to explain how to use it and how their cellular system worked. Today, this would hardly be necessary. A professional anchor or presenter talked to camera. Cutaways to close-ups showed how the phone worked. The video answered a number of the questions that came up for a person using such a product for the first time such as roaming, billing, or service. Most videos of this kind have a cost benefit. That is to say, the cost of making the video is compensated by a saving to the company in customer service calls and the employee time and overheads needed to deal with basic questions. In other words, this company anticipated a problem and found a solution by making a video. There are other factors and other benefits. Forestalling customer problems and making the product or service more successful is a strong benefit that is hard to value in dollars and cents. It is worth a lot and justifies the video dollars that a management decides to spend on the communication exercise.

This example shows that there is a rationale behind any video that is commissioned by an organization or corporation. Now corporate marketing and public relations employs nonlinear as well as linear media. Brochures and catalogs were produced on CD-ROMs and now DVDs. Product catalogs are searchable databases on a website. So the need to match a solution to a corporate communications problem extends beyond plain "vanilla" video.

Production companies have to be more versatile than they used to be. The range of media solutions has increased, and video has become a component of fixed interactive media and websites. Corporations and organizations have multiple types of communication problems that need solutions. Solving those problems is a creative service that production companies provide. They also offer production and post-production services. They deliver a finished product ready for distribution. Small business-card size CDs can hold a promotional brochure for products and services. Video is primarily motivational rather than informational, often a component of fixed interactive and online media. The range of media solutions has expanded so that step 6 of the seven-step method that queries what medium is appropriate and why becomes more urgent and a key part of developing a creative concept.

Scriptwriters have an important role in this process. You need to understand that role, and you need to see how to develop your thinking and writing skills to make a career in that field. Breaking into that market is easier than breaking into the entertainment market, which is smaller and highly competitive. It is easier to sell your talent to write a short $1,500 script for which the client or corporate producer is taking a small risk than to persuade a TV producer that you can write a series or even an episode of a series, let alone a feature film for which budgets run into tens of millions of dollars. Let it be said, though, that you should not limit yourself or your ambitions, and that you can migrate from one market to another and back again.

To understand the kind of problem that writers are given in the corporate market and for which they have to devise solutions, you have to start thinking from the clients' point of view. You have to see their needs, their predicaments, and, sometimes, their shortsightedness about their own communication problems. Corporate video is not about self-expression, or saying what you want to say. It is about expressing what others want to say. Sometimes they don't know what to say or how to say it. Selling your visual writing talent to help them find a solution can be creatively demanding and personally satisfying, as well as financially rewarding. It does mean, however, that you won't necessarily deal with themes or topics that you would freely choose to write about.

Because the client determines the subject matter and the message, the writer often has to learn about fields of activity, manufacturing processes, or technical information that are totally new. This makes the field intellectually exciting and challenging. You never know what is going to be thrown at you. You learn about all sorts of things that you would otherwise never come across. That is why a good general education, an understanding of science and history together with strong verbal and analytical skills, is important. Every company's business has unique products or services that you have to assimilate, understand, and communicate to an audience. You have to read and digest manuals and brochures; do background research, absorb verbal input from managers, subject matter experts (SMEs), and employees on site visits. You are often entrusted with confidential or sensitive commercial information. You need to get up to speed quickly and be able to discriminate between essential information and background noise. Corporate scriptwriting demands a creative imagination combined with a realistic understanding of business environments.

Corporate communication problems are never ending. The following examples represent classic stand alone video solutions, which are now less common because corporate websites offer both employee restricted and external audiences. A pharmaceutical company wants to get the attention of cardiologists, so it makes a video about pacemakers and the latest technology instead of trying to hard sell a particular drug. In this way, it can get the attention of its target audience, create an event, and promote the drug indirectly. Shell invents a bitumen compound that won't wear out but is more expensive than traditional road asphalt. It also results in a porous road surface that allows rainwater to drain away, thereby putting a stop to hazardous plumes of spray behind trucks and other vehicles. How can a petroleum company persuade municipal and highway authorities to use the new product when it is more expensive than traditional asphalt surfaces? One effective communication tool is to show how the product works. When trucks pass from a conventional road surface to the patented porous surface, the camera shows how the plume of spray

drops instantly. Then there is a story to tell—how the product was invented, case histories, testimonials, and benefits. The scriptwriter is the one who has to learn the story and interpret it to the chosen audience.

A department of education wants to ensure safety in school laboratories where Bunsen burners and chemicals pose a hazard. How do you do it? How about getting a known television comedian to dress up as a school kid and pretend to be going through all of the mistakes that schoolchildren go through? It is funny and serious at the same time. You have found a way to reach a young audience and get them to pay attention to a message and absorb safety information. Designing a successful script and seeing it made into a working video is exciting. Getting paid to do it makes it an even greater pleasure. Are you getting interested?

A telecommunications manufacturer supplies state-of-the-art light-wave multiplexers (switching fiber optic signals) and has to respond to an enhanced delivery and installation timetable imposed by its main customer, who is losing a million dollars a week in revenue because of lack of capacity to handle traffic. You have to communicate a new schedule and plan for a way to deliver and install exchanges and motivate the people involved to achieve the objective. You get a 2-inch-thick manual for technicians to read and have to figure out what it all means, what will make meaningful video, and what information is best left in print form. Maybe this is not much fun, but you are a professional. You can read the manual and filter the information so that you concentrate on the relevant passages. You can think through the communications problem and come up with a solution. The corporate world is willing to pay big bucks for these solutions. Consider these examples:

- An oil company faces perennial safety issues because hydrocarbons are volatile and flammable in both liquid and gaseous form. Every maintenance procedure involves serious hazards because teams with different skills are involved and may not know what the others are doing. A lockout safety procedure is in place that protects the life of each worker, not to mention the physical plant of the refinery or tank farm. When it has been ignored, it has led to loss of life in accidents. How do you get the lifesaving message across? The audience must watch, listen, and learn. Perhaps more important, the audience must change its behavior or put into practice what it learns from your video. You are the ringmaster, the impresario.
- A laboratory department in an oil company needs to show the executive board that its research facility saves its cost many times over because of specific improvements to drilling mud and a process that saves the loss of expensive chemicals in the refining process.
- A national chain of retail stores wants to train its personnel in procedures that reduce shoplifting and to make sure that they know how to deal with a shoplifting situation correctly if it occurs.
- A construction company that has built cooling towers for a nuclear power station wants to show its engineering innovations in managing the job with precast concrete sections and coordinating teamwork in erecting the tower. Construction takes longer than 2 years. What makes their engineering different or better than anyone else's? You have to find a visual metaphor or way of telling the story that makes the difference.
- A regional state or city government wants to promote itself as a dynamic region for investment to aerospace and biotechnology companies that can benefit from the existing national research laboratories and local research universities. You have to find a way to blend history and modernity and weave together a bundle of separate stories.[4]
- A company wants to educate new hires in the corporate jargon that is full of acronyms and abbreviations that are like a foreign language and must be learned by all new hires to understand written and spoken communications.

4 **Midi-Pyrénées: Nouveaux Espaces** is represented by video clips on the companion website.

GETTING BACKGROUND AND PRODUCT KNOWLEDGE

The most important job a writer has to do is to think, not just write. If the right thinking takes place, the right writing will follow. When you write for clients, you have to get inside their business, inside their mentality, and adopt their communication problem. Of course, you bring an outside point of view to their problem, which is one of your strongest points. You see with fresh eyes some salient feature that to them is habituated and sometimes no longer visible.

There are several ways to get background: by reading company brochures, visiting work sites, factories, dealers, and talking to people. Reading could start with an encyclopedia and end with a company memo. Most clients dump all the literature, manuals, and brochures they can find on you. Usually, there is more than you need. You have to apply a selective filter to it all. You have to formulate in your mind an inclusion/exclusion mechanism, learning to discard the material that is beyond the scope of your communication brief. You also have to measure the depth of knowledge you need about a given detail. You cannot become a cardiologist overnight, or a petroleum chemist, or a telecommunications engineer. You can, on the other hand, think through the audience's need and read intelligently on their behalf.

Another way you can collect information is by visiting the client's place of business, production sites, and sales outlets. This visual input is crucial for most writers. It shows you the most likely locations for action settings. It provides you with visual background and images that help you to write for the camera. Sometimes, it also enables you to see and understand industrial and manufacturing processes or technical problems that remain abstract if all you do is read about them.

The last way of collecting information, talking to people, is also indispensable. This could mean talking to your client's managers, employees, or customers. You frequently have meetings with small groups of people called together by your client because they all have expertise, experience, or interest in the subject matter. You have to listen carefully, think quickly, and ask relevant questions. Take names and contact numbers so that you can consult particular people when you are on your own and baffled by a question which one of these people will surely be able to answer. One or more of these people will be subject matter experts, referred to as SMEs.

> **Using Subject Matter Experts**
>
> A subject matter expert (SME) is someone designated by the client as an authority on a particular topic or subject matter. If a video project involves technical or scientific subject matter, an SME is a necessity. If an SME is not assigned to the job, you should ask for one or more. Talking to this person is often the breakthrough that you need. A good tactic is to ask the SME to explain things to you in response to specific questions that you prepare beforehand so as not to waste time. Most SMEs love to explain things. Most videos are targeted to an audience that is much less knowledgeable than subject matter experts. Therefore, your interrogation of an SME makes you an ambassador or a representative for that audience. It is an exciting and responsible job entrusted to you as a writer researching the topic or theme.

DEVICES FOR VIDEO EXPOSITION

In Chapter 5, we saw how ads and public service announcements (PSAs) are organized around a number of structural devices that help to organize content and keep the audience's interest. Humor, shock, suspense, and other strategies are useful for corporate video. Dramatization and case histories are also good ways to organize and communicate training content. There are a few formats that are perhaps more typical of videos.

JOB AND TASK DESCRIPTION

Most training concerns learning how to perform jobs. Jobs are broken down into tasks. The distinction is important. A task is specific, identifiable, and short. If you were dealing with driving a car, starting the car would be a task. Parallel parking would be another task. Several tasks in a sequence add up to a job. A job is then an undertaking that leads to a terminal action that completes the defined end objective. Many training videos are broken down into tasks and organized around task description.

SHOW AND TELL

The older training videos tend to be very basic and of a certain type known as show-and-tell, which usually involves some kind of task description. It is a tried-and-true technique because that is exactly what it does. Most writers have been pushed into doing one of these. The military and government agencies traditionally relied on this approach to reach a broad common denominator. If you want to teach hundreds or even thousands of recruits how to, say, change the caterpillar tracks on a tank, or service a diesel engine, you need to simplify the job into a number of separate, clear tasks. As the phrase "show-and-tell" suggests, the technique is to show on screen how to do something and then explain what you are seeing in a voice-over on the sound track. Many training tapes go on for 30 or 40 minutes and are unwatchable for anyone but the trainee who needs the instruction to pass a qualification. The show-and-tell technique is usually a standardized demonstration captured on video. A talking head introduction and a conclusion are typical of this kind of program, which is particularly useful and cost effective for training tasks that have to be repeated and are subject to variations in quality and style at each session depending on the instructor. Video training footage standardizes the content and the quality of delivery. This is important whenever a large number of trainees is involved. Interactive modules created for a computer and stored on a drive or a disk now provide an alternative to linear video and have more versatile applications.

The learning of a task can often be packaged in a show-and-tell video disk. Maintenance—operating radar, servicing machinery, or testing electrical circuits, for instance—is a good example. Learning how to drive a forklift, or how to back a truck into a loading bay, or how to sell a product are other examples. How-to-do-it videos are really training videos that the general public also buys or rents from video stores. They include cooking, exercise routines, or gardening topics. Now television and cable use this technique on cooking and how to do it shows. They use the visual medium to show by means of a moving picture what would have to be described at length and be difficult to follow in print. Many do-it-yourself television shows are based on the show-and-tell technique. The difference is that there is an anchor or presenter who is generally a personality of some kind, whether a celebrity chef is showing us how to make a soufflé or some other personality showing us how to install storm windows or remodel a kitchen.

In all of these programs, the common thread is that the subject matter, the content, is primary. An audience is going to be watching because it is interested in the subject matter per se, either because they want to be or, in the case of corporate training, because they have to be for their jobs. This kind of video does not always demand highly creative or imaginative use of the medium. How many ways can you show someone changing a spark plug? It does, however, require clear thinking and good organization of the material.

On a number of occasions, this writer has dealt with clients who wanted basic training videos and resisted all creative innovation. Once a client representative said to me that because the members of his audience were paid to watch the video, they didn't need anything creative or fancy. This thinking is mistaken because, even though an audience may be obliged to watch a video or work through an

interactive module on the company website as part of a job responsibility, there is always a motivation factor. You can oblige someone to sit in a room and be present for a screening, but you cannot control his mental attention. The person's mind can wander. You cannot stop someone from dozing off in a darkened room after lunch. You cannot control message retention by force-feeding someone a video. There is always a virtue in creative, thoughtful scripting that works to hold the audience's attention and improve message retention by imaginative use of the medium. This explains why much video has given way to interactive media that allows the individual to learn and pass quizzes that test absorption. A good example would be an online interactive module that teaches what constitutes sexual harassment. Either companies are obliged by some statute to administer this training, or they are protecting themselves against some future legal liability.

HOW-TO VIDEOS

If a picture is worth a thousand words, then showing an audience how to do something is the best example of it because explaining in words is nearly always long and often ambiguous. Everybody has had the experience of trying to follow written directions to assemble a piece of furniture or the operating instructions of an appliance, not to mention the instructions for a piece of computer software. For many retail items needing instruction, it is neither practical nor economical to provide a video manual. However, more expensive goods or services do sometimes come with a video manual. There is a commercial market for videos that show you how to do things: cooking, gardening, house repairs, exercise routines, and even how to make love. Although many are offshoots of television shows, plenty of videos are made specifically for this market. Video rental stores have a small section devoted to how-to videos. You see them advertised in magazines, sold by mail order, and promoted through infomercial programs on cable television.

INTERACTIVE APPLICATIONS

Interactive training came into its own with the invention of the laser disk. A computer interface with instant access to 50,000 frames of information made nonlinear instructional design a practical reality. The CD-ROM, successor to the 12-inch laser disk, has now been replaced by the DVD. Authoring software has been created that enables sophisticated interactive multimedia design. The ultimate medium for training is now interactive. Individuals absorb knowledge at different rates. Interactive media now allow self-paced learning. Computer-based training enables testing and scoring of individual performance. Authoring software allows the instructional designer to create feedback loops that not only foster self-paced learning but oblige the user to complete a test or learning module before proceeding.

Nevertheless, there is still room for the linear training video. One reason is that it costs much more to design and program a complex interactive training program than to produce a video. Such cost is not justified unless the training program will have long life and a large audience will need numerous copies of it. If training content changes rapidly or has a small audience, linear videotape can do a useful job of instruction at low cost in conjunction with print manuals. Lucent Technologies (since merged with the French company Alcatel in 2006) adopted this solution to facilitate installation of light wave multiplexers for which I wrote a couple of scripts of this very kind. The main objective of the videos was to improve the speed and efficiency of installation and the target audience was the installers. They had a three-inch ring binder of printed instructions. It was impossible to use the medium effectively because linear video does not allow the audience to retain detailed information,

which is what they had to do. So clearly they would be reading the manual. Video works best to motivate and communicate emotionally.

The fastest growing application for training is online, using real-time synchronous and asynchronous sharing of information to an unlimited audience who can log on to a website. Microsoft is promoting its meeting software, NetMeeting. More interesting is a tool like Adobe Acrobat Connect Pro, which allows video, audio, and white board synchronous communication and as well as asynchronous stored media such as stills and video for later access. So, increasingly, video will become an asset to be produced for uploading to a more versatile, interactive environment, either on fixed media or on websites. The traditional instructional video may well dwindle in value.

Most college students have encountered asynchronous online course delivery software such as Blackboard or taken distance learning courses wholly online based on Delta e-college, Angel, D2L, or similar LMS software. The principle is the same. All course content is delivered online as are test, exams, and lectures. All assignments are submitted online and the corrected and graded work uploaded to the student's account. Corporations employ the same methods for training employees in technical procedures, safety, and other content. Like colleges and universities, they also use blended learning that combines online with classroom or face to face instruction.

OTHER CORPORATE USES OF MEDIA

Corporate communications is a fast-moving and dynamic world. Producers are quick to innovate and propose media solutions that exploit the latest technology. Corporate video has changed over the years. It has become shorter, more motivational, and targeted at specific opportunities. There is no better way to capture a CEO's message to shareholders or to employees, now more likely to be streamed to the corporate website rather than distributed on videotape. Think of video as a component in increasingly interactive solutions on the web. This makes sense, especially when content needs to be updated regularly.

Fixed media are ideal for cheap distribution of catalogs, interactive brochures, and service manuals when the content will have a reasonable life expectancy. Corporate marketing can choose between a product launch in a meeting with a video component or a website with its potential for viral marketing as well as traditional video, increasingly likely to be on DVD, and therefore offer interactive options. So annual general meetings, product launches, product promotion, sales training, technical installations, service manuals, and product updates can all be delivered via interactive solutions on a website or on fixed media. There are public relations stories, annual reports to shareholders, and prestige corporate image videos. There are internal public relations explaining policy changes, product changes, and health and pension benefits. There are numerous **training** needs including safety training, personnel training, and management training. Chapter 12 in Part 4 dedicated to writing for interactive media has more on interactive corporate communications.

MEETINGS WITH A VISUAL FOCUS

Management means meetings. Management constantly needs to communicate to middle managers and employees concerning new policies, information, and strategies; so they have meetings. Small meetings might be built around a computer-produced slide presentation. These sorts of PowerPoint presentations with graphic presentation of facts and figures and bulleted points can be projected on larger screens for larger meetings. Big companies also hold big meetings with hundreds of managers or sales representatives. There are many reasons to hold a meeting: to motivate employees to do

a better job; to put a new policy into practice; or to bring all their dealers together to launch a new product or a new model. Good marketing starts by getting the dealers to believe that the new product or new model is competitive and that they can make money selling it. The manufacturer might spend what to us is a small fortune on a meeting with visual focus. This might include slides, video, music, live demonstrations, and a "reveal," which is a dramatic unveiling of the new model or product that inspires the audience of dealers. Without the visual focus, the meeting would boil down to speeches by sales executives and CEOs. Talk is talk. An audience can only process so much. High-level executives need meeting openers and focused videos that encapsulate a corporate story.

Meetings are also about rewards. IBM used to host the **Golden Globe Awards**, an annual awards event for its best salespeople. The event was often held in an exotic location, such as Honolulu, Cannes, or Las Vegas, with presentations and keynote addresses by senior executives in the company. It was a reward but also an opportunity for internal public relations and promotion.[5] If a company brings together a thousand or more of its salespeople or its dealers, it has an unparalleled opportunity to communicate corporate vision and motivate its people. Such meetings can be elaborate, big-budget extravaganzas with highly original concepts accompanied by elaborately produced multimedia presentations designed to motivate the sales force. Motivation, as we have said before, derives from the same root as emotion. Motivation with words alone is possible but difficult.

Video commentary can be voiced by experienced actors. Visual media can call on powerful visual images and multi-track stereo sound that impacts the senses so that messages are experienced as well as heard or read. Guess who is needed to think up these visual experiences and develop the management themes? Yes, scriptwriters! More work for scriptwriters who know how to deal with corporate communication! This is big business. It is also exciting to do. It is a kind of business theater.

Mars, a candy manufacturer, has an internal meeting of salespeople to launch a marketing and sales program. To dramatize the meeting and its rivalry with other candy bar manufacturers, the conference is built around a giant chessboard on which key pieces of the sales strategy correspond to chess pieces. A real chess game is worked out that ends in checkmate for the competition. Key executives speak to the themes, which are dramatized by moving life-size chess pieces. Writing the speeches and writing the scenario for the marketing chess game is work for a writer.

> **Orators** Historically, great orators have changed public consciousness with memorable language, whether Cicero in the Roman Senate, the representatives of the first Continental Congress of the States, Abraham Lincoln at Gettysburg, FDR's speech that the only thing to fear was fear itself, or Winston Churchill in his address to the British House of Commons after Dunkirk confronted with the possible invasion by Nazi Germany.[6] However, great orators are not common in corporate boardrooms. Corporate management usually benefits from professional writing for oral delivery and the power of visuals to deliver their messages.

5 See the companion website for a speculative proposal for such a conference.

6 "We shall not flag nor fail. We shall go on to the end. We shall fight in France and on the seas and oceans; we shall fight with growing confidence and growing strength in the air. We shall defend our island whatever the cost may be; we shall fight on beaches, landing grounds, in fields, in streets and on the hills. We shall never surrender and even if, which I do not for the moment believe, this island or a large part of it were subjugated and starving, then our empire beyond the seas, armed and guarded by the British Fleet, will carry on the struggle until in God's good time the New World with all its power and might, sets forth to the liberation and rescue of the Old."

DEVICES THAT TEACH AND ENTERTAIN

The challenge with a corporate video is to present a great deal of information in an engaging and memorable fashion. Sometimes the way companies use training video sinks the medium like an overloaded vessel. Because the medium is linear, it is hard to retain information beyond a certain amount. A scriptwriter needs to find a way to relay the information while keeping the audience's attention. A number of devices can do this. Most of them involve pretending that the training task is, for example, a game, a television show, or a story. Above all, we need some kind of structural device that holds the material together and helps the audience follow along. This can take many forms. Once again we need visual metaphors. We need images that impart emotion and meaning straight to the perceptive mind through the visual cortex in a way that language often cannot.

DEVICES THAT WORK FOR CORPORATE MESSAGES

The beginner looks at a corporate communication problem and probably thinks that the message is tedious, too factual, or specific to a product. However, some of the most creative and exciting opportunities for writing and program making come out of corporate communication problems. It is precisely because the message content is presented in the raw that the writer and production team have wonderful opportunities to innovate strategies to reach the audience and invent devices that make the program watchable.

Writing a script, whether fiction, documentary, or corporate, involves finding a structure. A writer's fundamental problem is to find a structure that will organize the material in such a way as to engage the audience. This idea that the audience must grasp can be either explicit or implicit. Most stories, whether novels, plays, or films, have implicit structures. The idea can be flagged as a key to the organization of the content for the audience. Or it can be a sort of rack on which points hang. An exposition such as a lecture or a business presentation is usually laid out as a plan with headings and subheadings so that the audience knows where it is going. The structure that enables the scriptwriter to bring together all the details and communicate a comprehensible message usually rests on one of a number of devices, which we need to recognize and to understand how they work. In corporate video, it has become commonplace to borrow from television and imitate other types of program.

Dramatization

Even though corporate drama or comedy productions might not equal entertainment vehicles in production value or talent, dramatizing a message is an effective way to engage an audience because it tells a story and creates characters with whom the audience can identify. It is particularly effective for training videos. In *The Right Direction*, a training video for financial advisors, the scriptwriter wants to make a point about communicating financial information to customers who are not familiar with financial matters. One effective way to make the point is to invent a dramatic situation with characters. First get the audience involved in the story. A driver, lost in the country, asks for directions from a local. The audience readily understands that the road and the map of where we are going is a good metaphor for the client's journey down a financial road. Road signs are adapted to warn of regulatory and other problems. Getting lost is the metaphor. Once the audience gets into the story, the moral of the situation can be made clear. This particular script uses several devices in combination—dramatization, voice-over narration, and graphics.

A generation ago, AT&T produced a very expensive video called **Connections**. Its target was the general public and therefore a nontechnical audience. Its objective was to imagine the future of telecommunications and how it might impact our lives. To bundle together all the diverse points, it needed a device like a story in which the audience would encounter the future telecommunications technologies in the context of work and leisure activities. In the story of the video, a young woman who has been working in Asia has become engaged to a Belgian doctor. When her mother and father meet her at the airport, she uses a future AT&T phone with voice recognition and simultaneous translation of foreign languages. The father is rather taken back. He faces his own struggles as an architect and city planner when one of their rebuilding projects meets resistance from a community teacher who needs classroom space. We are introduced to a universal terminal that functions as a video telephone and computer, networked to huge databases that enable efficiencies we were just beginning to see in the early 1990s when the video was conceived. Computing in the cloud and the mining of big data are only now becoming crucial to the next phase of networked communications. We learn how the mother, who is a doctor, can practice telemedicine and prescribe a prosthesis for a hockey player consulting a physician in China. The *Connections* video is an excellent example of corporate production values being used to communicate a complex message about where technology is leading. There is a parallel storyline about a challenge to the city planning office's project to redevelop a community center. The father is the Deputy City Planner. We learn about intelligent agents that search data bases for plans while we tell a social story.

Training videos often create characters and situations that embody a specific training issue. A safety training video might use dramatization to make a point about the consequences of ignoring safety procedures in a factory or a warehouse. Many training programs make use of comic drama. John Cleese, of *Monty Python* fame, cofounded Video Arts to exploit the situation comedy format to make management training films that are entertaining and instructive. The company has been very successful. Learning how to close a sale or interview a job applicant by watching John Cleese caricature how not to do it is an unforgettable experience. An omniscient voice-over watching this tells him what he is doing wrong and he replays the scene the correct way. Comedy captures the audience's interest. The errors and mistakes are hilarious to watch. The audience laughs at them and, of course, at their own errors. They are softened up to receive the training point about how to carry out some management function the right way. Job done!

The same approach is adopted in **Charley Wheeler's Big Week**, which teaches securities sales personnel the rules and regulations of the Securities and Exchange Commission (SEC). The wrong behavior and key infractions of regulations are dramatized in a character named Charley Wheeler. A training video is an invaluable aid that pays for itself many times over. The John Hancock company has a legal obligation to train the people who sell its financial products. *Charley Wheeler's Big Week* employs humor as well as dramatization. We get a smile out of Charley's obvious lies and subterfuges. He also breaks every rule.

It is more memorable to show a fictional character who does everything wrong than to explain what is right. A fictional character provides the writer with a great deal of license. It also means that the audience can laugh at a scapegoat or see faults that might be harder to acknowledge in a factual recitation. *Charley Wheeler's Big Week* tells a moralizing tale of malpractice by creating a fictional securities salesman who is careless about SEC rules and regulations. It would be awkward, if not impossible, to use real case histories as examples of how not to sell, or how not to follow Securities and Exchange Commission rules of conduct, to drive home the importance of regulation in the mutual fund industry.

When you have a lot of information to convey, you can deliver it as factual documentary narrative: "You must do this, you mustn't do that." In other words, you could create a video lecture. The

scriptwriter of *Charley Wheeler's Big Week* instead chose to organize the points within a moral tale of what not to do as a mutual fund salesman. The fact that we meet Charlie in the lower grade job of short-order cook after he has been barred from the securities industry for violating its professional codes makes sure that we, the audience, see the story from the correct ethical perspective. Clearly, the intended audience includes trainees and salespeople in the mutual fund industry. They are given a fall guy to explore all the dos and don'ts from a safe emotional position. This is a common and useful technique. The character is recognizable. He may even have a bit of us in him. It is usually more effective to dramatize a situation that allows your message to be sent via emotional attitudes or through character conflict than deliver a straight exposition. An audience is more inclined to give its attention to dramatic treatments and to remember the points more easily than from a recitation of dos and don'ts.

Humor

Another helpful device to capture audiences is humor. A lot of corporate clients are nervous about using jokes and humor in communications. The humor has to serve a purpose that delivers the message. Humor can help make a point that if, put in the form of explanation, would not be nearly as effective. So you enliven the situation with humor. The predicament of people lost in the country is amusing to most of us who have had a similar experience. This scene from *The Right Direction* helps the target audience to understand the predicament of the client, getting multiple directions from different sources.

POINT OF VIEW—DRIVER (8 SECONDS)

The car pulls up to another younger country farmer walking along the road. This fellow is the opposite of his older cousin. Where the older farmer was slow and thoughtful, this fellow seems to have overindulged in his morning caffeine. The younger farmer looks in the window and addresses the driver. (Also shoot alternate straight delivery.)

<div align="center">

YOUNG FARMER
(extremely fast delivery)

</div>

You can't miss it. Just take forty-three three miles to two-twenty-two then go north five minutes on twenty-five or twenty-five minutes on five. Got that?

POINT OF VIEW—FARMER (2 SECONDS)

Stunned look on the driver's face. His mouth hangs open. He blinks his eyes in disbelief.

POINT OF VIEW—DRIVER (9 SECONDS)

<div align="center">

YOUNG FARMER
(not waiting for an answer or
taking a breath)

</div>

```
Good.  Turn  right  on  seven  for  one  point  seven  miles  then  take  a
left  on  one-seventeen  'til  you  hit  the  seven-eleven.  At  the  seven-
eleven  you'll  see  a  sign  for  seventeen  cross  seventeen  then  back
over  seven  to  one-eleven.  You  with  me?

POINT  OF  VIEW—FARMER  (2  SECONDS)
The  driver  twitches  his  head,  nodding,  trying  to  follow  the  torrent
of  numbers  raining  down  on  him.
```

The audience understands the way a salesperson can confuse a customer by delivering reams of facts and figures familiar to the seller but unfamiliar to the customer. The other point made is that the customer needs to know these things just like the lost motorist needs to get directions. The situation is recognizable, humorous, and drives home the point.

Visual Metaphor

The same example uses a technique of visual metaphor. A metaphor is a figure of speech that shows one thing to be like another in a different context. In prose or poetry, it is commonplace. To speak of the sword of justice or the scales of justice is to use a metaphor. In a visual medium that strings images and actions together, it is extremely difficult to make up good metaphors and even more difficult to elaborate them without disrupting the narrative continuity of the piece. *The Right Direction* uses a visual and dramatic metaphor to make a point. In long hand, the argument goes something like this: If you are lost in the country and you ask a local to give you directions, the local is often so familiar with the area that the directions—although perfectly clear to him—are confusing to you. Such directions are usually given too fast and in too much detail. You end up being confused by the person helping you even though he feels he is trying his best to help you. Most people have experienced this dilemma and get the point of the scene. They get lost. Can you give good directions?

As a scriptwriter, you have a voice-over say something like, "Listening to a financial advisor talk about money and investment involves unfamiliar vocabulary." You convey to your audience of financial advisors that even though potential customers want to go in that direction and learn the necessary background to make good decisions about their investment, they are confused and lost. If you, the financial advisor, speak to them as if they know what you know, they won't get it. You will not be providing the necessary service and, worse yet, you could lose the customer. You could put all this in a voice-over and show a meeting going on with occasional cuts to staged dialogue between advisor and customer. This is the lazy way, and too often the weak way, of presenting a message that gets into corporate videos. The writer of *The Right Direction*, Peter Cutler, has found the kind of device that will carry the point in a way that the audience will grasp it without realizing that they thought about it.

The visual metaphor of the driver lost in the country asking a local farmer for directions is a situation with which the audience can identify. The extrapolation to financial advising can also be made in the voice-over once the audience is emotionally and imaginatively prepared. That is how this script works. Moreover, *The Right Direction* does something else worth noting as we learn the craft of corporate communication. It builds a visual metaphor into the structure of a script. Hence, the title! This allows the writer to use road signs and warnings signs about detours and dead end to continue the metaphor and its financial correlative. This demonstrates meta-writing—finding a visual metaphor that can organize the narrative for the viewer.

EMC Corporation's original business was data storage, but they have now expanded to information management. Storage is measured by digital capacity, but the value of the information stored is

determined by accessibility and functionality. Managing information flows makes storage work. So how do you express this abstract idea visually? What flows and changes shape and speed and has multiple applications in personal, industrial, and natural spheres? Water! Images of surf, streams, rivers, dams, waterfalls, and raindrops all illustrate information flow in all its variety and allow voice-over commentary to carry greater weight. **Sea Change** is composed almost entirely of stock shots edited together with music and commentary to make a provocative short video sequence that does not once mention the product. The abstract ideas become concrete, visual, and highly watchable If you can identify the problem and imagine a solution for which your client corporation's product is the solution, you get your audience's attention and make it receptive to a sale at some later point. **Visual metaphors** are the key to visual writing and effective scripts.

I once had a large construction company as a client. The company was building the cooling towers for a nuclear power station. The project managers wanted me to define their efficient methods and their uniquely innovative solutions to the engineering problems of the job. They had to work to a deadline to synchronize with the rest of the project. There was a lot of visually exciting action with a huge crane at the center of the tower. The complexity of the project and the orchestration of the different interlocking phases of the project, which unfolded over 2 years, explained the construction company's prowess. The last sentence contained a metaphor—orchestration. It became the breakthrough idea to bring the story together and explain the nature of the achievement. The plans were like the score. Getting 70 or 80 musicians to play together to the same beat and create great music is difficult. Not all orchestras are the same or as good as one another. Getting seven or eight teams of specialized craftsmen to work together efficiently is more than just a hiring job. The different teams of ironworkers, riveters, cementers, and scaffolders were like sections of an orchestra. They had to play in turn, in sequence, to produce the desired result. At the center was a conductor—the chief engineer. We wanted to differentiate this construction company from several others in the same business. The Boston Symphony Orchestra might play the same music as the Podunk Symphony Orchestra, but the end result, although similar, is not the same.

After obtaining footage of a regional symphony orchestra playing Beethoven's Fifth Symphony, I had the basis for a script. I also had the music for the sound track—heroic, dramatic, well known. I didn't have to buy the performance of the orchestra because I could buy a music library version of Beethoven and sync it to the images of the players that we had permission to use. Once the metaphor was set up, it could run throughout the video and be turned on and off at will, ending with a great finale as the dramatic shots of the two towers from a distance were cut to the *tutti* of the Beethoven finale. At the end I got a shot of all the worker teams with tools in hand standing in and around a huge cooling duct 10 feet in diameter taking a sort of a bow as the sound track played the applause of the concert audience.

The video I wrote and directed for the **Conseil Régional de Midi-Pyrénées** in France depends on visual metaphors. How do you explain that a region that is as old as Cro-Magnon man (whose drawings can be found in local caves), that has been inhabited by ancient Celtic peoples who raised stone monuments (dolmens) in ways that are beyond our understanding, that was conquered by Julius Caesar, and that is a traditional wine-growing region, is also a white-hot technological center of research and innovation in the aerospace and biotechnology fields? In the video, there is a shot of a traditional peasant in a beret tending his vineyard with a medieval village in the background. He looks up as a modern jet flies overhead leaving a trail. We cut to the Airbus assembly line in Toulouse. A visual language that can condense thought and make a point in pictures that is more succinct than words is what scriptwriters try to achieve.

Another device used to organize the multiple sections of the same video was to open the video with a computer screen on which titles appear as someone types on the keyboard. After each section, you return to the same device and introduce the next section.

Once you get a good metaphor going, it makes for strong structure and provides visual ways of communicating that use the medium with flair and imagination. The also-rans just do wall-to-wall voice-overs, which say "crane" on the sound track then show a shot of a crane. Every major word has an image to go with it that is controlled by the audio track. The whole video becomes predictable. It also becomes a struggle to find images that go with the commentary once you start. It becomes like a slide show with commentary. It results from writing the right-hand side of the script first—the classic mistake of the amateur. Never write the structure into the sound track when the medium is visual! The rare exceptions are documentaries in which the voice is important, such as the voice of a historical character in a biography. The point is that you need a visual concept and a visual lead in a visual medium. Otherwise, you are not using the potential of medium.

A number of devices for video have been borrowed from program concepts evolved for television. Because the visual language of television has become a universal idiom of popular culture, writers and producers of corporate video know that their clients and their clients' audiences will understand programs cast in that format. Some of these formats are broadcast news, the use of an anchor or presenter, documentary features, interviews, vox pops, quiz shows, and, from television advertising, testimonials.

Narrators and Anchors on Camera

Most factual or informational programs, whether news features or corporate videos, need some kind of narration. Although the use of voice-overs works some of the time, television producers have learned that audiences identify with people on screen. It is often more effective to have an on-camera anchor, presenter, or narrator take the audience through the story, whether it is about global warming, a political situation in a foreign country, or a product launch. Broadcast news relies on anchors to present the news. The camera techniques necessary to relate to an audience differentiate the professional from the man on the street talking to a camera. Professionals know how to deliver lines to a camera and carry an audience.

Creating a Loyal Client, written by Peter Cutler for John Hancock, relies on a to-camera narrator as its fundamental strategy. The host in the script is sometimes on camera and sometimes off. The narrator's role is to persuade, cajole, and instruct the audience so that the corporate message is secure. This is a common strategy in corporate video. The host becomes a kind of interpreter for the audience and an insurance policy for the corporate client. This technique borrows from the television format and leads the audience by the hand through the show.

Sometimes, a simulated investigative documentary style can work well in corporate videos. Shell Gas International is a company in the giant Shell group. As mentioned in an earlier chapter, their research side had developed a new catalyst that would allow natural gas to be turned into high-value lubrication oils and kerosene, which is jet fuel. There are huge reserves of natural gas in the world, much of it in underdeveloped countries, where it has no value. Natural gas is only valuable when it is near a large population that would justify the huge investment in infrastructure of pipelines required to deliver it to the consumer. Investment in the research had reached $100 million in yesterday's money, including a working pilot plant in Amsterdam. The CEO of the operation wanted a video to explain the breakthrough and sell the technology to a key decision-making audience of oil ministers and petroleum engineers in developing countries where the natural gas reserves could be found. There is a lot of archival footage in the Shell film and video library about everything the company has done. More to the point, the story to be told was complex and had to persuade the target audience to entertain a joint venture involving a multimillion-dollar investment. This all amounts to a big communication challenge. How do you construct a video that will carry the story, integrate all of the available material, and be persuasive?

One of the main psychographic problems for the audience would be believing Shell advocating and promoting its own patented process. The success of the video depended on convincing the high-level

audience that the process was cost-effective. The device that seemed to solve the communication problems and suggest a watchable video of tolerable length was to have an on-camera narrator reporting and explaining the story. In this way, an intermediary between the audience and Shell moderated the commercial propaganda. The audience would have a guide and a friend to take them through the story and make it into an exciting discovery, like in an investigative documentary. It would work because there was a story and because it was an interesting development in the history of petroleum chemistry. For decades numerous enterprises (including the Nazi regime during World War II) had tried to find a way to convert coal and natural gas into gasoline without commercial success. To create this script, the writer borrowed a device from broadcast television and from investigative journalism.

Ask a Question

This is an extension of the narrator/anchor technique. Whether the investigative question is asked by a voice-over or by an on-camera presenter, the technique is effective because you engage the audience by asking the question and set them up to want to know the answer. The question must be of interest to the target audience in some way. From then on, you are telling a story that leads to the answer and enables the script to deliver a great deal of explanation and information. In the Shell video, the story opens with the anchor looking at video footage of natural gas being flared off in huge flames in a Middle Eastern oil field. Turning to the camera, he asks, "Why would anyone burn off natural gas and waste colossal amounts of energy?" He launches the program by asking, "What if there were a way to convert natural gas to liquid fuels and save this energy?" Roll title: *Natural Gas: The Liquid Alternative*. Now the audience wants to know the answer. You have given them motivation to follow the story. On-camera presenters are used in science documentaries, investigative news reports, historical documentary, and cultural series: "Did Aliens visit the ancient Maya civilization?" or "Do sightings of a large hairy man like creature mean that the Sasquatch really exists?" The device is well understood and quite versatile because the narrator's voice can be run as audio only behind cutaways to location footage, archival material, and interviews.

Television Formats

All of the television formats get used now and then as models for corporate video. The basic strategy is to use a small screen idiom that we know the audience will understand. It is a given that every audience knows television and has been culturally trained to accept its formats and conventions. Variety shows, quiz shows, interviews, documentary narrative, television news, sitcoms, how-to-do-it demonstration shows, and more have been used in corporate videos.

How do you present retirement benefits to young employees who would be turned off by cold facts and figures? You present it as a television game show with audience participation anchored by a young host who can make it sound acceptable to the target audience. This is what happens in *Check It Out* for Fidelity Investments. Although the program is about the outwardly boring subject of benefits, the TV variety show format, humorous and cunningly embedded with employee testimonials, is fun to watch. Employees learn that benefits can make a significant difference in their lives later on.

Documentary

Another style of television documentary is the compilation documentary with an unseen narrative voice-over. Common in wildlife, historical, and reportage documentaries, the documentary style can be adapted to corporate narrative in all kinds of sales, public relations, and corporate image videos.

Corporate histories and product histories are often quite involved and complex, especially when applied science is involved. Corporate messages can also involve economics and public policy. Businesses and nonprofits alike have a constant need to narrate, explain, and communicate factual information.

As you will remember from discussion in earlier chapters, American Express in Europe had spent a large sum on market research into American tourist destinations, preferences, and spending habits. The research revealed that Europe's market share was declining as Americans discovered Caribbean, Far Eastern, and domestic destinations. The demographic of the American tourist was changing. European tourist organizations and businesses were complacent about their market share. American Express, like other cards, charges the establishment accepting the card a percentage of the charge. Sometimes restaurants and hotels resent having to pay this fee. A public relations opportunity existed for American Express to educate the member establishments and European tourist professionals and show the relationship as a partnership. American Express had valuable marketing know-how, historical perspective, and worldwide experience. With frequent opportunities to interact with travel professionals at conventions and meetings, high-level management needed a vehicle to present this valuable marketing information for mutual benefit. After all, if American travel to Europe declines, so does the card business of American Express.

You could give the target audience printed brochures of the market research, but that approach is passive and would not profile the company. A good video, on the other hand, is an invaluable opener for meetings and also a useful internal communication that could reeducate European employees of American Express.

So what approach would carry off this communication? You are talking to professionals. You have complex marketing data to interpret. You have a public relations function to perform. You have to achieve an informational and a motivational result. During my research visits, I found the attitudes of Europeans about American tourists to be not only complacent but patronizing, ignorant of the nature and breadth of American tastes and interests. There was a real need to shift the attitude of the audience and start them thinking. I came to the decision that one device was essential to the mix: to prove that the costly market research carried out by an outside contractor was accurate, we would need to match its categories to testimonials from real American tourists.

Vox Pops

Vox pops stands for *vox populi,* Latin for "voice of the people." This technique consists of sampling opinions on the street or some other location using unscheduled, random interviews. News reports often capture the unrehearsed opinion of the man on the street. That is relatively easy to do. For the most part, a television audience sees edited excerpts. A lot of footage gets shot, but only a short sound bite is rolled into the broadcast. For a corporate video, and for American Express in particular, the interviews had to be authentic, unpaid, and unrehearsed in order to be convincing. It was a gamble— a creative gamble and a production gamble. I could not guarantee the availability of the mix of demographic types that governed the market research. These types were defined as Business Travelers, Big Spenders, Gray Panthers, and Adventurers.

Choosing to use vox pops would result in production problems and costs. The obvious place to capture interviews of American tourists was at the Heathrow Airport check-in lounge in late August or early September. At least a dozen flights a day departed Heathrow for U.S. destinations. Most of the passengers were likely to be returning summer tourists. Shooting in an airport, however, is costly. Airports demand facilities fees and also require you to insure yourself for several million dollars worth of public liability. The point to keep in mind as a writer is that although you can write the questions, you can only write in a paraphrase of what you hope the interviewees will say. The questions have

to be well researched and well thought out. Whoever does the interviewing off camera has to have follow-up questions and be able to get the subject to talk. Anyone appearing on camera has to sign a waiver that has been approved by the corporate legal department. Waivers are commonplace.

Basically, the technique is a strategic fishing expedition. You know something is out there. You try to use the right bait to catch it. Of course, anything that is not suitable can be edited out. However, you cannot make up material that is not genuine. In Chapter 5 we alluded to the use of this technique by AT&T. The company ran a series of long-distance carrier ads based on the vox pops technique.

The fishing expedition in Heathrow Airport was successful. We had American Express personnel with clipboards canvassing the passengers to find out if travelers were American, if they would agree to be recorded, and if they had the time to be interviewed before their flights. Most people are pleased to express opinions on camera if given the right opportunity. This filter provided a steady trickle of American travelers to be interviewed on video. Afterwards, the interviewees were offered refreshment and a small goodwill gift of an American Express calculator.

Logical Argument in Documentary Narrative

The American Express video combined a number of techniques: voice-over narrative, vox pops, and documentary narrative. Another commonplace technique that works well for corporate videos is an adaptation of documentary technique that could be called *narrative argument*. This technique requires voice narration to support it. It is based on editing images that have relevant content but are not usually shot in continuity or covered from different angles. Therefore, editing can only mean arranging the sequence of shots and deciding on their length. It is a basic form of visual exposition found in news features, documentaries, and corporate videos.

In the American Express video, we wanted to put forward an argument based on the extensive market research and economic statistics about trends in travel destinations and the impact on American tourism in Europe. This involved drawing conclusions about projected growth in long-haul destinations and the statistics about tourist spending to make the point that Europe could lose market share if the trend continued. To retain market share, action could be taken to satisfy the preferences of the principal types of American tourists as analyzed in the market research.

Documentary argument often works by using a metaphor of some kind. Earlier in the chapter, we explained how visual metaphor works. Corporate videos are often called on to make wide-ranging philosophical arguments about adapting to change, understanding change, or ecological vision or social policy. In *Sea Change,* produced for EMC Corporation, the message is about the impact of information technology in the business world as a way of introducing a company that makes storage disks and storage systems. The documentary metaphor about change becomes a platform for introducing the relevance of the product without a hard sell.

Graphics

A strong way to represent statistical information visually is by means of graphs and charts. Effective **graphics** that are clear and colorful are a powerful means of communication for corporate videos. Today, computer graphics tools and animation software provide us with virtually unlimited capabilities at a reasonable cost. In the early days, computer graphic animation was a high-cost item in the budget because of the cost of hardware and software. Although costs have come down as computer processing power has become cheaper, animation can still be expensive. For instance, Industrial Light and Magic creates effects for feature films like *Titanic, Jurassic Park,* and *Star Wars* that are out of reach for corporate production. Adobe Photoshop, Illustrator, and Infini-D enable low-cost desktop

solutions that will get you a long way toward exciting graphics produced by high-end animations tools like Soft Image.

Corporate communications such as annual general reports and financial statements deal in facts and figures all the time. Basic graphics like the familiar bar chart or pie chart can help get across statistics, and are fine for Power Point presentations or print, but in a moving picture medium, you should animate the graphics. Even simple step-frame animation will help, but step-frame animation is still just 2-D graphics. Now low- and high-end tools are available for all budgets to create 2-D and 3-D animation. This is particularly helpful for explaining a process. For example, the Shell video about natural gas had to explain the chemical process of catalysis to explain the innovation that Shell used to achieve the change in molecular structure. Good 3-D graphic animation can show how the complex long chain hydrocarbon molecule changes when it comes into contact with the catalyst.

Visual Seduction

The television screen or computer screen, for that matter, is everywhere. It is a visual space on which all kinds of images, text, and scenes are projected. Some of it is ordinary, even banal. Some of it is visually stunning. Photographically powerful images captured on film by a skilled cinematographer compel attention and lift the medium to another level. Shots of nature or people can make the difference between something that passes before your eyes and something you watch with full attention. Visual seduction is a technique that is only minimally available to the writer and depends on the videographer and director to bring to the screen.

A writer can describe the intent and suggest the visual power of images. For example, exotic or dramatic locations often furnish the kind of breathtaking images that hold attention. These can be industrial images, such as a stunning crane shot, suspended from the cable of a crane turning around so that the camera pans the outside of the cooling tower of a nuclear power station under construction. The height and the point of view make it a compelling shot. Strong location visuals can be written in. *Natural Gas: The Liquid Alternative* required stunning shots of natural gas flaring off in the desert to make the point about wasting energy. The roar of this flame, like a jet engine, makes the point on the audio track. This type of footage already existed as archive material in the Shell library, so it could be written in as a predetermined image in the final video. In ***American Travel in Europe***, I chose to shoot in Ghent, Belgium, for the quaint period architecture and the canals. When the writer is also the director—frequently the case in corporate video production—location research is sometimes more efficient and more effective.

Interview

Of all the documentary and corporate techniques, interviewing is the oldest and most basic way of capturing expert opinion. You film a person answering questions that will illuminate the points you are trying to make. Usually we are accustomed to seeing the person speak to an off-camera interviewer so that the eye line is to the left or right of camera. This distinguishes it from the to-camera presentation of an anchor. The news-style delivery or confidential and personal delivery of someone speaking into the lens implies consciousness of the audience. It is by nature manipulative. When the camera observes someone speaking to an off-camera interlocutor, the statements come across as more authoritative and more objective. In *Natural Gas: The Liquid Alternative,* we interviewed the head of Shell Research to explain the breakthrough in catalysis. We interviewed the chief executive because of his vigorous, dynamic conviction about the future potential of the process. Although the point we wanted them to make was planned, it looks authoritative and objective, especially when it is seen in counterpoint to the to-camera anchor who takes us through the story.

Case Histories

A more specific technique that may be made up of several interviews is the case history. As the name implies, this technique involves in-depth documentation of a personal story to illustrate an idea or a point. The case history can become the governing structural idea of a program. *Charley Wheeler's Big Week* for John Hancock is a fictional case history built around a dramatic character invented by the scriptwriter to illustrate all the points about how not to conduct yourself as a securities salesperson. The case history is an effective way to structure a corporate program when you want to bring together a number of points whose order is not as important as the context in which they are understood. Case histories work well because they are basically stories. The story structure takes precedence over the points you want to make. If you were to make the points in some kind of order, the audience would experience it as a glorified bullet list. Ideas that are abstract and hard to remember out of context become concrete and easy to remember in the context of a story. *Charley Wheeler's Big Week* has it both ways by creating a supplementary review video in which the points are recalled as the key points John Hancock wants to get across to its audience.

Consider the difference between explaining the way cholesterol-lowering medication works and introducing the audience to a number of particular patients of different ages and types of lifestyle who have high cholesterol. You meet people. You get their story. In fact, even better, you do both. You provide case histories, and you have an animated graphic that explains how the blood chemistry works when arteries become clogged, how this produces angina or more critical heart attacks, and you use the same animation to show the intervention of the cholesterol-lowering medication in reducing bad cholesterol. This makes another point, namely, that adopting one device or technique does not exclude another. In this case, you set up the problem with case histories. Then you educate the audience about heart disease. You sell the particular drug product indirectly by association. The same company might make a 30-second television spot that would sell the brand. The two uses of video are completely different.

The Story of a Day

Sometimes a writer's material or the content that the client wants to see included is so disparate that none of the structures we have so far examined seems to work. Also we might be dealing with a process or a sequence of events that is time sensitive. A useful device is the slice through time, a unit of time, during which most of what you need to look at occurs. A company story can sometimes be nicely told in a day's activity—the story of a day. I used this technique in a script I wrote for the Saudi Aramco's Aviation Department. Finding, winning, and refining petroleum is a 24-hour operation for an oil company. Aviation is vital to company operations. To explain how the aviation department affected every aspect of the operational day was part of the story. To summarize the structure and organization of the aviation department would have resulted in a deadly dull recitation of images and explanations that would soon pall. The diversity of information and activities—including the repair and maintenance of aircraft, pilot training, and transport—had no natural order. The answer to the scriptwriting problem was to show a 24-hour cycle in the operation. The idea was to cross-cut between multiple stories of flights in preparation. The preflight check runs on the sound track as you cut away to simultaneous activities in other areas. Meanwhile, on an oil platform, a helicopter delivers a relief crew. Shots of cargo being loaded, from mail to drill bits and spare parts, take you into other stories. The clock becomes your narrative structure. At night, an executive Gulfstream flies an emergency mission to bring a pregnant woman with a breach baby from a remote site to a Dhahran hospital. Through this device, all of the different types of aircraft and missions can be covered in different locations.

In the final analysis, the corporate video has to tell a story. Whether the story is factual or fictionalized, it has to make a number of points. It has to convince an audience to respond to the informational, motivational, or behavioral objectives that we discussed in Chapters 2 and 5. In other words, the corporate video has to do a job, although it might entertain as a means toward that end.

WRITING THE CORPORATE TREATMENT

These organizing devices are expressed in a **treatment**. We discussed treatments in developing PSAs, but for a 30- or 60-second message, the treatment stage is less critical. In reality, when developing PSAs, it is sometimes possible to go from your creative concept to a first draft script. This is not true for corporate videos of 5 to 10 minutes in length. You have to go through the stage of outlining the narrative in chronological order in a prose treatment that describes action and suggests the role of commentary. You do not and should not write out the voice-over commentary at this stage or the dialogue you wish the talent on camera to speak. You can paraphrase the gist of what they are going to say. You can even paraphrase the content of interviews by suggesting what might be said in interview or what you hope will be said in response to interview questions. The final document that you want your client to read should give a complete account of action and activity that is to be filmed. You cannot generalize content. For example, instead of writing "We have interviews of managers or sales reps or tourists," characterize the expected content of those interviews. Instead of writing "We see the manufacture of the company's products," specify which products are being manufactured, at what location, and how. Before writing the treatment, do the necessary research. If you are not specific in your treatment, your client cannot evaluate what is likely to be in the script. Moreover, when you get to writing the script, you will have to give details anyway. A script is a concrete document that describes what happens in front of camera for every scene. A good treatment simplifies the job of scriptwriting: it allows both client and writer/producer to visualize and evaluate the structure and scope of the video. Writing a script is really translating the content outlined in the treatment into video production language.

SCRIPT FORMATS FOR CORPORATE VIDEOS

It is probably fair to say that the most common format for corporate video is a **dual-column format** (see the Appendix). Remember that in the dual-column format, the visual description of what appears on screen is written in the left-hand column, and the audio description of what is heard on the sound track is written in the right-hand column. The producer reads these two columns together to assimilate all of the information needed to produce the scene. It is the easiest way to write for video once you get over the beginner's tendency to mix up the two categories of audio and visual. In practice, corporate video uses any and all types of production concepts including drama, news, and documentary. Instead of using the dual-column format, scriptwriters may adopt formats that are typical of those other types of productions, such as a master scene script for a dramatic concept (e.g., *Charley Wheeler's Big Week,* by Peter Cutler).

LENGTH, PACING, AND CORPORATE STYLE

What is the length of a corporate video? Answer: it is as long as it takes to do the communications job at hand. Some corporate videos can be a few minutes; others are as long as 30 minutes. Over the

years, since video has become a commonplace corporate communication tool, practitioners have studied the success or failure of videos with audiences. When an audience is watching a television screen for reasons other than entertainment, its attention span is short. You will happily watch a 2-hour program with characters, plot, story, conflict, and action. When the content concerns ideas, information, products, management policies, or other informational subject matter, your capacity to concentrate and retain information falls off exponentially after 15 minutes. If a program can stay under 10 minutes, it might be more effective. The 15-minute limit has always seemed a good one. In recent years, the ideal length has come down to 8–10 minutes. There are exceptions. In every case, the length must be justified by the interest of the content and the effectiveness of the program. Dramatized stories always play longer than factual recitations or talking heads.

WRITING VOICE COMMENTARY

Commentary takes up program time. Running time for a program can sometimes be critical, whether it is a PSA or commercial, a corporate promotion or a documentary. It takes a long time in screen time to say things. Long-winded or overly detailed explanations can burden a program. Continuous commentary from beginning to end is tedious for the audience. It is always better to have pauses and rests in the spoken sound track to allow music or natural sound to carry the program. A voice artist has to be well cast and well directed.

Most important of all, we must always remember that in visual media, visual communication through images is more effective than the spoken word. Any corporate or documentary program should work at some level without a sound track. It is a good test to view a program without commentary and to make it as effective as possible in purely visual terms. Voice commentary should complement the visuals and support them, but the structure of a program must derive from visual sequences, not from spoken commentary. Innumerable documentaries and corporate programs violate this principle. Writers, particularly those who are not professional scriptwriters, often write the commentary first and then add visuals to cover the commentary. The visuals become a kind of fill-in wallpaper. Do not write what we might call wall-to-wall commentary! If you catch yourself writing the right-hand column of a dual-column script first, the quality of your work will suffer. The best programs are always conceived as visual statements first, and are driven by visual ideas. A voice commentary should be subordinate to the visual story. Voice commentary is best written in two stages. First write a draft commentary to help cut the visuals and pace the editing. Do you need to edit picture or edit voice-over to fit the picture? So the second stage is a final draft ready for voice recording. If you record the commentary first, then picture editing is driven by the commentary. A director or producer has to choose which is dominant. Some prefer to record a voice artist to video playback. So a writer might be given a rough cut to polish the final version—much easier when the writer is also the director.

DEVELOPING THE SCRIPT WITH CLIENT INPUT

Corporate scripts are not written for the writer; they are always written for the client. Before writing anything, you need to consult with the client and research the communication problem, as explained in Chapters 2 and 3. Each stage of development—presentation of the concept, treatment, and first draft script—involves informal feedback and finally formal acceptance of the work. Each stage needs client approval before you continue. This process is critical to the success of the project. Every writer has had the experience of working with a client who barely reacts, or reacts after the script is written. There are clients who do not understand their role in advising and collaborating to achieve

a successful corporate communication. Books devoted solely to corporate writing provide greater insight into this problem, which is part of the writer's job but not part of the writing.[7] The writer of corporate work has to be able to manage relationships and gently orchestrate the necessary responses if they are not forthcoming. Writers who work in the corporate field learn that clients sometimes waste their time and waste their own resources.

SELLING CREATIVE IDEAS

When you write, you sell. All writing for corporate communications involves selling the creative ideas on which your communication is based. This means that not only must your ideas work for the medium, but they must also persuade the client who is myopic about the message and cannot see the wood for the trees. Many clients, indoctrinated with "corporate speak," have difficulty hearing any other voice or mode of communication. They are nervous about creative ideas that may dilute the pure message. They have difficulty understanding that their audience, even a captive employee audience, is not necessarily going to absorb and retain the message in its pure corporate form without some strategy of communication that gains audience assent. The creative strategies outlined in this chapter are what the writer works with to exploit the medium and reach the audience effectively. Although our principal concern here is with writing, we should alert the beginner that most corporate writing involves presenting ideas in meetings—a form of pitching. Writers in this field need to be able to talk their ideas. They need to encapsulate them for the corporate client in such a way as to get this client to read the treatment or the script with understanding and assent. They want the client to "buy" the script.

WORKING WITH BUDGET LIMITATIONS

Every project has a budget. Even the grandest feature film has a budget. Cost is relative to length, location, and production values. Cost is paramount in corporate work. All corporate departments work with budgets. Audiovisual communications have to be designed and written within some kind of cost guidelines. Although in the learning stage one need not be hampered by cost, in professional work, creative ideas come with a price. If a creative solution is too ambitious and too costly, it will be rejected. Many corporate clients do not have discretion to spend more than a fixed figure. Often that figure is unrealistic for what they want. Every corporate producer has sat in a meeting and heard with disbelief what the client expects for a completely unrealistic budget. Writers have to learn how to compromise and modify creative ideas and concepts based on the amount of money available. In Chapter 5, we learned how certain ads can be not only very effective but cheap. Ads made on a small budget can be simple, creative, original, and engage the audience.

CONCLUSION

The corporate world makes liberal use of visual media to solve a wide range of communication problems, from marketing to external and internal public relations, promotion, brochures, service manuals, and training. Providing these solutions is big business for a large and diversified industry

7 See Ray DiZazzo, *Corporate Scriptwriting: A Professional's Guide* (Burlington, VT: Focal Press, 1992); see also William J. Van Nostran, *The Scriptwriter's Handbook: Corporate and Educational Media Writing* (Burlington, VT: Focal Press, 1996).

of media producers who employ writers to think through corporate communications problems and come up with creative solutions. Corporate scriptwriting involves designing media messages on behalf of a client. All of the creative devices of the medium are potentially useful to this end. Working in the corporate field involves a contractual and consultative relationship that is unique.

In this chapter, we learned that writing training programs involves specific goals that can be more closely measured and defined through techniques of formative and summative evaluation. Training and educational needs usually involve explaining or demonstrating an operation or a process. This kind of content is less and less produced as standalone video and increasingly produced for online interactive delivery. Media solutions deliver standardized content that meets agreed objectives. Imaginative devices are still a valuable part of the writer's repertoire to communicate how to perform a task or improve performance. The corporate need for training is virtually inexhaustible. Its needs are increasingly met by interactive instructional media, which are discussed at length in Chapter 12.

Corporate scripts typically adopt a dual-column format. On rare occasions, where dramatization carries the message, a master scene script format might be preferred. The non-broadcast industry is probably larger and more innovative than the broadcast industry. It is a highly creative and dynamic industry that is responsive to new technology and communications media. It offers more opportunities for employment than the entertainment industry.

EXERCISES

1. Write a short training video for a simple task such as tying a tie, parallel parking a car, or cooking an omelet. This should include a short formative and summative evaluation.
2. Write a plan for a formative evaluation for a college recruitment video. Use an existing video to do a summative evaluation. Optional: Put a focus group together to do the evaluations.
3. Write a task description of a familiar activity, say, brushing your teeth.
4. Go to the training department or human resources department of a local company and find out if the department has any training needs. Try to get detailed information so that you can write a script for the human resources personnel.
5. Go to the training department or human resources department of a local company and find out if the department has any training videos. Ask to see them and find out as much background as you can about their development.
6. Make a list of visual metaphors to explain situations or problems: for example, driving, resolving conflict, or using a piece of machinery.
7. Visit the admissions office of your college or university. Find out what the communication problems are with recruiting. Write a concept and treatment for an admissions video that would address those problems.
8. Contact the public relations or advertising department of a local company and find out if the department has any corporate video needs. Submit a proposal to write a script for them.
9. Contact the public relations or advertising department of a local company and find out if the department has made any corporate videos. Ask to see them and the script and see if you can get some background on the development of the project.
10. Find an organization on campus that you imagine needs a video. Interview the staff and design a video concept for them.

CHAPTER 7

Documentary and Nonfiction Narrative

🔑 Key Terms

actuality	expository, historical, investigative, narrative, objective, point-of-view, science, travel, wildlife	picture research
archives		reportage
commentary		scratch commentary
concept	fiction	treatment
crowdsourcing	funnel	voice-overs/voice-over commentary
documentary, biographical, dramatized, expedition,	inverted funnel	wall-to-wall commentary
	location research	

DOCUMENTARY COMES FIRST

Everybody has seen a documentary. This important program format has roots in photography and painting. The most fundamental urge we have as humans is to record both the world we see and our own existence. Some 25,000–30,000 years ago in the south of France, Cro-Magnon man struggled to document the fauna of his world by painting on the walls of caves. There are no portraits of the painters of those exquisite rock drawings. At the site of Pêch Merle in France, and at many other cave sites, there are prehistoric signatures in the form of an outline of a human hand. The need to record ourselves in the form of an image is central to all cultures, whether on Greek pottery or temple friezes, Roman coins or Egyptian obelisks. The portrait is our most intimate documentary. For centuries, painters have been commissioned to create likenesses of people for public display, family, or posterity. Since the latter half of the nineteenth century, photography has progressively taken over from painting. We have a photograph of Abraham Lincoln. We only have paintings of George Washington. Now a wider public has access to portraiture through photography. We take our own photographs of friends and family. In this respect, we are all documentarians. What is our objective? We want to record reality so that someone else can experience it at a later time. Today, we share digital photos immediately with friends and family via Facebook, Instagram, Twitter, and so on. We want witnesses that we were here; we want to document that we were here; and we want those documents to be acknowledged.

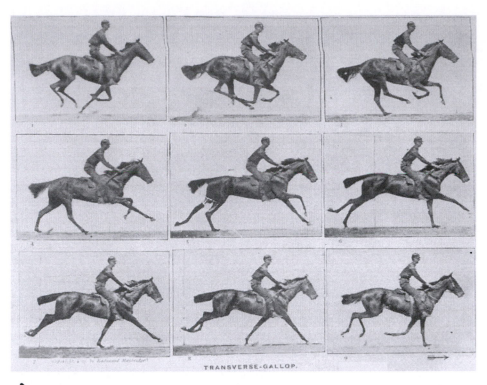

→ **Figure 7.1** "The Horse in Motion," photographed by Eadweard Muybridge in 1875.

The first moving picture documentary was inspired by a $25,000 bet—a tidy sum in its day. The challenge was to prove that a horse either does or doesn't lift all four legs off the ground at a full gallop. In the 1870s, **Eadweard Muybridge** rigged up a system of trip wires so that a galloping horse would release the shutter on a line of still cameras as it passed.[1] In this way, he could prove that a horse lifts all four legs off the ground and does not keep one hoof in touch with the ground as his adversary maintained.

The first attempts to make moving pictures were documentary. Dramatic storytelling uses of the medium came later. In reality, however, the documentary format in film, video, or television also narrates stories, but of a factual kind. Early documentary filmmakers, such as **John Grierson** and **Robert Flaherty**, were, in a sense, reporters. Film quickly became a news medium, and television continued the use of the moving image to convey reports of people, places, and events.

Recently, as happens from time to time, some documentary films have been distributed as theatrical feature films competing with fictional dramas and comedies. The Academy of Motion Picture Arts and Sciences awards Oscars for both short and long documentary films. *Bowling for Columbine* won in 2003 in the feature length category. *Spellbound* (2002) documents the agonies of children competing for the prize in the Scripps Howard National Spelling Bee. The extraordinary wildlife film *Winged Migration* (2001) allows us to fly along with migrating geese and cranes and know the life of birds that fly thousands of miles to seasonal feeding and nesting grounds. Documentaries like *Touching the Void* (2004), a reenacted documentary of surviving a climbing accident, and *The Endurance:*

1 The "zoopraxiscope" was patented in 1867 by William Lincoln. Moving drawings or photographs were watched through a slit in the zoopraxiscope.

Shackleton's Legendary Antarctic Expedition (2000) can command theatrical audiences because they are extraordinary tales of human endurance; and the personal documentary essays by Michael Moore—such as *Fahrenheit 9/11* (2004), *Sicko* (2007), and *Capitalism: A Love Story* (2009)—have generated political controversy and also record-breaking box office returns for the genre.

Even though some documentaries may be shot on film, it is risky and expensive to distribute them on film. The recent documentary successes we have just mentioned suggest people will buy tickets to see some documentaries projected as films in a theatre. We conclude that the desire to know reality or be told about reality is an abiding need of film and television audiences. With time, DVDs and the World Wide Web will probably become more important to the dissemination of documentaries.

Despite these successes, television, particularly cable television, remains the main distributor of documentary programs. Most documentary filmmakers look to television to commission or buy the broadcast rights of their work. With its inexhaustible appetite for documentary material that communicates information, explains ideas, or records history, television and cable have kept the

> ### Movement in Film
>
> Along with Muybridge, **Louis Lumière** and Thomas Edison worked on capturing motion.[2] What excited the first movie audiences was seeing realistic shots of motion—such as a train rushing toward camera, which gave a feeling of such realism that the audience ducked in fear of being hit. The same phenomenon was repeated in 3-D movie experiments in the 1950s and 1960s. I remember going to a Cinerama film and seeing a shot of a lion jumping at the camera, which gave the audiences of that day a thrill such that we all screamed and ducked. If you have ever been to an *IMAX* theater, you will find the same psychology applies. The huge wraparound screen on which a 70-mm film image is projected creates a realistic experience of "being there." I remember feeling dizzy watching a shot from an ultralight plane flying over the Grand Canyon or Niagara Falls or some other spectacular landscape. Not many dramatic fiction films are made in this format because of the cost. However, 3-D production is becoming more popular for feature film production. In 2009, 3-D television sets became available for domestic use.

tradition alive. Now we have television news features and whole channels more or less devoted to documentary programming. The Discovery Channel, A&E, SyFy, and the History Channel come to mind. PBS, especially WGBH in Boston, is a consistent producer of documentary series, carrying on a great tradition that originated with early producers of 16-mm film documentaries. They produce some of the best documentaries on television. **American Experience** captures uniquely American people, places, and events. **Nova** documents new discoveries and new thinking in science. **Frontline** is a current affairs program that analyzes contemporary social, political, and ethical issues in depth and has no equal.

You could also argue that the sports channels are, in a sense, documentary channels because they show you real games. Perhaps the most basic documentary function of television is performed by C-SPAN, which records congress in session, committee hearings, public events, debates, and so on. However, real-time, live broadcasts are different. They are not scripted. Could you script the progress of the World Series or the Super Bowl? They record an event as it happens. Even sports commentators or announcers ad-lib their broadcasts. No writers are needed. This is an important distinction because we are now proposing to examine the role of the scriptwriter in the documentary form and learn how it is done. How does the writer approach documentary? What is the role of the script? How is writing for a documentary different from writing sitcoms, movies, or broadcast news?

2 Leland Stanford, who was his patron, published a book in 1882, *The Horse in Motion*. The two quarreled over the credits, and Muybridge went on to publish further works: *Animal Locomotion* (1887) and *Animals in Motion* (1899). See the video at http://photo.ucr.edu/photographers/muybridge/contents.html.

TRUTH OR FICTION

Let us think about the word itself: *documentary*. Obviously, the word *document* is within it. Its root is the Latin word *documentum*. According to the Oxford English Dictionary (OED), its first appearance in English is close to the Latin, meaning "a teaching, an instruction, or a warning." Later, in the seventeenth century, the meaning shifted and the word came to refer to something that is written or inscribed that furnishes evidence, such as a deed or a contract. The growth of trade made documents important. A ship's manifest would show who owned the cargo. Hence, a document is a record of something that establishes a fact. Soon, it began to be used as a verb, *to document*, meaning to establish the truth, furnish the evidence. In 1802, the OED records the use of documentary as an adjective, meaning that something consists of documentary evidence. Only with the invention of the documentary film does the adjective become a noun, now shorthand for this type of film.

So the word documentary contains the idea or intention that it includes evidence establishing a fact and therefore tells the truth. This raises all sorts of interesting problems. For instance, the video footage on the news is supposed to be truthful reportage. That is our expectation, but it is not always so. Shots can be staged, and sometimes are. Shots are framed for effect. We do not see what is behind the camera or outside the field of view of the lens. The footage is also edited. A point of view is both contained in it and imposed on it. Nevertheless, we expect the truth. If a documentary follows an expedition to climb Mount Everest or the life of a pride of lions in the Serengeti, we expect it to be a truthful account. Documentary scholars and theorists argue about the relationship between truth and reality. For instance, to be controversial, ask whether a pornographic website that shows live sexual activity is truthful. Is it reality? Perhaps it is real but arguably not truthful because it is performed, even though it may involve real sexual acts whose participants are conscious of the camera. It is easy to confuse actuality with reality, and actuality in behavioral documentary is not necessarily reality because of the presence of the camera or because of the cultural differences between the observer and the observed.[3]

The name of the genre suggests an action of documenting a factual story in moving and still pictures. It can be a story of a person, a historical period, a historical event, an animal species, a work of art, or any other topic of investigation. The essence of documentary form is that it attempts to tell or show the truth in its totality. This commitment to recording reality can result in shocking or disturbing material. Georges Franju, in *Le Sang des Bêtes* ("Blood of Beasts," 1949), depicts the hidden horror of slaughterhouses. Alain Resnais, a French director, made a famous documentary called *Nuit et Brouillard* ("Night and Fog," 1955), which was one of the first cinematic attempts to reflect on the horror of Nazi concentration camps. The allied armies that liberated the camps had documentary film units that recorded the first images of that atrocity. The power of images to show the truth makes visual media compelling and persuasive. On the other hand, the same power can be devoted to fabricating falsehood and propaganda. Leni Riefenstahl's Nazi propaganda film, *Triumph of the Will* (1934), commissioned to commemorate Hitler's Nuremberg rally, is a masterful use of the medium. If you didn't know who Hitler was, you could be persuaded, just as many Germans were, that he was a great leader.

That is why we should consider whether all nonfiction narrative is documentary, even though all documentary is nonfiction narrative. We have to distinguish between telling a true story and telling a story based on true, historical events. A dramatized documentary tells a story of real people and real events, but it does so by inventing scenes and employing actors to portray what the writer imagines could have happened. The line between truth and fiction becomes blurred. If we cross the

3 See Barry Hampe, *Making Documentaries and Reality Videos* (New York: Henry Holt and Company, 1997), p. 87.

line completely, we end up with a biopic, as it is called in *Variety*-speak. Truth takes a back seat to entertainment. Documentary is still narrative, but narrative that is dedicated to telling the story of history.

Remember that the word *story* comes from the Latin word for "history." Story and history often overlap. The Old Testament and the New Testament tell stories, but some consider them to be history. The four gospels tell slightly different stories of the same events. Cultures tend to convert history into stories that become more compelling than the real thing. For example, the Boston Tea Party is both a story and a historical event, as is the ride of Paul Revere. Sometimes, the story becomes more important than the history, as is the case with the ride of Paul Revere. In history, he rode to Lexington; in legend, according to the poem by Longfellow, he rode to Concord.

How do you construct a documentary idea? How do you tell the truth in a visual narrative? True representation of something rests on knowledge. Knowledge rests on research. Research takes many forms: picture research, location research, factual research, background research, interviews with people, or historical research. Until you have done that research, you cannot meaningfully write down a treatment or outline for a documentary production.

Of course, you get an idea for a documentary based on an insight, a supposition, or a hunch that there is a truth to be revealed about something. It could be commonplace, such as what happens to a letter once you post it; or something unusual or exotic, such as the story of an expedition, or the life and behavior of an elusive animal species. We still call the main idea of the script a concept. It is an idea that guides your thinking, your research, and your discussion with producers and editors of program formats. Once you have a concept, you have to research it.

We say that seeing is believing. The scriptwriter should understand that film and television are both media made by editing footage in postproduction. They are assembled shot by shot according to a script or a vision of the maker. Because editing involves choice—choice of what to leave in and what to cut out—the editorial point of view can be biased. So documentary is not necessarily objective truth. It can be an argument against war or for the environment. Its point of view may be partisan and consciously adopted by the maker. Wherever the camera is pointed, some things are included while others are not. Camera placement on location and editing choices in the cutting room determine the final result.

Documentaries fall broadly into two types, according to their point of view: objective documentary and point of view documentary. The first strives to be a record of true observation, showing things as they are. It is the most difficult because the production method so often alters the reality in front of the lens. The latter is an examination of factual matter but from a point of view that is declared. An example of the latter would be Michael Moore's documentaries.

Usually, the director imparts the point of view. This is why documentary is primarily a director's medium. The writer, if independent of the director, is not going to have as strong an influence on the final shape of the program, for the obvious reason that the shooter chooses the images and frames the shot. Because the writer is subordinate to the director, documentaries are often made by writer/directors who can carry through their intentions from script to shooting and, finally, in the cutting room. The general public is not really aware of how the medium of film and video can be manipulated in postproduction or how the person looking through the viewfinder chooses the frame, which once again includes some objects or people but excludes others. The task of directing involves a continuous visual editing, which necessarily imposes a point of view. It can easily be abused—and often is—in news reporting to create more dramatic footage.

For this reason, true documentary is a noble form because it seeks to reveal the truth about a subject. Being truthful can be compatible with expressing a point of view, just as, in print journalism, editorial opinion can be stated in conjunction with factual reporting. The important point is to make a clear distinction between fact and opinion, or between the camera as an observation device and the camera as an editorial device that manipulates what the audience sees.

SCRIPTED AND UNSCRIPTED APPROACHES

Most directors shoot unscripted documentaries. Such productions can be undertaken on the basis of a treatment expressing the idea or intention of the documentary. Wildlife documentary is particularly unlikely to be scripted before shooting because you don't know what you are going to get until you shoot it. You cannot script moves for a pride of lions or plan what a gorilla will do. You just keep shooting and, very often, acquire footage of opportunity that could never have been planned. You can and must script a reconstruction of the assassination of President Kennedy, for instance.

Documentaries can be divided into two broad categories: those that are highly researched and structured and those that are observational or a filmed record of things as they happen. Historical and biographical documentary tends to need scripting to establish a structure and a narrative order. Like any production, a documentary script has to be broken down into sequences and shot lists, and then budgeted. If you need a certain shot or an archive picture, that location or that photo has to be researched and found, and rights or permission obtained. All this work adds up to determine cost. Therefore, the greater the detail of your script, the better you can plan the shoot and control the budget. All scripts, for every format, are an exercise in efficiency. If you know what you are going to shoot, you can limit shooting things on the spur of the moment that may ultimately have no use or shooting out of desperation to fill in gaps that show up during production. On the other hand, shots of opportunity often occur on location, and a good director knows when to improvise or grab an unforeseen opportunity. It comes down to simple pragmatism. It is worth paying a writer or spending the time writing a script to plan what you are going to shoot in order to save money. If we recall the blueprint analogy, we can remind ourselves that construction is the expensive part. So scripts save production costs, just as drawing up accurate building plans saves construction costs.

RESEARCH AND FORMULATING A THEME

Factual background, location research, and picture research are also necessary when creating a documentary. These are specialized services that are often independent of the writer. Research is based on reading background, interviewing experts, visiting site, and viewing archives of both still and moving pictures. From the research, a writer can establish what material exists, find a theme, and choose a way of organizing the narrative exposition. To undertake research without some kind of formulated project that is acceptable to an eventual buyer involves risk. The expense of time and money might not lead to production. Initial research might be enough to establish the topic or theme. Serious research enabling a script to go forward would be part of any budget.

Research means, above all, picture research. It is no good writing in a shot of Sigmund Freud analyzing a patient on his couch if either the picture doesn't exist or the rights to the picture cannot be acquired or are too expensive. Intellectual property rights are a huge part of documentary budgets. Therefore, a writer must write around the images that are available. If an archive image is not available, then a location shot of, say, a historical site such as a Civil War battlefield could be substituted. That means a location shoot with all the attendant expenses. Another alternative is to write in a dramatized reenactment. This means spending production money on actors, costumes, and sets. Every solution costs money. A writer has to write a visual narrative that is based on known resources as possible. At the same time, the story has to be credible and substantial. It is always tempting to carry the story in words rather than visuals, but the program will fail if it becomes commentary heavy. Research empowers the writer to write intelligently and judiciously to exploit the available resources.

Sometimes, a documentary is made because of the discovery of new material. After the dissolution of Soviet Russia, a whole new film archive about World War II was discovered in Russia, shot

from the Russian point of view. The archival material itself warrants a documentary, even though other documentary series about World War II already exist. This type of documentary, based on the compilation of existing footage linked by narration, is common. Obviously, writing this kind of script depends on viewing the archive footage and arranging it in some kind of order with a narrative voice-over and some selected interviews. It makes the writer into an editor. Indeed, an editor is like a writer who writes directly on the screen with the available images that have made it to the cutting room.

WHAT IS THE ROLE OF THE WRITER?

We now understand that the role of the writer can be different for different types of documentaries. Writing is largely restricted to the development phase for other types of media writing, but for documentary, it is coexistent with production and postproduction. Writing is critical for two preproduction documents. The first is the proposal. The second is the treatment. In postproduction, the writer returns to write voice-over narration. Only dramatized documentary, in which real events are reconstructed or historical characters are portrayed, is fully scripted because you need to create settings, action, and dialogue.

The Proposal

The proposal is the dealmaker. Like all media content, documentaries cost money. Typically, they are financed by presales to channels for certain rights. The proposal or concept sets out the idea of the documentary, the potential, and the promise. Essentially, a distributor such as a television network, here or abroad, buys the idea with a promise to make payment on delivery for a specific number of broadcasts in a specific territory over a specified time. All documentaries have an element of unpredictability. Therefore, the proposal and the proposer are all that the network or cable channel has on which to base its decision to invest in a yet-to-be-made documentary. The proposal matters because it will lead to the treatment. Previous credits for someone with a track record usually carry weight as well as the concept.

The Treatment

We know what a treatment is from previous chapters; for a documentary it is not really different except that it is probably the final document before production. Unless there is reenactment or dramatized narrative, there is no way to script a documentary scene before it is shot. The importance of the treatment is to organize the structure and the argument of the documentary and the intended sequence of visuals. It should also establish its point of view. The treatment could also be a scene outline that would identify locations and interview subjects. Unless a documentary idea is based on reenactment, there is not going to be script before shooting. Post scripting then becomes critically important because this kind of writing is a precursor of picture editing.

TYPES OF DOCUMENTARY TECHNIQUE

There are a number of recognizable documentary techniques in use today. Sometimes they are combined, just as techniques of corporate video are. However, on the whole they tend to work better when a consistent style is maintained throughout. What follows are simple, descriptive, common-sense definitions meant to help discriminate between different types of writing.

Reportage

Reportage is a French word meaning, literally, "to bring back." A journalist, writer, or filmmaker brings back information that gives an account of an event. Because reportage involves telling the story as you find it, it is really a contradiction to write down shots you plan to shoot or things you plan to see. There is an implicit understanding that you will record what you see as you see it. Of course, putting yourself and your crew in a particular place and time that will enable you to get the footage you desire depends on choice and implementation of opportunity. Writing is primarily going to take place in postproduction in the form of commentary.

Observation

The camera can be used as an observing eye from within the environment in order to introduce the audience to an unfamiliar world. As a general rule, the camera and its crew intrude in the world that is being recorded. People react to the camera. The crew, even a crew of one, is a presence that is not part of the environment. The camera disturbs the environment it is trying to record. Therefore, it cannot observe the natural behavior of subjects. If you put a camera into a classroom, it will be difficult for the students not to be aware of the camera and, as a result, they will probably change their behavior. The same would be true for, say, a prison, a street gang, or a family. It is a challenge to a certain kind of documentary filmmaker to approach human environments somewhat like a wildlife cinematographer. The technique is to introduce the camera and wait until people are used to it and then forget about it. They can then render the camera neutral. Flaherty's classic documentary about Eskimos, *Nanook of the North* (1922), has attracted controversy because he has been accused of staging actions and behaviors for the camera. This violates a cardinal rule of a purist because those being observed are directed to perform actions. From an anthropologist's point of view also, the observation becomes corrupted. This kind of documentary is basically constructed in the cutting room. In the silent film era of documentary, there was no commentary. Other documentaries of this kind have to be postscripted after the footage has been recorded to give shape and form to the narrative and to fit a meaningful commentary.

REALITY SHOWS

An early television offshoot of the observation technique lies behind *The Osbournes* (2002–2005), which debuted on MTV and followed the actual life of this rock star family. *Keeping Up with the Kardashians*, which began in 2007, is another show in the same mold. The modern television format of reality game or competition shows, beginning with *Survivor*, created in the U.K. in 1992, is also a variation on this observation technique. The basic premise of most closed-environment reality shows and game shows is the same. You put a group of people together and place them in isolation, on an island or in a house, and then have them compete for a prize, whether for money or the hand of a bachelor or bachelorette or some other prize. Multiple camera crews roam around and capture the contestants reactions to events, and many shows feature on-camera confessions and revelations about self, others, and strategy. Such series are essentially postscripted from a bin of footage captured both with and without the awareness of the players. How much acting out in front of the camera is conscious and how much is involuntary is hard to judge; both types of actions help to create the audience engagement in the spectacle. Obviously, you cannot script the outcome of a life, competition, or game; you can, however, shape the story unfolding to create suspense, drama, and surprises by judicious choice of the material. This relies on writers who must extract drama and excitement from the multiple camera angles and story lines evolving as the show and competitions develop. Reality shows require a vast amount of editing to give the programs shape.

Interviews

Whether an interview serves as research before actual production or whether it is going to be filmed as footage for inclusion in the edited documentary, successful interviewing underpins every documentary. The questions may not appear in the final edit. Audio only of the answers can also be used for commentary voice-over. Interviews are based on questions and answers to those questions, which might be recorded on camera or off. The techniques of interviewing were discussed at length in Chapter 4. Let us recall that there is a range of rhetorical techniques in different types of questions and a number of ways of structuring interviews. The funnel technique begins with broad and general open questions and narrows down to specific closed questions. The inverted funnel does the reverse. Strong interviewing is central to so many documentaries. Thinking about the purpose and method of any interview in advance is necessary to its success, especially for investigative documentary.

Investigative Documentary

Investigative documentary uses the medium of film or television to record an inquiry into the truth or falsehood of certain questions. These can be historical or contemporary. Numerous controversies exist in a pluralistic society. Conflicts of interest occur between corporations and public interest, between new advances in science and technology and public conservatism, between political policies and the public good. Global warming is of enormous consequence for the human race. Yet, scientific evidence has to be sifted and presented before we can know the truth. Establishing that a disproportionate percentage of the prison population in America is black demands an investigative analysis. Or revealing that prisons have become the dumping ground for the mentally ill as states cut budgets, the subject of an American Experience documentary (on PBS), requires that the producers obtain extraordinary entry into a restricted environment to get footage and interviews of inmates, prison administrators, and psychiatrists. The class-action lawsuit against Corning Glass by women who had silicone breast implants led to another documentary—*Breast Implants on Trial*—produced by Frontline at WGBH. More recently, Frontline revealed that the Obama administration did backroom deals with lobbyists for the pharmaceutical and health insurance industries to get the Affordable Health Care Act through Congress (*Obama's Deal*). Another classic investigation into the breaking of big tobacco with the cooperation of their chemist Dr. Wigand and the subsequent censorship of CBS is the subject of *Smoke in the Eye* (1996). Such investigative documentary depends on in-depth research. It is important to marshal all the facts and separate them from rumor, popular opinion, and corporate propaganda. You generally need to have a few good case histories on which to draw. This means getting the cooperation of individuals and paying experts for testimonial. Many well-prepared interviews with a good cross section of opinion help credibility.

Investigative documentaries always face a problem of balance. It is easy to create a bias by omitting, as well as by including, certain evidence. We expect impartiality. The question is, do we expect a conclusion? If a trial in a court of law must reach a conclusion in the form of a verdict or a mistrial is declared. Does an investigative documentary have to reach a conclusion? It seems unsatisfactory to leave things up in the air after arduously leading us through the evidence. A successful investigative documentary should point to a conclusion and make clear an editorial view set beside the arguments and the evidence.

Current affairs documentaries work best when there is a topic of investigation. Too many current affairs features are weak because they simply collect sensational material, juxtapose conflicting points of view, and end with a question or a kind of shoulder shrug, leaving the viewer to weigh the evidence. Although it is all done in the name of objectivity, it is a cheap and easy out. There is a difference between fairness and balance and abdication of editorial responsibility. If you have presented all the

evidence and point to a conclusion that is probable or likely, you still leave the viewer room to assent or demur, based on individual interpretation of the evidence. The audience can always form its own opinion, but with the knowledge that those who dug up the evidence would not make a program unless they could resolve the issues themselves or at least have conviction in their conclusions. **Frontline** documentaries, produced by WGBH in Boston, probably represents the highest achievement of current affairs investigative documentary in the country. Most of their productions are archived on the pbs.org website. Commercial broadcasting offers short documentary pieces on *60 Minutes,* but the show is tied to the need for variety and a magazine format. CNN produces respectable special in-depth reports from time to time such as ***Being Black in America***, produced by Soledad O'Brien.

Faux or Pseudo Documentary

Many pseudo documentaries on cable, usually about the supernatural, big foot, or aliens, just wind you up with a lot of intriguing, but unanswered questions. Did an alien spacecraft really crash at Roswell, New Mexico? Does the Sasquatch really exist in the Pacific Northwest? Unless they get a sit down interview with Sasquatch, I don't want to see another documentary tease about this creature. Do you believe in mermaids? ***Mermaids: The Body Found*** (2012), aired on Animal Planet, argued for the existence of Mermaids as an offshoot of an early hominid that adapted to an aquatic existence like other mammals that inhabit the sea. Many critics called this a faux documentary. There is footage of a mermaid washed up on a beach along with dolphins and whales, discovered by two boys. The documentary argues that the evidence was suppressed by the U.S. Navy because it would reveal the evidence of a secret sonar weapon that destroys aquatic mammalian species like whales and dolphins that communicate by sound across long distances. The Navy does have such weapons, and in 2013, protestors persuaded California not to allow the Navy to test weapons of the California coast because of the threat to whales, seals, and dolphins. Some parts of the argument are credible but there is a critical missing link in the argument, and actors played the roles of the scientists involved.

Nowadays, CGI and digital manipulation of images are good reasons to be wary of footage of mermaids, sasquatches, aliens, and flying saucers. Part of the evidence is often a Pentagon or military conspiracy to suppress the evidence attested to by credentialed experts or former military witnesses. While there is no doubt that government engages in propaganda and suppression of the truth for political or administrative convenience, the mermaid question involves a paleontological and scientific hypothesis that sooner or later has to be proven or disproven. The history of human evolution has been rewritten many times and new species found based on newly discovered fossil remains. The problem here is that such a program is convincing in many ways but does not prove the hypothesis or provide the criteria that would enable a viewer to evaluate the evidence. The Department of Commerce's National Oceanic and Atmospheric Administration (NOAA) declares that no such evidence exists. Yes, that's the government. Two boys filmed a beached dying mermaid on their cell phone cameras, which we get to see. You must think about the issues involved. A prominent part of cable programming is to provide factual entertainment or infotainment whose primary objective is to capture audiences, not to pass scientific muster. Google mermaids and look at the websites and see the **Mermaid** footage together with the audience commentary and articles that take a critical view.

Narrative Documentary

One of the most appealing forms of nonfiction is biography. Every life has some mystery. Famous and infamous lives invite all the emotions of curiosity, admiration, and amazement. Documenting a life in pictures through the recollections of friends and relatives, through the evidence of the public

record, or through private papers can get closer to the truth. A human life has a natural narrative structure—a beginning, a middle, and an end. We all recognize it. We all empathize. Putting the facts in order, balancing the differing views, or debunking myths about a historical figure is absolutely a documentary endeavor. Who doesn't wonder about the personal life of Marilyn Monroe and question the manner of her death? Who is not curious about the life of a genius like Albert Einstein? Figures of wealth and power in history forever fascinate us. The Discovery Channel and A&E program a lot of biographies, particularly of celebrities. The story of a life may also be a window into the historical period in which the person lived. *TR: The Story of Theodore Roosevelt* puts a mythical figure in perspective. Narrative documentary can tell us the history of a town, a work of art, a war, a political movement, or a revolution. The story, as the Latin root of the word suggests, becomes history. While some documentaries about history are educational and informative, others can be superficial and badly researched, and then there is the occasional masterpiece. Consider Ken Burn's exemplary multi-part series, *The Civil War (1990)*. Detailed, objective, and thorough, it distinguishes fact from conjecture and interpretation.

Dramatized Documentary

The dramatized documentary has become a popular form on television. Instead of hopping between archive images, narrators, interviews, and location shots, a factual story is recreated or reenacted with actors in costume. The purist might object to the invention of dialogue or scenes that may or may not have happened the exact content of which is not known. A case in point would be the life of Shakespeare, the world's most famous playwright. Very little is known about his life beyond official records in Stratford and the Public Record Office and written comments by his contemporaries. One treatment would be to construct a narrative with a presenter showing us where documents about his life exist and linking present-day sites to historical engravings; another approach might be staged reenactment of probable or plausible scenes from his life.

What is the difference between a Hollywood biopic like *Ray* (2004), a compelling and convincing portrait of the singer Ray Charles, and a documentary? A documentary of Ray Charles relies on video and photographic documents as well as interviews with contemporaries who knew him, whereas a biopic has a scripted narrative structure, and all characters are played by actors. A story of a life has shape, but not necessarily three acts and a dénouement. What is the difference between a movie like *Little Big Man* (1970, directed by Arthur Penn), about the defeat of General Custer at Little Big Horn, and a documentary about the same subject?[4] Arthur Penn is also a documentary filmmaker. It is interesting that the movie is structured around a simulated documentary interview of a 111-year-old man who witnessed the event. The movie tells a story that concentrates on the trials and misfortunes of a particular character who lived in both white and Indian cultures. There are also documentary accounts of these events that try to establish the facts from sources. *Legends of the West* (1993) is a documentary film that goes over the same ground. The result of a fictionalized movie is different from that of a documentary and creates a different experience for the viewer.

In practice, dramatized and narrative documentaries can be, and often are, combined. Sometimes the gaps in archive material or location can be filled with an actor playing the character of the biographical subject. An actor's voice can be used to read letters and create emotional impressions that would not come across in the stricter form of exposition by voice-over, archive, and interview.

4 Some documentary background can be found at www.garryowen.com, www.curtis-collection.com/tribe%20data/custer.html, and www.mwac.nps.gov/libi.

This is how the life of Albert Einstein is treated in the WGBH Nova production. An actor playing Einstein on screen narrates parts of his life story; these scenes alternate with the broader story of Einstein's life and scientific theories, as narrated by a voice-over. Such techniques offend purists and remind us that the documentary form is varied and often the subject of hot debate.

Expository Documentary

The term *expository documentary* is meant to describe the kind of documentary that explains something. It is typical of science documentaries that explain a hypothesis or a theory and the way the experimental evidence supports it. Someone with the aid of experts explains the theory of relativity, big bang theory, string theory, and other arcane hypotheses of theoretical physics. These are often constructed as narratives that unfold in a kind of suspense story. Exposition is a nondramatic function of film and video. It shows us a place, or an artist's work, or how a life form grows, or how a product is manufactured. *The Triumph of Evil* documents the failure to prevent genocide in Rwanda. *Inside the Tobacco Deal* tells the "inside story of how two small-town Mississippi lawyers declared war on Big Tobacco and skillfully pursued a daring new litigation strategy that ultimately brought the industry to the negotiating table" (**WGBH website**). Compare this last documentary story with the dramatized, feature film version, *The Insider* (2000), starring Al Pacino and Russell Crowe. Both are powerful narratives. The question to ask is whether the truth is revealed more accurately in factual documentary narrative or in emotionally convincing dramatic narrative portrayed by actors. Biopics and dramatized stories tend to want to take license and exaggerate or distort the facts for the sake of dramatic advantage.

Propaganda

In democratic societies, we do not like to think that we produce propaganda—politically or socially targeted messages that are dictated by a government, political party, or commercial organization—but such documentaries have been made since the beginning of the moving picture medium and will continue to be made. All governments make them in time of war. The Nazis made use of film to advance their political and racial philosophy. Leni Riefenstahl made a classic political documentary for the Third Reich, *The Triumph of the Will* (1934). It is brilliant filmmaking but for an unpalatable cause. Britain and the United States also produced plenty of biased propaganda films during World War II.

More disturbing are the social propaganda films produced in post-war America. One example of public policy propaganda is the film made in the United States to show the population how to survive a nuclear attack—pretty much a pack of lies. Then there were FBI films, such as *Reefer Madness*, that were made to show the effect of smoking marijuana and how it leads to uncontrolled sexuality and madness. Marijuana undoubtedly modifies behavior in certain ways, but the film is a hysterical distortion of the truth and an example of grotesque social propaganda.[5]

We live in an economy in which advertising is rife. You could argue that advertising is a form of commercial propaganda, which is, after all, hardly concerned with truth but with persuasion. It is not difficult to turn those persuasive talents to making nonfiction programs to convince audiences what to think about social or political issues. Political parties do it. Presidential candidates do it. Public relations firms and advertising practitioners sell their expertise to all comers, even foreign governments. The government of South Africa retained public relations firms to counteract the negative publicity of

5 See the *Frontline* documentary titled *Busted: America's War on Marijuana* (www.pbs.org/wgbh/pages/frontline/shows/dope).

apartheid. Propaganda—whether social, political, or commercial—usually masquerades as documentary. That is why a strong, true documentary tradition is a priceless cultural asset that contributes to the free speech and cultural health of a nation.

In the United States, government departments, particularly the White House, try to influence the media and public perception of policy. Why else is the press secretary such an important appointment of any president? The Pentagon and other interests manipulate foreign policy and actions abroad, especially military action, to inculcate a favorable public perception.[6] If you want to understand the difference between managed media coverage and the truth, a fruitful topic of study is the American invasion of Panama in 1989, ostensibly conducted to deal with the corrupt government of General Manuel Noriega. To understand what really happened, view the Academy Award–winning documentary *The Panama Deception* (1992), directed by Barbara Trent and written by David Kaspar. It is an excellent example of an investigative documentary that goes beyond what any news special or news feature would dare to air and could be seen as a kind of antipropaganda documentary. It has never been aired on television or cable, only sold as video (as far as I know). Controversy surrounds it because it makes harsh and damaging claims about the way the United Sates conducts its foreign policy. It also provides evidence that the U.S. Army massacred 3,000 civilians and buried them in a mass grave.[7] This is not without precedent in any military action the United States has undertaken since World War II. Are we doing it again with drone warfare? Most important, the documentary analyses a propaganda model that is strikingly similar to the one used in the run-up to the invasion of Iraq in 2003.

OTHER DOCUMENTARY APPLICATIONS

Expedition Documentary

Archeological, mountain-climbing, and other types of expeditions often include a documentary film project that serves as a record of the voyage and a possible source of revenue, through television and video sales. Some wildlife films are in effect expeditions in search of rare or endangered species. The hunt itself and the struggle to overcome obstacles become part of the story. Common sense tells us that it is going to be difficult to script an expedition documentary in advance. Interviews on location are always desirable but once again, by definition, unscripted. So writing becomes a postproduction exercise, especially for voice-over commentary.

Historical expeditions that are in the past really follow the standard documentary model of assembling still pictures, archive footage, interviews of experts and authors who know the subject, and footage of the locations that the expedition passed through. The famous Lewis and Clark expedition to explore the Louisiana Purchase of vast territories of the American west was made into a series for WGBH by the well-known documentary film maker, Ken Burns: *Lewis & Clark: The Journey of the Corps of Discovery* (1997). The Antarctic expedition of Ernest Shackleton received documentary treatment in the WGBH production *Shackleton's Arctic Adventure* (2000) and again in George Butler's documentary *The Endurance: Shackleton's Legendary Antarctic Expedition* (2000), which had a theatrical release; and then again in a reenacted TV biopic, *Shackleton* (2002), starring Kenneth Branagh.

6 A powerful study of this evidence can be found in the video *Manufacturing Consent—Noam Chomsky and the Media* (1994).

7 A bonus of the World Wide Web is the opportunity to read reviews on amazon.com, where the video is for sale, by individuals who served in the military in Panama during the Bush intervention, *Operation Just Cause*.

Travel Documentary

Everyone has seen one. In the days when movie houses had shorts and supporting features, travel documentaries were common. In the days when travel was more difficult and more expensive, film and video could provide a vicarious visit to an exotic country or region. Of course, travel documentaries have a marketing or promotional function and were often sponsored rather than motivated by discovery. They are somewhat passé because they have been replaced by television series, in which this kind of footage is shot for a wider television audience curious about tourist destinations and exotic places. These now tend to be television programs with a host appearing on camera while on location and taking you on a tour. Exotic places are also the subject of documentaries shot in super-widescreen format for IMAX theaters. A lot of people would watch a documentary about Antarctica who wouldn't spend their vacation dollars on a trip to the South Pole. They are generally spectacular and outside the normal tourist experience.

Documentaries about the Making of Feature Films

This is now indispensable material for DVD releases, which are interactive and offer the viewer a menu of outtakes and background on the film's story, actors, and the shooting itself. Documentaries such as these have to be shot on the basis of an outline and are largely written in postproduction. They have to include shots of the movie intercut with interviews of the actors and production personnel. Of course, they have to be planned before the production of a film and require permission from the producers. They are now indispensable for the extra footage included in most DVD releases.

Wildlife Documentary

The genre of wildlife documentaries is omnipresent in the television schedule. Such programs are the mainstay of Animal Planet, NGO, and the PBS program Nature. Wildlife documentary programs have endless appeal to a wide audience demographic. Seeing the secret life of a rare species, being taken into the life of a pride of lions, or seeing the life of an ant colony is an experience that would not be possible without the help of the wildlife filmmaker. Because wildlife shooting is unpredictable, the narrative is necessarily constructed in postproduction when the writer becomes an important contributor through writing the commentary. Some of these productions require years of observation and expensive expeditions into remote territory with specialized equipment. Most of the filmmakers appear to be specialists in some region of the wild or some species. They are quite often narrated as expeditions with a guide as narrator who speaks to the camera explaining to the audience what the crew are doing and explaining the animal behavior.

WRITING COMMENTARIES

Narrative Voice-Over and Postproduction

Probably the most noticeable writing in the documentary form is the commentary, which requires a special kind of writing that must function in conjunction with the images on screen. Therefore all voice-over narratives or commentary are finalized in postproduction based on the running order and the running time of each sequence. The salient fact is that every word written must be spoken. Every word spoken takes time. Beginners always underestimate how long it takes to speak a commentary. The commentary cannot extend beyond the relevant images that the audience sees. Typically, a

"scratch" commentary is written and recorded and laid against the rough cut. When the two are finalized, then the true recording with the voice-over artist is recorded, often against a projected picture. Alternatively, some directors will record the commentary and cut the picture to fit. The problem with this approach is that if your picture and commentary don't match either in length or emphasis, you have to pay for the recording process all over again.

Wall-to-Wall Commentary

You must let the commentary breathe, that is, give the audience a break from a droning voice. After all, film and video are visual media. Their success lies in the power of the images on screen that have intrinsic meaning without need of commentary. Some documentaries and corporate videos have what I call wall-to-wall commentary. The voice-over starts at the beginning and continues with scarcely a break until the end. The result is monotonous and exhausting. It is made worse when there is a continuous music track running underneath it. Commentary should support the picture when it augments the visual or supplies indispensable information about the image. Even great documentaries fall down in this respect. Alain Resnais's great cinematic essay on the holocaust, *Nuit et Brouillard* ("Night and Fog"), suffers from an interminable verbal assault on the ear, which deprives the images of their power to evoke a self-made commentary in the mind of the viewer.

Commentary Counterpoint and Commentary Anchors

One way to combat the wall-to-wall commentary effect is to set up topic sentences of commentary that are then completed by the visual sequences that follow. Skillful use of commentary sometimes results in an effect similar to musical counterpoint. You create a deliberate tension between the spoken commentary and the visual content. The commentary can give a clue to the deeper meaning of the images. It resembles the way music can be used both as an ironic comment on the visuals and as an emotional intensifier. The NBC miniseries *500 Nations* (1995), produced and narrated by Kevin Costner, exhibits some examples of this. The devastation of European invasion and settlement of the Americas is explained but played out in a visual sequence that makes a statement independently of the commentary. It is advisable to use this technique as a change of pace. It sometimes works as a commentary anchor for a sequence. Commentary often has to bridge and combine disparate and diverse images in a montage. It is impossible to comment on every image; this is not the purpose of commentary. Commentary can set up a sequence that then runs better without commentary because the audience is cued and sees what it is supposed to see. The writer must search for a generic phrase or a collective idea that anchors the sequence so that it can float free visually.

Dual Commentators

Most programs have a single voice narrating the commentary. There is no reason why you cannot have more than one. Two voices could break the potential monotony of one voice in a long program. It also offers the advantage of having both a male and a female voice. Although it is really a director's or a producer's decision, the writer might write a dual narrator concept into the script. Female voices do not necessarily go with so-called female subjects. As a corporate producer, I sometimes used female voice-overs for male target audiences as a form of counterpoint to expectations so as to get attention. The female voice is attractive to the male ear, and messages that might make little impression in male tones can sound intriguing. There is nearly always an element of seduction. The female voice can also be maternal and persuasive. It can also be a teacher's voice and, therefore, authoritarian, shrill, nagging, and possibly off-putting.

The psychology of voices is complex. Some voices are pleasant to listen to, and others are not. Some voice artistes make small fortunes each day running all over town from studio to studio providing voice-overs for ads and corporate videos. If you listen to voice-overs on TV spots, you can recognize certain recurring voices. They are persuasive, resonant, and believable.

Commentary Clichés

The most obvious abuse in writing commentary is the predictable and obvious linking of image and commentary such that the commentary either follows literally what is shown on the screen or telegraphs exactly what we are going to see just before we see it. This kind of literal linking reduces documentary to a kind of slide show. Unfortunately, programs continue to be made in this way. Sometimes it is better to say nothing and let the pictures tell the story. Commentary can destroy the visual life of a film. Another chronic problem of documentary commentary is the use of predictable phrases and clichés that lazy writers use, such as "age-old," "Nature's fury," "a land of hope," and so on. You know when you hear them. You've heard them before in a dozen other commentaries.

Writing commentary for wildlife documentaries seems to present a great challenge that is rarely met successfully. Although this is my personal view, it is fair to say that the commentary of a large number of wildlife documentaries is obvious, predictable, or too sentimental. It has become commonplace to personify places and animals leading to flowery language and sentimentality: *The Serengeti breathes a sigh of relief as the rainy season brings life back to the parched earth.* Or we get a warthog personified as Leonard: *Leonard is playful and wants his brothers and sisters to play with him. Leonard's dad is an unsociable male whose only role is to fertilize the female.* Animals have names and are personified. This can easily turn into parody. The otherness of certain animal behaviors is the source of our fascination. We may need to explain animal behavior in terms of human behaviors, but to do so is scientifically misleading.

On-Camera/Off-Camera Combinations

The classic voice-over commentary is spoken by a talent, sometimes a well-known actor, who never appears on screen. The audience accepts this voice narrator without needing to see the person. This script has to be written carefully for the spoken voice and in short phrases that flow naturally and fit the visual sequences. The commentary has to be apposite to the picture. Above all, where the meaning of the images is self-evident and no commentary is needed, it is a writing skill to say nothing.

A scratch commentary is written in postproduction against a rough cut, if not a fine cut, of the program. It has to be timed to fit the running time not only of the overall program but of individual sequences. It is no good writing brilliant commentary that runs beyond the visual sequence. If you are still explaining the dry season on the Serengeti and there are no more dry season shots, and thunderclouds fill the sky and rain is sheeting down on the screen, you are forced to curtail your dry season remarks. It is easier to rewrite the commentary than to recut the film. Moreover, you want to avoid a rewrite in the recording session when you are paying big bucks for the studio, the engineer, and the voice talent. So you need a breakdown of the film with timed sections in order to write. You have to test out what you write by reading it aloud against the picture.

There are two ways of fitting commentary to film or video. You record a roughly timed commentary and then lay it over the picture as a separate audio track. Where it doesn't fit exactly, you edit out pauses in the audio track or edit images so that you get the picture and voice-over to sync up for the emphasis and effect that you want. Once it is set, you lay the music and then mix the tracks so that the levels fade up and down or in and out to achieve the final result.

The second technique is to record the commentary to play back. You loop sections of the final cut and cue the voice artist to deliver the commentary in a sound booth while watching the sequence

projected. This sometimes has the advantage of getting a more nuanced and effective delivery compared to reading a text in a recording booth without the benefit of picture. Voicing lines to picture, or ADR (automatic dialogue replacement), for lip sync is indispensable to the postproduction of dialogue films or for dubbing a foreign language, but for ordinary documentary it is usually too expensive.

Narration can also be delivered to camera by a talent who appears on screen. Sometimes this can be a celebrity or a well-known actor who lends interest to the topic. Obviously, if the narrator stays on screen all the time, you end up with a continuous talking head. This type of commentary always involves running the voice track of the narrator while cutting away to shots of something else, usually what the commentary is talking about. In that way, you can alternate between an on-screen narrator who looks into the lens and engages the audience emotionally and a voice-over whose identity you know while liberating the screen for images that support the story. This technique requires writing prior to production and commits the director to shooting the narrator in certain locations and backgrounds. It is usually reserved for programs that advocate a point of view rather than try to be objective.

One of the earliest of this type of documentary style was *Civilization*, a series produced by the BBC in the 1960s with Kenneth (Lord) Clarke, the distinguished art historian, as on-screen narrator. Alistair Cooke, the well-known columnist and radio commentator, narrated a documentary series titled *America* (1972) in a similar way. More recently, Kevin Costner made and narrated *500 Nations* (1995), a series about the North American native peoples, their rich civilization, and its destruction by European invasion. The reasons for using this technique are numerous. It works when you have an on-screen authority or personality whose presence enhances the audience experience; however, sometimes, it can get in the way of showing the audience the pictures you want them to see instead of this intrusive character. It works in conjunction with interviewing techniques. Your narrator can interview experts, characters, or passersby, and seamlessly integrate interviews, on-screen narration, and voice-over. This versatility is attractive to makers of factual programming. This choice has to be made before production and commits both writer and director to that decision.

YouTube

Now anyone with a personal computer or cellphone can create and publish video footage on video sharing websites such as YouTube. Crowdsourcing allows amateurs to bring images to light that formerly would be impossible to distribute. We'll pass on discussing the performing cat and dog videos, the crowdsourced version of *America's Funniest Home Videos*. Rather, pay attention to the way portable video cameras or cell phone video have documented wars and atrocities inside countries that bar journalists. The Arab Spring has probably been amplified, if not enabled, by social media and visual communication across them. Citizen journalism thrives because of this new technique of video capture and distribution. In fact, this phenomenon really requires no scriptwriting or writing per se. It is shoot-from-the-hip video. However, scripted footage, whether ads, PSAs, or documentary, get quoted and distributed over YouTube even when the copyrighted intellectual property is uploaded without the permission of its producer. In some cases, the producer doesn't care because of the free publicity. In fact, the website accompanying this book is dependent on a great deal of video available on this Google website.

CONCLUSION

Documentary and nonfiction narrative have an honorable place in the history of visual media and will continue to do so. Most Internet content falls into the category of nonfiction narrative of some kind. Immense numbers of websites are now dedicated to documenting and documentary objectives. Informing a public, as well as entertaining a public, remains a significant goal of all media

formats. Documentary investigation is essential to news analysis, but few news organizations invest in the expense of foreign correspondents and on-location reporting. It is largely excluded from regular news because of the airtime required for in-depth exploration of a topic. Most news channels just read edited copy from the newswires on their teleprompters with short clips of B-roll to spice up the verbal delivery. Worse, they spin the news to reflect an editorial bias of the station or network. Fox News (not news at all) represents this kind of pseudo journalism; some will argue that CNBC does the same thing from an opposing political perspective. For what it's worth, there is an argument that Fox News reports the news with an editorial bias that is concealed; whereas CNBC and CRT are purely editorial. They do not claim to be news organizations. Fortunately, the cable channels continue to buy and commission documentary work. Stories about science, nature, people, historical figures, and historical events make for compelling nonfiction narratives.

Although documentary is probably a writer/director's medium more than a writer's medium, the background research and the writing of a treatment are a crucial contribution to the form. In post-production, writing good voice-over can make or break a documentary. Whether the director/writer or an independent writer composes this text, it remains a key writing job in factual narrative film and corporate video.

EXERCISES

1. Record a documentary from television. With the sound turned all the way down on playback, write your own commentary or voice-over narrative for the visual content.

2. Find an example of a good documentary. Play the audio track without looking at the screen, or dub off the audio track. Time the phrases and time the pauses.

3. Write an outline or treatment for a biographical documentary on a celebrity or historical figure. Make a list of research needs for pictures, locations, and interviews.

4. Write a set of interview questions for the subject of a biography of someone you know or of someone whose life you would like to document.

5. Write an outline for a documentary on events at the Little Big Horn. Make a shot list of key images.

6. View *Manufacturing Consent—Noam Chomsky and the Media* (1994); *The Panama Deception* (1992); the WGBH–Boston documentary *War and Peace in Panama* (1991); and *Missing* (1982), a feature film written by Donald Stewart II and directed by Costa-Gavras about American involvement in a Chilean right-wing coup d'état. Make a list of those features that make a film a documentary and those qualities that make it dramatized entertainment with a message.

7. Compare the investigative documentary *Smoke in the Eyes,* produced by Frontline, with the feature film *The Insider* (1999), in which Al Pacino portrays Lowell Bergman, the CBS *60 Minutes* newsman who later became a Frontline producer when he resigned over CBS's refusal to air the story about Dr. Jeffrey Wigand blowing the whistle on Big Tobacco. It was suppressed by the CBS parent company, Westinghouse.

8. Compare the various documentaries and reenactments of Ernest Shackleton's Antarctic expedition mentioned in this chapter to see which is most truthful.

9. Go to the part of the website reserved for this chapter and study the program *Mermaid: The Body Found* together with the critics and the popular commentary; then write a critique arguing whether this is faux or real documentary.

PART 3

Entertaining with Visual Media

In *Get Shorty* (1995), John Travolta plays Chili Palmer, an enforcer for loan sharks who want to collect from a movie producer. As he gets caught up in the movie world, he comes out with the perfect line with which to launch this part of the book: "I've got a great idea for a movie." Let's face it. Everybody has an idea for a movie. We've all seen more films and television movies than we can count. We can all imagine a story, a character, or an imaginary world that would be just as good as some of the movies we have seen. Now is the time to look more closely at what it means to conceive and write a feature film or a long-form television script. Many dream of a concept, but not many have the perseverance to write a 2-hour screenplay. Even if you can complete a screenplay, the fact is that many are written, but few are chosen. Hollywood is reputed to spend $500 million on development of stories and screenplays and buy at least 10 times more scripts than are ever produced. Most professionals would agree that there is always room for good writing and original ideas. The lure is the lucrative fees that are paid for good scripts and even for some not-so-good scripts.

The market changes constantly. Unknown writers and directors sometimes strike a chord that resonates with the public imagination and see their creation soar into the spotlight. Some low-budget movies such as *The Blair Witch Project* (1999) have grossed millions. In 1969, Dennis Hopper and Peter Fonda made *Easy Rider,* a low-budget movie which spoke to a new generation of moviegoers and threw Hollywood into confusion in an era when it was making big-budget musicals and spectaculars that lost money. The studios at that time did not understand the youth market that made up a large portion of moviegoers. Studios usually try to back known quantities and spend the bulk of their development money on projects written by writers with demonstrable talent.

Let's backtrack a little and look at how it all started. The companies that were making films for the arcades and nickelodeons competed fiercely. There was no talk of art. The objective was to sell the novelty of the moving picture sensation and visual amusement for profit. This meant finding ways to appeal to the general public. Within a short time after the invention of the moving picture medium, early filmmakers experimented with short fictional narratives. With the first attempt to tell a story on film, a need for scriptwriting arose. To set a camera in front of an onrushing train doesn't require a script, but to tell the stories of the *Perils of Pauline* (1914) in which we see Pauline tied to the track by a villain and wonder what will happen in next week's episode requires storytelling. It requires a sequence of shots to be set up. Although directors might keep simple stories in their heads, the economy of the medium dictates that production be planned and produced for a known cost. In order to plan and budget, there has to be a written script. The American inventor of the motion picture projector[1] created the Edison Company to make films for the new and growing entertainment

[1] The Edison company demonstrated the Kinetoscope in the United States in 1891, which enabled one person at a time to view moving pictures. In 1896, Edison brought out the Vitascope projector.

industry. The archives are part of the film collection of the Museum of Modern Art in New York. If you examine the scripts and the distribution scripts for foreign versions, you quickly realize that production was highly organized, even in the first decade of silent movies.

Of all the forms of film and television, the most captivating is the feature film. The power of the medium to hold audiences the world over has endured for a century. The public has embraced this experience of escapism, laughter, tears, fantasy, and drama. Talented writers and directors, in spite of the studio film factories, have made out of the medium a seventh art.[2] Visual storytelling was firmly embedded in the popular culture of the twentieth century and promises to be a significant part of twentieth-first-century media. Therefore, the writer who conceives the story or adapts the story and writes the dialogue must continue to be indispensable to content creation.

2 Andre Bazin, in *Le Septième Art* (New York: Penguin Books, 1958–1962). The other six arts are music, drama, painting, sculpture, literature, and dance.

CHAPTER 8

Visual Storytelling: Dramatic Structure and Form

Key Terms

act	logline	sequence
action	low-concept film	setbacks
antagonist	master scene script	seven-step method
archetype	photoplays	shooting script
character	pitch/pitching	shot
comedy	pity	story engines
concept	play-within-a-play	subplot
conflict	plot	subtext
dénouement	premise	tag line
deus ex machina	problem	three-act structure
dialogue	protagonist	three-stage process
fear	resolution	throughline
flashback	reversals	tragedy
genre	scene	treatment
hero	scene heading	Writers Guild of America
high-concept film	scene outline	
key moment	screenplay	

ORIGINS OF DRAMA

Drama in Western culture has its roots in the theater of ancient Greece. The playwrights of fifth century Athens created dramatic structure. Its philosophers and rhetoricians, principally Aristotle in the *Poetics,* defined the theories of tragedy and comedy, concepts that hold true to the present day. Its architects created amphitheaters. The Romans, admirers of Greek culture, continued the theatrical tradition by writing and performing plays in their own amphitheaters. The remains of their amphitheaters as well as their viaducts survive to this day across Europe and the Mediterranean in what were once Roman colonial outposts.

Although performance, singing, juggling, reciting poetry, and storytelling must have continued over the centuries, there is little evidence of theatrical culture after the Romans until Medieval morality plays and the Elizabethan theatre in sixteenth-century England. In this extraordinary ferment of poetry, of rediscovery of the classical literature of Greece and Rome, and of reinvention of the theatrical stage, the genius of Shakespeare flowered among contemporary dramatists and endowed us with thirty-seven plays (seventeen comedies, ten histories, and ten tragedies). Ever since, English-speaking culture has continued to produce playwrights, plays, and players.

Let's cast the net wider and think about storytelling as a phenomenon in human culture. In every culture in every age, people have told communal stories. The authors are unknown and were probably collective and multigenerational. You could consider the Bible to be a collection of stories about the Hebrew tribes, their struggles, their wars, and, of course, the evolution of their religion and relationship with their God. It began as oral tradition passed from generation to generation. Stories antedate alphabets and writing. Homer's *The Iliad* and *The Odyssey* are also stories that describe history on a grand scale and the interaction between gods and men; they were recited by bards and entertainers. In both cases, we can presuppose multiple authors modifying and refining the narratives. The New Testament is a perfect example of oral narratives transmitted across generations that tell different stories of the same events with huge gaps, which finally got written down in Greek, a different language than the Aramaic of the witnesses and contemporaries of the events in the life of Jesus.

We also need to include folk tales and fairy tales in the discussion. Again, they are usually anonymous fables whose origin is unknown but were eventually written down both in the ancient (Aesop's fables) and the modern world (Grimm's fairy tales). None of these stories would have survived unless they resonated in some way with audiences across many generations. So many movies, both animation and live action, now retell Grimm's fairy tales in visual media. Their recurring popularity proves that they still work for audiences today.

The easiest way to understand the appeal of story to the human imagination is revealed in the way children respond to storytelling. This is something most of us can verify either through our own memories of having stories told to us, especially at bedtime, or through the experience of telling stories to children, whether as parents, babysitters, or siblings. When you read to children, you discover the unschooled responses of humankind to narrative. We recognize that children respond intuitively to narrative structure and that they want more stories or to hear the same story over and over again. We now need to understand what this response pattern is, how it works, and why it works. Audiences respond to narrative; they don't analyze it; for them it either works or doesn't work. As writers, we need to do what audiences don't. We need to understand why and how stories work.

If you were alive at the beginning of the twentieth century and somehow became involved with the new medium of movies and wanted to create dramatic films, you would have naturally drawn on the theatrical tradition that you knew. Plays and photoplays, as they were initially called, had certain things in common that made them work. In the beginning, they were shorter than the modern screenplay. They were silent and therefore unable to use dialogue except as text to be read by the audience in the form of occasional title cards. They had to have some kind of dramatic premise. They had to have some kind of physical action. They had to have characters. They had to have a conflict. To have drama or comedy, you have to have conflict.

CONFLICT

Conflict is the basis for all dramatic plots. Conflict creates tension. Tension demands change and resolution of that tension through action, choice, and dialogue. This is the energy that drives a plot forward. You can identify the conflict engine in any film or television drama. The conflict

can be between characters, between a character and his or her own nature, or between a character and natural forces. Conflict produces a situation that is by definition unstable. Something has to change. In the first few scenes of Shakespeare's *Hamlet,* which has one of the world's greatest plots, we know that Prince Hamlet's uncle murdered Hamlet's father, usurped his right to the throne of Denmark, and married his mother in a matter of weeks. Guards and Hamlet's friend Horatio have seen the ghost of his dead father on the castle battlements. Hamlet is in love with Ophelia, the daughter of a high-ranking courtier who is currying favor with the new king and sees this relationship as a way to advance his career. Hamlet is alone and his life in danger in a treacherous political situation. What is he going to do? We are wholly invested in the outcome and the resolution of his problem. He must choose action or speech that impacts on the other characters and moves the play forward. Watching this tragedy unfold until all of its complications are resolved in a magnificent duel scene grips audiences in every new generation and will do so as long as theatre and literature survive. As Ben Jonson wrote in the Preface to the First Folio, Shakespeare was "not of an age, but for all time."

Tragedy is a much abused word in public discourse, particularly in the news media. A plane crash is not a tragedy; it is an accident; it may be a catastrophe, as is any disaster. Somebody dying young in a car crash or being murdered is not a tragedy. It is sad; it is painful for the loved-ones and relatives. Death is not tragic in and of itself; it is after all the common fate of all mankind. To be a tragedy, that death has to be preceded by certain actions and choices that have caused it; it has to result from a choice or a series of choices, not from an accident.

Aristotle summed it up pretty well about 2,400 years ago in the **Poetics**. He explained tragedy as an action that is serious, complete, and of a certain magnitude. This action evokes the emotions of pity and fear in the audience, which are then purged through their witnessing the spectacle. Pity is aroused when we see someone suffer the consequences of mistakes or human frailty, and fear by recognizing that the tragic character is somewhat like ourselves. We identify with the tragic hero— *there but for the grace of God go I.* Aristotle also defined a key characteristic of good drama, namely, that "the unraveling of the plot . . . must arise out of the plot itself . . . not be brought about by the deus ex machina as in *The Medea,* or in the return of the Greeks in *The Iliad.*" A lot of Hollywood producers ought to be made to memorize this. Of course, maybe they have, and, in the absence of box office figures from Athens, don't consider those ancient Greeks to be A-list writers.

So we see deliberate violations of this principle that ruin plays and movies by having some external force, like the gods in Greek mythology looking down, interfering in the destiny of characters and resolving the tension of the plot. *Deus ex machina* means, literally, "a god outside of the mechanism"—that is, a force or event outside the premise of the plot invented by the writer that fixes the problem of the plot. The main character's distant relative dies and he inherits a fortune: the protagonist wins the lottery. The cavalry rides over the hill and rescues the hero. Such contrived intervention short-circuits the completion of the purge of the emotions of pity and fear that are engendered in the conflict. Tragedies don't, or shouldn't, have sequels. However, they can be broken up into more than one piece. Sophocles' *Antigone* grows out of the tragedy of Oedipus.

What about comedy? Comedy has the same premise—a conflict of interests, a conflict of expectation and reality, a predicament that cannot stay the same. The conflict must be resolved. The need to resolve it drives the characters and the plot forward to increasingly hilarious dilemmas until the problem is resolved and we can all go home contented. Aristotle said that comedy aims at representing men as worse, tragedy as better, than in actual life. Try this! A brother and a sister are shipwrecked in a foreign country. The young woman disguises herself as a man and seeks favor at the court of the local count. This count is courting a beautiful lady and uses the cross-dressing woman as a go-between. The lady falls in love with the messenger who (herself) is in love with the count on whose behalf she

must woo. Her good fortune depends on pretending to be a man. If her true gender is discovered, the game is up. The harder she works at being the messenger of love to the lady, the worse the situation becomes. What a delicious spectacle for the audience! For the Elizabethan audience, there was the added irony that female parts were played by young male actors.[1] Between this situation and its resolution, there's going to be lots of hilarious confusion. And we haven't even brought in the subplots of Malvolio, Toby Belch, and Sir Andrew Aguecheek.

Do you recognize Shakespeare's *Twelfth Night*? Shakespeare is the master. The Elizabethan English of 400 years ago does not obscure the sheer theatricality of his plays and the plain fact that his theater was commercial entertainment for a paying audience of all classes.[2] The parallel to the birth of the movies as a new form of commercial entertainment is interesting. The Elizabethan theatre was a commercial enterprise from which Shakespeare profited as producer and part owner rather than as a writer. Some of the problems are the same. There is a great literary tradition, technical innovation, and a bottom line. The difference is that the cinema was, from the outset, an industrial enterprise based on mass production rather than individual artistic talent. Nevertheless, artistic talent was necessary both in front of, and behind, the camera.

Lots of people—studio heads, producers, and agents—have ideas for movies or buy rights to novels, plays, and musicals to turn into movies. Rarely can they write the scripts. Even if they have the talent, they don't have the time because they are making more money producing and distributing the product. The people in control of production cannot function without writers because they cannot make movies and television series without scripts. From the beginning, they have sought to control this creative person, whose work is difficult to evaluate or measure. The friction between creative artists and industrial moviemakers continues to this day. Hollywood is a town dedicated to deals and to making money. It is no wonder that writers are organized into a trade union, the **Writers Guild of America** (East and West).[3]

To some extent, **the screenplay** is a form created by Hollywood. It is true that playwrights have, since the theater of ancient Athens, found structures that, when analyzed, help us to create our own plays. If the aim of Hollywood film production is to mass produce entertainment or, more recently, to find the formula for product that will quickly produce cash flow avalanches from box office hits, then it becomes important to be able to pick the right scripts. It is probably more important to be able to define the script (or script elements) that will form the basis for box office success. Industrializing the script is a consequence of industrializing movie production and distribution. It became the practice to employ more than one writer on script development in order to keep creative control. The practice continues to this day.

THREE-ACT STRUCTURES FOR FILM AND TELEVISION

When we go to the theater, we experience scene changes, a division of the play into acts, and an intermission. When we watch television, we get commercial breaks that usually happen at a significant point. So television appears to have acts. When we go to the movies, however, we have a seamless narrative experience from beginning to end. In reality, many movies have an intrinsic three-act

1　This type of mix-up was part of the fun in the Academy Award–winning movie *Shakespeare in Love* (1998).

2　For those who want to bypass serious background reading, the film *Shakespeare in Love* (1998) paints a picture of the trials of the new medium, although its tale of Shakespeare is wholly fictional and improbable.

3　Consult their website: www.writersguild.org.

structure. The popular audience does not think about acts or structures; nevertheless, this structure is what makes the form work, even if the audience is not conscious of it. There is a parallel to music. Music has structures that the composer uses: counterpoint, refrain, repetitions, chords, key changes that follow conventions and rules based on harmonies and rules of composition. People may not be aware of the rules of musical composition, but they unknowingly respond to them when they listen to music. Sound without structural form is noise, and movies and television without a dramatic structure leave audiences confused or dissatisfied, even if they can't explain why.

As we pointed out earlier in this chapter, many stories, legends, myths, and folktales exhibit a natural form of storytelling from an oral tradition. It seems to correspond to how the human psyche responds emotionally to stories. Perhaps it is akin to forms in nature, like the golden ratio in the shell of the nautilus, or the spiral of nebulae, or the mathematical ratios of musical notes. This cultural story fabric shows patterns that are probably universal or archetypal. If you can find that pattern and embed it in your film story, you will probably find a wide audience. That is what Hollywood writers and directors have learned.

What are the characteristics of good stories? They have a main character or hero. That hero has a problem that is life altering or life threatening. The hero has an adversary, either animal, such as a monster or dragon, or human, such as a rival, a wicked uncle (as in *Hamlet*), or a stepmother, as in *Cinderella*, which leads to significant conflict. The story unfolds with a rising action that includes heart-stopping reversals, setbacks, and turning points. The hero learns something about the world or about himself and delivers himself, his family, village, city, or tribe from harm. This archetype of the hero was identified by Joseph Campbell in *The Hero with a Thousand Faces* and was discovered by Hollywood decades later as a kind of talisman for storytelling.[4] Hollywood storytellers have identified it as a structure having three acts. Many movies exploit and enhance a natural three-act storyline and archetypal heroes that are recognizable in myth and legend.

The folktale *Little Red Riding Hood* has a basic structure that is easy to follow and has worked for generations of children. It has been adapted into films many times. Interestingly, it works even if you know the story. Stories that work, work forever. Children know the story but still respond with the same emotion each time they hear it or read it. In fact, the repetition of the story enhances its value. Homer's *Odyssey* and *Iliad* do not wear out. Shakespeare's great tragedies are revisited in every generation, whether it is *Hamlet* (1990) with Mel Gibson as Hamlet, the modernized *Romeo and Juliet* (1996) with Leonardo DiCaprio playing Romeo, or *The Merchant of Venice* (2004) with Al Pacino playing Shylock. Filmmakers can't stay away from these classic dramas.

Back to *Little Red Riding Hood*! Let us now examine the structure of the story through the intuitive responses of children to discover what makes it work. Little Red Riding Hood is given a task by her mother. She has to take a basket of food to her Grandma, who is not well. To get there, she has to walk through the forest. It is a journey. It is also a test. She is instructed not to wander off the path or talk to strangers. So the young girl is the protagonist, the lead character. The audience identifies with her. She has a problem. She has to find the way to her Grandma's house. This is a test of character and resolve and an adventure that is seemingly innocent but is fraught with serious moral and character issues. You might argue that Little Red Riding Hood's mother should be had up for child abuse and neglect exposing to her to such risk wandering through the woods; clearly we have become soft and weak. Life was tougher then.

4 Joseph Campbell's *The Hero with a Thousand Faces* was first published in 1949, was revised in 1968, and has been reprinted many times since. The archetype is an idea he borrowed from Jungian theory to find universal meaning in primal stories. George Lucas acknowledged the influence of Campbell in *Star Wars*.

The sun is shining. The sky is blue. The birds are singing. What could happen? Little Red Riding Hood sees banks of wildflowers, starts to gather them and chase butterflies, and ends up wandering off the path. Many movies start in the same way. Then Little Red Riding Hood loses her way. Soon the audience learns that there is a Wolf in the forest, who spies the little girl, sees high-quality protein and an easy meal, and clearly intends to eat her. This character is the antagonist, or the villain. Now we know something she doesn't know (*dramatic irony*). This creates suspense. It also creates sympathy, fear, and pity for her and concern about her destiny. She is alone and lost in the woods with a hungry, cunning Wolf slinking around who wants to eat her alive. What will happen to her? Being lost in urban society is an inconvenience; being lost in nature—a desert, a forest, a jungle, at sea—is a life-threatening trial. You can run out of food or water, be overcome by the weather, and be attacked by wild animals. Now we have roads, signposts, emergency services, cell phones, and GPS. Animal predators such as wolves and bears are threatened with extinction. We have forgotten what children know instinctively. The fear of being lost is primordial.

This is Act I of the fairy tale. Act I has to establish several fundamentals for the audience:

- Introduce the main character.
- Introduce supporting characters.
- Establish a task, an intention, a desired outcome.
- Establish an obstacle, a problem, an adversary.
- Create conflict, suspense, tension.
- End with a reversal or a setback.

By the end of Act I, we want to know what is going to happen. When the audience reaches this state—understanding the problem, knowing the main character, and wanting to know the outcome—Act I is complete. If the story stopped now, the audience would be frustrated. This does not mean you have to mark this point. On television, this is where you would place an advertising break because you give the audience a reason to stick around to see what is going to happen. Act I is simply the completion of a response pattern.

Now Little Red Riding Hood is lost in the forest and a little worried. Although the sun is still shining and the birds are still singing, the hours of the day are numbered. In our movie version, we could have dark clouds blot out the sun or a storm build up on the horizon. This would signal the audience that danger threatens (in literary rhetoric, when nature seems to mirror human emotions, it is called *pathetic fallacy*). In many versions, the Wolf goes up to her, smooth-talks his way into her confidence, and finds out where she is going. We hear the sound of an ax chopping wood. We come upon a Woodcutter. Little Red Riding Hood is so glad to see him because she can ask him the way. This is the seeding of a subplot, not fully developed, but indicative of an important component of movie narrative structures. The Woodcutter gives her directions and sends her on the way. There is temporary emotional relief. Little Red Riding Hood is going to make it. Then cut to the Wolf who has overheard the conversation and now knows where she is going, if he did not learn directly from sweet talking Little Red Riding Hood earlier. So he runs ahead and gets to Grandma's cottage first.

This is the R-rated version, by the way. If you are under 17, you need your mother's written permission to continue reading. We now have a terrifying scene in which the snarling Wolf eats the helpless Grandma alive. The horror of this is amplified in intensity because it now sets up a fearful apprehension about what will happen to our heroine. Turn the screw a little tighter. The Wolf now dresses in Grandma's clothes and with an evil chuckle goes to her bedroom and gets into her bed. We show the Wolf rehearsing imitating Grandma's voice. Now the audience is really worried. Whatever problems Little Red Riding Hood had in Act I are now intensified

and complicated. Sometimes the main charac-
ter knows and sees the problem, and we share
in the consequent anxiety. Sometimes only the
audience knows. This story device is known as
dramatic irony. It makes us worry about the
character, and you will notice, is frequently
used in horror movies. After rushing along
through the forest, Little Red Riding Hood sud-
denly comes into a beautiful clearing and sees
Grandma's cottage. She rushes up to the front
door and knocks. This is the end of Act II.

Now the audience is really invested in the
fate of Little Red Riding Hood. What is going to
happen? If the story stopped now, the audience
would go out of its mind crazy with frustration.
The situation has become worse. The predica-
ment of the main character is as serious as it can
get. It has to be resolved. There has to be a con-
clusion, a resolution, or a dénouement as it is
called. That's when you know Act II has finished
and it is time for Act III to begin. Once again, it
is not announced. It is a point in the emotional
response pattern of the audience to the story.

Act II must accomplish the following:

→ **Figure 8.1** Engraving by Gustav Doré from *Perrault's Fairy Tales and Fables de la Fontaine.*

- Complicate the predicament of the main character, raise the stakes.
- Introduce a subplot.
- Introduce subordinate characters.
- Create an overwhelming need for final resolution.
- End with a setback and a new level of crisis.

Now the Wolf (pretending to be Grandma) calls her to come in, or maybe the door is left open by
the earlier arrival of the Wolf. Little Red Riding Hood wonders where her Grandma is. We could write
in shots that show evidence of a struggle and a fleeting reaction of puzzlement on her face mixed with
joyful anticipation of seeing her Grandma. "I'm in the bedroom," calls the Wolf in his granny voice.
We cut to the surprise on Little Red Riding Hood's face as she sees the false Granny. The Wolf encour-
ages her to come nearer. She goes through the classic dialogue: "Oh Grand Mama, what big eyes you
have!" "All the better to see you with," replies the Wolf. "What big ears you have!" "All the better
to hear you with, my dear," replies the Wolf. And then the climactic line, "Oh Grand Mama, what
big teeth you have!" Children hold their breath, torn between fear and excitement, and squeal with
anticipation—"All the better to eat you with," cries the Wolf and rips off his disguise with a snarl.

The sequence ends with the terrifying revelation of the true identity of the Wolf. Little Red Riding
Hood screams in total, absolute terror. This is the ultimate horror story and the paradigm for many
horror movies. The audience is in agony at the prospect of her downfall. The jaws open wide. She
screams as the Wolf devours her. She is gone. This is the ultimate setback.

At this point, the audience is in a state of shock. Could this be the end? Surely not! While the
Wolf rips off the disguise of Grandma's clothes, we cut to the Woodcutter with his ax coming into

the clearing. Just as he is about to go up to the door, he stops as he catches sight of a Wolf through the window. He sneaks up and notices the signs of struggle and the blood of the victims and then sees the Wolf triumphant. Audience morale rebuilds. There is hope again. The Woodcutter catches the Wolf off guard and with a roar splits his skull with his ax. Audience emotion soars with elation. The Wolf dies in agony. The audience rejoices in the violent and painful end of the Wolf. This is the fundamental emotional mechanism through which movies introduce violence and slake the audience's thirst for revenge. Although revenge is satisfied, we've lost Grandma and Little Red Riding Hood. For some narratives this is the trade-off, the only satisfaction, and we must accept the loss.

In many children's books, this doesn't happen. This is the R-rated version, the European version. The earliest known version was collected and set down by Charles Perrault in 1697.[5] In the nineteenth century, the brothers Grimm introduced or set down a version that brought in a Huntsman who kills the Wolf and rescues Little Red Riding Hood and her Grandmother.

Now we hear the strange sound of cries from inside the Wolf. The Woodcutter takes his hunting knife and slits the Wolf open and pulls out Little Red Riding Hood and Grandma slimy, bloody, and exhausted but whole. Sobbing, she falls into the Woodcutter's arms. Of course, this is not realism, and we have to suspend our disbelief, which children do easily, that they were swallowed whole; whereas real wolves obviously chew their food. It could end here, or we could see them cleaned up and recovered, saying goodbye to the Woodcutter as he goes off into the woods. Of course, one variation of the Woodcutter subplot is that because he saves the heroine, he gets the girl and they get married and live happily ever after. You recognize that happy ending in many movies.

Act III must accomplish the following:

- Intensify the problem.
- Close the subplot by resolving it into the main plot.
- Create an ultimate reversal or a setback in the predicament of the main character.
- Bring about a dénouement or resolution of the final setback and the whole story.
- Create the triumph of the hero, protagonist, or main character and the downfall of the antagonist or villain.

To summarize, Act I usually must accomplish three main tasks: introduce the main characters, establish a problem or conflict that will drive the movie forward, and establish the setting. How do you know when Act I has ended? It usually ends with a major crisis for the main character or protagonist (we are still using the language of Greek theater) and a temporary triumph for the antagonist.

Act II brings complications and a subplot. It usually ends with a reversal in which the main character is in even greater difficulty.

➜ **Figure 8.2** Woodcut by Walter Crane from *Household Stories from Grimm* (1882).

5 *Histoires et contes du temps passé, avec des moralités. Contes de ma mère l'Oye.* In this version, the Wolf triumphs and there is no rescue and no happy ending. The author draws a moral about how young girls should not talk to strangers. It has clear sexual or seductive implications about predatory males.

Act III must bring a resolution of the original conflict, sometimes through the agency of a character from the subplot.

Little Red Riding Hood is the archetype of the majority of horror films in which there is always a female victim and always some menacing man/beast/alien/mutant/creature who threatens her. The ending could be happy or tragic, funny or serious. Every turn of the story can be nuanced by writing, by directing, or by casting to express horror, drama, or comedy. An animated version for children was produced in 1995. Ever since Perrault introduced the sexual nuance to the plot in the seventeenth century to warn girls and young women about smooth-talking, deceptive strangers, there has always been an implicit sexual threat in the story that is made specific in many horror and suspense films. *Red Riding Hood* (2004, released in 2006), a recent film version intended for children, bears out the Perrault interpretation of the story with clear sexual innuendo that is ostensibly inappropriate for its target audience. Notice the "Little" is left out of the title. The *Little Red Riding Hood* plot was loosely adapted into a contemporary suspense thriller in *Freeway* (1996), with the tag line, "Her life is no fairy tale." A similar storyline of a woman menaced by male (wolf) aggressors showed up in the low-budget thriller *While She Was Out* (2008). Indeed, the cultural assumption is that the wolf is male, even though a female wolf could be equally dangerous, just as a female lion or tiger is as deadly as the male. We also have the cultural marker in the term *wolf whistle* and in the idea that single males are often cast as sexual predators despite the millions of devoted husbands, grandfathers, brothers, and sons—among them a few woodcutters too. *Once Upon a Time* (2011) is an adult version of Little Red Riding Hood plot in which the wolf is kind of werewolf who is attracted to the adult Little Red Riding Hood.

Other folk and fairy tales are repeatedly mined by Hollywood for adaptation and for plots. From early on, Disney was the main producer of feature-length animations of classic fairy tales, including *Snow White and the Seven Dwarfs* (1937), *Fantasia* (1940), *Pinocchio* (1940), *Beauty and the Beast* (1991), and many more.[6] Disney is not alone. With the advance of special effects, many of these stories that contain magic or fantastical elements can be brought to life. *Hansel and Gretel* was made into an animated feature in 2002 and again as live action adult variation of the fairy tale with a twist: *Hansel and Gretel: Witchhunters* (2013). Competing with it in 2013 are *Hansel & Gretel* and *Hansel & Gretel: Warriors of Witchcraft*.[7] In 2012, two live action movies have purloined the Snow White story. *Mirror, Mirror* (2012) starred Julia Roberts. Universal produced a full-length feature called *Snow White and the Huntsman* (2012), starring Kristen Stewart of *Twilight* fame as Snow White and Charlize Theron as the evil Queen.

Why are fairy tales the basis for expensive feature films with major acting talent, many special effects, a large cast of extras, horses, and location shooting? The only explanation must be because age-old stories have been tested for generations and never lose their appeal. Now with contemporary 3-D animation and compositing techniques, a more spectacular experience attracts audiences who want to see the fantastical made real. The original storyline or plot often lies hidden behind scripts that do not refer to the characters by name but mimic the plot. Cinderella lies behind *Pretty Woman* (1990). It is about transformation of destiny and redemption from misfortune. So, ugly sisters are other hookers; the prince is a billionaire venture capitalist; and the coach and horses becomes a stretch limo. Rather than further document this thesis that fairy tales are an important story source for many entertainment films, which could take up a chapter, if not a book, let us get to grips with the story structure that attracts filmmakers, and understand how it works.

6 From a French folk tale also adapted as a TV series with big changes in story and character in the 1980s in which the Beast lives underground in the New York subway and sewer system and Beauty is an attorney.

7 Three similar movie titles based on the same source, which is in the public domain, show how Hollywood producers hope to cash in on the possible success of whoever gets there first. This is only possible because the source material is in the public domain. Also you cannot copyright a title. See Chapter 15 for further discussion of copyright.

→ **Figure 8.3** Illustration by Edmund Dulac from *The Beauty and the Beast*. Originally published in 1910.

→ **Figure 8.4** Illustration from *Le avventure di Pinocchio, storia di un burattino*, Carlo Collodi, Bemporad & figlio, Firenze 1902 (Drawings and engravings by Carlo Chiostri and A. Bongini).

THREE-ACT STORY STRUCTURE

The three-act movie has evolved into a Hollywood convention for plot-dominated stories. It accommodates a variety of movie genres. Although there are a thousand variations, broadly speaking, most film stories fit themselves around a skeletal structure. This structure is not just the plot; it is, as we have already argued, more a map of the emotional response pattern of an audience. It is the difference between life and art, fact and fiction, reality and fantasy. You can't watch life, your own or anyone else's, like a movie. Life is what we are living and experiencing every day. It has no beginning and no ending for us because we are always in the middle, in the present. Time does not exist before our birth, even our first memory, nor can it exist for us after death. In some sense, life has no apparent plot, no dramatic structure. In fact, we are constantly trying to give it shape and structure by ceremonies, time divisions, or self-invented narration. For a movie, the writer has to create a story, or, in other words, give the experience of life a beginning, a middle, and an end. That is why the three-act structure works. It also works for television. Television episodes sometimes have four acts so that commercial breaks can be inserted with the least disruption. Indeed, the breaks are used cleverly to heighten the audience's anticipation by leaving them at key unresolved moments in the natural rhythm of the drama.

Why three acts? Shakespeare had five. However, you can discern the three-act structure in *Hamlet*. Many modern stage plays seem to have two acts, separated by an intermission. Movies run for approximately 2 hours without any break. So why three acts? The reason is simple—it works. Nobody has legislated that screenplays have to have three acts. It is just the case that most of them do. They are not marked down as acts in the screenplay and most certainly not indicated in the screen image that the audience sees in a movie theatre. The three-act structure seems to accommodate the way stories can be told in moving pictures. However, not all movies use the three-act structure. There are **alternative story structures**.[8] There is an argument for seven acts that allow a writer to control the development of the main character more successfully.

However many acts we want to use to think about story structure, we need to think about what underlies all stories and screenplays. To make sense of story structure in film and television, we need to understand what is referred to by the terms *low concept* and *high concept,* which in turn means we need to talk about the idea of a premise that underlies every story. The two types of concept are usually reflected in the premise.

The Premise

A premise—a shorthand way of referring to the essence of the story idea—can be summed up in a phrase or a few sentences. The premise has to be in the logline (see below), but it could also be expressed as a slighter longer plot outline. A great deal of business is done on the basis of pitching a premise. You can think of it this way: if a friend who had not seen a movie that you had seen asked you what the movie was about, what would be your answer? At the moment, you probably wouldn't make a supreme effort to capture the essential driving idea. You just say something like, *I liked it, or it's no good. It's about this guy who. . . .* Now imagine that instead of telling a friend, you have to tell someone about a movie that hasn't yet been made and needs a million dollars to develop the script and another $50 million to produce (These days that is a low budget). The premise has to be the idea that defines a movie, the reason for writing it, and the reason for making it. Ultimately, the reason for writing it and the reason for making it have to be congruent.

Sometimes the premise can be embodied in the title itself. Some argued that Paul Schrader's movie *American Gigolo* (1980),[9] based on his screenplay, contains the premise in the title. The idea of a male prostitute sets up a tension with the idea of the American maleness. It also explores an interesting gender issue of male sex for hire. His lover, a senator's wife, has to provide an alibi for him when he is suspected of murdering one of his clients. It is a nice irony that Richard Gere plays opposite Julia Roberts in *Pretty Woman* (1990) a decade later in the moral mirror image of this sentimental sex fantasy. In any case, the title and the premise should connect with one another. *Titanic* (1997) is another title containing a premise, as do many disaster movies.

Comic book movies, which are almost always high-concept movies, all have a strong basic premise. Some of them challenge credibility, but once you buy into the premise, you can go along with the story. The premise of Superman (the source of multiple television series and multiple films) is that a fugitive from another planet lands on earth. Although he looks human, he has powers that derived from conditions on his original planet, which become superhuman on earth. His Achilles heel is kryptonite, which renders him powerless or normal because on Krypton, the planet of his origin, his powers are normal. Spiderman involves an even more challenging premise that Peter Parker was bitten

8 A valuable critique of the traditional three-act structure and an examination of other narrative strategies for film can be found in Ken Dancyger and Jeff Rush, *Alternative Scriptwriting*, 2nd ed. (Burlington, MA: Focal Press, 1995).

9 You can see a trailer of the movie online.

by a spider which gave him some kind of filament-producing gland (where exactly it is, I have never been clear) that allows him to fly/swing on threads like a spider can drop on thread. Some caterpillars can do this too. Caterpillarman somehow doesn't cut it. Besides, lots of people get bitten by spiders and either die or get sick without getting transformed into spider men. The foregoing demonstrates that a premise does not have to logical or realistic. *Alice in Wonderland*, a literary classic of the fantastical, has been made into feature length animation (1951) and live action movies (1998 and 2010). Both Spiderman and Superman transform into superheroes to do good and save the world from villains, while a witless female is infatuated with the superhero double, who is disguised as a wimp right under her nose. Such premises must become high-concept movies with spectacular special effects, more astounding now in the digital age of computer animation and motion control rigs. A huge part of the budget goes into special effects, which make or break the film almost irrespective of the simple story and two-dimensional acting that is required.

We are going to discuss two films with a different kind of premise: *It's a Wonderful Life* (1946) and *Bartleby* (1970). The premise for the first might go like this: A decent man, pushed to suicide by bad luck, is saved by an angel who grants him the wish that he had never been born. Seeing how altered the lives of people he cared about would be in that alternative reality, he begs to reverse the wish and is reconciled with his wonderful life. The premise for the second might be: A social drop-out takes passive resistance to the ultimate conclusion in a battle of wits with his employer who, trying to save him, then rejects him, cannot get rid of him, and ends by feeling guilt and responsibility for his death. We are forced to look at the social contract we all make to survive while harboring a deep rebellion within.

The premise is really the cinematic idea that forms itself in the writer's imagination. When it won't go away and cannot be ignored, it should be written. This is the seed idea. This seed of a screenplay has to be grown through stages into a finished production-ready script. The premise usually leads to a pithy, shortened form known as a *logline*.

Let's look at some movie titles and construct loglines for them:

The Bachelor (1999)

Premise: After his marriage proposal is rejected by his girlfriend, who then leaves on a trip, a man finds out that to inherit $100 million from his grandfather, he must be married by his thirtieth birthday, which is in 24 hours. After he exhausts his list of old girlfriends, his friends and relatives try to fix him up to save the company and their jobs by putting an ad in the paper for women prepared to marry a multimillionaire that day. A thousand would-be brides show up to be married, chasing the hero until he is mercifully reunited with his girlfriend who returns from her trip just in time, oblivious of what has happened but feeling reconciled to the proposal. Happy ending!

From this would come a shorter, pithy, and concentrated essence of the movie we call a logline: Love or money, which is more important?

Audiences can relate to that dilemma. Ask yourself how much would you be prepared to forego to pursue true love, and how much would you be prepared to accept a marriage of convenience to get great wealth. In reality, many people are confronted with this dilemma. In folktale, Cinderella is a story about social mobility in which love and money or love and status go together. The reality show *The Bachelor* and a few other imitations pitch love against money and test a similar premise and turn it into a game.

The logline for *The Bachelor* could be:

One thousand brides. One hundred million dollars. Jimmie Shannon is about to discover the true value of love.

This was in fact the tag line. In some cases, a logline can also be the tag line. The difference is that the former is selling the producer or studio or distributor prior to production, whereas the latter is selling the audience after the film is in distribution on the prospect of becoming immersed in a story and carried away for a couple of hours.

Tag Line

So a tag line is really the postproduction cousin of the logline. It is created after production in the distribution phase to market the movie. It is usually shorter than a logline so that it can appear in posters and advertising copy. It is a provocative phrase that sums up the audience interest or the way the audience might respond to the premise. So it often has an oblique relation to the premise. It is designed to make you curious and to want to see the movie: "In space nobody can hear you scream" (*Alien,* 1979) is a classic. It is the kind of writing that goes with creating the trailer for a movie. It's the line you will find on the poster or on the DVD cover. *Shattered Glass* (2003), about a journalist at the New York Times who plagiarized his work, has the tag line "Read between the lies." Earlier, we mentioned *Freeway* (1996) as a contemporary *Little Red Riding Hood* premise and its tag line "Her life was no fairy tale." This, like the *Alien* tag line, is a pure tag line and could not be a logline.

Concept

Now we can understand why in Hollywood, movie premises are often referred to as "high concept" and, by opposition, "low concept." A high-concept film generally depends on strong basic three-act plot and storyline within a genre and usually furnishes a vehicle for star actors. A low-concept film, by contrast, depends to a greater degree on character and dialogue. They are often low-budget vehicles for first-rate actors who are not necessarily box office titans but who create compelling performances and break new ground. A good example would be *The Visitor* (2008), which explores the life-changing encounter that occurs when a widowed professor returns to his New York apartment to find illegal immigrant squatters living there. The man happens to be a musician who plays the drums and who teaches the professor how to play. Priorities in the professor's life change as he is transformed by the discovery of new worlds and different types of people than those found in the academic world of which he has become tired. So-called low-concept films are often more realistic and more truthful about human experience and human emotions than are high-concept films, even when they are well written and produced, like the latest Batman films, *The Dark Knight* (2008) and *The Dark Knight Rises* (2012). To make a grand but possibly useful oversimplification, high-concept films are based on fantasy and often spawn franchises: the Batman films, the Bond films, the Mission Impossibles, and the Bourne Conspiracies.

What is a concept? The concept is a statement of the premise of the movie stated briefly in a paragraph. From this essential idea, the drama or comedy must unfold. The idea can be simple, but it must be unassailable to producer doubt; it must compel the listener or reader to believe that and audience will want to follow the idea to some necessary conclusion. Sometimes, the same or a similar premise can lead to different movies with different outcomes. Many argue that there are only a limited number of plots. All movies are just variations of this finite pool of storylines. We often have the feeling that movies begin to resemble one another, or that we are seeing the same story premise in a different setting or different costumes. Very often a basic premise that finds audience acceptance results in a genre. The basic genres, along with examples from each genre, are described in the Appendix for those who want to refresh their understanding.

A good example of a concept might be this: A guy makes a bet with a friend that the friend cannot seduce a certain woman. Although the romance starts out as a bet, it turns serious when the guy

really falls in love with the woman he has to seduce. She finds out about the bet by accident and is heartbroken. How does it end? In fact, several movies have been built on this same premise. Although they share the same premise, the movies are quite different in time, place, and character. One is the classic, worldly French film *Les Grands Manoeuvres* (1955), directed by René Clair with Gérard Philipe and Michèle Morgan. Another is the commercial Hollywood comedy *Worth Winning* (1989), starring Mark Harmon and Leslie Anne Warren.

In the French film, the setting is nineteenth-century provincial France. The guy is a French cavalry officer and a lady's man. In the officer's mess, while drinking and fooling around, he accepts a bet from a fellow officer that he cannot seduce a certain lady of the town before the regiment leaves on maneuvers. He woos the lady. She falls in love with him and he with her. One day she comes to the officers' quarters to seek him and overhears the teasing about the bet. She is heartbroken. He doesn't realize she knows. His wooing has become serious. He is no longer interested in the bet. He has fallen in love with her. As the regiment rides out to the cheers of the townsfolk, he looks up anxiously at her window. She is inside behind the curtain in tears. It is tragic, bittersweet, and ironic. The maneuvers of love have parallels to the maneuvers of war, hence the irony of the title. The bet has become a trap.

In the American film, a handsome weatherman who is a bachelor and has enviable success with women is challenged by his married buddy to seduce three women of his choice and get them to accept a marriage proposal and prove it by a certain date. The married buddy's wife happens to own a Picasso, and the wager becomes the painting, unknown to the man's wife. His proof of seduction has to be a videotape of the successful proposal. He really falls in love with the third woman and wants to marry her. The bet catches up with him because the videotape of a previous seduction is seen accidentally, after it is left in the VCR, by his (now) fiancée when she visits the wife of the buddy who made the bet. The women get together to teach him a lesson. At the marriage ceremony, his bride confronts him, refuses him, and exposes his two-timing. He is made to repent. To get her back, he has to bid for his would-be bride at a charity auction, donating not only to charity but publicly making promises to her. They are reconciled.

You can see the how differently the same premise can be developed and how each movie expresses the European and the Hollywood approaches. The same premise lies behind comedy and tragedy. One is nuanced, textured, and ironic. The other is staged, sentimental, and ideological. The European film is an observation about the fickle nature of love and sexual attraction in which there is both understanding with a realistic ending without a moralizing text. The American film reveals a hidden cultural code and a cultural agenda. It is a comedy about the taming of the male fantasy by the female in which there is a moralizing subtext and a sentimental happy ending that saves face. It embodies the subtext of so many American films and television series in which the male although pushed to woo and forced to abandon bachelor freedom is ultimately subject to female conquest in the ritual of the proposal. The American male bachelor is tamed and conscripted into marriage. There are recent variants on this classic plot such as *Made of Honor* (2008) or *Friends with Benefits* (2011). *The 40-Year-Old Virgin* (2005) plays an ironic descant on this theme in which the female pursues a reluctant male. *Knocked Up* (2007) reverses the premise and starts with accidental pregnancy and works its way backwards to achieve the classic romance resolution. *She's All That* (1999) and *Mean Girls* (2004) are both crossed with another genre, the teen comedy.

OTHER NARRATIVE STRUCTURES

The three-act structure won't work for every story. The strict three-act film narrative has one potential weakness that is the flip side of its strength—it is often predictable. Alternative story structures are often unpredictable like life itself. Many alternative films are often the work of writers who also

direct or at least co-write the script. Woody Allen's films mostly work without a three-act structure. They are often like short stories that turn on the realization of a character finding out something about himself, or the film might just illustrate an irony. The first type could be illustrated by Owen Wilson's character in *Midnight in Paris* (2011) as a writer visiting Paris and tripping into a time warp every night, where he meets all the fabled writers of the early 20th century who lived and wrote in Paris. During his excursions, he meets Gertrude Stein and hopes she will read his novel, and he begins to gain the confidence to assert his values against the bourgeois materialism of his fiancée and her family. In *Vicky Cristina Barcelona* (2008) two American girls have to confront another culture that defines sexual mores for Europeans and Americans differently. It is also about characters understanding something or not and about a place as well as a moral "space." These are psychological musings about different characters thrown together in an existential cultural dilemma. They are not set up with a three-act problem. Both of these films, as well as many others of Woody Allen, are based on a comic premise that involves several characters whose interaction must play out so that they evolve or sometimes just stay in some kind of bewildered state that throws the problem to the audience. The premise has to be resolved in the imagination of the audience, not necessarily within the movie.

Other narrative forms have an ancient pedigree that probably conforms to a human emotional template. Since ancient times, minstrels have sung and recited epic poems and mythical stories for communal audiences. These stories have exerted a powerful influence on poets and storytellers for centuries: the story of the war of Troy, told by the Greek poet Homer in *The Iliad* and continued by the Roman poet Virgil in *The Aeneid.* These epics and their subject matter have captivated Western civilization for two millennia. The structure of epics is episodic, multilayered, and populated by numerous heroes and figures, often including divinities. The wanderings of Odysseus returning from the war of Troy in Homer's *The Odyssey* is, in a sense, a subplot of *The Iliad.* In the epic, there are often stories within stories. This multilayered form of storytelling reappears in Boccaccio's *Decameron* and Chaucer's *Canterbury Tales,* in which characters in the story tell one another (and the reader) stories while they are part of a larger story.

Multiple interweaving story structure is replicated in television series and soap operas, like *The Bold and the Beautiful* or *The Young and the Restless*. Soap operas are a kind of modern minstrel tale for the community, telling multi-character, multi-plot tales of greed, love, revenge, and justice. Soap operas, crass as many of them are, thrive on parallel storylines that do not follow a three-act structure. Now that many television series like *The West Wing* and *The Sopranos* are available on DVD, audiences can see them as television novels or epics with complex storylines. However, it is often true that a single episode has a three-act structure.

Another device with origins in the complex weaving of epic narratives is the play within a play. Shakespeare uses this device more than once. In *Hamlet,* Hamlet stages a play to reveal the truth that underlies all of the deceptions of the various characters. It is no accident that the players that Hamlet asks to perform his play ("wherein to catch the conscience of the King") are asked by him to recite a speech about the murder of Priam, the king of Troy, from a play based on *The Aeneid* (which connects the story of Troy to the origin of Rome through a survivor of the sacking of Troy). Those lines, often cut from modern productions, set in epic context the meaning of the murder of the king, Hamlet's father, for the Elizabethan audience. The play-within-a-play technique, beloved by Shakespeare, has a parallel in the film-within-a-film technique. The appeal of the movie within the movie device has been exploited by François Truffaut in *La Nuit Americaine* (1973) and by Robert Altman in *The Player* (1992), which has a kind of allusion to Hamlet in its plot. We've mentioned *Get Shorty* (1995), which is a film about how the film we are watching gets made. There is an offensive movie called *8 mm* (1999) about an illicit market in snuff films, which is essentially a film within a film. **The Blair Witch Project** (1999) is a film about making a documentary about a supernatural phenomenon,

which effectively disguises the low-budget production techniques of handheld 16 mm in the device and recruits the audience as a partner in the plot of investigation. It is an eternally appealing way to conceal and reveal meaning at the same time.

A clever variation, *Seven Psychopaths* (2012), has a plot that is a story that a scriptwriter is trying to write, which ultimately merges with the outer story as a character in the serial murder story is also the friend of the scriptwriter and the real killer who is feeding input into the plot until the two stories conflate in the final scene. The scene resolves the story for the script the scriptwriter in the film is trying to write, in which he is also a character. It is a clever variant of the film-within-a-film technique directed by Martin McDonagh.

Mark Twain's *The Adventures of Huckleberry Finn* is an episodic and peripatetic (meaning "wandering") story. The peripatetic form of the novel is a distant cousin of *The Odyssey*. Henry Fielding's eighteenth-century novel *Tom Jones* was turned into a hugely successful movie.[10] Even a mainstream film like *Forrest Gump* (1994) has a story structure that is peripatetic and almost helical and spiral in its structure, unlike a three-act film. The road movie is a modern American equivalent of the peripatetic novel in which the hero, or often a pair of lovers (*Bonnie and Clyde,* 1967) or a pair of friends, cross the country or trace out a career. The buddy movie was probably established with *Easy Rider* (1969), which is about two hippie bikers who travel across America trying to get to the Mardi Gras in New Orleans. *The Defiant Ones* (1958) is about two convicts—one white, one black—bound together, escaping from a chain gang. One of the most successful of this genre is *Butch Cassidy and the Sundance Kid* (1969), which chronicles the career of two historical outlaws.

Two very skillfully written films serve to illustrate how films can have plots and characters that do not fit into the simple three-act narrative structure. They involve conflict between characters who have problems that have to resolve but do so in unsuspecting ways that are entirely unpredictable. It can lead to a character or a situation, which lies behind the story and script. The concept of meta-writing helps us understand a storyline and its subtext that is behind the screenplay. Let's break it down.

The Cooler

The first example is *The Cooler* (2003), starring William Macy, Maria Bello, and Alec Baldwin. The original screenplay was written by Frank Hannah and Wayne Kramer (also the director). The casting is impeccable. The film and actors received many nominations and awards, including a Best Supporting Actor Academy Award nomination for Baldwin and Golden Globe nominations for Baldwin and Bello. William Macy's performance deserved a nomination as well. This is a very low-budget film in Hollywood terms ($3–$4 million) and, therefore, is a low-concept film with no special effects or big production values. Its strength is its story and its characters. Let's analyze how this screenplay and film work. The meta-writing could lead to a logline that would go something like: *how does a total loser turn into a winner?*

A *cooler* is a gambling industry term for someone who brings bad luck to a table or a player in a casino. The setting is an old-style casino in Las Vegas, where William Macy's character, Bernie, is a cooler. Wherever he goes he appears to bring an aura of bad luck. In fact, we learn later that he has accumulated a large gambling debt, which he is working off and that the casino part-owner and manager, played by Alec Baldwin, broke Bernie's knee cap for welching on a debt. Bernie lives alone in low-rent apartment complex, seemingly without friends or a social life.

10 The script adaptation was written by an important modern British playwright, John Osborne, and directed by Tony Richardson. It won the Oscar for Best Picture, a nomination for Best Screenplay, and a host of other awards in 1963.

In the first scene, we establish the cocktail waitress, Natalie, played by Maria Bello, who is insulted by a client and rescued by Bernie, who calls in the minders and then tells her to watch while he ruins her aggressor's winning streak. Later, they go out for a drink after work, and Natalie suggests going to his place. Bernie, not an attractive man and not used to a good-looking woman liking him, assumes she is a hooker on the side and he will have to pay and says he can't afford it. She is insulted, and he apologizes. It turns out he is not far from the mark because we learn later that Shelly, the Alec Baldwin character, who is a controlling boss and alone, if not lonely himself, has paid her to seduce him and keep him around because Bernie has announced to Shelly that in the near future he is going to quit when he has paid his debt. Shelly's scorn that he is good for nothing else and that because of him Bernie has status in Las Vegas is mixed with alarm that he is going to lose a good thing. This sets up a conflict and a struggle of wills and character between the two men. This is one of several interlinked premises.

Sitting with Bernie in a diner, Natalie is interested in astrology and tries to analyze his horoscope. We then learn from Natalie's looking longingly at a young boy playing at a fairground stand that she had a son and gave him up for adoption to pursue her dream of becoming a showgirl, which she now regrets. Bernie sees something emotional happening, and she explains to him what happened to her. To change the mood, Bernie proposes to beat her at the arcade game throwing balls. She is now genuinely attracted to him because he is sensitive, perceptive, and fun to be with. They go back to his apartment where she seduces him. He has low self-esteem and has obviously not had sex in a while. This seduction scene is convincingly realistic and uninhibited. Natalie actually finds she likes him and tells him that he has "a great cock." This is not in any way romantic and not your usual Hollywood seduction scene. Their relationship begins with convenience sex unrelated to any wooing proposition.

So now we have an interesting and complex premise that is not a three-act structure. Bernie is not really a hero, but he has a problem and a goal to get out of his dependent life. There is a conflict with Shelly, who does not want him to leave and will do what it takes to stop him. Natalie is masquerading as a real girl friend when in fact she is being paid by Shelly to keep Bernie happy. Shelly also has a problem and conflict of his own involving his silent partners who want to make over the casino and have brought in an MBA with modern management ideas to increase revenue and a model of the new structure they want to build, which Shelly rejects. He is attached to old-time Las Vegas and the classic casino. He also protects an aging and heroin addicted-singer who performs in the casino theatre, whom the new management want to replace, and whom Shelly defends and supplies with heroin. Although Shelly is a hard man and hardly sentimental, he has buried within him a kind of reluctant, caring human side. This makes his character three dimensional.

At this point, three major characters, each of whom has a problem, are tied together, each trying to manipulate or control the other two in different ways. Each is alone and trying to control his or her destiny. In story theory, each is an impact character for the other. There is also a hidden fourth character— chance or Lady Luck. This Roman goddess Fortuna and her wheel of fortune is a force that governs this world of winners and losers and all the characters in this story. She is really part of the plot. So far the plot is not a straightforward three-act story. There are three more-or-less equal characters, whose interaction involves contradictions and conflicts that must be resolved, and we want to know how.

The outcome, unlike, most Hollywood narratives, is completely unpredictable. In a way you could say this is the end of Act I except that too much has happened. In a sense, it is a story about winning and losing and what that means and about individual destiny.

What began as a business proposition for Natalie turns into a love affair in which she is wholly involved because she realizes that Bernie really loves her and finally that she loves him. Bernie now transformed is no longer a cooler. When he stands at a craps game or a blackjack table, he creates

winners. Lady Luck no longer spurns him but favors him. Shelly is alarmed. Bernie doesn't understand it, but just says he cannot help it. Natalie declares her love of Bernie to Shelly to his utter disbelief and fury. He paid her to keep him interested in continuing his job, not fall in love. He belittles Bernie as a worthless loser. But he is more concerned with losing his cooler and the effect on casino profits. Meanwhile he is fighting the innovations that his investor partners want to bring in. His world is beginning to fall apart and he begins to lose control.

Now a subplot emerges when by chance Bernie's son turns up with his apparently pregnant girlfriend, whom they meet on the street. When he visits their apartment, he finds Natalie alone and wonders why she, a piece of "prime pussy," is with a pathetic loser like his dad. We have learned that Bernie had an alcoholic wife whom he abandoned. When Bernie shows up, the son says he and his girlfriend are broke and wonders if his dad would like to help him out for the sake of his grandson soon to be born. Bernie, presumably wanting to redeem himself for being an absent father who abandoned his son, takes a couple of thousand dollars he has saved up from a cookie jar.

Next we find them in the casino playing craps and winning big. Bernie and Natalie working in the casino are watching. Through the security cameras, Shelly sees what is happening and comes onto the floor to investigate. He sees that the son is playing with his own loaded dice. When they quit with big winnings to cash in, Shelly, surrounded with his bouncers, suggests they have a drink while they arrange payment, which is larger than usual. Shelly leads them into the back, not the private suite, he promised. Then he confronts the son's cheating and proceeds to beat him up to teach him a lesson. He takes a baseball bat and is about to smash his knees to pulp when Bernie intervenes and reveals that this is his son. Shelly then suspects complicity. Bernie swears not. The girlfriend then appears to be going into labor and calls for help. Shelly then takes his baseball bat and delivers a swinging blow to her pregnant belly to the horror of all present and the audience. It doesn't affect her, and Shelly pulls out the concealed cushion, which is her fake pregnancy. He mocks Bernie rocking the pillow and invites him to hold his grandson. Shelly is about to cripple the son when Bernie offers to be good for the debt. Someone has to pay. Shelly then smashes the son's knees, leaving him in agony.

Shelly threatens Natalie to quit seeing Bernie, who goes back to his apartment where his dead plants have come to life and his cat who was lost now returns. Natalie refuses, declaring her love. Now Shelly goes to the apartment complex with his thugs, who grab Natalie and take her into the apartment where Shelly roughs her up and insists she break up with Bernie so that he can become a loser again. She refuses. He then throws her about the room, by accident throwing her into the mirror which shatters and cuts her badly on the face. Shelly and the thugs leave. When Bernie comes back and finds Natalie nursing her wounds, he takes her to the hospital. She looks in the car's vanity mirror at the damage to her face. Bernie tells her not to worry about her face, to look at him and see herself in his eyes. He is saying he loves, her not her looks, her real self not her appearance.

He then confronts Shelly in his office and takes a swing at him and the thugs take him out on the roof. Bernie has no fear. He tells Shelly to his face that he is the loser. He is alone. He has nothing. Bernie pities him. So the self-effacing Bernie redeems himself and becomes heroic in terms of his own life. He is quitting. Shelly lets him go, having a grudging respect for the fact that he stood up to him. Bernie then gets Natalie and takes the rest of his savings and tells her to wait in the car while he goes to gamble. He shoots craps. Shelly watches as **Bernie wins** and wins. The thugs look at him and his business partners wonder why he allows this. Bernie is no longer a loser, a cooler. Love has redeemed him. Lady Luck or the goddess of fortune blesses him. He wins big, cashes in his chips, and goes out to the car. They drive away with their winnings to start a new life.

Shelly gets drunk. He smashes the model of the new casino, breaks the arm of the MBA. He goes to drive home. In typical mob fashion, his partner is in the back seat. The score is going to be settled. Shelly has redeemed himself as a human being but loses his life. The mobsters are going to get their money back.

Shelly is murdered by his mob backers and the winning lovers are pursued by a hit man disguised as a state trooper who stops them, orders them out of the car, and is about to execute them. They are so much in love they have no fear and look lovingly into one another's eyes prepared to die together because they have fulfilled and healed one another. We are waiting for the love-death, the ultimate setback, a kind of Tristan and Isolde, when Lady Luck plays her hand again. A drunk driver—it is night—hits the executioner and kills him and himself. The two lovers are waiting for the bullets in the back of their heads and then turn around to find out that they have been saved and drive off with their winnings. You could say that Bernie is a kind of anti-hero, an ordinary man who has courage and above all is capable of love that redeems both himself and his lover. You realize that Lady Luck, the goddess Fortuna in the ancient world, is a force that is unpredictable in the casino, in our lives, in a world that we really cannot control. You could argue that she is the main character in the movie.

The narrative of *The Cooler* interweaves three separate destinies that turn the world, all their worlds, upside down. So although the premise sets up problems, they are not resolved in a straight-line narrative. There is also an interesting way in which a *deus ex machina*, in this case a *dea ex machina*, scorned by Aristotle, works in the plot in an integrated way. So there is a kind of classical comedy snatched out of tragedy. By *comedy*, we mean a happy ending in a cruel world without funny lines and escape fantasies. No one can even suspect that what seems like a crime story is going to be a powerful, but realistic love story that begins as lustful sexual encounter, with none of the marriage-proposal-taming-of-the bachelor conventions of a Hollywood romance. What began as a kind of low-life underworld story ends as a convincing story about love and redemption. This love is not romantic soppy sentimental love. This is hard-won, moving, and convincing emotion. It begins as just sex with no relationship and turns into something both ordinary and extraordinary. The flawed characters find love in a tawdry, shabby world. You cannot see it coming.

In a way, you cannot now experience the movie as it really works because you are forewarned and know the plot and storyline. However, this low-concept film is a strong example of powerful and successful unorthodox screenwriting. It opens our eyes to another kind of American filmmaking, the independent film that relies on script, repertory acting by stalwart actors. One test of a good script and the resulting film is that you can watch it again and again and still love it. I hope you agree with me.

Thirteen

Thirteen (2003) is another memorable low-concept, low-budget film flawlessly written, acted, and directed by Catherine Hardwicke, who also directed the first of the Twilight films. She also co-wrote the script with Nikki Reed, who plays one of the main characters and who also plays a vampire in the Twilight saga. Although this film and *The Cooler* represent my taste, they are legitimate illustrations of alternative story structures for film. They are both low-budget, low-concept films that represent the best of independent American filmmaking. Readers may find other titles that fit this mold.

What is special about this kind of narrative?

This is not the kind of film Hollywood really likes because it does not have a happy ending. However, there are exceptions such as the Oscar-winning film *Precious* (2009) about a Harlem girl who is trying to survive. She has been abused by her parents and is expecting a second incestuous baby. *Thirteen* involves realistic observation of social behaviors of adults and adolescents that are troubling, that contradict the idealistic vision of American life that is portrayed by advertising and television. Like *Precious,* it obliges the audience to think about American life that is not "the American dream." As the title suggests, this is the story of a 13-year-old girl, Tracy, played without a single false note by Evan Rachel Wood, who is transitioning to junior high school and coping with new peer pressures. She meets Evie, a dysfunctional, popular, and sexually precocious girl who Tracy's older brother thinks is "hot."

Tracy is on the threshold of sexual awakening and struggles to follow her sexually precocious friend, who comes from a broken home with little supervision. Tracy also comes from a broken home with a single mother, played by Holly Hunter (nominated for an Oscar as Best Supporting Actress), who runs a hair dressing salon from her home and struggles to support the household. Tracy detests her mother's boyfriend. Wanting to transform her life, Tracy rebels against her mother and follows Evie's lead, experimenting with drugs, sex, and shoplifting to make her transition from adolescence to teenager. Tracy is a troubled masochist who cuts herself with razors to manage her pain. Evie comes to stay with Tracy, and she sucks up to the mother, using the mother and Tracy to conceal her drug habit. The finale brings about the complete betrayal of Tracy by framing her with the drug problem and leaves her deceived and destroyed. She learns that although formerly an A student, she has failed eighth grade and must repeat the year. This is not a happy ending. It is realistic. The only ray of hope is that Tracy probably values her mother more, and her mother is awakened to the full extent of Tracy's problems.

The narration is essentially told from Tracy's point of view. We see the world through her eyes. In the language of story theory, her character *throughline* is also the story *throughline*. This film has what critics call a subtext, as do most films. Even high-concept films have subtext that indirectly shows us something about good and evil, right and wrong, just as romantic comedies tell us something about social mores, usually to do with fidelity, love, and marriage. The subtext in *Thirteen* warrants discussion because of the way it is effortlessly woven into the film through visual writing and enables us to understand the world which these characters inhabit and their behavior. The totality of the film is really an implicit commentary on the failure of the American family, the dominance of materialism, the rule of popular culture, and the way in which consumerism defines our identities. It shows us how young people are basically consumers in waiting. They are being indoctrinated into the Bush economy that depends on spending, consuming, and money. There is a generation of adolescents and teenagers that are cut adrift from love, family, and a nurturing environment. Nobody says anything about this in the film. There are no subtitles, no speeches, or even dialogue that says this. We glean it by seeing the world in which the characters live and the forces that act in their lives.

At school, a key sequence begins after Tracy gets to talk to the hottest girl in the school. Camera tilts and close-ups show Evie mocking Tracy's girlish shoes and jeans. The comparison between Tracy's clothes and Evie's hip-hugging low-riding sexy clothes is wordlessly conveyed to the audience. Tracy, who has silently understood how uncool her clothes are, is shown at home throwing her adolescent wardrobe into the trash. This is a symbolic action that marks her transition from girlhood to teenager. Tracy now finds that Evie had given her a phony phone number. Tracy had thought that Evie really wanted to be her friend. In rage and frustration Tracy sets out to go down to the mall. For Tracy, Evie is an impact character in story structure terms. She forces her to act, decide, change, and know herself.

The shopping mall is the new American playground for adolescents and teenagers. With nowhere to go, brainwashed, and conditioned by television advertising since their earliest years that teaches them material cravings and brand recognition, they congregate as junior shoppers, window shoppers, watched by security in cathedrals of commerce. Tracy takes a bus. As she rides, the camera shows us a montage of billboards and ads that define a person's self-image and self-esteem through fashions, brands, and an image of sexiness and style to which youth aspires in order to join the adult world of conspicuous consumption and display. The billboards are cues to personal style and social behavior. An advertising poster at a bus stop defines the product with the phrase "beauty is truth." This is a perversion of the concluding lines of John Keats's "Ode on a Grecian Urn":

'Beauty is truth, truth beauty,'—That is all
Ye know of earth, and all ye need to know.

The billboard version not only perverts but inverts poetic sentiment. You just need to know the right brand on earth, and that's it. In Keats's poem, the Grecian urn is an ideal world from which the material world derives, which is illusory but leads us to the ideal form from which it is derived. Art and, therefore, poetry is a means of perception that brings understanding. Suffice it to say that the poster takes a phrase out of context and corrupts the meaning so as to mislead and undo the poet's description of an experience of transcendent meaning, but used in the film in a context that both validates the original meaning, gives us an aesthetic handrail to navigate the complex world observed by the camera. Few viewers will catch this meaning from such a brief cutaway in the montage.

That simple shot, lasting only a couple of seconds, is loaded with subtext and meaning. Perhaps, it is naïve of me to assume that many viewers will catch this meaning from such a brief cutaway in the montage. We, the inhabitants of this culture, are left with a kaleidoscope of superficial images of what we are supposed to be. We do not know who we are. The point to take away from this is that the scriptwriter and director, by visual narration alone, without dialogue, use the camera to describe the commercial world, which the dramatic characters inhabit, that explains the transformative sequence that is to come.

At the mall, Tracy finds Evie and her friends in a store. She tells Evie that she tried calling her. Evie, smirking, says her phone didn't ring, underlining the calculated insult of the action. The girls are laughing and picking up panties and other accessories that they casually shoplift. Tracy is shocked and doesn't know how to deal with this. She has a moral center that her single-parent mother has given her. In a later scene when Tracy swears at her mother and signals her teenage rebellion against parent in favor of peer group approval, her mother says: "Baby, I didn't raise you this way." This articulates the despair of a million parents.

Tracy leaves the store and, stymied, sits on a bench in the street where a woman is absorbed in a phone conversation with her open purse beside her. Tracy sees her wallet. Again the narration is purely visual telling us the internal thought and moral choice of the character. Tracy snatches the purse and leaves to rejoin the girls she wants to emulate. She has crossed a moral line and violated her values by stealing and seen the path that will enable her to join the clique she thinks will validate her. She has, in the language of the film's subtext, putting two and two together, understood the role of money, consumerism, and the power of self-transformation through appearance. She rushes back to meet them and show them a wallet full of cash. They squeal with delight; Tracy is initiated and accepted. They now go on a spending spree. Tracy and Evie go back to Tracy's room and dress up. Her mother sees her transformed from an innocent adolescent girl into a sexual female in imitation of Evie, who is considered the hottest girl in the school by Tracy's brother.

This film is superbly scripted, directed, and acted, with powerful and meaningful sequences that exemplify visual narrative that does not allow a sentimental **ending**, but a powerful awakening for the characters. Watch it and judge for yourself.

The Place beyond the Pines

Sometimes alternative structures don't work. *The Place beyond the Pines* (2012) exhibits a number of mistakes that teach us something about story structure. The story begins with a good-looking, tattooed, bad boy motorcycle rider (what could be more cliché) who makes his living stunt riding in a traveling carnival. He is played by tight-lipped Ryan Gosling. We find out he has had a brief relationship with a woman (Eva Mendes), a waitress (another cliché) who now lives with another man. He wants to get back together with her, but she is unenthusiastic and in a stable relationship with another man who owns his own house. Bad boy finds out that he is the father of her baby. He decides to quit so that he can support the child even though the mother has not agreed to it (smart waitress).

How? This sets up two main characters and a problem. We can get interested. He meets up with a marginal character who lives on the edge of town and runs a dilapidated garage. They meet as recreational riders in the woods on cross-country machines. The man offers him a lift back to town and then a job. He also proposes a scheme to rob banks, which involves our hero's bike riding skills for the getaway. After initially rejecting this choice, he gives in, motivated by his wanting to care for the mother and child even though she has a new boyfriend who is already doing just that. We can get involved in this character's struggle and want to know the outcome. You could call it act one, but the girlfriend is an impact character and not fully drawn so that we do not really care about her. This is unsatisfying.

After a series of successful bank robberies, a violent irresponsible, unjustified altercation with his ex-girlfriend's current man in his own house, he is again rejected by the woman. The next bank robbery goes awry, and the cops are on his tail. After a long car chase with our hero doing all his motorcycle stuff, he crashes, escapes on foot, and is finally cornered in a house and the cop who goes in after him shoots him. He crashes through the second-floor window and falls to ground and dies in a pool of blood. What? Is the movie ending? Well, goodbye Ryan Gosling (his agent should not have let him take the role)! Now we are taken into the life and career of the cop, played by Bradley Cooper. He has been shot in the exchange and is celebrated as a hero by the upstate New York community. He has a wife and baby boy. It seems there is a group of corrupt policemen in the department who now involve him in shaking down the girlfriend of the dead bank robber. We were shown him throwing a wad of money at her before his fatal move. The cops figure bank money must be in the house. Illegally, without a warrant, they search the house and find the money, which they then give to the convalescing cop, whom we are now learning to accept as a new main character. The cop sees the son of the dead bank robber, who is the same age as his own son. He feels some guilt or remorse for killing the father. The movie overlooks the fact that the father was a deadbeat loser and that the boy has a wonderful stepfather as does the mother, a reliable partner.

The cop is deeply conflicted about the corruption he discovers in the department. When he goes to the commissioner, he is then threatened by his former comrades. He consults his father, a retired lawyer. He then goes to the District Attorney and exposes the corruption. Wait! How did this movie begin? What is happening now? It's a different story, main character, and conflict. Since our upright cop also has a law degree and has passed the bar exam, he can force the DA to make him an assistant DA rather than bury the whole corruption scandal. So he becomes a hero DA after being a hero cop. Now what?

Fast forward 15 years, and our successful DA decides to run for political office. By this time he is divorced and his surly now-teenage son has come to live with him. It turns out (what a coincidence!) that the bank robber's son is also a troubled teenager in the same high school. They are both doing drugs and hang out. Now we are in a movie about the two boys and how they cope. The DA's son, socially better off, bullies the poor, insecure son of the bank robber. It takes too long to explain the sequence of events involving supplying drugs for a party in the candidate's house, but the two end up in a fight. The weaker bank robber's son gets a gun and beats up the spoiled boy. The father comes home and confronts the armed friend/nemesis of his son. He is taken at gun point into the woods, where it looks like he is going to be executed as some kind of poetic justice that has him killing his father's killer. He relents. He goes off, buys a second-hand motorcycle from a farmer, and rides off into the horizon, never having ridden a motorcycle before. It's in the genes. Deep symbolism and symmetry!

You would have to argue in its defense that this story has three acts, each of which features a different character whose problem grows out of one of the other acts. The only story arc is *like father like son*. The next generation repeats the actions of previous, and the story comes full circle. This storyline is not strong enough to bind each act together. Each act launches a different character and a different

problem that is linked, but not necessary, one to the other. This is a deeply flawed screenplay that cannot be rescued by performance. There is no main character, no resolution, and no satisfaction. When the story of a movie disintegrates, it becomes very clear how necessary a good screenplay is.

The Flashback

The flashback is an alternative story structure that scrambles the classic three-act structure. It was developed in the Greek theatre. Sophocles' *Oedipus Rex* is a flashback narrative. The story begins with Oedipus as king in a land that is cursed. The oracle at Delphi tells him that it is because of an unnatural sin. Through a series of discoveries, Oedipus finds out that he was the son of King Laius, who was given the prophecy that he would be killed by his own son and had ordered him killed. His mother took the son to die of exposure on a mountainside, but a shepherd found the baby and raised him. Later, as a young man, he meets his father on the road, but neither knows the other's identity; because of a quarrel about whose chariot has the right of way (road rage ancient Greece style), Oedipus kills his father in a fight and then goes into Thebes, where he ends up marrying the widowed Queen, who, unknown to either of them, is his mother. This now inescapable tragic fate is revealed through a series of inquiries initiated by Oedipus to dispel the prophecy that is given him by the blind prophet Tiresias. Oedipus by choice sets in motion a mechanism by which he must discover the knowledge of his past and leads to his wife/mother committing suicide and his blinding himself with her hairpins. So the blind man sees, that is, understands, what the sighted man cannot. This theme is recapitulated in the character of Gloucester in Shakespeare's *King Lear:* "I stumbled when I saw" (Act IV, scene i, line 21). Also think of the first verse in the hymn, Amazing Grace: "I was blind, but now I see."

Citizen Kane (1941), the Orson Welles masterpiece, is considered to be one of the greatest films of all time for its storytelling power, its cinematography, and its direction, and it is also probably the greatest example of the flashback structure. It begins with the death of Kane, a ruthless and egomaniacal newspaper baron whom everyone understood to be a portrait of the real-life William Randolph Hearst. The story unfolds as a newspaper reporter interviews a number of key characters who knew Kane and who recount their differing recollections. We flash back to the dramatized scenes of Kane's life in long sequences and flash forward to scenes of the reporter, who is a kind of narrator, interviewing Kane's alcoholic ex-wife or his senile former colleague and employee of many years. The script, by Herman J. Mankiewicz and Orson Welles, is brilliant movie writing.

Quite a few filmmakers have experimented with alternatives to the linear narrative line by making flashback part of the plot. For example, *Memento* (2000) features a character who has no short-term memory and has to reconstruct

➜ **Figure 8.5** Oedipus in a Dutch production of *Oedipus the King,* c. 1896.

events to find out who raped and killed his wife. The linear narrative is in black and white, whereas the contemporary events are in color. Flashback is a psychological phenomenon usually recalling trauma of some kind. Writers and directors are interested in the relation of time to consciousness. We live in the present moment but also in memories that are part of our present. The television series *Lost* makes use of flashback in almost every episode as characters try to figure out how they got to the island on which they are lost.

Many of the best American movies come from the independent sector—interesting, gritty movies that explore out-of-the-way themes. They go to the Sundance Film Festival and get picked up for distribution, and the makers move on to bigger budgets and greater temptations. Complex, subtle movies are difficult to create, such as *Sling Blade* (1996), which was rewarded with an Oscar. *Election* (1999) looks at ambition and sexuality in a high school election that hints at the realities of the larger political world in which the heroine ends up. *Chasing Amy* (1997) deals with youth, gender, and sexuality in a way that is refreshing and funny. *Body Shots* (1999) is a tightly observed comment on the complexity of the social and sexual behavior of men and women and their different expectations in post-feminist Los Angeles at the end of the 1990s. The script uses the theatrical aside in an interesting way so that characters break off and speak to the audience through the camera lens, making comments about the way a man or a woman sees the opposite sex. It recalls the innovation in the 1999 television series *Once and Again.* So many good independent films don't get a theatrical release. The major distributors are the gatekeepers. Around the country, you can find independent art house cinemas that manage to show some of these interesting films that Hollywood ignores. Hollywood will spend $100 million to market a big budget film, with costly special effects such as *Jack the Giant Slayer* (2013) and make multiples of their investment in both production and marketing. Many of us like to think that good stories and entertaining films can be profitable without being dependent on the scale of the budget. Hollywood does not share that point of view. They would rather bet big and win big, counting on one or two winners to cover the box office losers.

SCRIPT DEVELOPMENT

Adapting the Seven-Step Method

It is probably true to say that the seven-step method is most useful when applied to corporate communications. The communication problem of entertainment is more elusive. The basic communication problem is that potentially huge audiences want to be entranced; made to laugh or cry; or be transported out of their daily reality. They don't know how, and they don't know exactly what they want. They just want entertainment that is going to work for them, an end result that is satisfying. Because we cannot interview individuals, and because most people don't know what they want to see until the day of their choice, it is difficult to define the communication problem except in the most general terms. If Hollywood could find the answer, it would be able to avoid the risk entailed in every film production.

Step two, which asks us to define the target audience, helps a great deal more because we need to think about our audience. Some choices are obvious. If children are the target, or teenagers, or a general audience, we know how to write differently for them. Audience demographics are very important. It is easier to measure at the front end than at the back end of the process. As a writer you must be a million people who all want to see your movie.

What is the objective? It is, in Hollywood terms, always, to entertain. If you are writing comedy, the objective is to make people laugh. If you are writing suspense, the objective is to make people sit on the edge of their seats. As you write or revise, you can evaluate what you have written by reference to this objective.

The strategy that is the answer to the "how" question is about how you are going to entertain them, how you are going to make them laugh or cry. In effect, the answer concerns genre: is it a comedy, tragedy, or action film? The genre will help determine story structures and character development. So in some sense, the strategy becomes the premise and the genre.

The content is the storyline, the narrative, or what will become the treatment. What will happen in the movie? The medium is going to be film or television, but there is a difference between theatrical film and television film, between multi-camera live-to-tape sitcom and single-camera recording, whether on film or video. The choice of medium is important for scripting.

The seventh step, determining the creative concept, is akin to determining the premise of the movie. Getting to the premise is a lot of work. Getting it clear, getting it right is half the battle. Setting it down in such as way as to attract development money is to embody all six of the previous steps in one compelling outline. It could be what is called a logline in the industry.

Loglines

The logline is a term you will often hear mentioned in the movie business. It is an even more concentrated form of the premise. It is a short statement that sums up the movie, a kind of teaser to make someone think about the script and ultimately want to read it. We have identified a link between meta-writing and loglines. They are often the means by which an agent, a producer, or a studio decision maker will be introduced to your script and, according to many, the basis for any decision to read further. From your point of view, your script is unique. From the industry point of view, your script is one of hundreds that someone has to sort through and make decisions about whether to recommend it to others for consideration. Given a problem of choice, human psychology typically approaches the problem by eliminating the also-rans, whether it is choosing clothes, vacation destinations, or job applicants. So most people agree that the logline has a primary function of ensuring that your script gets read and considered.

A logline is also the foundation for a pitch—the verbal presentation of the project in a meeting. You may pitch your own script, but it also highly likely to be pitched by someone else on your behalf, such as an agent, a producer trying to raise finance for the project, or a studio executive who believes in the script and needs to persuade others. So the logline actually continues to work for you and your script by supplying others with a readymade handle for your script. In recent years, a few websites have emerged that serve as market places and bazaars for independent producers to search for interesting new talent and new scripts. Once again, the logline does duty as the pocket version of the script that allows an interested party to make a preliminary decision. Sometimes this has to do with genre. If you are a producer looking for a kung fu action story, you do not want to be bothered with romantic comedies. You cannot always tell from the title alone.

The logline has almost become a minor art form. Many professional writers and others concerned with creating entertainment content for the media argue that if you cannot sum up your script or movie idea in, say, three sentences, you don't truly know what your screenplay is about. Can it be two or could it be four sentences? That's not really the point. It has to be short, pithy, express the essence of the story, and make someone want to read further.

A logline must have the following characteristic (in no particular order):

- be in the present tense, as always. It is as if you are seeing it now before your eyes on a screen.
- identify implicitly or explicitly the genre for the reason given earlier.
- establish a main character and that character's problem or challenge.
- show a conflict or a situation that will drive the story.
- suggest a climax and a resolution or dénouement.

Screenplays are developed through a three-stage process similar to the one we examined for the shorter film and video formats. The concept and premise is the first job of writing. Although story-lines and premises are sometimes invented by actors, producers, directors, and studio executives, a writing skill is needed to set one down in a convincing form that everyone can study and discuss. Most projects begin as a concept in the writer's imagination. Either the project gets written on spec, as they say, or it gets financed, in which case it has to be sold by pitching it to a decision maker who will finance the development. The concept and the pitch are really about the premise. Today, most films and television series are sold as pitches. At least the process of development starts with a successful pitch to a producer, a network, or a studio.

Story Engines

Most of the stories in the world can be broken down into a finite number of basic plots with different variations. This has led to the development of story engine software, such as **Dramatica Pro**, which tests out story concepts and develops a storyline and characters out of the premise. An American distributor, parodying the similarity of storylines, is reported to have said, "Listen, in television and film, there's only one goddamn plot. There's a guy in Zanzibar with a cork up his ass. There's only one guy in the world who can get it out, and he lives in Newark, New Jersey. We spend the next fifty minutes seeing the second guy fighting overwhelming odds to reach the first guy before he dies of toxic poisoning. Okay?"[11]

Ideas about story structure are certainly strong in Hollywood. The pressure to find the magic formula for a successful movie is great. Some might worry that story engines reduce all movies to a limited number of archetypal plots and their variations. If you now see movie storylines and plots starting to resemble one another, it could be because of the search for formulaic stories reduced to archetypes by story engines. Whether it is the use of story engines or the copycat mentality of studios trying to make money by doing their disaster movie or their science fiction adventure of the season, it is hard to know. We all know that there are stereotypes and fads for certain kinds of subject matter. Of course, genres lead to certain predictable storylines, whether it is a western or a road movie. We know what we are in for. Even though genre movies have conventions that are understood, there is always room for originality and innovation.

Traditionalists might argue that most of the world's literature and drama has been composed without the benefit of story engines. By the same token, most of the world depended on the horse and buggy rather than the internal combustion engine and the quill pen rather than word processors. It probably boils down to deciding that whatever helps you is a good thing. We owe it to ourselves to examine story engines.

In previous chapters, we have emphasized the importance of the thinking that precedes the writing. Getting to the creative premise, concept, or outline and getting it right are fundamental to success. This is what story engines help the writer to do. Story engines analyze plot structures and story elements so that writers can generate plot possibilities from the premise. Story engines use computing power to examine a huge number of choices that represent permutations and combinations of a similar premise. Story engines rest on certain assumptions about plot and story.[12] Dramatica Pro, which is one of the programs in Screenplay Systems' stable of scripting software, rests on a theory of story structure. The software asks questions that lead to a definition of the story type, plot, and characters.

11 Reported by Eric Paice in *The Way to Write for Television* (London: Hamish Hamilton, 1981), p. 8.

12 Melanie Anne Phillips and Chris Huntley are the authors of the Dramatica theory of story.

Dramatica Pro could be described as a writer's tool for creating a treatment. Dramatica Pro certainly teaches the user a great deal about how stories work. In it, the StoryGuide is an elaborate process that asks questions about character, story, and issues to establish the fundamentals of your story. "Storyforming" deals with "the underlying dramatic skeleton of a story"—the structure, theme, and throughline, which can result in 32,768 possible "storyforms," presumably the number of permutations and combinations of the archetypal variables. All stories begin with a problem that must be resolved. The theory posits that all stories have four throughlines:

The overall story throughline (the big picture)
The main character throughline (the protagonist)
The main versus impact throughline (passionate and subjective perspective)
The impact character's throughline (perspective forces change)

The overall story throughline is what the story is about. It involves all the characters. In *Star Wars*, this throughline is about a war between the Empire and the Rebellion. It takes place in several locations, but there is always a struggle between the two forces, in some sense a struggle between good and evil. The main character throughline is about the problem of the main character and how it drives the story and leads to some resolution. The impact character is not necessarily the antagonist in the classic theory of drama, but a character who makes the main character question his or her basic assumptions, and therefore choose, act, and change. In the Dramatica Pro demo analysis of *Star Wars*, Luke Skywalker is a main character and Obi-Wan Kenobe is the impact character. The main versus impact throughline charts the conflict—the interaction between these two key characters that determines the outcome for each of them.

Storytelling describes characters, their problems, problem-solving style, actions, concerns, situation, and environment; how things are changing; and the time and option locks that limit the story and create the drama. By question and answer, the characters and plot are defined and refined. However, the questions have to be very much in the vein of the structural theory that the authors set up behind the software. The software is a patented way of getting someone to think through all the issues of a story.

"Storyweaving" involves creating scenes of specific action from the storyforming and storytelling bank of raw material. The "end result is a complete narrative treatment of your story, a rough first draft if you will" (Dramatica Pro). This document can then be exported to Movie Magic Screenwriter as a formatted screenplay or as a novel, or even as a text document for a word processor.

WRITING A MOVIE TREATMENT

Once the concept has been accepted, the next stage is to expand the idea into a treatment. We have already defined what a treatment is in the context of writing other types of script. In terms of a film, a treatment is a contractual stage in the writing process that is recognized in the standard contract negotiated by the screenwriters' union, the Writers Guild of America. A treatment for a feature film or a television movie is a substantial document running 30 pages or more. The producer who pays for the screenplay usually makes suggestions and requests changes to the story and character development before the first draft screenplay is commissioned. Of course, treatments, like screenplays, are also written on "spec," that is, without payment.

A treatment for a screenplay is a prose narrative of the main storyline (in chronological order) with characters described and occasional samples of dialogue. A movie treatment should be a complete account of what happens, a complete storyline, and a readable narrative that looks forward to

the screenplay. A treatment is written in conventional narrative prose without any special formatting but always in the present tense.

The purpose of the treatment is to allow producers, directors, studio executives, or whoever is going to pay for the script to evaluate the story and its entertainment potential. It serves the purpose of getting writers to show their hand and tell the story. It also allows all of the aforementioned people who have a say in the creation of the final product to react to an early version and respond with comments, concerns, and encouragement. The treatment is less expensive to create than the screenplay. It is, if you like, a prototype for the screenplay that enables everyone to test out how it will play. It is a lot easier to revise a treatment than a screenplay, just as it is a lot easier to revise a concept than a treatment.

Another way of understanding what a treatment is would be to ask what is missing from it that will eventually be delivered in the screenplay or script based on it. The foremost missing element is dialogue. The exact words to be spoken by all the characters are essential to the screenplay, but not to the treatment. Every scene to be shot must be described in the screenplay, but not necessarily in the treatment. Major scenes and major actions are going to form part of the treatment. The supporting scenes and the detail of many scenes only come to the fore in the screenplay. Because a screenplay describes every scene and every word spoken, it decides the pacing and flow of the movie. This cannot be delineated precisely in the treatment.

If we go back to the blueprint analogy of Chapter 1, then the treatment could be roughly compared to the sketches of the finished building. The screenplay is the equivalent of detailed drawings in plan, elevation, and section that provide exact dimensions. The sketch allows you to see what the building will look like and appreciate many of its features. The plans allow you to know how large the living room is and how many bedrooms there are. Above all, it allows the builder to build it just as the screenplay allows the director to shoot the movie.

A large number of treatments by students and beginners fall down because they essentially misplace the three-act structure, usually in the same way. Perhaps this can lead us to a better understanding of how to narrate a story in a visual medium. The typical error is almost always structural and involves the collapse of the three-act structure. Yes, we have said there are other forms of narrative, but they arise because a writer wants to go beyond the three-act structure not because that writer creates a storyline that unintentionally fails to fulfill a three-act premise. My observation is that the problem arises most frequently in the third act. Almost always, the writer has written two acts and called them three. So both the setback and resolution given us in the third act are in story dynamics the crisis of what should be the end of the second act, or the intensification of the problem. Then, in turn, as a rule, the conflict that ends the second act is in reality the end of the first act. What we see is an artificial division accomplished by labeling the acts and not a division that marks the emotional response pattern of the audience. The treatment provides writer, producer, and director with the proof that the story structure is working. Writing a treatment is an essential exercise for all screenwriters but especially for the apprentice writer. If the treatment is flawed, the screenplay is doomed to fail.

SCENE OUTLINE

Another step that can be very useful in constructing both a treatment and a screenplay is the scene outline. In essence, film and television narrate by scenes. Scenes are defined by the slug line or scene heading (see Chapter 3). Every time there is a change of time or place, the scene changes. It is the sequence of scenes that tell the story. The audience only experiences what is enacted in the given scenes. If you can put a skeleton narrative together by means of brief scene summaries, you have a solid structure for a screenplay. Each scene should have a key moment. The key moment is

really the distilled moment or action that advances the narrative. Lots of scenes are possible for any given character, even probable in terms of the story premise, but not necessarily essential to the hundred-minute story. If they are not essential to the forward movement of the story or a deeper understanding of the character, they are a liability. They get in the way; they dilute the power of the narrative.

One way to approach writing the scene outline is to ask what you see rather than what you hear. On the whole, narrative unfolds through the action and choices of the principal characters rather than what they say. It is probably preferable to see it first and hear it second. In other words, narrate through action; or put another way, show the story rather than tell the story. Most scenes need dialogue. The point here is not to talk the plot. If characters have to explain the plot, you have failed.

SCREENPLAY

A **screenplay** or script is the translation of the treatment into a visual blueprint for production, laying end to end the particular scenes employing the specific terminology of the medium to describe what is to be seen on the screen and heard on the sound track. This means the action and its background and each new character in the scene must be delineated. Every word of dialogue must be written down. Every scene must be described. The scene is the basic unit of visual narrative for the screenplay and the writer who writes it, whereas the shot is the basic unit of narrative for the camera and the director who shoots the movie. Why do we say, "Shoot a movie?" The verb *shoot* corresponds to the noun *shot*. A movie is made out of shots.

Although writers may indicate the importance of certain camera shots (always capitalized) and certain transitions from scene to scene (CUT TO, DISSOLVE TO), the director has both the right and the responsibility to break down the scene into camera setups or shots that will cover the action of the scene. A director must shoot the same scene from several angles so that action and dialogue are repeated in different camera angles in order for the editor to create continuity. Without this "cover," a scene cannot be edited. This thinking about setups is not really part of the writer's thought process. The screenplay is the writer's construction of the sequence of scenes in the order and length that will make the story come alive. Although the writer may dip into detailing a shot for particular emphasis—for instance, to describe a CUTAWAY that carries dramatic and visual significance—as a rule, the writer leaves shots to the director. You cannot and should not try to direct a movie from the screenplay.

To pursue the blueprint analogy to the bitter end, it would make sense to say that the shooting script is the plan for the builder. It gets down to a list of shots. This list of shots makes up the shooting schedule and leads to each individual camera setup. This is why the director is so important to a movie production, or indeed any production, because it is the director who makes that final translation of words describing visuals on paper to images in a moving picture medium by means of camera setups in shooting and scenes edited together in postproduction.

The screenplay is a unique form of writing because it must rest on a solid narrative structure that engages the audience by means of a compelling premise, but at the same time it must create believable characters and convincing dialogue. It is visual writing because it is the precursor to production in a visual medium. At the same time, its strength or success is not just technical clarity but story clarity. It must work as a whole; it requires meta-writing, that is, the use of a controlling idea that is behind the finished screenplay but not necessarily revealed in any one line, scene, or character within it. Meta-writing creates a world that we as audience are prepared to enter and inhabit through the involvement of our imaginations. It must also take us somewhere that we have never been before but at the same time recognize as plausible, believable, or objective.

MASTER SCENE SCRIPT FORMAT

The master scene script is the accepted script format that is now well understood and accepted in the industry. It has very clear conventions. It is best understood by looking at the sample page in the Appendix. The description of action and character behavior runs from margin to margin. Character names are always capitalized and centered. Dialogue is separated from action under the name of the character speaking. Dialogue margins are set within the margins for action. It is a way of organizing visual narrative on the page to show scenes. Every scene begins with a slug line. Each slug line announces a new scene because of change of place or time. The slug line abbreviates the information summarizing whether the shoot is inside or outside, where it is, and whether it is day or night. The slug line is always in caps. The action is described in lowercase and is single-spaced. If the scene contains dialogue, the character's name is centered in the middle of the page and typed in caps. Dialogue is written in lowercase and is single-spaced. The breaks between slug lines and action or between action and character name are double-spaced. The breaks between scenes are twice that. Doing all this on a keyboard involves considerable typing skills with tab settings and spacing. Current scriptwriting software systems make this job easy.

SCRIPTING SOFTWARE

With the advent of computers and word processing, formatting a script has become nearly effortless. Not only does dedicated **scriptwriting software** take the chore out of formatting the page by providing macro keystrokes to create slug lines or keeping lists of characters in memory, it has become an industry requirement. Script formatting software provides an easily manageable computer file that can be imported into scheduling and budgeting software that simplifies a difficult and costly preproduction task. A writer must adopt one of the accepted screenplay formatting software systems in order to get the attention of professionals.

SHOOTING SCRIPT

Before we conclude this chapter, we must draw a clear distinction for the new screenwriter between the master scene script and the **shooting script**. The difference is not always apparent. As the name suggests, a master scene script is constructed out of scenes that describe a setting and the action that takes place in that scene together with all the dialogue spoken by the characters. It translates the narrative of the treatment into scenes. Because most of us know that a director will cover the action in the scene from more than one angle and cut between shots and because many beginning scriptwriters are also shooters and editors, many make the mistake of trying to direct the movie from the script. Writing in camera angles and camera directions is a distraction from the essential function of the master scene script, which is to tell the story visually and establish a strong clear storyline. Writing anything other than NIGHT or DAY in the slug line or scene heading, such as 3PM or AFTERNOON, must be justified by a clear need for this description to make the action and the story clear. Finally, writing elaborate transitions other than CUT TO or trying to edit the movie from the script is again unprofessional. Directors and editors will be irritated by all this intrusion into their domain; they won't be ruled by it; and it will make it harder for other readers to follow the story during the decision-making process.

This transition from scene to shot is the last barrier between the writing and the making of the movie. This means a director has to create a shooting script out of a screenplay. When a master scene

script goes into production, the director will translate scenes into shots, setups, and camera angles, and number them so that production personnel on the shoot know what the specific technical problems are. Do not try to do this before time. Limit your camera directions and scene transitions strictly to what is indispensable to understanding the visual concept of the scene. Once again, tell the story, don't try to direct and edit the movie!

CONCLUSION

The need to tell stories is innately human. A story frames experience so that some idea of reality is understood by the audience. Stories seem to work because certain structures make emotional sense of human reaction to situations. The dominant story structure has three acts generated by a conflict or tension that must resolve with a denouement and a resolution of the conflict contained in the premise.

The stages of development of a screenplay are similar for most uses of the linear visual media we have discussed so far, whether public service announcements, corporate videos, or feature films. In fact, we need to bring forward everything we have learned from Chapters 2, 3, 4, and 5. We need to describe one medium through another. We need to be able to define the problem in terms of entertainment.

In writing for entertainment media, the problem is a plot problem or character problem in the form of a premise that will intrigue and hold an audience. So the objective is now entertainment for its own sake. *Entertainment* is a loose term. Fictional narrative in visual media has to be believable, or if not believable in the realistic sense, then it has to be seductive. A fantasy world, whether animation or science fiction or even a mixture of live action and animation (for example, *The Mask* [1994] or *Sin City* [2005]) has to work for the audience.

Determining the audience is an art, not a science. Many studio executives have been humbled and unknowns vindicated in the unpredictable judgment of the box office. Legion are the stories of scripts turned down by one studio or producer only to be made into gigantic successes by another. Small, independent, low-budget films that nobody expects to do well can end up capturing huge audiences. The British film *The Full Monty* (1997) defied the usual Hollywood formula for a big box office success. This film has now become adapted as a musical set in Buffalo. *Billy Elliot* (2000)—about a young boy in a coal-mining town who wants to become a ballet dancer—is yet another example of a small film that won over large audiences. It is safe to say that these films would never have been made if the producers had followed standard Hollywood practice. They are full of local British accents and have no American stars. For some reason, the two stories and situations struck a chord with a huge American audience.

We now have an overview of the forms and structures and a broad understanding of the stages of the process of developing a story and a screenplay: premise, logline, concept, treatment, first draft script, or screenplay, followed by a second draft. This process has well-recognized contractual stages in the industry. In the next chapters, we examine some of the specific problems and creative techniques of the scriptwriting process.

EXERCISES

1. Watch a movie and summarize the conflict that lies at the root of the plot.
2. Everybody in your class is to think up an idea for a movie and then pitch those ideas to the rest of the class. Take a straw vote to get an instant reaction to the ideas. If class members were in control of a production budget, would they commit development money for the script based on the pitch?

3. Write a list of five conflicts—physical, moral, or historical—that could be the source of a dramatic movie.
4. Write a list of conflicts that could be the source of a comedic movie.
5. Write a paragraph each about the premise of three movies you have seen.
6. Develop one of your ideas of conflict into a premise for a movie.
7. Write a scene for your premise that is action only, without dialogue.
8. Write a scene for your premise with dialogue.
9. Write a treatment for a feature-length movie based on your premise.
10. List three of your favorite movies and then write a new logline for each.
11. Take a movie you know well and outline its three-act structure.
12. Take the plot of *Little Red Riding Hood* and rework it as horror movie with different characters but the same plot.

CHAPTER 9

Writing Techniques for Long-Form Scripts

🔑 Key Terms

action	dramatic irony	realism
adaptation	gag	realistic
audience	hubris	running gag
character	key moment	scene
character as victim	mistaken identity	slapstick
comedy	narrative tense	storyline
cover-up	omniscient or third-person narrator	title cards
cross-cutting		tragedy
deus ex machina	plot	verbal comedy
dialogue	point of view	visual narrative
disguise	public domain	

So far we have outlined the broad process of developing and writing long-form scripts without going into the craft of how you do it. This chapter introduces some basics on which the beginner must build. In other words, if you have never written a screenplay or tried to conceptualize a narrative in a visual medium that lasts for an hour and a half or two hours, here are some of the issues you need to think about. Many good books are dedicated to writing screenplays for the movies and scripts for television that elaborate techniques in greater detail than here. There are also many websites, seminars, and webinars about specific aspects of this craft.

Previously, we said that a writer is paid for thinking as much as for writing. We mean by this that the quality of the meta-writing or thinking that underlies the writing determines the quality of the final product. Writing screenplays is not about putting words on paper so much as thinking out storylines, visualizing scenes, and imagining characters. Although we can identify many elements of the screenplay form, none of them will, independently, make a successful screenplay. Put together, they pretty much cover those issues that scriptwriters have to think about. Writers have to execute technically the finished working document that will manifest in actors' performances and directors' shots. The script is a complex structure you can travel through or examine from a number of points of view. Let's start with character.

CHARACTERS AND CHARACTER

Every story must have at least one character whose identity is clear and whose destiny is engaging. Otherwise, we, the audience, have nothing to relate to and identify with. Hemingway's *The Old Man and the Sea* pits one man against the sea, the elements, and the great fish that he struggles to bring in. We identify with his struggle, his hunger, and his fatigue. Herman Melville's *Moby Dick* is about Captain Ahab's obsession with hunting down a white sperm whale. The struggle of man against beast probably goes back to ancient heroic, mythical stories such as the Anglo-Saxon *Beowulf,* and St. George against the dragon. A more recent version of this archetype is **Jaws** (1975), in which Melville's whale is replaced by a Great White shark as the animal adversary. This has spawned a host of similar beast and monster movies based on the same premise of a confrontation with an outsize animal opponent, such as a giant alligator, piranha, or **giant squid**, who then take on an adversarial character or personality (see "Genres" in the Appendix).

Normally, we assume characters to be human, but in this genre the animal is a character in the story with personified characteristics of will, motive, and intelligence. Don't tell me animals are not characters! A whole franchise, as they call it nowadays, was built around a collie, Lassie. Dozens of *Lassie* movies were made, and a television series of the same name ran for many seasons. Don't tell me characters have to have lines! Lassie barks. Think of Frankenstein's creature! There's another character without lines, who is also a variation on the theme, now a man-made monster.

Most stories need more than one human character. They need a protagonist and an antagonist, or a hero and a villain. The struggle between them is typical of archetypal stories. Think of Achilles and Hector in Homer's *Iliad,* Julius Caesar and Brutus, or Octavius Caesar and Cleopatra, or Grant and Lee in the American Civil War. The entire Batman series is about a struggle between a protagonist, Batman, and his adversary, the Joker, or some other wily scheming villain. There are usually two points of view or two sets of values that define each character. In its most commonplace and generic version, we have a hero and a villain, the cop and the criminal, good guys and bad guys. Then there are the hero's friends, girlfriend, lover, parents, children, and all those possible relationships that fill out the plot. The list of characters makes up the cast.

What makes characters interesting to an audience? A character has to be someone the audience can identify or with whom the audience can identify. What's the difference? Who identifies with Hannibal Lector in *Silence of the Lambs* (1991)? You recognize him as a fascinating psychotic personality, but you identify with the vulnerable young FBI agent, Clarice, who must navigate the mind games of the imprisoned and cunning cannibal for clues to capture a serial killer. Her problem—to pluck knowledge out of danger—involves the audience and makes it feel concern for her predicament and want her to succeed while they are fascinated with the wily adversary Hannibal Lector, who is recognizable and identifiable to all. The gender of the character does not prevent both genders in the audience identifying with her because both genders in the audience are caught up in her challenge. Likewise, female audience members can identify and identify with male protagonists.

A more subtle idea of character has to do with characteristics and traits—the inner and outer nature of a person that defines who they are. Writers have to give character to their characters. A character has to have what we might call personality and a unique and interesting voice. Otherwise, a character appears to be flat, like a cut out two-dimensional picture that you might find in a movie theater lobby advertising a coming attraction.

A writer has to create that believable reality in act and speech. To do that, a writer has to think about the name of the character, the character's background and life story, so that he or she comes to life on the page and on the screen. That means hearing how the characters speak (what voice do they have?), seeing how they walk (what is their physical appearance?), and imagining their ambitions, hopes, and fears. What defines them, and what drives them? To differentiate characters we have to

give them identities that make sense for the story and the world in which the characters live. It could be an imaginary world as in science fiction (*Star Wars* [1977], *Blade Runner* [1982], *Dune* [1984]), or a fantasy world (*The Wizard of Oz* [1939, reinvented in 2012]), and most feature-length animation films (*Toy Story* [1995] or *Brave* [2012]). The world of the film defines the characters, and the characters help to define that world. To sum up, the audience has to believe in the characters.

DIALOGUE AND ACTION

The two engines of story are dialogue and action. Dialogue must not drive the story; rather, the story must drive the dialogue. When characters speak, they define who they are. Their words can also give forward momentum to the story. Dialogue spoken by characters must be essential to the plot and essential to their character. So when George Bailey makes his impassioned speech at the board meeting in *It's a Wonderful Life* (1946), he expresses himself as a right-thinking, ethical character and sets in motion his own appointment to the manager's position of the savings and loan of Bedford Falls and the second frustration of his lifelong dream to travel and see the world beyond Bedford Falls, this time on his honeymoon. So his character is tested and expressed in choice. This choice has consequences

→ Figure 9.1 The Guardian Angel and the suicidal George Bailey in *It's a Wonderful Life.*

and moves the plot forward. It sets up his suicidal despair at the end when he feels responsible for the depositors' funds falling into the hands of his adversary, the unprincipled slumlord, Mr. Potter.

The unit of composition in a screenplay is the scene. It has unity of time and place. Each scene must contribute to the necessary structure of the story. In the economy of a screenplay, a scene has to be a key moment. If it is not, it is not necessary and should not be there. By key moment we mean a point in the narrative when choice or an action by the character tells and implies who that character really is, which allows the audience to confirm what it already knows or can deduce from it what it needs to know and understand the character. If a scene can be defined as a key moment in the story, then the dialogue should be only what is necessary to carry the scene. It is no trouble to put words into the mouths of characters. In real life, we chatter away all day long but little of it has much meaning or consequences. If your dialogue is not tied to the action, before you know it, your character is talking the screenplay and, even worse, talking the plot. Avoid having characters explain the plot; rather, let them speak from within the fiction. This goes back to Aristotle's criticism of the deus ex machina as a device. If characters talk about the plot, it destroys conviction. This is a common fault in suspense and mystery dramas, which can only be resolved by someone explaining the ambiguities that result from tying the story in knots and withholding dramatic information from the audience, often because the situation would have no mystery, were the audience told in beginning, or at least the middle, what they need to know. I will accuse *The Sixth Sense* (1999) of this fault because the dead spirits are shown to us as real people part and parcel of the living reality. The truth is a dramatic ex post facto. Withholding this information is trickery. It is like an **optical cognitive illusion**.

➜ **Figure 9.2** Do you see a young woman or an old woman?

The same is true of the schizophrenic character in *Fight Club* (1999), who is played by two different actors and thereby conceals an essential piece of information. Much more interesting would be getting one actor to play the two personalities, as in the classic *The Three Faces of Eve* (1957) with Joanne Woodward.

Characters interact with their environments or with other characters by making choices and doing things that have consequences. In fact, *It's a Wonderful Life* turns on the choice by George Bailey to live or not to live (Hamlet's "to be or not to be"). His decision to kill himself moves the story forward, with divine intervention, of course. This is a successful use of Aristotle's deus ex machina, probably because it is the premise for the story, not the resolution. Events in nature or in history act on characters such that they must change or perhaps die. In *Flight* (2012), an investigation into the causes of a plane crash force the pilot, played by Denzel Washington, to confront his alcoholism, and make a life-altering choice. Action is not dependent on dialogue. In the best writing, dialogue complements action. Dialogue creates the understanding of action. Action creates the context for dialogue. Dialogue must advance the action or plot. They work together. At any given plot point, sometimes dialogue is more important, sometimes action. However, the narrative must be told by visual events and action as much as by the words characters speak.

When a character does speak, the dialogue must define something about the character, or at least be consistent with the character and appropriate to the moment. This brings us to a question of realism. Most people can write down words and phrases that are a plausible representation of the way people speak. The trouble is, the way people speak is usually long-winded, rambling, disjointed, repetitious, and boring. To check this out, take a recorder into the cafeteria. Listen to people conversing on a bus or subway. Listening in on a telephone conversation (cell phones sometimes give us no choice) reveals speech that is the opposite of film dialogue. It goes nowhere. So strict realism kills a screenplay.

Dialogue in films and television has to be realistic, not real. That means characters have to speak in character, have to be believable, and have to sound as if they are real. In actual fact, such lines are carefully crafted and edited to carry the plot and to convince the audience from moment to moment that the illusion is reality. We expect a doctor in *ER* or *House* or *Greys' Anatomy* to talk like a doctor or a nurse to talk like a nurse. When we are absorbed in the story, we do not want to hear all the inconsequential utterances of an intern or ward physician. Perhaps you have had the misfortune to have to go to a hospital emergency room either for yourself or with someone else. It is really dull. You can hang around a hospital emergency room for days and not experience anything that would be exciting enough for a television show. To make an interesting television show about a hospital, you have to graft many separate key moments together. You have to create an interaction of characters that will bridge imagination and reality. You exaggerate; you heighten; you intensify. If characters still get to say ordinary things, they do so while racing down the corridor with a gurney or answering the phone while looking at a lab workup on the patient. You condense speech and action.

What does movie dialogue do for the plot and the character? Compared to novels and even stage plays, movie dialogue is sparse. The reason should be apparent from the experience of going to the movies. The most successful way to tell a story on screen is by showing characters in situations or doing things that explain implicitly what is going on in the story, rather than showing characters jawboning with one another—more typical of older black and white films, which had the whiff of filmed theater, where dialogue dominates. When they do speak, the exchange has to be necessary to the moment, to the plot, and to the revelation of that character. So dialogue explains character, advances the plot, and informs the audience. When you subtract dialogue you must have action, which requires visual narration. Visual narrative is key to writing for the moving picture medium.

In the *Godfather* (1972), there is a great moment of American cinema that illustrates visual narrative without dialogue and how narrative is condensed by means of the quintessentially cinematic technique of cross-cutting parallel, simultaneous storylines. The master scene is **the christening** of Michael Corleone's sister's baby. Michael Corleone is going to stand as Godfather to the baby, but during the ceremony, he will also become godfather in the mafia sense as all the rival gang leaders are assassinated and his family's honor revenged. The sequence intercuts the intricate ritual of baptism with its unguents and intoning of the sacrament in Latin with the ritual preparation by the various hit men for the multiple assassinations. Applying holy oil to mark the baby's forehead with the sign of the cross cuts to a barber applying shaving cream to the face of one of the victims; the gesture of the priest handling the ritual objects corresponds to a hit man assembling a weapon. The only dialogue is the Latin liturgy and the ritual questions put to the godfather. The pace quickens when we cut from the priest's question, "Do you renounce Satan?" and Michael's answer, "I do renounce him," to the targeted victims being gunned down. It is a masterpiece of American cinema because the writing organizes the narrative to show Michael Corleone becoming godfather in both senses, underlining the meaning of family in both senses. The visual writing of this key scene establishes the juxtaposition of evil and innocence, the moral and ethical context in which we are bound to see the story as a world of hypocrisy, duplicity, and internecine murder; it leads to Michael alienating his wife and later killing his brother.

One mistake beginners often make is to have characters make set speeches. Another is to gum up the forward motion of the movie with tedious small talk. It may be real and just the way people talk, but movies are realistic not real. They condense life into key moments. Total realism would be unbearable. People have to sleep, eat, and go to the bathroom. They have to ride the subway, take a bus, or drive for half an hour to get somewhere. No one is going to pay money to see a truly realistic movie. Remember that Andy Warhol made a 5-hour, 20-minute movie of someone sleeping. That's realism. You could not survive without sleep, but sleep is not entertainment. In fact, it is the opposite. We all use the expression "puts me to sleep" to register that something is the opposite of entertaining.

What we feel to be realistic is a true representation of a moment of human experience. We accept the moment of fear, of doubt, of emotional expression, or the embarrassment of a comic predicament as convincing. So from moment to moment, the prevailing style of movies is to craft dialogue to sound natural and to show characters—whether in offices, crime scenes, or homes—that are plausible If you analyze almost any moment in a well written script, it is a *key moment* stripped of excess *action* and *dialogue* so that we understand in that moment what went before and what consequences are likely to follow. Most of what we are saying applies to television as well, with the exception of sitcoms, which are predicated on continuous dialogue to set up laugh lines.

On the other hand, the drive to condense plot and make dialogue as dramatically efficient as possible leads to a number of recognizable clichés. For example, detectives stride purposely through a building barking serious-sounding orders, while another character enters and delivers a realistic comment about what forensics found out about the murder weapon, all shot with a sweeping, fast-moving Steadicam tracking shot showing background action that tells us we are in a police precinct. We end up in an office. The character grabs some coffee. The phone rings. A psychotic serial killer calls in a taunt. Trace that phone call! Or a new piece of information is delivered to set up the next stage of the plot. You could sit for days in a police station and be bored out of your wits and never see this kind of condensed action. Rewrite the same cliché, and we are in a hospital corridor going into emergency, going up the steps of a courtroom, striding through an office at the Pentagon, tracking into an airport disaster room, at a fire—you name it. That is not how it really happens. It is a movie and TV convention for condensing the action and the dialogue.

Think how movie dialogue writing evolved. It began as title cards for silent movies interspersed between scenes. The words to be read by the audience had to capture key moments, key sentiments that would support the scene of intense looks and silently moving lips. From the beginning, movies had to reduce dialogue to the essential. If you compare older movies with today's product, you generally find that they are verbose. With the invention of synchronized sound, the "talkies" seemed to lean on the theatrical tradition again. Actors who looked good but couldn't deliver a line were replaced by actors capable of delivering dialogue, often trained in the theater. Writers could go to town on the dialogue because hearing actors speak in lip sync while seeing them on screen was a novelty that exploited the new technology.

Writing dialogue is an art. The words a character speaks can be ambiguous, nuanced, and mask who he or she really is. Such is the dialogue of Hannibal Lector, for instance, as is the dialogue of Hamlet simulating madness to fool his uncle (stepfather and king), his mother, and Polonius. The constant danger of writing dialogue is the tendency to talk the plot. This frequently happens in suspense thrillers and murder mysteries in which the audience is kept guessing. There is frequently a key scene at the end in which the hero confronts the culprit and then talks through the explanation of how he figured out the truth. Even in the classic thrillers like *The Maltese Falcon* (1941) and *The Big Sleep* (1946), Humphrey Bogart does a lot of plot explanation in confrontational dialogue scenes. The old television series *Columbo* consistently resolves the crime story in that way, as does Agatha Christie's Hercule Poirot in the TV series and movies based on the famous detective novels. You could argue that it was successful and that Peter Falk became a popular television character. Now you get it in *CSI*. Styles change.

Robert Altman brought about one of the great innovations in movie dialogue writing and delivery in his movie *M*A*S*H* (1970).[1] Later that movie was spun off into a television sitcom. Until *M*A*S*H*, characters spoke in turn. In real life, people hesitate, interrupt one another, talk at the same time, and overlap one another. Altman broke the old convention, and movies have never been the same since. We now hear more realistic speech with interruptions, half-finished thoughts, and speech fragments. However, the fragments still have to be crafted and mean something dramatically. We also get uninhibited vernacular speech that includes four-letter words that were formerly anathema.

Filmmakers soon learned that it was more interesting to tell a story through action and images rather than theatrical speech. Early scriptwriters got the point.[2] By contrast, in television soaps, most of the narrative is conveyed by duologues between two characters in medium shots and close-ups. They never stop talking. Talk is cheap; it just needs a few basic sets and a team of writers compared to movie locations and special effects, stunts, car wrecks, and exploding buildings. In the contemporary Hollywood movie, dialogue must carry its weight in describing character and advancing the story for the audience. This is particularly true of action films. Classic novels by writers such as Jane Austen and Henry James that are adapted for the screen usually allow lengthier dialogue. One reason is that green berets and kung-fu masters are not prone to extensive verbal communication, whereas a nineteenth-century lady or gentleman with an education is more expressive. Dialogue should fit the character. There are other exceptions, like Woody Allen films, which thrive on verbal interaction between characters. The Woody Allen talk is part of the character.

1 Check out the screenplay by novelist Ring Lardner: www.geocities.com/Hollywood/8200/Mash.txt.

2 Bradly, Willar King, *Inside Secrets of Photoplay Writing* (New York: Funk & Wagnalls, 1926): "I once asked David Ward Griffith what he considered the best course for one to pursue in writing for the screen, and he answered, 'Think in Pictures!' He had just completed *The Birth of a Nation*" (p. 33). See also Esenwein, J. Berg and Arthur Leeds, *Writing the Photoplay* (Springfield, MA: The Home Correspondence School, 1913): "it is action that is of primary importance. It is what your characters do that counts" (p. 112).

It's easy to write dialogue. It's hard to write good dialogue. Almost anybody can string together an exchange between characters. The difficult part is to develop an ear for the way words will play so that a character speaks consistently, so that an audience will believe in the character, and so that the lines don't slow down the movie. Remember that words take up screen time. Lots of words take up lots of screen time. What is your character doing while speaking? Do they complement one another? If the action is self-explanatory, you don't need dialogue. When it is, the dialogue has to fit the action and the circumstance. We are so used to seeing the performance of actors that makes the lines credible that we forget that we have to create that potential for convincing performance. Many forget that the actor didn't write his lines and that performance can rarely salvage bad writing.

It is elementary that a college professor doesn't talk like a car salesman, a teenager doesn't talk like an adult, and a Boston banker doesn't talk like a Southern farmer. You have to be observant of people and develop an ear for speech. All of us can probably get to that stage. Not everybody can find the words that sound right for the moment. Because most stories involve conflict, struggle, love, revenge, mistakes, or comic embarrassment, dialogue usually expresses emotions. Writers have to find the words that fit the emotion that corresponds to the action and to the character. It must be a new piece in the mosaic that you are building. You can see it individually, but it fits in the whole.

PLOT OR STORYLINE

The plot seems to be the mechanism that most of us see as the embedded structure of the screenplay and movie. It is somewhat like a skeleton. By itself it can't stand up. It needs muscles and ligaments and a life force to animate the total organism. So the plot or storyline is one way of understanding a screenplay. What happens in what order? The way you arrange the sequence of scenes determines the way the story unfolds. That is important.

A plot is really the sequence of actions that traces out a progression of events. This constructed sequence distills the essence of life and shows us something about the way life works.

Even if characters are not tomb raiding, saving the world form asteroids, or trying to defuse a bomb, they are always making choices. The choices they make spring from their values and their nature as characters, which then lead to consequences, another scene, and so the story moves forward.

Action in Hamlet

When Polonius hides behind the arras to eavesdrop on Queen Gertrude's meeting with Hamlet, he creates a circumstance that leads to Hamlet reacting defensively to stab him through the curtain, thinking or perhaps hoping that it is his uncle Claudius, murderer of his father. Because it is Polonius, the plot intensifies and complicates things for other characters. Laertes now has to avenge his father's death. Hamlet has killed the father of the woman he probably loves but cannot acknowledge, Ophelia. Hamlet himself is now in greater danger because of his risky action. Claudius is very much alive and now fearful of Hamlet and therefore much more dangerous. So one action sends stress lines into every corner of the play. The tension is heightened. More action must follow.

COMEDY

As writers, directors, and actors know, comedy is difficult. Good comedy is very difficult. As Sam Goldwyn once said, "Our comedies are not to be laughed at." Writing funny lines as you devise comic situations presents another kind of challenge. Comedy depends on action as well. Even if it is

not slapstick action, it requires physical situations in which characters have to confront embarrassing situations and act in outrageous ways. Comedy requires conflict as much as tragedy. Whereas the tension that arises from conflict in tragedy is released in violence and suffering, the tension that arises from comedy is released in laughter. Silent film developed a visual vocabulary for comedy. Obviously, the slapstick traditions of vaudeville translated to film. The difference is that film had to develop stories not stage acts. The master of this new form, Charlie Chaplin, was writer, director, and star. In *The Gold Rush* (1925), Chaplin plays a tramp who is trapped inside a cabin in a snowstorm in Alaska with a huge, ugly fat man. They have no food. You could just as well imagine this premise as a survival drama. You have seen dozens of them on film and television. The big man starts seeing Chaplin as a meal, hallucinating that he is a large chicken. Chaplin sets about his own survival. He boils his boots for dinner and makes us laugh while he treats the shoelaces as spaghetti and sucks the nails like chicken bones.

Situations of physical danger lend themselves equally well to suspense that is dramatic and suspense that is hilarious. Later in *The Gold Rush,* the cabin is teetering on the edge of a cliff where it has been blown by the storm. The movement of the occupants tilts the cabin and threatens doom at every moment, obliging them to cooperate in order to escape. Some of you may have seen the Harold Lloyd silent comedy in which he is clinging to the hands of a clock on a clock tower. As the hands move, he is in constant danger of falling, but he miraculously avoids it. Buster Keaton also pioneered hair-raising physical gags in movies like *The General.* The line between comedy and drama is sometimes thin.

Comic Devices

Almost any comic device can also be a tragic device. Aristotle contrasted tragedy and comedy by saying that one makes characters look greater or better than they are in real life and the other makes them look worse. Almost all comic devices can be found in Shakespeare's plays. Even the hoary cliché of the comic spectacle of drunkenness is there. See Sir Toby Belch in *Twelfth Night* and the Watchman in *Macbeth.* We have comedy inside tragedy—the fool in *King Lear.* And we have tragedy and cruelty inside comedy—Malvolio in *Twelfth Night* or Shylock in the *Merchant of Venice.* Studying comic devices and how they work will enlarge our understanding of those devices and improve our comic writing.

The Comic Character as Victim

The comic character can be a physical victim or a victim of circumstance; we can call this device *the character as victim.* Silent film relied on physical comedy, and physical comedy works. In *Modern Times* (1936), Chaplin is selected from the production line to test a new feeding machine that a vendor is trying to sell to the factory owner that will allow workers to eat on the job, thereby putting an end to lunch breaks. Chaplin is strapped into the machine and eager to eat, but the machine starts to malfunction and the corncob holder spins out of control until Chaplin stops it with his nose. The soup is thrown in his face. The spectacle of Chaplin desperate to get a bite of this food, which is mechanically delivered too fast or out of range, makes you weak with laughter. The audience empathizes with the hunger, the enjoyment of food, and the frustration. Then there is the spaghetti fight in the official dinner in *The Great Dictator* (1940). In *Lost in Translation* (2003), Bill Murray is forced to run faster and faster on an out-of-control treadmill. In the hospital scene in *Something's Gotta Give* (2003), Jack Nicholson gets out of his hospital bed and wanders around in a hospital gown that shows his bare butt just as his women friends are arriving to visit. He is oblivious, but we are not.

Life of Pi (2012) is little bit of a mixed genre, but essentially the character Pi is a victim. Named after a swimming pool, he is taunted at school. When his parents move their zoo to America, the ship is sunk in a storm and Pi finds himself in lifeboat with a zebra and a Bengal tiger. This problem is real but also a funny because of his endless ingenuity in dealing with the threat. So he is a victim of fate and circumstance, which also means it is a story of survival.

Verbal Comedy

In *Lost in Translation*, the Japanese director of the Suntory whiskey commercial Bill Murray's character is making yells cut and then gives a long speech of direction. The American actor played by Bill Murray and we, the audience, wait with baited breath to find out what this is all about. The Japanese production assistant then translates it in a single sentence: "He wants you to turn to the camera." Then there is another minute of Japanese direction and discussion with the production assistant. And she then turns to him and conveys the direction: "with intensity." Bill Murray's character says, "Is that all? He must have said more than that." The anticipation of what the Japanese means is given a comic anticlimax in the short simple direction. We laugh at the contrast. The dialogue gag enriches the situation, and the dialogue gag works because of the situation. For the most part, this bittersweet film depends on the visual irony of putting characters in background and letting us see how alienated they are. The comedy is situational. The alienation and culture shock is a fundamental driver of the plot. So miscommunication because of language, whether it is foreign language or emotional language (between Scarlett Johansson's character and her husband and between Bill Murray's character and his wife on the other end of the phone and fax), makes the comedy. The screenplay by Sofia Coppola won the Oscar for Best Original Screenplay in 2003.

In *The Devil Wears Prada* (2006), a tyrannical fashion magazine editor treats her assistants like dirt and the new girl, played by Anne Hathaway, disappoints her. So she says petulantly something like, "I thought I would take a chance on the smart fat girl." The deadpan amazement on Anne Hathaway's face, seen in cutaway close-up, is masterful comic acting. The expression validates the line, which is itself hilarious because Anne Hathaway is not fat but extremely attractive. Meryl Streep understates the comedy and allows the audience in. It is a good example of a well-scripted line validated by great acting, authoritative directing, and perfectly timed editing.

Woody Allen's films rely strongly on verbal comedy, both those in which he plays a leading role and in the earlier films, which involved different variations of a kind of stereotype Manhattan persona close to the comedian Woody Allen himself. He has also written and directed a number of films in which he does not appear. His characters are either verbally clever or ironically funny as characters who are not trying to be funny but whose persona, situation, or reactions are funny in context. *Christina, Vicky, Barcelona* (2008) is funny in that way, as is *Midnight in Paris* (2011).

Running Gag

A running gag is comic setup that because it has been introduced to the audience as a premise for humor keeps working over and over again. The repetition enhances and enriches the comedy. In Chaplin's *Modern Times* (1936), a running gag is set up because Chaplin's factory line repetition of tightening nuts with a wrench on the production line leaves him with an involuntary twitch , which then is provoked when he sees big square buttons on the bosom of a lady in the street who runs off in fright with Chaplin in pursuit of his industrial duty. This repeats.

Some Like It Hot (1959), written by I.A.L. Diamond and Billy Wilder, is one of the great movie comedies of all time. You could argue that the premise of the movie is a running gag. Two musicians who unwittingly witnessed the St. Valentine's Day Massacre in Chicago are pursued by hit men from the mob who want to eliminate all witnesses. The musicians disguise themselves as women and join an all-girl band going to a gig in Miami. Cross-dressing is a kind of running gag itself and also a mistaken identity device. Every encounter between Sugar, played by Marilyn Monroe, and the musicians, played by Tony Curtis and Jack Lemmon, reinvigorates the running gag. They are sleeping in the midst of a railroad car full of women in nightgowns. They want to make out but have to preserve their disguise in the sleeping car. Then in Miami, when a millionaire falls for Jack Lemmon in drag, and **Tony Curtis assumes the identity of the same millionaire to woo Sugar**, the gag gets richer and funnier because it is building on what we, the audience, already know.

When Jack Lemmon steps into the elevator with Joe E. Brown as the millionaire, we cut to the floor indicator. The door opens again and Jack Lemmon slaps him for getting fresh. The comedic moment depends on this running gag of impersonation and disguise. Don't be surprised to find that comic and dramatic devices often work in tandem.

➡ **Figure 9.3** *Some Like It Hot* poster.

The Visual Gag

Visual gags are found in pantomime, puppetry, Shakespearian comedy, and, of course, vaudeville. They easily migrated into silent film, but easily survived with the introduction of the talkies. The Marx brothers made numerous comedies that thrive on both verbal and visual gags. **Harpo Marx** developed the visual gag into an art form. The gags often develop and thread scenes together in a fluid way as in *Horse Feathers* (1932). In **Duck Soup** (1933), the hilarious and witty mirror scene shows Groucho in an extended silent gag. Contemporary scriptwriters still rely frequently on visual gags. How many times have you seen a restaurant scene in which the waiter drops a tray or collides with a character? The visual gag is often combined with the character as victim, such as Jack Nicolson walking around in a hospital gown that reveals his backside in *Something's Gotta Give*. The visual gag and the verbal gag can and do work together, especially in modern comedy. So Jack Nicolson's character lying about Viagra in his **heart attack scene** in the hospital let's one reinforce the other.

The Cover-Up/Impersonation

As already noted, devices work in tandem. *Some Like It Hot* involves cover-up, impersonation, and disguise. The musicians are disguised as girls so as to play in the girl band to escape the mob, and they are constantly in peril of being discovered. Not only that, the Tony Curtis character starts a double impersonation as a man pretending to be a woman pretending to be a man in order to seduce or woo Sugar. Recall Viola in Shakespeare's *Twelfth Night*, a woman disguised as a man who cannot achieve her love without abandoning her cover-up persona.

Set in period before the outbreak of World War II in London, *Miss Pettigrew Lives for a Day* (2008) follows the misfortunes of Guinevere Pettigrew in what is sometimes called a screwball comedy but it is also a charming love story. A vicar's daughter, governess, and nanny, who has been fired from several jobs and dropped by her agency, sneaks a job file from the office and meets her new employer, a flighty ambitious American singer masquerading as a star. This character played by Amy Adams immediately recruits her into an elaborate and frantic scheme to juggle her simultaneous relationships with three men. The comedy of the cover-up into which Guinevere is thrust also involves her covering up her real identity as a nanny and pretending to be a social secretary. The excitement of the comedy for the audience is the unpredictable and precarious nature of each scene and its unknown outcome. In this comedy, as in most cover-up plots, the truth must come out for the premise to be resolved, but each character finds truth in a real identity, which completes the unexpected romance. This particular script launches the plot with gags but also sustains a touching story that transcends the gags. Shakespeare's comedies often do this, as in *Twelfth Night*—a masterpiece of gags and romance. Cover-ups can be plot based or transitory comic devices that drive a scene.

Two cross-dressing impersonation movies—*Tootsie* (1982) and *Mrs. Doubtfire* (1993)—deserve mention because the plot of each depends on the audience understanding that the main character is a man pretending to be a woman. In the case of Mrs. Doubtfire, the comedy is also poignant because the character has adopted this disguise so that he can be with his children who are in the custody of the divorced mother.

The Marx Brothers made some great comic films that almost always turn on some kind of cover-up. In *A Day at the Races* (1937), Groucho plays Hugo Z. Hackenbush, a horse veterinarian who pretends to be the doctor of a sanatorium that is going bankrupt. Groucho doing medical exams is so funny it hurts. *A Night at the Opera* (1935) was scripted by a major American comic

writer, George S. Kaufman. The plot is too complicated to summarize in detail but let's just say that it involves Groucho masquerading as a business manager, Otis P. Driftwood. It starts in Milan and unfolds aboard a ship where Groucho's accomplices and two aspiring operas singers are stowaways. When the stowaways hide in Groucho's cabin to evade the ship's officers, it is another laugh-till-you-cry scene. This kind of zany whacky comedy seems to be nothing more than a romp, but all comedy conceals a meaning that is, for want of a better word, serious. Very few people are genuine. To gain approval, success, or fulfill ambitions, we all put on faces or behaviors to conform to what we think employers, friends, and lovers want. We all masquerade, pretend, and cover-up who we really are.

In *Silver Linings Playbook* (2012), Pat, a man with psychological problems, has been released from a mental institution and has moved in with his parents. Desperately trying to reunite with his ex-wife, who has had an affair with someone and run off, Pat gets involved with Tiffany, a troubled woman, who pretends to know his ex-wife and deliver his letters to her and, unknown to him, writes replies. Tiffany convinces Pat to be her partner for a dance competition. Meanwhile, Pat's father, a gambler who bets big money on the home football team, is convinced his son's association with Tiffany is spooking his bets on games. There is a **hilarious scene** in which she quotes game statistics to prove him wrong. After losing to his friend, the **dad doubles down** betting on his son and Tiffany getting higher than a 5 in the judges' average score at the dance competition for which they have been practicing. Once again, comic devices are amplified by suspense twists to the plot. In the end, Pat finally realizes his relationship with his wife is over and that he loves Tiffany. This film is full of great one-liners and verbal comedy as well.

Cover-up and impersonation always involves a degree of suspense. At any moment, the cover might be revealed and the impersonation discovered. In *Argo* (2012), six American diplomats are hiding in the residence of the Canadian ambassador in Tehran right after the coup overthrowing the Shah and the storming of the U.S. Embassy. The CIA is looking for a way to get them out of the country. The least bad plan they can come up with is to disguise them as members of a film crew scouting locations in Iran for a bogus science fiction film with the title *Argo*. It is also a kind of film within a film creating a tension between the fake film which is ridiculous but essential to the tense reality of the film itself and its tense and serious story. Each of the Americans has to have a fake Canadian passport and invent a fake identity with back story to their lives in case of questioning by the revolutionary guards. The CIA gets a couple of Hollywood producers to mount a fake production with all the trappings, which ruthlessly satirizes Hollywood, to authenticate any investigation. This story also involves cover-up and impersonation, which are closely related. The audience is laughing and biting its nails at the same time. There are also scenes that rely on verbal comedy. The premise is absurd, funny, and life threatening at the same time. It is also somewhat falsified. In reality, the Canadian Ambassador did a great deal more than depicted. There was no suspense scene at the airport as depicted with revolutionary guards chasing the plane down the runway.[3] This is one more lesson about the difference between realism and reality.

Disguise and Mistaken Identity

Disguise is a variant of the cover-up. Mistaken identity is when cover-up happens in spite of the characters. We can call on *Some Like It Hot* again to illustrate disguise. The cross-dressing is essentially a form of disguise. It has a wholly different meaning in *The Crying Game* (1992), in which

3 Ty Burr, "Truthiness and Consequences," *Boston Globe*, February 23, 2013.

an IRA defector fleeing to London looks up the girlfriend of the British soldier he had to guard, becomes attracted to her, and finds out that she is in fact a transvestite. In a previous chapter, we mentioned *Twelfth Night,* which turns on the transvestite disguise of Viola, which then leads to many comic complications. She falls in love with the duke for whom she is the love messenger but cannot reveal her true gender. She is mistaken for her brother Sebastian, which gets her into a sword fight with Sir Andrew Aguecheek that they both desperately try to avoid. The entire plot of Shakespeare's early *Comedy of Errors* is based on an old premise from Latin comedy of twins being taken for one another and confusing those around them and the twins themselves. It is hard to top Shakespeare.

Burn After Reading (2008) involves a hilarious misunderstanding that the manuscript of a memoir of an ex-CIA agent is a secret document that can be used to get reward money. Every character in this movie misunderstands and mistakes every other character for someone else until finally the CIA agrees to finance Linda Litzke's plastic surgery makeover if she promises to keep quiet about a train of events and murders that they do not understand. Consider *Never Been Kissed* (1999), in which Drew Barrymore plays a reporter pretending to be a high school student to do an undercover story, or *Miss Congeniality* (2000), in which Sandra Bullock trying to be a tough guy FBI agent has to go undercover as a beauty queen to prevent a terrorist plot against the Miss America beauty pageant, or the original screenplay of *Dave* (1993), in which a character who looks like the president of the United States (who is seriously ill) is persuaded to fill in for him and govern the country. *The Master of Disguise* (2002) is comedy thriller whose title incorporates the comic premise itself. We'll finish with a remake of a Humphrey Bogart movie *We're No Angels* (1989), in which two escaped convicts played by Robert de Nero and Sean Penn disguise themselves as priests to get to the Canadian border and freedom.

Dramatic Irony

A simple kind of dramatic irony occurs when the audience knows more than the character or characters in the novel, play, or movie. So their actions or words have a meaning to us that is more complex than it is to them. Again, *Some Like It Hot* provides a comic example. Because we know that Tony Curtis and Jack Lemmon are men disguising themselves as women, we know something the other characters don't. Without the audience being in on the joke, the comedy wouldn't work.

Burn After Reading (2008) also involves dramatic irony in that each character does not know what we know. So we see them working at cross-purposes. Chad, played by Brad Pitt, is shot by the treasury agent played by George Clooney when he discovers him in his closet and assumes he is a spy because he has no identification. So Chad, the innocent gym instructor who thinks he and Linda have found secret documents, ends up being caught up in a CIA drama even though it is all a complete and total misunderstanding on the part of all players. Most comedies depend on dramatic irony that requires the character to know less than the audience about his or her own situation.

DRAMA

Almost any dramatic device can be turned to comedy, and almost any comic device can be turned to drama. How many times have you seen a nail-biting scene in which the hero or heroine is hanging by one hand from a building or stuck in a wreck about to fall over a bridge or cliff? Then they slip and fall to the next ledge, or the rescuer seems like he cannot hold on. The scene is milked

for suspense, but you don't laugh like you do at Harold Lloyd hanging from the hands of a clock. Why? There's the difference between comedy and drama. In drama, such a scene is written and played for tension and suspense. The premise is identical to the premise for comic disaster. Drama means conflict, high emotion, and usually action. Suspense drama turns heavily on plot. The consequences of action are critical for life and death, success or failure, so that we worry about what will happen. In comedy, the consequences of action are also critical, but we are allowed to laugh at the victim who represents all of us faced with the indignities of life. Although the premise of comedy and drama may be similar, the outcome is always different—happy as opposed to serious. How is the writing different? Dialogue and character weigh heavily in pushing the concept one way or the other. Comedy requires gags, tension, and overreaction. Drama requires tension, conflict, and understatement.

Cover-Up/Mistaken Identity

Cover-up and mistaken identity are usually essential to much detective fiction and many crime thrillers. Someone innocent is taken to be guilty. There is even a film whose premise is its title—*Mistaken Identity* (1999; the alternative title is *Switched at Birth,* a title that was used three times in the silent era). Two mothers find out that their babies were accidentally switched in the maternity ward. The same premise allowed Mark Twain in *Pudd'nhead Wilson* to explore the thesis that character and social status derive from conditioning. A light-skinned slave and his master's son are accidentally switched in the cradle so that the scion of the plantation grows up as a slave and the Negro slave grows up to be a cruel plantation owner. Wilson is able to show by the new science of fingerprinting that the slave is the master and the master a slave. In Mark Twain's hands, this premise is a devastating condemnation of slavery and racial prejudice.

Disguise

The Wolf disguises himself as Grandma in *Little Red Riding Hood.* Almost all the comic book superheroes—Batman, Superman, and Spiderman—go in disguise. Superman disguises himself as reporter Clark Kent, but Batman is a disguise for Bruce Wayne. *V* (2003) is about a masked avenger. Then there is the old Saturday movie serial hero Zorro, subsequently made into feature films, and *The Lone Ranger,* remade in 2013. *The Man in the Iron Mask,* a novel by Alexander Dumas, which brings the premise into the title, has been made into a movie several times, most recently in 1998. *The Mask* (1994) again brings its premise into the title, with Jim Carrey playing a timid character who finds a mask that transforms him into a daring and powerful character opposite to his reality. Horror films that play with the Halloween theme often use masks and disguises as suspense and frightener devices: *Scream* (1996), *Halloween: Resurrection* (2002) and its predecessors, *2008* (2009) and its predecessors. All vampire movies basically turn on disguise. The vampire looks human and has human form but has another identity that is in conflict with human nature: see *Interview with the Vampire* (1994) and, recently, *Twilight* (2008) and its sequels.

Dramatic Irony

Dramatic irony occurs when words or actions mean something different to the audience and the character. Dramatic irony that is not comic in effect but an intensifier of drama, suspense, and tension is central to *Little Red Riding Hood.* We know that the Wolf knows where Little Red Riding Hood is

going. We know that the Wolf has eaten Grandma and is waiting for Little Red Riding Hood, but she doesn't know. Every horror film and suspense thriller depends on a key moment of dramatic irony when a character, usually a female victim, walks into a trap or into danger that we, the audience, know is there because of a prior shot of the lurking monster/rapist/slasher. We watch knowingly as a character walks into a trap, a situation of danger, or sometimes the opposite, a situation of triumph. The most powerful dramatic irony in a tragic character is Oedipus. A man unknowingly kills his father and marries his mother.

The Bank Job (2008), a brilliant script, tells the true story of a 1971 bank robbery in London that was never prosecuted because the government wanted to cover up scandalous photos of a member of the royal family that were in the bank vaults that were looted. The British secret service convinces a woman that she won't be charged if she helps them to recover the pictures. She gets an old flame, a shady car dealer, to put together a gang to tunnel into the bank vault. The irony is not only that they don't know that they have been put up to the job, but it is heightened when they get off scot-free when caught in the act because the scandal would threaten VIPs in government and the royal family.

In Bruges (2008) involves two hit men who are sent to Bruges, Belgium, to wait for orders. Meanwhile they become out-of-place tourists interacting with a range of characters from a dwarf actor shooting a film, to a woman selling drugs, to the people on the set of the film, to a hotel manager. The film ends in a bloody climax in which one of them, in carrying out a hit, kills an innocent boy. The characters are in a world that they do not understand, and they do not even know why they are there. The dark comedy turns into strong suspense because we learn with the characters why they are there and who their controller is. *Doubt* (2008) is a title with a double meaning. It refers to the doubt that the Meryl Streep character has after destroying the career of the priest she accuses of pederasty, and it refers to the doubt that we, the audience, experience because we are momentarily receptive to her conviction but finally we are uncertain and left in doubt.

Ambition/Pride

Hubris is the Greek word for that delusion of invincibility or being in control, that is the pride which "goeth before a fall." The spectacle of human beings convinced that they are in control of their own destiny or of an ego that cannot give way has an implicit dramatic premise. Tragic characters are deluded into thinking that they are masters of their own destiny. Spiritual teaching, both Eastern and Western, tells us that "thine is the kingdom, the power and the glory." Many use the expression "What goes around, comes around." This is *karma*, the Vedic understanding that there is a law of cause and effect in the actions of human beings that plays out over more than one lifetime. Drama requires action and consequence to play out in a single lifetime, such as when Macbeth murders his liege lord out of ambition, showing a fundamentally good man who makes a bad choice. *Frost/Nixon* (2008) explores the downfall of a president who was impeached for his criminal choices. *There Will Be Blood* (2008) explores the ambition of a man who wants to annihilate his competitors and be the king of oil, only to lose his own son.

A somewhat gentler version of ambition and pride drives the plot of *Hitchcock* (2012), which tells the story of this legendary director's struggle to produce the classic horror masterpiece *Psycho* (1960) with the famous and controversial murder scene in the shower. It also involves challenge and survival. The studio will not finance his concept. So armed with his conviction about his greatness and mastery as a director, he and his agent decide to finance it themselves and do a distribution deal with the studio. Hitchcock is arrogant and self-assured about his narrative powers and will not let the studio executives on the set or see any footage before the finished film. His

patient wife is a silent co-partner who participates in solving his storytelling problems. There is an undercurrent of jealousy—her jealousy of his secret lusting after nubile blond actresses that he casts in his movies, him of her relationship with a scriptwriter who wants to collaborate with her and have an affair. *Psycho,* initially disappointing and displeasing to the studio, became a gigantic hit. The famous shower scene seems tame now, but in those days, the Motion Picture Association of America board would not give it a rating. His eventual success allows Hitch to acknowledge his wife's intelligence in helping re-edit the picture and brings them together. This may be an invention of the screenplay.

Challenge and Survival

Treasure of the Sierra Madre (1948) is a classic story of greed about a down-and-out American in Mexico who teams up with a prospector who has a gold claim that needs to be worked. Once they mine enough gold to be rich for life, they then have to get it back to town to sell it. They have both inner and outer challenges. But this is also a story of greed, a category we discuss later. *La Vie en Rose* (2007) is the real-life story of Edith Piaf, who survived an orphaned existence on the streets of Paris and became a beloved music hall singer. *The Wrestler* (2008) tells the story of a down-and-out wrestler who has lost his family, his daughter, and his friends, and struggles to survive in ignominious jobs until he decides to make a final comeback against all medical advice. He dies in the attempt to claim his only identity. *Gladiator* (2000) shows us a character who, despite a terrible loss of status, wife, and children, learns to survive and confront his tormentor. *Jurassic Park* (1993) turns into a drama of challenge and survival as soon as the park structure fails and the visitors are at the mercy of the genetically engineered dinosaurs that inhabit the island. *Slumdog Millionaire* (2009), which won the Oscar for Best Picture, tells the story of a slum orphan who wins a *Who Wants to Be a Millionaire* million by turning his fantastic life experiences into knowledge and insights that enable him to answer the questions. Some survival stories lead to loss and suffering; others lead to triumph. In *Dances with Wolves* (1990), there is a temporary triumph in the flight and escape of the Sioux and Lieutenant John Dunbar before the U.S. Cavalry, but we know the ultimate fate of Native Americans; so it is only a temporary survival.

The fairy tale of Snow White is about survival, as is Cinderella, as is Hansel and Gretel. The movie *Snow White and the Huntsman* (2012) is a free-wheeling version of the fairy tale. It lends itself well to the three-act structure and offers an opportunity for advanced special effects. *Hunger Games* (2012) is absolutely about survival as is an unusual independent film, *Beasts of the Southern Wild* (2012), about a Cajun subculture community that is confronted by a hurricane.

A major production of 2012 was Steven Spielberg's *Lincoln,* a real-life story of challenge and conflict. After signing the Emancipation Proclamation, Lincoln is determined to get the Thirteenth Amendment to the United Sates Constitution through a fractious and divided Congress.[4] The political desire to end a bloody, costly, and exhausting Civil War by some kind of negotiation conflicted for many with outlawing slavery, which would exclude negotiation with the Confederacy. Finding an ethical bearing and managing the politics of this achievement put Lincoln in a political bind. He had to gamble on military victory to save the Union and pass the Thirteenth Amendment. Compromise was not possible. The script for this movie is limited to portraying this

4 Section 1. Neither slavery nor involuntary servitude, except as a punishment for crime whereof the party shall have been duly convicted, shall exist within the United States, or any place subject to their jurisdiction.

Section 2. Congress shall have power to enforce this article by appropriate legislation.

historic struggle as a way of looking at the private and public personality of Lincoln and the politics of the period. In fact, the writer Tony Kushner, a well-known playwright, falsified history for dramatic effect in the roll call scene of the House vote. The two *no* votes are fictional; the roll was called alphabetically by name, not by state, and all four Congressman from Connecticut voted for the amendment. The producers didn't think that a barrage of random names gave the audience enough "place holders" (Kushner's phrase) to sustain their interest in the scene. "In other words, the writer sacrificed the facts not to art, nor to greater thematic meaning, but to his audience's attention span—to the prerequisites of commercial cinema in a Darwinian entertainment marketplace."[5]

Greed

Greed is one of the seven deadly sins. The pursuit of money and material things and the craving for wealth is a common denominator that any audience understands. In fact, the other six sins are a pretty good source of drama too: lust, gluttony, sloth, wrath, envy, and pride.

Treasure of the Sierra Madre (1948) begins with a down-and-out American losing a lottery with his last peso. Later, after becoming rich beyond his wildest dreams, the American ends up stuck on a mountaintop with two other gold prospectors. The three fall into a paranoid state of suspicion about each other. Each fears that the others will kill him and take his share of the gold. It is based on a classic morality tale in Chaucer's *Canterbury Tales* told by the Pardoner. *There Will Be Blood* (2007), based on Upton Sinclair's novel *Oil*, is about a ruthless dominating character who cheats people out of their oil rights as he build an oil empire and great wealth. He loses his only son and gains nothing but emptiness and loneliness.

Wall Street (1987) is a classic story of greed. There is the famous line by Gecko, the film's corporate raider: "Greed is good." So this film focuses on greed as a phenomenon that motivates ambitious financial operators whom many want to emulate. It is suddenly relevant to the present day in which greed and speculative fever brought down the American and world banking systems and brought about the worst recession since the Great Depression.

Most crime dramas are really motivated by greed. Robbery and stealing are fundamentally about greed and coveting money, wealth, and a life of ease. Although some crime capers involve wit and socially intriguing relationships, like *Ocean's Eleven*, first made in 1960 with Frank Sinatra, and then remade with Brad Pitt and George Clooney in 2001, followed by sequels *Ocean's Twelve* and *Ocean's Thirteen*, most of them involve desperate and avaricious men who are prepared to use violent means to get what they want. There seems to be a great ambivalence in the culture or in the audience about right and wrong. Criminals are often turned into protagonists and heroes. We identify with their ambition and vicariously want them to succeed. The antagonists therefore become the police, which creates a moral dilemma. This moral ambivalence separates them from the anti-hero, who is a main character that is not necessarily heroic, like Jay in *The Great Gatsby* (1974 remade in 2013). Whitey Bulger, the notorious Boston gangster played by Jack Nicolson, was the main character in Scorsese's *The Departed* (2006). Sometimes, we identify with the forces of law and order and can accept their triumph, indeed, even root for them. That usually happens when we strongly identify with a victim of crime. Victimless crimes like white-collar crime or even certain kinds of stealing and robbing of banks appeals to our fascination with the challenge and risk that we understand to be part of the enterprise.

5 Ty Burr, "Truthiness and Consequences," *Boston Globe*, February 23, 2013.

Love Gone Wrong

We all know *Romeo and Juliet* as the classic story of love gone tragically wrong. In this case, the world around the two lovers conspires to frustrate their union. *Sylvia* (2003) is the true story of the love and marriage of the American poet Sylvia Plath to the English poet Ted Hughes, the disintegration of their relationship, and her eventual suicide. *The Lover* (1992) adapts a novel by the French novelist Marguerite Duras, which is a recollection of a tragic love between her as a teenage girl and an older, wealthy Chinese man. They are divided by culture, age, race, and class. It is a powerful story of loss that haunts two lives. The lyrics of an old French song express it: "the pleasure of love lasts but a moment; the pain of love lasts a lifetime."

Although *Doubt* (2008) is not about carnal love but spiritual love, it is nevertheless relevant because the caring of the priest accused by the head of the convent school of perverting a young black boy is probably a true expression of love, *agape* not *eros*. The Greeks had a distinction between erotic love and love that does not have a sexual dimension that is precious to human beings: the love of parents for children, of siblings for one another, of children for grandparents, and of friends for one another.

The Duchess (2008) is a biographical portrait of a woman who finds herself in a loveless marriage to the richest and most powerful duke of eighteenth-century England. She must find the strength to bring up children, endure his mistress, and renounce her love of a future Prime Minister of England for the sake of her children.

Desire/Lust/Jealousy

Everyone understands desire. Lust, intense, often uncontrollable desire, is one of the seven deadly sins. Whether desire is a sin is a religious question, but it is certainly an inevitable component of human lives and a cause of endless pain, jealousy, and drama, as well as a certain amount of happiness. In comedy, we imagine the happy outcome of this force of attraction. In drama, we confront the ways in which this hormonally driven emotion enters our lives and unleashes possessiveness, jealousy, pain, and even hate when love is spurned or rejected. *The Lover* (1992) expresses truthfully the strength of desire as a driver in human relationships. It is different because the characters know they are doomed. The girl deliberately destroys their potential for love until at the end she realizes that she really loved and was loved. Not many Hollywood films can go the distance with this kind of story. Great works of literature such as Flaubert's *Madame Bovary* or Tolstoy's *Anna Karenina* deal with destructive adulterous love. *Anna Karenina* has been filmed for movies and television at least a dozen times, the latest adapted by Tom Stoppard in 2012. Adulterous love induces an instant situation of conflict, which can only resolve with unhappiness of one kind or another for the lovers, their spouses, and, sometimes, their children. Nevertheless, it happens over and over again in real life and in the movies.

Body Heat (1981), an original screenplay written by Laurence Kasdan, shows how a man can be set up by seduction into killing a woman's husband so that she can inherit his wealth, even though there is no intention on her part to continue the relationship. Controversy surrounded *9 1/2 Weeks* (1986), which explores eroticism and desire as a force of attraction and seduction without romance. The film involves a wealthy businessman who captivates a young, recently divorced woman. It tests extremes of trust and goes where most American films don't go. The most radical exploration of desire as an all-consuming force of almost any film ever made is Japanese director Oshima's *In the Realm of the Senses* (1976). Initially banned in North America, it chronicles the true story of obsessive love and desire that leads to sexual mutilation and death by strangulation because the character seeks greater extremes of sexual

pleasure. A weaker version of this theme would be Madonna's role as a woman charged with knowingly murdering a man by causing him to have a heart attack during extreme sex in *Body of Evidence* (1993). She later seduces her defense lawyer, who then is forced to question the innocence he is defending. *Two Lovers* (2008) shows us a young man who misses the loving woman right under his nose and whom his family wants him to marry pursuing a more complex, mixed-up woman who is in a destructive affair with a married man. In *Elegy* (2008), an older man who is a professor makes advances to an attractive female student but does not have the courage to follow through when she responds. *Lolita*, the novel by Nabokov, was made into a movie twice—in 1962 with James Mason and in 1997 with Jeremy Irons. It tells the tragic attraction that a professor of French has for the daughter of the woman at whose house he boards because she recapitulates his teenage love who died and left him trapped in a lifetime of nostalgic yearning to recapture his youthful relationship. This leads to his seduction of and by Lolita. It becomes an increasingly destructive relationship, initiated by the 15-year-old Lolita.

WRITING TECHNIQUES FOR ADAPTATION

When you go to the movies, you should watch the screen credits and see who the writer is. See whether it is an original screenplay. Pay attention to the writer and to the writing talent that makes movies possible. Don't be one of those vulgarians who walks out as soon as the credits come on. Although the audience remembers the actors, whose lines we write, maybe the director, who interprets our story, they rarely remember the writer. The basis of every movie is a screenplay. Every screenplay is the work of a writer.

Although most movies discussed here are adapted from another source work, the glory of the medium is the original screenplay. Writing directly for the screen is a great craft and difficult to do well. *Citizen Kane* (1941), written by Herman J. Mankiewicz and Orson Welles, is one of the greatest original screenplays ever written. Lawrence Kasdan is an accomplished writer/director. His *Body Heat* (1981) is a flawless murder-mystery thriller. Jane Campion wrote and directed *The Piano* (1993) to international acclaim. One of the true talents of movie writing in America is Paul Schrader. His writing and directing credits are numerous and include the original screenplay for Martin Scorsese's *Taxi Driver* (1976).[6] My favorite Schrader film is *Mishima* (1985), about love and honor in a cross-cultural love affair in Japan involving an ex-GI. Don't forget to read William Goldman's original screenplay of *Butch Cassidy and the Sundance Kid* (1969), published in *Adventures in the Screen Trade*,[7] which tells you a lot about working realities for writers in Hollywood.

Let us reprise a point we made in Chapter 1 while working up an understanding of visual writing, the kind of writing that is special to the screen. We used Hemingway's novel *A Farewell to Arms* to show the difference between prose fiction and screen writing by asking how we would translate the opening descriptive paragraph into a screenplay. We were showing the difference between two types of writing, two types of storytelling. We now need to look at a much bigger issue, which grows out of that initial problem of what you represent in a scene when you adapt a source work for filming. We need to deal with techniques of adaptation.

In the entertainment world, writers are frequently called on to adapt their own or someone else's work, but adaptation also happens to be a really instructive exercise for the beginner; it can help the

6 Paul Schrader, *Taxi Driver* (London: Faber & Faber, 1990). See also Paul Schrader, *Schrader on Schrader & Other Writings*, Directors on Directors Series, edited by Kevin Jackson (London: Faber & Faber, 1992); and Paul Schrader, *Transcendental Style in Film: Ozu, Bresson, Dreyer* (London: Faber & Faber, 1988).

7 William Goldman, *Adventures in the Screen Trade* (New York: Warner Books, 1983).

beginner learn how to write for the screen and discover the art of visual writing. Adapting can be one of the best ways to appreciate what screen writing is and, by the same token, what prose fiction is. If the storyline and the characters already exist, then the writer can concentrate on the problem of key moments and the 2-hour continuum of the movie.

The Problem of Adaptation

Adaptation presents a special problem of translating one medium to another. Shakespeare, the master dramatist, was also a master adapter. Most of his plays drew from existing literary works. The parallel between the new medium of Elizabethan theater and the new medium of film is revealing. Although many great screenplays have been written originally for the screen, it is probably safe to say that most movies that we see are adapted from source works. Sources can be novels, short stories, stage plays, musicals, epics, fairy tales, and folk tales. You might think that a play is easy to adapt to film because it is made up of dialogue and action, but in a play, action takes place on a stage. A movie cannot just film a stage, although that is how many early silent movies were shot. People thought in terms of watching performance on a proscenium stage. It didn't take long for someone to figure out that you could move the camera and liberate the actors from painted scenery. Then, camera angles were invented, which necessarily led to the art of cutting shots.

Although the original screenplay is, in a way, the glory of the medium, risk-averse producers and movie studios look to properties that have succeeded with audiences in other media as a form of insurance. Producing and distributing movies is a high-risk business. Producers will look for any way to reduce the odds and increase the likelihood of recovering their investment. A best-selling novel has a ready-made audience. A Broadway hit has a prior reputation that helps to sell the movie. Filming successful new works in the theater or in print comes with a price. Getting the rights to a John Grisham novel involves competitive bidding against other producers. So the insurance of buying a pre-sold audience and a ready-made story increases production costs and obliges the producers to share profits with the original writer. Increased production costs then demand the security of box office stars and known directors, what is known in Hollywood as "A list talent," which increases the production cost yet again.

For these reasons and because the rights are in the public domain, producers also look to classic works from Homer, through Shakespeare, to Dickens, and other classic writers. Not only are their stories in the public domain and therefore free, but they have withstood the test of time and held audiences' attention for generation after generation. The ready-made audience is proven. The trade-off is that it may be a smaller audience that is educated and literate, rather than the worldwide popular audience that does not read or does not know the great works of literature. The other element that sometimes dampens enthusiasm for these stories is that they are set in the historical past. This does not always appeal to audiences who have an appetite for seeing contemporary life reflected in the movies.

Period movies involve costumes, locations, and props that considerably increase the cost of production. In 1995, Jonathon Swift's satirical work *Gulliver's Travels* was turned into a television miniseries. The producers took advantage of modern computer-generated special effects. However, they introduced a shell story not in the original, in which Gulliver has a son and a wife who want him back. When he returns and is condemned as a madman, the son saves him by finding some of the miniature animals from Lilliput in their luggage. It tampers with the author's intention and sentimentalizes the final satire that has Gulliver preferring the company of horses (Houyhnhnms) to humans and going to live in a stable.

In the 1990s, producers discovered the works of Jane Austen and Henry James, two authors whose novels are not generally mass audience fare. Yet both authors have subtlety and texture that

is surprisingly modern and cinematic. Hidden emotional forces in the lives of their characters can be portrayed in the visual language of cinema. Implied sexuality can be more readily understood in looks and gestures. Consider the film adaptations of *The Wings of the Dove* (1997) and *The Portrait of a Lady* (1996). Filmmakers can find contemporary values in old stories. Jane Austen's struggling and independent female characters can make the changing role of contemporary women all the more poignant because of the social strictures of early nineteenth-century England or the conventions of social behavior in Golden Age America. Films such as *Pride and Prejudice* (1940; and again in 2005), *Sense and Sensibility* (1995), and *Emma* (1996) have won Oscars and have been remade several times since the invention of film and television.

Here is the author's adaptation of a scene from Henry James' *Daisy Miller.* Let us look at two versions to see how and why dialogue works and doesn't work in adaptation.

INT. MRS. WALKER'S APARTMENT—DAY

A SERVANT ushers WINTERBOURNE into the crimson drawing room of a Rome apartment filled with sunshine. MRS. WALKER greets him and WINTERBOURNE kisses her hand.

> MRS. WALKER
> My dear Winterbourne! How nice
> to see you! How are you? How is
> Geneva?
>
> WINTERBOURNE
> Geneva is less delightful now that
> you no longer winter there. I am
> very well and happy to be in Rome
> again. How are your children?
>
> MRS. WALKER
> We have an Italian tutor for them,
> but he is not as good as the Swiss
> school and their teachers.
>
> THE SERVANT ENTERS AND ANNOUNCES
> DAISY MILLER AND HER FAMILY.
>
> SERVANT
> (with Italian accent)
> Signora e signorina Meellair!

The fault in the writing is that Mrs. Walker asks two questions. Winterbourne then answers them in series. It would be better to revise it as follows to facilitate the flow of dialogue:

> MRS. WALKER
> My dear Winterbourne! How nice to
> see you! How is Geneva?
>
> WINTERBOURNE
> Geneva is less delightful now that
> you no longer winter there.

```
                    MRS. WALKER
           How are you?

                   WINTERBOURNE
           I am very well and happy to be in
           Rome again. How are your children?

                    MRS. WALKER
           We have an Italian tutor for them,
           but he is not as good as the Swiss
           school and their teachers.
```

On the other hand, when Mrs. Miller speaks, her voluble aimless recitation is not a conversation. She has no social sense. While she rants on about her health, the camera shows Winterbourne trying to contain his boredom, his furtive glances at Daisy talking to someone else, and the leaping about of the restless Randolph, her 12-year-old brother.

Length

Movies and television play in real time. A minute is a minute on screen. The movie narrative has a time limit. A paragraph or a page has no fixed time value. A novel can condense time and expand time. It can pack into descriptive prose numerous locations and casts of characters that would cripple a movie budget. Also, the novelist can describe characters and express their thoughts by means of the omniscient narrator. So the first problem of adaptation is to find a visual and action storyline that is not dependent on the omniscient narrator. In general, source works are longer than the movie can be because prose narrative is, in certain ways, more efficient than narration in visual media, which depends on action. Short stories and novellas generally make a better transition to the screen. A case in point is the classic Western *High Noon* (1952). The screenplay was written by Carl Foreman, adapted from a *Collier's* magazine story "The Tin Star" (by John W. Cunningham), published in December 1947. The film is better than the original story. Another is *It's a Wonderful Life* (1946), discussed in full below.

Point of View

Some readers might have tried their hand at prose fiction, either short story or novel. It is quickly apparent that the writer of fiction has options that the screen writer does not. The most important of these is the narrative point of view. Prose narrative must have a point of view. Although Melville's *Bartleby,* for example, is narrated in the first person from the point of view of a single character and the way he perceives events, the most common style of narration for the novel is usually referred to as the omniscient or third-person narrator. The writer can see everything and know the thoughts of all the characters. The writer can write objective description that sets time, mood, and place without reference to a character's point of view. Or the writer can describe what a character sees and thinks as well as put lines of dialogue in the character's mouth. This flexibility is part of the richness of fiction as a form. In some ways it is easier to write fiction because of the versatility of its narrative devices.

Writing for the screen means, similar to writing for the theater, confining the narrative to a certain duration. The story must be told within a time frame defined by the medium. We have all seen movies of a book we have read and felt the disappointment that the movie is not as good as the book. A movie can never be like the book because it is a different medium. Parts of the novel have to be left out. A novel can luxuriate in passages of description and describe the inner thoughts of characters in

omniscient third-person narrative. For the film adaptation, however, the plot usually has to be tightened up. Sometimes the setting has to be changed. And a novel that one can read in 10 or 20 hours has to play 2 hours.

The question of point of view is important for movies because the camera must point one way or another for every shot. As an optical recording instrument, it necessarily creates a literal point of view. The viewer cannot see anything other than that which is included in the frame. In some ways, this makes the medium powerful because it is concrete and because it creates emphasis. On the other hand, it also limits what the audience can see and experience by placing a specific image in the viewer's consciousness and excluding all others.

Narrative Tense and Screen Time

After point of view, the second great variable is narrative tense. A novel can weave in and out of present time, but a movie camera narrates in the present tense because what we see is necessarily present time.[8] So screenwriters have to think in terms of seeing and hearing what characters do and say in front of us. A screenwriter cannot represent the characters' thoughts in the same way that a novelist does. Thoughts must be revealed through action and reaction in situations. Voice-over narration in the voice of a principal character or even hearing parts of a novel narrated verbatim on the sound track sometimes work. Choosing this solution often seems to be an opt out from screenwriting, which must be visual and based on action. Scriptwriters have to narrate through key moments of the story.

We have to narrate by means of key moments. A novelist can write in the past tense (which is the most common), can write in the present tense, or, to a degree, and with care, can even change tenses, depending on the point of view.

This cannot happen in film unless you admit the flashback to be a tense change, which for film it most approximates. Even in a flashback, the camera films in the present tense, as it were, and the viewer experiences the past now. It often has to be cued by subtitles on screen or a voice-over. We have referred to *Citizen Kane* as a film that relies successfully on flashback. It succeeds by introducing a reporter who is putting together the life of Kane by interviewing those who knew him, which is an effective device that unifies the film and legitimizes voice-over. In some films, the manipulation of tenses of time relative to the main time of the story can become confusing. Viewers need to know when the story is in the past and when it is in the present. Some films create confusion when playing with chronological order. This is not the case with prose fiction. The signposts are usually unambiguous. This is probably because some of the time shifts in film are created by editing in postproduction. Tarantino's *Pulp Fiction* (1994) is a prime example of chopping up the chronological order of the story, which smacks of postproduction decisions, to make the film more intriguing and keep the audience guessing. *Memento* (2000) comes to mind, even though the premise of the film posits a character with short-term memory loss.

Setting and Period

The first issue that comes up with adaptation concerns setting. Do you do the piece in period? Or do you transpose the story to another time? Is the story attached to its time? These questions came very much to the fore in adapting *Bartleby*. The question was whether an audience in the 1970s would respond to this story if it were set in a legal office in the New York of a century before. Could the

8 See Kenneth Portnoy, *Screen Adaptation: A Scriptwriting Handbook* (Boston: Focal Press, 1998), p. 7: "In the novel, there are three time periods—past, present, and future. The screenwriter must deal in the present and devise ways to reveal the past."

timeless element of the story be transposed to the modern day and thereby reveal a meaning that many would not recognize in a setting of frock coats and quill pens? The passive resistance, the portrait of a loner who would not cooperate with an employer or with social norms, seemed intensely relevant to a post-Vietnam world of political protest and a generation of youth who did not buy into the social contract. The story seemed to be a commentary on the contemporary social phenomenon of the dropout. There were hundreds of Bartlebys. In fact, many people have said to me that they have met or known a person just like Bartleby. So the character seems to be timeless because Melville is making an observation about human nature.

There are tremendous risks to transposing the story. A lot of elements change. For instance, a modern law office does not use scribes to make copies of legal documents. Legal secretaries, and now word processing, take care of that chore. So what is a modern equivalent? From my observation of dealing with lawyers and accountants, the answer seemed to be that an accountant's office, where bookkeepers' work with figures and balance sheets demands meticulous drudgery, would be the modern-day equivalent. Of course, with a contemporary setting, other details would have to change. However, setting it in London, England, in a kind of stuffy, retrograde British professional, gentlemanly environment seemed to be a perfect equivalent to the mannered stiffness of the New York lawyer of a hundred years earlier. Once you go in this direction, everything changes. A more recent adaptation of *Bartleby* in 2001 was based on the same decision to bring the story forward to a contemporary setting.

A comparison might be that of changing the setting of a Shakespeare play. It is frequently done in the theater and in movie adaptations. *West Side Story,* the famous musical by Leonard Bernstein, reworks Shakespeare's theme of "star-crossed lovers" by placing them in modern New York among Puerto Rican gangs. Think of the film of *Romeo and Juliet* (1996), in which gangs with .45-caliber automatics in a Latin setting substitute for the houses of Montague and Capulet in Renaissance Verona. The emotional truth of the story is largely intact, but the text has to be edited for anachronisms. In many ways, that movie idea derives from Bernstein's musical crossed with *Miami Vice.* An English movie made in 1995 set *Richard III* in a ruthless fascist world that recalled Nazi Germany as a way of making the unprincipled villainy of Richard's political plotting more plausible. A new *Hamlet* came out in 2000 that set the play in contemporary New York. In it, Denmark is a corporation and the king a CEO. Sometimes, the device of moving the period creates more problems than solutions. I remember seeing an absurd theatre production of *The Merchant of Venice,* which misinterpreted the play as being about anti-Semitism and therefore cast the Antonio-Portia-Belmont crowd as Nazis. Consequently, in the last act, Portia, now disguised as a Nazi lawyer trapping Shylock with the legal consequence of his taking a pound of Venetian-Nazi flesh, is in the ridiculous position of pronouncing the famous lines:

> The quality of mercy is not strain'd,
> It droppeth as the gentle rain from heaven
> Upon the place beneath. It is twice blest:
> It blesseth him that gives and him that takes.

> Bad idea!

Dialogue vs. Action

In novels, there is often more dialogue than can be used in a film adaptation. The question is whether the character dialogue that works in the novel will also work in the film. As we know from earlier discussion, it usually doesn't work to talk the plot. Bartleby's classic line ("I prefer not to") can be

supplemented with looks and gestures. However, the opposite is true for Frank Capra's classic movie *It's a Wonderful Life* (1946). The short story on which it is based is thin on dialogue. The film script adds a great deal of dialogue that is not in the original story to good effect, dialogue that makes the characters come alive, and gives the audience information. For example, the angel in the original simply turns up and engages George in talk. In the movie, we get a shot of the sky with voice-over dialogue from some kind of heavenly administration that is assigning duties going down the list of available of angels until we get to Clarence, who hasn't yet got his wings. The movie opens with an original scene of people praying for George Bailey, which seems to activate the prayer-answering department of heaven:

```
CAMERA PULLS UP from the Bailey Home and travels up through the
sky until it is above the falling snow and moving slowly toward a
firmament full of stars. As the camera stops, we hear the following
heavenly voices talking, and as each voice is heard, one of the
stars twinkles brightly.
```

```
                    FRANKLIN'S VOICE
          Hello, Joseph, trouble?

                    JOSEPH'S VOICE
          Looks like we'll have to send
          someone down.

          A lot of people are asking for help
          for a man named George Bailey.

                    FRANKLIN'S VOICE
          George Bailey. Yes, tonight's his
          crucial night.

          You're right. We'll have to send
          someone down immediately.

          Whose turn is it?

                    JOSEPH'S VOICE
          That's why I came to see you, sir.
          It's that clock-maker's turn again.

                    FRANKLIN'S VOICE
          Oh! Clarence. Hasn't got his wings
          yet, has he?

          We've passed him right along.

                    JOSEPH'S VOICE
          Because, you know, er, he's got the
          I.Q. of a rabbit.

                    FRANKLIN'S VOICE
          Yes, but he's got the faith of a
          child. Joseph, send for Clarence.
```

```
                  A small star flies in from left of
                  screen and stops. It twinkles as
                  Clarence speaks.

                          CLARENCE'S VOICE
                  You sent for me sir?

                          FRANKLIN'S VOICE
                  Yes, Clarence. A man down on earth
                  needs our help.

                          CLARENCE'S VOICE
                  Splendid! Is he sick?

                          FRANKLIN'S VOICE
                  No, worse. He's discouraged. At
                  exactly ten forty-five PM tonight,
                  Earth time, that man will be
                  thinking seriously of throwing away
                  God's greatest gift.

                          CLARENCE'S VOICE
                  Oh dear, dear! His life! Then I've
                  only got an hour to dress. What are
                  they wearing now?

                          FRANKLIN'S VOICE
                  You will spend that hour getting
                  acquainted with George Bailey.
```

At this point, we get back to the earthly level of the movie and we get the angel's flashback of the life of George Bailey as a young boy when he saves his brother's life. So apart from the comedy of George getting a second-class angel who gets us on his side, we have inserted into the original story a cinematic device that enables the movie to tell us the story of George's life free of chronological sequence and to introduce the characters of Bedford Falls. None of this is in the original story. It is the decisive device that makes the movie different from the short story and makes the movie work.

Descriptive Detail and the Camera Frame

In Chapter 1, we discussed the opening of Hemingway's *A Farewell to Arms* and how the descriptive prose of the novel, if literally turned into film images, would extend the movie to unworkable length and impractical cost. The freedom of the novelist to describe detail presents the scriptwriter working on an adaptation with a problem of choice—what to turn into a scene and what to ignore. What contributes to the story? What contributes to the atmosphere that is necessary to bringing that world alive?

Although novels frequently describe appearances or surroundings in detail, a great deal is also left out. Everything that is in front of a camera lens has to be specific and concrete. Although some of these issues extend into production rather than scriptwriting, the screenplay might need to specify things that the novel does not—props or decor that need to be imagined to create a screen image.

The novel can afford to develop characters at length by describing their past and by representing characters' inner thoughts. A movie has to reveal a character in the present and through action or interaction with other characters.

Implied Action

Novels also imply action that a film version might want to use. For instance, when Melville's narrator tells us that he finally moved offices to get rid of Bartleby, he doesn't describe moving. A powerful image suggests itself of movers taking away the furniture and leaving Bartleby standing in a bare office. When the lawyer drops into his office one Sunday to discover that Bartleby is living in his office, what should we see on screen? A novelist can leave it to the reader's imagination. A scriptwriter cannot. To convey that Bartleby is living in the office, a few shots can show him washing in the bathroom or getting dressed. Melville describes how the lawyer discovers evidence that Bartleby is living in his office. In the novella, there is a paragraph. In the screenplay, three short scenes expand on the prose. We need to see the lawyer (now an accountant) arriving, his suspicion, his surprise, and his reactions. It is an opportunity to reveal a discovery in purely visual terms without dialogue. This is what makes movies work. Interestingly, in this case the script expands on the novella: whereas novels have to be cut down in length, short stories usually require expansion.

For instance, the adaptation of Melville's Bartleby presented a problem in that the novella is narrated in the first person from the point of view of the lawyer who employs Bartleby. He shares his thoughts with the reader. In a movie, you have the choice of rendering this as a voice-over narration or you have to create a situation in which some of his thoughts are revealed by interaction. It therefore seemed reasonable to create a **lunch scene with a colleague** in which Bartleby's boss tries to rationalize his behavior toward Bartleby. The responses of the colleague spoken from convention and common sense set in relief the obsessive state of Bartleby's employer, which stands in contrast to what you would expect from someone in his profession. This approach entails risk. You alter the original. Earlier in this chapter, I criticized the TV script of *Gulliver's Travels* because it creates a false shell story with a wife and a child, who are reunited at the end after Gulliver's fantastic voyages. These are extra characters. They fundamentally alter the meaning of Jonathon Swift's satire, in which there is no reunion. Gulliver wants to live in a stable so as to be closer to Houyhnhnms, or horses, who he has found to be more intelligent than and superior to Yahoos (human beings).

It's a Wonderful Life

It's a Wonderful Life is a well-written, well-made, and well-acted film. The story premise (see the website for the script) almost forms a genre—a movie story with recognizable or predictable elements. In this case, it is an angel movie. An angel or two intervene in the earthly drama of a human life with complex plot consequences about time, cause and effect, and free will. Everyone is fascinated by the problem of free will. You don't have to be a philosopher or a theologian. You just have to wonder if your life is controlled by fate or your own doing. Everyone, from time to time, has a notion that some greater force controls life's events, not individual choice. Most people wonder what would have happened if they had married or not married someone, made a different choice of university degree, job, or profession, or chosen not to move to San Francisco or somewhere else to live. There is also envy—some people seem to be getting a better deal in life than others. So the premise of the film, despite the unrealistic, supernatural elements, finds fertile soil in the imagination of any audience in which the plot can grow.

The basic premise of *It's a Wonderful Life* is that an angel trying to earn his wings intervenes in the life of George Bailey to save him from committing suicide when his life hits a crisis. The angel fulfills George's wish that he had never been born. George then visits the alternate world that results and discovers that his life has made a difference in the world. The moral is that each individual life counts and affects the lives of others. In other words, the universe is affected by our individual existence. Individual destiny is universal destiny. It is dramatically intriguing because it makes the audience into an omniscient observer. It's a film that has stood the test of time. This is why a number of contemporary television series and movies make use of the same basic premise.

We can learn more about the challenge of screen adaptation from the granddaddy of all the destiny and free will plots. The story "The Greatest Gift," on which *It's a Wonderful Life* (1946) is based, is shorter and simpler than the movie. George and the angel are the only two main characters. Even George's wife is a minor character. In the movie, we see George's life from the time he was a boy to his falling in love with Mary, and we meet a huge cast of supporting characters including his brother and various townspeople, not to mention the savings and loan customers. Of particular importance is his alcoholic uncle who precipitates the ultimate reversal that makes George contemplates suicide. None of these characters are to be found in the original story. They were invented by the scriptwriters who needed to flesh out the detail of the essential plot idea and make it emotionally convincing in all the detail that brings Bedford Falls to life.

The story kicks off with voice-overs of people praying for a certain George Bailey. Who is George Bailey? This question is, of course, a hook for the audience. We want to know. Then we hear the voices (off-screen) of angels discussing the case and who will be assigned to it. When Clarence, angel second class, who still has not attained his wings, is summoned (this piece of droll invention has no basis in the original

The Destiny and Free Will Premise

Quantum Leap (1989) built a series on a science fiction premise, that a researcher time travels and finds himself in a different body each week. His only guide is a hologram angel or alter ego who furnishes him with critical, omniscient information about his time and situation. Our hero is desperately trying to get back to his own body and own time. You can see how the premise lends itself to a series.

Groundhog Day (1993) is another variation on this same plot. The main character is a television weatherman who by some fluke is able to replay and relive the same day over and over again. When he catches on that time is repeating like a scratched record (or a dirty CD, for those who don't remember vinyl records), he takes advantage of his prescience to experiment with alternate choices. In other words, he is able to stand outside of time and see the causality of events and make different choices to have different outcomes for himself and those around him.

Touched by an Angel (1994) is a popular TV series that explores the premise of angels intervening to teach people in crisis, who are about to make bad or destructive decisions, how to act positively. Poor mortals get the benefit of angelic counsel in the midst of sin and suffering, proving that the universe is benevolent and good can triumph over evil.

Michael (1996) is a feature film that looks at a *National Enquirer* story in which an angel with wings has come into the world of the owner of the Milk Bottle Motel, somewhere in the Midwest. The reporters that investigate have their life problems untangled, and the angel works small miracles to bring lovers together and a dog back to life. The comedy of an angel behaving contrary to expectations is milked for all it's worth. Again, the plot turns around free will and intervention in destiny.

The television series *Now and Again* (1999) explores the fiction that a man who dies in an accident is brought back to life by a secret government agency in a genetically engineered body. His brain, memory, and self-identity remain intact.

story), we are given a potted history of George Bailey by way of a briefing for the angel's mission to intercede because George Bailey is about to take his own life. This briefing takes the form of a flashback story (another device of the screenplay not in the original story) of George's life that takes us from his boyhood to early manhood. We are introduced to his father, the manager of the savings and loan association that finances the houses of low-income people in the small New York town of Bedford Falls. Mr. Potter, a kind of Scrooge character, dominates these townspeople's financial lives. George is all set to fulfill his boyhood dream of leaving Bedford Falls on a great trip abroad before going to college.

On the eve of his departure, we are introduced to Mary, the kid sister of his friend, at the high school dance where the film's love relationship is seeded. Their night's romance is cut short when George's father, Peter Bailey, has a heart attack. Three months after his father's death, George, having postponed his trip to keep the savings and loan going that was his father's life's work, is present at the board meeting where Mr. Potter, the money-grubbing villain, moves to disband the savings and loan. George's passionate speech in defense of his father's work and of the importance of the institution for the ordinary people convinces the board to reject the motion and to appoint George to replace his father. Although George insists he is going to leave town to go to college, he stays and sends his kid brother to college with his savings, with the plan that they will trade places in four years.

This is approximately the end of Act I. We have met all the characters. George has made a choice to postpone his life. So it becomes a story about small-town America and about a community.

In Act II, George's brother comes home from college married to a woman whose father has offered him a job in his company. The more George tries to break out of Bedford Falls, the more it seems to entangle him. He visits his old flame, Mary, who is being wooed by a rival,

He is not allowed to make contact with his wife or daughter on pain of termination. He is a fat-slob insurance salesman reborn as a superman. The premise produces numerous comic episodes in which he encounters his wife and daughter but cannot reveal his identity.

The satirical movie *Dogma* (1999) is based on the plot idea of an alternative destiny that depends on intervention in the lives or actions of characters by supernatural beings. In this case, God is trapped by the devil in a human body, and the whole reality of the universe is at risk unless the good angels somehow manage to avert the contradiction that God's will is not absolute because two fallen angels are trying to get back into heaven.

Run Lola Run (*Lola Rennt*, 1998) is a film about three different versions of the same scenario that explore alternate outcomes when slight variations in action alter the coincidences and events that follow. We see Lola run to save her lover in three plot outcomes. This makes the audience into the omniscient observer.

A classic exploration of this theme of knowing what is true or what is real lies behind the breakout Japanese film by Kurosawa, *Rashomon* (1950), which shows us a rape and murder seen through the eyes of the three characters present. A newer variant is *Vantage Point* (2008), which narrates the attempted assignation of a fictional American president seen from the point of view of eight characters. We all know that reality can be complex and certain events not what they seem. To put it simply, we cannot know for certain what is real.

All of these variants of the angel/intervention plot illustrate different ways you can construct a movie plot from the same basic premise in original ways. You may be able to add to the list. In *Family Man* (2000), Nicolas Cage plays the central character in yet another destiny plot in which a rich capitalist bachelor gets switched into an alternative life in which he's married to an old girlfriend and has numerous children. This genre will continue to thrive on television and movies.

pushed by the mother. The renewed mutual attraction between George and Mary results in their marrying.

As they are about to leave on their honeymoon, there is a panic run on the banks and the savings and loan during the Depression. Mr. Potter tries to buy the members' shares at a discount. George uses his savings to pay the depositors, who want all or some of their money, and manages to stave off the collapse of the bank, much to the disgust of Potter. After refusing an offer to work for Mr. Potter, George, always the man of principle, opts to defend the people and their savings institution. He and Mary have four children. World War II turns his younger brother into a fighter pilot and a war hero who wins the Congressional Medal of Honor. His uncle, who is a drinker and an absentminded character, is taking the savings and loan association deposits to the bank when he runs into Mr. Potter. Showing him the headline about his war hero nephew, the uncle accidentally gives his envelope of cash deposits to Mr. Potter when he hands him back his newspaper. Potter, who now owns the bank, discovers the envelope and is about to return it when he sees his chance to realize a lifelong ambition to destroy or take over the savings and loan. The uncle now frantically retraces his steps looking for the money. At the savings and loan, George learns of the predicament on Christmas Eve. Meanwhile, a bank auditor has to go over the books. Evil is about to triumph over our Everyman hero who faces impossible odds. This is the end of Act II.

Now George must go to Potter and beg for a loan at any price. He offers his life insurance as a surety to cover the missing money. Potter not only refuses but acts to have George arrested for embezzlement and fraud. When George returns home, in despair of finding a solution, his erratic, impatient, and uncharacteristic behavior with his children alerts his wife Mary. After venting his frustration on his family, he goes out to the local bar (quite out of character) to drown his sorrows. The children and his wife start to pray.

We have now completed the flashback. Snow is falling. George, now drunk, smashes up his car as he drives to the bridge. When George gets to the bridge over the falls and prepares to kill himself so that his life insurance will redeem the provident society, the angel, Clarence, finally intervenes to stop him. Clarence jumps off the bridge himself as a ruse to appeal to George's better instinct to save someone else. As they dry off in the tollhouse, Clarence reveals his identity. When George expresses the wish that he had never been born, Clarence seizes upon the wish as the way to teach him. He grants George's wish.

George goes back into town to find an alternate world in which he does not exist. All the people he knows, including his wife, have lived other destinies, much worse for the absence of George Bailey who has affected so many. This reversal seems disastrous, so George asks Clarence to give him his life back. At this point he returns with joy to his wife and children. The many people whose lives he has affected now turn up with baskets full of money as the word has spread. The crisis has been averted and George reconciled to his wonderful life as the people, affected by his life, sing a Christmas hymn and then "Auld Lang Syne."

Most of the movie is about George's growing up and falling in love and his defense of the townspeople from the rapacious banker and landlord, Potter, through the savings and loan created by his father. George never gets to go away and fulfill his youthful dreams. One circumstance after another conspires to keep him in small-town America, hopping from decision to decision, which seems the right choice at the time. It leads to the ordinary life of a good man whose heroism is modest and whose deeds consist of doing the right thing. It is a paean to the life of the average American, who is, of course, sitting in the audience.

The original source turns out to be a short story of great simplicity that turns on the essential plot idea of a man called George in a nameless town, who is standing a bridge contemplating suicide on Christmas Eve. A nameless stranger appears to save him by granting his wish that he had

never been born. Skeptical, he decides to return to his hometown to find out that it is physically different and that the people in his life have lived different destinies because he, George, had never been born. After seeing this alternate reality (which poses a few problems in quantum mechanics and entropy), George rushes back to the bridge to find the stranger and have his wish undone. Rushing back into town he is overjoyed to discover his old life restored. It is a basic, simple moral fable about the value of the life of each individual. The big difference between the story and the movie is that the story provides little information , at least very general motivation that would not intrigue an audience. All he has to say is:

> | The Source Work—"The Greatest Gift" | This short story was originally published privately by Philip Van Doren Stern in 1943. See the afterword |

written later by Marguerite Stern Robinson in the new Penguin Studio edition (New York, 1996) and Frances Goodrich based on the novella **The Greatest Gift**. A scan of this publication can be found on the companion website together with other references. Note that no fewer than five scriptwriters contributed in varying degrees to **It's a Wonderful Life**, including Frank Capra, the director, Philip Van Doren Stern, and Frances Goodrich.

> I'm stuck here in this mudhole for life, doing the same dull work day after day. Other men are leading exciting lives, but I—well, I'm just a small-town bank clerk that even the Army didn't want. I never did anything really useful or interesting, and it looks as if I never will. I might just as well be dead. I might better be dead. Sometimes, I wish I were. In fact, I wish I'd never been born!

Taken by itself, this is just a bunch of petulant whining. The screenwriters, basing their adaptation on this short story of a dozen pages, invented and elaborated on huge amounts of detail and fleshed out the main character. They added characters and altered the sequence of the story to construct the film as a long flashback. All these radical additions to the story make George's suicidal urge believable. When we get to **the bridge scene**, we have seen George's whole life; we know him, identify with him, and agonize over his final humiliation and final setback of losing the savings and loan deposit, playing into the hands of his lifelong adversary, the villainous Mr. Potter, who sees the opportunity to destroy George and take over the savings and loan. Are we worrying about what's going to happen? You bet! For the entire movie, George has thrown off every setback and disappointment. This ultimate reversal sets up the dénouement. Remember the Woodcutter, the minor character in the second act of *Little Red Riding Hood*? In *It's a Wonderful Life*, George's woodcutter turns out to be one of his friends. George Wainright, now wealthy, who offered him a chance to get rich in his youth, hears of the problem and wires funds to bail out the savings and loan. All the townspeople contribute their dollars and cents. The dénouement is not just a happy ending, it ties up all the loose ends of the plot, which explain and motivate the actions of all the characters. In this case, the movie is far superior to the source work.

Bartleby

The opposite is, in a way, true about **Bartleby** because it derives from a small masterpiece of American literature. The film becomes a commentary and a reinterpretation of it. It also presents a number of challenging problems of adaptation.

In 1853, Herman Melville published a novella called *Bartleby, The Scrivener (a story of Wall Street)* in Putnam's *Monthly Magazine*. The story is written in the first person. A lawyer, who remains nameless, hires a new scribe (or "scrivener") to work in his law office. He describes his law chambers and

his employees and recounts the extraordinary relationship with the mysterious and impenetrable character called Bartleby. Bartleby, little by little, refuses to carry out the tasks that are asked of him. The lawyer does not know how to deal with this unpredictable character, his passive resistance to the work contract, and, finally, his refusal to obey instructions. Bartleby gets under his skin. He does not want to get angry. It becomes a psychological battle of wits.

In the end, Bartleby becomes a liability to the business. When Bartleby is fired, he won't leave the building. Eventually, to deal with the problem, the lawyer moves his office, leaving Bartleby behind. Then the next tenant comes to his new office to complain about the ghostly presence of Bartleby, who lives and sleeps in the building. Finally, Bartleby is arrested and thrown into prison, where the employer feels compelled to visit him and where Bartleby finally dies.

The lawyer has gradually assumed a kind of responsibility and even a kind of guilt, early on, for the circumstance of this solitary and obstinate character. One Sunday, he visits his Wall Street office to find evidence that Bartleby is sleeping, eating, and living in his office:

> For the first time in my life a feeling of overpowering stinging melancholy seized me. Before, I had never experienced aught but a not unpleasing sadness. The bond of a common humanity now drew me irresistibly to gloom. A fraternal melancholy! For both I and Bartleby were sons of Adam.[9]

In the **shooting script** of the film, the scene is without dialogue.

EXT. STREET—DAY

During the weekend, the Accountant drives over to his office. His car pulls up at the curb. He gets out and walks into the building. He is dressed casually.

 CUT TO

INT. CORRIDOR OUTSIDE OFFICE—DAY

The Accountant approaches down the corridor and opens the door to his office and goes in.

 CUT TO

INT. OFFICE—DAY

The Accountant stops noticing something unusual as he passes through reception. He sees a blanket on the sofa and then looks into Bartleby's cubicle where he sees a piece of soap, a razor, and a towel on the desk.

 CUT TO

9 Melville, Herman, "Bartleby: The Scrivener," in *Selected Writings of Herman Melville*, The Modern Library (New York: Random House, 1952), p. 23.

```
INT BARTLEBY'S CUBICLE—DAY
```

He walks into Bartleby's cubicle half expecting to find Bartleby there. Then he becomes curious about further clues. On Bartleby's desk are the remains of some food, a cup, and a knife. The Accountant is agitated and scandalized by this unheard of arrangement but also moved and depressed by the implied solitude and poverty of Bartleby's existence. He goes to Bartleby's desk and looks through to discover more personal belongings: a change of underwear, money saved and wrapped in a handkerchief. He puts everything back.

CUT TO

```
INT. OFFICE—DAY
```

When the Accountant has finished, he stands up and turns to confront Bartleby who is standing behind him at the door looking mildly reproachful. Without a word he turns and exits. The Accountant follows him. FADE IN MUSIC.

The lawyer rather likes Bartleby: "there was something about Bartleby that not only strangely disarmed me, but in a wonderful manner, touched and disconcerted me." Later, he comments, "Nothing so aggravates an earnest person as a passive resistance." Then he rationalizes, "He is useful to me. I can get along with him."[10] When Bartleby continues to greet every request with the line "I prefer not to," the lawyer gets frustrated because he thought he could handle Bartleby. He suppresses his anger. This reflective narrative is difficult to turn into film. The solution for this writer was to invent a scene in which the lawyer, now an accountant, has lunch with a colleague. Psychologically, it works to have him try to rationalize his Bartleby problem out loud and to hear an outsider with a commonsense point of view reveal to us how obsessed and isolated the character is becoming.

```
INT. RESTAURANT—DAY
```

THE ACCOUNTANT and a COLLEAGUE are sitting at a table eating lunch. THE ACCOUNTANT is talking about BARTLEBY with animation, trying to justify himself to his COLLEAGUE. The COLLEAGUE is mainly interested in his lunch. For him it is a simple matter—fire Bartleby. We hear the general background of a restaurant.

```
                    COLLEAGUE
          Why don't you just sack him? Could
          I have the salt, please?

                    ACCOUNTANT
          Sack him? I know it seems the
          obvious solution, but I can't quite
          bring myself to. He's so utterly
          civil, so dignified . . .
```

10 Ibid, pp. 16–17.

> (THE COLLEAGUE shrugs and goes on eating)

He's actually a very efficient worker except that he refuses to do certain things from time to time. It's sort of . . . passive resistance.

 COLLEAGUE
Oh yes, what's he against?

 ACCOUNTANT
Nothing, nothing! It's a mood; it's his manner. If I humor him a bit, I feel he'll come round. He could be a first-class clerk. He needs someone to take him in hand. In another firm, he wouldn't have a chance.

The COLLEAGUE looks up and smiles sourly.

 COLLEAGUE
No, he'd be sacked immediately.

 FULL SHOT
The meal progresses. A waiter's hands are seen to clear the table of plates and utensils. The ACCOUNTANT is half thinking to himself, half talking to his companion as he becomes caught up with reflections about BARTLEBY's rebellion against him.

 ACCOUNTANT
Funny, I always end up giving him a chance even though he irritates me. I'm damned if I'm going to let him get away with it. But then I just wonder how far he'll go. I wonder how far he would go.

 COLLEAGUE
You ought to listen to yourself. You're obsessed with this character. Do yourself a favor. Get rid of him. People in the profession are beginning to talk

```
                about it. Your Bartleby will
                queer your reputation and put off
                clients.

                (THE ACCOUNTANT begins to perceive
                that his judgment is confused. His
                prudence and his business sense are
                stirred.)

                        ACCOUNTANT
                Really? Well, there's a limit. But
                you know he's there first thing
                in the morning and last thing at
                night. In his way, he works hard.
                I'll bring him round yet. If not
                he'll have to go.
```

The scenes extracts the essential conflict the lawyer narrates at length, but which has no filmable content. This is the kind of leap of imagination that a scriptwriter must have to adapt a work of literature. At the same time, it violates the integrity of a literary classic. This is the dilemma. The adapter has to both add to and subtract from the original, or find the equivalent. In the jail scene in the book, there is another character called the Grub Man. The film changes the prison to a mental hospital and the Grub Man to an anorexic inmate who is able to speak most of the lines in the original. To explore how the adaptation works, read the 47-page novella and the script, and then see the film. Others have wrestled with the problem and made changes to the characters when adapting the story for the screen in other productions.[11]

Some adapters take a novelist's narration and read it as a voice-over to accommodate the thoughts and comments expressed. This is a solution chosen by another film adaptation (2001) of the same story, also transposed to modern times. Since Melville's narration is in the first person, the voice-over on the audio track becomes the thoughts of the main character. It preserves some of its literary origin. Most of the time, this comes across as an evasion of the essential problem of creating a film equivalent. Hemingway's *A Farewell to Arms* (1957), scripted by Ben Hecht, takes the same way out.[12]

Two adaptations, however, come to mind in which the voice-over technique works. The first is a remake of Nabokov's *Lolita* (1997) with Jeremy Irons. The second is a superb adaptation of an autobiographical novel of Marguerite Duras, the French novelist. The voice-over narration for *The Lovers* (1991) is delivered by the throaty, world-weary voice of Jeanne Moreau. The other tactic of the filmmaker is to make the camera narrate visually and to frame close-up detail that reveals the emotional intention of the narration. When the two lovers meet, we see their shoes. He is an elegant dandy. She is a teenager, learning to walk in heels, unsure of herself but wanting to explore her emerging womanly allure. There is a wonderful moment as they board the river ferry and we see their mutual looks, the detail of their clothes and gestures. Their attraction now leads on to a tragic love affair.

A lot of Melville's characters are outsiders and social misfits. As a writer he explored the intersection of normal and abnormal behavior and the experiences of people at the edge of conventional society but engaged in real-world activities. He shows us how a slight shift in circumstance, character,

11 See the account by George Bluestone, "Bartleby: The Tale, the Film, in *Bartleby, The Scrivener*": *The Melville Annual,* edited by Howard P. Vincent (Kent, OH: The Kent State University Press, 1966), pp. 45–54.

12 The novel was first adapted for the screen in 1932 with Gary Cooper and Helen Hayes in the lead roles.

or point of view alters everything. *Moby Dick* and *Billy Budd, Foretopman* have attracted filmmakers.[13] Adapting a literary masterpiece is a dangerous undertaking. The source work has a huge audience and lives as an independent work. "The Greatest Gift," however, was bought as a story and was not even published until after the film had established itself as a classic.

Bartleby fascinated me because it was a psychological story and because, before its time, it seemed to explore the anonymity of modern urban life. It seemed to document a forgotten population whose lives are dominated by economic and social conditions that marginalize them. I had met people of my generation who had dropped out. They lived in the same environment I did, but they had no Social Security number or health insurance, and squatted in abandoned houses. Some of them were just disoriented, but others were politically articulate and consciously rejected the social economic roles that are forced on us. *Bartleby* seemed to speak to the post-Vietnam world. It probably still does. The idea was to reveal the character in our own day. As soon as you decide to change period and setting, multiple problems arise.

One of the reasons why the story has cinematic potential is that it leaves a lot to the imagination. It also has a narrative point of view. Could you adopt that first-person point of view for the film? Possibly! One could imagine a film that explores the lawyer's perception of the character. It would make a very claustrophobic visual narrative. It seemed to me that if you were going to do it, you should explore both characters with the camera and invent scenes that visually define the psychological space in which the character moves.

So I wanted to reveal Bartleby as a loner in a crowd, in the world but somehow not of it. The urban landscape of impersonal buildings and concrete spaces he inhabited helped to make his character plausible without necessarily getting behind his impenetrable mask. His words are few. We see him as the anonymous commuter in the tube train. He rises on the escalator like a damned soul coming back from the underworld to redeem himself and to allow others to redeem themselves. When he sees the massed starlings in the square on one of his walks, we see that these birds live in spite of the urban landscape just like he does. The sights that he sees and the camera records for us legitimize his character. Instead of having him put in prison, implausible in our own day, he is committed to a mental institution. The throughline of the character is the same, but the universe through which he travels changes color and texture compared to the original.[14]

All literary classics have a rightful place in our cultural imagination. Adapting them for the screen risks alienating those who know and love the original. An audience that sees the film without knowing the original experiences a great story but may never know the truth of the original work. It is an interesting phenomenon that movies sell books, even literature, just as they sell the music of the film. Most entertainment conglomerates have a book publisher somewhere in their empire. When the movie is an original screenplay, media companies often commission a novel of the movie to garner the sales in their publishing market. When the source is a classic in the public domain, they also reissue the classic and sell the source story on the back of the movie release. One powerful reason to adapt a literary classic has to do with copyright. Many great works that have great cinematic potential, such as the works of Melville, Jane Austen, and Henry James, are in the public domain and therefore free.

Henry James wrote a brilliant novella, a story of manners called *Daisy Miller*. It tells the story of a nouveau riche American family on the grand tour of Europe. The beautiful and wealthy young Daisy, her mother, and her small brother have no idea of manners and society. They are seen through the eyes of Winterbourne, a cultivated American who is attracted to Daisy but too cowardly to declare his love because of his social snobbery about this wealthy but gauche American family. When the

13 John Huston made *Moby Dick* (1956) and Peter Ustinov made *Billy Budd* (1962).

14 See reviews of *Bartleby* (1971) and (2001) on Amazon.com in which some of these issues are discussed.

family arrives in Rome, Daisy scandalizes the ex-patriot American community by socializing with an Italian who is married. The story is full of comic situations and colorful visual locations. It would make an excellent exercise for adaptation even though it has already been made into a film by Peter Bogdanovich in 1974.

CONCLUSION

Adaptation involves the translation of narrative from one medium (novel, play, or true story) into another, the motion picture. Writing a screenplay that adapts a source work usually involves compromises to make the story work in the new medium. The most basic problem is length. Films usually have to shorten the story and dispense with descriptive and reflective prose. Film narration depends on visual action in key scenes and sparse dialogue. A film must work on its own terms that can alter the proportions of the original. Some films, such as *It's a Wonderful Life* and *High Noon,* improve on the original story. The chances are that lesser-known, short works make better films than long, complex novels.

It's easy to write a screenplay. It is just hard to write a successful screenplay that a producer, director, or studio will buy and turn into a motion picture. We know the process: write a concept; expand it into a treatment and then a screenplay! We recognize some of the devices and storylines that make existing films work. We have analyzed a number of devices and themes that successful films appear to have in common. It is easier to see how they work after the fact than to construct a compelling story from whole cloth. You can't start with the device, but you can recognize the promise of your concept by seeing how these structural devices can carry a dramatic premise.

Film writing seeks to exploit the large screen and the impact of surround sound and to narrate through action rather than dialogue. Writing visually is essential to good film writing. You compose narration out of images. Your story, its characters, and its world live for 2 hours through the collaboration of vast numbers of talented people in front of and behind the camera who bring the script to life. Film scripts are composed of scenes. Depending on whether a film is viewed on the big screen, television, video, or DVD, the experience changes. Although films are shown on television all the time, other types of entertainment programming are produced for television only. Writing for television has its own issues and requires its own chapter.

EXERCISES

1. Write a 2- to 3-minute scene without dialogue that tells the audience that one character is in love with another. You can explore variations, such as one character being in love but the other rejecting that love.
2. Write a 2- to 3-minute scene that builds suspense and anticipation.
3. Write a 2- to 3-minute scene in which no character is allowed more than one line of dialogue.
4. Record a real conversation in the cafeteria or some other public space. Transcribe 5 minutes of it on paper in screenplay format. See how realism looks. Now try to edit the dialogue down to 1 minute.
5. Edit and rewrite the dialogue you recorded in Exercise 4 to create comedy.
6. Edit and rewrite the dialogue you recorded in Exercise 4 to create drama.
7. Find a novel that has been made into a film and write an analysis of how it has changed for better or worse in the film medium.

8. Take a children's story like *Little Red Riding Hood* or *The Three Little Pigs* and write a movie adaptation in the form of a scene outline. Change the names and the settings if need be.

9. Find a short story out of an anthology, a freshman English text for example, and adapt it for the screen.

10. Write an analysis of a movie adapted from a book you know or have read, and evaluate whether it works or doesn't work and figure out why.

11. Take a standard fairy tale or folk tale such as *Cinderella, Sleeping Beauty,* or *Beauty and the Beast,* and turn it into a film story with your own characters in a modern setting.

12. Read Bram Stoker's *Dracula* and write your own screenplay of the Dracula story. Compare the original with some of the screen adaptations of this story.

13. Read "The Greatest Gift" and compare it with the screenplay and the film of *It's a Wonderful Life.*

CHAPTER 10

Television Series, Sitcoms, and Soaps

🔑 Key Terms

beat sheet	miniseries	series editor
double take	one-liners	setup
Federal Communications Commission (FCC)	pace	sitcom
language codes	putdown	slug line
4:3 academy ratio	running gag	soaps
HDTV 16:9	scene heading	"spec" script
hook	scene outline	teaser
laugh line	serials	trailers
master scene script	series bible	visual gags

Television devours programming. Think of the number of channels! Think of the need for new ideas! Think of the need for writers to write episodes of long-running series that reappear season after season! Although the total program lineup for the medium includes news, documentary, sports, game shows, reality shows, and so on, we are going to emphasize the program content that is acted entertainment, such as series, sitcoms, and soaps. The special requirements of television writing are not the same as for movie screenplays. We need to learn the basic techniques of thinking and writing for television. Then we need to look at the premise and techniques for writing television comedy and drama. There is also the question of script format—how you lay out the page. Many television series have developed their own idiosyncratic variations of script formats, which its scriptwriters follow and some of which have been reproduced in this chapter. The formats of most television series and sitcoms can be found in **Movie Magic Screenwriter**. Lastly, keep in mind that there are many books devoted exclusively to writing for television that will take you deeper than we can ever go in one chapter. Your job right now is to make a first effort at writing for this medium.

Television broadcast channels and cable channels now compete for audiences, ratings, and therefore the revenue from television advertising. This is a different kind of programming competition than movie theaters because movies are one-offs and going to a movie is a discrete event outside the home; whereas television in the home has a repeated daily or weekly line up with episodes. The movie short and documentary, once a regular part of movie programming, vanished or migrated to factual programming on cable channels. The emergence of television had a marked effect on the way movie programs were composed and marketed. It also altered the kind of movies that were made. To compete, movies were made so as to offer a unique experience in screen size and production scale and, of course, color, back when television was black and white. Many movies were and still are made for television or more frequently cable release (e.g., HBO) with no planned theatrical release, and most movies released theatrically are subsequently sold to cable and television channels for home viewing.

Understanding some of the history of the medium helps to explain the formats for television content and how they relate to distribution and viewing patterns. The difference between a television movie and a theatrical movie often goes unnoticed. The general public as passive consumers of entertainment doesn't really pay much attention to the differences between a made-for-television movie and a movie made for theatrical release; however, writers have to because the way television content is conceived and written is different than movies.

THE PREMISE FOR SERIES, SITCOMS, AND SOAPS

The premise for a television series is slightly different than for a movie. A television premise has to keep generating new episodes and new scripts

The Antecedents of Television

In the first half-century of motion pictures, serial programming had evolved as a way of appealing to audiences. A weekly news report from Movietone News or Pathé was part of the program, as was a cartoon. People would often go to the movies on a weekly basis. Kids would go to Saturday matinees. Each week brought a new episode of Charlie Chaplin, or Abbot and Costello, or the Lone Ranger, or Hopalong Cassidy. The idea of producing a new weekly segment of a continuing program formula was part of the movie distribution model. So the television formula was, in a way, anticipated by the movies. The television medium just makes it much easier to distribute program content and much easier for the audience to access that content on a regular basis.

The other source of television genres was its broadcast antecedent, radio. Radio had coped with the problem of devising formats to fill the day's schedule: news, variety, comedy, drama, sports, game shows, and children's programming. Radio serials such as *Superman* have been reborn as television serials. Comedy that had to be verbal could now be visual. Tuning in to the radio on a daily or a weekly basis transferred to television. Television was a convergence of radio and film in both technology (radio pictures) and programming. The idea of watching a program in serial segments was familiar to TV viewers because of their experience with radio and, to some extent, with movies and therefore was a natural fit for television, which developed and refined series for the new medium. We need to remember that television was broadcast live and that there were no cable channels except in remote areas that could not receive the over-the-air signal. The cable system retransmitted the broadcast channels. The must-carry rule for cable companies, which prohibits charging for retransmission, is still in force as an FCC rule governing the cable industry.[1]

1 "The abbreviation CATV is often used for cable television. It originally stood for Community Access Television or Community Antenna Television, from cable television's origins in 1948: in areas where over-the-air reception was limited by distance from transmitters or mountainous terrain, large 'community antennas' were constructed, and cable was run from them to individual homes. The origins of cable broadcasting are even older as radio programming was distributed by cable in some European cities as far back as 1924" (http://en.wikipedia.org/wiki/Cable_television).

each week, and sometimes each season; whereas a movie is conceived as a single story even though producers exploit some box office successes by making sequels and prequels. Sequels are generally an after-thought based on box office success and the desire to create what is known as a *franchise*. There's Rocky, X-Men, Batman, Superman, Spiderman, and many more. A few are planned that way. The Star Wars epic was conceived on a multi-movie canvas. Quentin Tarantino's *Kill Bill Vol. I* (2003) and *Vol. II* (2004) were clearly conceived and released in two parts, as was *The Matrix Reloaded* (2003) and *The Matrix Revolutions* (2003).

ER ran for a decade. Let's start with that series because most people have seen it. An emergency room is at once a setting and a premise because the setting provides an endless stream of incidents and episodes. You have a cast of characters from doctors to janitors; you have the constant throughput of patients each with a different diagnosis and challenge to the ER doctors. During each episode, medical admissions often come with a drama that can reach out into a wider social world and bigger ethical issues. You have the ongoing professional and personal relationships between interns, physicians, nurses, and technicians, interspersed with drive-by patients with interesting and quirky stories. Every medical series—*House, Bones, Grey's Anatomy*—shares a broadly similar premise. The setting is the premise. Just think! *General Hospital* ran for 48 years. Generations of actors passed through it.

There is also the law premise. Think of the older series *L.A. Law*—a law firm with a cast of characters ranging from partners, to clients, to legal secretaries. In its day, it was original. Now we have a legacy of law shows with variations like *Boston Law* and *The Practice,* in which the district attorney and a defense lawyer are roommates and two of the defense attorneys have a love relationship. So we see a more intense exploration of the working of the courts, and we see another city background—Boston. *Family Practice* is yet another way to vary this premise. Endless stories about social issues, childcare issues, and marital issues that intersect with the law can be spun out of this premise.

Each case is a new drama that provides a plot for a week or even two or three weeks. Each case introduces new characters. Some episodes present more than one case, each with a different lawyer or partner as the focus. Each episode can explore a new legal and social issue or an anomaly of human behavior. The series also gives its audience insight into the workings of the business and practice of law—the commercial pressures, the competition, and the internal politics of a firm. In all of these series, the courtroom creates dramas of confrontation because of our adversarial system of prosecution and defense together with a citizen jury (really representing the audience), whose decisions will always provide a moment of climax and suspense. Cross the premise of the legal setting with the military and you get *J.A.G.,* which stands for Judge Advocate General (for the U.S. Navy). Now you have a way to spin stories about moral conflict between human nature and military discipline, politics and military necessity, not to mention social issues to do with race, gender, and cultural diversity. You also have superb opportunities to open up interiors to the occasional exterior of military theaters of action involving ships, aircraft carriers, and foreign locations. Can you do the next one? How about *Patent Law*? I like it. We see how new inventions, scientific discovery, and corporate skullduggery intersect. The little guys fight the big corporate interests. Corporations sue one another, which is now a significant part of the competition for patents between IT, mobile phone, and Internet companies. We learn about new economy start-ups, business law, IPOs (initial public offering of shares), biotechnology, information technology, and e-commerce.

Wait! We forgot the police premise, or cop shows—*NYPD, Miami Vice, Law and Order, Hill Street Blues,* and *Hawaii Five-0,* and the list goes on, as the cliché phrase has it. Usually, there has to be a pair of officers who are partners. There has to be a troubled or conflicted character (drinking problem, trigger happy, marriage issues, and so on). The perennial theme is the conflict between police officers confronting crime and criminals and their problem of getting convictions by legal means. In the name of a kind of visceral justice, they are sometimes in conflict with the law and constitutional rights. They

want to take short cuts. There is the vengeance for the murdered buddy motif. Basic to the premise is the point of view that police officers have a difficult job, that we need them, that they are conflicted characters. They have conflicts with police commissioners, mayors, district attorneys, and criminal defense attorneys. The hospital premise and the police premise are all virtually inexhaustible formulas for television series that are as old as television itself.

We should not overlook the comedy side of the police theme, starting with the classic *Police Academy,* which originated as a movie franchise that also spawned a television series. More original is *Reno 911,* which has the unique quality of being so dead pan there are moments when it seems like a reality show or a documentary, or rather, what has been called *mockumentary.* Unlike most television series, it is largely improvised, adlibbed, and postscripted. The actors don't know what will be kept and what edited out. They also break the convention of never looking at the camera, or referring to their own characters, which is both humorous and contributes to the confusion about whether we are watching a spoof or a documentary record. It parodies the Fox Television show *Cops.* It is often risqué and "politically incorrect" about contemporary issues.

The oldest series programming, soaps, derives from radio drama series sponsored by the soap and detergent manufacturers that wanted to reach the daytime audience of housewives who would likely buy their products. The tradition continued into television. Long-running chronicles of passion, ambition, jealousy, and revenge, such as *The Young and the Restless* and *The Bold and the Beautiful,* have loyal followings. The way they are written and produced follows a pattern that we need to understand to avoid writing clichés. Then there are the single-name shows like *Frasier, Harvey, Seinfeld, The Bill Cosby Show,* which are built around a star's character and particular brand of comedy.

Another prominent genre is the gang of three, four, five, or six characters that make up a caste for a show driven by the characters and their interaction. The premise is a group of friends of a certain late twenty- or thirty-something generation—most of them seem to be set in New York—who live together, or work together, and who have quirky personalities that lead to constant fights, make-ups, and sentimental attachments. Dating, sexual liaisons, and engagements (the American bachelor theme of obsession with sex and avoidance of marriage) are perennial themes. The characters are set so that their behaviors and manner are like running gags. You will notice that they share some recognizable environment, which is a studio set that the audience recognizes and gets used to like the couch in *Friends* or the apartment in *Seinfeld. Modern Family, How I Met Your Mother,* and *Big Bang Theory* are recent manifestations. Then there are the workplace comedies like *30 Rock* and *The Office* (an adaptation of a British television series). Typical episodes introduce some problem or conflict related to one or more of the characters, requiring input and interaction from the rest of the cast, which is then resolved back to the familiar status quo where we started. There are few locations, recognizable sets, and lots of entrances and exits. Sitcoms are conceived for other demographics, such as *The Golden Girls* for seniors and others for teens and tweens, a territory which I dare not enter.

Broadly, there are two types of series. The first has a constant style and cast of characters, but each new episode tells a new and independent story. The plot of one program has no connection with the plot of another. Each week, we see another self-contained variation on the kind of theme that makes the series work.

The other model is a serial, more typical of soaps, in which the story continues from one episode to another. If you do not watch *The Young and the Restless* on a regular basis, you may not grasp the full significance of some storylines or relationships. You do not know the back story of the characters. This is true for an old series like *Star Trek* and more recent series such as *The Wire, Nip/Tuck, The Sopranos,* and *Sex and the City.* The continuing series allows lengthier and more complex storylines

that become almost epic in their proportions. This model leads to different writing problems. In the one-off episode, the storyline is brief, the formula for resolution known, and the audience given completion at one viewing. The continuing series leaves the story incomplete at the end of the episode and needs an audience that is willing to come back again and again. It is an interesting form because unlike the one-off episode and unlike a movie, the writers and producers do not know the eventual evolution of the story at the outset. Pre-program updates for new or occasional viewers are complemented by teasers for the next episode. Although both models are typical of television, the longer, multiple-episode story is rather unique to the medium. It allows a canvas that is more akin to the novel—full of texture and detail that would not be possible even in a feature film—although sometimes the writing is so simplistic that the opportunity is lost. Producers and writers have to deal with killing off or retiring characters and introducing new ones because actors do not renew their contracts or because the story needs new life.

Drama Series

So far we have given the impression that television and cable entertainment are just laugh channels. As citizens, news stories give us glimpses into underworlds, drugs, police corruption, wrongful convictions, perversion of justice, political cover-ups, bribery, financial scams, among other unfunny aspects of our society. Fortunately, meaningful, gritty, original writing and producing that addresses serious social issues exist on TV, such as in *The Wire* and *Breaking Bad.* Although *West Wing* contained wit and banter between characters, it was a fundamentally political drama as was the more recent *Scandal.* Although *Law and Order* and *The Shield* belong in the police genre, they also treat the problem of police corruption. Sometimes, television series can do a much better job than movies of taking us into these worlds and their inhabitants.

Miniseries

The formula of the miniseries entails two, three, or more episodes that might be scheduled on consecutive nights or spaced out over weeks. *Roots* (1977) was one of the most successful of these extended miniseries. A dramatized adaptation of Alex Haley's documentary investigation of his African roots and family history through slavery to the present day, it was a complex and epic story about African American history that worked far better on television than it would have as a movie. It was also very successful in terms of audience share, achieving one of the largest TV audiences ever. One of the best miniseries, and certainly one of the greatest works of the Western genre, was *Lonesome Dove* (1989), which was adapted from the novel of Larry McMurtry. Both the writing and the acting, particularly by Robert Duvall and Tommy Lee Jones, were outstanding. Many of these works can now be enjoyed on DVD.

The television miniseries is a long-form narrative that has a predetermined end as opposed to an open-ended, long-running series. It is an effective way to adapt major novels and classic works such as the novels of Charles Dickens. The great allegorical and satirical work by Jonathan Swift, *Gulliver's Travels* (1995), was adapted as a miniseries with a great deal of fiddling with the integrity of the original work. Further in the past, *The Thorn Birds* (1983) was one of the most successful serial stories on this model, followed by the sequel, *Thorn Birds: The Missing Years* (1996). The canvas for these two series was huge, covering 60 years in the lives of the Cleary family in Australia. A great miniseries that really took advantage of the scope of this long form of television program was *Shogun* (1980), adapted from the long novel by James Clavell and starring Richard Chamberlain. We cannot overlook the stream of BBC produced series that fill the schedule of PBS and command large audiences. *Downton*

Abbey is the current hit. Very often a long novel with many characters works better as an extended miniseries than as a two hour movie, which must condense too much. Although we have to keep in mind the variety and scope of television writing, the half-hour and hour episode are the most common form and the best place to start looking into writing for this medium. These key television units or modules need a basic three- or four-act structure.

THREE-ACT STRUCTURE AND THE TV TIME SLOT

After appreciating the dramatic structure of long-form movies, you might wonder how that structure works for the television half-hour and hour episodes, which are interrupted by commercial breaks. In the series model in which each episode is a self-contained unit with the same main characters, a problem is introduced, usually a challenge to the main character. This sets up an antagonist who delivers a number of reversals that rise in severity until some kind of dénouement occurs in which the hero triumphs and order and equilibrium are restored. Because the episodes are reborn each week, a recognizable structure is helpful to the audience. The basic formula of the three-act structure has to become a four-act structure to accommodate commercial breaks. It still works.

The serial structure—multiple storylines that extend beyond a single episode—works better for some soaps, sitcoms, and series that have complex stories. The soaps offer the clearest example. Each episode involves several story strands running simultaneously. None of the stories follows a strict three-act development structure, but rather they alternate as foils for one another. Just as one storyline reaches a crisis, we end with a close-up on the character doing "the look": an actor or actress holds a blank ambiguous look that conveys worry, thought, or some intense interior emotion, after having learned that their wife or husband has been unfaithful, that they have been disinherited, or that they are not the father of their child. Then, we cut to another parallel story strand involving another set of characters that develops to its temporary climax, and then we cut to a third or cut back to the second. Intercutting storylines adopts a sophisticated editing technique but for spurious reasons. It is not a clever writing technique. It is simply a crude way to keep several storylines in play at once and to disguise the lack of dramatic structure. Whenever you run out of ideas or get into trouble, cut to a commercial or another storyline. This style of editing also facilitates production, the scheduling of actors, and the advantage of more economical simultaneous shooting of various segments of the story. This episodic structure has no real beginning and no real end. It is just a way of spinning out episodes for the cast of established characters. The series of indeterminate length, written as original work for television, illustrates both the most interesting and most bathetic potential of the medium.

USING COMMERCIAL BREAKS

Because most television programming is broken up by commercials, the writer has to take them into account and write scenes or acts so that the audience's interest is held, if not heightened, by the break after a climactic moment. The commercial break has turned every episode into a four-act structure because the hiatus of the break has to be incorporated into the dramatic rhythm and narrative structure of the story. Apart from the fact that we use breaks to go to the bathroom, or get a snack or a drink, or make a phone call, we also sometimes switch to other channels. It makes you think that the modern audience is capable of running multiple storylines in its head and taking in emotional and factual information at several levels. Sometimes, the television screen performs the

function of a social, informational heads-up display that modern urbanites consult almost like a pilot reads multiple inputs of information from the flight deck instrumentation. The modern audience interacts with the medium through the remote control, surfing multiple channels, sampling multiple programs, and watching more than one program simultaneously, whether by switching at commercial breaks or watching via picture-in-picture enabled TV sets, or time shifting with digital recording. Add to this the feverish and real-time second-screen communication via social media about the story content between viewers. To some extent, television writing has developed so as to work in short episodic bursts so that its comedy, dialogue, and characters are instantly recognizable, enabling the audience to pick up the program at random and figure out what's happening. The audience watches behaviors, styles, and mannerisms that it learns to model in speech and emotions. The social impact of television makes it difficult to know sometimes whether life is imitating art or art is imitating life.

VISUALIZING FOR THE SMALL SCREEN

Sometimes writers need to think carefully about the difference in size between movie and television screens. This difference can affect the way you write and the way you think about writing. Size of image counts. A large projected image has great impact and allows a different kind of cinematography and camera work. You may argue movies are shown on television all the time and movies are rented on video. Nevertheless, the experience is not the same. When I fly transatlantic, I watch movies on a little LCD screen on the back of the seat in front of me. This does not give me the same experience I get in a movie theatre. The visual value of the images changes. The same may be said of the size of the viewing image on mobile phones. Panoramic shots or big actions shots are less exciting. A lot of detail gets lost. The same is true for television on tiny screens.

High-definition television is now the standard, and the aspect ratio of the screen has changed to HDTV 16:9 ratio, which will fit Panavision wide-screen ratios for the most part. The resolution and the definition (crispness of detail) of the image together with the color reproduction have improved. Nevertheless, it is still a different experience than watching a movie at a large-screen movie theatre, sitting in the dark with an audience of strangers. Parts of the picture are cut off on old TV sets with the 4:3 academy ratio.

Television is a close-up medium. News anchors, interviewers, and their subjects come across better in medium shot or close up. So this is how camera operators and directors tend to compose the shot for so much television material. They are thinking about what it will look like when the audience experiences the program. That is what counts. Think about the content of television sitcoms and soaps! Most of the scenes play in medium shots or two-shots. They deliver intimacy so that you can see the subtle emotional body language of the face of the character. This is what soaps are all about—showing feelings, looks, and concealing the same—up close and personal as the saying goes. The audience wants this intimate contact with the character. You have to think and write in terms of the screen size of the image and how it will communicate with the audience.

TV DIALOGUE

The characteristics of the screen image have an impact on dialogue. If you want the audience to feel the characters, you have to put them in proximity to one another so that they talk and relate. Television is a talking medium as well as a close-up medium. You will notice that television writing

tends to make characters talk more than in movies. Dialogue carries more of the weight of a television storyline. The dialogue may refer to action or events, but we experience characters through their interchange. *The West Wing* is a good example of drama and complex relationships carried in tightly scripted dialogue.

Television is more likely to be produced in studio sets, whereas movies tend to exploit action, locations, special effects, and stunts. However, original cable shows like *The Wire* and *Justified* are shot like movies on location. Television shows are shot on smaller budgets and tighter schedules than movies. The soaps always come to mind as the primary example. Most scenes consist of two people meeting in an office, an apartment, or a restaurant or talking over the phone to play out some relationship drama in verbal exchange—consider *Seinfeld,* for example. The primary technique, which is also the most economical way to shoot, is two-shot and matching singles, or a two-shot and over-the-shoulder reverses. The content of the shots is talk and emotional body language. So the writer writes the storyline and the dialogue to carry it. Series of this kind are also built around certain fixed interior settings; these can be created as permanent studio sets that reduce the cost of production and allow most scenes to unfold in settings that are familiar to the audience.

REALISM/REALISTIC DIALOGUE

When characters open their mouths, we always expect their language to correspond to their world and their personality. In cop shows, medical shows, and legal shows, characters have to speak like those professionals do. They have to use the professional jargon. This is a writing responsibility. Think of another kind of dialogue writing problem in a series such as *Star Trek*. Apart from the fact that the Klingons have their own language (can you write Klingon?), the setting is not just fictional but hypothetical. All sorts of vocabulary are invented to refer to futuristic technology. It is easy to parody. We see serious-looking people in colored lycra body suits leaning over winking panels of controls and turning to say things like, "The particle shield is down; there's no response," "Activate the thrust inhibitors," "Fire the gravity phaser," or some such nonsense. I just made those up. Technical background on weapons and other functions of starship *Enterprise* gadgetry are part of the plot and part of the series bible. You have to know what certain weapons are or what certain terms mean, such as the *holodeck,* where holograms can simulate alternative realities in other time periods. Science fiction establishes conventions of credibility. The idea of accelerating to warp speed or beaming someone down to a planet surface becomes accepted as concepts, which, in the case of *Star Trek,* have entered the general culture. So although it is invented language, it has its own realism in context.

In *The West Wing,* you expect senior staffers, whose world revolves around political and governmental issues, to use language that most people read in the papers; likewise for the journalists, advisors, and lawyers who live in the White House basement. At the same time if you study the script of a *West Wing* episode, you will not find realism but something that is realistic, a distinction we have made before. Real staffers probably spend hours working on keyboards, reading memos and briefs without talking. When they do talk, they are probably more long-winded than their fictional counterparts in **The West Wing**, whose dialogue is taut, witty, and full of repartee. Just as real doctors and nurses probably don't behave like the fictional ones we see on *ER*, White House staffers probably do not trade witticisms in tight dialogue exchanges. As we have said before, simulating reality means making it believable, not necessarily realistic. Realism is too long winded, too messy, too complicated. So we can get an exchange that is good television. The high drama that erupts in every episode probably doesn't occur with the same frequency in the life of

real staffers. The point is the events and the dialogue are believable. People are people as well as staffers.

INT. WEST WING/MAIN LOBBY/CORRIDOR/BULLPEN JOSH'S OFFICE - SAME TIME

CONTINUED:

JOSH knows what this means and stops walking, holding onto DONNA's arm to get her to stop walking as well. They speak in hushed tones.

<div style="text-align:center">

JOSH

</div>

What did I do?

<div style="text-align:center">

DONNA

</div>

How would I know?

<div style="text-align:center">

JOSH

</div>

Because you know everything.

<div style="text-align:center">

DONNA

</div>

I do know everything.

<div style="text-align:center">

JOSH

</div>

Donna . . .

<div style="text-align:center">

DONNA

</div>

I'm saying you say that now, but anytime I want to make a substantive contribution . . .

<div style="text-align:center">

JOSH

</div>

You make plenty of substantive contributions.

<div style="text-align:center">

DONNA

</div>

Like what?

<div style="text-align:center">

JOSH

</div>

This. This could be a substantive contribution.

<div style="text-align:center">

DONNA

</div>

I need a raise.

<div style="text-align:center">

JOSH

</div>

So do I.

<div style="text-align:center">

DONNA

</div>

You're my boss.

<div style="text-align:center">

JOSH

</div>

I'm not the one who pays you.

 DONNA
 Yes, but you could recommend that I
 get a raise.

 JOSH
 Donna, she's looking for me. Do you
 think this is a really good time to
 talk about a raise?

 DONNA
 Mmm. I think it's the best time to
 talk about a raise.

 JOSH
 Donna, you're not a very nice
 person.

 DONNA
 You gotta get to know me.[2]

BREAKING UP DIALOGUE

Dialogue has a certain rhythm that works and is different from real speech. As we have noted before, real speech is rambling, disjointed, and static. One of the mistakes of a beginner is not to break up dialogue so that the characters ping-pong the lines back and forth as they do in *The West Wing*. There is a tendency to crowd too many thoughts into one speech rather than letting one character start an idea and then get a response, which leads to the next development of the thought and a satisfying dialogue exchange. Long speeches slow down the show and lead to predictable responses. Beginning scriptwriters make characters say too much and deprive the other characters sharing the scene the opportunity to respond. They end up trading set speeches, as in a debate.

PACING

Another tendency of novice writers is to put too much of the story in the first scenes. Beginning writers typically are big in the first act and then find that their treatments underestimate how to pace the material. This fault is easily concealed in the treatment and always revealed in the script. One of the best ways to combat it is to make a step outline or a scene outline, also called a *beat sheet*. This prevents self-deception about the amount of material you really have to work with. It also shows you the storyline and structure in a way that the treatment does not. The beginner tends to peak too early and not to use subplots.

2 Aaron Sorkin, *The West Wing Script Book; Six Teleplays* (New York: Newmarket Press, 2002), p. 80–81.

THE BEAT SHEET

The **beat sheet** is basically a numbered scene outline that lays out the narrative structure of the episode in a similar way to a treatment. It identifies the scene setting and summarizes the action or plot development with paraphrases of dialogue. It is an instrument of television writing rather than movie writing. It helps to navigate the fragmented intervals of television playtime. Let us consider a beat sheet for an episode of *ER*. It is broken down into a teaser and four acts to fit around the commercial breaks. Here is a beat from Episode #3 of an *ER* episode:

> ADMIT—Where Weaver is introducing TEAM ER—her latest brainchild to unify and motivate her troops. Romano is down in the ER. He makes a disparaging remark about Carter, still none-too-happy to have him working here. Weaver assures him that Carter's only working half shifts and no traumas. Before he leaves, Romano spots Chen. Asks who's the daddy? Nobody knows. Fine don't tell me—as long it's not me. Huh? Malucci figures somebody must know who the father is. Everybody has their own ideas. Bets are made. So begins the "Who's the Daddy?" pool. Abby overhears Kovac taking a phone call in Italian. It's brief but amorous, and Abby can't help but eavesdrop, even if she doesn't know what he's saying.[3]

This is fleshed out into three pages of production script. Some ideas are still left by the wayside. For instance, the betting pool about Chen's pregnancy didn't get into the final because it was probably too much of a diversion from the forward momentum of the story. Also, the beat sheet does not hint at the dialogue exchange between Carter, Romano, and Weaver. Carter is a resident who has come back from drug rehab, a detail which extends our understanding of the characters. Romano is a mocking, sarcastic, nasty guy, and Weaver is the quick-witted head of ER.

 ROMANO
 Doctor Carter, when did they let
 you out?

 CARTER
 A few weeks ago.

Romano stares into Carter's soul. Carter could try to do the same
to Romano, but since the man has no soul, it's pretty pointless.

 CARTER
 I've got a patient.

 ROMANO
 Go forth and heal.

Romano gestures for Carter to go, but then while he's still within
earshot-

 So who's watching the Drugstore
 Cowboy?

 WEAVER
 ER is my department. That makes
 Carter my responsibility.

 ROMANO
 Correct me if I'm wrong, Kerry,
 but didn't he develop his drug
 addiction under your watchful eye?

 WEAVER
 Did you need something, Robert?

 ROMANO
 Do I need a reason to stop by and
 say hello?[4]

The dialogue and the character development are all part of the writing of the script beyond the story structure work of the beat sheet.

TEAM WRITING

Most television scripts are rewritten by teams of writers who keep the production line going with scene and dialogue rewrites right up to the time of shooting. Play time is fairly critical in the television world because time slots with commercial breaks are exact. You cannot run over. Some writers specialize in dialogue and are assigned particular scenes to write. The team is managed by a series editor. So what appears to be the uniform work of a single writer is often a team effort of multiple writers rewriting a half dozen times.

HOOK/TEASER

A hook is a device that gets the attention of an audience, involves them, and makes them want to keep watching. A teaser is a short scene that precedes the commercial break before the episode starts that contains a hook. It may also be the premise of the episode, although that is not always possible and not necessary. Most television series and episodes have to provide something to whet an audience's appetite quickly because there are a dozen other channels, a dozen other choices. In the movies, this is less critical. Not that the movie does not need a hook, but if you have paid for a ticket and you are sitting down with your popcorn, you are going to accept a more complex development of story and plot. It takes an enormous failure to make you walk out of a movie; it takes a minor lapse for you to hit the remote and check out what's on another channel. Major series often build interest with quick trailers inserted into earlier programming on the same channel. These trailers are often the hook. They also play at the end of the episode to entice the audience back for the next episode.

THE SERIES BIBLE

All series have a *series bible* that describes each character, including backstory, personality, past life and details of props, settings, and other information that enables new writers on the series to stay faithful to the spirit of the series and true to character. For this reason, a head writer or editor will oversee the development of episodes. All writers eventually get worn out in series writing. Even the original writer who might have developed the idea for the series and written the first episodes becomes weary and runs out of ideas. So there is a regular rotation of guest writers. This is why writing a "spec" script of a long-running series can be a good way to show your stuff and help an agent to get you some freelance work.

CONDENSING ACTION AND PLOT

We have already commented on the difference between reality and realism. Life is mostly banal—eating dinner, doing laundry, flossing your teeth, trying to get some sleep. Work involves tedious routine, paperwork, long meetings, and utterly undramatic data entry at a computer keyboard. You can't make riveting television programming out of such things unless you select key moments, condense activity and action, and shorten the screen time in a plausible way. So you need characters to walk and talk at the same time. You need to combine action and dialogue.

The scene from *ER* quoted above condenses action and plot in a walk/talk moment. In a *Nash Bridges* episode, Nash, Joe, and Katie are on the case of a psychotic serial killer who is murdering people who use cell phones. This dates it. They have called him on the cell phone he took from a victim. He hangs up. As they stride purposefully through crowds to the car, Nash says, "Get the triangular on the phone and check all patients released from mental hospitals in say the last six months." This scene condenses action and plot so that the viewers know some background detective work is going on. The writers get these points across by having the characters move from one scene to the next. This kind of efficient use of time, motion, and dialogue is typical of police and detective series, which always have to deal with a lot of off-screen detail that could never be filmed because of time constraints. In this same series, there is a lot of movement from one location to another. Nash's trademark is his souped-up yellow convertible in which he and Joe roar from one part of town to another. This type of motion scene is useful to get through a lot of dialogue that fills in the plot or fills us in on background and provides personal interchange between characters.

TARGET AUDIENCE

Although the seven-step method we developed in Part I does not apply in exactly the same way when dealing with a television entertainment objective, it is important, nevertheless, to give some thought to the demographic of a target audience. Shows that go on late at night are allowed to present more sexual themes and scenes than family shows. Broadcasters are bound by Federal Communications Commission (FCC) language codes that exclude the kind of realistic dialogue, sexuality, and violence that movies allow and that some cable channels allow. So realism for underworld settings or gang worlds must find the style without the four-letter words. There seem to be fewer qualms, however, about showing explicit violence than showing explicit sexuality or including bad language. Cable television is less restricted. The brilliant show *Deadwood,* which came out in 2004 on HBO, portrays a lawless frontier town in South Dakota in the 1870s with a degree of realism about the West probably

never before seen in movies or on television. The foul language is relentless and persistent among uneducated greedy people competing for gold, space, food, pleasure, and life itself. Wild Bill Hickok and Calamity Jane are passing through, and she is as foul mouthed as any. The story is convincing, the writing brilliant, and the acting first rate. The target audience is clearly adult and worldly wise. Another ground-breaking, realistic, and uninhibited series is *The Wire,* which began in 2002. It has a documentary style that examines facets of ghetto life in Baltimore, Maryland. Cable channels like HBO and FX are much more innovative and daring than the networks. Unlike the networks, many cable channels such as FX have given more creative control to producers with shows such as *Nip/Tuck, Justified,* and *Sons of Anarchy.*[5] HBO had a major hit with *The Sopranos.* Now AMC has scored with *Breaking Bad,* which just concluded in a much-anticipated last episode as this book goes to press.

SCRIPT FORMATS FOR TELEVISION

As with writing for other visual media, the project should also begin as a concept, an outline, from which you write a treatment. The treatment is then made into a script. For the most part, two formats with some variations cover most television script layouts. The format most resembles the master scene script. Each scene is announced by a slug line or scene heading. This is followed by action description in uppercase, which differentiates it from the screenplay. The character name appears above the dialogue and is centered; the dialogue follows and is also centered. (See formats in the Appendix.)

```
INT. HELMER'S STUDY—NIGHT

HELMER AND NORA STAND IN THE CENTER OF THE STUDY.

                    NORA
        Oh, Torvald, it hurts me terribly
        to have to say it, because you've
        always been so kind to me. But I
        can't help it. I don't love you any
        longer.

                   HELMER
        And you feel quite sure about this
        too?
```

In a variation of this format, the script is aligned to the left margin and introduces act and scene numbers. The last variation is that stage and action directions are contained in parentheses. The Writers Guild of America has published a *Professional Writer's Teleplay/Screenplay Format Guide,* which it sells by mail order.

TV COMEDY AND ITS DEVICES

Most television comedy involves some kind of subtle or not so subtle insult or putdown. It is a question of degree from crude putdown humor to witty and clever portraits of human behavior.

5 David Carr, "Shunning the Safe, FX Indulges Its Dark Side," *New York Times,* February 3, 2013.

Contrast *Married with Children* with *Seinfeld*! Low-grade insulting humor continues a vaudeville tradition. Comedians like Jimmy Durante, Sid Caesar, Eddie Cantor, and Abbott and Costello were all familiar with playing visually to an audience. Radio comedy necessarily had to do without the visual comedy. Then the radio broadcasters also became the television license holders. The radio comedians like George Burns, Jack Benny, Fred Allen, and Ozzie and Harriet were co-opted into television. The writers were radio writers. Skit writing with clever one-liners migrated into television from radio comedy, which in turn had grown out of vaudeville. This writing style of the double take, the setup, and the putdown still thrives in sitcoms. This writing developed in other ways when the shows moved to the West Coast television production facilities from their original production base in New York.[6]

Running Gags

We discussed **running gags** in the chapter on writing long-form movies, citing *Some Like It Hot*. A running gag, as the name suggests, depends on repetition. The audience knows the premise of the gag so that each new exploitation of the gag gets a rise from the previous one. You keep going back to the same premise to work it from another angle. This device enriches a lot of comedy. Marx brothers movies exploit this device to the maximum.

Just Marcy is a student-written and student-produced pilot for a television series. The complete script and some video are reproduced on the website. It is about a college-aged girl who needs to find a roommate. She has money problems, and her landlord is threatening to evict her unless she pays the arrears. This creates the pressure to find a roommate. We can illustrate the comic device of the running gag with the following situation. Marcy has the landlord at the door. She is showing a new roommate around. The audience knows something that the roommate character doesn't. So her responses are doubly funny. The scene is built around the physical action of going back to the door where the landlord is waiting. Each time Marcy appears, the comedy ratchets up a notch. Marcy is showing the prospective roommate around when . . .

THE DOORBELL RINGS

 MARCY
Can you hold on for a minute?

SHE ANSWERS THE DOOR, IT'S HER LANDLORD.

 MARCY (CONT'D)
Oh my god, Mr. Jacobs, hi.

 MR. JACOBS
 (he says in a monotone voice)
I want the rent.

 MARCY
Can you hold on for just a minute?

6 I am indebted to Nancy Meyer for this background information and research presented in her paper, "The Situation Comedy Script Format: Its Evolution from Radio Comedy and the Traditional Screenplay," delivered at the Broadcast Education Association Convention in Las Vegas in April 2000 at a panel I chaired, "Who Invented the Screenplay?"

SHE CLOSES THE DOOR AND GOES LOOKING FOR SANDRA.

SCENE THREE

INT. MARCY'S ROOM—MOMENTS LATER (MARCY, SANDRA)

> MARCY
>
> Sandra?

> SANDRA
>
> Oh I just love this room.

> MARCY
>
> This is my room. Let me show you
> the room for rent.

SCENE FOUR

INT. SANDRA'S ROOM—MOMENTS LATER

> (MARCY)

THEY WALK INTO THE OTHER ROOM AND THEN THE DOORBELL RINGS AGAIN.
MARCY GOES TO THE DOOR.

SCENE FIVE

INT. MARCY'S FRONT DOOR—MOMENTS LATER (MARCY, MR. JACOBS, SANDRA)

> MR. JACOBS
>
> $500 dollars for last month . . .

MARCY SHUTS THE DOOR AND RETURNS TO SANDRA.

SCENE SIX

INT. MARCY'S KITCHEN—MOMENTS LATER (MARCY, SANDRA)

> SANDRA
>
> WOW! I really like this place.

> MARCY
>
> About the rent . . .

> SANDRA
>
> You know I'm really desperate.
> My roommate just kicked me out
> and . . .

> MARCY
>
> $500 for last month's rent

SANDRA EXPRESSES CONFUSION.

> MARCY (CONT'D)
>
> . . . I mean this month's . . .

THE DOORBELL RINGS AGAIN.

> MARCY (CONT'D)
> I'll be right back

SHE HOLDS UP HER FINGER AND RUSHES TO THE DOOR.

> SCENE SEVEN

INT. MARCY'S FRONT DOOR—MOMENTS LATER (MARCY, MR. JACOBS, SANDRA)

> MR. JACOBS
> (he has his arms folded on his
> chest and is glaring at Marcy)
>
> . . . and $500 for this month.

MARCY SLAMS THE DOOR AND GOES BACK TO SANDRA.

> SCENE EIGHT

INT. MARCY'S KITCHEN—MOMENTS LATER

> (MARCY, SANDRA)

SANDRA IS STANDING BY THE TABLE.

> MARCY
> Sorry to keep you waiting . . .
> (she is slightly
> out of breath as
> she speaks and
> smiles)
> . . . and $500 for this month . . .
> I mean next month . . . no, I mean,
> you know, a deposit.

SANDRA TAKES OUT HER CHECKBOOK. MARCY'S EYES GO WIDE.

> MARCY (CONT'D)
> Er . . . you wouldn't have cash by
> any chance?

> SANDRA
> A thousand dollars in cash?

> (Marcy shrugs)
> How do you spell your name?

> MARCY
> Mr. Jacobs . . .

SANDRA DOUBLE TAKES

> MARCY (CONT'D)
> . . . I mean, just leave it blank, ok.

<div style="text-align:center">

SANDRA

Whatever you say, roomie.

</div>

SANDRA HANDS HER THE CHECK. MARCY GOES STRAIGHT TO THE DOOR AND OPENS IT.

<div style="text-align:center">

SCENE NINE

</div>

INT. MARCY'S FRONT DOOR—MOMENTS LATER (MARCY, MR. JACOBS, SANDRA)

MARCY OPENS THE DOOR.

<div style="text-align:center">

MR. JACOBS

Now, or you're outta here.

</div>

MARCY HANDS HIM THE CHECK. MR. JACOB'S JAW DROPS. SHE SHUTS THE DOOR AND GOES BACK TO SANDRA.

Each time Marcy answers the doorbell, the gag builds and the scene intensifies the comedy at the door with the prospective roommate.

A character often has a foible that generates endless comedy. Take the character of George in *Seinfeld.* He is slightly pompous and always trying to get even for an insult or involved in a convoluted scheme to get one up on some adversary. We know his character and can't resist the pleasure of seeing his downfall or of his being exposed and brought down to size. Part of the reason is that we see an aspect of ourselves in this character.

Visual Gags

Visual gags help comedy in a visual medium. However, if every joke is spoken and the humor is purely verbal, the visual potential of the medium is wasted. In an office comedy, someone hiding under a desk, or in a domestic comedy, someone trying to dress up in disguise, or someone trying to hide evidence of a mistake, all make the camera an ally and engage the visual part of the audience's brain. The tradition goes back to vaudeville stage gags if not further. Shakespeare used visual gags. Think of Malvolio in *Twelfth Night* dressing in yellow stockings and cross garters to please Lady Olivia because he thinks she has suggested it in a faked letter written by the Fool, Sir Toby Belch, and Sir Andrew Aguecheek. Chaplin articulated the visual gag for the camera together with Harold Lloyd and Buster Keaton in silent film. Without a sound track, the comedy depended on visual gags. Early television gave *The Three Stooges* a lot of scope for fairly crude visual comedy. Someone being hit with a ladder when his friend turns around has its limits. Comic violence shades off into a kind of sadism that is evident in huge numbers of animated cartoons in which Tom gets endlessly flattened or blown up by Jerry.

A student of mine developed a successful visual gag. The story is about two Jamaicans coming to visit their cousin in New York. The immigration officers think that they are illegal immigrants, although we learn later that this is a case of mistaken identity. Meanwhile, they have to do something. So when the immigration officer comes to the apartment, he finds them dressed up as women. The dialogue is hilarious and the scene all together succeeds very well. It also complicates their other ambition, which is to find American girlfriends whom they can marry so as to stay in the country. Cross-dressing, which we discussed in the previous chapter, works as a kind of visual gag.

Visual gags carry over to animation comedy such as *King of the Hill* and *South Park. The Simpsons* has become the longest-running show on television. Here is a little visual gag combined with a verbal one-liner by Lisa.

INT. SIMPSON HOUSE—BASEMENT—NIGHT

Homer is at the pool table, carefully lining up a shot. Lisa is resting her head on the table, facing Homer.

 HOMER
 Steady, steady . . .

Homer **TAPS** the cue stick lightly and it neatly **KNOCKS OUT** one of Lisa's baby teeth.

 LISA
 Thanks, Dad. That loose tooth was
 driving me crazy. (Looking at
 tooth) Hey, I wonder if I could use
 this for my science fair project.

She exits.[7]

Insult and Putdown

The Insult in Shakespeare

The insult is an ancient comic device going back centuries to restoration comedy, Elizabethan theater, and Shakespeare. *Henry IV Part I/ Part II* introduces the well-known characters of Prince Hal (the future Henry V) who frequently insulted Falstaff, who in turn frequently insulted those around him. The contemporary audience must have adored this comedic element in a serious history play that legitimized the Tudor monarchy. Elizabethan English had a vocabulary of vituperation and insult without equal. It was not limited to comedy:

Oswald: What dost thou know me for?

Kent: A knave; a rascal; an eater of broken meats; base, proud, shallow, beggarly, three-suited, hundred-pound, filthy, worsted-stocking knave; a lily-livered, action-taking knave, a whoreson, glass-gazing, super-serviceable finical rogue; one-trunk-inheriting slave; one that wouldst be a bawd, in way of good service, and art nothing but the composition of a knave, beggar, coward, pandar, and the son and heir of a mongrel bitch: one whom I will beat into clamorous whining, if thou deniest the least syllable of thy addition.

King Lear (2.2.14–24)

In *Henry IV, Part I*, there is an exchange between Prince Hal and Falstaff that is as good as any in Shakespeare:

Prince: I'll be no longer guilty of this sin. This sanguine coward, this bed-presser, this horse-backbreaker, this huge hill of flesh—

Falstaff: 'Sblood, you starveling, you elf-skin, you dried neat's tongue, you bull's pizzle, you stock-fish! O for breath to utter what is like thee! You tailor's-yard, you sheath, you bow-case; you vile standing-tuck!

1 Henry IV (2.4.219–225)

The comic insult, became the staple of vaudeville, as it was in Shakespeare, and now television comedy. The Marx brothers, who transitioned from the stage to the screen, developed it to a fine art. An insult is a full on vituperative attack. More subtle, however, is the putdown. This is a verbally oblique comment that frames a character on the receiving end as stupid, vain, or naïve. Sometimes, characters recognize it and are humiliated; sometimes, they are unaware and the joke is completed through the audience awareness. This device is a staple of sitcoms. *Two and Half Men* is full of such lines. Alan has met

the ex-wife of a friend of his who is friends with his ex-wife whom he wants to date. The scene is at the door of Judith, Alan's ex-wife:

> ALAN
> I know you two are still friends, and
> I was wondering if you'd be okay if I
> asked her out.

> JUDITH
> Fine!

> ALAN
> Really?

> JUDITH
> Sure, you're both adults; you're both
> single and most importantly, I know
> she won't go out
> with you.

> ALAN
> How do you know?

> JUDITH
> I know.

> ALAN
> Has she said something to you?

> JUDITH
> No, but you're not her type.

> ALAN
> Oh, really! What is her type?

> JUDITH
> Like her ex-husband—smart, funny,
> sensitive, good looking.

> ALAN
> And that's not me?

> JUDITH
> Oh, no! You can be funny.

The putdown usually needs a build up before it drops. It is a successful comic device because it engages the audience's intelligence.

Double takes

Like many comic devices, the double take is a compact with the audience. The character takes an extra long time to react to a putdown or before delivering a reply. Although it can be an acting technique, it is also very much a comic effect that can be written into a script. It needs the right line or situation with an indication in the script. You do this by writing PAUSE, BEAT , or even DOUBLE TAKE.

Here's an example of a comedy beat from one of the most popular shows on television—*Two and a Half Men*:

```
FADE IN:

INT. KITCHEN—DAY

THE TWO BROTHERS AND THE SON/NEPHEW ARE SITTING AROUND THE KITCHEN
TABLE EATING. THE DOOR BELL RINGS.

                    WOMAN'S VOICE (Off)
          Hello, Alan, are you home?

ALAN LEAPS OUT OF HIS CHAIR AND GOES TO ANSWER THE DOOR.

                    ALAN (Off)
          Wendy, what are you doing here?

                    WOMAN'S VOICE (Off)
          I thought I'd surprise you with a
          booty call.

                    ALAN (Off)
          Lower your voice.

                 CANDY (Off in a lower voice)
          Booty call.

              JAKE (Innocently to Charlie)
          What's a booty call?

                    CHARLIE
          Well, it's . . .

BEAT

          . . . it's the kind of thing a son
          should learn from his father.

                    JAKE
          Well, okay.

BEAT
```

CHARLIE (Mischievously deadpan)
Maybe you should ask him now.

JAKE
Alright.

HE GETS UP AND GOES TO THE DOOR.

BEAT

CHARLIE
Oh, I'm going to hell.

HE GETS UP AND GOES TOWARD THE DOOR.

CUT TO

INT. DOORWAY—CONTINUOUS

ALAN AND WENDY CONVERSE AT THE ENTRANCE

ALAN
It's a sweet gesture, but it's
not a great time.

NEPHEW WALKS UP WITH CHARLIE NOT FAR BEHIND.

NEPHEW
Hey, Dad, what's a booty call?

ALAN
Hey, Jake, you remember Candy.

JAKE
Oh, yeah. Hi, Candy.

CANDY
Hi.

JAKE (turning to his father)
So what's a booty call?

BEAT

ALAN LOOKS IN DESPERATION AT CANDY THEN TURNS AROUND TO FACE HIS
BROTHER WITH ANOTHER DESPERATE LOOK.

BEAT

CHARLIE
I figured you didn't want me telling
him. Was I wrong?

BEAT

```
ALAN LOOKS AT HIS BROTHER SPEECHLESS AND THEN TURNS TO CANDY.

BEAT

                          ALAN
            Er, well . . . it's, er, Candy came
            by to do her laundry.

BEAT

CANDY IS SPEECHLESS

BEAT
```

The scene develops with double takes, one-liners and plenty of laugh lines. Watch the scene on the website and see how these devices work. They are the staple of sitcoms like **Two and a Half Men**. This scene goes on with an excruciatingly ridiculous and improvised explanation of "booty" call by Alan getting deeper and deeper into his absurd explanation of cowboys in the old West who have to wash their dirty clothes from being out on the range. But they kept their boots on. And then somebody would shout out "booty call." A comic script of this kind requires really skillful comic acting to pull off. It depends on timing, facial expressions, and other body language. Charlie Sheen is a consummate comedian, as are his cast mates. It is or was a hugely popular show until Charlie Sheen was fired after insulting the producer. The writing and the acting of the new version is not nearly as effective. You can form your own opinion.

Sitcoms of this kind are better as half-hour shows, which conclude the story in each episode; now, with thirteen episodes of shows online and DVDs, people can watch a whole series with a story line extended over many episodes in what has become known as *binge viewing*.

One-Liners and Laugh Lines

One-liners are the staple of situation comedy. Characters say lines that stand alone and get a laugh track because they are snide, deadpan, sarcastic, self-evident comments about another character or a situation. Most sitcom characters, especially those that head up a series, are given one-liners as a regular feature of their episodes. The previous example of a beat from the scene in *Two and Half Men* also illustrates the one-liner. After the preposterous and fantastical explanation of "booty call," the wide-eyed Candy then comes back with a great deadpan one-liner and laugh line that gives the game away: "So when did it start meaning casual sex?" The scene builds though a combination of these recognizable devices. It is also a perfect example of a running gag because as the embarrassment spins out of control, every evasion becomes funnier and funnier until the scene pops with the one-liner. Then Candy is invited to go off to play a video game with Jake and gets invited to his birthday party the next day to the silent astonishment of the two brothers. This last twist integrates the device into the storyline and raises the comic sequence to another level, which is not often the case. In mediocre comedy, the one-liners are stuffed into the script like raisins in a cake. The are too often arbitrary, off-the-cuff throw-away lines. In *Two and a Half Men*, episode after episode, similar scenes are played out with these same devices.

You will notice that **laugh tracks** simulate a live audience from the old days when television comedy was performed live on a set in front of an audience and went straight to air because video recording had not yet been invented. Laugh and applause cue cards were held up for the audience to respond. Laugh tracks are endemic in sitcoms. They help punctuate the comedy but also, in this

writer's opinion, sometimes mask the underlying weakness of the humor. The audience is not laughing; it is being cued to get the joke.

In this context, we might mention *The Big Bang Theory*, which relies more heavily than most on laugh tracks to make humor out of lines or scenes that are not that funny (full disclosure: I am not a fan). The premise is a variant on *Friends* and similar shows about groups of friends that are living on top of one another. Four roommates have PhDs in physics or other sciences and yet behave like morons and act out their lives in one set. Sheldon is the ultra nerd who cannot say anything without a kind of bombastic, overelaborate, verbose, academic phrasing. He is a puerile, self-centered, immature personality. The comedy formula replays ad nauseam the conflict between the one-dimensional Sheldon character, his roommate foils, and the neighbors and girl friends. The mockery of educated intellectuals, who behave like college students, probably appeals to the latent anti-intellectualism of American popular culture. Nevertheless, it follows the rules and employs the typical comic devices we have been discussing.

Laugh lines and one-liners are typical of sitcom writing. Although the line should fit the character who delivers the line, such lines come in two varieties—those that rarely depend on the plot or advance the plot (They are opportunities that almost stand alone or are added on to the situation. Shakespeare did it to the delight of the groundlings.)[8] Then there are those we illustrated in *Two and a Half Men* that integrate with the story and keep it alive.

South Park is full of one-liner putdowns and one-liner exclamations that belong to the character's mode of talking. It is worth noting that neither *South Park* nor *The Simpsons* rely on laugh tracks. Despite the trademark simple stop-frame animation, they seem to handle beats by eye blinks or other very simple reactions from the cut-out characters Cartman and Stan:

```
INT. SCHOOL CAFETERIA—DAY

The kids are all in line for lunch. Cartman farts a huge fireball.

                    CARTMAN
          OOOOWWWW!!! Ooh, I sure am hungry.

                    STAN
          How can you eat when you're farting
          fire?

                    CARTMAN
          Shut up, dude. You're being totally
          immature.
```

SPEC SCRIPTS

What is a spec script? If you are intimately familiar with a show, you know the main characters, you know the format, and you know how they talk. You also know the back story and previous episodes; therefore, you know what hasn't been done and what might be a new twist on the premise

8 These were the lower classes or poorer class who stood in a space without seats in front of the stage, now found in the replica of the Mermaid Theatre in London, where the plays are produced again.

of the series or sitcom. You don't have to invent a new series with all the risks and unknowns. You can experiment with a known premise and in world of characters and dialogue with which you are familiar. The characters are already alive for you. You have plenty of examples in a season or two of episodes. Can you do it? Why not try? You have to do this if only to demonstrate to yourself that you can do it, that you can write to a professional standard.

Writing a "spec" script for a television series you are familiar with is not only one of the best ways to learn; it also can be a way to get the attention of executive producers on the show, especially if you know someone who works on a series. Even if you don't succeed right away, it provides a valuable learning experience that will give you new respect for the work that goes into creating what you are used to consuming as a television viewer. You can't persuade anyone that you can write unless you have samples of writing that they can read. It is one way to get the attention of an agent. A spec script can also demonstrate writing ability to producers and series editors of other shows that are looking for writers; it shows them that you are versatile.

REALITY TV

In 2000 a new series, *Survivor,* captured the ratings, pushing out the popular *Who Wants to Be a Millionaire?* The format of the show requires the "survivors" to vote one of their number "off the island" each week; the evicted player, thereby, becomes ineligible to win the million-dollar prize. Audiences can now interact with the program in real time as the survivors present themselves to the mass audience. Reality TV has mushroomed both because it is cheaper to produce than scripted series and because audiences become involved with the outcomes of fierce competitions and eliminations of contestants. All this spills over into the social networks and blogs. All media are accessible on multiple platforms, fixed and portable. Content will seek to exploit mobile platform audiences to engage a larger audience and therefore make a higher return on investment. How this works is explored in depth in Chapter 14 where it seems to be a better fit.

NEW TECHNIQUES AND INNOVATIONS

Once and Again, a new ABC series in 1999, was an exciting departure in television writing that took creative risks. It avoided the formulas of soaps and most of the clichés of potted plots and canned emotions. It was and is the polar opposite of the soap. It is the story of two families whose parents are separated or divorced and whose children, of teen, adolescent, and preadolescent ages, are trying to cope with growing up in a splintered household. The love relationship between the divorced father of one and the separated mother of the other family magnifies the problems of each family. The mature television writing manages to capture some of the texture of middle-class American family life. The portrait of the angst adolescents feel about their parents and the parents about their children rings true. More than any other series, this one tries to document the scale and amplitude of people's emotions and reactions to the everyday events and crises of American middle-class life. It has comedy, tragedy, and ordinary and extraordinary moments. The writing is clearly at the foundation of this series, even though the acting is flawless, especially that of the young actors. At every moment, the depiction of a certain kind of contemporary living experience is seamlessly convincing.

 JESSIE SAMMLER
 This isn't how I am.

 KATIE SINGER
 What do you mean?

 JESSIE SAMMLER
 Sarah's really giving the impression
 that. . . she's acting like this is
 just some big contest. Like you have
 to choose. Like, if you're friends
 with me then you can't be friends
 with her and. . . that is SO not
 how I am, and it's so stupid, and I
 just think that we should . . .

 KATIE SINGER
 I choose you.

 JESSIE SAMMLER
 What?

 KATIE SINGER
 I choose you over her.

 JESSIE SAMMLER
 But I don't want anybody to choose
 anybody.

 KATIE SINGER
 I know you don't, but . . . I can't
 help it.

The writing also experiments with an innovative technique of cutting away at key emotional moments to a black-and-white interview of the character talking to the audience about his or her innermost thoughts. It is a television equivalent of the theatrical aside. It allows us to learn more about the character's point of view and to see the interweaving of past and present into a complex tapestry of emotions and gestures. This could have been artificial and disturbing to the emotional experience of the viewer. Quite the opposite occurs, however. The black-and-white shot differentiates the interior monologue from the external drama. We recognize a level of emotional truth in the characters that has rarely been seen on network television. This kind of complex narrative developing over many episodes is difficult to write and produce.[9] One advantage can be that once an audience is hooked, it will follow the story week after week. However, *Once and Again* was above the low common denominator of television series and did not survive its third season.

Interestingly, this technique of **characters speaking into camera** with asides to the audience has been adopted by *Modern Family*. Although the series is basically a comedy series, it also explores the hypocrisy and posturing of characters in certain social situations and in their relationship to other characters. We all know that we put on a face socially and conceal many real thoughts and feelings to

9 The series, created by Marshall Herskovitz and Edward Zwick, won many awards. These two producers have been involved with numerous quality television and feature film productions.

grease the wheels of social intercourse or to avoid family drama. Family relationships are often tense and complex, most notably at holiday moments such as Thanksgiving, Christmas, and weddings. How many movies have you seen that are centered around the family holiday visit? The topic is pretty much inexhaustible. They can be examined, as many movies do, from a dramatic or a comic perspective. *Once and Again* was about modern family but without jokes and comic confrontations. *Modern Family* explores the funny side of the contradictions between outward behavior and inner feelings. They both use the aside.

Some innovation that we see in television series may be the result of direction or editing. There is a tendency to borrow flashy camera moves and jump cuts from car commercials (see the old series *Nash Bridges*). Effects such as location exteriors, stunts, or taking the Chroma out of a scene to create mood, or the use of slow motion all creep into drama and action-oriented series like *24 Hours, The Wire,* or *Breaking Bad.* Cutting techniques and camera movements are borrowed from the world of commercials where the need to condense messages and get the viewer's attention constantly pushes the envelope. A recent series, *Scandal* (2012), about the White House and a former beautiful black staffer and mistress of the president who goes independent, uses a signature transition of rapid cuts accompanied by a sound effect to condense events.

INTERACTIVE TELEVISION

Some years ago, you might have noticed that a number of programs on television ran a subtitle with a web page address that extended or continued the content of the program. The PBS channels pioneered this and seem to be the most evolved. WGBH in Boston produces *Frontline*, a current affairs documentary program, which has a very extensive website with transcripts and background material. During many documentary and current affairs programs, a URL is periodically superimposed as a subtitle. If you are online during or after the program, you can explore in-depth interviews and outtakes that are not in the edited broadcast footage. There are associated chat rooms and forums for audience participation in discussion about the content. I have seen a Saturday night movie program, which holds audience attention by running a quiz and interactive exchange on a website posted on the program and announced by an anchor before commercials so that audiences will stay with the program by going to the website and playing to win prizes. This was the rudimentary beginning of what is now referred to as the *second-screen phenomenon.*

Jon Stewart's *The Daily Show,* severely limited for time to do interviews on air, always invites viewers to go to its website for a fuller interview experience. Most network news programs post website links on screen so that viewers can consult other levels of information and background online while viewing the program. Television sets can also be linked via broadband cable to the web and serve as monitors for browsing. The program URLs can then become active links. A few television series, such as *CSI* and *The Practice,* have created websites that extend the story and create enhanced experiences for the audience. **Hawaii Five-0** ran an episode early in 2013 in which there were three alternative endings. The plot involved (no surprise) a murder. As the episode proceeds, there are three suspects. In the old days, all would be revealed in the last act or last few minutes of the episode; in this episode, the viewers were invited to choose the culprit in real time by tweeting in their choice. By a kind of majority vote, the fate of one of the three suspects would be decided.[10]

10 Liz Shannon Miller, "Hey, Twitter, *Hawaii Five-0* Wants You to Pick the Killer," *Gigaom,* January 13, 2013. Nellie Andrews, "CBS' 'Hawaii Five-0' Lets Viewers Choose Episode Ending In Real Time," www.deadline.com, January 3, 2013: "Fans will be able to vote on CBS.com or Twitter during both the East and West coast broadcasts. The votes will be tallied immediately and the most popular ending will become part of each broadcast. All three endings will be available at CBS.com later that evening." Rich Heldenfels, "Hawaii 5-0" Lets Viewers Choose Episode Ending," *Akron Beacon Journal Online,* January 3, 2013: "For the first time in television history, a primetime drama will allow viewers to choose the ending of an episode in real time when CBS's HAWAII FIVE-0 lets fans vote on CBS.com or Twitter during the East and West Coast broadcasts, Monday, January 14, 2013 (10:00–11:00 PM, ET/PT) on the CBS Television Network."

This illustrates how television can become interactive. It also shows how interactivity plays out on a second screen. The engagement of the audience as a flash mob via mobile devices then drives audiences to the channel. In turn, advertising fluctuates in value and can be sold online to the highest bidder. This could be the beginning of a trend.

There are also websites that sell products within a program. Product placement, which has become an important part of film and television financing, enables interactivity to grow audience responses beyond mere recognition and selling to actually buying what they see. The ideal marketing technology will enable the viewer to click on the object in the picture and be linked to a website to buy the article. This is only going to increase because as cable and Internet converge, the same monitor will be able to display both as connected HDTV displays high definition digital television and Internet to the household through the same fiber. Manufacturers are selling television sets that can be connected to the Internet. Viewers can use the same screen to view television and see the Internet. Computers can display television broadcasts and tune into podcast programs of cable and radio. This potential is increasingly exploited to cross-collateralize cable, TV, and Internet.

At the moment, most television programs and most movies have web pages that enrich the audience interaction with the program content. Remember that the moving picture medium began as a silent medium. Writers and producers did not think in terms of sound. When sound was introduced, whole new ways of imagining and writing scripts must have opened up opportunities for those who could exploit the new dimension. The potential of interactive movies is technically feasible with Blu-ray technology and DVD authoring software. The same will be true for cable television. Nevertheless, the kind of story that can be made interactive is limited to a certain type. The alternate ending chosen by Twitter input could become more common.

The series *Once and Again* innovated with black-and-white cutaway asides that allow characters to communicate inner thoughts to the audience. This suggests an interactive potential with different writing and production so that an audience could choose to hear an inner thought or back story at any given moment. New apps synced to the program might allow the viewer to explore ancillary material to the main story. Interactivity could develop in this way so that rather than just choosing story outcomes, audiences could select deeper levels of back story or character information.

The possibilities with documentary programming, reality TV, and game shows are not hard to imagine. Documentary could easily escape the restrictions of linear editing by presenting outtakes, background interviews, text, and interactive chat rooms not much different from the established PBS practice. Game and quiz shows could easily add an interactive dimension from the viewer audience.

Viewer response or even viewer choice of program outcomes could become a feature of next-generation entertainment. Second-screen dimensions to concepts and scripts are driven by consumer behavior, and forward-looking executive producers are thinking about how to exploit social media interactivity. The question for writers, producers, and directors is how this will impact the concept of programming? How this will change writing and conceiving program content is examined more closely in Chapter 14.

CONCLUSION

Television is a big marketplace for writers. The range of programs is enormous from daytime soaps to primetime series and sitcoms. Although TV is commercial and dominated by ratings, good writing does occasionally get onto network TV—*Once and Again,* for example. There is a demand for writers and an opportunity, albeit highly competitive, for writers to break into established series with

spec scripts. Almost all writing in the entertainment industry is freelance work, but television series hire staff writers on longer term contracts. Staff writers can become head writers who determine the content. Writers can also become producers and directors. The audience is large, and the demand for good new material never satiated. However, there is a disturbing trend in recent years for networks to reduce the amount of scripted programming and opt for talk shows, reality shows, and other less scripted formats because the production cost is lower and the risk lessened, in spite of the fact that independent producers take the largest part of the risk of developing a new show. They have to recoup some of the production cost from syndication, foreign sales, and DVD boxed sets of a season.

The second-screen experience that audiences sought using their mobile devices for simultaneous social media interaction has become the most significant development in television programming and content creation. Broadcasters and cable channels have been obliged to take account of viewer behavior that creates social media connections that media companies must penetrate and organize in order to maximize audiences and sell advertising in that new dimension.

EXERCISES

1. Pitch a new episode of *NYPD Blue*, *The Practice*, or *J.A.G.* to the class.
2. Write scene outline for an episode of *NYPD Blue*, *The Practice,* or *J.A.G.*
3. Write a scene for a hospital drama such as *ER*. Check the technical and professional vocabulary that each character would be likely to use.
4. Devise a short scene with a running gag. First, write one with no dialogue. Then, write a different one with dialogue.
5. Write a scene that gives the audience visual cues about character without using dialogue or a voice-over. For example, write a scene about a young college-age couple or a senior couple in love. Then, write a scene showing an engaged couple in which one of them believes their engagement is a mistake.
6. Write a scene in which one character is trying to hide the truth from someone he or she loves.
7. Write a comedy scene that relies on one-liners.

PART 4

Writing for Interactive and Mobile Media

In the 1980s, before interactive video became a reality, I was involved as a scriptwriter in a project to create a mail-order multimedia course to teach accounting to managers. A prominent business college in the United Kingdom saw a market for distance learning. It wanted to create a learning package that would enable working professionals to acquire the knowledge of the course without physically attending the classes. We built in some primitive interactivity by using three independent media: print, audiocassette, and videocassette. The videocassette was produced with planned pauses indicated by a subtitle on screen instructing the user to stop the tape and refer to a page in the manual to read in-depth background. Similar cues were recorded on the audiocassettes. The video dramatized a business situation; the text provided facts and figures and exercises; and the audiotape had testimonials from managers.

Today, we would create hyperlinks to audio files or video clips, or hyperlinks from picture to text. This kind of continuing education could now be run through a website or a DVD. This anecdote shows that interactive multimedia is a technical response shaped by the longstanding need to inter-relate media and build in user input. Current computer technology enables that need to be filled. Interactivity is now a fundamental component of new media and an increasingly common feature of traditional media. The term *new media* is often used to describe interactive media. Since these media are not so new anymore, people tend to refer to them as *digital media*. The Writers Guild of America considers this kind of writing to include "not only video games, but also content developed for other digital technologies, including the Internet, CD-ROMs, DVDs, interactive TV, wireless devices, and virtual reality."[1]

In the early 1990s, the multimedia computer was a novelty. Now multimedia functions are standard. The idea of interactive multimedia developed in fixed media because all the media components (video card, graphics card, audio card) could be incorporated into the desktop. Code could be written so that by mouse click and key stroke, the user could navigate around the content of a CD-ROM. The first exploitation of interactivity on the multimedia computer was informational. The importance of fixed interactive media was signaled by the breakout Multimedia Convention, which set up separately from the main convention floor of the National Association of Broadcasters in 1994. It occupied a ballroom in the Las Vegas Hilton. By 2001, it had grown so large that it occupied another entire convention center at the Sands Convention Center. With the expansion of the Las Vegas Convention Center, the multimedia trade show moved back under the same roof as the broadcasters, which mimics the convergence of media on the desktop. At that time the World Wide Web, although in development, did not yet exist.[2] A year or two later it began to transform mass communication as we know it.

1 See www.writersguildeast.com.

2 Tim Berners-Lee founded the World Wide Web Consortium in October of 1994, which was the foundation of the Web as we now know it.

While the first edition this book was being conceived and written at the end of the 1990s, the world of interactive media was in ferment. It continues to evolve and change. This phenomenon of change is something we have to learn to live with, as Alvin Toffler pointed out in his seminal and prophetic work *Future Shock*.[3] It is a truism that media technology evolves at an exponential rate. New applications continue to impact business and change the workplace. Knowledge workers need to master new tools to manage and process information on a continuing basis. The speed, memory, storage capacity, and shrinking size of these systems drive the new economy of information technology.[4] The convergence of video in digital format and digital computer processing brings about the possibility of universal networked interactive multimedia. Broadcasting becomes netcasting and also mobile digital television, or DTV (see Chapter 14). A screen becomes the display for any and all possible communications media, with wireless access to all content increasingly stored in the cloud. Since the last edition, we have seen the burgeoning of handheld computers, tablets, cell phones, and wireless networking. The emergence of the iPhone and Android and Microsoft operating systems and downloadable apps set off another metamorphosis of the media world. In our homes, we have switched from analogue to digital video and TV. Producers now have to create program content in the new high-definition standard. Professional cameras are now all digital and high-definition (HD). DVDs offer 9.4 gigabytes of storage on a single side, which is sufficient to encode a full-length feature film plus outtakes, background story information, and eight channels of audio. Distributors can put multiple language versions of a movie on one DVD. Blu-Ray (double-sided)now supersedes DVD with more than five times the storage capacity of traditional DVDs.[5] This extra capacity combined with the use of advanced video and audio codecs offers consumers an unprecedented HD experience. Movies are being distributed in interactive versions with outtakes and alternate angles included such that the viewer can alter the edit by remote control. Information about the production, the actors, and the making of the movie are also commonly included.

Even before digital video, video boards in computers allowed us to bring live-action video into the computer and thereby combine live action, graphics, animation, still pictures, sound, and text. Computer games and other types of interactive software that take advantage of this multimedia environment are familiar to most of us. The Internet has given birth to the World Wide Web and a form of interactive communication that exploits the multimedia capabilities of computers, smartphones, and television. All computers are now multimedia with integrated video, sound, graphics, and Ethernet or wireless receivers. We are now used to user input that modifies the playback or viewing experience by means of hypertext and hyperlinks.

These new digital technologies and networking capabilities alter the way producers, writers, and directors have to think about media. Cable providers now offer retrievable digital content and embed program and other information in all channels accessible through the remote control. Television programs are linked to websites, which extend the program. WGBH in Boston produces the documentary program *Frontline,* which innovated years ago with subtitles of URLs (universal resource locators) where further information about the program could be found and where online discussion about the program could continue in chat forums. Since television and the Internet are delivered over the same network and on the same screen for certain models, television can become increasingly interactive so that viewers can shop for products that are "placed" in the program. Objects will increasingly

3 Alvin Toffler, *Future Shock* (New York: Bantam Books, 1991). See also *The Third Wave* (New York: Bantam Books, 1990), by the same author.

4 Bill Gates, author of *Business @ the Speed of Thought* (New York: Penguin Books, 1999), makes the case that the success of any enterprise now really depends on the speed and efficiency of its digital nervous system, meaning its total internal and external communications.

5 See the Writer's Guild of America West's website at www.wga.org.

be clickable to take viewers to a website where they can make a purchase online. New digital flat screen televisions already incorporate these internet-connected capabilities. Content producers increasingly have to think in terms of multiscreen and multimedia experiences, as do advertisers.

Whatever we know and accept now as visual entertainment will inevitably change. Nor is it difficult to foresee ever-increasing instructional and educational use of this kind of interactivity, combined with multiple media on DVDs, BDs, and websites. Most K-12 schools have adopted iPads, tablets, and smartphones to invert methods of instruction. Corporations and universities use websites for interactive distance learning. Courses at world famous institutions such as MIT offer many of their course free (but not for degree credit) over the Internet in what are known as MOOCS (massive open online courses). If production companies whose business was creating videos don't also design and produce DVDs and websites, they go out of business.

The interactive combination of the computer and the World Wide Web, with its open architecture, reveals new opportunities every day for learning, training, entertainment, and commerce. Think content! Wherever there is content, there is writing. More writers are needed. New media require changes in the conceptualizing and the writing that precedes production. Scriptwriters have to acquire new skills and learn new kinds of visual and structural writing techniques. However, these new writers, who were accustomed to write for linear media have to write for new media that are now nonlinear; therefore, they must be able to think differently (for Mac users, "think different") about content. The meta-writing changes.

CHAPTER 11

Writing and Interactive Design

🔑 Key Terms

artificial intelligence	hub with satellites	parallel paths
assets	hypertext	random access
authoring tool	interactive design	scripting language
branching	linear	sticky
cross-platform	meta-writing	storyboard
design document	multipoint-to-multipoint communication	virtual space
flowchart	navigation	visual metaphor
functionality	nodes	wheel
hierarchical	nonlinear	
HTML		

DEFINING INTERACTIVE

First, we need to define more closely what the term *interactive* means. Although interactive media were enabled by the convergence of computer, video, and audio technology in the same digital environment at the end of the twentieth century, there are previous examples of interactive structures in our culture.

In the fifteenth century, the printed book was a stunning piece of cutting-edge technology that changed European civilization and had a revolutionary impact on social and political culture, somewhat like the computer and the Internet do today. Books and magazines are disappearing and re-appearing as online editions, which can be accessed by a variety of portable devices and readers. But let's pay tribute to the still-useful interactive

Interactive or Linear — Although the term interactive is new, the phenomenon is not. Although we associate books with print technology, a book is a form of technology that preceded Gutenberg's printing press, which is only now being displaced by digital information technology. Medieval monks wrote books with numbered leaves of paper or vellum bound together in a sequence so that the reader could keep the printed matter in a compact space and access any part of it very readily. Consider some of the historical alternatives—clay tablets, parchment scrolls, or palm leaves sewn together—all difficult to handle and absolutely linear.

technology of printed matter. Consider the book you are reading now! If you are reading the print version, in a flash you can look at the table of contents, the index, or the glossary and go back to this page or the chapter you are reading. In addition, of course, you can browse (where did the term "browser" come from?) through a book and delve into any other chapter. Surely, this is the beginning of user input—namely, interactivity. Early on in the 500-year history of printing, dictionaries and,

Those more primitive technologies use the writing medium in a sequence that is analogous to a straight line. You have to move along it in one direction, forward or backward, starting at the beginning or at one particular point. If you are in the middle of a scroll and you want to consult the beginning, you have to roll the scroll backwards, just as you have to rewind a videotape.

later, encyclopedias exploited the potential nonlinear design of printed books. You open it at any point of alphabetical reference and you move between pages that are cross-referenced. This is also the logical model for hypertext that is now integral to the World Wide Web. Dozens of reference books, including the commonplace telephone directory, were never designed to be read in a linear fashion but consulted interactively. Did you ever meet anyone who reads a telephone directory, a dictionary, or even an encyclopedia from end to end? Can you imagine a telephone directory or an encyclopedia as a scroll? Most of the knowledge in the ancient world was recorded on these primitive handwritten media.

Interactivity means that the reader or user can make choices about the order in which information is taken from the program. You cannot get information from the Yellow Pages without making choices. You cannot progress through a website experience or a game or a training program without making menu choices or activating a link that starts a new chain of choices. Whereas the information in a reference work is pretty much on one predictable level, the experience of a game or a website is an open-ended discovery. It is not only about a number of choices but about permutations and combinations of choices. So the number of choices becomes mathematically very great. This is why navigation is a primary problem for many giant websites. Users get lost. Sites have to incorporate search engines. The paramount issue of the day is how to design choice for the user that is efficient and clear so that hits on a website lead to burrowing down and deep exploration without disorientation and no way to get back to where you started.

LINEAR AND NONLINEAR PARADIGMS

Interactive narrative paradigms have evolved rapidly with the advent of video games. This new dimension to storytelling makes the audience part of the story. In the most sophisticated examples of the genre, the player of a video game interacts with an imaginary world, determines actions for characters, and influences the outcome. In multiplayer games, the player interacts with other players in a virtual space that all players can to some extent modify within rules and conventions. The development of artificial intelligence opens rich new opportunities for interactive illusion.[1] At the

Linear and Nonlinear Narrative

Narrative works, whether in poetry or prose, appear to be linear in construction. Drama is linear because, like music, it plays out in time for a specific duration. We saw that one problem of writing screenplays is the linear play time that drives how you think and write. However, epic poetry from ancient time has usually been based, as with The Iliad and The Odyssey of Homer or the Sanskrit Mahabharata, on a

1 See the discussion on the International Game Developers Association website: www.igda.org/writing/InteractiveStorytelling.htm.

start of the twenty-first century, we are experiencing the burgeoning of information technology that alters and develops preexisting forms of narrative and exposition. Social websites such as Facebook, LinkedIn, and Twitter have become real-time interactive universes that depend on multipoint-to-multipoint communication, and are now critical components of traditional broadcast channels, marketing, and corporate communications.

huge mythological background web of stories that is not strictly a linear narrative but a cluster of interlinked narratives. Even European works such as Boccaccio's Decameron, Chaucer's Canterbury Tales, or the peripatetic novels of the eighteenth century, such as Fielding's Tom Jones or Laurence Sterne's Tristram Shandy, explore structures that are not end-to-end linear but layered or multidimensional and not necessarily chronological.

It seems reasonable to argue that the human brain does not function in a linear fashion. It is more akin to a computer processor that multitasks and uses different types of memory. Physiologically, the human brain processes different sense impressions with different cells in different areas. Visual sensation is processed in the visual cortex and auditory sensation in the auditory cortex in the temporal lobe. Touch and interaction through the mouse and keyboard, is processed in yet another sensory area of the cortex, probably the cerebellum and the parietal lobe. We all know how we can hop between mental tasks and suspend one operation while we process another. Indeed, our lives seem to depend on being able to do this more and more now that we have the tools to exploit this potential of the human brain. All our memories, all our knowledge, and all our consciousness coexist with random access. We use them like a relational database but without the same efficiency or speed. We can even think and do two things simultaneously. Not only do we have to chew gum and walk at the same time, we have to multitask all day long. We listen to the radio, drink coffee, put on make up, plan the events of the day, tweet and talk on a cell phone. Some try to do this while driving and endanger the rest of us because of the limits of multitasking.

The way the human brain manages this reality stream and programs the actions that follow provides a nonlinear model. Linear media increasingly make use of multiple information streams. Television puts text titles on screen, or the stock market ticker under the news at the same time as the anchor is talking and the picture moving. It uses pictures within pictures so that the eye and brain must sort multiple streams of information simultaneously. We use mobile media platforms at the same time as viewing and interacting with content through websites. Many channels have preview popups of the next program in the corner of the screen so that the viewer is engaged in program planning while engrossed in current viewing, even of dramatic material that calls on the audience's "willing suspension of disbelief" (Samuel Taylor Coleridge). That kind of engagement without distraction is one reason why movie theaters maintain their appeal.

COMBINING MEDIA FOR INTERACTIVE USE

Although we have probably always had nonlinear imaginations, we have not always had nonlinear media nor the tools to make them interactive. Our entire linguistic education encourages us to think, read, and write in a linear fashion going from left to right (or right to left, as in Arabic, Hebrew) and from top to bottom. For traditional script formats for television, film, and video, we write for two media that can exist independently—sound and vision. Now we have additional media—graphics, animation, still photos, and text. So, just as it is a bit of an adjustment to write a script with two or three columns, writing for interactive media requires a new layout to accommodate not only more elements of media production but also the nonlinear form and the interactive possibilities of the

program. This is true for both interactive instructional programs and for games and interactive narrative. Because a script is always a blueprint or a set of instructions for a production team, we have to figure out how to express interactive ideas in a way that enables the makers to produce the actual media content.

What comes first, the chicken or the egg? Do you design the interactivity first, or do you write the content? This is the key question for understanding the problem of interactive writing and design. For linear media, presentation of content is predictable in flow and direction. Sequencing is critical to all the writing we have discussed so far, but for nonlinear media, sequencing doesn't mean a thing because the user or player is going to choose the order of multiple possible content sequences by mouse clicks and links. We are creating menus of choice. To continue the metaphor, we are used to starting with appetizer, soup, starter; going on to the main course; and finishing with dessert. We can serve wonderful sit-down meals in this way. An interactive media experience, on the other hand, resembles a buffet. You eat what you want in any order at any time. Some people may want to eat dessert first, or stay with starters. Like all analogies, this one is limited.

In a traditional script, the relationship of one scene to another, one page of script to another organizes the structure of the resulting film or video. For interactive media, there is no such relationship. The order in which you write down something does not reveal the final order of the program or even the order in which the user can access it. You can write words to be recorded as audio, pieces of text for display on screen, or images to be created by graphics tools or shot on video, but this has no necessary relationship to the way all these elements will be arranged in an interactive program. Nor would these individual pieces of writing express the interactive relationship between them. That interactive potential has to be conceived, designed, written down, or represented so that it can be programmed.

You have to know that an interactive design will work. Hence, interactive content cannot meaningfully exist without interactive design, at least to a degree. How do you prove that the interactivity will work, whether it is on a website or a DVD? You have to write that interactivity into computer code that will make it happen. You have to use an authoring tool. The content, or assets as they are called—text, graphics, video, audio, or animation—cannot be created first before design. It may not always be clear at the outset what media you need. These bits of content that might be greater or smaller or added on later are written as descriptions of what is going to come. The final result, what you are purveying, is an interactive click stream or a potentiality of interaction. You have to model a kind of prototype. The plan for this is difficult to describe in prose. Some kind of diagram would seem to explain it better. This diagram is known as a flowchart. A **flowchart** can map the interactive idea more efficiently than lengthy prose descriptions of multiple opportunities for user choice.

However, the flowchart does not describe the content—the text, the dialogue, the pictures, or the video clips. Out of each node on the flowchart comes a piece of writing that describes a graphic, a photo, an audio element, a piece of video, or text. So you have to think in two dimensions. One relates to the content of a particular piece of media. The other relates to your overall interactive purpose. Let's illustrate all this by some communication problems for which an interactive multimedia design would be a solution. We need to recall the seven-step method:

1. Define the communications problem. (What need?)
2. Define the target audience. (To whom?)
3. Define the objective. (Why?)
4. Define the strategy. (How?)
5. Define the content. (What?)
6. Define the appropriate medium. (Which medium?)
7. Create the concept.

Until you answer these questions, you cannot intelligently decide whether an interactive medium is the solution. Defining the objective is going to weigh heavily in making this decision. Many producers despair of corporate clients who do not know the communication problem and objective for a particular project, see that rivals and competitors have used an interactive DVD or website, so they want one. It is essential to start by looking at the communication problem, rather than starting with the communication medium, and then finding the solution that will use the medium.

A video game is an exception to this analysis because it is interactive by definition and by its very nature. If you are designing a video game, you do not have to determine whether it will be interactive; it has to be interactive. Your spend your energy defining the target audience and thinking about the strategy that will make the game different, new, or appealing to that audience. The objective might be to excel in graphic realism or to innovate in streaming video or to create a totally engrossing imaginary world.

Let's start with the website that accompanies this book. What communication problem does it solve? Beginning scriptwriters have difficulty seeing the relationship between words on a page and the finished product. They also have difficulty translating a visual concept such as a shot or an image into descriptive scripting language. Descriptions and illustrations interrupt the flow of reading. To be able to show a script or have a video clip to illustrate a scene then solves a communication problem that is essential for the user of this book. Scriptwriting terminology for camera shots and transitions is easier to understand if you can see or hear an example. An interactive multimedia lexicon is a solution to a need to understand new concepts. The objective is to make scriptwriting terminology more accessible to the target audience, beginners, who might not retain the concept by reading a definition. The strategy is to make it easy to use, which could be enhanced by presenting it as a game or quiz.

Consider the following initial proposal document that is the formal beginning of the project:

Design Objective

The main objective is to provide an interactive tutorial for scriptwriting terminology and its use. The idea is to provide a lexicon that combines text, image, and sound to explain each term. An efficient interface and clear navigation are important so that the module is easy to use. The user can select terms in any of the three main areas—camera, audio, and graphics—to increase familiarity with scriptwriting terminology and have a better understanding of the industry-wide conventions for this type of writing. The strategy is to create an easy interface with interactive links that make all definitions two or three clicks away from any place in the glossary.

Navigation

The flow is hierarchical with links so that the user has an opportunity to connect traditional text definitions via hyperlinks to illustrations in the medium itself—video, graphics, and audio. Each page has a button link to the other branches so that the user can move at will between topics. Each page is designed to offer a choice to a deeper level with button or hyperlink options that move the user through branching to a graphic illustration. The hierarchy has three levels and then a return back to the top or a link to another branch. There is a link to a complete alphabetical lexicon that itself links to every definition (e.g., MEDIUM SHOT).

Creative Treatment

Although the content is educational, the graphic style establishes a bright and user-friendly environment with clear navigational choices to click through the bank of information. Each

link has a visual change such as a new color or a rollover effect together with a sound cue to support the navigational choices. Apart from the text that defines the term selected, we see a choice of visual icons for each type of illustration that embody links to that illustration. For example, the camera movements are represented by a camera icon, the camera shots by a TV frame icon, the audio by a speaker icon. When an illustration is a QuickTime movie, we set it in a quarter frame with relevant text. The usual player controls enable the reader to play, rewind, and stop. Likewise, audio illustrations have player controls including volume.

Text definitions travel with the navigation from level to level. Choosing camera leads to a choice of three subtopics: shots, movements, and transitions. So "movement" is added to the camera identity of the frame. Then at the next level, the specific movement is added: "movement—PAN." A short definition is fitted into the layout with a movie frame and controls so that the movement can be seen as live-action video. In this way the information is cumulative. Links to websites about scriptwriting and productions could add another dimension but would also distract from the central purpose, which is instructional.

The written proposal is a necessary start. It does not solve the many problems of design but rather states what they are. It does not enable you to experience the navigation, which is the key to the nature of interactive experience. In fact, between proposal and production, many things changed as the reader can verify by using the website. The provisional flowchart included an interactive game that had to be abandoned because it did not work in practice.

One of my students proposed an interactive project on national parks, something like a kiosk, DVD, or website. The idea appeals immediately. The Department of the Interior (specifically the National Parks Service) would be the theoretical client. The project provides a solution for dealing efficiently with public inquiries, but it goes even further and anticipates a need to promote tourism. Much of this type of information has no linear logic. Geographical location, wildlife, and recreational facilities need to be accessed through some kind of interface. The hierarchical content becomes enormous. The amount of content was far greater than ever imagined in the written proposal. In this case, the organization of the interface determines the content. **"The Adirondack Adventure Guide"** is an excellent example of this type of interactive guide. You can examine the design document in detail on the website.

Many projects get out of control and cannot be finished because the design-versus-content relationship is not understood at the outset. In a professional world in which you are paying graphic artists, videographers, and sound engineers to create assets at great cost, you cannot afford to ask for content in a script phase without an interactive design. What you are selling or what the producer is selling is the interactive experience, not the content per se. That interactive experience is rather a way of experiencing and using the content.

BREAKDOWN OF SCRIPT FORMATS

It is probably true to say that no industry-wide standard script layout for interactive programming exists. Each creator adapts a layout that suits a particular project because these layouts are still being invented. You will come across a patchwork of script formats. For example, if a game involves dialogue, then a miniscript, similar to a master scene script, might be useful for a dramatized section or cut scene. An audio recording might be prepared like a single-column audio script. A description of a graphic can be a simple paragraph, but sooner or later, a graphic is going to have to be sketched in storyboard format. Finding ways to lay out the screens or sequences is probably manageable by common sense. You really need to group the different kinds of assets together. You need a shot list of all the

audio and a folder with those scripts numbered or indexed to relate to a flowchart of the navigation. The same is true for video and graphics. The relationship between the scripting elements cannot be understood without this plan of navigation that explains the interactive sequencing and menu choices that must be built in with authoring software like Adobe Director. Although you need a written design document describing the objective, the interface, and how the navigation will work, you also need a flowchart, a document that is a diagram of the navigation. You cannot write much specific content without a flowchart because of the nature of the production process. The sequence is as follows:

1. Write a needs analysis defining the communications problem for the client.
2. Write a creative proposal demonstrating that interactivity is an answer.
3. Write a design document describing the interface and how the navigation will work.
4. Map the interactive navigation by creating a flowchart.
5. Create storyboards for graphics/animation.
6. Write key miniscripts for video, audio, animation, and text.

Step 3, navigation, is vital. We have already pointed out how difficult it is to describe the process of navigation. Should a writer be drawing flowcharts? In the new media world, the role of writer is either to break down the interactive design into assets or write out the assets in their appropriate script format, depending on how you define your role. Is the writer the designer of content and the designer of the audience interface with that content? The answer ought to be yes.[2] The Writers' Guild of Great Britain maintains "that writers, rather than designers, should be composing the scripts for games."[3] This suggests that designers have to learn writing and that writers need to learn how to design.

The capacity to think imaginatively about the final experience and media result before production resources are committed to the project has always defined the role of the writer. The writer has to have a grasp of what interactive code and computer scripting language can do to describe interactive possibilities. The carriage builder has to become an autoworker. It is a symptom of change in the media landscape.

Writers do not necessarily have artistic skills. What if you cannot draw? If you do not conceptualize navigation, you take a backseat to some other member of the team. The question is whether the writer becomes a co-designer or just a wordsmith called in to write dialogue, commentary, or text. Perhaps collaboration is possible. Writers could also be designers and vice versa. There is a parallel between this and the writer/director relationship in linear media. Writers lose control to directors once production begins.

So what enables you to think about, conceive, and express navigation?

Branching

The easiest concept to grasp is branching. The metaphor is a tree that starts with a single trunk and then grows branches, which in turn grow smaller branches until there are thousands of twigs with leaves on them. The directory structure of a computer hard drive in most operating systems is presented to the user in this way. You navigate through directories and subdirectories until you find a specific file. This is known as a hierarchical structure. It is not an interactive structure because you can only go backward or forward in your click stream. You quickly find this out if you construct too many folders and subfolders. Computer directory structures can be unwieldy unless you have a tool like Windows Explorer to look down on the branching structure from above and navigate around it.

2 A sample of opinions by writers who have worked on interactive projects can be found in *Interactive Writer's Handbook*, 2nd edition, by Darryl Wimberly and Jon Samsel (San Francisco: Carronade Group, 1996).

3 See http://cgi.writersguild.force9.co.uk/News/index.php?ArtID = 147.

→ **Figure 11.1** WIP Rowan tree in bud, by Sam Kelly, www.flickr.com/ photos/ravenmagic/8571503959/

Those who remember MS-DOS will remember the tedium of switching drives and changing directories to find a file.

You are probably familiar with organizational charts that show a chain of command or a chain of relationships. The limitation of this model as an interactive plan is apparent as soon as you go down or up a few levels. The number of branches increases geometrically. Getting from one branch to another is workable if you look at a page because your eye can jump from one part of the hierarchy to another. If the structure has embedded sequences that are hidden from view through menu choices, we are stuck with a tedious backtracking procedure that is like turning a book into a scroll. The depth of certain websites leads to real navigational problems.

To return to the model of a tree, we need to be like a bird that hops or flies from branch to branch at will, not an ant that has to crawl down one branch to the trunk in order to go up another branch.

→ **Figure 11.2** Hierarchy diagram model.

Hence, we create hyperlinks between branches—active buttons or screen areas that switch us instantaneously to another page or another file. The cross-referencing can become very complex. You cannot link everything to everything else because the permutations and combinations would quickly become astronomical. This is the point at which you begin to design interactivity. You start to think about those links that will be either indispensable or useful. This thinking has to be set down. It is not just a crisscross of links; it must also be an interface that reveals the intention of your interactive design. You need to invent a visual metaphor that immediately communicates the organizing idea. This is the visual imagination at work. Once again, can you do it in prose? Partly!

Although it overlaps graphic design, inventing and organizing content and designing the look are two different tasks. The organizing idea could be that you see a bulletin board. Each of the notes posted on it is an active link. For another example, you have a room, and in this room each object has a visual meaning and links to the other areas of content. Doors or windows can lead to subsets of information. Obviously, the visual metaphor should relate to the content, the objective, and the target audience. If you are designing learning materials for children, you might want cartoon animals in a zoo or objects in a space fantasy. If you are creating an interactive brochure for a suite of software tools, you would look for a classy and clever interface (say a stack of DVDs that slide out when you mouse over) that expresses something unique about the applications. Once again, can you do it in prose? Partly!

Computers now depend on visual metaphors codified as icons to communicate functions: a trash can for Macs, a recycle bin for Windows, the hand with the pointing finger, the hourglass, the hands turning on a clock face, or the animated bar graphing the amount of time left for a download. The visual writer has a talent that works with images projected on a screen and should be able to propose visual metaphors for navigation and organization. In fact, the best writers can manage content and communicate ideas precisely through visual metaphor and visual sequencing. So the visual writer has an imagination that can migrate from the linear to the nonlinear world. Nonlinear thinking is probably the key to your professional future and essential to a lot of media creation in the years to come.

We can represent the linear paradigm as a piece of string. We thread beads—events, scenes, chapters, sequences—on the string to create linear programming. Once we break with the linear world, we have no specific model as an alternative. We should consider other analogues or metaphors of organization that will lead us out of linear into nonlinear. For example, take the wheel. It is a nonlinear paradigm. It has a hub, spokes, and a circular rim. There is no beginning and no end. You can go from the center down a spoke (think link!) to any part of the circumference and vice versa. You

can also connect between any spoke contact with the circumference to any other spoke contact with the circumference. A variation would be a hub with satellites. You can combine branching with other structures after one or two levels, somewhat like a plan for an airport. Then there are pentangle patterns, which join up all nodes to all other nodes. A narrative journey can follow parallel paths with alternative routes, useful for interactive video games.

Again, witness certain websites, particularly university websites! You know the problem. You spend hours trying to find your way through the maze. You need an understanding of the organizational idea presented on the home page. Website design is a problem of visual organization but also of navigation. If you want to express an interactive idea, limiting yourself to writing only a word script would be like tying one hand behind your back when you can also draw a diagram with a purpose-built computer tool.

Flowcharts

A flowchart is a schematic drawing that represents the flow of choices or the click stream that a user can follow (Figure 11.3). If you don't plan it, it won't be there. Although you can compel the user

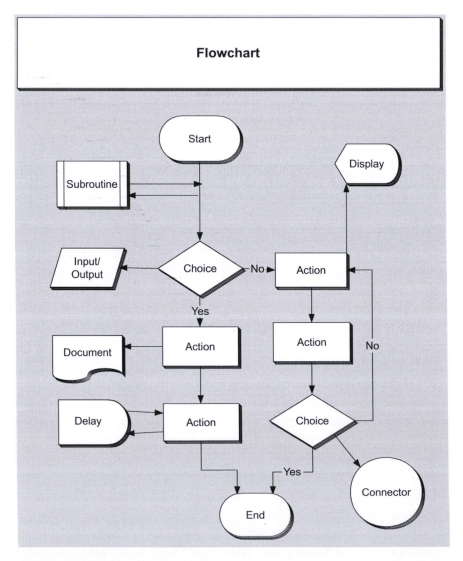

➔ **Figure 11.3** Flowchart symbols.

to make a choice, you do not know which choice. Although users may think of choices that you haven't, they cannot insert new choices into the finished interactive program. If a link is not there, users cannot put it in. They cannot build their own bridges or impose their own interactive design on a program that is already authored.

Interactive multimedia designers have come to think of the flowchart as the first step in designing interactive choice. This map or diagram of the interactive click stream has become the ubiquitous planning document for interactive design. The problem of communicating the flowchart has resulted in a convention that reduces verbal explanations of choice to symbols. In fact, you can use the tables and boxes of a word processor to create flowcharts. More versatile tools exist, such as Inspiration, Smartdraw, Storyvision, and StoryBoard Artist. Each has a dictionary of shapes and symbols and drawing tools that enable anyone to create a flowchart. How else are you going to design navigation?[4] These **software applications** were invented to cope with the complexity of relating navigation diagrams or flowcharts with multiple storylines to the text that describes scenes. You are able to manipulate text files and graphics in a way that is beyond the scope of word processors. Movie Magic Screenwriter also has a template for an interactive script format (see Appendix).

Storyboards

We saw that storyboards are useful for laying out visual sequences of TV commercials and PSAs. **Storyboards** are also very useful for graphics and animation sequences (see the **First Union** example on the website). Computer software exists that enables nonartists to visualize directly in the medium and design motion sequences for animation and live action. Storyboard Artist is a software program that allows you to create animated sequences out of a repertoire of characters and backgrounds that you can play as a movie.

AUTHORING TOOLS AND INTERACTIVE CONCEPTS

To understand interactivity, it is helpful to grasp how it is constructed. All of the assets—video, graphics, text, audio—have to be assembled as computer files and set into an interactive script that plays them when the user clicks on a button or link. So all the scripts or miniscripts of individual pieces of media do nothing until you orchestrate them into an interactive scenario by means of an authoring tool. This software application writes a scripting language with commands in computer code that make the various files display on screen in response to user input from the mouse. You cannot author this interactivity from a script easily unless it is expressed as a flowchart. The way an authoring tool works illustrates exactly why scripting content in segments does not express the interactivity.

The professional authoring tool of choice for fixed media is Adobe Director.[5] Video game authoring tools or programming software are often proprietary, such as Electronic Arts' RenderWare. The function is the same, which is to encode the interactive choices available to the player or user. In Director, all the graphics, movie clips, audio clips, and text exist as separate cast members that are called onto the stage, that is the screen display, as "sprites." Each cast member, when it comes to the

4 See Smartdraw at www.smartdraw.com/exp/ste/home and Storyboard Artist at www.powerproduction.com.

5 See Phil Gross, *Director 8 and Lingo Authorized* 3rd edition (Berkeley, CA: Macromedia Press, 2000).

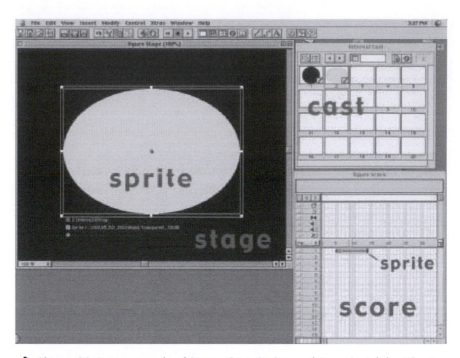

→ **Figure 11.4** An example of Stage, Cast, Sprite, and Score in Adobe Director
showing their relationship.

stage, becomes a sprite, which occupies a frame in a complex score (Figure 11.4). Each sprite and each cast member can be assigned behaviors that tell it to respond to a command such as "mouse enter" or "mouse down." The way the score plays, with its pauses for user input that jumps from one screen to another, is controlled by a computer scripting language called Lingo. This code makes the events happen in response to user input—clicking on a button—or a rollover or a link to a website outside the CD or DVD. The sophisticated coding of the score at the high end requires a programmer, somewhat like a movie or a video requires an editor, to create the final shape of the program by writing the Lingo code which tells the computer what to do.

From Director, Macromedia (now Adobe) derived a web animation tool called Flash that copes with frames that move and layers of visual elements. The same software developer devised Dreamweaver for website design so that you do not have to master hyper text markup language HTML (hyper text markup language), the open source computer code with which web pages are constructed. HTML is the primary computer language of the World Wide Web. There are many other web page authoring tools that put the web page designer at one step removed from HTML; nevertheless, webmasters still need to know the actual code that makes the pages work, both for the execution of design and for maintenance.

To summarize production:

Step 1 is to assemble the media elements.
Step 2 is to position the media elements on stage or screen display.
Step 3 is to write the interactivity by means of a scripting language.
Step 4 is to render it as a stand-alone program that will play from a CD-ROM or DVD on any computer platform, or translate it into HTML.[6]

6 See Timothy Garrand, *Writing for Multimedia*, 2nd edition (Burlington: Focal Press, 2000) and also Darryl Wimberly and Jon Samsel, *Interactive Writer's Handbook*, 2nd edition (San Francisco: Carronade Group, 1996) Larry Elin, *Designing and Developing Multimedia: A Practical Guide for the Producer, Director, and Writer* (Boston: Allyn & Bacon, 2000).

Director can also publish a Shockwave version of an interactive program, which can be embedded in an HTML document and played on the web.

It probably makes sense to divide the world of interactivity into two broad categories. The first is fixed interactive, including storage media such as DVD-ROMs, BDs, and proprietary disks or cartridges that companies like Sony and Nintendo use for video game consoles. When the program is completed, the producer publishes it, manufactures it, and distributes it in physical form. To change it means going back to the authoring tool and burning a new glass master from which to manufacture new disks. That is what we had to do to revise the DVD that went with this book for the second edition. We changed from a CD to a DVD and now to a website to gain real estate for all the new media content.

The second category is web-based nonfixed media, or interactive pages, uploaded to a server that is linked to a network. Most of the time, this network is the Internet. This site becomes part of the World Wide Web, which is a construction of unlimited connectivity between servers on that network. In practice, the network on which the nonfixed media work could also be a local area network (LAN) or a wide area network (WAN) not connected to the public Internet or part of the World Wide Web. Many corporations and organizations maintain their own networks that work on the same principle as the Internet, but you and I have no access to them.

All this background is perhaps more than we need to know as writers. However, because of the relatively recent emergence of the Internet, it seems wise to ensure this understanding so that we can see how writing is different for different interactive media, just as writing for movies is different from writing for television or video. The difference comes about because of the nature of production and distribution in each. Fixed and changing interactive media rest on different computer languages. One can be translated into the other, but there is a different functionality between a closed disk with a predetermined audience and use and a computer file open to anyone in the world with a computer and a connection to the Internet. This difference is dramatized by the problem of hackers, who can enter and modify those files, whether on a server or on your computer; but not a manufactured disk.

Now we should consider what kind of communication problems find better solutions in interactive media. Always remember that the writer is paid to think as much as to write. So

The Internet Platform for the World Wide Web

The Internet itself was originally the growth of a Pentagon WAN (called ARPANET) to decentralize command functions, which was then used by the defense establishment and the research establishment to send documents and messages. The Internet is simply a network of connected computers that is not owned by anyone and to which anyone can have access so long as they can connect their computer to a portal, or ISP (Internet service provider). Companies that maintain the servers and the infrastructure of the network (fiber-optic cable, satellites, microwave circuits) and provide access to this network charge a tariff and rent space on their servers for the web page files to reside and be accessible to browsers.

The World Wide Web adds another dimension to that Internet by virtue of a connectivity built out of a new computer language, hyper text markup language, known as HTML, invented by **Tim Berners-Lee**. It is a universal computer language with open-source code. That means it doesn't belong to its developer, like operating systems (excluding Linux) and other proprietary software programs do. Anyone can use it free of charge and also propose modifications and improvements thereby engaging the best minds to collaborate. HTML describes what a web page looks like as to colors, fonts, type, and layout. In order to find web pages, you not only need a connection to a server that is the portal to the Internet, you need a browser, a piece of software that will display

the question arises whether traditional linear video will do a job better, or whether it is better to create an interactive solution. To think clearly about the uses of interactive media and understand how to write for them, we need to observe to what uses they are put. The uses are not always confined to either fixed or fluid media. For example, video games can reside on a website or be distributed on a disk. Multiple users can access a web-based game, whereas only those with access to the player console have access to a game on fixed media. The same is true for, say, an interactive training or educational program. Broadly, the uses of interactive media are similar to linear media except that the new capabilities of interactive media allow some new applications. You can't use linear media for a kiosk in a mall, for example, where you want to provide shoppers with an interactive guide.

the HTML code as a page on your desktop, and URL (the universal resource locator), the web address of the location of any page.

Because thousands of web pages are added to the web every day to the millions that already exist, the World Wide Web is pretty much inaccessible without a search engine. This software will scan all web pages that fit limiting descriptions you provide. You can enter a word. Or you can enter phrases in quotation marks, or use Boolean statements that limit the list (e.g., "Presidents" NOT "Republican"; or "Presidents" AND "Vice Presidents"). Websites are tagged by key words, which the creator puts in a header (called a meta-tag) and are also indexed for content by the search engines. Different search engines use different criteria and search differently to bring up a list of sites that potentially relate to your search.

MULTIMEDIA COMPONENTS

Although the writer is not directly concerned with the production issues of making sure a program works cross-platform or is compatible with the average computer speed and RAM, it is wise to be aware of them. The more you know about how graphics, animation, and authoring tools work, the more intelligently you can write for interactive media. If you make something interactive on tools like Dreamweaver or Director, you get a much clearer idea of what the process is and what you need on paper as a planning document before you create assets or start programming. Just as a screenwriter should understand the language of cinema and how the camera frames shots and how shots can be edited, so a writer of interactive media would learn from using an authoring tool.

The interactive world is made up of several components: text, graphics, animation (2-D and 3-D), still photos, video, and audio. Each of these assets is produced independently with a different production tool. Some, such as text, graphics, and animations, can be created within the computer environment. Still photos, video, and audio originate in other media and have to be produced externally and imported as digitized computer files so that they can be edited with sound editing software and video editing software.

FINDING A SCRIPT FORMAT

What script formats are acceptable to interactive media producers? No clearly defined format has come to the fore such as those that exist for the film and television worlds. Published books that cover the subject in most depth cite a number of variants, which suggests that the format can be tailored to the writer, the production company's established format, and the interactive nature of the project. *The Interactive Writer's Handbook* cites thirteen key elements in a design document. Some of them, such as a budget, schedule, marketing strategies, and sample graphics, require input other than the

writer's. There is an area of overlap between layout, graphic design, and visual writing. Graphic design is the technique of visual communication, not necessarily the visual conceptualizing of content that precedes it. The graphic designer chooses fonts, colors, layout, and orchestrates the look and coordinates the aesthetic detail to make the idea work. Writing precedes graphic design, which is a facet of production and execution of the vision. Visual thinking, or meta-writing as we have described it throughout, is a way of construing the content with an organizing idea that precedes conceptual writing. The design document then embodies that meta-writing in a creative concept that becomes the solution to a communication problem.

To understand meta-writing or visual thinking in website communication, we can contrast several sites and see that the look and navigational design are wholly different and at the same time apt complements to the nature of the product or business that the website serves. The first example would be a website you use for online banking or a credit card to access your accounts and effect transactions. The financial sites are relatively clean, simple, and functional because they have a primary utilitarian function. However, a site like **RedBull.com** has in the past experimented with no text, only images and Flash movies that respond to mouseovers.

The navigation is intuitive and the visuals communicate lifestyle activities that sell a world, the world of Red Bull. You can see that the visual meta-writing behind these two examples is different. Yet another would be Nabisco.com because its demographic and target audience is young and responds to bright primary colors and product pictures and interactive games. In other words, it is trying to be "sticky" and keep youthful surfers engaged and exposed to product marketing. Go to **Nike.com** and you will find another approach which, like Red Bull, relies on streaming video clips of sports and hyperlinks embodied in images rather than text. A word of warning: whatever can be seen in the site today will likely change by the time this gets to the reader.

Nike.com combines sidebar navigation via hyperlinked text menus to navigate to e-commerce, other countries, and corporate information. The look and functionality of the website are related and are critical to the objective of the website. The objectives of large corporate websites are inevitably multiple. Banks tend to open with functionality (check your online banking website); whereas Nike and Red Bull engage the user in a world of sports, achievement, and images that are not about the products so much as the aura of the world in which the products are to be perceived. Nevertheless, all corporate websites have to manage several publics, such as investors, shareholders, and financial analysts. They also serve as tools for public relations and human resources recruiting as well as product information and sales. A great deal of conceptual thinking has to precede the huge developing and programming cost. Something has to be written down so as to coordinate multiple facets of production.

A game presents a different set of design problems and demands different writing. Visual writing would come into play for a concept, a story summary, character descriptions, and an interactive screenplay. Where characters and drama are involved, a modified master scene script works very well to describe setting, characters, and dialogue. When characters have different responses depending on choice, the format has to indicate a numbered sequence of choices. In ***Where in the World Is Carmen Sandiego?*** (first released in 1985 with the latest version in 2011), the player avatar has encounters with characters in different locations to solve a mystery and teach geography.

Different interactive choices produce different responses from the characters, who give you information and clues. So in a given location, a character's replies are going to have to be numbered and related to where the player clicks on active parts of the screen. So the script format is going to vary with the type of project. Scripting has to provide instructions for production and programming. We can see how the medium demands another way of writing by consulting examples in the Appendix and on our website.

CONCLUSION

Most writers of traditional media seem to be afraid of interactive media. It dethrones the writer to some extent. Linear media present the writer with a clear task, a clear role, and a definite authorship from which all production proceeds. Interactive media do not make the script the premise or predecessor of the product. Writing is necessary to flesh out a design. A number of different writing skills can be employed in the same production. One interactive producer explained to me that he uses three kinds of writers: one for text on screen, one for concept, and one for dialogue or voice-over. Sometimes he gets all three skills in one writer. This is why writers are not the authors of interactive media in the same way that they are for movies or television. Collaboration is, has, and always will be indispensable to creative media program content. It seems even truer for interactive media because of the nature of the media. We now need to examine more closely the uses to which interactive media and interactive writing can be put.

EXERCISES

1. Write an organization chart to document the chain of responsibility for an organization such as a company where you work, a college or university, or a club or other organization to which you belong.
2. Write or draw a logical branching sequence for an interactive CD about (a) pasta, (b) automobile racing, (c) solar energy, or (d) cats.
3. Devise visual metaphors for the commands "Wait," "Think," "Danger," and "Important."
4. Describe the navigation in prose for an interactive CD about (a) pasta, (b) automobile racing, (c) solar energy, or (d) cats.
5. Write a flowchart for a simple game in which you have to click on a moving circle to score points, which are then displayed on screen.
6. Design an interactive multimedia résumé for yourself.
7. Describe an interactive game based on a world concept. Describe the main characters and what the objective of the game is.
8. Write a proposal for a training CD-ROM that teaches the highway code for your state with an interactive test at the end.

CHAPTER 12

Writing for Interactive Communications

In the previous chapter, we drew a distinction between fixed interactive media and web-based interactive media that consist of pages of HTML code residing on a server. At one stage, it seemed a good idea to write a chapter on each. In the end, it became clear that the media writing involved is independent of the computer code or the type of authoring tool employed in production. The same distinction applies here that related to our consideration of linear media when we found it useful to separate the writing in Part 2: Solving Communications Problems with Visual Media from the writing considered in Part 3: Entertaining with Visual Media. It is more helpful to group the types of interactive media according to their broad objectives. Some websites are predominantly informational and commercial, but others are dedicated to entertainment, whether it be online journals, blogs, e-books, or online video games. Put another way, it is useful to separate, once more, writing that solves communication problems from writing that trawls the imagination to amuse, divert, and tell stories. Some web portals certainly combine both functions. A third category would be online journalism. Not only are most daily newspapers in America also published online, but television news organizations also edit the same stories for their websites and web portals linked to the journalistic side of their empires.

The World Wide Web now looms over our world and is the transforming phenomenon of the age. It has changed business, lifestyles, leisure, commerce, journalism, education, research, and information so that there is almost universal connectivity that is happening much faster than the time it took to build out of the old twisted copper wire voice network. Interactivity links web pages through hyperlinks, embedded in pictures, graphics, or animation. The link can be to a page on the same website or anywhere on the World Wide Web.

INSTRUCTIONAL AND UTILITARIAN PROGRAMS

Interactive media apart from websites serve most of the main needs of corporations. These include public relations/marketing, catalogues, brochures, product manuals, and training. What used to be distributed as print media can now reside as interactive catalogues on websites. What used to be printed brochures can now be published as interactive CDs or DVDs. What used to be a linear video solution to corporate communication now becomes an interactive DVD that may include video clips and much more besides. So much linear program content for corporate use involves a transfer of information to the audience. Audiences have difficulty following, absorbing, and retaining a lot of factual detail. Traditional linear video works best as a way to motivate by dramatizing or documenting corporate stories and presenting corporate personalities. Video works well in management groups and large motivational meetings at which an audience has a viewing experience as a group.

In contrast, interactive media rarely involve a group experience, even across a network, because interactive responses are, by definition, individual. Whenever the corporate communication problem involves information transfer, complex data, or training, the intelligent solution must be interactive. The limitation on fixed media is the degree to which the information is volatile and needs frequent updates. In these cases, websites on intranets work better because the cost of site maintenance is lower than manufacturing DVDs. Understanding these issues enables a writer to think critically and creatively in interactive media and do the meta-writing into which the writing of frames and blocks will fit.

DIFFERENT WRITING FOR WEBSITES

Websites are now well established as a fundamental form of communication that can solve a number of communication problems. We should go back to basics. We can get further value from the seven-step method set out in Chapter 2. The potential answers to the six analytic questions will lead to solutions that include websites, which then require a certain kind of writing. The sixth step, which asks what the most appropriate medium is for delivering a solution to a particular communication problem, becomes the key to this present chapter. Understanding why we should choose an interactive solution is critical before selecting that option. Then choosing which interactive solution, fixed or web-based, becomes a further refinement of that selection. Let's remind ourselves of the questions and consider how they might be answered when interactive solutions are probably appropriate.

1. *Define the communication problem.* What communication need does it fill?
2. *Define the target audience.* Who are the intended visitors to the site? What are their demographic and psychographic characteristics?
3. *Define the objective.* What is the purpose of the site? Sales, marketing, information, instruction, presentation, public relations, human resources, corporate, personal, or a combination of several? What functionalities are key to fulfilling the objective?
4. *Define the strategy.* How can you make the site capture the browser, define meta-tags that will bring it up in search engines, and then make it "sticky" so that browsers will engage and investigate the contents? How will navigational design serve the objectives and the content?
5. *Define the content.* What assets are needed to provide rich content? What assets are needed to make the functionalities succeed?
6. *Define the appropriate medium.* Why is this communication essentially interactive and how does it exploit the interactive functionality of a website or fixed interactive media?
7. *Create the concept.* Write out a design document that sells the ideas and motivates designers and programmers.

We always need to ask ourselves about the strategy for achieving the objective. Think about all the websites you have visited. Some of them, like Nike's and Red Bull's, are intensely visual with Flash animation, stunning graphics, and color experiences that require a visual response. Some sites are dominated by text and links. Other sites, such as Apple's, combine visuals and text. Each one has a look, a design, a feel that expresses something complementary to the content. E-commerce sites have pragmatic features such as catalogues, shopping carts, and secure payment links. Corporate websites serve multiple needs that can include public relations, financial information for investors and shareholders, product information, recruitment of personnel, customer services, billing and payment capability, and finally sales.

Most Internet portals, such as Yahoo! and MSN, are somewhat like electronic newspapers. They are different from newspapers in that the home page is not the equivalent of the front page. A newspaper puts leading stories on the front page to complete them on inner pages. An Internet portal has to be multifunctional. Sometimes this leads to too much business, distraction, and confusion. The front page of a portal links you to many other types of information and activities, such as stock market and finance news, popular culture forums, chat, e-mail, trivia, entertainment, games, commerce, and specialized interests. Sidebars usually list all the headings from which you can explore the site. There is no dominant theme in the home page experience that many corporate sites try to achieve because it changes daily, if not hourly. Corporate home pages make a statement of corporate identity, mission, and purpose; or the best do and the rest should.

We can apply our classifications from Chapter 6 on corporate communications that divide objectives into broad types: informational, motivational, and behavioral. Without being exhaustive, we could categorize website functions in the following ways:

- Informational: Internet portals, government sites, library sites, universities, corporations, newspapers, databases
- Motivational: entertainment, marketing, advertising, selling, pornography, movie trailers, games
- Behavioral: e-commerce, shopping carts, payments, instruction, surveys, video games, e-mail feedback

Many sites combine one or more of these objectives. Most of us are so familiar with web pages that we do not stop to think how they get conceived, designed, or written.

Conceptual Writing vs. Content Writing

Writing for a website means thinking clearly and analytically about its function and being able to describe it. We have raised the question of whether the writer's and the designer's work overlap. Similarly, the writer and the webmaster's work overlap. Because a website is a kind of living organism that changes, evolves, and adapts over time, maintenance, pruning, and updating become critical to web success. Clearly, the webmaster is going to decide how to lay out and incorporate disparate and diverse elements on the website. So let us consider this to be an editing function, not a writing function. At the beginning someone has to describe the purpose and function of a website.

Creating content for a website is different. The interactive journalist can say more with pictures, video clips, and audio clips. This new media writer has to conceptualize interactively and think more about the relation of text to other elements. Although interactive media are laid out visually, their content does not necessarily involve visual writing in the sense that we have defined it. The distinction lies in the difference between something that is written and read to be made into media as opposed to writing of text that is incorporated into this interactive medium. After all, a journalist or a feature writer for magazines could be published on a website. *Time* magazine and CNN stories and

articles were linked to AOL. They all belonged to the same corporate entity. The rationale behind the merger of AOL and Time-Warner was to match content to the medium.[1] Can this be considered writing for the web? Isn't it print writing that has been cannibalized for web content?

The most important writing, consistent with the writing philosophy of this book, has to be conceptual. Such writing is not apparent to the eye; it is the writing that the surfer never reads because, just as the moviegoer doesn't read the script of the movie, it lies behind the interactive planning and construction of the site. The writing that analyzes the communication problem, articulates the solution in the form of a concept, and then describes the functionality of the website is design. The fruit of such thinking and writing is navigational design. The strongest kind of navigational design communicates information to the user by intuitive visual metaphors. Such thinking is apparent in the graphical user interface that is now fundamental to operating systems. The trash can on the Mac, the recycling bin in Windows, the turning circle or spinning color wheel for a process, a progress bar for a download—all these are visual elements of navigational design. Tabs for folders use an intuitive metaphor. Whatever engages the intuitive visual response of the user elevates the communication and invites the participation of the use. Conceptual writing leads to production of various kinds such as graphic design and audio and video recording. Thinking through the function of the website, being able to translate that function into visual ideas, and organizing its content by visual metaphors are critical tasks to complete before beginning the costly phase of production. The internal content of a web page keeps changing, sometimes daily. The question of how the website will serve a corporate communication needs writing of a different order—meta-writing—that relates functionality, look, and mission. It is the writing behind the writing. It is the writing that the audience does not read, as opposed to the written text on the website. Writing for the web and interactive media involves structural writing—that is, writing out the idea of what the content is going to be and how it will work. A well-designed website has to have a concept behind it that addresses its organization in terms of the structure, the links, and the layout. A thoughtful, creative proposal is essential. Call a writer—but a writer who understands interactive media!

Websites do not follow a linear throughline of content, which can be represented as beads on a string or an arrow. Relevant paradigms for organizing content on a website include:

Branching. (tree metaphor: trunk, branch, twig, leaf). A hierarchical model; navigation is arduous.

Circle. Anything on the circumference is connected; there is no beginning and no end, and all points on the circle can connect with all other points across the circumference.

Wheel with spokes. A variation of the circle in which points on the outside connect to a single central point.

Hub with satellites. A circle with smaller attached circles or systems and subsystems.

Clusters. Clusters allow random relationships between groups of objects.

Parallel paths. Parallel paths allow direction but with exchanges between the paths.

In interactive design, these relational forms can be combined. Different structures lend themselves to different material so that ideas and media can be accommodated. Content can consist of clusters of cognate or related material, sometimes raw material. In fixed interactive media, such as a training module, the parallel path might be ideal to get to a goal. A website allows unlimited links to source material that would sink a linear exposition. Branching in websites is a natural tendency,

1 This merger broke up at the end of 2009, and AOL is once again an independent company.

but it can quickly lead to exponential increase at every level and to surfers losing their way, like ants crawling up a tree trunk to get to one particular leaf.

WEBSITE CONCEPTS

If you wear the hat of a conceptual writer for a website, you have to think through the function of the site. What is the objective, the purpose of the site? Again, we confront the writer/designer issue. It seems clear that this kind of writing implies design and therefore must express design concepts that in production become design features. A website makes a statement. Many websites make wrong or inadvertent statements. They are not only ugly but also confusing. A website must be functional. It must communicate right away how users can interact with it and get what they want or get what you want them to get. A site implicitly and explicitly makes a visual statement and demonstrates functionality. The two should coincide and reinforce one another. A site has style and personality. In some cases, it is that of the creator, of that one person, but normally corporate communication is not personal expression. The site has to reflect the identity and mission of the corporation or the portal. More often than not, there is a conscious design, which a writer can articulate and a graphic designer and webmaster can execute.

Why is one kind of web writing visual writing? A site makes a statement visually, verbally, and functionally. Deciding how the home page should be organized is conceptual writing for design. Should it be bold and brash to attract attention, like Red Bull's site? Should it be sober and functional so that a bank or financial services company can inspire confidence, like the sites for T. Rowe Price or Bank of America? Should it be minimalist and intuitive to draw in the surfer, like the Nike site? How much Flash animation will succeed in visual seduction or, conversely, confuse the user. Nowadays, certain functions such as links to e-mail options in a "Contact Us" link, or "About Us" are near universal. The questions we need to ask are: What is unique about a particular site? What will engage the surfer or user at an intuitive level visually that relates to the overall objective of the site? What keeps users on the site and gets them to go deeper. Writing out the idea for the website is a thinking-writing function, crucial in all scriptwriting and crucial to interactive media, both web-based and fixed. Although a designer might make decisions about layout and build the look, the layout has to flow from a concept that unites function and look, articulated by a writer thinking through the organization of content. Maintenance then falls to the webmaster.

NAVIGATION: THE THIRD DIMENSION

Reading web pages involves responding to navigational prompts. So awareness of navigation is critical in writing web pages. This is the ever-present problem of the third dimension. Whatever you read, whatever you write, exists in a vertical context as well as the linear one we know from reading a book or an article. This awareness of navigation has to modify the style of writing. So it makes sense to think carefully about links to pages offsite. Because hypertext is the same whether it jumps to a page on or off the site, users do not necessarily know where they are. There need to be signposts. You can't look down every rabbit hole.

Define the cyber-boundaries that allow or direct your user to leave the site. Some websites are fairly self-contained and present opportunities for navigation around the site. Other websites fan out with ever denser links. Most e-commerce sites will want to be self-contained. However, with Amazon.com, the links across the web through a title or a product become so heavily layered that it is easy to lose your way because of links. But think about the concept. Amazon is not organized to be

self-contained because its original main products—books and videos—by their nature take you down a road of exploration. Amazon has become a virtual department store. Many sites compete within themselves for your attention. This is true of web portals. You are called to follow so many different directions and links, which are not necessarily related, that you become pole axed with indecision. This arrangement would not be good for a corporate website. Clear navigation and accessibility govern successful interactivity inside websites.

Consider Yahoo.com, which, despite being a relatively clean web portal, includes a bewildering range of directions to take the user from obvious news headlines to topics like "9 Simple Things Women Want." These outside topics can be a distraction. It works for entertainment but not for business or corporate sites. Linking within a site helps organization. Linking to the web or diverse sites can fragment the user experience. You forget what you were looking for in the first place because you followed incidental links and ended up wandering in a maze of links.

WRITING THE INTERACTIVE IDEA

Once again, we have to contemplate that fascinating transition from something conceptual written on paper to something visual and fully produced in the medium itself. We know that in the professional world, you cannot just keep this in one individual's head. Ideas have to be pitched to a client, costed out in a budget, and communicated to a team of specialists who will translate them into concrete visuals. Translating from the page to the screen—the computer screen, in this case—is the essence of the media business.

Concept

Production methods and the role of scripting are not standardized and predictable for websites in the way that they are in the world of linear media. Nevertheless, we can outline a best practice that will ensure a satisfactory result. If more than one person is working on a project, a written concept and more is essential. It is probably indispensable even for a single creator to define a concept before committing resources.

Design Document

A design document is unique to interactive media. It addresses the need to know two important characteristics of a website: what it will look like and how it will be organized. Navigational design sets apart the pros from the amateurs. All interactivity is based on links. Anybody can create links. The question is whether the links serve a coherent purpose and whether the navigational idea is well communicated to the user. If this stage has any equivalence to the linear world, it would be to the treatment.

Flowchart

A **flowchart** is a diagram that does not require writing skills per se but requires skills to order information spatially and sequentially. Whether a writer, developer, designer, or programmer does it, the production team needs to have a flowchart in order to create the site. Making a flowchart is enabled by software such as Inspiration, Smartdraw, and Storyvision. For each click and link, there

is another page on screen. So it has to be designed and laid out and the assets necessary to that page assembled. The purpose of the flowchart is to chart the intended navigation to be presented to the user. It becomes a way of verifying functionality and a basis for programmers to write the code that will make the links work.

Breakdown for Production

Any given web page is comprised of multiple media. Each of these media elements is called an asset. If your idea calls for a still picture, you have to create that picture or buy it from some copyright owner. If you need a video clip, once again you have to shoot it or buy it ready-made from some source. A list of assets for each page of the website must be compiled and broken down into production-specific categories: video, audio, graphics, still photography, and text. A production manager or project manager can assign to graphic designers, video producers, or animators the list of needed assets in each category that have to be assembled for construction of the site. Once production begins, in practice, the writer hands over to the project manager, developer, or designer, but can be called back to write something needed as the site or game is developed.

Text

Text on a website is a job for a writer reappearing as writing to be read. This writer might not be the same writer/designer who conceptualized the site. Text content is itself an asset. It may be writing that is technical or that is based on specialized knowledge that has to be commissioned. Web writing differs from print writing because interactivity is part of the way it is put together and contributes to the experience of the web user. The use of colors in text and backgrounds changes the web reading experience. Key words or sources offer potential links in the form of tangents, statements, and questions. Writing for web content is visual writing in that it involves media other than text.

Video, Stills, and Audio

Images, video, and audio clips can enhance the user experience and bolster the content. The web writer has to write with multimedia content in mind and consider where additional content such as still photographs, video, and audio might be appropriate. If a video clip or other media is anticipated for a given page, you may need a short script (we will call it a miniscript) to tell a video production crew what to shoot, or an audio technician what to record, or a photo researcher what picture to search for in the libraries or archives. Once again, the writer of multimedia content of individual pages may not be the same writer/designer who conceptualized the site.

Applying the Seven-Step Method

To construct a site, use the seven-step method, as outlined earlier in the chapter. Many students getting involved in website construction or interactive media want to compose their interactivity directly with the authoring tool and are impatient about the writing that precedes it. It is important to keep in mind that what you do in higher education is free of commercial pressure, such as competition and cost. In the professional world, however, you need conceptualizing skills. Not the least

of these problems involves cost. If you promise to build a website or an interactive CD for x dollars and then find that it costs more than your estimate, you will be working for nothing or actually making a charitable gift to your client. I don't believe in corporate welfare. Back in the first chapter, we explored how the need for scripts arose in the early film industry for the simple reason that in an expensive production medium you need a plan. This same principle applies to interactive media. The more you can get down on paper, the more secure your project!

We cannot illustrate all the issues of concept writing. Suppose we are going to create a writing website. Let the domain name be MediaWriting.com. Although we have argued the importance of thinking through the seven steps, in the professional world, this may not be presented to a client in writing. Personally, I always write a response to a client briefing setting out my understanding of the communication problem and my rationale for my creative solution. The first six steps of the seven-step method are embedded in that preamble to the creative concept or treatment. We will begin with our six-point analysis of MediaWriting.com's needs:

1. *Define the communication problem.* The communication problem arises from the fact that many corporations do not know how to solve communication problems in written and visual media. We want to market a consultancy service to corporations and a coaching service to other writers who have ambitions to write for various media, mainly the visual media, and don't exactly know how to go about it. They need a guide, a writing clinic, a list of resources and information concerning the professional writing world.
2. *Define the target audience.* The target audience is businesses and media writers who have an ambition to write for corporate or entertainment media. The site should accommodate all levels of writers, including beginners or experienced writers who need a second opinion. The interactive characteristic of the medium will facilitate self-selection.
3. *Define the objective.* The objective is to provide a reassuring environment that is also commercial and useful to professionals. A forum for writing issues and chat rooms should be directed at creating a virtual community. Training and script-reading and critiquing is fee based. Click-through signage is desirable to generate supplementary income. An e-mail function is important for communication.
4. *Define the strategy.* The main strategy has to be a unique proposition of some kind that will invite the browser to click. Some video clips and stills might help break up text, but the main visual impact has to be in the look and design. It has to be clear and to the point in delivering services and information. The look and design should be professional and attractive.
5. *Define the content.* The content comprises tutorials for purchase, advice columns, a forum, a chat room for writers, a virtual bookstore with click-through links to Amazon.com, a resources guide that includes lists of agents, links to other writing websites and competitions, script reading and doctoring, corporate scriptwriting service for clients, e-mail, a hit counter, script samples, the author's writing, and a personal profile.
6. *Define the appropriate medium.* There is dynamic interaction between users over the Internet. Because this function involves interactive exchange, the web is the unique medium that can deliver all this. Everything is updateable.

Step 7, as you will remember from Chapter 2, is to state the creative concept. Because the chosen medium is an interactive website, the concept must address things such as look and navigational design that will be developed later. This concept could be a memo for a meeting to pitch to a client for team clarification.

Concept

Concept for MediaWriting.com: The first impression of the surfer has to be a combination of intrigue and efficiency. Something has to catch the eye, but then immediately engage the brain. The layout of the home page has to present clear options. There should be a discrete Flash movie that keeps interest without being distracting. The visual metaphor could be a quill pen morphing into a fountain pen, a typewriter, a computer, or a handheld PDA. A clean sidebar should list the major navigational links: Bookstore, Tutoring, Personal Profile, Script Samples, Writing Links, E-mail, and Login/Logout. There should be a hit counter.

Sidebars with headings are a way of organizing text topics that are related. Mouse-overs cue sub-menus, and subtopics can be set in a different color and become hypertext. Body text should be in sans serif type, which generally reads better on the web.

The objective of the site is to generate inquiries and sell consulting services and writing instruction.

We want to see a clean, sober, easy-to-read site that presents an uncluttered spectrum of writing services both to the client needing a writer or consultation and to the writer needing information, advice, or writers' goods. If there is Flash animation, it has to be clean and simple. It has to be functional. It has to be fresh in content. The website www.mediawriting.com is up and running, a work in progress that is harder to create than to imagine. Budget and resources are significant in writing design concepts for clients.

WRITING TO BE READ ON THE WEB

One way of thinking about the difference of web writing is to see it as multilayered writing. By means of hyperlinks, panels, sidebars, fonts, and colors, you can reach more than one audience at a time. In fact, one problem of web writing lies in the unpredictable demographics of the surfer in your domain. On some sites, there is something for everyone. It is like the sections of a newspaper. You go for the sports pages; I go for international news; someone else goes for the classifieds. Websites are also the broadsides of the information age. In the seventeenth century, a printer would put together a news sheet and run out on the street to sell it to curious passersby until the innovation of the weekly and daily newspaper in a later century. Websites look for passing trade among the surfers as well as formal communication generated by e-mails and published links. Similar to seventeenth-century broadsheet publishers, bloggers provide alternative views or sources of information.

Linear writing, or prose exposition, which is the centuries-old model for print writing, requires a sequential development of ideas moving from a beginning through a body of argument or narration to some kind of conclusion. The whole experience of reading linear writing is contained in the pages of the article or book. In contrast, web writing, which at its simplest could be a box containing the equivalent of a print article, is not limited to linear delivery in a frame of text. The information or idea can be developed with hyperlinks that highlight themes in the article that explore, sideways as it were, tangents that supply a lot of detail about something that would otherwise interrupt the flow of the main text. It is somewhat like the idea behind the footnote in print media. Many writers, especially those presenting factual arguments, want to back up their points with sources or comments or asides, which are then put at the foot of the page or at the end of the chapter. In a sense, the web expands the footnote by making it interactive, by linking and branching to the actual source or another line of argument.

You see words on the printed page just as you see text on the web page. In fact, text dominates web communications. The Gutenberg concept of a page has migrated across to the web. However, web pages are not laid out the same way and do not restrict themselves to text. They make use of boxes, panels, sidebars, color, different fonts and typefaces, and, of course, animation, such as animated GIFs and Flash animation, so that the eye is engaged visually by the design rather than the text. On the other hand, web pages have fallen back into pre-Gutenberg ways of arranging text—scrolls and folding palm leaves. We have the expression "scrolling" up and down to describe our navigation through a web page document. At the same time, there are navigation arrows or "next" buttons or numbers to jump to the next page. Page turning does not make for true interactivity. It is really more like a slide show or a PowerPoint presentation. Arabic and Hebrew read right to left and Japanese and Chinese ideograms read vertically. The web page seems to accommodate all possible ways of arranging and sequencing text. The writing of text for web pages has to be different from ordinary print media because text has to be organized in layers of hypertext with links that draw together concentric circles of information. So although paragraphs of text may read just like print media, the editing and thinking must take into account another dimension that does not exist in print media. Print media, or straight text, has backward and forward relationships, whereas web text has a third dimension, a vertical dimension, which links and positions it in a matrix of information or of associations.

If you monitor your own experience of surfing, common sense tells you that when you read an online article you do not always read it as a stand-alone piece. More often than not, you find the article through links embedded in a previous text or in a list compiled by a search engine. So the web complicates life for the writer and the reader to some extent. Both can lose track of where they intend to go or where they came from.

Portals and browsers are a kind of Internet theatre. They have something for everyone. So what we encounter is an omnibus of writing drawn from multiple sources. Websites make generous use of text. Some, like the portals of the major browsers, are cluttered with text leads and banners. So short, effective prose that headlines ideas and topics does the job. To communicate effectively, you need to conceptualize interactivity and introduce effective, functional graphics so that the options and functions are clear. The home pages of AOL, MSN, Yahoo!, and other major portals and ISPs have a format that is akin to a newspaper front page, except that the headlines and tag lines are hyperlinks. Therefore, the writers and editors of these websites need a strong background in journalism and in the editing of breaking stories and weaving together of a combination of news and entertainment. However, this kind of writing is not visual writing. Even though the home pages also use still pictures, video, color, and graphic design to present opportunities to users, the text is prose exposition meant to be read and not a script meant to be produced.[2]

Most web pages contain text of some sort, whether titles, headings, or labels. We might call that designed text, the same use of text that we find on posters, billboards, and print ads. It has a graphic function as well as verbal exposition. Then there is the text that works like text in a book, newspaper, or magazine. It is prose exposition. It is meant to be read for content. It reads like print media, even though it may incorporate hypertext links to other pages. Gutenberg technology survives inside the website although the prose style may change in ways that reflect a busy screen full of banners and sidebars. Website articles have to be written at multiple levels. The first level is broad outline. The succeeding levels amplify and link the story to an ever-widening circle of archival and related materials.

2 Interestingly, the OECD argues in its published standard for web communication that there should be "a text equivalent for every nontext element." See Priority 1, Introduction on the webpage www.w3.org/TR/WAI-WEBCONTENT/full-checklist.html 1.1.

In the early days of journalism, when the early telegraph could break down or the correspondent could run out of money, wire stories were written with the most important, leading elements first. Detail and elaboration came later. This is called the inverted pyramid. A parallel problem exists today. Surfers come on to your site from all directions and may be bounced back off other links. A website benefits from the same inverted pyramid practice developed in wire service journalism so that leading ideas come first and impatient surfers do not click away. A new dimension is the multimedia content that tempts surfers to click on pictures, listen to audio, or find out answers to leading questions like Is She Cheating On You?, How to Tell Whether Someone is Lying, or The Ten Hottest Jobs for Graduates. There are tax tips, real estate advice, and celebrity news to distract the surfer and compete for attention. Unlike print newspapers and magazines, the web is a visual medium that is also a text medium. The visual writing lies in the design concept and not the text as content. Although this primarily applies to web portals, there is a similar phenomenon on commercial sites such as Amazon.com. Who has not had the experience of searching for information on the web and then losing sight of the original intent of that search because of spontaneous response to hyperlinks that take you away from your main search? It is even possible to forget what you were trying to find in the first place and, what is worse, be unable to get back to where you started.

Newspapers are in crisis because so many readers, including the author, read newspapers online. It is not just that most of them are free and all are paperless, which allows readers to avoid the smell of newsprint and the problem of recycling; they are metamorphosing into something different than the print version. New dimensions are added so that we interact with them in a different way. *The Boston Globe* was a pioneer among online newspapers. Some features that illustrate what makes an online interactive newspaper different are unique to the web edition:

1. Articles and reports contain hyperlinks to related articles in the same or prior editions and to outside sources so that a reader can drill down into the background if need be.
2. Articles can be accompanied by a gallery of pictures, not just one picture that is chosen for the print edition. Slide shows can be attached.
3. Articles are often multimedia; they incorporate not only stills but video clips and graphics.
4. Graphics can be interactive so that they present complex information easily, whether it is the location of crime across the city in different categories or economic data evolving over time. A mouse-over or click can bring up ancillary data or trigger animation.
5. No print edition runs the same article or feature in multiple editions. In online editions, important articles or high value series can stay on the website for extended periods. There isn't a problem of space and cost. Major stories that might run over weeks can be assimilated and reread in one place and be available to a wider readership.
6. Readers can e-mail journalists and contributors and can post reader comments to the story. Although many comments are banal, even ignorant, it democratizes the letter to the editor that is so restrictive in print editions.
7. Articles and images can be saved and downloaded and forwarded to friends and acquaintances.
8. Readership of most newspapers, even a national newspaper of record like *The New York Times,* is local, whereas access to the online edition is not limited by geography. In fact, any online newspaper is of necessity a worldwide edition accessible to anyone.

Although we cannot deal extensively with journalism in this book for all the reasons stated in the Introduction, it is easy to see how convergence of media imposes visual thinking on print journalists whose future now seems inexorably dependent on interactive media.

E-COMMERCE AND INTERACTIVE DISTRIBUTION

Online pornography pioneered the techniques of e-commerce because it fits, accidentally, the ideal business model. In that model, you can shop, choose, sample, pay for, and have delivered directly to your desktop the data, goods, or service that you seek. Amazon.com, on the other hand, is still warehousing books, videos, and DVDs and physically shipping them to the customer, as are most other web-based extensions of mail-order businesses. The introduction of Kindle exploits the technology of digital distribution of print media. The true e-businesses actually deliver goods and services and take payment over the Internet. Banking and online stock trading fit the criteria. Another business that leads the way is software. You can buy and download software directly to your hard drive, or you can use it on a remote server. Why should

> **Early Interactive Entertainment**
>
> Although the first interactive fixed media were reference works, there were also early attempts to make interactive entertainment. The best-selling CD-ROM for a while in the 1990s was *Virtual Valerie*, an interactive strip tease, which allowed the user to tell Valerie, the stripper character, what to do. Porn always seems to drive new media, whether the belly dancer in George Eastman's demonstration of moving picture at the Chicago Exhibition in 1895, which contemporaries considered to be pornographic, or the pornography that drove the consumer VHS format to triumph over Sony's superior Betamax format, not to mention the early dominance of porn websites on the World Wide Web.

you buy highly marked-up, shrink-wrapped packages of DVDs or software that have to be manufactured, warehoused, shipped, and displayed on shelves in expensive retail floor space that you have to travel to, park near, and spend time getting to when you can get the software directly from a website?

Just as the music and film industries have been thrown into confusion by the rapid evolution of media compression technology (including MP3s, Netflix, and DivX movies), combined with high-speed Internet access, so the publishing business has been forced to change. Books, magazines, movies, and music cannot only be sold over the Internet, they can also be distributed over the Internet. The major media companies have been slow on the uptake. Authors can now self-publish on the web. Stephen King experimented with publishing a serial novel on the web. Books on websites could become more interactive and can be sold as incremental chapters or selections, much like music tracks can be sold individually rather than as albums. This book could potentially be fully interactive on the website that comes with it. With this edition, it becomes a true e-book, integrating the text and the online media and sold chapter by chapter, or by subscription. No doubt traditional writers will have to rethink how they write when the distribution medium for their product is interactive. Fiction has many interactive possibilities. Perhaps games and storytelling will converge in a way that we cannot now predict.

INTERACTIVE REFERENCE WORKS

Although we have had dictionaries ever since the eighteenth century, when Dr. Johnson put together a dictionary of the English language, and later encyclopedias and other reference works in book form, the emergence of interactive media on CD-ROM offered an increase in the versatility of interactive referencing. Although cross-referencing was always part of the concept in print, the multiplicity of the links and the speed of linking in CD-ROMs enhanced the user's experience. In addition, the old concept of the illustrated encyclopedia could be expanded to include not only more still pictures in

color but video clips, audio clips, and graphic animations. Publishers of reference works such as encyclopedias were quick to see how they could enrich the content by introducing stills (already part of the print editions), video, and audio with links to make searching and cross-referencing more dynamic.

Grolier's Encyclopedia and Microsoft Encarta were given away as part of the software packages in new computers. They are maps to giant websites that can be updated continually. The primary interactive structure would seem to be more or less dictated by the traditional alphabetical listing. Hypertext and other links thread new instant interactivity through the content by topic or theme. Seeing video of President Kennedy's inaugural speech, hearing the voice of Martin Luther King's "I Have a Dream" speech, seeing a 3-D graphic of a part of the human anatomy—all transform hypertext cross-referencing into multimedia interactivity. Medical, legal, and other technical references works on DVDs make knowledge more accessible. Databases and search engines online make information available that would otherwise be inaccessible, but more to the point, they enable the processing of statistical data from commerce and government in ways that would defy research in the days before the invention of computers. With the invention of the personal computer, all those capabilities are within the reach of the individual.

Since the second edition of this book, Wikipedia has emerged as a collective web encyclopedia to which anyone can contribute. It is the knowledge-based equivalent of open architecture in software that can be modified and improved by anyone. This evolution of the encyclopedia from proprietary fixed media to open-access, web-based content in Wikipedia has changed the way we count on sources for information. Although you hear complaints that some entries are not authoritative, ultimately inaccuracies or incompleteness will be challenged and corrected by experts or interested readers and contributors. This phenomenon of crowdsourcing has emerged with the proliferation of the World Wide Web and the consequent empowerment of individuals to create media content without the censorship and filtering of media gate keepers. This applies to web pages, video, and music. It affects marketing, advertising, and social behavior. Individuals in crowds can change media campaigns, perception of corporate identity, products, and media content. Many smart corporations have embraced it; others have fought it to retain control at their peril. The new movement for crowdsourcing can enhance brands and improve content.

Cloud Computing

Cloud computing is a logical outgrowth of the architecture of the World Wide Web because more and more content, applications, and data exist on servers in cyberspace off the desktop and are always accessible. Savvy enterprises like Apple and Amazon have seen the need for personalized lockers in the cloud by creating apps such as iTunes, which allow a user to aggregate all media content in one place and, of course, buy that content from the cloud provider. The emergence of cloud computing has changed everything. We already had e-mail services working in the cloud. When software and data started to move off the desktop or local storage drives to a large configuration of servers accessible to everyone, that liberated PC's and laptops and enabled tablets and mobile devices to dispense with storage and some software to accommodate more functions through apps that accessed the data in the cloud. So entertainment lockers for songs, videos, and books can now be located in a remote server with the user connected to that content by an app.

INTERACTIVE CATALOGUES AND BROCHURES

One of the best uses of interactive media in business involves a fundamental need to list large amounts of information about products, which were formerly exclusively delivered in print. Now a catalogue can be a searchable database with pictures and web links either on a website or on fixed media.

Typically, websites of business that have a large inventory are well served by an online catalogue which is enhanced by being interactive, even if it is not directly linked to e-commerce and a shopping cart checkout, which it often is. Then there is business-to-business (B2B) inventory with added functions of online ordering and invoicing.

Print brochures had, and still have, the function of presenting essential information about a company, a service, or a product. Although you can print expensive glossy brochures, you cannot know whether they are read. An interactive brochure allows user selection and allows readers to select the informational depth that matches their interest. Consequently, corporations can create denser brochures without the risk of overloading the audience, which might happen with a print brochure expounding information in a linear fashion. Customers or clients can choose how much technical detail they need to know. Thus, a web brochure for Sony video cameras can satisfy both the engineer and the videographer as well as the casual shopper.

EDUCATION AND TRAINING

In a previous chapter, we noted the enormous need for training in the corporate world, in government, and in the military; for example, how to fire an antitank missile, how to service a jet engine to Federal Aviation Administration standards, how to invest in stocks and shares, how to bake bread, or how to speak French. Interactive media lend themselves very effectively to the learning process. There are several advantages. The learner sees pictures, hears audio, and reads text. Multiple sensory inputs reinforce ideas. Many studies show that learning and retention improve with visual intake. In addition, the learner has to interact with the program by thinking, choosing, and applying incremental blocks of knowledge. The learner can pace the process to suit an individual rate of assimilation, repeating where necessary. Most interactive learning programs test and track performance on the host computer or on a server. Training problems also cry out for interactive solutions, although there is still some life in the old-fashioned training video. Interactive design for training tends to lean on the use of branching and hierarchies, although testing and **learning games** can be effective components. Testing enhances interactivity by giving the user a role beyond page-turner. Basic interactivity requires just a menu and links, which can be created with Adobe Acrobat or PowerPoint.

Interactive learning programs can be set up on websites as well. In the educational environment, there are systems such as Blackboard, which allows asynchronous delivery of course content and online drop boxes, white boards and chat rooms, and testing. Adobe Breeze, Gotomeeting extends the spectrum of functions to include real-time video conferencing and desktop sharing as well as presentations and tests that can be downloaded. The possibility of web-based learning and web-based testing facilitate corporate training needs, continuing education, and traditional academic learning. Blackboard allows the delivery of asynchronous learning. Students are able to take tests in their own time by a certain date by logging on, or they can engage in class discussion on a bulletin board. Likewise, corporate training, which is a huge problem for companies that constantly need to train new hires and upgrade the knowledge of existing personnel, can run interactive training from a centralized website and serve both a national or international population of workers. In many businesses, licensing or laws governing an industry entail compliance that is a legal responsibility. To create these learning programs, technical writers are in demand. Someone who can combine media writing skills with instructional design and training will have a strong combination of skills for future employment.

KIOSKS

Most people have had the experience of needing to search a small database of information at a location such as a shopping mall. You might want to know what stores are in the mall or find out where a store is in a large mall. I was on a university campus, which had addressed a fundamental communication problem of direction on campus by using an interactive touch-screen kiosk to guide students and visitors to faculty offices, classroom locations, and campus buildings. The kiosk application works well for cruise ships, theme parks, museums, malls, and department stores. Most kiosks rely on touch-screen interactivity.

CONCLUSION

The video production economic model, which charges for time and creative services, doesn't apply well when the product is software or code or something you do with a product. The software developer spends a large amount up front in development and debugging and then shrink-wraps boxed copies that sell in increasing numbers and are upgraded and provide a revenue stream. The other model is the advertising agency that has an account and can develop campaigns and brand awareness and can charge a retainer plus commission on media buys. None of these models exactly fits nonlinear production businesses which, in effect, combine all three. However, some companies like Planet Interactive in Boston see no problem in charging for the time of highly skilled creative people, including writers, marking it up and billing a client, just like traditional video production companies.

The most important idea to carry forward to the next chapter makes the distinction between a certain kind of writing for content and what we now call meta-writing, which addresses site functional objectives, visual design, and navigation. This writing requires thinking through all the communication problems and thinking across parts to grasp the whole. This is true for all interactive media, but the website has evolved in a short time span to serve critical communication needs in the twenty-first century. Websites will extend their own functionality and importance because of accessibility via portable wireless devices such as tablets and cell phones. These new input and output devices will be leveraged to provide more services and enable buyer response to advertising—for example, websites that allow you to book a table at a restaurant from your cell phone. Voice recognition and smaller phones will change the traffic and function of the device, which was originally engineered just to enable wireless access to the voice network. Voice recognition means that functions that now depend on keyboards and text input will operate by voice commands like on *Star Trek* and in other science fiction worlds. Voice recognition is already being used in customer service voice menus.

We have laid down some foundations for interactive writing for the web. Apart from the need to consult more specialized works, if you want to develop your writing in this area, you will need to stay in touch with developing trends and techniques as the Internet continues to evolve as Web 2.0 and cloud computing assumes greater importance. It seems clear that writing for interactive media, particularly for websites, is going to evolve rapidly, perhaps more rapidly in the next 10 years than over its first 10.

EXERCISES

1. Compare three web portals, such as Yahoo!, AOL, and MSN, and analyze the functionality of the sites.
2. Compare two or three major corporate websites, such as Nike, IBM, or Hewlett-Packard, with the website at your college or university.

3. Invent an interactive kiosk for a ski resort, a national park, or a tourist guide for your area.

4. Write an interactive training proposal for how to apply to college, how to make salads, or how to use your campus library.

5. Pick a familiar product and write an interactive manual of instruction for it.

6. Write a high-level design document for a website or a CD-ROM on mountain biking, in-line skating, or any other sport or leisure activity of your choice.

7. Write and flowchart an interactive kiosk guide to your local museum or shopping mall.

Writing for Video Games

🔑 Key Terms

Artificial intelligence	HUD (heads-up display)	platform
avatar	isometric view	RPG (role-playing game)
cloud computing	MMORPGs (massively multiplayer online role-playing games), MMP, or MMO (massively multiplayer online)	shooter
cut-scenes		simulation games
design document		storymapping
dialogue engine		third person
engine	MOOCs (massive open online courses)	world building
first person		
flight simulator	MUD (multiuser domain)	
game bible	narrative design	

The previous chapter explored writing for interactive media that basically serve a utilitarian, commercial, or informational objective. This chapter looks at writing for interactive media that are primarily designed to divert, amuse, or entertain an audience. The media discussed in the previous chapter usually have some corporate or organizational function. The kind of interactive media we want to consider here generally offers an experience for which the audience is prepared to pay, and which satisfies a need for knowledge or entertainment, or both. The principal genre is the video game. It can be sampled, bought, downloaded, or played on line; or it can be delivered on fixed media or DVD.

GAMES, NARRATIVE, AND ENTERTAINMENT

Video Games

In the early 1990s, a number of educational games combining play and learning came out. I bought *Maths Blaster* and *Where in the World Is Carmen Sandiego?* for my son to make learning more fun. Play is a profound need of human nature. Children's play is a form of learning, and computers enable us to engage the natural propensity for play in the cause of learning to add or subtract fractions or learn geography. Interactive entertainment is a natural outcome of the marriage of computers, graphics,

and video, and it is consistent with the interactive structure of the web. Computer graphics can now create any world, any fantasy, and any morphology that you can imagine. The interactive game market, whether distributed on proprietary cartridges for platforms, DVDs, or posted to a website, reaches a huge market. Video gaming is international and transnational. Gaming competitions, supported by corporate promotional money, have produced gaming professionals who make a living playing video games. It has become a spectator sport. We are looking at a growth industry. Cell phones now link to the web and are able to download games and video and act as portable game consoles. Universal portable handheld devices on which all networked communications are accessible are the trend of the future, which we examine in greater detail in Chapter 14.

Video games are now big business. The Writer's Guild of America website says that this is "an enormous and continually evolving area of entertainment that now rivals feature films in terms of profits and popularity. Video games have become one of the three major forms of screen-based entertainment, alongside motion pictures and TV."[1] Statistics quoted in an article in *The Boston Globe Magazine* in 2005 put the figure at $9.9 billion for video games, software, and hardware, and another $1 billion for PC games.[2] Phenomenal growth has occurred since then. The Writers Guild of America website mentions $15 billion as an estimate of the size of the industry. In 2011, it was a $25 billion industry, which has penetrated 72 percent of American households. The average age of gamers is 37, and 29 percent are over 50. Gender demographics reveal that 58 percent are male and 42 percent female. Of **the gamer population**, 33 percent say that it is their preferred form of entertainment. The fact that 55 percent of gamers play on portable handheld devices represents a major shift that reflects the rising adoption of the smart phone and tablets in place of PCs.[3]

Video game developers bid millions for video game rights to movie properties, and it can cost millions to develop a video game. Development budgets are starting to rival feature film dollars. Games can easily cost $500,000 to produce at the low end and a **$100 million at the high end**,

Are video games art?

"Are video games art?" Paola Antonelli, senior curator in the department of architecture and design at the Museum of Modern Art in New York, asked in a post on the museum's web page. "They sure are, but they are also design, and a design approach is what we chose for this new foray into this universe. The games are selected as outstanding examples of interaction design—a field that MoMA has already explored and collected extensively, and one of the most important and oft-discussed expressions of contemporary design creativity." The games, Ms. Antonelli wrote, would be selected according to the same criteria the museum uses for other collections, including "historical and cultural relevance, aesthetic expression, functional and structural soundness, innovative approaches to technology and behavior, and a successful synthesis of materials and techniques." The first items in the museum's new collection are Pac-Man (1980), Tetris (1984), Another World (1991), Myst (1993), SimCity 2000 (1994), Vib-ribbon (1999), The Sims (2000), Katamari Damacy (2004), EVE Online (2003), Dwarf Fortress (2006), Portal (2007), Flow (2006), Passage (2008), and Canabalt (2009). The museum's wish list for future acquisitions runs from the early Spacewar! (1962), through Minecraft (2011). The initial fourteen games were installed in a 2012 exhibition in the museum's Philip Johnson Galleries.[4]

1 The WGA established a pro forma contract for this kind of writing and formed a New Media Writers Caucus in 2004. See www.wga.org.

2 Tracy Mayor, "What Are Video Games Turning Us Into?" *Boston Globe Magazine,* February 20, 2005.

3 2011 SALES, DEMOGRAPHIC AND USAGE DATA, (Essential Facts about the Computer and Video Game Industry), Entertainment Software Association (www.theesa.com/facts/pdfs/ESA_EF_2011.pdf).

4 Allan Kozin, "MoMA Adds Video Games to Its Collection," *New York Times,* November 29, 2012.

for something like Grand Theft Auto 4. Although most of that money is spent on programming and sometimes elaborate 3-D animation, some money has to be spent on writing. As with feature film, the higher the budget, the more important the writing! The concept of the game, the world of a game, and how it is to be played has to involve writing.

MOBILE GAMES

With emergence of smartphones, which can download apps, pioneered by Apple with its iPhone, a new genre of video games has come into being—the game app. Just as PCs are delivered with a few games installed, phones and tablets pre-install some games. However, better and more complex games designed for mobile platforms and written as apps to operate on the iOS, Microsoft, or Android platform have mushroomed. Independent app developers design games for kids, teenagers, and adults to be sold and downloaded through the Apple or Android online storefront. The smartphone lends itself to first-person shooter games, platform games, and puzzles. The best known game is probably Angry Birds, which has gone viral and generated enormous revenue and spin-offs for the developer. You probably have a smart phone. If you have not bought or downloaded free games from your operating systems app store, browse the games to see the range and appeal of this genre. Developers who can write code rather than writers are the designers of game apps.

GAMES FOR WEBSITE ENGAGEMENT

Many retail corporations, which now must have a website presence to engage customers, provide video games to create a "sticky" experience that keep surfers on the site. A good example would be Nabisco.com, many of whose products target a youth audience. They commission and make games, puzzles, and brainteasers inviting users on their site to engage with the site and then explore other features and absorb product information, itself involving simple game play. Then they changed their strategy in response to user and customer input. Now Nabisco's home page is a kind of game, which creates engagement from the get-go. The user must interact and trigger sophisticated Flash animation designed to draw the user in.

WRITING

We have already established that writing for interactive media is different. Writing interactive entertainment can be exceedingly challenging. It is difficult to represent multiple-choice and alternate scenarios that result from user choice. What changes from linear media plots is that the writer has to create player choice. In a sense, the player becomes a character. Exactly how writers are employed and what kind of writing they do vary a great deal depending on the producers and developers of games. The Writers' Guild of Great Britain website reported "some writers are being asked to write dialogue for characters and animation that have already been put together. Writing the script for a game can be the very last part of the process" (since deleted from the website). A similar observation can be found on the website of the International Game Developers Association (IGDA), which has a special interest group for writers. The association published a white paper, "IGDA's Guide to Writing for Games," in November 2003. In it, the association discussed the cross-over between writer and designer that we addressed in Chapter 11. One person

can do both jobs, but increasingly, higher budgets and more complex game design will create opportunities for writers.

Few writers make a living writing only for games, but that is likely to change. The IGDA white paper identifies two main writing skills that are particular to video games: narrative design (creating a story) and interactive dialogue scripting. **The role of writers** is not standardized as it is in the film and television industry. Indeed, "the role of the game writer remains ill-defined and poorly understood." At the same time, the authors of this document, who are all professional game developers, believe that the medium has to "mature and broaden its potential audience." They see the need for "new material and new ideas," and they think the "game writer will have an important role to play in facilitating this evolution" (www.igda.org/writing).

Early video games such as Pong, which came out in 1972, soon followed by Pac-Man were coin-operated arcade and bar amusement. They were software or programming creations that did not need a script or a story. We can draw a parallel to the early days of movies, which also began as coin-operated arcade entertainment. Soon the moving picture novelty embraced more ambitious storytelling. At that point, you couldn't run out into the woods with a camera and a bunch of actors and make up a story as you went along. In the first place, it would not produce a good result. Second, it would be an expensive way of producing film. So as video game development budgets climb into the millions, the need for preproduction, creative storymapping, and planning becomes indispensable. Just as the scriptwriter became the key creator in movie preproduction, the video game writer promises to become the key creator in constructing, imagining, and designing a complex game. A video game has to have all the things that writers are good at creating—characters, plot, and dialogue. A game that has characters and dialogue needs a writer to invent the characters, write their dialogue, and create a storyline.

The locus of the writer in the process also varies from one developer to another. Sometimes writers are called in relatively late to create or polish dialogue, especially when the game has originated in another country and another language and needs what is essentially a foreign version for the local market. A significant writing task involves writing the game bible, with descriptions of characters, for a large development team to work on. Also every game comes in a box with significant text describing settings, worlds, and game objectives and with a more detailed instruction booklet that the player will read. As with films and television, there are two basic ways to originate a game. Either you create it from scratch, or you buy a license to create a game out of source material such as a movie, a comic, or a book. This adaptation process depends on a unique writer's skills. Behind every game is some kind of written proposal and some kind of script. So where there are video games, there must be writers.

Character in Video Games

Characters in interactive media have to be developed differently than in linear media. They may have back stories, as characters in linear media do, but they behave differently and are unique to an environment. Lara Croft in the early Tomb Raider games can only walk, jump, climb, shoot, and react in terms of the script for the environment and her given weapons and responses. In Rockstar's game Grand Theft Auto: San Andreas, the third-person character that the player controls, has to be fed to maintain his energy. If you overfeed him, he gets fat and can't run fast. So you can have him work out and build strength. Is there interaction with the player or just with other characters, or with environment, or with robots or other nonhuman characters? How will communication take place? What actions are scripted for the character? What dialogue supports the game? How will change of strength, health, and energy level affect the character and be impacted by scenarios that are imagined for encounters with other characters or environments?

Dialogue is an important component of linear narrative and game narrative. However, dialogue functions differently in games. First, it might appear as text. It might be a narrow range of responses to specific questions or situations. The character may develop and can be affected by the environment rather than the plot or interaction with another character. Although dialogue has to fit character, it has an altered functionality in games. It may present choice to the player with critical consequences for the outcome of the game. Dialogue may be voice-over or text as opposed to lip-sync delivery by an actor with body language to go with it. You lose actors and acting because it is cheaper to create animated figures in 2D or 3D and voice the dialogue if need be.

Writers are called on to develop game ideas from intellectual property of a nongame source, such as a movie or a book. Although this is a form of adaptation, it bears little relationship to writing a movie script based on a book or a play. The game writer has to translate a story into interactive choice and play that keeps the spirit and style of the source but creates a wholly new experience and even extends the story and perhaps develops fuller minor characters in the game. The Matrix movies furnish a good example because the success of the movies generated games that extend the world of the matrix. In the MMORPGs (massively multiplayer online roleplaying games), you can create a character and teach it skills to navigate the world of the matrix as modeled after the third and last episode of the movie. Star Wars was probably one of the most successful movie franchises to exploit its video game potential, especially because Lucas Arts was an industry leader in 3D animation and could produce its own video games.

This brings us to the most complex and demanding form of writing for games—narrative design. Design implies some understanding of programming, or at least what it is capable of doing. It requires imagining the style and scope of the game, often within the framework of narrative set by the game developer. Its nearest relative in the linear entertainment world is the treatment. Whereas the treatment in film or television comes early on in story development, narrative design may occur in tandem with, or parallel to, the game design of the developer. If writers assume a stronger role, by grace or by choice, in the process of game development, perhaps the writing of narrative design will become stronger. It goes back to the question we have raised elsewhere—whether the writer designs or the designer writes.

World building involves writing that imagines and describes the world or environment that the player experiences in the world of the game: what it looks like graphically, what kind of laws govern its physical and psychic space, and what kind of creatures or behaviors are part of that world. These determine the colors, sounds, and style or look of the game. It seems that, once again, this can happen after the basic game design is already in place. It fleshes out the game environment.

In contrast to the linear entertainment world, writing for games might involve a stable of writers, who might have differentiated, specialized writing skills. Scriptwriting breaks down into three types. There is scriptwriting for text that appears on screen; there is scriptwriting for video segments or modules that run as QuickTime or Flash movies or 3-D animation; there is scriptwriting for voice narrative. Sometimes this can involve three different writers. Sometimes, a writer has the skills for all three. A fourth type would be the conceptual writing, the meta-writing of the

> **Second Life** Second Life is a new game-like phenomenon. It is a virtual world you enter as a person whose identity you create—an avatar. You can be anything you want to be. You can create the virtual environment in which that person (avatar) moves. Now you can buy and sell clothes, weapons, and décor through virtual Second Life commerce, which involves real dollar transactions. Corporations use Second Life for meetings, training, and product launches. Real products are advertised on Second life. It has become a kind of hybrid between social networking and gaming.

narrative design. One writer might be able to do all the types of writing, but many writers will develop specializations.

Another area of concern would be researching the background so that dialogue is consistent with the world that prevails in the game. Just as TV series have a series bible, so the video game needs a game bible, which details all the back story of the game and its characters and defines the objectives and the outcomes for the player. Its first function is to provide the production team with a common body of knowledge so that consistency of style and story is maintained. This would give rise to the booklet that is normally delivered with a game disk to prime the player how to start playing the game. This writing requires someone who understands video games and marketing.

Some idea of writing for video games can be gleaned from the pro forma contracts for game writing and interactive writing that are obtainable on the website of the Writer's Guild of America. Although the writers who would seem to be closest in background and talent would be the movie and TV scriptwriter, there would have to be a radical shift in mind set to deal with the nonlinear nature of composition. It is analogous to the early days of screenwriting when the writers were either novelists or playwrights, often with little understanding of the new medium. Gradually, a new kind of writer emerged (a scriptwriter) who was able to see the particular writing problem of the medium and do the meta-writing that led to strong program content.

THE ORDER OF WRITING

Broadly speaking, video games face similar production problems to video, film, and television. You have to start with an idea. That seed idea has to be a written concept of the content and style of the game and how it will look and play. It then has to be elaborated in a treatment or design document that articulates the vision for a larger production team. As with film and video, content has to be created except that production involves huge amounts of graphic design and programming as well as audio recording of dialogue, sound effects, and music. Video editing roughly corresponds to programming and debugging. However, the relation of writing to linear production inevitably differs from interactive production.

Electronic Arts, the world's leading independent developer and publisher of interactive entertainment software, had an outline of the video game production process on its website. The writing phase is somewhat concealed in the description of their design document "that specifies game play, fiction, characters, and levels." In preproduction, artists and software developers work up a prototype 2-D and 3-D design, animation, and programming from the design document. Production assistants then break down and prioritize the tasks to create the finished product. Teams of artists and animators are coordinated as they create the assets that are the visual experience of the game. Likewise, teams of software engineers write the code with game authoring tools that create the interactivity. As with all interactive media production, there is a chicken-and-egg situation near the beginning in which developers have to toggle between creating interactive play choices and then translating that into visual assets that are needed, whether video, audio, or graphics, to fulfill the vision. The miniscript for some dialogue or a storyboard for an animation sequence could be written in response to the evolving game. The written concept becomes modified in production, which leads to renewed writing and/or design. This back and forth is not true of film and video. Production proceeds from a finished script and its breakdown into a shooting schedule.

To summarize, the logical sequence of game development follows these steps:

- Concept/proposal (writing)
- Preproduction (design, writing story, characters, levels, game play)
- Prototyping (continued writing as design evolves)
- Full production (continues writing as design evolves; scripting for software engineering)
- Postproduction (alpha, beta, and final testing; marketing and promotion)

Writing and rewriting for video games is not confined to one stage. Conceptual writing that imagines the game play and design is meta-writing, whereas dialogue and character description is content writing. The conceptual writing at the early stage should contain a short premise, describe the type of game play, and outline a map of the game story, challenge, or goal. It should describe the look and style of the world of the game. As production begins, the sequence of writing and its relationship to production seems to vary with the developer and the way the production team is structured. Dialogue writing for characters and the cut-scenes can arise after considerable game design but necessarily before production of the assets (picture and sound). You cannot write dialogue for stages of the play until you know the game design and the kind of choices that the player has, which trigger alternate responses.

Writing for games differs from writing for movies and involves other craft skills not part of screenplay writing. The layout and format is different and less rigid. It is a case of how you get your exposition of the game play and the game world across. It can involve a number of elements particular to video game writing.

Treatment or Overview

Where a writer originates a game, there has to be an overview document that, more or less like a treatment, tells a complete story from the opening scene through the major steps and some description of game play. This is going to be the document on which selling and pitching game developers will be based.

Describing the World of the Game

The next critical writing job is to describe the background world of the game to enable the game designer to visualize what the look of the game, including, for example, the landscape, characters, tools, weapons, or money.

Flowchart

Flowcharting separates the game writers from other media writers. Games are complex with multiple decision points that alter the possible paths through the game. You have to use a flowchart, which is a specialized diagram. There are flowcharting applications that can help. Using a flowchart to represent interactive choice involves a different kind of thinking.

Description of Sub-Quests

Many games, such as Skyrim, have intermediate tasks or quests that precede the main quest along the way. Creating these and describing them enriches the game play.

Character Descriptions

All stories have characters. The strength of a video game concept depends on the strength of character identity and on the interaction of those characters. Here there is something in common with other types of entertainment writing although the characters cannot be revealed by action in the plot as in linear storytelling. The closest relative might be the Series Bible in television. Strong detailed descriptions help the game designers and the animators.

Interaction with Non-Player Characters

Interaction with NPCs (non-player characters) involves dialogue or physical interaction (or both) with the main characters or the player in role playing and platform games.

Cut Scenes

Cut scenes are scripted actions and dialogue that play in entirety in response to player choice. A cut scene marks a decision point or confirmation of choice. It can also repeat when triggered by a wrong choice to provide information or reward in the case of a right choice.

Storyboard Script

The word *storyboard* suggests a distinction between game writers and linear scriptwriters. Writers of linear scripts do not normally create storyboards. Directors storyboard difficult action scenes, stunts, or special effects. A **storyboard script for a game** is the most detailed preproduction document. It describes location, audio, main player characters and non-player characters, the player goal at that point in the game, and the action. It must relate the scene to the flowchart, whether needed by a decision point or because play creates alternate action that can trigger cut scenes.

Notes

Notes about how a scene works supplement or clarify other information where useful. Scenes are separated. They are not sequential, unlike linear scripts. This marks the essential difference between the two types of scriptwriting and explains how the game writer thinks differently. The two types of writing have one characteristic in common; the audience is the game developer not the game player who never encounters the script. The techniques of communicating to the developer who will create the game experience involve many more elements than are employed in a linear script. The developer needs more layers of information than the film or television producer.

Writers work on project pitches, intellectual property development, narrative design, world building, dialogue scripting, and dialogue engine design. A project pitch is not going to differ a lot from concepts in the traditional linear media, except that it has to be thought out in terms of interactive values and appeal. It will necessitate composing something like a log line or a premise—a brief and provocative statement that tells us what the game is about. Let us remind ourselves of the concept of meta-writing. The writing is not in the words so much as the thinking and conceptualizing behind the words. That is where the specialized knowledge and understanding of interactivity and gaming will enable someone to write for this industry. According to the IGDA's white paper, "Game writers need to be game-literate, which is to say, they must understand how games function." Clearly there is a vocabulary and a jargon that the industry uses and understands that sets it apart.

Defining Game Types

Games are defined in terms of the point of view the player enjoys and the type of game. The point of view also has implications for the structure and design of the interactivity. The first-person game presents a subjective experience, with the real-life player seeing and hearing what the player character sees and hears. An example would be HalfLife, produced by Valve Software and distributed by Sierra. Flight simulators also tend to follow that model for obvious reasons. Then there is a third-person or objective narrative, somewhat like the omniscient narrator of the novelist. An example would be Tomb Raider. You see Lara Croft as a character, but she only makes the moves you decide and input via a player console. The third kind is the platform game. In this, a camera sees the character. The camera can pan and track, showing the player all points of view including maps of position. The player can switch between angles and viewpoints and can do inventory of weapons or energy. An example would be the PlayStation game Metal Gear Solid. The fourth kind of video game, multiuser domains (MUDs) and MMORPGs like the World of Warcraft, can be played on the web by anonymous players logged on to a server from anywhere in the world. In the World of Warcraft, players enter the game by creating an avatar and then adding weapons, armor, and powers that enhance their play. In a MUD, like Second City, real commerce has evolved where users sell clothing, furnishings, objects, and earn real dollars.

Then there are simulation games such as SimCity and Civilization that have apparently limitless combinations that occur following your choices of different scenarios. They do not have a point of view because they create a world with its internal forces and dynamic. If you build roads or public transport in SimCity, you could run out of funds and have to raise taxes or deal with an economic crisis. Every choice has huge numbers of permutations and combinations with unpredictable results. So it seems that every game you play is unique compared to challenge games like Tomb Raider in which you have to progress by scoring and by problem-solving strategies that you can learn and repeat. There is even a game that allows you to simulate running a university. Simulation games seem to be very reliant on strong navigation and design work.

Glossary of Gaming Terms

Games have developed terminology that describes the type of game, platform, and the point of view:

- **Platform game:** Involves jumping on platforms of various sizes, avoiding obstacles, and jumping on enemies to destroy them. Examples include Super Mario Bros. (NES), Sonic the Hedgehog (Genesis), and Jak and Daxter (PS).
- **RPG (role-playing game):** A game genre for both PCs and consoles in which the player develops intelligence and skills by collecting points and solving puzzles.
- **Platform:** The type of system a game is played on proprietary non-interchangeable platforms such as PlayStation, Xbox, Game Boy, and GameCube.
- **Flight simulator:** Simulates the action of flying an aircraft. Realistic controls make the flying itself the point of the game. Driving simulators do the same thing for car racing.
- **Shooter:** A game in which the object is to kill an enemy with a weapon that fires bullets or rays while avoiding being shot by the adversaries. Such games are usually constructed in a 3-D environment, assume a first-person perspective, and are referred to as FPS, or "first-person shooters."
- **Simulation games:** These games describe a world that evolves and grows according to the player's choices based on rules and dynamic forces in the game environment.

Point of View

- **First person:** You see the action through the eyes of your characters. You don't see your own body.
- **Third person:** An omniscient point of view that lets you see the character you are controlling, in contrast to first person.
- **Isometric view:** A view of a game and its action from an angle instead of directly from above or directly from the side.

Other Terms

- **Cut-scenes:** Live or computer-generated videos clips, usually not interactive, interludes between stages that furnish additional information, such as story elements, tips, tricks, or secrets.
- **Avatar:** The character that you control in the game or that you create in a multiplayer game.
- **Artificial intelligence (AI):** The programmed characteristics of behavior and response of a nonhuman character. All characters not controlled by the player have some form of AI.
- **HUD (heads-up display):** Used most in first-person games, the heads-up display, like a flight deck or a dashboard, presents information on the screen, such as the life meter, level, weapons, ammunition, map, and so on.
- **Engine:** The application that powers a game. One primary engine (the graphics engine) and several smaller engines power AI and sound. People refer to the whole product as the engine, "the computer code that is programmable and usually proprietary to a platform or publisher."[5]

GRAPHICS VS. LIVE ACTION

A game could be created with computer graphics or live-action video. Take, for example, the PlayStation game, Metal Gear Solid. This game world is created purely out of computer graphics. It is a challenge adventure that requires the player to infiltrate a military base for disarming nuclear war heads in Alaska, which has been overrun by terrorists, find out if they have the capacity to launch a nuclear strike, prevent a nuclear launch at all costs, and rescue two high-level hostages, one military and one the president of Arms Tech. This game, like many others, has evolved over more than a decade. There is a complete game bible. The game introduces you to the characters, who are played by voice actors. The player has an inventory of weapons and rations. There is a bank of clues to call on when the player gets stuck.

The majority of games are created on a computer with 2-D or 3-D graphics tools. Not many are produced with photographic backgrounds and live-action sequences. There are practical reasons for this. Actors and video production are expensive, but you don't have to pay computer graphic characters for their performance. You merely have to record their voices. Audio production is less expensive. Video requires a huge amount of bandwidth, or it has to be severely compressed. Most of the worlds of computer games are extravagant fantasy worlds in space with aliens or in mythical kingdoms with

5 See also Mark S. Meadows, *Pause & Effect: The Art of Interactive Narrative*, (Indianapolis, IN: New Riders Press, 2002).

monsters. It is easier and probably cheaper to create those environments and their characters with computer graphics tools than with live-action video, and animation occupies less drive space than full-motion video. With graphics and animation, you can create whatever you can imagine, without having to pay for actors and video production, which are both expensive.

FORMATS

We have not tackled the thorny question of a format for this writing. Unlike with other media we have discussed, we cannot be final and definitive: "Game writing has no real corollary in mainstream entertainment. Books, movies, television, theater—they all involve the creation of specific documents with established formats, which the interactive industry does not have."[6] There are some emerging patterns, dictated by logic and need. The Appendix shows one example from the Movie Magic Screenwriter templates.

An example of dialogue writing for a kung-fu style game called Seven Shades illustrates one approach:

```
Fox. Known is set TRUE if Xia Tu has learnt that Zhapian Hu is a
fox spirit and not a human being.

Bandits. Wuhan is set TRUE if the bandits led by Shao Lung are
currently hiding in the Wuhan marshes. If not, they have no fixed
base of operations at this time in the script.

AREA: Kongmoon

SCENE: Mansion

//The upper floor of FOX's mansion; plushly furnished. HARE enters
through the window, looking around furtively. She moves forward,
looking for any sign of habitation. FOX opens the shutters to a
lantern, illuminating the room, and casting HARE's shadow against
the wall. FOX: It seems impatient to steal from a Nobleman's estate
without waiting for the master of the house to be absent.

HARE: Forgive me; I meant no disrespect. I bring a message of vital
importance to the safety of Kongmoon.

FOX: Messengers come by doors. Thieves come by windows.

HARE: And thieves who bring messages?

FOX (amused): So you admit that you are a thief?

CONDITION: if Fox. Known

{

HARE (pointedly): An honourable thief would do so, I would hope.

FOX: Can there be honour among those who steal?
```

6 See the article "How Do You Become a Game Writer?" (www.igda.org/writing/HowDoYouBecomeAGameWriter.htm).

```
HARE: Those who steal treasures? Assuredly. We shall see about
those who steal cities.

FOX (amused): You are remarkably well informed for a common thief.

HARE: There is nothing common about anyone in this room, fox
spirit.

}

ELSE

{

HARE: It would be dishonourable to do otherwise.

FOX: That must make it difficult to avoid justice.

HARE: Have you not heard? There is no justice in Honan.

}

FOX (somewhat surprised; then moving the conversation forward):
Indeed? You said you brought a message.

HARE: Huang Leng plans to march upon Kongmoon and bend it to his
will. He is ruthless, and intent on procuring not only the throne,
but dominion over the entire middle kingdom. Already his agents
are within the walls of the city, seeking a way to subdue your
defenses.

                    Reproduced by permission of ihobo international.
```

As you can see, the dialogue has to relate to another kind of document, which is a design document, in order to make sense because of player choice that is the essence of any game. As you look through the examples of design documents, you find diversity. However, something has to be written down at the beginning. A detailed map of the game is indispensable to production but may be modified as graphic artists develop scenes and programmers code play. Dialogue for the sound track and for cut-scenes must be written to keep pace with the evolving game and precede the creation of those assets.

INTERACTIVE GAMES FOR TRAINING

Gaming Statistics (2012)

According to the Entertainment Software Association:

- The average gamer is 37 years old and has been playing for 12 years. Eighty-two percent of gamers are 18 years or older.
- Forty-two percent of all players are women. Women over age 18 are one of the industry's fastest growing demographics.

- Today, adult women represent a greater portion of the game-playing population (37 percent) than boys age 17 or younger (13 percent).
- Twenty-nine percent of game players are over the age of 50, an increase from 9 percent in 1999. This figure is sure to rise in coming years with nursing homes and senior centers across the nation now incorporating video games into their activities.
- Sixty-five percent of gamers play games with other gamers in person.
- Fifty-five percent of gamers play games on their phones or handheld device.[7]

MILITARY TRAINING GAMES

For a long times, the Air Force and the airline industry have used simulators to train pilots, which saves cost compared to in-flight training. These elaborately interactive machines respond to pilot choice, show video on a heads-up display, and, by means of hydraulics, simulate the corresponding physical movement of the plane. They cost tens of millions of dollars. Similar machines can be found in some museums and places like Disneyland and other amusement parks. Flight simulators of a simpler kind such as Microsoft's Flight Simulator game attract many players who can vicariously experience the problem of piloting an aircraft. The military in general has training challenges for all sorts of equipment which are well served by interactive games. Strategic war games for implementing battle tactics are now part of command training. A familiar entertainment parallel might be something like SimCity or Civilization. Games can create a virtual reality in which the training audience has to test its reactions and strategic choices.

Many modern weapons systems have game-like joysticks and video displays. Real battlefield experience cannot easily be understood by military personnel who have not yet been in a theater of war. Although virtual reality war games can simulate war, some argue that there is no convincing simulation for actual battlefield reality. Nevertheless, the Army uses first-person shooter games. In 2013 the Army awarded a five-year contract of $44.5 million to a developer to replace Bohemia Interactive's Virtual Battlespace 2 in its Games for Training Program with a game that will move multiple players across a landmass and will play across PC and mobile platforms. The Navy awarded three $100 million contracts for virtual training programs for maintenance and for anti-submarine, surface, and mine warfare.[8] This gives us a clue as to the significance of gaming for military training.

CORPORATE TRAINING GAMES

Corporations have huge training needs. Corporations are accustomed to using video for training. Video games connote play, not work; so it has taken time for the corporate world to accept a medium that has a reputation for frivolous diversion for slothful teenagers. As the demographic moves up the age range and the utility of game training proves itself, resistance has fallen away. Second Life was quickly adopted by the corporate world for meetings, training, and even promotions and product launches. Video games can often simulate business decision making problems,

7 Julie Brink, "Game-Based Learning for the Corporate World," *TrainingMag.com*, May 7, 2012.
8 Alexa Ray Corriea, "US Military Looking for Better Video Game Training Technology," *Polygon.com*, January 18, 2013.

financial planning, and standard corporate procedures. Video gaming can be applied to safety, equipment, and maintenance training for personnel. Games are applied to motivating teams, simulating administrative decision making processes, and planning meetings. Most of these can be made accessible on corporate websites. Video games are cost-effective because they avoid the hours lost traveling to a training facility or classroom. Employees can even play the game at home on their own time. By industry standards training games are cheap to make. Training game vendors who produce entertainment games also produce training games because developing games is not the core business of most corporations. "The market for **corporate training games** is small but growing fast."[9]

EDUCATIONAL GAMES

Educational games can be a learning delivery solution for K-12 and beyond. They can teach and test almost any subject and engage the youth mentality because they relate to the recreational game. The movement toward flipped learning is growing in which classroom time is spent working with students after they have absorbed online content, interactive modules, and assignments on learning delivery systems. Even at advanced levels of learning, interactive games can simulate medical problems, for example, using realistic digital 3-D anatomy to provide diagnostic and surgical training. The game solution is particularly suitable and cost-effective for universal subject matter and learning challenges.

> ### The Value of Video Games
>
> In a recent report, The Federation of American Scientists (FAS) argues "that kids need more, not less, video game play, arguing that video games directly address one of America's most pressing problems—preparing students for an increasingly competitive global market. 'The success of complex video games demonstrates that games can teach higher-order thinking skills such as strategic thinking, interpretative analysis, problem solving, plan formulation and execution, and adaptation to rapid change. . . .' These are the skills U.S. employers increasingly seek in workers and new workforce entrants."[10]

Live instructor–based training in a classroom, whether military, corporate, or educational, can vary from day to day from person to person and become monotonous for the instructor over time. Moreover, live training personnel entail travel costs, benefits, office space, and the usual overheads. For all critical training problems, another singular advantage of video games is their cost-effectiveness and their assured quality, independent of human variations in performance.

Most universities are growing their online course enrollment. Distance learning is growing. Some for-profit universities are exclusively on line. Major institutions like MIT have opened their courses to free unlimited enrollment but without degree credit. These massive open online courses have introduced yet another acronym—MOOCs. **Learning Management Systems** (LMS) that enable the construction and management of online learning are endemic throughout the academic and the corporate world.

9 Reena Jana, "On the Job Video Gaming," *Bloomberg Newsweek* March 26, 2006.

10 Scott Steinberg, "Video Games Are Tomorrow's Answer To Executive Training," *fastcompan.com*, March 14, 2012. In 2006 this type of game made up 15% of the nonentertainment market, including educational and medical training products. This was projected to grow over five years, "doubling, to $100 million, with trainers accounting for nearly a third of that."

CONCLUSION

Writing for interactive media is no doubt the fastest growing opportunity for new writers. It is also the most elusive because of the newness of the field and because the writer has an altered role and the writing is unlike linear narrative. Storyline and action are determined by players within the matrix created. Clearly, video games are overtaking movies and television in dollar terms. The situation of writers is somewhat like that of writers at the beginning of the twentieth century in the early days of the movies. Nobody knew exactly what a scriptwriter was, but the need for preproduction writing quickly emerged. As we noted in Chapter 1, novelists, dramatists, and even journalists turned to the new kind of writing required by the first visual medium. The difference now is that we have had a century of films, television, and video scriptwriting that,

Twenty Proprietary Learning Management Systems

- Moodle
- Edmodo
- Blackboard
- Sum Total Systems
- Skillsoft
- Cornerstone
- Desire2Learn
- Schoolology
- Net Dimensions
- Collaborize
- Interactyx
- Docebo
- Instructure
- Meridian Knowledge Solutions
- Latitude Learning
- Sakai
- Eduneering
- Mzinga
- Epsilen
- Inquisiqr3

although linear in content, is not so far removed from nonlinear interactive content. The formats have yet to be firmly established. Different developers establish in-house conventions that are not industry standard. Those who want to develop their writing for interactive media further need to understand programming and code and what the potential of the medium is. Interactive media are the apotheosis of the digital age. In every sector, whether training, business, education, or entertainment, interactive media extend the range of human response and provide novel solutions to communication problems.

EXERCISES

1. Write a concept for an interactive quiz show.
2. Write a concept, then a design document, and a flowchart for a simple video game based on animation.
3. Look at your favorite video game and write a design document for it so that a game developer from another planet could re-create the game.
4. Using Inspiration or Storyvision, construct a flowchart for the game in Exercise 3.
5. Devise a concept that would be both a game and a linear narrative.

Writing for Mobile Media Platforms

Key Terms

Advanced Television Systems Committee (ATSC)	mobisode	Search Engine Optimization (SEO)
	Nielsen	
apps	open mobile video coalition (OMVC)	second screen
bandwidth	platform	"snackable" media
branded content	pre-roll ads	video strips
minisode	product integration	viral
mobile media	product placement	walled garden
mobile TV		webisodes
		WiMax

To understand how to create content for mobile media, we have to get a handle on a fast-changing technology, whose evolution affects consumer behavior, which in turn influences content. This feedback loop is quite complex and generates unpredictable consequences. For this reason, this chapter presents unique challenges and places unusual demands on both author and reader to understand contemporary phenomena in the digital mobile ecosystem.

You cannot create content in a media vacuum. Imagine you are living in 1947. At home, you listen to radio, which is housed in a massive cabinet that dominates the living room. You have heard about television and while window shopping you see a little black-and-white screen in a huge console. It is a very expensive new medium of home entertainment. I accost you on the street and ask you to explain to me what kind of content it will deliver and how that will make you want to buy one. You can't answer. This is not exactly but somewhat like the position we are in now talking about content for mobile media and explaining how it is different and how we will create it. Let's understand the context, historical and technical.

TECHNICAL ANTECEDENTS

How did this worldwide telecommunications revolution happen? My first cell phone was a monster with a separate battery pack you had to carry around that weighed a ton. What began as a portable, wireless apparatus designed initially to connect only to a voice network which was part wireless and

mostly copper wire land lines has evolved over a dozen years into a multifunction device that uses vast and growing wireless networks in multiple ways. As all the world knows, this portable device has evolved into a multimedia, multifunction digital platform now converging with the Internet, the PC, tablets, and television.

The changes in broadband access, Wi-Fi, and digital mobile media continue at an accelerating rate. Even before the previous edition of this book, we saw the emergence of the smartphone and the tablet loaded with apps and the decline of the PC. This trend is confirmed.

The cellular phone has metamorphosed into the iPhone and other smart phones with operating systems that enable hundreds of thousands of downloadable apps to extend their functionalities and seduce users to build their lives around mobile connectivity. The speed and complexity of this evolution unnerves even those business professionals who expect technological development at a rapid pace.

While the manufacturers of these smartphones and tablets are leapfrogging one another to bring out new models with must-have cool new functionality, legacy media companies are scrambling to find and understand new business models that can work for mobile. Through inno-

Apple iOS vs. Android OS

Whether the Apple proprietary operating system, exclusive to its own devices, will prevail over that of other cell phones and tablets, whose functionality is enabled by Google's Android OS and now the new Microsoft mobile OS, is not completely resolved. Catching up with the iPhone lead (which made Apple the world's biggest company in 2012 [although not for long]), presents a challenge, but Android OS now runs more devices and now has more downloadable apps. Perhaps it will be a rerun of the Apple vs. PC marketing contest in which Apple led with its innovation of the graphical user interface (GUI) but lost market share because the IBM PC was licensed to other enterprises to manufacture clones, which in turn brought the price down and increased the population of PC owners. Then Microsoft Windows incorporated the graphical user interface in its operating system for PCs, which were cheaper. That eventually attracted developers to invest more time, energy, and money in more applications for PCs, which then became cheaper due to increased sales volume by the turn of the century. Apple lost that contest in the 1990s, and the PC and Microsoft Windows ruled.

vation and experimentation they have to figure out how to monetize ways to connect with the public's appetite for smartphones, apps, and mobile media content. The iPhone has driven this evolution because it changed expectations of the design and functionality of pocket-sized mobile platforms. This has made it the leader in sales volume and compelled other manufacturers to compete and innovate in their design, functionality, and operating systems, or go out of business.

The mobile platform, now a pocket computer, is only limited by its inability to install certain software applications. Keyboards, physical or virtual, have become indispensable. To the mix, now add the iPad, again innovated by Apple, which again captured another population of users with a connected lifestyle and now imitated by Samsung, Amazon, and others. The PC (even laptops) is declining in favor of portable devices. *Yawn! I know all this*, you say. How does this digital media revolution change our lives, our consumption of media, and the kind of content consumers want, and therefore the writing of that content?

CONTENT ON MOBILE PLATFORMS

Mobile platforms raise interesting questions about the video content that is delivered to subscribers. Redistributing existing TV series on a mobile platform does not change the narrative style or the scriptwriting because clearly the product was preconceived for broadcast television. Are mobile

platforms just another channel for delivery of existing content or a new medium with unique content that demands a new kind of writing? If the latter, then writers need to think about how they are going to tell stories that exploit mobile formats. The nascent indications on mobile platforms suggest there is a new and unique kind of content and therefore a new kind of writing and producing specific to these platforms. If the use of mobile media platforms is going to drive the demand for new and original content, content providers will turn to writers for their proven narrative skills. We need to investigate how mobile content modifies visual narrative for mobile platforms. Writers will have to investigate how this changes the meta-writing and the storytelling. Understanding the present and future of media begins with understanding past media revolutions. From early and current experiments in content for mobile media, we can plot the curve into the near future.

ANTECEDENTS FOR MOBILE CONTENT

The change in content and readership styles that emerged with the flourishing of newspapers when compared to the centuries-old way of reading books has a parallel. Books involve long sessions of reading that must be repeated over days and sometimes weeks to absorb the content. Newspapers, evolving from broadsheets and newsletters, accommodate short sessions of reading and are made up of multiple parallel segments of unconnected content. Newspapers are portable and fill in time while waiting or riding on a bus, train, or plane. We read independent articles, comic strips, or columns disconnected from one another. Another change has occurred with the evolution of interactive editions of newspapers that are published on websites. Context and use alter the way content works. Prose narrative has come to include multimedia and in many ways reconceived to exploit the hyperlinks across the World Wide Web and the interactive potential of the computer through which it is delivered. Likewise, smartphones are portable and serve both functional and spontaneous entertainment needs in disconnected and unpredictable intervals between other activities. The functions, apps, and connectivity that we use are unrelated. They are all instantly accessible.

Some mobile phone content could be seen as video strips, a video form of comic strip that is short, entertaining, and apt for the viewing device. For newspapers, successful comic strips built audiences, readership, and cult followings. The video strip or other kinds of short form content for mobile devices such as games keep the user on the channel and paying for data or time, and this type of content also sells other features. It could loosely be seen as an electronic version of newspapers, attracting readers with the

> **The Comic Strip and New Storytelling Paradigms**
>
> The advent of the comic strip in the late nineteenth century as a new form of quick self-contained or serial narrative made sense in the context of the daily, expendable nature of newspaper content and the conditions under which newspapers were read. Comic strips are still going strong more than 100 years later. Comics are now a major source for big budget movies and video games.
>
> Traditional prose storytelling consists of the short story, the novella, and the novel. In the nineteenth century, authors like Dickens in Britain and Melville in America serialized novels in magazines. In recent years, something called flash fiction has emerged. It tells a story in 500 words or less. The short story format is enjoying a renaissance because it fits into patterns of e-reading. Younger generations have less time and inclination to read. Web content about lifestyle, celebrities, or social commentary is brief and to the point. These short narratives for blogs and websites alter the dynamics of storytelling. There is a video equivalent to found on YouTube and Twitter.

"funnies" who then go on to read other parts of the newspaper and see the ads. The newspaper, or magazine for that matter, sold the medium and the content and owned both. However, the interests of mobile device manufacturers, carriers, and content producers are separate. Each makes money in a different way for a different service.

Device manufacturers make money from innovation and obsolescence in hardware design and functionality in a cut-throat business that rewards massively (iPhone) and punishes mercilessly (Blackberry). Carriers make money from access and data streams. That is why they discount phones and want subscribers. Content producers make money from intellectual property and digital rights management. These three different business models have nothing in common even though they depend on one another. The mobile platform changes the way users of these devices consume media and therefore complicates how new digital media companies make money because crowd behavior drives the changes.

Another historical antecedent is television. With the birth of television and its rapid growth post World War II, the need for content was desperate. The medium was live to air. The lineup had to be filled. Content providers, who were the networks, basically brought the content of radio shows they produced that audiences already knew—soaps, quiz shows, comedians, and variety shows—into their studios for live broadcast. Then as the potential of the television medium became better understood and the technology of video recording and editing improved, producers invented content unique to television, including sitcoms, series, miniseries, talk shows, game shows, and, most recently, reality television. Going from an audio medium to a video medium is a radical shift, whereas going from one visual medium to another form of visual medium with a change in screen size and mode of access requires less adjustment. We can draw a parallel to the difference between movies and television.

Even though theatrical feature films can be shown on television, seeing them on the small screen interrupted by commercials is not the same

Flash Media, Twitter, and Visual Responses

Many have heard of the haiku, a Japanese 17-syllable poem that captures a fleeting but essential sentiment or perception. Now we have Twitter, which limits messages to 140 characters, a kind of messaging haiku. In January 2013, Twitter released the Vine app, which allows 6 second videos to be sent as Tweets. We see 15- and 20-second television advertising spots that are highly compressed forms of visual statement. This has taught audiences to read visual messages in condensed, rapid, staccato narratives that depend on editing messages stripped-down to the absolute bare minimum for visual comprehension. This often involves shots cut to fractions of a second, a matter of frames, accelerating the pace of visual narrative. The human mind can absorb visual information 60,000 times faster than reading text. Contemporary audiences, habituated since childhood from thousands of hours of watching television, have altered their response time, sense of visual literacy, and expectations. Watch a few older movies from the black-and-white era, and you will see the difference in pace!

Television vs. Movies

The size of the television screen, the viewing context in the living room, and the multiplicity of channels offered a different form of visual entertainment than movies. Initially, they were deadly rivals. Film studios forbade their contract stars to appear on television and would not allow movies to be shown on television. Movies set themselves apart by turning to color cinematography and new widescreen formats that prevail to this day and even 3-D formats (now reemerging), while television was stuck with a black-and-white image, a small screen, and the academy ratio of the 4:3 screen format. Even though television screens grew in size, and the quality of the video and audio improved and eventually became digital high definition, there was, and still is, a difference between television and movies. We know that movies narrate more by means of action, special effects, and setting, whereas television series rely more on dialogue.

experience as seeing them in a theater. There is a different kind of writing and thinking that lies behind each medium. By the same token, you could argue that seeing episodes of television series on an iPad or on a smartphone connected to the Internet by subscription to a service provided by the carrier is not the equivalent of viewing content written and produced expressly for mobile platforms. The length, the pace, the screen size, the viewing context all impact on the meta-writing and the kind of storytelling that engages a new expectation in the audience. Increasingly, innovative media companies such as Netflix, Amazon, and even Microsoft are creating content for streaming across the web and mobile platforms.[1]

> **Webisode and Mobisode**
>
> New words have been added to the lexicon. The Internet viewing experience spawned the word *webisode,* or segments tailor-made for streaming on the web. Smartphones can access the web and stream video. The trademarked term *mobisode* is a short serial form of narrative uniquely adapted to the mobile platform.[2] So there is no question that producers have been experimenting with new media formats. The question is, what makes them different and how might they develop?

VIDEO ON MOBILE PLATFORMS

How does video get delivered to mobile platforms? First, any device that can access the web through any carrier's network and has a browser can open the video stream of a broadcaster's website, or on YouTube or Hulu Plus. However, a lot of video requires a Flash player and for this and other technical reasons will not play on Apple devices. The strength of the signal and traffic on carriers' circuits will also affect this viewing experience. There is also a question of cost to the user paying for the data stream over significant stretches of time.

The second way, Mobile DTV, is the major innovation of the broadcast industry to remain relevant to the mobile media revolution. Open Mobile Video Coalition[3] (OMVC) is a group of some 800 stations that established a mobile digital television (DTV) standard enabling a multiplex signal of high-definition, standard-definition, and mobile DTV program streams. The DTV signal comprises not only the television signal but a

> **Advanced Television Systems Committee**
>
> When Advanced Television Systems Committee (ATSC), the U.S. digital TV standards body, ratified the ATSC-Mobile/Handheld (ATSC-M/H)[4] in 2009,[5] manufacturers of consumer mobile platforms such as cell phones, tablets, and portable DVD players could theoretically incorporate the receiver chipset in next-generation devices. A broadcast signal emitted from TV stations that equip themselves with the Mobile DTV transmitter can be picked up by cell phones equipped with a Mobile DTV receiver in a chipset that the device manufacturer must build in to the cell phone. That adds cost. Is it a feature that cell phone users want to pay for? Check your local cell phone store for the answer. How many people do you know who have cell phones that pick up Mobile DTV? On the other hand, quite a few

1 Brian Stelter, "Don't Touch That Remote: TV Pilots Turn to Net, Not Networks," *New York Times,* March 4, 2013: " Netflix is following up on the $100 million drama *House of Cards* with four more series this year. Microsoft is producing programming for the Xbox video game console with the help of a former CBS president. Other companies, from AOL to Sony to Twitter, are likely to follow."

2 The word was registered as a trademark by Fox after the term came into use in connection with new media produced for Verizon.

3 See http://open-mobile.org.

4 Eleven companies filed patent disclosure statements with the Advanced Television Systems Committee (ATSC). It raises a question about the cost for open access. I am indebted to John Hane of the law firm Pillsbury Winthrop Shaw Pittman LLP, Washington, DC, for making this point in his presentation on the panel at NAB 2009 on April 22: *Finding the Distribution Model for Mobile Television: The Decidedly Unsexy Legal Issues We Would All Prefer to Ignore.* Presumably this is now settled.

5 Glen Dickson, "ATSC Hails End Of Analog TV," *Broadcasting & Cable,* July 6, 2009.

back channel that carries parallel packets of information. The signal allows device-executable functions that can map location and possibly open up a wholly new form of advertising similar to Internet contextual banners and messages.

The third way involves the manufacturers of mobile devices building into their product a capability to receive a dedicated video stream. Apple won't because they are developing Apple TV. Google won't for similar reasons. The carriers are not motivated to offer DTV enabled phones. Even though the device must use a carrier's network to do so, the access to the content now becomes device specific. In 2009, Motorola contracted with Blockbuster, itself an obsolete videotape distributor, to stream movies to new feature-rich cell phones. The difference between this and the third way described earlier rests on exclusivity tied to the hardware. The third way is more like a cable channel that may or may not be in the bundle your cable provider offers, or at least be part of a premium package that increases your subscription cost. Several years ago, Motorola executives recognizing that mobile video entertainment was exploding and mobile touting consumers wanted a menu of content on the mobile phones that more or less matched that in their living room and on their PC. So what happened? Blockbuster debuted as a film service on Motorola, but limiting it to one brand of phone makes no sense. In 2013, you can install an app that allows you to play Blockbuster movies you have already downloaded. It is not successful, however. It all failed, and Motorola was bought by Google. In January 2014, Google announced the sale of Motorola at a loss to the Chinese company Lenovo.

This initiative by mobile device manufacturers to make money from content, not just from making the mobile platforms, begs a question. Which service, which channel, or which form of access to entertainment content will the public prefer? The business model for radio, television, and cable, for that matter, is well understood. Not so for mobile media! Revenue can accrue to the provider either by subscription, somewhat like cable, or by selling ads around content or in pre-roll while

cell phones have an FM radio chipset,[6] which may become standard. Sprint announced at the Consumers Electronics Show in 2013 that it would commit to putting FM into its phones. The Google phone Nexus One already comes with this feature. The 2013 Windows 8 mobile OS upgrade will enable FM.[7]

Mobile DTV Mobile DTV was new when the third edition of this book was in preparation. Four years later, it still has an uncertain prospect. It has three handicaps. First, it runs real-time programming not video on demand; second, it is local; and third, the same content in some cases can be viewed from the same device through the web browser on the mobile platform. By 2013, mobile DTV has not taken off. The number of mobile devices that can receive the signal is few and far between. The cost of a DTV equipped mobile phone is increased by about $100. Who wants to pay?[8] Mobile DTV content from TV stations in most of the country is sparse. TV stations are caught in a chicken-and-egg problem. There are few

6 The National Association of Broadcasters has lobbied the Federal Communications commission for years to make FM standard in all cell phones for local emergencies, if not entertainment.

7 David Ayala, "Google's Nexus One Specs Leaked," *PC World*, December 16, 2009. www.pcworld.com/article/184778/googles_nexus_one_specs_leaked.html. Radio executives approached the FCC in November 2009 to advocate incorporating HD FM in all cell phones for public safety (RBR-TVBR Newsletters, November 11, 2009). See also John Eggerton, "CES: Sprint Agrees to Make Some Phones FM Radio Receivers," *Broadcasting & Cable*, January 8, 2013. See also Tom Warren, "Windows Phone 8 Update to Activate FM Radios, Enable Double-tap to Wake Lumia 920," *The Verge*, March 26, 2013.

8 Harry A. Jessell, "Networks Should Energize Mobile DTV Push," *TVNewsCheck*, January 4, 2013: "The big hurdle in all this has been persuading the wireless carriers and mobile device makers to equip their phones with the mobile DTV receive chip. Why would any of them agree to make such an investment without the full and unqualified backing of the entire broadcasting industry?"

providing the content free. The business model is in interactive relationship to the behavior of its users and subscribers. What do they want? What are they willing to pay for? And how do they use their mobile devices? Is the revenue in the network provider's data stream or in the content provider, and what is their relationship?

Are you confused yet? Join thousands of media executives trying to make critical decisions about how to invest capital and choose what technology to bet on for the future! Doing

> Mobile DTV broadcasts because the audience is so small; the audience is small because there are so few broadcasts. Viewers won't get "interested until there are more broadcasts."[9] Who goes first? Not the viewers! At the NAB convention of 2013, attendees saw a new solution in the form of a dongle that plugs into a mobile handset and processes the Mobile DTV signal to display on that device. We will see how successful it is.

business in the digital mobile media ecosystem is not for the timid or weak of heart. Fortunately, as a writer, you can stay on the sidelines and wait for the mobile industry to evolve. However, even as a writer, you must think about how the changing technologies, viewer preferences, and business models will impact content and how you can make your writing relevant. There some clues to follow.

VIDEO AND CELL PHONE USE

The preceding background helps us to understand what will shape cell phone content and hence answer the question of how content and the writing for that content may differ from traditional media and rest on some technological issues and sociological issues of user behavior. To plot the curve into the future, we need to understand the demographic of users and more particularly how this demographic uses these ever-more-versatile mobile platforms.

Viewing on YouTube from mobile platforms has increased dramatically. The chief of YouTube's original programming services predicted "that viewing content on mobile devices will soon become the main means of viewing content . . . following the revelation that over the past 18 months, viewing traffic to the website through mobile devices has quadrupled."[10]

> **Nielsen Metrics on Mobile Viewing**
>
> Nielsen metrics show that "mobile phones were the fastest-growing means of watching television over the past year." All other sources were either "flat (the Internet) or declined (DVD/Blu-ray), and video game platforms in terms of TV usage." Americans "(236.5 million) watched TV on their phones during the second quarter of 2012," which is an increase; whereas viewership declined on conventional TV sets (283.3 million).[11]

9　Hiawatha Bray, "Mobile TV—Not a Lot to See Here," *Boston Globe,* January 16, 2013. Harry A. Jessel, "Networks Should Mobilize DTV Push," TVNewsCheck.com 2013: "We just keep waiting for the widespread deployment of mobile DTV. What we need is for the broadcast networks to make a real commitment to the new technology. If mobile DTV were real, don't you think Chase Carey, Les Moonves, Steve Burke and Bob Iger would be talking it up wherever and whenever they could? I have no evidence that any of those executives even know what mobile DTV is."

10　Steve Sanger, "YouTube Reveal Quadruple Viewing Figures For Mobile Platforms," *OnLine Media Daily,* October 12, 2012.

11　Joe Mandese, "Nielsen: TV Usage of 'TV' Continues to Erode, Mobile Is Fastest-Growing Segment," *OnlineMediaDaily,* November 13, 2012.

Viewer behavior is changing with astonishing speed. In 2012, "smartphone penetration crossed 50 percent for the first time, led by Android phones. People spend 63 percent of their time online on desktop computers and 37 percent on mobile devices, including smartphones and tablets, according to comScore."[12] Could this alter the way content is conceived and produced to favor mobile devices and viewing habits?

The mobile phone is portable, personal, and aggregates numerous functions such as voice communications, GPS, text messaging, calendars, alarms, still and video image capture, music, and (for cell phones with an operating system) hundreds of potential killer apps that facilitate life in a multitasking world. Many of these functions, except voice calling, are duplicated in the tablet. It could be that the immediate accessibility of the mobile phone will make it the viewing platform of choice. iPhones led the way for devices that can download and store content, which meant that the cell phone, if we should still call it that, could increasingly function as an offline viewer and as portable storage for media that can then be played back through laptops, desktops, and television with USB inputs or even wirelessly.

So cellular phones now become satellites of our mother ship platforms that duplicate functionality and furnish greater speed, power, and more apps. Will the cell phone be a storage device to carry content to plug into a larger screen for viewing, or will it be the viewing device itself? Why

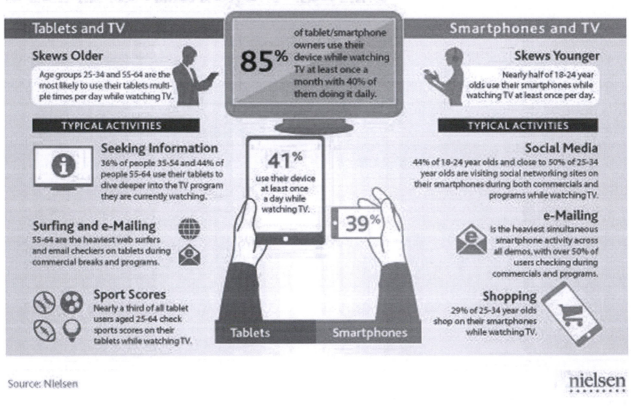

Source: Nielsen

→ **Figure 14.1** How mobile platforms are used.

12 Claire Miller, "Tech Predictions for 2013: It's All About Mobile," *New York Times,* February 18, 2013.

keep media content on your mobile device when you can buy it, store it, and access it in the cloud—concepts well understood by Apple, Google, and Amazon. A whole new generation that cannot live without mobile phones doesn't really care about the cinematic experience of the projected image. Convenience, accessibility, and personalized on-demand viewing drive the next generation.

Historically, the idea of unique content for mobile platforms is relatively old and predates even the previous edition of this book. Media technology often develops under the radar, and innovation is of necessity not main stream but the province of early adopters. With 3G services about to launch, carriers saw the opportunity to deliver video to a new generation of phones. The idea was probably ahead of its time and the technology ready in 2004/2005.

> **Increased Cell Phone Viewing Time**
>
> In 2009 the average viewing time was about 3.5 minutes a day according to Nielsen. In the first quarter of 2011, viewing on mobile devices such as tablet or smartphone reached 8.67 minutes a day (at the same time average TV viewing time was 5 hours and 20 minutes a day).[13] Another source puts mobile viewing at 2 hours and 7 minutes a day. The metrics and demographics will always be in arrears and therefore not up to date at the time of publication. After publication, as this edition ages, the data will inevitably change, but there is a clear trend of increased viewing time. This might become a clue as to the kind of content that will succeed on mobile platforms.

THE MOBISODE

What's the difference between a webisode and a mobisode? The name *webisode* has embedded in it the association with the web, whereas the *mobisode* suggests a new network and is a trademarked piece of terminology. In both, the writer is faced with extreme abbreviated storytelling techniques. However, the mobisode compresses narrative into a shorter and more elliptical style. Dialogue takes screen time. Visual narration becomes key. Think back to the dialogue balloons of comic strips and their relation to picture. There is a movement toward downsizing and compression. As life speeds up, there is less time to watch and to read. The comic strip really invented the extreme close-up and established key frame narration as a way to tell a story. In mobile media minisodes (to coin another phrase), it is almost as if the key frame of a storyboard becomes the program. The storyboard is, after all, a kind of comic strip of a full-motion

> **The History of the Mobisode**
>
> The *mobisode* was a new media serial that was produced specifically for cell phone distribution by Verizon, to be shared subsequently with European Vodaphone, the world's largest cellular phone carrier, to launch its 3G service. The concept was pioneered by Daniel Tibbets, a producer working for Twentieth Television and running the experimental Foxlab at the time, which shut down in 2005. This was the first *mobisode,* a term that Fox then registered as a trademark when it formed a new division, Fox Mobile Entertainment. Several such series were made before that Fox unit was closed down. See http://en.wikipedia.org/wiki/Mobisode: "Lucy Hood, then head of FME, conceived the idea of a short video series produced by Daniel Tibbets, which then FME SVP Mitch Feinman coined a Mobisode™

13 Steve Sanger, "US TV Viewing Time Rises to Highest Ever," June 16, 2011. www.worldtvpc.com/blog/report-shows-younger-viewers-increasingly-watch-tv-mobile-devices/.

linear narrative. Whereas the writing formats for games and interactive media are difficult to tie down, the script format for mobile media follows the linear media script for film and television. Do they differ in the meta-writing or conception that responds to the new qualities of this new medium? That is the question. To answer it, let us turn to a pioneering mobisode.

Love and Hate and *Sunset Hotel*, created by Daniel Tibbets, were the two original mobisodes for Fox Mobile entertainment. *Love and Hate* and, later, the existing series *24* premise became the basis for a short-form mobile series. In interviews, Daniel Tibbets has made it clear by telephone inverview that cell phones invited a new kind of narrative content. After his work for Fox

Series and trademarked for News Corp. The word came into popularity as Vodafone, its U.S. partner Verizon and FME launched several Mobisode Series . . . around the world in nearly 30 countries and 7 languages. Over the next few years, several other Mobisode series launched, including some original ones produced by Daniel Tibbets of FoxLab Inc., a division of 20th Television's syndication arm, which shut down shortly thereafter." The Wikipedia entry is inaccurate. By email exchange with Daniel Tibbets and Paul Palmieri, I have established that Verizon was indeed the first carrier/company to commission an original mobile series. See http://en.wikipedia.org/wiki/Daniel_Tibbets.

Mobile, he continued to develop unique mobile content as Executive Vice President and Studio Chief of GoTVNetworks for several years.[14] Likewise, Jana Veverka revealed in a telephone interview that in writing *Sunset Hotel,* she was keenly aware that they were engaged in a new form of short narrative episode that had to tell a serial story in short episodes of 1 to 2 minutes for cell phone viewers.[15]

Sunset Hotel consists of a storyline centered in a Los Angeles hotel. This recalls the California settings of *The Strand* and *Something to Be Desired.* The characters are straight out of film noir and crime/suspense genres with good guys and bad guys and an alienated demi-monde femme fatale. Genre provides an immediate frame of reference and a way for audiences to recognize characters and situations. It is probably fair to say that this mobile series does not resonate with any profound philosophy or solve any existential problems. The bad guy is Peter, a womanizing, manipulative manager/owner and pimp. We discover the world of Sunset Hotel through Jack, the new bartender. Bianca is a sexy call girl who has a working relationship with Peter and a suite at the hotel. There is a maid, Robin, who makes up the rooms, and her friend, Charlie, whose picture-taking cell phone is a key prop and plot device that exposes the culprit of the murder of a client staying in the hotel. Jack is attracted to Bianca, who falls in love with him. Jack's sister, Emily, comes to visit him, and Peter uses her as a courier. The dialogue is mostly stylish and smart with comeback repartees and put-downs. While Peter is a classic domineering villain, Bianca is an unconventional free spirit who challenges Jack. Jack cannot deal with Bianca's chosen profession as call girl until his baby sister gives him a lesson on love. In the end, Charlie saves Bianca from being set up by Peter. Emily's relative purity and innocence are preserved, and Jack nearly misses out on Bianca because of his conventional scruples about returning love from a call girl, dramatically the most interesting aspect of their character development.

The characteristic of the writing and the storyline is its curt style and unresolved story issues. The premise is the story in the sense that we do not need complete third-act resolution. Jack gets a one-way telephone message in the last episode of Bianca's address. The use of cell phone ring tones

14 Based on a telephone interview and email communication in July 2009.

15 Based on telephone interviews July/August 2009.

makes the content use the medium it's on to good effect. The mobisodes are like snapshots of a fictional world that seems familiar because of film noir and other suspense films. Let's take the episode in which Emily comments on Jack's relationship with Bianca before she goes home:

```
"REALITY"

EXT. GARDENS BY BRIDGE—DAY

JACK says goodbye to EMILY.

                    EMILY
          You're staying because of Bianca.
          Aren't you.

                    JACK
          I'm not sure.

                    EMILY
          What's your problem?

                    JACK

               (incredulous)
          My problem? I don't have a problem,
          she does.

                    EMILY
          You're such a guy. So damn
          territorial. How many girls you
          slept with, Jack?

                    JACK
          That's none of your business.

                    EMILY
          Exactly! Bet she never asked you.
          Because it doesn't matter to her.

                    JACK
          I never paid for sex.

                    EMILY
          Everybody pays, Jack. One way or
          the other. The point is, why can't
          you accept her for who she is. Not
          what she is.
```

 JACK

 How am I supposed to get over that?

 EMILY

 I don't know what she sees in you
 anyway.

 JACK

 Thanks. I needed that.

In effect, a scene becomes an episode. So the scene is like the key frame of a comic strip or a storyboard. If a 1-minute mobisode is going to work, playing of genre helps, but conventional television writing also has to be stripped down to essentials. Now the plot question has to resolve.

 EMILY

 Oh, stop. You love her. She loves
 you. What else matters, Jack. How
 many times have you told me that?

 JACK

 Never!

 EMILY

 Yeah, but you will someday!

EXT. TERRACE/BIANCA'S SUITE—DAY 2

BIANCA stands at the edge looking down.

BIANCA'S POV

Jack and Emily in the gardens.

RESUME SCENE

PETER (O.S.)

Back to business as usual.

Peter stands next to her looking down. Her phone RINGS. Her special "Client Ring." She doesn't move.

 PETER

 Aren't you going to get that?

 BIANCA

 In time.

 PETER

 The police found your scarf in
 Tommy's room.

 (off her look)
 I've forgotten who it belongs to.

Her phone rings again.

 PETER

 Our regulars are back.

He walks to the door.

 PETER

 So are you. Time's up.

 FADE TO BLACK.

At this point we have to resolve whether Jack will have the courage of his love and whether Bianca will break her business arrangement with Peter.

Each episode is set up with a tag line, a boiled-down quintessence of the mobisode, which is itself almost like a trailer for a bigger story. The storyline is like a series of pods or seeds that grow in the audience's imagination. In *Sunset Hotel,* each episode is stitched together with a voice-over narrative somewhat like the nondialogue narrative of comic strips. The voice-over, which is not in the original script, provides a string to thread through the beads of the episodes. In the final cut, the voice-over of Jack reveals some interior dialogue. *Sunset Hotel* as shot and edited is perhaps shorter than the script. The shooting style evolves from television shooting, which relies on close-ups and two-shots, but with an even tighter, more elliptical style that the director Joe Rassulo realized would be needed to make it work.[16]

The scenes are shot like key frames of a storyboard and tell the story through staccato scenes with minimal dialogue and a voice-over link. Body language in close-up becomes more critical in mobisodes. Cutting style changes—jump cuts compress action. Audiences have learned to read short cuts from the narrative compression of so many TV ads, which also influences the narrative style, shooting, and editing techniques. One way to understand this new format is to realize that even though television episodes and even movies can be downloaded to cell phones or viewed on cell phones, the kind of content developed specifically for the cell phone format would never really work on television because our viewing expectations of the pace of narrative differ in the living room.

Elsewhere, this short-form concept was expanded in some TV spots created from *Desperate Housewives* for Sprint, in which the carrier's Palm Pre figures in the interaction of the characters and then becomes incorporated in the on air-script later so that there is seamless connection between the

16 In a phone interview with the director, Joe Rassulo explained he shot 26 1-minute episodes in four days. He confirmed the idea of a compressed staccato style of narrative derived from film noir and the comic strip.

advertisement and the content.[17] Product integration is the new commercialism of the mobile media age. It began in feature film production as a way of selling opportunities for companies to expose their products when necessary props had to be in shot. The art director or property master could arbitrarily choose one brand over another of a car, a soft drink, or other commonly used product that would appear in shot, or producers could mine the script for props that could be sold as product placement opportunities and defray the cost of production.

The next step that has emerged in the context of the unstructured, undefined, and shifting business models of the mobile media worlds is branded entertainment. This involves more than product placement. Branded entertainment allows advertisers to have products written into the storyline and even fabricate story moments that walk a fine line between a detour to feature a product and a product that happens to be a logical part of the story. This blending requires skillful writing and needs to be part of the webisode and mobisode writer's almanac. The advertiser can underwrite the production cost, somewhat similar to the old soap opera model and sponsored TV show.

A defining characteristic of minisodes is their length and, hence, their production cost. A 1-minute minisode is not that much longer than a TV commercial spot. Moreover, the spots are an intrusion that the audience can reject or screen out either by means of technology or by simply leaving the screen to get a snack or go to the bathroom. Branded content makes the message unavoidable for any audience that is absorbed in the story.

GoTV Network (no longer active in this field) developed some branded entertainment centered around strong product integration for corporate sponsors such as Tide for the hilarious mobile sitcom *Crescent Heights*, with slightly longer episodes of approximately 2–4 minutes. It is really the old soap opera model from radio. Comedy succeeds in any format because it is funny. The quick comic sketches of *Crescent Heights* use well-understood comic devices but with a refreshing structural efficiency. The setting is an apartment complex with a typical laundry room that becomes the venue for several episodes and numerous encounters. Because Tide is the series sponsor, laundry themes are frequent. Here is an episode that exploits the comic hero as victim. Our hero has a temp job that terminates in disaster on the first day—in fact, morning, to be more accurate. While in the laundry room, Will tells it as a flashback to his roommate Eddie, from whom he borrowed a white shirt that he has ruined. A dragon office lady tells him that he must have coffee on his boss's desk by 8:45 A.M. or face the boss's ballistic rage and his own termination.

In minisodes, we skip dialogue and once the comic problem is set up we go straight to the sequence of physical comedy that ends with our hero slipping on spilled coffee and knocking himself out in the kitchenette while trying to make the coffee. We see him on a stretcher, and then we understand why he is talking to his roommate with a bandage round his head. In mobile serials, we have to allow the audience to fill in the bare bones. It is not that this doesn't happen in regular television or even movies; in mobile media, it drives the mobisode. In a feature film, we see someone hail a taxi in the street. Maybe we let the character get in the cab. We cut to the character at his destination. We don't want to watch a cab ride. It is a form of elision that shortens the action and relies on the audience's powers of deduction to fill in what happened that is not shown on screen. Audiences like contributing their imaginations to interpret a story.

In minisodes, the action is constantly stripped down to its bare minimum, in this case a slapstick disaster. The character Will goes to the coffee machine. He sees no filters. So he looks at the empty paper towel dispenser in frustration then seizes on toilet paper to make a coffee filter. He searches the

cabinets for coffee. He finds a packet of coffee. In tearing it open, he spills the contents on the floor. Cut to Will scooping coffee off the floor and sticking it in the machine. Enter the dragon lady to drop the line: "I hope you didn't add water. It's connected." She exits.

INT. OFFICE CUBICLE—MORNING

Will sits at his desk and unloads a box of his personal items. He places a framed photo on the desk along with a miniature hula girl figurine.

CAROL, 40's, annoyingly cheerful, suddenly pops into Will's cubicle. Surprised, Will jumps back.

> CAROL
> Good morning, I'm Carol. You must
> be Mr. Eubanks's new temp.

> WILL
> Yeah, I'm Will.

Carol looks at the desk and sees all of Will's personal items.

> CAROL
> I see you brought a few knickknacks
> with you. Personalizing your area
> on the first day. Quite a bold move,
> temp.

> WILL
> Well, I was kind of hoping that
> maybe this will turn into a full-
> time position.

> CAROL
> I wouldn't count on it cubicle
> squatter, because while you were
> "unpacking," precious time was
> slipping away.

> WILL
> What do you mean?

Carol gets in Will's face—she's uncomfortably close. She looks around making sure that her next words will be private.

> CAROL
> (intense)
> If Mr. Eubanks's coffee is not on
> his desk when he walks in at 8:45,
> he'll go B—A—double L—istic!

> WILL
> B—A—double L—istic?

> CAROL
> Ballistic! Tick-tock, you've only
> got five minutes until Mr. Eubanks
> gets here. And if he blows, you
> goes.

Carol suddenly makes an EXPLOSION sound, which startles Will. She quickly composes herself and breezes away. Will is a bit shaken.

> WILL
> What's the big deal, it's just
> coffee?

Carol pops up again, surprising Will—he jumps out of his seat.

> CAROL
> Remember . . .

Carol makes another EXPLOSION sound.

> CAROL (CONT'D)
> (cheerful)

> Have a nice day!

Carol disappears. Will looks up at the clock—it reads 8:41 A.M. He bolts from his desk.

 We then get the physical comedy, which is much more compressed and faster than the script might suggest.

Will looks at the empty coffee filter basket. He shrugs.

> WILL (CONT'D)
> It is paper.

Will pulls off a few sheets of toilet paper and lines the coffee filter basket.

> WILL (CONT'D)
> Now for the coffee grounds.

He grabs the last bag of coffee grounds. Will struggles to open it but cannot.

He looks up, it's 8:44 A.M. More sweat builds on his brow.

Will wrestles frantically with the bag of coffee grounds. Then with huge GROAN, will pulls on the bag with all of his might.

The bag explodes—covering Will and the rest of the kitchen in a thick layer of coffee grounds.

Will looks up and sees a large photo on the wall of Carol with the words, "Employee of the Month." It looks like she is leering down at him.

> WILL (CONT'D)
> Oh no.

Will quickly sweeps the grounds off the floor with his hands and dumps them into the basket. He shakes the remainder of the coffee grounds off of his shirt and into the basket as well. Then he slides the basket back into the machine.

Will grabs the coffee pot and fills it with water. He pours the water into the machine and hits BREW. Proud, will steps back and watches the coffee fill the pot.

Suddenly, Carol enters the kitchen, opens the fridge and grabs a yogurt.

> CAROL
> I hope you didn't add water because
> it's already connected to the tap.

Carol takes a bite of her yogurt.

> CAROL (CONT'D)
> Mmmm, peaches and cream. Yummy!

Carol breezes out of the kitchen.

> Reproduced by permission of GoTVNetworks.

Will turns to the machine, slips on the coffee grounds on the floor, then bangs his head and knocks himself out. There is a cut to Will and his knick-knacks being rolled out of the building on a gurney. A single scene implies the outcome of the previous scene and implies the missing scene of the emergency room. Time is also a character. Will is racing against the clock—a classic comic device.

Being Bailey was a teen drama for a key demographic distributed on AT&T, Sprint, and alltel that works like a kind of video diary of Bailey and her two best friends who are starting high school. The main character adopts the convention of talking to the audience through the camera in a confessional, confidential style.

The short-form concept was picked up by ABC for a series of 2-minute minisodes exploiting the premise of the TV series *Lost,* called ***Lost: Missing Pieces*** and tentatively sold to Verizon's V-Cast network but foiled by disagreements with the Director's and Writer's Guilds over residuals. The take-away point is you can see the tentative attempts to exploit mobile video in unique and pioneering ways. Even though it has not survived in exactly the way imagined at the outset, we still find a wealth of short-from narratives on YouTube, if not on smartphones.

Taken together, these examples of minisode suggest a range of narrative experiments that flourished and then died out—but maybe not. Initial experimentation with short-form series for mobile

used to be dictated by a technical issue of bandwidth. Given the speed of the network, how much video information with the packet switching and buffering could be delivered to a mobile device in the available bandwidth? About the maximum amount of continuous video the network could deliver was a minute. This then dictated the length of the episodes and a new kind of abbreviated storytelling and production. The old adage—form follows function—means in this case that if the medium cannot deliver the length, your storytelling has to be modified to fit. Given the looming popularity of the mobile platform, content producers saw what appeared to be an opportunity to create a new format.

In 2013, there was a kind of rebirth of the potential for short-form narrative based on applications like Twitter, Tumblr, and Instagram, which can distribute video clips. Twitter launched Vine, its video sharing app, which limits video clips to 6 seconds. Lo and behold, The Chernin Group has, according to an article in *Variety*, produced a new short-form, unscripted series that will be distributed just on social media platforms: "'@SummerBreak' follows a group of real-life graduating seniors culled from high schools in the Westside area of Los Angeles for eight weeks before they depart for college and elsewhere. Instead of the traditional 30- or 60-minute episodic format, the series will play out 24/7 as a series of tweets with photos and videos attached."[18] The reappearance of short-form storytelling, however mutated and evolved in terms of new media technologies, completes the picture and confirms the validity of the pioneering of a decade earlier. By the time you are reading this, you will know whether it has taken hold and become a recognizable production format.

Not only has bandwidth increased, phone screens have become larger and switchable between portrait and landscape format according to the function desired with touch screen controls. Above all, battery life and efficiency have improved so that watching TV or video on a mobile phone is manageable. Fourth-generation (4G) networks now offer speeds 5 to 10 times faster than 3G.[19] A competing network technology called WiMax promises similar speeds that, whatever the technology, could challenge DSL and cable broadband. Google is experimenting with a high-speed network in Kansas City that is 100 times faster than broadband. Samsung announced an ultra-fast 5G network in May 2013 for deployment in about 2020 that would be several hundred times faster than 4G and permit unlimited streaming.[20] Video and TV content on cell phones is here to stay and will grow its audience and hence its advertising and revenue.

WEBISODES AND NEW DIGITAL FORMATS

Television series have developed a significant web presence with blogs, chat rooms, bios, and added value content for fans and followers of the series. In particular, a web-based extension of series storylines has spawned what is popularly known as *webisodes*, which use the same characters as the main series. Viewers can expand their sense of that imaginary world and find story dimensions that might otherwise be restricted by primetime episodes. These webisodes are by definition separate scripted extensions of the story. So it is a new form of writing. There are also web-based series that are only distributed as webcasts or podcasts. Most shows now develop an elaborate web presence if not new web content. **The Walking Dead** provides an example.

18 Andrew Wallenstein and A.J. Marechal, "Social Reality Show to Skip TV, Play Entirely on Media," *Variety*, April 25, 2013.

19 Hiawatha Bray, "Hub to Get Early Look at Next-level Web Link to Test High-speed 4G Cellular Network," *The Boston Globe*, August 13, 2009.

20 Choe Sang-Hun, "Samsung Advances Toward 5G Networks," *New York Times*, May 13, 2013.

Before mobisodes, there were webisodes. Whereas *mobisode* is trademarked, *webisode* is in the public domain and newly added to *Merriam-Webster's Collegiate Dictionary*. As the name implies, webisodes were a new form of video content consisting of short serial episodes found on websites of successful television shows such as *Battlestar Galactica*. They are often preceded by pre-roll ads. In some ways, they could be seen as satellites to the network series or trailers to promote the full-length series on cable or network television. The website for *The Office* offers webisodes and full-length episodes. However, certain webisodes exist in their own right, not as offshoots of conventional series. They take existing characters and add story not found in the broadcast version but scaled down in length and free of the three-act structure of the main series. Webisodes are not like outtakes that adorn DVDs where you get to see what the director and editor painstakingly removed from the final version. They are more like footnotes or excursions into tangential story matter that would interrupt the flow of a conventional television episode. There is another form of webisode, to complicate matters, which is freestanding serial narrative that exists only on a website.

The Spot (thespot.com) pioneered serialized fiction on it's website, which ran from 1995 to 1997, and also pioneered a business model that included paid advertising banners and product placement in the interactive journals that characters wrote to engage the audience and get them to participate in the story by posting advice to characters on bulletin boards and emailing ideas. The "Spot" was a beach house in Santa Monica, California, that rented out rooms to cool 20-somethings. It flourished, attracted investment and then failed as a commercial venture. It was briefly revived by two of its producers in 2004 with an exclusive wireless connection to Sprint, but it has not survived.[21] Thus, we find the first instance of a webisode migrating to mobile media.

Something to Be Desired, about a group of young people working as deejays in a Pittsburgh radio station, originated in 2003 as a dedicated entertainment website rather than a satellite of a network series. It is the longest-running webisode and still going. It represents a form of pure web-based serial narrative with episodes of 5- to 6-minute duration. It shoots in real locations and has an ensemble cast. Its audience demographic must be roughly equivalent to the demographic of its characters. The website has interactive features that allow voting and rating of episodes and audience comments as well as a forum. It is now distributed on Amazon and iTunes.

The Strand, set in Venice, California, is another web original brought to life in 2005 by one of the creators of *The Blair Witch Project* (1999), the success of which was very much due to the brilliant and pioneering viral marketing through its website. This webisode mingles actors and real characters and exploits an improvisational style. The audience cannot interact directly with the storyline but can explore background blogs and anecdotal details of production. As of 2013, it is no longer being produced.[22] Bigger players got involved in the format with bigger budgets. Michael Eisner, the former head of Disney, produced *Prom Queen* with 90-second minisodes and a production cost of $3,000 per segment.[23] The minisodes achieved an audience of 15 million, which led to a sequel, *Prom Queen: Summer Heat*.

Let us note that production costs are a fraction of the cost of broadcast television. The low-budget production model has implications for the kind of writing you can do. In Chapter 1, we examined the production consequences that can arise from a few words on the script page. The concept has to be clean and simple and must allow some kind of narrative shorthand. Webisodes are often launched on

21 See http://en.wikipedia.org/wiki/The_Spot.

22 Carolyn Handler Miller, *Digital Storytelling*, 2nd ed. (Boston: Focal Press, 2008), pp. 261–262.

23 Marisa Guthrie, "What's a Webisode Worth?" *Broadcasting & Cable*, November 24, 2007.

social networks. The message here is that small independent writers and producers have direct access to the world without intermediaries. You can experiment with audiences without the intervention of a bunch of suits that want to makes big deals and big money. Even mainstream Hollywood producers have produced webisodes, such as Marshall Herskovitz and Ed Zwick's *Quarterlife*, which premiered on MySpace. It was then picked up by NBC.[24]

WGBH Boston is producing ***Dot Diva***, a new webisode in collaboration with the National Science Foundation about two young women in a start-up video game company, which also tries to connect to real women who have created apps or made a mark in the Internet and IT environment. It aims for social and educational value beyond entertainment and encourages audience interaction.

➜ **Figure 14.2** Dot Diva © 2010 WGBH Educational Foundation. All rights reserved.

The consensus seems to be that this is a new media frontier, and nobody is certain how to monetize the webisode. The audience demographic is adolescents to young adults (although this demographic is extending annually) who have adopted social networks, send video over cell phones, and snack on media tidbits grabbed on the fly. The webisode is viral and unpredictable. It offers an alternative experience to traditional television. It innovates on-demand viewing, interactivity, and free personal viewing—on a laptop or computer monitor rather than a living room TV. It is not interrupted by ads like traditional television. It is free of constraints imposed on broadcasters licensed by the FCC to use public airwaves. The innovative style, format, and content are noticeably different than those of network TV, which is driven by ratings and hunger for advertising dollars tied to the size of audiences. Network TV's heavy reliance on advertising ultimately limits the kind of writing and subject matter that the viewer will see. The webisode invites unconventional writing and storylines that push the envelope of the medium. It is accessible to mobile platforms that can access the web and is becoming part of the media mix available through cell phone carriers and mobile broadband.

24 Ibid.

WRITING CHANGES

Writers take notice: formats are changing. This chapter documents that formats have been evolving over a much longer period than most people realize. The Writers Guild of America has recognized these new formats and that creative script writing is involved: "New Media includes all writing for the Internet and mobile devices as well as any new devices using these technologies as they evolve, or any other platform thought of as 'new media' by the industry as of the start of the 2008 MBA, which was February 13, 2008."[25] A scale of minimum fees has been negotiated that binds the Alliance of Motion Picture and Television Producers, which refers to programs up to 2 minutes in length as sort of standard units, clearly recognizing the kind of minisode for mobile platforms that we have discussed in this chapter.

Since this is a book about writing rather than technology or marketing, our interest must be in the content that fills these screens and in the writing behind that content. More particularly, our interest must be in innovative writing specific to mobile platforms. Redistributing existing TV series on a mobile platform does not involve a change in the narrative style and scriptwriting. So we need to turn to the unique content and investigate how it modifies visual narrative for mobile platforms. If the use of mobile media platforms is going to drive the demand for new and original content, content providers will turn to writers for their proven narrative skills. However, writers will have to think differently.

Writers Guild of America

A *New Media Program* is deemed original and covered by the WGA Minimum Basic Agreement ("MBA") if it is produced by a signatory company ("Company") for the Internet, a mobile device, or any other platform thought of as "new media" by the industry, and meets either of the following tests: First, the program is covered if the Company employs or purchases literary material from a "professional writer" as that term is defined in the MBA.1 Second, the program is covered if the actual cost of production exceeds any one of the following limits, even if the writer is not a professional writer: • *$15,000 per minute of program material as* between the writer and the Company • *exhibited; or* • *$300,000 per single production as exhibited; or* • *$500,000 per series of programs produced for a single order*. When a New Media Program meets one of the above criteria, the WGA has jurisdiction over it. Under WGA jurisdiction, certain terms of the MBA automatically apply, while other terms remain freely negotiable.[26]

Writers tend to want to stay at arm's length from the technical problems of production, but it would seem indisputable that the technology of the medium and distribution drive changes in format and, therefore, the nature of storytelling and writing.

How must writing change for the new market of mobile media scripts? Clearly, characters have to become easily recognizable. Genre will probably help, but that can mean capturing comic strip conventions of compressed narrative that leave intervening frames and action to the imagination. Shorter length means shorter dialogue because speech takes screen time. In this respect, movie dialogue might be the model. When dialogue plays, it must be hip, short, and to the point. Action trumps dialogue. One plausible model could be television advertising in which ongoing narratives are built on the success of some storyline or character. GEICO has built a kind of series story of the Cockney-accented gecko who has mini episodes with a continuing story arc, which ends with the pitch line that "15 minutes could save you 15% or more." Stories built around a product are going to

25 See www.wga.org/content/default.aspx?id = 1116.

26 See www.wga.org/contract_07/NewMediaSideletter.pdf.

sell to sponsors. The style must be contemporary and reach a primarily younger demographic, below the age of 30, although this is going to change as this audience ages. Single location settings will match the limited production budgets. We don't know whether this short-form narrative will thrive or just become a flash in the pan. Right now something bigger is happening.

SECOND-SCREEN AND MULTIPLE MEDIA CONCEPTS

In just a few years, things have progressed beyond mobisodes and webisodes and moved in a different direction. The second-screen phenomenon is a recent mutation in the rapidly developing mobile media ecosystem. What is it? For several years, series, sitcoms, games, and movies have had websites for fans and followers. Even newspapers and magazines have had websites with extra features. Simultaneously, the rapid evolution of the smart phone with 4G access to the internet and its enthusiastic adoption by the public has given viewers new options as to how they consume media content. A coincidence of phenomena gave rise to a new, spontaneous form of consumer behavior.[27] The crowd invented something that media companies did not at first see or understand.

People started to have options as to what screen to watch for one. So you could watch a program on living room TV and simultaneously open its website for a third dimension. Because phones, tablets, net books, and game consoles now provide access to the Internet and social media, viewers began to use Facebook and Twitter to communicate within their social network about what they were watching and what they thought about it. Even though the members of that social network might be in separate locations, they had instant contact and were able to alert their own social network about something cool, interesting, or exciting so that in some instances it became viral. More people tuned in to the program. More eyeballs means more money but only if you can count them and then sell access to advertisers.

The music industry was overturned by the crowd phenomenon of file sharing. The control and licensing of intellectual property is a major preoccupation of the legacy media companies. They fought against digital media and web based distribution.

Digital Distribution

When file sharing took off, music companies sued their potential customers—students, even grandmothers and grandfathers,[28] to set an example. The crowd using digital technology took over. Apple recognized what was happening and created the new business model in the form of iTunes. Did you ever ask the question how come a computer manufacturer became the world's largest distributor of music? Apple invented the iconic device (iPod) for modern consumers of music together with the iconic virtual storefront to distribute that content, which now include books, films, and TV. The music companies learned slowly. Now the music companies writhing in agony have to pay Apple 30 percent commission for everything downloaded from iTunes. They are just beginning to rebuild their business model and their revenue in 2012: "$16.5 billion, was a far cry from the $38 billion that the industry took in at its peak in 1999."[29]

27 "Nielsen reports that during the second quarter of 2012, 86% of tablet owners and 84% of smartphone owners in the United States said they used their second screen of choice while simultaneously watching TV at least once during a 30-day period. But for 41% of tablet owners and 39% of those owning smartphones, that multitasking is more like once a day, at a minimum" (www.cnn.com, September 15, 2012).

28 See http://betanews.com/2005/02/04/riaa-sues-deceased-grandmother/ and http://brainz.org/14-most-ridiculous-lawsuits-filed-riaa-and-mpaa/.

29 Eric Pfanner, "Music Industry Sales Rise, and Digital Revenue Gets the Credit," *New York Times*, February 26, 2013.

They acted like spoiled children complaining that people didn't come into their walled garden and buy their music the way they wanted to sell it. How come all the suits in the executive suites didn't get it?

The video and movie companies faced the same phenomenon. Netflix was a little bazaar streaming movies across the web on the edge of town that nobody paid attention to. Then media companies had to fight off file sharing websites that were pirating their content and saw their audience melting away. Suddenly, they desperately needed Netflix who was willing to pay for content because it understand the new audience behavior and had built the new distribution and business model. Just as legacy media companies fought and played catch up with television, videocassettes, and DVDs, they could add new revenue streams but had to share it with upstarts like Netflix because they didn't see it coming. Blockbuster went bust.

Netflix has begun to spend money on production and creating its own content: *House of Cards.* Amazon is competing with pilots for its own content in development. We are seeing a new media platform growing on a broadband distribution channel that competes with traditional broadcast networks. It does not signal a change in writing so much as new opportunities for writing and a new distribution pattern and a changing business model that will shake up the media business.[30]

Publishing media came next, refusing to acknowledge the logic of distributing print media (relatively small files) across the Internet—online newspapers, magazines, blogs, and the big one, e-books. Books can be produced and distributed more cheaply for digital readers. Amazon, originally, a bookseller, becomes a publisher. Authors don't need publishers as gatekeepers who hog the lion's share of the revenue and pay miserable royalties. Authors can self-publish through Amazon subsidiaries or numerous e-publishers and get larger royalties more frequently paid.[31] As with music and video, the creator has direct access to a potential audience.

It is critical to understand that the crowd has taken control, or at least changed the rules, and traditional media companies lost control over audiences and ratings. Almost overnight, audiences can watch content free, on demand, when they want, how they want across the Internet with access to a cluster of media channels. Media companies saw revenue decline and their precious intellectual property being given away on YouTube, Hulu, and even streaming it free from their own websites. Word of mouth and discussion around the water cooler in the office was being replaced by upstart social media networks. Panic in the executive suites all over again!

Media companies were no longer the gatekeepers for distribution because audiences could create and upload their own content (music, video, images, books) to website, YouTube, blogs, or stream video across the World Wide Web for free. The creator or publisher of such content (you and me) gets revenue from Google for the number of impressions and click-throughs from the advertising sold around it. A good example is Jenna Marbles who has built a huge youth audience with self-produced, self operated video clips that get a million hits a day: "She has more Facebook fans than Jennifer Lawrence, more Twitter followers than Fox News and more Instagram friends than Oprah."[32] This kind of production is being professionalized. Google has built a studio to enable this activity to grow, presumably because it will become the content around which its advertising will grow. Managers, agents, and PR people are getting involved.

The comfortable business model of the walled garden to which media companies controlled access disintegrated as the crowd phenomenon disrupted their business model. Basically, the business

30 Brian Stelter, "Don't Touch That Remote: TV Pilots Turn to Net, Not Networks," *New York Times,* March 3, 2013.

31 Leslie Kaufman, "New Publisher Authors Trust: Themselves," *New York Times,* April 16, 2013.

32 Amy O'Leary, "Jenna Marbles, the Woman With 1 Billion Clicks," *New York Times,* April 12, 2013.

model was and is to sell audiences to advertisers. The more eyeballs they can track through industry agreed ways of measuring audiences, the more money they can charge advertisers for access to their audiences. In unfamiliar online territory, the media companies are forced to keep audiences by offering nearly ad-free content. It was not clear how to exploit an audience you could not measure, whose viewing behavior you could not follow. Traditional television advertising declined while Internet advertising mushroomed. But how do you price it? How do you monetize this fickle, unpredictable viewing audience? Basically, you have to understand second-screen behavior and infiltrate it and work with it so as to recapture your audience.

WHAT IS SECOND SCREEN?

This term refers to a media distribution strategy that includes the new consumer behavior of watching two or more screens simultaneously. For example, a person watches television, which could be Internet-connected TV, and surfs the web or uses a laptop, a tablet, or a smartphone to communicate, to look at the series website, to text, tweet, or connect to a social network about what he or she is watching. So the viewers interact amongst themselves, and a random network of potential viewers gets interested. The larger the social network, the greater the potential for interaction (Reed's Law).[33]

The second screen follows and exploits the rapidly increasing consumer behavior of watching multiple screens,[34] which radically alters the way executive producers have to think about how to market, distribute, and create content. Alert and savvy producers started to think differently about traditional ways of distributing content for digital media platforms and figure out how to turn audiences' views and viewing on second screens and their parallel communications about the content to the advantage of the first screen, which is under producers' control. That means driving eyeballs to the first screen by engaging audiences directly and indirectly through crowd input and response through Twitter and other parallel social media channels.

The second screen also requires creating content in more than one digital medium and making it a seamless viewing experience across multiple screens. Instead of writing for discrete channels and media formats, the name of the game becomes to create a concept that can play

Reed's Law

Reed's law is the assertion of David P. Reed that the utility of large networks, particularly social networks, can scale exponentially with the size of the network. This grows the audience exponentially beyond peer groups.

The Internet is a network of networks, and its value lies in the connections it enables. As managers and entrepreneurs try to measure that value, they have paid a great deal of attention to two types of networks. The simplest is the one-to-many—or broadcast—network, through which a central supplier broadcasts information to a large number of users. An example is the Web portal, which delivers news and other content to many visitors. More complex, and more valuable, is the one-to-one—or transactional—network, which connects individual users with other individual users to exchange information or complete other transactions. Common examples are e-mail and instant messaging. But there's a third type of network that, although less understood than the other two, is actually the most valuable of all. It's the many-to-many—or group-forming—network, which allows network members to form and maintain communicating groups. Examples of group-forming networks, or GFNs, include on-line communities, business-to-business exchanges, and buyer cartels. (Reed, Harvard Business Review)

33 David P. Reed, "The Law of the Pack," *Harvard Business Review*, February 2001.

34 Carl Marcucci, "40% of Americans Use Tablets, Smartphones while Watching TV," *RBR.comTVBR.com*, November 13, 2012.

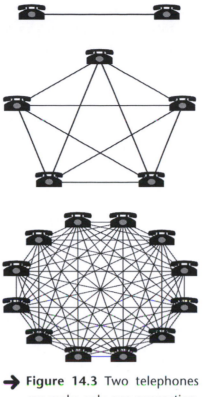

→ **Figure 14.3** Two telephones can make only one connection, five can make 10 connections, and 12 can make 66 connections.

out in multiple formats and can be produced simultaneously for different platforms. This is a mode of production that emerged fairly rapidly in 2011 and 2012. The same narrative can and should ideally spawn second-screen and multichannel variations that enhance and cross-sell between television, website, and mobile app, thus driving audiences, increasing revenue, and extending the life of the content. Bunim-Murray, an independent company in Hollywood, produces games and reality shows for television and mobile media that keep second-screen behavior in mind.

What if you could combine an exciting new experience that will eventually reside on a variety of different platforms? The concept anticipates all the possible platforms on which it could work. It can be sold as TV content with a ready ancillary life as a game on the Facebook page of the channel or as an independent game. An example would be a game *The Controller: Medal of Honor Warfighter*. This is a video game that has an extension in reality to a live action reality competition that can be watched on the second screen.

For writers and producers, the question becomes how can a website extend the main narrative or the way it engages an audience? We won't stop seeing new sitcoms and series that are familiar television programming on the main screen to audiences oblivious of the second-screen experience, but we will see an expansion of content on websites and apps that enhances the main narrative.

ABC was one of the first to experiment with a second-screen experience with the high school mockumentary *My Generation*, back in the fall of 2010. They tried using YouTube to promote and launch it—a pretty simple approach compared to now. The series failed with audiences and was canceled after airing two episodes. Since then entertainment companies are catching up fast, putting a lot of resources, thought, and ingenuity into second-screen concepts. Fast forward two years to the fifth season of

Breaking Bad on AMC. The producers developed an app to install on second-screen devices that would enable the viewers to interact with the series and prompt them with pop-ups of trivia about the scene at key moments, deleted scenes, extended scenes, and different camera angles. In its final season, **Breaking Bad** has a story-synced website that by means of an app plays interactively with the television screen. Actors use social media to interact with the audience. This is full-throated engagement that pays off by maximizing audiences.

Sports broadcasts can offer second-screen dimensions for viewers to see different angles of plays as the show airs. Let's examine an example of second-screen smarts by a traditional network. NBC had an exclusive contract to broadcast the

> ### NBC Olympics and the Second Screen
>
> NBC were fully prepared to lose money in the short term on this long-term contract, that is, not sell enough advertising to pay for the rights; however, they caught onto the second-screen phenomenon by first streaming the whole games 24 hours live on their website, accessible on mobile. They partnered with "with such companies as Facebook, Twitter, Adobe and YouTube . . . (to) . . . provide coverage and social media tools for the delivery of a record 3,500-plus hours of content on digital platforms, (sic) NBC Olympics also announced that it would be working with Google+, Shazam, Instagram, Tumblr and Get-Glue."[35] All this provided audience data, which enabled them to sell real-time advertising around key events in the games. In the end, they broke even or even made some money and were able to promote their fall shows at the same time.[36] They had understood how to produce content in this new ecosystem.

> ### ABC and Second Screen
>
> Another example of real-time media producing, also in 2012, was a dare devil stunt by a tightrope walker to walk across Niagara Falls. Once again, ABC exploited digital social media to grow its audience and learn how to cover the next event—tightrope walking across the Grand Canyon. The television audience grew as the event progressed: "ABC had a 1.2 rating among 18- to 49-year-olds at 8 P.M.; a 1.3 rating at 8:30 P.M.; a 1.7 rating at 9 P.M.; and a 1.8 rating at 9:30 P.M. At 10 P.M., as Mr. Wallenda started his walk, the rating spiked to a 3.1; at 10:30 P.M., it topped out at a 3.4. The walk was a momentary phenomena [sic] on Twitter and Facebook, as viewers watched and chatted about it simultaneously."[37] ABC paid attention to the broadcast data and found out that 353,000 Twitter messages about the high-wire walk were sent between 10 P.M. and 11 P.M. No other special events could compare to it: "The Twitter messages peaked when Mr. Wallenda stepped into Canada, with 14,000 messages a minute."[38]

2012 Olympic Games. Since the Olympics is a kind of reality show in which the outcome of contests is unpredictable and the competition through heats and semi-finals builds up interest and anticipation in American competitors, audiences were exploiting social networks to share excitement, screen shots, and video clips of suspenseful competitive events.

ABC has a free app that it wants all its affiliates to promote to create a TV-everywhere experience for viewers. TV anytime, anywhere, on any device! This is the goal of all media companies—to create a seamless video on-demand experience that will keep audiences tuned in. ABC's Watch app can track what any viewer is watching "giving the networks and its affiliates the ability to sell the mobile and online audiences

35 George Winslow, "NBC Lays Out Final digital Plans for Olympics," *Broadcasting & Cable,* July 24, 2012.

36 Anthony Crupi, "Lazarus: NBC Broke Even on Olympics: Long-term Impact of London Games Yet to Be Determined," *Adweek,* September 6, 2012.

37 Brian Stelter, "Niagara Falls Tightrope Walk Is a Ratings Bonanza for ABC," New York Times, June 16, 2012.

38 Ibid.

to advertisers."[39] This has now evolved into live streaming of its broadcast line-up via its app and its "live" option.[40] The new digital ecosystem has abandoned the exclusive domain of over-the-air broadcasters and tries to reinvent them as a mobile platform experience. Meanwhile, Nielsen brought out a new metric to track online television viewing without which the monetizing of audiences presents a problem.[41] ABC has taken the plunge ahead of the other broadcasters and without the security of audience measurement.

New movie releases present a publicity and promotional challenge to capture interest in a short window of time through social media and search engine optimization (SEO) techniques. Universal had ticket sales of $1.8 billion for the *Fast & Furious* car-racing series. Although there were no computerized special effects like *Transformers,* or rising young stars like *The Hunger Games,* or literary cachet like Harry Potter "what *Fast & Furious* does have . . . is an astounding online following. Its Facebook page had 24.9 million "likes," more than any active film series except *Avatar*. Mr. Diesel (the lead actor) had 39 million Facebook fans; among actors, only Will Smith has more."[42] When movies are released on DVD, which is an important revenue stream, distributors are turning to apps and social media to generate sales. The app adds value to owning a Blu-ray Disc because users can sync their Blu-ray Disc to this app on their iPad, iPhone, or Samsung Galaxy device (including popular S2, S3, Nexus, Note and Tab devices)[43] and can then access a cache of supplementary information tied to the action unfolding on the screen. Users "get everything from maps, gadgets and trivia to photo galleries and behind the scenes featurettes."[44] Fox has announced they will launch a new syndication network that will distribute the network's TV show companion content.[45]

Consultants and nimble independents saw the opportunity to create apps and advance the second-screen technology, which they can sell to the big media companies. Many second-screen apps get audiences to register, which means they capture valuable user data and enable chat with others watching the same program. Knowing what this new fickle second-screen audience is doing is the Holy Grail for marketers because they can analyze consumer behavior within specific networks. In a very short time, the crowd that initiated the second-screen behavior and escaped big media control and ignored the walled garden has been corralled and exploited by smart programmers who figured out how to build a Trojan Horse the crowd let through its network gates. Now apps can mine the data and eavesdrop on the social media conversation. Media companies adding app content can then match compelling messages to audiences, based on what they are communicating about. The click-through can be converted to purchase and new revenue from ads and merchandising. In this way,

> a Second Screen Social Network is born for the broadcaster, advertiser, content provider or production company, and you are provided with a value-added experience that enhances your normal TV viewing. And you don't even have to take the additional step of visiting a website; it's provided in a seamless, effortless experience.[46]

This is the future eloquently stated. It has evolved out of Google's pioneering contextual ads matched to your web browsing. The topicality of second-screen programming and advertising was

39 Harry A. Jessell, "ABC Floats TV Everywhere Plan to Affiliates," *TVNewsCheck*, February 26, 2013.

40 Brian Stelter, "ABC to Live-Stream Its Shows via App," *New York Times,* May 12, 2013.

41 Amol Sharma, "Nielsen Gets Digital to Track Online TV Viewers," *Wall Street Journal*, April 30, 2013.

42 Brooks Barnes, "'Fast & Furious' Stresses Social Side of Fandom," *New York Times,* February 17, 2013.

43 These models will soon be history. This is being written in 2013.

44 "Warner Bros Offer Unparalleled Second Screen Experience with *Dark Knight Rises* App," *www.WorldTVPC.com,* December 2, 2012.

45 See www.forbes.com/sites/roberthof/2013/02/26/fox-gets-serious-about-second-screen-apps/.

46 Russ Stanton, "Second Screen Revolutionizing the Television Experience," 2012. www.tcs.com/.

strongly reflected in the conferences and seminars in the NAB Convention of 2013. Nielsen now has an iPad app that is synced to the main screen content by watermarks on the audio track that through the iPad microphone triggers pop-up ads at precise moments in the show. Not only that, they will now count connected TVs in their ratings. Nielsen plans to measure viewers on iPads and other mobile devices. Media executives have to prove that the ads are being seen for them to charge for access to the audience. They have infiltrated the social networks by stealth and delivered the crowd to producers and publishers of almost any media company. If you can measure the audience, you can sell the audience to advertisers. You have monetized the second screen.[47] Media companies, one; crowd, zero! The media companies win again.

➜ **Figure 14.4** Samsung Tablet.

But wait! This opera ain't over until two fat ladies sing. The next big thing is likely to be an all-out war between arch rivals Apple and Google to decide the nature of app-based television platforms may be based in the cloud. Each company is developing a connected television ecosystem. Several other television manufacturers have also recognized this and formed a consortium (the Smart TV Alliance) to collaborate on a common operating system in the hope of competing with Google and Apple; the alliance does not want to be forced out of the market because of what's coming.[48] In the recent past, Apple and Google have developed iconic and environmental changes in media technology with their commitment to fast networks, enabling app development, exploiting mobile connectivity, setting up virtual store fronts for media content that can be stored in lockers in the cloud, and enabling new consumer behavior. Both companies opened up their cell phone operating systems to third party app developers.

What about the writing? Without understanding the background and context, you will not be able to grasp how the writing will have to change. Samsung launched a competition in 2012 for concepts for second-screen additional television content offered on a smartphone, tablet, computer screen, or Smart TV that enhances the viewer's experience. That should be a heads up for all writers.

47 Brian Stelter, "Nielsen Adjusts Its Ratings to Add Web-Linked TVs," *New York Times,* February 21, 2013.
48 Cornelius Rahn and Jonathan Browning, "TV Makers Join Forces Against Smartphone Giants," *New York Times,* September 5, 2012.

As a manufacturer of connected TV going up against Apple and Google to sell these devices, it is already aware of the significance of this change in the digital media environment.

Samsung's promotional contest required:

- An original short pilot or excerpt scene that is 6 to 10 minutes in length
- One piece of corresponding second-screen content that is a maximum of 2 minutes in length
- One series treatment outlining the show concept and second-screen extension opportunities that is a maximum of four pages in length

We don't know whether this will be just a one-off competition or an annual event; however, it signals something is changing fast in the media ecosystem. It also tells us what we should have suspected that writing is involved. Notice the word *treatment* in the contest's final requirement! You now are well informed about what a treatment has to be. A treatment for the **second-screen** experience has to describe how the material would work on the second screen. Anyone interested in writing and producing for this new digital media world must understand how this world works and modify their conceptualizing for the second screen. This means that the meta-writing has to change. Although this is hot now, how this develops in the next 3–4 years (before a new edition of this book is called for!) is hard to predict. Stay tuned!

We have already noted how sports programming and other real-time events are suited to second-screen audience engagement that amplifies the appeal and multiplies the advertising revenue that is drawn to increased traffic. Reality shows by definition seek to create a formula that by nature of some form of competition or contest engenders suspense, anticipation, and a following. This is ideal content for exploiting second-screen dimensions with website interviews, Twitter followers, and Facebook likes. The writer who develops a reality concept and treatment must sketch out how second-screen quizzes, games, bios, and interactive engagement with participants will work. Writers might have to understand how to exploit the numerous apps and new niche social media. No doubt Internet start-ups and app developers are working on "the next big thing" as we write.

"SNACKABLE" CONTENT

The term *"snackable" media* denotes dispensable, instantly gratifying media content that is not just scaled down but maybe different in style and flavor. Technical quality and the size of the image may be less important than the program content and the fact that it is controllable and on demand. Most mobile phone users whip out their phone when they have downtime or nothing special to do, or even while they are otherwise occupied (for instance, sitting in classrooms or watching television, not to mention while in the company of friends all scrutinizing their devices).

Information netcasting or mobile information content and even documentary are part of the mix. *Imaginings,* sponsored by Lexus through Saatchi and Saatchi, exploits the high-definition **slow-motion** action shot at 1,000 frames per second. It is a gallery of the poetry of motion to be found in the movement of athletes and animals. It reminds one of the early silent movie days of the muto-scope and the kinetoscope, which offered short clips without storylines to be viewed for sensation. You watch the clips of *Imaginings* for pure visual sensation and, in this age, for its hi-tech multicam montage of extreme image capture. This kind of content and the rest of the documentary coverage of music, news, and other events do not need narrative scripting.

It would be a mistake to limit our ideas of mobile content to second-screen content for main stream films or television. Other ideas for stand-alone mobile content already exist similar to certain

kinds of website content: extraordinary images, themed slide shows of animals or celebrities, ultra-slow-motion cinematography to capture phenomena the human eye cannot see. Watch a base-ball pitcher in ultra slow motion! Or see plants grow in speeded-up motion shot in **time-lapse cinematography**! Although these ideas are visual, they do not rely heavily on scripting, more on a visual concept and then research and editing. This kind of "snackable" media content, an outgrowth of website portals, is short, unique, and captivating.

WHAT DOES ALL THIS MEAN FOR WRITERS?

No rest for the wicked! No resting on your laurels, either the ones you've got or the one you hoped to get! Armed with all this knowledge about digital platforms and crowd-driven responses to media content, an executive producer and writer are compelled to think about narrative content with second-screen engagement at the preproduction stage of a project. They will have to engage the audience in the second-screen ecosystem alongside the primary concept to include such things as back story, celebrity actor participation, games, contests, quizzes, prizes, and apps. The writer putting this together could be the original scriptwriter, or a second specialized writer could be assigned to come up with concept and treatment of the second-screen experience. Television writing is often written by a team of writers, so it is not hard to imagine that the writing will be divided in the same way that writing episodes and scenes for series are parceled out among several writers. Rather than think in linear episodic narratives, writers and producers now must come up with ideas that can be exploited across multiple media and offer potential interactive derivatives. Could the character you invent in a world with a conflict or a problem have a second life as character in a game or second-screen subplot? What starts as a game might become a series and vice versa. The once-familiar media landscape has turned into the Wild West.

CONCLUSION

In the recent past, the business model for most entertainment media was what has come to be called *the walled garden*. The entrance to this world of entertainment was controlled by the owners of intellectual property (IP) and creators of the entertainment content or product, whether it was a circus, a play, a movie, or a video. You had to buy a ticket, pay a subscription (and still do), or watch advertising before, during, and after the program. Owning this intellectual property and selling rights to view it, read it, or own copies of it were the cash cow of legacy media companies. New technologies enabled consumer behavior that by-passed the walled garden, thus upending the business model. With access to the World Wide Web and platforms like YouTube, creators of content can by-pass gatekeeper distributors and reach audiences directly. New audiences with a preference for mobile platforms took the traditional control of media away from companies. New digital viewing habits for free, on-demand video, anytime, anywhere, on any screen left the legacy media companies in the dust, slow to react and recognize what was happening. The crowd took control, at least partially, of how content was to be viewed, used, and distributed. Now we have a volatile, rapidly evolving ecosystem of digital media platforms.

New streams of video content can be delivered to mobile devices in a number of ways. Although a dominant technology of transmission and reception has not emerged, the arrow points to growth and development of smartphones and mobile operating systems that allow more sophisticated entertainment options. As more eyeballs turn to mobile devices, carriers, broadcasters, and content providers search for the business model that will monetize the potential by means of ever-more sophisticated apps. Many consider this to be a new digital media marketplace, even a new media industry even though it is in part an offshoot of existing media. You could argue that the portable wireless platform

and its adoption as a personal mobile entertainment device is a kind of genetic mutation of media into a new species. There are signs that although recognizable brand entertainment of movies and TV shows are the bait to attract early adopters, a mass audience will follow.

We can identify a number of innovative forms of program content that are specific to the medium and beg the question of how you invent narrative and write scripts specifically for mobile media production incorporating second-screen engagement. Although a limited amount of original work is produced for mobile and Internet formats, talent agencies and producers are waking up to the potential of this content and the discovery of new voices.[49] Once again, where there is demand for content, there has to be demand for writers who know how to create that second-screen content surrounding the stories. Historical parallels and antecedents support the likelihood that content will evolve to fit the new digital platforms, exploit the viewing behavior of the audiences, and fulfill the new potential of a mobile viewing experience with experimental formats. New formats and new narrative styles are evolving to meet the unique viewing habits of a generation brought up on a new kind web and mobile media experience. It is all happening as this chapter is being revised.

EXERCISES

1. Look on your cell phone for content that is original video, not retransmitted content from another medium.
2. Write a story premise for drama or comedy that can be told in 2- to 3-minute minisodes.
3. Based on review of Chapter 8 dramatic theory, write a premise for a series for a mobile platform that will break down into 2- to 3-minute episodes and write a scene outline.
4. Write a 1-minute video strip.
5. Storyboard an extreme moment in sports or wildlife for a cell phone video interval.
6. Writer a short treatment for second-screen content to engage the audience of a series or sitcom you know.
7. Invent a new story to exploit the second-screen phenomenon.
8. Working from a series or TV show you know, devise a second-screen extension to include games, quizzes, social media, and a possible app.
9. Invent a concept for a reality show that incorporates rich second-screen content.
10. Can you devise a storyline that could be developed as a series narrative and/or have separate life as a game?

49 iHollyfoodforum.com at a Mobile Entertainment Summit in March 2009 has interviews with two major agency department heads who are specifically targeting mobile- and web-based authors and content.

PART 5

Anticipating Professional Issues

Writers hope that there will be an audience for what they write and that they can get paid for their writing. To come full circle, we should remember the opening chapter of the book in which we made the point that scripts are blueprints (i.e., instructions to a production team) and that audiences don't generally read scripts. Although writing may begin as a purely creative act, at some point questions arise: What is the value of this writing? If writing is a professional skill, then how much is it worth? What is someone paying you for? What are your obligations? Can you support yourself by writing for one or other of the visual media?

The answers to these questions can vary according to the market sector in which you choose to practice your craft. Broadly speaking, the writing market divides between the entertainment world, the nonprofit world, and the corporate world. The first is perhaps more glamorous, more competitive, and more highly paid but is also a great deal riskier than the second and third, which are less familiar to most would-be writers. In any of these worlds, the overwhelming majority of writing jobs are freelance.

Whatever you create, you want to sell. First, you have to write something for which there is a buyer and an audience. Then you have to understand the nature of the transaction. The essential transaction between a writer and any media enterprise involves a transfer of ownership or an assignment of copyright. This transfer is governed by the law of the country in which the contract is made and by the Berne Convention for the Protection of Literary and Artistic Works of 1886, to which 196 countries are signatory.

You Can Get Paid to Do This

Key Terms

agents	logline	public domain
clear title	pari passu	service for hire
common law	percentage of the gross	statute
concept	per minute of finished program	treatment
copyright		work-made-for-hire
first-draft screenplay	piecework	Writers Guild of America
flat fee	pitch/pitching	Writers' Guild of Great Britain
indemnity	premise	
intellectual property	producer's net	

WRITING FOR MONEY

The process of script development is a critical activity on which all projects depend. Therefore, the writer is indispensable, yet not always valued—at least in the entertainment world. Sam Goldwyn, in one of his classic aphorisms, is reported to have called scriptwriters "schmucks with Underwoods." An Underwood, for those who have no cultural memory of this technology, was a make of manual typewriter. So now, you can think of yourself as a schmuck with a laptop.

Most studios and independent producers have readers who read all submissions and write a report that often determines the fate of the particular script. This hidden process causes much heartache and frustration and maybe prevents quite a few brilliant but idiosyncratic scripts from being produced. There is no way of knowing how effective or systematic the selection process is.

Every time you see a bad movie, you wonder how it got into production. Although people make mistakes in judgment, we like to assume that overall the best scripts eventually rise to the top. Skepticism is permitted, however. It makes sense to say that no one intends to make a bad film although trying to make a film by following a formula just to make money is probably the principal reason they get made. Sequels and prequels that are made to exploit a franchise often make money with an inferior product. Also, many producers make low-budget product for the DVD market that never gets a theatrical release. Another reason could be that studios, producers, and writers are trying to reproduce a formula for success based on past successes. However, many successes, even Academy Award winners, break that mold and are probably successful precisely because they are not like some

movie you've seen before. Once you grasp the familiar premise of certain Hollywood movies, the outcome is predictable even though it is disguised in different colors than the last one.

For the studios, commissioning scripts is like sowing seeds. Some will germinate. Others will not. Yet others that become fully developed scripts might be bought and paid for and never get into production. Although the industry constantly changes, Robert Altman's brilliant film of an original screenplay *The Player* (1992) gives you an idea of what life as a writer in Hollywood might be like, even though it is edged with satire and more in-jokes about the industry than most of the audience would understand. In the movie, a studio executive makes an interesting statement that goes something like, "My studio accepts a thousand submissions a year and puts twelve of them into production." There are no formal statistics to support this, but it seems like a good point of departure. Multiply that by several studios and independent producers, and you can estimate the number of received screenplay submissions in any given year. Let's say 10,000 as a round number. In 2012, an estimated 400–500 films were produced in the United States for all categories of release—theatrical, DVD, and television. Again a rough estimate might be 1 in 20 scripts bought or optioned gets made, never mind the thousands written and offered. That's a lot of competition. Of those, many are bought or optioned, but few are ever actually produced So income from writing, as I know from personal experience, does not necessarily lead to screen credits.

Script development is the cheapest part of the process of movie production. The name of the game is to get money behind a project at the earliest stage possible, namely, the writing stage. Writers, producers, and directors often have to develop scripts to the treatment stage or even first-draft screenplay before seeking financial backing. To have a multiple-picture development deal is the most desirable situation. Only successful producers and directors get this kind of speculative backing. Financial investors, studios, and producers make decisions about large investments based, in part, on casting and behind the camera talent as well as on scripts.

PITCHING

So you want to write a screenplay. The writing is hard, the revision harder, and selling it hardest of all. Distributors need product. Studios need scripts and story ideas to stay in business. A movie idea begins as something relatively simple—a story premise—which is often presented in meetings to agents, producers, and other principals in a process known as *pitching*. Although we have discussed pitching in other contexts, it is useful to revisit the issue now. In the entertainment business, a writer must be able to talk about movie concepts as well as write them. *The Player* (1992), mentioned above, an original screenplay written and produced by Michael Tolkine, provides excellent insight into the art of pitching.

Most writers and their agents want to bypass the readers and get straight to the main decision makers higher up the food chain who listen to pitches. Sometimes development deals are made on the basis of meetings at which creative people, such as writers, producers, and directors, or their agents, talk about their ideas to a production executive. Pitching is a brief oral delivery of a summary or key concept of a movie. If the idea is strong, it is seen as a firm anchor for the ensuing work. A writer should be able to pitch, but it is a skill that does not always accompany writing talent. There is an element of salesmanship. You have to carry conviction in your manner, in your voice, and in your language. The pitch has to go beyond the reason why you want to write or do the project. It has to give reasons why someone else should want to get involved. It has to indicate how you see the project and how it will work for an audience. It has to do this in language that makes sense to the executive making the decision to commit funds to your project over all of the other projects vying for the same

resources. As we have noted, there is no shortage of scripts and projects, only good scripts and good projects. However, when one comes along that appeals strongly to producers, writers or, more usually, their agents can generate bidding wars for a desirable property.

LOGLINE

A *logline* is another key term in the pitching process. It either begins or ends the pitch, or both, like bookends. It could be understood as a distillation of the pitch—the pitch boiled down to a single idea that, as we discussed in Chapter 8, contains the premise of the plot or story by implication. You could think of it as a dehydrated pitch, which, if you add water and heat, will expand into the longer pitch and beyond that into the movie itself. It has its origin in the old days when studio readers would put a logline on the spine of a script so as to be able to pull it out of a pile when looking for a certain type of story. Later, the old TV guide used a kind of logline to identify what a movie on television was about. As we learned in Chapter 8, it has a relationship to a tag line—a slogan or promotional sentence or phrase that piques interests in a finished movie now in distribution.

According to common wisdom, a logline has to identify the main character, that character's problem, and what stands in the way of solving it. It must also identify something that is unique in that premise. It's tough, isn't it? Many argue that you should have the logline before you write. If you cannot nail this logline, the argument goes, you do not really know what your story is about and therefore you will not be able to write the screenplay successfully. As with all rules, there are probably plenty of exceptions. Did Shakespeare write a logline before writing *Romeo and Juliet*, which has one of the most successful premises of tragic love stories that has been adopted and reinvented many times? Then there are the fairy tales and folk tales which got filtered and honed into shape by generations of retelling. This could be an argument for writing a log line. First, you are not a genius. Second, you don't have time to prove your story across countless generations of narrators and their audiences.

In Chapter 8, we used *Little Red Riding Hood* to examine story structure. What is the logline for the story? If you put down the essentials of the plot as briefly as you can and then edit them, the process might go something like this.

- A small girl has to deliver food to her sick grandma on the other side of a forest before dark.
- A wolf stalks her and beats her to her grandma's.
- The wolf eats the grandma and waits for the girl.
- They are rescued by a woodcutter.

That's a start, but it's too long. We don't need the details about sickness, food, and where grandma is. We could condense this to:

A girl stalked by a wolf has to get to her grandma first before dark.

Or

Who will cross the forest and get to grandma first, a hungry wolf or Little Red Riding Hood?

These examples set up suspense; identify the main character, the objective, and the antagonist; and communicate the setting, the task, and the menacing outcome. Try another version!

Can Little Red Riding Hood find her way across the forest to grandma's before a hungry wolf?

In one way, it doesn't matter who gets there first; the wolf will still get them both. We need the Woodcutter and the happy ending. After a devastating setback, the Woodcutter is also the solution to the problem. This is a challenge.

Little Red Riding Hood must find her way through the forest to her grandma's before a cunning, hungry wolf—who will save her?

I'll have to quit there and let someone else go one better. Now we have the logline, the basis of a pitch for this story. The pitch can put in a little more detail and color to help visualize the film.

We've got a ten-year-old girl. Her mother sends her with a basket of provisions to cross a dangerous forest to grandma's cottage. She is stalked by a wolf, who gets there first, eats her grandma, and disguises himself in her clothes to wait. Who will save her?

It's a start. You try it out on your wife, your agent, or your fellow scriptwriters. If it doesn't work, use feedback to revise. Remember that there are no second chances in pitching an idea (except with another producer or another studio), so work hard to get your pitch just right so that you can deliver it with conviction .

Pitching must be an efficient way to process proposals; otherwise, why would major studios and distributors keep doing it? On the face of it, it seems incredible that a meeting conducted orally could lead to such high-budget commitments, but it is a well understood practice in the industry. Many executives who make decisions about development don't read. They don't have the time, ability, or inclination. If they do, it is said that most will read up to 10 pages and if they are not hooked by then will toss the script aside. It imposes a pressure on screenwriters to set up a dramatic conflict or problem very early that will hook the reader and the audience. Certain kinds of film stories lend themselves to this, but not all. A beautiful first film directed by Dustin Hoffman, *The Quartet* (2012), would probably have failed that test; yet, it was one of the finest films of the year (a personal opinion and a matter of taste), ignored in industry awards.

I learned about pitching the hard way. I was commissioned to write a movie script for American International Pictures. I was working in London at the time with an executive in the London office. The day came when Samuel Arkoff, president of the company, came to town to decide what to do about this sequel, which the company had commissioned from me, to their remake of *Wuthering Heights* (1970). He checked into a suite at the Savoy. A meeting was scheduled in his suite at the hotel with me and the London executive producer. Sam Arkoff was in his bathrobe and slippers. He ordered a sumptuous lunch of oysters, smoked salmon, and château bottled French wine delivered to the room. Then the moment came. He asked me what the movie was about. I was stunned. I assumed that if the company had paid me to write the script (it had been sent to the Hollywood office), he would have read it. He hadn't read it.[1]

He wanted the premise expressed in a way that would convince him to make this film. He wanted a pitch, which would not tell the whole story but provide a compelling and concise statement of who the lead character is, what his problem is, and how he is going to solve it. This had to be expressed in a few apt and eloquent sentences. He wanted to know what the approach was. What was the driving

1 Correspondence included on the website shows that he had read the treatment.

idea that would hold audiences and give him the conviction to put money into producing the movie? I made a mess of it. I got bogged down in too much detail. In retrospect, I realized later I was being paid to pitch. To get my movie into production, I had to pitch to save the project and the London executive. I earned the scriptwriting fee, but the movie was never made and the London executive was let go and the office shut down as the industry hit a crisis of rising debt and falling box office.

In the end, this is a commercial business. Hollywood is in business to make money. Of course, nobody knows for sure what makes money. There are tried-and-true formulas that keep resurfacing. You put money into a movie just like another one that made money or that is going to make money. The copycat syndrome is evident in every season's releases. Another way to try and minimize risk is to build a project around proven box office elements, such as a bestselling novel (think Harry Potter), a successful play or musical. Another ingredient is to cast from a so-called A list of actors and actresses whose movies have nearly always made money. Of course, their agents know this and push for the highest fee and participation they can. So movies get more expensive. If a project starts to become a package with a famous director, star actors, and so on, it usually affects the script both before and after it is written. William Goldman's book is the best document from a writer's point of view of how and why this happens.[2]

Big-time pitching is not a real possibility at the beginning of a writer's career. There are pitching fests to which agents and producers come to pick over ideas, because without a script or an idea for a script, nothing can be produced. There are two essential facts to keep in mind; in the beginning the deal makers are dependent on writers and storytellers; no one can predict where the next good idea for a movie will come from. That keeps everyone in a constant state of suspense, ignorance, and anxiety about missing out on the next big hit. This gives a tiny advantage to the writer for a short window of opportunity. Of course, whenever studios and producers can shorten the odds of success by buying known talent or stories that have proven themselves in another medium, they will. Still there is no guarantee, hence the long odds for the beginning writer to get a hearing. However, there are **online markets and competitions** that give a new writer access to producers and production companies looking for stories and scripts. A number of websites call for scripts usually in the form of loglines that are circulated to producers looking for production ideas, or producers communicate to the intermediary what they are looking for. Their demands are usually fairly specific in terms of genre, budget, and what they want to see—logline, treatment, or screenplay. The site then facilitates the connection between the two parties. There are also writing contests which give access to the industry for the winner and runners-up.

Included in some of these exchanges are independent producers although, frequently, independents are directors and writers who co-produce or are involved in setting up the film. There is an amazingly vigorous independent movie sector of low-budget, interesting movies. These movies are made outside the mainstream studio system. There are money finders who work on putting finance deals together for low-budget independent productions like *The Blair Witch Project* (1999) that might make it into release. *Slumdog Millionaire* (2008) was a low-budget independent film that won eight Academy awards, including best picture. There are a lot of hungry, ambitious people. You have to become one of them. You have to learn the business. Pitching at this level means finding like-minded people and persuading them that your idea or your script is worth spending time and effort on to move forward. In every generation, new talent arises and old talent retires. Each generation produces a new audience that craves to see its realities reflected in movie and television stories and images. Life is a pitch, as someone once said.

2 William Goldman, *Adventures in the Screen Trade* (New York: Warner Books, 1983). See a more recent article in Salon.com about the frustrations of writing in Hollywood and the mystery of its workings: www.salon.com/2013/04/22/tk_5_partner_13_partner/?goback = %2Egde_2718442_member_234678922.

AGENTS AND SUBMISSIONS

Agents have become indispensable in the entertainment business for selling ideas and scripts. To get a start in the entertainment side of the business, you need an agent who can represent you and in turn sell your work to producers and studios. You understand now why producers and studios are extremely prudent about where their material originates. Unsolicited manuscripts and scripts are usually rejected out of hand because of negative past experiences of lawsuits and claims by people who submitted work, had it rejected, and then saw a movie that contained what they saw as their idea. By dealing with agents, intellectual property lawyers, and professional intermediaries, studios are protected from frivolous lawsuits and are ensured they are acquiring bona fide intellectual property rights.

Getting an agent to represent you as a writer in the entertainment world is almost as difficult as getting a producer to read your treatment or screenplay. You have to persuade the agent that you have talent that can be nurtured and that your work has commercial potential. Why? Because agents make a living from a percentage of the negotiated price for the option or the commission to write a screenplay or the sale of a screenplay. It is at least 10 percent of the deal and any residual income that flows from it; sometimes it can be more, up to 20 percent. Agents don't earn any commission until they sell your work. Obviously, they have to be convinced that their work of representing your work and your talent will bear fruit. There are a lot of agents competing with one another. They have to get the attention of a director or a producer or a studio. Although they have an advantage over you because they have contacts and some kind of professional record that will often give them an entrée and a hearing, they still have to pitch the concept and sell the potential of an unmade film.

Relationships with agents can be crucial. A relationship with an agent can be deceptive. Sometimes you can make assumptions about how well you are being represented that are unfounded and lull you into complacency because you think that someone is spending night and day selling your work while you, the busy genius, just write away. There has to be mutual trust and understanding. Realistic expectations on both sides are critical. This is a business relationship that is very important and a difficult one to make work well, and as with all businesses, you need to understand the rules, customs, and practices that pertain to that business. Getting an agent means not only having compelling writing to show, but also good communication. Some agents have a full list of talent to represent and will not consider new clients. The first task is to find agents who are open to representing new clients. A letter of enquiry should be sent before submitting any work. An introduction from one of their existing clients can often pique their interest.

A good place to start is the Writers Guild website, which lists agents by state, classified according to their business orientation.[3] The list identifies agents willing to read unsolicited manuscripts and those who won't. A number of agents or script advisors will read and critique your work for a fee. Some of them may be legitimate and give value for money. Some advertise merely to make money from the endless stream of "wannabes" who dream of success. The best advice would be to get a reference or a recommendation from someone you know. Even better, make use of your writing classes. Your writing instructor is a sounding board and is duty-bound to read your work and give you feedback. Any course you take, therefore, provides a structured way to test your writing talent. You will get a clue as to whether it is worth the struggle to go forward and commit the time, energy, and ambition necessary to succeed professionally.

Getting an agent to represent you is half the battle. If you have an agent, the agent will negotiate the remuneration and the details of the contract that affect your delivery schedule and responsibilities.

3 See www.writersguild.org.

In the entertainment world, a number of trade union agreements are in force. The Writers Guild of America (East and West) and the Writers' Guild of Great Britain, which have reciprocal agreements, have contract models and minimum payment scales for film, television, and radio. The Writers Guild of America recently worked out a contract for the newest field of writing—the Internet. Many readers might remember the writers' strike of 2008, which stopped all production for many months because the producers would not meet writers' terms. Eventually, movies and television ran out of scripts already commissioned and under contract. With nothing in the pipeline, they had to come to the table and negotiate, which underlines the point that without a script there is no movie, no TV series, and no content. The writers' guilds in different countries are strongest in the film and television industry.

Guild contracts are mandatory for all as are those negotiated by the craft unions for production crew even though some writing and production occurs below minimums. The contracts set lower rates for low-budget and independent films. A signatory studio or producer may not pay less than the minimums set by the unions. You and they are governed by these agreements even if you are not a guild member because the industry producers are signatories to these agreements. Under certain conditions payment can be exchanged for a participation in the revenue from the film, which of course entails a risk. Writers and directors routinely negotiate a participation in the film as well as payment for their immediate work. Flexible combinations in which pay is either deferred or given up in exchange for participation in profits can help a producer and be good deal for all. Deferred pay is usually paid out of first receipts whereas profit participation comes after the cost of production, distribution, and interest are paid off, and is contingent on revenue and may mean nothing further is paid.

Writing for money means someone is paying you to think creatively and represent that thinking in coherent form on the page. In the entertainment world, this process is well understood in its three stages that we have explained in the preceding chapters. It begins with a concept that expresses the premise and outlines the theme or story idea. This may be what starts the project after pitching. A lot of discussion with producers, directors, and possibly actors who are part of the project precedes the treatment.

Rates for Writing Screenplays

As of 2014, the Writers Guild of America minimum for an original screenplay was $124,190 for films with budgets over $5 million and $66,151 for films budgeted between $1.2 and $5 million, and slightly less for adapted screenplays.[4] Successful writers with a track record of box office successes earn 10 to 20 times the minimum. A sought-after writer can sell a screenplay for $1 million and up. Some writers are able to negotiate a profit participation position in the producer's net. Major actors and other talent can negotiate a percentage of the gross, that is, the total revenue collected by the distributor. This is the most desirable position because it is the most transparent and hardest to disguise by creative accounting. The most likely profit participation that a writer can expect is a percentage of the net, the money that the distributor pays to the producer after its commission and expenses are deducted off the top. Whatever revenue comes in after that goes first to the cash investors until their production investment is paid off with interest. If the movie makes a profit, the money is split pari passu (a legal term meaning "proportionately to each at each step") according to the original deal, with a percentage split between investors and the producer. The producer's share is known as the *producer's net*. If actors, writers, or other creative people have given up money payment up front for a percentage, they get a percentage of this net revenue coming to the producer. Many movies make money but never make a profit, in which case there is no producer's net (5 percent of zero is zero).

4 See www.wga.org/content/default.aspx?id=1027.

The treatment is described in the contract and involves a partial payment of the total fee. A producer is usually entitled to pay for the treatment and then withdraw, depending on how the contract was negotiated. After the treatment has been read, a great deal of discussion ensues that allows the producer to respond and ask for changes to the storyline and the vision expressed. Apart from the fact that money is changing hands, there is a strong need to look at story and character issues before committing further time and money to create the screenplay or script.

The first-draft screenplay is the next stage of the contract that involves a delivery date and a payment schedule. This stage involves the most substantial investment of time and money. Most contracts provide for one revision after reading and discussion. After this, the contract is complete. When payment is made in full, the writer no longer owns the work. Copyright created by the writer is assigned to the producer or studio paying the writer. The writer creates intellectual property and then sells it for an agreed sum. The writer then has no more rights other than those expressed in the terms of the contract. The producer might pay another writer to rewrite, or an actor or director might want his or her chosen writer to rework and revise the script. The producer then has to raise finance for the production, complete a production deal, and make the script into film or television programming that can be sold. More than one writer often works on a script. I have rewritten scripts and, in turn, my scripts have been rewritten by someone else. This is less common in the corporate world. However, I had to rewrite a corporate video made by for Shell that had been rejected by the client within the Shell group. Television scripts go through many rewrites by teams of writers.

WRITING FOR TELEVISION

We have drawn a distinction between television writing and writing for the movies. The formats are different; the audiences are different; the industries are different. The broadcast industry originates, buys, and finances content differently. Network television is served by a tribe of independent producers who develop and pitch series, sitcoms, and other content to program executives who have to think in terms of schedules, time slots, competition with other network programming broadcasting at the same time, and selling advertising around the content. This is how they make money. The value of their advertising slots is based on Nielsen ratings that measure audience share. The producers and writers are the creative engines behind the programming. Whatever they produce costs more than the television network pays for the program. Hopefully, the producers make good on their investment with revenue from reruns on local television, on cable, in syndication, and from the sale of broadcast rights to foreign territories. Further revenue can come from series and sitcoms distributed on box set Blu-ray Discs or DVDs if the program is successful.

The networks first step after greenlighting a show is to commission a pilot. If they deem that to be promising, they will commission thirteen episodes. The producer gets a contract to produce a first season. As many know, networks can ruthlessly cancel a sitcom or a series before its first season is finished if the ratings do not please the networks. To sell an idea, a producer needs a writer to create a series bible, which includes a description of the characters, their world, and their back stories. If the series goes into production and has more than one season, the bible grows with the series. Then the writer has to script at least one, more likely two, complete episodes and substantial outlines for eleven more. All this is dependent on a strong premise and interesting characters that allows for unpredictable numbers of episodes to come. Some successful series go on for years. The episode storylines were not even imagined at the beginning. Characters may be eliminated or introduced. The writers will change because the original writer will probably burn out or be unable to handle the pace of writing and production. Freelance writers are usually commissioned to write additional episodes after a

season or two. Not only that, an episode written by the head writer may be assigned to members of a team of writers who rewrite and polish scenes as production proceeds. A successful series or sitcom has to be a production line with episodes being scripted, at least one shooting, and others in postproduction. The pace is intense.

So there is a kind of apprenticeship process going on. Dialogue writers, scene polishers, episode writers are ranked by importance, responsibility, and remuneration. Each episode has a trailer for the next episode, which has to be written after the initial script is delivered because too much can change between scripting and the finally produced episode. Some series which tell a continuous story also have intros which recapitulate what happened in the prior episode for the benefit of viewers who missed it or are tuning in for the first time. It is probably easier to get into television writing than writing and selling a screenplay. The two centers where production takes place are New York and Los Angeles. It would be difficult to imagine breaking in unless you were resident in one of these cities.

A major difference between writing for movies and television is the **beat sheet**. Since the television hour is divided into four for commercial breaks, the script has to be structured to fit into an exact time frame. The episode has to stop for commercial breaks. Therefore the story has to reach a certain point before the break. The audience must be left with a strong reason to return to the story and not switch to another channel. Constructing the narrative in beats (see Chapter 10) is easier to manage. In effect, the pacing and development of the plot has to break down into four acts. Learning to work within this structure is particular to television writing.

Television needs writers. Writers need television. The classic way for a new writer to break in is to write a spec script for an existing series. Each series tends to develop a format that has idiosyncrasies that the writer must learn. Doing so shows knowledge and professionalism. Scriptwriting software like Movie Magic Screenwriter has dozens of templates for the best-known television series. It wouldn't be hard to get an old script from the production company or another source. Clearly, you would have to know the show inside out. You would have to understand how the characters speak and behave, and you have to preserve some kind of consistency while inventing new storylines. Most episodes have bit characters who appear once or twice for the sake of the story. In Chapter 14, we examined the new second-screen dimension of television, which requires ancillary writing. Treatments for website extensions of the series, games, social media content, and more require writers.

Television devours content. As usual, there is competition from plenty of ambitious writers who want to get a start in television. If you know a television writer, that can be a channel of introduction. Other writing credits in theater, documentary, and even some corporate writing might bolster your chances. Documentary is yet another part of television and cable programming with its own disciplines. We noted before that documentary writers are usually also the director except for voice-over commentary.

PRODUCING AND WRITING VIDEO GAMES

Unless you understand the structure and the business model of the industry you want to write for, you will be unlikely to sell anything you write. Game developers are like producers in other entertainment media. The term *producer* can have two meanings in movies, music, television, and video games. Producers can be companies that might employ individuals who produce the content, that is, put together the idea, the talent, and manage the process. Producers can also be individuals who function independently as entrepreneurs in the entertainment world. In the music industry they acquire and distribute music, which individual independent producers package song, arrangement, band or

musicians, recording studio, and other elements such as DVD graphics and publicity. They build into the budget a producer's fee and collect a negotiated royalty.

In the movies, studios produce and distribute movies that are packaged by individual producers who likewise built a producer fee into the budget and participate in any profits. Television is slightly different in that the producer assumes risk that the network buyer does not. Video games have a similar production structure. The console manufacturers such as Microsoft's Xbox, Sony's PlayStation, and Nintendo have produced some of their own games, especially in the early days with in-house developers. They are sometimes referred to as first-party developers, but ultimately they cannot collect enough talent under one roof to create really competitive games. Nor can they ultimately carry the overhead to be competitive in both. Their core business is hardware and its operating system. Hardware and software (meaning what you play on the hardware) tend to be separate businesses (e.g., Microsoft does not manufacture computers). Movie studios do not make Blu-ray players, except Sony; it bought Columbia Pictures to own the software or content. This is known as *vertical integration*. Sony also makes a game console and produces games for it; however, just like Hollywood, the video game industry needs creative production houses and independent producers to create content to sell to developers.

Video game companies like Electronic Arts, UbiSoft, and Sega have budgets that approach and sometimes even exceed those of some feature films. They are second-party developers because their games depend on adoption by console manufacturers. Sometimes, the game release is exclusive to one console, like Ratchet and Plank, Halo, and Little Big Planet. A television producer cannot sell a series to two networks, but you don't need to buy separate television sets to watch each channel. Others, such as Call of Duty, Grand Theft Auto, Minecraft, and Madden NFL, negotiate a release across platforms. Multiplayer online games like World of Warcraft, Team Fortress II, and League of Legends, are on the PC platform. You install the game from a website and play on your PC connected to other PCs, which is accessible to any independent developer as long as you have the resources to run the server. There are also single-player games that can be installed on a PC.

Individual entrepreneurial producers, long on creativity and short on resources, who have a variety of game design talents, bring ideas forward to get financed and create games for the publishers who are third-party developers who depend on first-party developers and second-party developers or publishers to finance production. Remember how a television producer has no outlet for his production without the networks or cable channels to distribute the product. Although some product is distributed on the web or on YouTube, the big money is still via networks and cable.

Smartphones are now an important platform for single player games downloadable from an app store. Some are free like Angry Birds; others are for sale. This is a huge market for independent producers who can easily get access to the Android and Apple app stores. It is free, but they share the revenue from games that are sold.

Writers invent games and try to sell them to all levels of developer. Developers need writers to execute several writing functions during the development process. Who controls how the game is played? Although a writer might devise a game concept and treatment, as we observed in Chapter 13, the programmer ultimately determines how the interactivity works or the manner of play somewhat like a director and editor combined. Designers control the look and feel of the game. Different games bear the stamp of each of these creators in varying degrees depending on the interplay of personalities and how a production company functions. Animation, graphics, and programming all influence the outcome as much as the scripted concept. As a game is developed, more writing might be needed for different elements of the game such as dialogue, cut scenes, or story from different writers. Producers and developers need writers who understand interactivity and who have some sense of programming. A writer has a much less clearly defined role than in movies or television. Getting writing

commissions as well as selling game ideas is just as difficult as in the other entertainment media industries. The shape and form of video game writing is illustrated in Chapter 13, and examples are to be found in the Appendix. Writers of video games are increasingly recognized as authors and as belonging to a craft section in the writer's guilds and for awards in academies.

IDEOLOGY, MORALITY, AND CONTENT

Broadly speaking, the entertainment industry is an uneasy alliance between true storytelling, artistic talent, the box office, and the bottom line. No one will back a movie or television project without the belief that there is a large audience for the finished program. And why should they? Hollywood producers and distributors speak of movies as "product." *Produce* is the key verb of the industry. Product is the result of production. Product is what generates revenue that allows a company to survive, grow, and pay dividends. More particularly, it allows a producer to stay in business and produce again. To a considerable extent, the same rationale governs the work of writers and directors. If your movies don't make money—that is, don't attract an audience large enough to generate a return of at least the cost of production and distribution—your talent will be viewed with suspicion.

The uneasy alliance between art and commerce makes for a permanent tension and a continuing debate. It would be difficult to believe that there is a single writer who is not touched by this conflict. Remember, it is called the film *industry*! The extreme of the Hollywood industrial view is epitomized by the classic bon mot of Samuel Goldwyn, "If you've got a message, take it to Western Union." MGM's movies were about entertainment, pleasing the public, and supplying it with whatever sensations would make the most money. Movie distributors are often contemptuous of so-called art house and independent movies because they are hard to sell and have smaller audiences and, therefore, less return for the same effort. The predominant mentality seems to be the hunt for the biggest box office rather than the smaller budget films that bring a proportionate return from smaller audiences. Again, in the words of Sam Goldwyn about one of his films, "I don't care if this movie doesn't make a nickel. I just want every man, woman, and child in America to see it."

If you survey the movies you know and those that are celebrated successes, you could very well argue that large audiences do in fact thrive on messages. Some of these messages can be paraphrased:

- Good ultimately triumphs over evil (Westerns, police thrillers, most films).
- Life is basically good and worth living (*It's a Wonderful Life, The Silver Linings Playbook*).
- Sacrifice for a cause such as your country is noble; think of the old Roman dictum *dulce et decorum est pro patria mori,* meaning "It is sweet and proper to die for your country" (most war films).
- Love conquers all (most romantic comedies).
- True love is happiness, or happiness is true love (most love stories).
- Action trumps intellect (most action films celebrate the man of action, not the man of rational thought).
- Revenge is sweet (killing an enemy who has done someone wrong is his right).
- The underdog can win (*Rocky* [1976] and a whole host of films about reversal of fortune).

In Ecclesiastes, we read that "the race is not to the swift, nor the battle to the strong," but if you are a betting man, as Damon Runyon said, or a movie producer, that's what you put your money on—strong or proven success. To put it simply, most popular movies are stuffed with messages about heroism and myths about love conquering all. The biggest message of all is the happy ending. Whether this is the narcotic of audiences everywhere or the superstition of producers is hard to tell. It is

difficult to sell stories without a happy ending, whether it is the triumph of the hero or the proposal of marriage that concludes a romantic comedy. There usually has to be a strong message of hope, of overcoming adversity, or at least benefiting the nation or the human race. This is not a bad thing. However, tragedy, loss, and pain have another truth that audiences also recognize. Taking the measure of human limitations can also attract and resonate with audiences because they recognize and respect truth and genuine insight into human experience.

In our time, algorithms, information technology, and big data have been applied to the problem of how to attract audiences. A new startup in Hollywood can evaluate scripts by comparing them to an existing database of films and their box office so that script decisions with certain scenes or a certain variation on a premise can be based on probability influenced by an algorithm. For example, bowling scenes show up in films that do poorly (so cut the bowling scene); "a cursed superhero never sells as well as a guardian superhero" like Superman.[5] Such an approach removes all creative flair, instinct, genius, whatever you want to call it from the process. If Hollywood adopts this practice widely, it will be one more hurdle for creative storytelling. Movies will become, if they are not already, homogenized replications of one another, sequels, prequels, and remakes with precious few new narratives.

The dilemma here lies in the question of what appeals to audiences. Fantasy seems to appeal more than realism, the spectacle of special effects more than complex stories and great acting. Action sequences involving fights, now almost always some kind of kung-fu or karate, are spectacular choreographed ballets. Opponents fight almost without panting or sweating. Uma Thurman as Beatrix in *Kill Bill Part II* (2003) dispatches several dozen expert samurai swordsmen not to mention a couple of women martial artists that would leave any man weak and exhausted long before the scene ends. Did you ever watch world champion boxers who are rigorously trained athletes fight for 5 or 10 minutes? They have 3 minutes rounds broken up by a brief rest in their corners with the attention of seconds, a drink, a toweling down to remove the blood and sweat. By the twelfth round, they are exhausted, slowed down, and groggy from punches. Not many fights go to the final round. Our film heroes trade blows that would in real martial arts would cripple or disable you very quickly or at least leave you panting and exhausted. Watch Olympic Judo contests for messy realism and the exhaustion that sets in. Gunfights are another case in point. Characters seem to be bullet proof, their opponents incompetent shooters, and nobody runs out of ammunition. Movies are often fantasy escapes from the laws of physics, human biology, and human nature.

A number of ideological themes are woven into a lot of movies and television. World War II movies are nearly always patriotic propaganda. Although characters might die, they do not die in vain, and they die heroically. It was noticeable how few movies about Vietnam were filmed because that undeclared war involved war crimes, brought humiliation to the United States, and sowed discord at home. The movies that were made, like *The Deer Hunter* (1978), *Apocalypse Now* (1979), and *Full Metal Jacket* (1987), dealt with the dark side of America—the My Lai massacre of civilians, the defoliation of jungles with agent orange, the high-altitude bombing of Hanoi with B-52s, and the draft dodging and political protest. Coppola's *Apocalypse Now*, partially based on Joseph Conrad's *Heart of Darkness*, is a parable about moral degeneration. It is difficult to find redemption in these Vietnam War movies, except, perhaps, when Robert De Niro's character refuses to shoot the noble stag at the end of *The Deer Hunter*, thereby celebrating life.

A new generation of movies about the long wars in Iraq and Afghanistan are coming out. Perhaps the granddaddy of this type of movie is *Black Hawk Down* (2001), by Ridley Scott. *The Hurt Locker*

5 Brooks Barnes, "Solving Equation of a Hit Film Script, With Data," *New York Times*, May 5, 2013.

(2008) won an Academy Award for best picture and best direction by Kathryn Bigelow, not warranted in the author's opinion. The war against terrorism has a different kind of story, and the struggle has become in some ways morally ambivalent with torture and abuse at Abu Ghraib, detention at Guantanamo, and CIA rendition and torture. The U.S. military is not always heroic in asymmetrical warfare against an unconventional enemy: *Battle for Haditha* (2007) was a powerful film about an American massacre of twenty-four Iraqi civilians in the Iraq war.

The world of undercover operations and Special Forces missions makes a different kind of narrative partly because the theater of operations is not large scale. So the stories involve physical suspense and character and leadership struggles. *Seal Team 6: The Raid on Osama bin Laden* (2012) was a TV movie about the killing of Osama Bin Laden as was *The Last Days of Osama bin Laden* (2011). *Zero Dark Thirty* (2012) seems to validate torture, which is against international and United States law, as a way to get information.

We see a constant ambivalence concerning crime and law and order. The movies have always glamorized gangsters even though they may have to die in a hail of bullets in the end. Until then, the audience gets a kind of fantasy outing in which power and invincibility rule. The writer has to make the central characters interesting. The movie and television series literature about the Mafia reveals the greatest ambivalence. The Mafia began as neighborhood protection of poor immigrants but ended up as a cancer corrupting everything it touched. Only the Godfather trilogy made by Francis Ford Coppola really shows the destruction of family, self, and relationships that are the inevitable consequence of the Mafia code of silence, violence, and revenge. Sometimes it seems as if this genre of movies is a propaganda machine for the Mafia itself, showing its power, creating larger-than-life characters, and solidifying its mythic status in American society. *The Sopranos* became a major television hit. A mass audience could cozy up to a mafia family as if it were a next-door neighbor and just another way to make good in America. Tony Soprano even goes into therapy. Crime is just a psychological adjustment.

Crime makes for more interesting dramatic material than the humdrum life of law-abiding citizens. In films, the police are often the butt of ridicule. Their cruisers are involved in spectacular pile-ups. The cliché chase sequence makes you root for the fleeing criminal rather than the police. Think of how many films you have seen about heists, bank robberies, and criminal protagonists in which you the audience sides with the criminal protagonist. The viewer wants the criminal to succeed, and the police sometimes become the antagonist, especially if you can spice up the plot with law enforcement corruption or cruelty. Television, in contrast, seems to favor the police and the heroic public service of the keepers of law and order.

In either medium and in every script, the depiction of violence is an overwhelming fact of screen entertainment. For a century, the movies have evolved certain cliché set pieces—the fistfight, the shootout, and the car chase—that each generation seems to reinvent. It began in the modern era with Sam Peckinpah's slow-motion shootout in *The Wild Bunch* (1969). It becomes a kind of stylized entertainment in kung-fu movies. Quentin Tarantino's movies (*Reservoir Dogs, Pulp Fiction,* and the latest, *Django Unchained*) are all based on a similar premise. The trick seems to be to provide a legitimate excuse for the audience to indulge in a spectacle of violence by setting up a character with a plausible motive for revenge, and then it is delivered with clever, almost blasé ruthlessness. Violence is exciting and raises adrenaline. Tarantino's signature style violence taps into this audience psychology. He is a skillful scriptwriter and director but that does not remove discomfort about his unrelenting preoccupation with violence. For this writer there is an ethical issue involved in how you exploit human emotions and psychology. Each writer has to confront these issues. Or maybe, you choose not to.

The theory is simple and perhaps oversimplified here (but this is not a book about media theory). Bad guys define themselves by their heartless, ruthless violence. In the real world, criminals and drug

cartels are extremely violent. The bad guys kill and appear to be getting away with it. The good guys or the protagonist is then licensed to kill and respond with equal violence. Only this violence is good violence. True, it has roots in folk tales like *Little Red Riding Hood.* Remember the woodcutter kills the wolf and makes us feel good. The audience gets a free pass and can comfortably rationalize and enjoy the violence of revenge and settling scores, which in turn legitimizes the narrative purpose of the initial provocative violence. We are caught in a trap. We don't want the bad guys to get away scot-free. We would rather have good guys capable of defeating the villains offset and stop the violence. However, the audience is basically hooked on violence and feels that violent feelings can be legitimate.

Is this violence linked to sexual repression in a Puritanical culture? We are much more tolerant of literal graphic violence than we are of literal graphic sexual behavior. Movie makers seem to restrain themselves quite successfully depicting strong sexual reaction between characters. Is sexual desire a greater common denominator for the audience than murderous rage and violence, or vice versa? Perhaps you can argue that pornography, a huge industry indirectly supported by major corporations,[6] fulfills that need. What if

> ### The Social Effects of Violent Images in Entertainment
>
> Although this is not a forum in which the issues of violence in entertainment can be resolved, it is difficult not to suspect a relationship between the violent themes, images of big- and small-screen entertainment, and the sickening gun-related violence that pervades American society (34 people a day die—roughly 1/7 the number of murders in the whole of Western Europe sees in a year). We witness adolescent kids, the most vulnerable audience, resort to guns and mass killing to express their anger and frustration in school shootings. Although it may be controversial to say so, movies, video games, and to a lesser extent television desensitize impressionable viewers to violence. Are they acting out what they see on the screen? A kung-fu kick that doesn't hurt? Kids imitate the martial arts ballets that are choreographed for fight scenes. Movies glamorize violence and sensationalize life, on the one hand, while sentimentalizing it, on the other, with fantasy relationships. Like an addict who needs larger doses of a drug to get high, modern audiences seem to need more and more graphic violence to get their fix.

violence were confined to a kind of pornographic subculture and real sexuality were incorporated in narrative? Consider that scenes of violence are shot in greater detail and at greater length than sexual love—make war not love?

Most of the movies that are successful, which means large audiences and large grosses, are based on fantasy worlds, heavily influenced by comic book heroes or other action heroes, in which we can vicariously enjoy super powers or a charmed life. We fly; we have supernormal strength; we withstand physical punishment that would be lethal in a real world. Why do we have to live in fantasy worlds in which obstacles are always overcome, violence is justified by the menace of stereotyped villains, and women are idealized or denigrated? The success of fantasy, whether animated or live action, seems to suggest an audience that is fundamentally immature. It also heralds the triumph of popular culture over literary culture somewhat like processed, refined food is designed to deceive the immature palate and dissociate food value from taste. America suffers obesity from mass-produced food, and moral duplicity and confusion from mass entertainment that smooths over the complexities of real life. There are exceptions in some low-budget, low-concept films, as we have discussed. There are few special effects, stunts, or violence in Woody Allen's films that constitute a significant body of work by a film auteur. However, because Woody Allen is unique, you cannot realistically set out to be like him.

6 See *American Porn*, a Frontline documentary available on PBS.org.

Highest-grossing films of 2012			
Rank	Title	Studio	Worldwide Gross
1	The Avengers	Marvel	$1,511,757,910
2	Skyfall	MGM / Columbia	$1,108,561,013
3	The Dark Knight Rises	Warner Bros. / Legendary	$1,084,439,099
4	The Hobbit: An Unexpected Journey	Warner Bros. / MGM / New Line	$1,017,003,568
5	Ice Age: Continental Drift	Fox / Blue Sky	$877,244,782
6	The Twilight Saga: Breaking Dawn – Part 2	Lionsgate / Summit	$829,224,737
7	The Amazing Spider-Man	Columbia / Marvel	$752,216,557
8	Madagascar 3: Europe's Most Wanted	Paramount / DreamWorks	$746,921,274
9	The Hunger Games	Lionsgate	$691,247,768
10	Men in Black 3	Columbia	$624,026,776

➔ **Figure 15.1** The Highest Grossing Films of 2012.

How do you deal with these issues as a writer? There is a definite pressure to do likewise, or even to up the ante, go further, and think up a novel way to present violence to the audience so as to sell your work. It would be appealing to assert that writers have an obligation to create ethical, truthful narrative. Are we writing violent suspense stories because they are commercially more saleable or sentimental romantic comedies because they comfort us with happy endings rather than human stories that involve other kinds of deep emotion? Whatever you write, you will have to think about whether you are writing imitative or authentic scripts. There is no doubt that commercial pressure places the media writer in a moral dilemma. You have to make a buck and write what the industry wants. Who is responsible for creating quality work? Producers, directors, or writers?

EMOTIONAL HONESTY AND SENTIMENTALITY

The most significant form of emotional dishonesty is sentimentality. It substitutes a lesser emotion for a greater one while trying to achieve the same result; it thereby appeals to the lowest common denominator of our emotion. It oversimplifies life, death, and love to perpetuate a comfortable illusion. Escape versus realism glosses over the complexities of experience to provide an easy tear, laugh, or patriotic swelling of the chest. It turns complexity and subtlety into cartoons. Indeed, the Disney product, whether in movies or in theme parks, has always been larded with great dollops of sentimentality. *Pinocchio* (1940) is the one animated feature that seems to keep a truthful moral center. In fact, the main message of the film seems to say that most boys (people, the American public) are seduced by easy, immediate gratification in Pleasure Island, which is the equivalent of the Magic Kingdom, and get turned into donkeys. You could contrast Disney with a Pixar product such as *Toy Story* (1995) and its sequels (even though Disney distributed), which manages to avoid sentimentality, or with the Wallace and Gromit series. *Wall-E* (2008) is probably the exception which proves the rule about Disney. It is a somewhat bleak vision of a distant future.

Disney presents images of innocence and purity with all the nasty bits cleansed away. The projection of human emotions onto animal characters, cuteness as virtue, love without sexuality—it all gets served up as an easy substitute for experience, like processed food with sugar and coloring added

to make it more attractive.[7] Two animated films deserve mention in this context—*The Little Mermaid* (1989) and **Pocahontas** (1995). The first is based on the fairy tale by Hans Christian Anderson but turns it upside down. Instead of the Mermaid, who falls in love with a prince and has her heart broken when he marries someone else, turning into sea foam and becoming a spirit of the air, she marries the prince and lives happily ever after. What a falsification of an interesting morally complex tale that has held audiences over centuries! *Pocahontas* is a sentimental falsification of history that is racist even though Disney paid for historical research into the true story. Nevertheless, most of us are still going to let our children watch Disney and take them to Disneyworld. There are some parents I have met who keep Disney at bay and will not let their children into the Magic Kingdom for the reasons stated here.

Sentimentality drives **Pretty Woman** (1990)—the fantasy that a hooker is really a lady and gets to marry a millionaire and be treated like a princess. This is betrayed by the tag line "She walked off the street, into his life and stole his heart." Little of the sordid reality of this profession is ever revealed. Nor is the psychology of prostitution ever dealt with. It is a fantasy world. Julia Roberts is just playing at being a streetwalker. She is really never anything but a nice college drop out in hooker's clothing, who knows that by the end of the movie she is going to change her costume. The contrast with her hooker friend, Kit, played by Laura San Giacomo is notable. Vivian negotiates her sexual services at the beginning and then later after the improbable graduation to the role of respectable lady, being well paid all the while, she negotiates again, gambling everything: "I want the fairy tale." She starts out as a hooker and ends up as a bigger hooker—a wife who trades sex for wealth and security.

By contrast, consider the portrayal by Elizabeth Shue of a prostitute falling in love in **Leaving Las Vegas** (1995), a truly great American low-concept, low-budget film. The unconventional love story with an unhappy ending compares to one we discussed in *The Cooler* (2003), also set in Las Vegas. It is another story of redemption which is sad, challenging, and beautiful. Apart from the most convincing performance ever of an alcoholic by Nicolas Cage, there are scenes of authentic sentiment.

Sera persuades Ben to come and live with her. In one scene, Sera is talking about her relationship to Ben while we see her slip down her skirt, go into the open bathroom door, sit on the toilet, pee, and wipe herself, get up, come back without interrupting her dialogue. It is simple, intimate, and real portrait of how lovers live together. This is the antithesis of American romantic screenwriting. It is absolutely convincing and a persuasive portrait of how two needy people with their respective destructive problems find brief solace in one another. Ben, whose wife and son have left him and who is a failed Hollywood screenwriter decides, to give up and drink himself to death. Although this is a powerful adapted screenplay by director Mike Figgis and obliquely a commentary on working in Hollywood, the reader should not follow the example of the main character but of the quality of writing and filmmaking. Although the actors won Golden Globe awards and **Nicolas Cage an Oscar** for best actor, the film is not commercial by Hollywood standards, shot on 16mm for $3 million—a fluke that no respectable studio executive would greenlight.

Most people experience a lot of pain from falling in love. Half the time it is with the wrong person, or the love is not requited, or the relationship stagnates into a routine, low-temperature marriage full of compromises and the extinction of passion. Fifty percent of marriages end in divorce. Everyday relationships are not often the stuff of movies and television. Passion, lust, and jealousy are. So movies and soaps are seldom about the routine married life unless they satirize it.

7 See *Rethinking Disney: Private Control, Public Dimensions,* ed. Mike Budd and Max H. Kirsch, (Middletown, CT: Wesleyan University Press, 2005). See also my review in *Scope* (an online journal of film and TV studies), Institute of Film & TV Studies, University of Nottingham: www.scope.nottingham.ac.uk/bookreview.php?issue = 11&id = 1031§ion = book_rev&q = friedmann.

A television show like *Married with Children* mocks the state of marriage as daily warfare and endless insults. The Academy Award–winning original screenplay and movie of 2000 was *American Beauty* (1999), which is a searing exposure of the social and emotional failure of the American family at the turn of the century. So truthfulness without a happy ending can sometimes result in commercial success.

Movies and television are about human emotions. People in conflict and under stress react emotionally. Their principles and morals are tested. The spectacle of a character confronting destiny and undergoing evolution through challenges fascinates audiences. Just as the Greeks explored the tragic dilemmas and comic absurdities of their society in their theatre, movies and TV mirror all our cultural dilemmas and moral conflicts. We have a long list of social issues such as divorce, drugs, racial discrimination, crime, gun violence, and so on. It is interesting to speculate whether the program content reflects or leads the cultural consciousness of the day. Many movies and television programs have a distinct cultural bias and a subtle, and sometimes not so subtle, political agenda. The story plays to an ideological message as surely as Communist countries used to make films that celebrated the working-class hero.

GI Jane (1997) seems to me an example of an agenda-driven storyline. A woman wants to become a Navy SEAL. At a political level, she is the pawn of a woman senator who wants to push the issue of gender equality in the armed services. The heroine is shown going through the training, including being physically beaten up by the master chief—total equality. Her head is shaven. She has to meet the same standards of physical endurance as the male recruits. She has to stand up to the master chief, and insults him with the utterly illogical line: "Suck my dick!" A fight ensues. She wins and proves herself. It ends with a secret raid inside Libya in which she proves her operational skills and gains acceptance as one of the guys. It is easy to fabricate the endurance and the performance in the movies, which in real life would not be likely. How could a woman stand up to a man who has the same Navy Seal training? Perhaps it is symbolic. It is in a sense exploitation and sensationalism. Because Demi Moore is the lead, her character has to be written to succeed.[8] Women characters regularly beat up or defeat male opponents in martial arts contests. Is it credible? To shoot a movie, you can use stunt doubles, multiple takes, and cover angles that enable editing. In *Kill Bill: Vol. 1* (2003), Uma Thurman defeats legions of trained samurai swordsmen and martial artists without a drop of sweat on her lovely brow.

The feminist agenda is quite prevalent in movies and television today as is the homosexual agenda. Although many issues of gender equality are topical and meaningful, men in turn become stereotyped and masculinity pilloried. Sometimes there is a bias that distorts the truth. John Updike's novel *The Witches of Eastwick* (1987) was made into a movie that turned it upside down. The three leading ladies, Cher, Susan Sarandon, and Michelle Pfeiffer, played the witches who became the victims instead of the persecutors of a new man in the neighborhood, who in the movie becomes the Devil incarnate, played by Jack Nicholson. Instead of three women trying to undo the man, who is the victim in the novel, with spells and esoteric practices, it is politically more attractive to play it the other way around. The basic message is female power is good, male power is bad. There used to be a grade-school chant, "What are little boys made of? Slugs and snails and puppy dogs tails, that's what little boys are made of. What are little girls made of? Sugar and spice and all that's nice, that's what little girls are made of." It is interesting to note how easily men's bodies are used as cannon fodder. The message is that men's lives are expendable and men's pain allowable. Think how often you see men getting kicked or hit in the genitals. This is often made into a joke. Men kick men. Women kick

8 See the review at the Internet Movie Data Base website, http://us.imdb.com/CommentsShow?119173.

men. You never see a woman kicked in the genitals or punched in the breast, and it wouldn't ever be particularly funny. Alert yourself to the amount and the extent of ideological agendas that are built into many scripts.

In **40 Days and 40 Nights** (2002), mainly a romantic comedy with a brilliant premise about a guy who vows to stay celibate the 40 days and nights of Lent after being dumped by his girlfriend. Then he meets a girl who he falls in love with and who loves him. Now he is trapped by his oath of celibacy. People in the office where he works start a betting book on whether he can keep his vow. The movie makes an interesting comedy about the power politics of sex—that women retain the power. They try to sabotage his vow by seduction. In the last act, he is raped while handcuffed to a bed by his former girlfriend because he won't come back to her and also to win the bet. It invalidates his vow and threatens to destroy his relationship with the new love who is waiting for his vow to expire. Why is rape, date rape, or other forms of sexual aggression visited on men by women not taken the same way as when women are the victims?

Hall Pass (2011), a comedy romance, is predicated on a set of values, which are at bottom abhorrent. Men are denigrated as crude sex-obsessed creatures who are reduced to juvenile dependency on women as dispensers of sexual gratification. The subtext is in the title. A hall pass is after all a high school protocol that allows a student to be out of class and in the halls of the school. It is issued by authorities such as teachers and administrators. So what is the analogy? Men are boys; women are superior adults. The other cultural lie or convention of this kind of American film is that women don't want or don't have sexual needs, whereas men are obsessed with theirs. Their wives basically control them by rationing sex, and men revert to fantasies of some mythical pre-marital freedom. The truth is probably the opposite. Many women have a real need for sexual pleasure and satisfaction that extends into mature years after menopause that is quite often unfulfilled by men whose testosterone and virility is declining. The film contains an offensive idea expressed in the dialogue that women after child birth have stretched vaginas that are the subject of ribald jokes that reject mothers of children as sexually undesirable. This is factually dubious and furthers an offensive and crude mentality rooted in a juvenile mentality. The film manages to degrade men and insult women at the same time.

A contrast is the much harder more truthful film, *Hope Springs* (2012), in which Meryl Streep plays a sexually frustrated older woman married to a sexually dead husband played by Tommy Lee Jones. She agitates to get him to a sex therapist with her to confront all their difficult and embarrassing issues and revive the romance in their marriage. It is basically a two hander with two superb actors navigating the emotional reefs of relationships between the sexes. It is emotionally and psychologically convincing. In Hollywood terms, this is a low-budget movie that probably did not make a lot of money, but what a treat! Funny and touching at the same time!

Men and women are so often seen to be a joke to one another or exploit one another in a kind of continual gender-based warfare. This is also the premise of a lot of television comedy, the classic being *Married with Children*, which is still running in syndication. The humor is based on gender antagonism and insults that are supposed to be funny, cued with laugh track dubbed in. The very popular series *Sex and the City*, which also spawned film spinoffs, explores a different thesis about women's sexuality although it trails themes of marriage as the apotheosis of sexual relationships. Somewhere in this spectrum, the male perspective is both mocked and preserved in eternal bachelordom and seduction, as celebrated in *Two and a Half Men*. All this is thrown topsy turvy by the new acceptance of homosexuality as the basis for relationships and committed relationships not to mention polygamy as explored in the reality show *Sister Wives*. So *Modern Family* explores the new normal, in which homosexuality is acknowledged and accepted although not necessarily free of its own stereotyping and sentimentality that does not include the full spectrum of homosexual behavior in uncommitted

relationships, which includes promiscuity, rape, and priests who abuse children and adolescents on a vast scale.

D.W. Griffith, one of the greatest and most inventive pioneers in the medium, made the first feature-length epic, *Birth of a Nation* (1915), which celebrated the Ku Klux Klan and was distinctly racist. The movies have often glossed over American historical realities such as genocide of Native American peoples, slavery, segregation, discrimination, lynching, social inequalities, and political corruption although there are notable exceptions. Movies have also become a way to change public perception. *In the Heat of the Night* (1967), with Sidney Poitier, showed how a black detective in the South dealt with prejudice and a Southern sheriff. Sidney Poitier also pioneered in portraying a mixed-race relationship in *Guess Who's Coming to Dinner* (1967). Kevin Costner made a 4-hour movie (director's cut), *Dances with Wolves* (1990) that reexamined the racist and genocidal assumptions that lie behind the American folklore of the frontier. *Little Big Man* (1970) explored a story of one man who witnessed the massacre at Little Big Horn that has to confront this crime against humanity that is integral to the conquest of the American West.

> **European and American Films in Contrast**
>
> European films have less of the sentimental tradition; however, few of them receive wide distribution. If they do, they often are remade into a softened version for American consumption. *Trois Hommes et un Couffin* (1985), about three men who get stuck with a baby and have to learn to look after it (a great comic premise) was turned into an American version, *Three Men and a Baby* (1987), that takes gritty social observation and turns it into sentimentality. The British TV sitcom *Until Death Do Us Part* was bought, tamed, and turned into *All in the Family*. Although there are cultural reasons why one country's humor won't play in another's, the Puritanism in American culture has always restricted the way movies treat many themes.

Reflect about those movies that command attention and hold audiences long after their initial release and the DVD sales have dwindled! Their success is difficult to predict beforehand. Big box office is sometimes ephemeral, resulting from a fad or a public mood. Some big grossing movies fade into oblivion. *Citizen Kane* (1941) was not a box office hit, but it is a great movie that is technically brilliant and compelling viewing every time you watch it. Of course, its release was sabotaged by William Randolph Hearst, whose life it paraphrased in an unflattering way. *Casablanca* (1942) is a great love story that is compelling because it is not sentimental. Rick does not get Ilse. Although he is bitter about losing her, he deals with the reality. He salvages something from it. They love one another, but they are not going to be together. Rick helps his rival instead of trying to beat him, as is the custom in American movies of the day.

Truthiness and Consequences

It is too tempting not to steal this clever heading from a newspaper reviewer who points out that several of the important films nominated for the 2013 Oscars have serious distortions of fact for the sake of entertainment.[9] *Argo,* which won the Academy award for best picture, invents a fictional tense scene at the airport security manned by revolutionary guards looking for Americans, with a dramatic chase down the runway after the plane taking off carries them to safety. It makes a hero out of the CIA operative and underplays the role of the Canadian Ambassador. The CIA has publicly challenged the depiction of water boarding leading to the capture of Osama bin Laden in *Zero Dark Thirty*. In

9 Ty Burr, "Truthiness and Consequences," *Boston Globe,* February 23, 2013.

order to make the roll call vote on the Thirteenth Amendment more suspenseful, the screenplay of *Lincoln* has two Connecticut congressmen vote against the amendment when in fact the whole delegation voted in favor. And the vote was called by States not by alphabetical listing. The choice to fabricate the details of this historical scene is puzzling because the audience already knows that the Thirteenth Amendment passed. This is not a new phenomenon. Best pictures such as *Titanic* (1997) and *Lawrence of Arabia* (1962) change the facts of history. The very popular winner *Braveheart* (1995) is second on a list of the ten most historically inaccurate films of all time, drawn up by *The Sunday Times* of London.

Should movies be truthful? Millions of people will get their knowledge, or rather their idea, of history from these winning films. There is no easy answer. There are many commercial pressures to create or include elements that are imitative—the car chases, the fight, the love scene with the movie seduction scene and kiss. It is hard to be original. It is hard to be truthful. It is hard to be successful. There is no future in writing scripts that are never produced. You can train to be a journeyman hack and make a living writing low-concept scripts that are often not produced or you can shoot for the big time. There is a vast body of technique that can teach you how to write a screenplay that sells. It's up to you to sort out these dilemmas. It seemed to this writer dishonest not to acknowledge them. You decide.

Despite craft and technique, the animus for your writing has to come from your center, from what you know and believe. That voice of authenticity is what carries the day in the end. It is probably true to say that there is room for so many kinds of writing that you would be foolish to fabricate writing that you cannot sustain and that you do not genuinely want to do. It is very difficult to write without conviction. Ultimately, you have to **write what your gut tells you is true** for you and true for the audience.

WRITING FOR THE CORPORATE WORLD

At first, most beginners are ambitious to work in the entertainment side of the industry. Although it is the most lucrative, it is also the hardest to get into. Other opportunities exist in the corporate world where writing skills are needed to tell corporate stories where the stakes are not as high as in the entertainment world mainly because the amount of money involved is small by comparison. Script writing talent is highly valued in the advertising world, as we found out in Chapter 5. In corporate communications, you get to write professionally while you work on that screenplay.

The largest employer, both in terms of salaried jobs and freelance work, is the business world. The need for writers who can design content for corporate communications needs is large. In every major media market across America and in many other countries, wherever businesses are to be found, you will also find production companies and advertising agencies that are in business to solve their communications problems. The corporate world is a highly creative and stimulating place to work. It is innovative and requires you to be able to think about new media and keep up with what is happening in the industry. Every job is different. Every job exposes you to a new product or service and introduces you to whole new worlds of business activity. Sometimes these are highly technical and about business-to-business products and services that you wouldn't normally come across. These jobs require a curious and adaptive spirit and someone who is able to assimilate new material quickly and get to the heart of a communication problem. You have to be able to communicate your ideas to clients and producers that employ you.

Although some assignments are less exciting than others, my personal experience writing for corporate media has been rewarding. You can perfect your craft and be paid, which might enable

you to write your screenplay between jobs or on nights and weekends. As we learned in Chapter 6, dramatization is one of the devices that work well for certain corporate communication problems. This means writing dialogue, casting talent, and directing. Corporate work also is a good training for documentary writing because it relies on clear visual exposition and a kind of factual narrative even though the conclusion is predetermined. Corporate videos are less common than they used to be because so much communication now takes place on the corporate website. Another corporate writing sector is training. Once again, much of what used to be distributed as video or DVD is now interactive programming that lives on a website.

How do you start? There is a chicken-and-egg problem. You need experience before someone will entrust you with a high-value corporate job. To get experience you need to get a writing credit. One way is to write for no pay for a charity or public service organization that usually gets pro bono creative help from the industry. In Chapter 5, we discussed a public service announcement about addictive gambling. This was produced by Pontes/Buckley Advertising, Inc., and by writers, technicians, and talent from the Boston chapter of the Media Communications Association. Find a small non-profit organization that needs a video. Another way would be to write for cable access channels, which by law and FCC-regulated conditions for cable monopolies exist in every community. You can even produce the program yourself. If the program is successful, it can be played on other cable access channels or even taken up by a commercial cable channel. More important is that you have a "reel" (now digital media) that shows program content for which you have a writing credit. It can become a calling card.

CLIENT RELATIONSHIPS

When you work for a client, you have entered into a business relationship. You are being paid to do a job to your client's satisfaction. A client pays you for your creative writing talent to solve a communication problem that they cannot solve on their own. A creative service has its own rules and is hard to measure. I once worked for a management consultancy writing training videos. I had to go to Belgium and visit their client's site—the national steel company. I was given a desk where I could write. The manager would come in now and then and wonder what I had produced in the last couple of hours because he was paying for my services by the day. His idea of writing was constant output. My approach was to visit the factory for visual input, read background, and stare out of the window with my feet on the desk, or go out and have some of that Belgian Stella Artois, until I had thought the problem through and found a solution. All the while I was using the seven-step method, as outlined in Chapter 2. Once I knew the answers to the questions and I had the creative concept, I could write quickly. The manager of this consultancy job was getting more and more agitated with me because he didn't see an hourly output. He just did not understand the writing process. It does not involve a constant output eight hours a day. It happens in fits and starts. However, he was pleased with the script that resulted. Then he ruined everybody's evening by calling a late night meeting of all his people to discuss it with me. Some people!

The point is that clients do not always understand what they are paying a writer for. It is problematic for them to put a value on the work. Are they paying by the hour? The hour that you chew pencils also counts but seems a waste of money to the client. On the whole, writers are paid for piecework. You quote a fee for the whole job, broken down into stages with a schedule of payments. Some people pay by the minute, say, $250 per minute of finished program. These last two methods of payment hide the pencil chewing and the thinking time and deal with a measurable result. The most common mode of payment for corporate work is a flat fee for the finished script. You estimate

what time is involved in terms of research, travel, and writing. You multiply that by your notional or daily fee. You come up with a price for the whole job. Your producer or your client either agrees or negotiates. Sometimes you need to be working on more than one job at a time because there is waiting time while your producer/client reads the script or circulates it to others for reading. You need to be productive during this downtime.

CORPORATE CONTRACTS

Unions have virtually no presence or influence in the corporate field. In my experience, however, the market in corporate video seems to reward competent writers adequately without the need for union representation. If you are hired to write for compensation, make sure you have a contract. A contract can take many forms. The first is a verbal agreement. Surprisingly, many people work on terms negotiated verbally. It is good practice, however, to follow up any verbal agreement with a letter stating the terms under which you are going to proceed with the project. A verbal contract can be legally binding. It's just hard to enforce. Hence, writing out the terms in a letter of confirmation saves misunderstanding. I have never used a lawyer or an agent for a corporate job. Agents do very little business in the corporate world because the fees are low. Agents prefer to spend time and energy in the entertainment world, where they are indispensable and make more money.

The transfer of intellectual property is implicit in all corporate writing as in writing for entertainment media. Either you are employed as a writer by a corporation that by virtue of paying you a salary for your work owns your writing output, or you are a freelance writer who is contracted by the corporation or a producer in a production company to create a script. That contract may often be, and usually is, verbal and implicit, governed by custom and practice in the industry. You will not often have a written contract because to provide a written contract usually incurs legal costs. The nature of the contract and its salient features are so well understood that most work is done on trust.

Even so, when a client gives the go ahead on a treatment or a script, I always write a letter saying that following our meeting and discussion on such and such a date, I am now proceeding with the treatment/script/revision based on agreement of the following points. Mentioning delivery dates is also a good idea. The letters have legal value in the event of a dispute or in the event that the client changes his mind. You need to have an agreement about a payment schedule and state what it is in a confirming letter. If the client does not raise any objection to your letter, the lack of response implies consent. It is vitally important to get some form of partial payment up front as a sign of good faith. You do not expect to get final payment until the client has signed off on the final draft. Once again, your copyright in your work is assigned to the person who pays you, but only after you've been paid. The problem is that if you are not paid, the custom-crafted script is of little value to you as the writer. You cannot usually resell it to some other client.

Several types of payment agreement are used for corporate writing. You can divide the project into concept/outline, treatment, and shooting script. Each stage is valued at a third of the total and paid for in increments. This method of payment allows producers to pay as they go and protects you, the writer, from not getting paid at the end. In fact, it is a good idea to get one-third up front. Any resistance to partial payment up front usually signals a problem of integrity.

One formula commonly employed is to value writing by the minute of final program. Another is as a percentage of the production budget. A script for a video that costs $100,000 to make might have a script element that is worth a percentage of the production budget, say, $5,000. All of these ways of calculating a writing fee are based on experience and history. You can generally work out what it takes to write a minute of script based on research time, outline and treatment work, and final scriptwriting. You express that time and effort as a figure defined by the end result.

Writing involves two elements that both cost money. The first is time. It takes time to think and write. Based on your experience, how long will it take you to write a 10-minute video? You calculate the hours and put a price on your time. You round out the figure. You also have to think about what other writers are charging in your market. If you are experienced and respected in the industry, you have your price and can afford to be choosy. If you are a beginner, you have to be as flexible as you can. There are producers who try to exploit writers by asking for a script at a knockdown price on the promise of other work to come. I have learned that this other work never materializes. I usually refuse these kinds of deals by offering to discount the second script. That usually flushes out the dishonest operators.

The second aspect of writing is creativity. Creative work and imagination have a value. It is hard to measure and impossible to cost. When it works, it is priceless. Advertising agencies charge for creative services. Graphic designers charge for creative flair. The writer is in the same business—selling creative ideas. A great creative idea cannot be valued in terms of time. Sometimes I have made it through my seven steps in a flash. I know before I leave the meeting how I will solve the problem. Creative talent has a value. To the extent that the market will bear, you can charge for creative flair and originality. You hope to build a reputation that people will be glad to pay a premium for. Your demonstrated track record and finished work back it up. It takes a lot of work to build this kind of reputation. It also gets you prestige projects to work on rather than run-of-the-mill training videos. So different jobs can be priced and charged differently based on the nature of the product and the client.

WORK FOR HIRE

Marketing Yourself and Your Work

In the business world, you hope for repeat business. You must also build business by introducing yourself to new producers and new corporate clients, usually by showing them some of your work and a résumé. Whenever you are not writing, you should be on the phone trying to make new contacts. You have to sell your talent and your creative services. Not many agents represent corporate media writers. There is not enough money in it for the agent, and it is too specialized. This is an advantage because you are not shut out of the game by an agent barrier, which can indeed inhibit your entry into the entertainment world. In addition, you get to keep all the money earned without having to pay a commission.

Copyright

Copyright is an agreement, either in common law or statute, that the original work of a creator of words, images, music, or other media is an intellectual property as opposed to a physical property. The creator has a right in what is created and owns that work until that ownership is assigned to another for payment. The purpose of the contract is to transfer title in the property parallel to the transfer of title in real estate. If you do not copyright your work in the United States, it falls into the public domain. This means anyone can use it. Eventually, all intellectual property falls into the public domain 70 years after the author dies. Copyright law is different in different countries. In Europe, for instance, you do not have to create copyright as you do in the United States. It is deemed to exist de facto because of the act of creation. Copyright therefore inheres in what you write or create. The Berne Convention dating back to 1886 assures the protection of creative work beyond the national borders of its country of origin.

You need to understand that you cannot copyright an idea. You have to create something that has recognizable shape and form and individuality in order to copyright it. This is very important when dealing with scripts and ideas for entertainment program content. An idea or concept for a movie is hard to copyright. A treatment is an expressed idea that has particular characteristics and acquires the quality of intellectual property. A screenplay, book manuscript, or play manuscript has clear identity as the output of a particular creator. Because you cannot copyright an idea, it is important not to discuss it before making it into intellectual property. The various Writers Guilds provide a service that enables you to register a script. This becomes a strong, dated proof of ownership, although it does not create copyright under U.S. law. You should register your script if you submit your work to any potential buyer.

Copyright and clear title to intellectual property are crucial to the entertainment industry. Whether the source is an original screenplay, a book in the public domain, or existing intellectual property in a book, play, or manuscript of the same, it is essential that at each stage of production and distribution, every element of writing, performance, and sound track has clear title. Any flaw in title puts a huge investment at risk and leaves the producer open to claims for payment from any party who holds title to a part of that intellectual property. All contracts involving the assignment of intellectual property require the grantor of the right to indemnify the grantee against any flaw in title and to assume all liability for any flaw. Investors, studios, and end distributors, right down to the end exhibitor, demand this indemnity.

Because the integrity of the title is of paramount importance, lawyers involved in drafting contracts will always demand proof of title or an indemnity against all liability and any future claims resulting from any flaw in that title. Again, there is a parallel to real estate transactions. You cannot acquire title in something the seller does not have title to. This is why you buy title insurance in a real estate transaction. However, it is easier to verify title in the registry office of a town or county that probably keeps very good records of ownership for reasons of taxation levied on the property. Title in works of imagination expressed in words that anyone can copy, or ideas that anyone can copy, are more difficult to trace and protect.

Students sometimes take plagiarism lightly and are careless about identifying their sources. As a professional writer, you must have a rigorous respect for these issues because you are proposing to sell a piece of intellectual property. You must be able to assert your title to what you have created and what you propose to the buyer. For example, you cannot sell a script or screenplay based on a work that you do not own. You can write it, but it will have no value. Although you have created copyright in writing your screenplay, you will have created a piece of work that has a split copyright. I once optioned a novel through an agent. I wrote a screenplay to set it up as a movie. The option expired before I could get any preproduction going. Of course, I could go back and re-option the book. In the end, it didn't work out. My screenplay is a work with split copyright. Any producer can buy the underlying work and decouple it from my screenplay and get someone else to write another screenplay based on the same source work. I have no rights.

When novels or plays are popular, their media rights have high value and are sold through competitive bidding. Only major players in the entertainment business can ante up the option money or bid for these rights. For this reason, it is better to adapt work in the public domain. However, there is still a split copyright because anyone else can go to the same source in the public domain and create a new derivative work equal to yours and independent of yours. This happened to me. I wrote an adaptation of Henry James's *Daisy Miller*. I approached Peter Bogdanovich, the director, with the idea that it would be a great idea for a movie and a perfect role for Cybill Shepherd, his girlfriend at the time. It just so happened that he had had the same idea and was developing *Daisy Miller* as his next project. I had no claim, and he had no obligation. For legal protection and to stop a possible rival production, he bought the screenplay.

Work-Made-for-Hire and Freelance

Writers who are employees of a company, such as a production company or, indeed, journalists working for a publication, are deemed to be offering a service for hire so that the employer who pays the writer's salary automatically owns what the writer produces. The analogy is to the worker on a shop floor. Ford does not have to pay a worker for creating a car but only for the time on the job. By analogy, a freelance writer who is paid by the hour or by the minute of finished script or for a completed script is governed by a work-made-for-hire principle. If a company pays a writer in this way, it owns the copyright in the work produced completely.

There is another way to govern the contractual relationship. A freelance writer is paid for a piece of work, created by the writer as an independent, imaginative enterprise. It remains the property of the creator until a bargain is struck and terms are set by which the ownership in the creation is transferred. Freelance writers enter into agreements to transfer ownership in their intellectual properties for payment. Broadly speaking, there are two ways to do this. It is sometimes part of the agreement that the writer retains some rights for some media or some territories, especially in journalism, where content can be resold or sold in another medium like a website. So a writer might be paid by the word for a specific publication.

In media writing, scripts are usually dedicated to one production and can have no afterlife. Nevertheless, in the entertainment world, new media are springing up all the time. There is some dispute now about whether content that is delivered to cell phones is covered by agreements that did not include those rights. Writers' guilds try to defend writers' copyright. Publishers, producers, and employers of writing talent try to word contracts to include all media and those not yet invented because they have been burned so many times by having to renegotiate rights for sales for new media. We take DVDs, MP3s, and the Internet for granted, but writers want participation in the revenue for sales of content based on their work in new forms of distribution. These issues constituted one of the principal reasons for writers striking in 2008.

NETWORKING, CONVENTIONS, AND SEMINARS

Writers are rather solitary creatures on the whole. For the most part, they work alone. Getting to know other writers is not that easy. That is why going to seminars and attending conventions are beneficial. In a way, it doesn't matter whether you meet other writers. You want to meet the people who will commission your work—producers, directors, and corporate advertising, and public relations executives. Networking is key. There are social networking tools such as LinkedIn through which you can build a network of trustworthiness. Today, having a website is a strong way to market yourself and display your work.

A number of traveling writing seminars are given by scriptwriters and script doctors.[10] One of them is sure to be coming to a venue near you during the year. That is a good way of getting a fast track to real professional issues. These events are not cheap. They are usually 2- to 3-day affairs and cost about $500. If travel and hotel accommodations are added, attendance can be a costly exercise, but it is worth doing at least once to get professional advice and meet other like-minded people.

Writing seminars and panels are also given at a number of professional conventions. The Media Communications Association International has an annual convention at which there are always some

10 See links for Chapter 15 on the companion website.

panels devoted to scripting issues and marketing of writing skills in the corporate media marketplace. The National Association of Broadcasters brings people on all sides of the industry together. Again, panels are conducted and papers presented that are of interest to writers, particularly new media and interactive writers. These conventions are quite expensive when you add the costs of registration, travel, and the hotel. If you are making an income as a writer, these expenses become tax deductible, as do independent writing seminars.

There are lots of **webinars and courses** online that cost a great deal less and are naturally free of travel costs. The Writers Store website offers dozens of them and gives you easy access to a range of script doctors, writing gurus, and patented methods of solving craft issues of screen writing. Some of these script experts have their own websites where you can join webinars and pay to have your script read and critiqued with suggestions for improvement identifying weaknesses.

RESOURCES ON THE WORLD WIDE WEB

With the spread of the World Wide Web, writing and scriptwriting have benefited from dedicated websites full of valuable information, such as the one for the Writers Guild and other professional bodies. Sites provide valuable databases of scripts, movies, and television production, as cited throughout this book. You can download or buy copies of scripts from most films and television series. There are chat rooms, script competitions, and websites for current television series and movies in production. There are online writing courses and script services. The web offers numerous resources for research and for professional contacts.

There are sites that provide shop windows for scripts looking for a producer, which provide a way for writers to circumvent the problem of finding an agent. In the companion website, lists of active links that will take you directly to the sites are included in the **Chapter 15 page**.

Writing seminars, webinars, and live workshops allow anyone to hone their skills and get deeper understanding of what is involved in writing a successful screenplay. There are tutors and consultants who will critique your work for a price. This kind of service is difficult to evaluate and awkward to recommend because of the range in price and value. Sometimes, you wonder why people are making money out of teaching scriptwriting knowledge when they could be writing screenplays. Many of them have respectable credentials and impressive credits.

Screenplay competitions offer a shortcut to getting attention for your writing. Most competitions offer a monetary prize, which is welcome, but perhaps more important in terms of career development, as part of the prize they guarantee that your screenplay will be read by professionals. These could include: agents, producers, and studios. Sometimes, the runners-up are also promised a reading and a critique by a professional. Sometimes an agency might be prepared to represent the winner or a producer option or buy your screenplay. Even though studios and producers like known quantities, they also need freshness and originality. Entering screenplay competitions also means that you are going out of your private world of conviction and into an arena of competition with like-minded aspirants. Some of these competitions are one-offs, but a lot are perennial. **Amazon**, after running competitions with guaranteed publication for novelists, is casting its net wider and has just initiated a screenplay competition.

There is an annual screenplay competition for students run by the Writing Division of the Broadcast Education Association, which I instigated when I was Vice Chair and then Chair of the Writing Division in 1997. It has been continued by my successors to this day. Information is on the BEA website on the Writing Division page. You can start there and try to enter a competition every year or so, preferably with a new screenplay or at the very least a thoroughly revised one.

HYBRID CAREERS

Writers should also have some knowledge of production. They have, or can also develop, skills as a producer or director or both. We have alluded to multitalented figures throughout the book, from Orson Welles to James Cameron. Both in the entertainment world and in the corporate world, a combination of talents can be useful. You have to do whatever it takes. The path of development for each person always involves an element of character and an element of destiny.

Are you someone who walks out of the movie when the end credits roll? You should stay and study them for information about personnel, shooting locations, and technical information. Above all make sure you know who wrote the script and who wrote the story and whether it is based on a novel, play, or unpublished story concept by one of the producers. At the very least, honor those who worked on the production just as you hope someday people will look at your name in the credits.

Writing skills can also lead to careers other than writing television or screenplays on spec or on commission. Understanding the way scripts work and learning about story structure, character, and dialogue could lead to a career as a script reader or editor. There is also a growing business of script consultancy and live and online seminars although such practitioners have to have some kind of credential usually based on writing credits. Producers who commission writers benefit enormously from having tried to write themselves, as do directors and actors. Some writers combine writing and directing, or writing and producing. A director has to work very closely with a scriptwriter, especially if the director cannot write. Actors also combine acting with writing scripts as they do acting with directing, which is probably more common. Story and writing is so fundamental to creating content that a wide array of people and craft skills needs to work with scripts. Beginning with selection, readers and script editors have to know what makes writing work and be able to evaluate it. Almost anyone involved in preproduction and many involved in production need to understand scripts and scriptwriting. At the back end, an editor, working with the director, has to interpret the intention of the script with the actual produced material. Time invested in learning about writing, taking courses, trying to write can be valuable to many tangent careers in the entertainment world.

CONCLUSION

Writing is a risky business. It is a bet on your own talent like most artistic pursuits. You can train and develop your talent. There is, however, no guarantee of success. If you are going to try to make a living as a writer of scripts, you have to be professional and disciplined. You have to want to reach audiences. You have to want to move audiences. That is your motivation, not just the money. You have to be the audience as well as the writer. You have to be obsessed with understanding what makes people choke with emotion, laugh, feel outrage, and cheer for a character they identify with. This feeling for the audience must underlie any writing. Even writing a training video for a corporate client requires careful consideration of the people in the audience. You need to think about what they need to know, how they will understand, and whether you have communicated successfully. An audience is an audience, whether for a big-screen movie, a how-to training video, or a website that presents a corporate face to the world.

To get ready to earn a living by writing for media, you should read the work of professionals and read books by professionals about the craft and business of writing. There is a selected bibliography at the end of this book. There are also a number of websites dedicated to writing to be found on the companion website and also listed in the bibliography. Above all, you have to have conviction about your writing. It can be a lonely business. Nobody will recognize you until you have produced work that you can show. Persistence is indispensable. It is difficult to give advice on this matter. What would you

say to a basketball player or any athlete who has ambitions to play professionally? You'll never know if you don't try. At some point, you may realize that even though you have talent, you are not succeeding. So you go to plan B. Or economic necessity drives you to take up some other activity, perhaps related.[11] These choices are intensely personal in nature. Nobody can really tell you how to make them.

To be a successful writer you must consider the following general rules and principles to govern your life and work. You must:

- Write regularly if not every day
- Learn to take criticism and feedback
- Learn from your mistakes
- Rewrite and love doing it
- Avoid talking about your writing except in very narrow professional contexts
- Write out of conviction and not out of desperation or false ambition
- Take risks and challenge yourself
- Believe in your capability and validate it by writing
- Love writing regardless of the end result

The ambition to make it as a writer has to be strong; it can also be exhausting and discouraging. The writer is by turns a craftsman, a hack, a professional wordsmith, and an image maker. There are triumphs and disappointments. Live to write another day! Remember, many write; few are chosen. Whatever you do, whatever you become, this writer wishes you the best possible breaks and the courage to fulfill your creative potential. In this spirit, I hope this book has been a worthwhile learning experience and will provide you with a foundation for your chosen craft.

EXERCISES

1. Call up a few agents and try to find out whether they will accept new writers or read unsolicited manuscripts.
2. Visit the Writers Guild websites (UK and USA East and West) and find out what you have to do to register a script.
3. Contact a television series editor and find out whether you can submit a spec script for that series.
4. Make a plan for your professional development as a writer.
5. Call up three corporate production companies in your area and find out whether they will look at some of your work.
6. Contact a nonprofit organization or a charity and ask the organizers if they have any media projects planned and whether you can do some writing for them at no cost.
7. Write a pitch for a well-known classic story such as *Hamlet* or *Romeo and Juliet* or *Oedipus Rex*.
8. Write a log line for a well-known classic story or for a well-known successful film such as *Jaws*, *Titanic*, or *Casablanca*.
9. Write a logline for your idea for a screenplay.
10. Practice pitching your story idea to another writer or a writing class.
11. Research screenplay competitions online. Submit an entry for one of them.
12. Take and online webinar about some aspect of screenwriting.

11 Lorian Tamara Elbert, editor, *Why We Write: Personal Statements and Photographic Portraits of 25 Top Screenwriters* (Los Angeles: Silman-James Press, 1999), p. xiv: "only five percent of the approximately 8,500 Writers Guild members actually make a living from their writing."

Script Formats

DUAL COLUMN: PSA, DOCUMENTARY, CORPORATE

The visual look is cold, monochromatic blue.	
FADE UP ON...	(MUSIC—increasing tension.)
EXT. ALLEY—DAY (4 seconds)	(SFX—The pulse of a racing heart.)
An urban alley in a poor part of town.	(Over this sound, we hear a series of DESPERATE VOICES.)
Garbage and debris litter the ground.	
From a low angle, we look up at a tough, angry thirteen-year-old BOY. A CIGARETTE is jammed into the corner of his mouth. He walks through the alley with anger and attitude, kicking at the trash and smashing his book bag against the wall.	VO: WOMAN'S VOICE (angry, frustrated, desperate, rising in pitch, losing control) The school called again. What am I going to do with you?!
The image in the alley is interrupted by a FLASH CUT (1 second)	(SFX—Glass cracking.) (1 second)
(Full color.)	
A happy family PORTRAIT. A single mother and the thirteen-year-old boy.	
He's dressed neatly in a tie.	
A jagged CRACK slices across the glass.	(SFX—Woman crying. Struggling. Bottle breaking.)
CUT TO...	

INT. ROOM—NIGHT (4 seconds)	VO: FATHER'S VOICE (angry, drunk, slurred speech)
A young BOY, six or seven huddles against a wall, terror and pain in his eyes. Behind him, we see the SILHOUETTES of a man hitting a woman.	(SFX—SLAP.) Don't you ever turn away (SLAP) from me when I'm talking! (SLAP)

DUAL COLUMN ANCHOR NEWS SCRIPT

ON CAMERA: SHERRY	DRIVERS BETTER KEEP THEIR EYES PEELED. NEW 55-MILE-AN-HOUR SPEED- LIMIT SIGNS ARE GOING UP... TO KEEP OUR POLLUTION DOWN. W-B 39'S KATIE MCCALL TELLS US ABOUT THE CHANGES.
TAKE VTR	SOT 1:38
17 SUPER: JANELLE GBUR DEPT. OF TRANSPORTATION	
32 SUPER: KATIE MC CALL REPORTING	
40 SUPER: MIKE STAFFORD HARRIS COUNTY ATTORNEY	
1:38 TAPE OUT	1:38 STD OUT CUE

DUAL COLUMN MULTI-CAMERA SCRIPT

FADE IN:	
CG title	FADE UP MUSIC INTRO
SEMINAR SET	SEGUE TO
WIDE SHOT of instructor and learners Instructor to camera	INSTRUCTOR: (smiling) The industry has a standard layout for dual column scripts using for corporate, documentary, and public service announcements. EAGER LEARNER: Why is the action in caps?
WIDE ANGLE of seminar table STILL STORE script page	INSTRUCTOR VO: It doesn't have to be. I have seen the reverse where spoken dialogue is in caps and action is in lower case.

CU Eager Learner taking notes. WIDE ANGLE of the group MS of Instructor	SECOND EAGER LEARNER: Can we choose? INSTRUCTOR: I advise putting speech into upper and lower case because it is easier to read. Action description can also be in lower case.
	EAGER LEARNER: What font do we use?
CU Eager Learner LS Instructor	INSTRUCTOR: I use Courier New 12 point, but outside the entertainment industry, the rules are less rigid. The most important point about the dual column format is that the columns should be equal in width and action and speech should be related by horizontal position opposite one another.

PACKAGE SCRIPT FOR NEWS

VIDEO	AUDIO
NAT SOUND: "SPEED LIMIT 60" SIGN FALLS FORWARD & HITS GRASS, NATS WORKER TIGHTENING SCREWS	NAT SOUND :03
COVER BEGINNING OF BITE WITH FREEWAY SIGN THAT READS "SPEED LIMITS REDUCED THIS WEEK"	SOT :03 ALMA NICKELBERRY: "I DON'T LIKE IT. I THINK, WELL, I CAN'T REALLY SAY WHAT I THINK."
ALMA AT GAS PUMP NEW SPEED LIMIT SIGN CARS ON FREEWAY	ALMA NICKELBERRY AND OTHER HARRIS COUNTY DRIVERS GET THEIR FIRST GLIMPSE OF THE NEW 55-MILE-PER-HOUR SIGNS ON AREA FREEWAYS.
NAT SOUND: TRAFFIC ON FREEWAY	QUICK NAT SOUND TRAFFIC OF FREEWAY :01
SOT JANELLE GBUR COVER END OF BITE WITH TIRES ON FREEWAY	SOT JANELLE GBUR "IT BASICALLY MEANS IF THEY'RE GOING 55, IT'S TAKING THEM 14 SECONDS LONGER TO DRIVE THAT MILE." :06
WORKERS PUTTING UP SIGNS	THE PLAN IS TO GET ALL SIGNS UP BY MAY FIRST... TO HELP BRING HOUSTON INTO COMPLIANCE WITH THE CLEAN AIR ACT.

TRAFFIC	CARS ARE SUPPOSED TO EMIT LESS NOX... NITROGEN OXIDES... AT THESE SLOWER SPEEDS.
STANDUP (ZOOM OUT FROM 55- SPEED LIMIT SIGN TO KATIE MCCALL IN FREEWAY MEDIAN)	STANDUP: "BUT AS QUICKLY AS YOU'RE SEEING THESE SIGNS GO UP, THEY COULD COME RIGHT BACK DOWN. SOME SAY THERE'S NEW EVIDENCE THAT SHOWS SLOWING TRAFFIC DOWN WILL NOT CUT DOWN ON POLLUTION." :11
SOT MIKE STAFFORD	SOT MIKE STAFFORD "THE EPA MODEL INDICATES THAT WE ARE NOT GOING TO GET REDUCED NOX EMISSIONS BY LOWERING THE SPEED LIMIT." :06
STAFFORD AND REPORTER WALKING ALONG ROAD, IN FRONT OF SPEED LIMIT SIGN	COUNTY ATTORNEY MIKE STAFFORD HAS PETITIONED THE TEXAS NATURAL RESOURCES CONSERVATION COMMISSION TO STOP THE SIGN CHANGING... BECAUSE A
WORKER REMOVING SIGN	RECENT E-P-A STUDY SHOWS, CONTRARY TO PREVIOUS STUDIES, THIS –
SOT WORKER IN CHERRY-PICKER POSTING NEW SIGN	QUICK NAT SOUND SIGN GOING UP WILL NOT CLEAN UP THIS –
DOWNTOWN SKYLINE & SMOG SOT TRAFFIC	QUICK NAT SOUND SMOG & TRAFFIC
MIKE STAFFORD SOT	SOT MIKE STAFFORD "AT THE SAME TIME, THE TEXAS NATURAL RESOURCE CONSERVATION COMMISSION'S OWN STUDY INDICATES THAT EVEN IF YOU WERE TO REDUCE NOX EMISSIONS, THAT MAY NOT REDUCE THE GROUND OZONE THAT APPEARS AS SMOG ON OUR SKYLINE." :13
FREEWAY TRAFFIC & SMOG	STAFFORD, ALONG WITH COUNTY JUDGE ROBERT ECKELS AND GOVERNOR RICK PERRY, IS ASKING THE T-N-R-C-C TO LOOK AT OTHER WAYS TO REDUCE OZONE.
SKYLINE ON CLEAR DAY	IF IT CAN FIND THEM—AND PROVE THAT TO THE E-P-A—YOU COULD SEE AN OLD

SPEED LIMIT 60 SIGN	FAMILIAR FRIEND BACK ON THE FREEWAY.
FREEWAY OVERPASS	BUT UNTIL THEN, CHANGE IS IN THE AIR.
SPEED LIMIT 55 SIGN	KATIE MCCALL, W-B 39 NEWS, HOUSTON.

RADIO SCRIPT FORMAT

1. SOUND FX: INTERIOR CAR SOUND OF MOTOR AND EXTERIOR TRAFFIC
2. MUSIC BED CAR RADIO—HEAVY METAL FADE UNDER.
3. COLLEGE STUDENT 1 What a great party!
4. COLLEGE STUDENT 2 I'm wasted.
5. COLLEGE STUDENT 1 Are you all right to drive?
6. COLLEGE STUDENT 2 Hell yes.
7. COLLEGE STUDENT 1 (PANICKED) Look out!
8. MUSIC BED SEGUE TO
9. SOUND FX: SCREECH OF BRAKES THEN CAR CRASH
10. SOUND FX: AMBULANCE SIREN
11. ANNCR: If you drink and drive, death could be the chaser.
12. MUSIC STING ORGAN CHORD

MASTER SCENE SCRIPT: FEATURE FILM FOR CINEMA AND TELEVISION

EXT. LAKE FRONT—DAY

There is a lot of commotion as passengers board a steamer moored along side. DAISY and WINTERBOURNE in LONG SHOT. She is quite sudden in her movements as she moves up the Gangway. The steamer blows its whistle and prepares to cast off. There is a summer breeze rippling the lake.

EXT. LAKE STEAMER DECK—DAY

WINTERBOURNE feels they are on an adventure as they stroll the deck. DAISY is animated and charming. She is not flustered when she is aware than people are staring at her. People look at her because she is pretty and because of her unconventional manners and apparent liberty with her escort. They find a seat on the deck and WINTERBOURNE looks at her enchanted while she chatters on.

 DAISY

 I wish we had steamers like this in
 America.

 WINTERBOURNE

 Well, what about on the
 Mississippi?

 DAISY

 I don't live near the Mississippi.

 WINTERBOURNE

 Well, we've got the trip back to
 look forward to.

 DAISY

 What's your first name, again?

 WINTERBOURNE

 Frederick!

SCENE SCRIPT, VERSION 1: TELEVISION
SITCOMS AND SERIES

EXT. LAKE FRONT—DAY

THERE IS A LOT OF COMMOTION AS PASSENGERS BOARD A STEAMER MOORED
ALONG SIDE. DAISY AND WINTER BOURNE IN LONG SHOT. SHE IS QUITE
SUDDEN IN HER MOVEMENTS AS SHE MOVES UP THE GANGWAY. THE STEAMER
BLOWS ITS WHISTLE AND PREPARES TO CAST OFF. THERE IS A SUMMER
BREEZE RIPPLING THE LAKE.

EXT. LAKE STEAMER DECK—DAY

WINTERBOURNE FEELS THEY ARE ON AN ADVENTURE AS THEY STROLL THE
DECK. DAISY IS ANIMATED AND CHARMING. SHE IS NOT FLUSTERED WHEN
SHE IS AWARE THAN PEOPLE ARE STARING AT HER. PEOPLE LOOK AT HER
BECAUSE SHE IS PRETTY AND BECAUSE OF HER UNCONVENTIONAL MANNERS AND
APPARENT LIBERTY WITH HER ESCORT. THEY FIND A SEAT ON THE DECK AND
WINTERBOURNE LOOKS AT HER ENCHANTED WHILE SHE CHATTERS ON.

 DAISY

 I wish we had steamers like this in
 America.

 WINTERBOURNE

 Well, what about on the Mississippi?

SCENE SCRIPT, VERSION 2: TELEVISION SITCOMS AND SERIES

EXT. LAKE FRONT DAY

(THERE IS A LOT OF COMMOTION AS PASSENGERS BOARD A STEAMER MOORED ALONG SIDE. DAISY AND WINTERBOURNE IN LONG SHOT. SHE IS QUITE SUDDEN IN HER MOVEMENTS AS SHE MOVES UP THE GANGWAY. THE STEAMER BLOWS ITS WHISTLE AND PREPARES TO CAST OFF. THERE IS A SUMMER BREEZE RIPPLING THE LAKE.)

EXT. LAKE STEAMER DECK—DAY

(WINTERBOURNE FEELS THEY ARE ON AN ADVENTURE AS THEY STROLL THE DECK. DAISY IS ANIMATED AND CHARMING. SHE IS NOT FLUSTERED WHEN SHE IS AWARE THAT PEOPLE ARE STARING AT HER. PEOPLE LOOK AT HER BECAUSE SHE IS PRETTY AND BECAUSE OF HER UNCONVENTIONAL MANNERS AND APPARENT LIBERTY WITH HER ESCORT. THEY FIND A SEAT ON THE DECK AND WINTERBOUNRE LOOKS AT HER ENCHANTED WHILE SHE CHATTERS ON.)

 DAISY
 I wish we had steamers like this in
 America.

 WINTERBOURNE
 Well, what about on the Mississippi?

 DAISY
 I don't live near the Mississippi.

INTERACTIVE GAME SCRIPT

(This Is One Type of Interactive Script)
(Reproduced with permission of Screenplay Systems Movie Magic Scriptwriter.)

ROCKY COURTYARD

It is a rock-hewn courtyard, old and decaying, but clearly having once been elegant.

To the north is the imposing edifice of a temple, to the west is a gaping chasm, completely impassible.

South of us is a gate, an apple orchard just beyond it.

 GO TO GATE (2)

 GO TO TEMPLE (3)

 GO TO CHASM (4)

ORCHARD GATE

IF YOU TRY TO OPEN THE GATE THEN

IF YOU HAVE THE <KEY TO THE ORCHARD GATE> THEN The gate creaks open.

 GO TO ORCHARD (5)

 OTHERWISE

The gates rattle but you can't get through.

 ENDIF

 ENDIF

 GO TO ROCKY COURTYARD (1)

TEMPLE

The temple is elegant, bas-relief images of strange animals covering the walls.

You can go around the temple to the left or right.

 GO TO RIGHT AROUND TEMPLE (7)

 GO TO LEFT AROUND TEMPLE (6)

CHASM

An uncrossable chasm at your feet.

 IF YOU JUMP THEN

 GO TO YOU'RE DEAD (16)

 END IF

 GO TO ROCKY COURTYARD (1)

ORCHARD

Congratulations! You're in. Eat an apple while you're here.

 GO TO ORCHARD GATE (2)

LEFT AROUND TEMPLE

Broken columns litter your path as you walk around the temple, finally opening up and leaving you at the inner buildings.

 GO TO INNER BUILDINGS (8)

RIGHT AROUND TEMPLE

Broken columns litter your path as you walk around the Temple. Midway around, you'll find an open door.

IF YOU ENTER THE DOOR THEN

```
        GO TO TEMPLE ROOM (13)
                ENDIF
```

The Walkway continues around finally opening up and leaving you at
the inner building

```
        GO TO INNER BUILDINGS (8)
```

INNER BUILDINGS

```
            IF <CLOCK IS SET> THEN

        GO TO BACK OF TEMPLE (10)
                ENDIF
```

A large ornate door blocks your way, a lion headed knocker on the
front door.

```
                IF YOU USE THE KNOCKER THEN
```

It hits the door with a loud booming sound, but no one opens it.

```
                END IF
                IF YOU LOOK UP THEN
```

You will see more carvings and a sign over the door, held up by
two clocks.

```
                IF YOU EXAMINE THE SIGN THEN YOU'VE <EXAMINED SIGN> AND
```

It says:

When time and place are correct, then the doors to opportunity will
open.

```
                END IF
                IF YOU HAVE <EXAMINED SIGN> AND YOU CLIMB UP THEN
```

You can reach the two clocks.

```
        IF YOU SET THE TWO CLICK HANDS TO BOTH POINT
        AT THE DOOR THEN THE <CLOCK IS SET> AND
```

The door opens silently.

```
        GO TO HALLWAY OF INNER BUILDINGS (9)

        GO TO BACK OF TEMPLE (10)
                ENDIF
                ENDIF
                ENDIF

        GO TO BACK OF TEMPLE (10)
```

HALLWAY OF INNER BUILDING

It's a long hallway, water on the floor. There is a door to the
right of you.

IF YOU TRY AND OPEN DOOR THEN

it creaks open.

```
        GO TO LIBRARY (14)
              ENDIF
the hallway extends to an inner courtyard
        GO TO INNER COURTYARD (15)
        GO TO INNER BUILDINGS (8)
```

BACK OF TEMPLE

More bas-relief, these even weirder. From here you can go either left or right around the temple.

```
        GO TO INNER BUILDINGS (8)
        GO TO RIGHT AROUND TEMPLE II (11)
        GO TO LEFT AROUND TEMPLE II (12)
```

RIGHT AROUND TEMPLE II

Broken columns litter your path as you walk around the temple, finally opening up and leaving you at the rocky Courtyard.

```
        GO TO ROCKY COURTYARD (1)
```

LEFT AROUND TEMPLE II

Broken columns litter your path as you walk around the temple. Midway around, you'll find an open door.

IF YOU ENTER THE DOOR THEN

```
        GO TO TEMPLE ROOM (13)
              ENDIF
```

The walkway continues around finally opening up and leaving you at the rocky courtyard.

```
        GO TO ROCKY COURTYARD (1)
```

TEMPLE ROOM

A small temple, long pews on either side.

An OLD PRIEST stands with his back to you at the alter, mumbling something in what sounds like Latin.

IF YOU SPEAK TO HIM THEN

> Go away!
>> PRIEST (without turning)

IF YOU CONTINUE TRYING TO TALK TO HIM THEN

>> PRIEST (CONT'D) (still without
>>> turning)

If you value your soul, then turn back before it's too late... go, leave me!

```
        ENDIF
        ENDIF
```

IF YOU WALK UP TO THE PRIEST THEN

He turns, and you see that he's quite dead, maggots crawling in what's left of his face... he lunges for you and you quickly join his condition...

```
    GO TO YOU'RE DEAD (16)
            ENDIF
    GO TO RETURN (0)
```

LIBRARY

Lots of books and a large key on the table.
 IF YOU TAKE KEY THEN YOU HAVE <KEY TO THE ORCHARD GATE>.
 GO TO RETURN (0)

INNER COURTYARD

Lots of cool statues.
 GO TO HALLWAY OF INNER BUILDING (9) YOU'RE DEAD

That's it!

Gods & Monsters

Video Game Concept for *Gods & Monsters* (copyright 2003 International Hobo Ltd.) reproduced with permission.

Premise

The story of two brothers, Telamon and Peleus, who were friends of Heracles, voyagers on the Argo and enemies of the goddess Athena. Quest-based gameplay in which the player controls Telamon to fight, but Peleus fights alongside using unique combat mechanics. Together they combine talents to defeat armies and mythic creatures. After playing Telamon and Peleus' story, more quests become unlocked telling tales of different pairs of heroes (e.g. Heracles, Jason etc.). All heroes can be powered up by an RPG-style mechanic.

Mechanics

Controls

PS2	XBox	Meaning	Notes
X O	A B	Attack Power	Can press up to four times for a sequence of attacks Used with direction push to dive, flip etc.
D	X	Shoot Arrow	If locked on, fires at target
	Y	–	*Currently unused*
L1 or L2	L	Lock On	When held, locks player onto target enemy If no other button pressed, automatically blocks
R1 or R2	R	Call to Partner	Changes between Open, Co-op and Guard

Attacks & Special Attacks

The player's first three attacks (on the Attack button) come in quick succession; the fourth is more powerful, but much slower. The most efficient way to attack is therefore to get the rhythm of the first three attacks and never trigger the fourth (a standard fighting game mechanic).

Special attacks can be pressed by using the Power button after a different number of Attacks (A = attack button, P = power button, + = 'then press . . . '):

- **P:** if Power is used without a direction (or when pressing forwards), causes a jumping weapon attack carrying the player forward a short distance
- **A + P:** power blow, that knocks back opponent a short distance
- **A + P + P:** as above, but followed by the jumping attack to close distance
- **A + A + P:** wide arc attack clears surrounding opponents (low damage)
- **A + A + A + P:** crushing blow, which can stagger opponent and lower their shield

These different combinations are simple to enter, and hence 'button mashing' still produces useful actions.

Locking On

Holding the Left trigger locks on to an opponent in the front arc. In this mode, the player can use all of the attacks they can use when unlocked, plus they can press Shoot to fire an arrow at their opponent.

Partner Trigger

When the Right trigger is pressed, the player's hero calls out to their partner for help. The partner switches between three contexts:

- **Open:** partner chooses own targets, staying within about 20 m radius of player
- **Guard:** partner stands back-to-back with player to protect their rear
- **Co-op:** partner attacks the same target as the player, using co-operative attack

Which context the partners goes into depends upon the circumstances, using a highly intuitive system which can easily be learned experientially:

	Final Context	
Current Context	**If no enemy locked**	**If enemy locked on (L-trigger held)**
Open	→ Guard	If enemies in rear arc, → Guard Else, → Co-op
Guard	→ Open	→ Co-op
Co-op	If enemies in rear arc, → Guard Else, → Open	If enemies in rear arc, → Guard Else, → Open

Informally, when unlocked, pressing Partner trigger switches between Open and Guard. When locked on, pressing Partner trigger switches between Open and Co-op.

If the player is being attacked from behind, pressing Partner trigger instead switches to Guard.

Armor

To help build atmosphere, the player's state of health is shown visually, by their armor. As they take damage, they lose items of armor. First, they lose their shoulder plate (75% Armor), then their breastplate (50% Armor), then finally their helmet (25% Armor). From 24 to 1% armor they are down to just a loincloth. At 0%, they are dead.

Their partner also has armor, *but cannot be killed*. Instead, when their armor runs out they automatically go into Guard position (the safest position).

The Legends

Initially, only Telamon & Peleus can be played, but the other legends unlock progressively:

1. **Telamon & Peleus:** the two brothers travel on the Argo, until Heracles leaves the voyage, and ultimately face off against the daughters of Medusa.
2. **Atalanta & Jason:** the first half of the story of the Argonauts, told from the perspective of Greece's legendary female warrior, Atalanta, who is partnered here with Jason.
3. **Jason & Medea:** the second half of the story of the Argonauts, as Jason returns to Greece with the Golden Fleece, partnered with his new wife, the sorceress Medea.
4. **Peleus & Heracles:** the tale of five of the twelve labours of Hercules (Heracles), told from the perspective of his friend Peleus, who helped him on several labours.
5. **Theseus & Telamon:** the legendary story of Theseus and the Minotaur, with Telamon partnering Theseus.
6. **Medea & Atlanta:** as Jason betrays Medea, she seeks revenge upon him, and partners with Atalanta for her own legend.
7. **Heracles & Theseus:** the story of mighty Heracles is concluded, with him partnered with his cousin and admirer, Theseus. Ultimately, Heracles ascends to Olympus as a god.

The Quests

As well as the seven story-driven Legends above, the player can also complete seven quests—one for every hero. This is carried out in Quest Mode, in which the player can take any pair of heroes into any of the game levels. Each hero can acquire a mythic item (the Silver Bow of Artemis, Zeus' Thunderbolt, the Helm of Hades, the Winged Sandels of Hermes etc.) by completing a series of challenges which are 'hidden' in the levels, but marked with the seal of the hero's patron god. The hero then uses the item to complete a final challenge.

> *For example, Medea's quest begins when her patron deity, Hecate, orders her to acquire the head of one of the daughters of Medusa. To do this, she must find where the Adamantium Sickle is held (the only weapon strong enough to cut off the head), and also acquire the Kibisis Pouch (which can hold the head safely). Only when she has found, and defeated the guardians of, these items, can she go to the daughters of the Medusa and get a Gorgon's head. Then, Hecate sends her into the Underworld to 'rescue' Persephone from Hades, using the Gorgon's head to turn her enemies to stone.*

These quests provide a reuse of resources at very little cost, and provide an extended play window, extending the value of word-of-mouth and other consumer-lead market effects.

Additionally, the player receives a letter grade (Epsilon, Delta, Gamma, Beta, Alpha or Omega) for each level in Quest Mode, allowing hardcore players to strive to get Omega on every level.

Gameplay Example

This is set in the first Legend, Telamon & Peleus, during the part of the voyage of the Argo when these two heroes were aboard. The player is Telamon; Peleus is their partner.

The Argo has set ashore on the Arcton penisula, en route to the Black Sea and Colchis (where the Golden Fleece is held). Desperately short of food, all the Argonauts are told to go out seeking sup- plies. Telamon briefly talks to Heracles, whom both he and Peleus have befriended. He tells them that the Arcton peninsula is notoriously home to certain Earth-born giants with a bad reputation. Heracles asks the two heroes to take care, and heads off on his own.

Telamon and Peleus talk amongst themselves as they head out into the peninsula—their conversation is ended by unintelligible talking from a ridge nearby. A short engine cut shows the group of six-armed nine-feet tall giants on the other side of the ridge.

The heroes engage. At first, Telamon wades into open combat (Peleus picks his own targets), but the enemy is strong. Soon, Telamon is surrounded. He tries a wide-arc attack to throw them off, then hits his trigger to call to Peleus ("I need some help here!"). Because there are enemies in Telamon's rear arc, Peleus rushes to fight back to back, guarding Telamon's back.

They cut the group down to just two opponents, but another giant arrives. This one is twelve feet tall, and is dressed in black armor—the leader of this group. Telamon hits his trigger to free up Peleus ("Go get them. . ."), and then locks onto the leader of the group. He starts hitting, but the giant's defense is too strong, and it keeps using a shield to block.

Telamon decides to take out the grunts first, then deal with the leader. Still locked, he hits his trigger to assign Peleus to that target ("Keep the leader busy for me!"), putting Peleus in Co-op mode, then releases the lock trigger (Peleus continues attacking the leader).

Locking onto a distant foe that Peleus has already reduced to just a helm, Telamon hits his arrow button repeatedly and the giant falls down dead—but as he does the other giant hits him and sends him flying. He loses his breastplate—he's down to 50% Armor. He's scored a 3-hit combo at the moment from the arrows, and Peleus hits the giant leader 4 times, extending this combo to 7 while the player while gets their bearings.

Quickly locking onto the last grunt before the combo fades, he starts hitting it just in time to continue the combo. Because a second opponent has been added to the combo, a ×2 appears by the combo count, and after 8 hits (15 hits total) the giant falls.

The player locks back onto the leader (combo ×3), but as he does, Peleus' last piece of armor is removed—Peleus falls into Guard ("I can't hold him any longer"). Telamon will have to defeat the giant on his own. After another 4 hits, the player is knocked back and with Peleus in Guard mode, the combo is broken at 19 × 3 = 57. The player's helm is knocked off—they only have 25% Armor left.

Falling back a safe distance, the player locks on and lets loose with arrows. Although Peleus is in Guard, Telamon hits trigger to toggle Peleus into Co-op . . . since Peleus cannot leave the Guard position without getting some armor, this causes Peleus to shoot arrows to defend Telamon—so the two unleash a rain of arrows together. The giant leader falls, and the highest combo score of the battle (57) is used to upgrade the loot—which includes full armor and a big plus to Attack.

The two carry on, and come to a flock of sheep. Perfect food for the voyage! Telamon tries to grab one, but they run away too fast. Flipping into Co-op ("Help me corner one of these damn sheep!"), the two co-operate to bring down the sheep. They round up the last few with arrows, leaving a dead flock and mutton for all.

The camera pans back to a nearby ridge. From behind it can be see a smooth mound, which rises upwards . . . then higher . . . and higher . . . until a huge thirty foot tall Cyclops shepherd can be seen towering angrily above it's now slaughtered flock!

Telamon locks on, and triggers Peleus into Co-op ("Try and hit its skullcap!"). Peleus begins hitting the Cyclops' skullcap (a context-specified behavior in this case), which partly covers the single eye. When he does, the shepherd stops briefly to readjust its position. Telamon times his shot perfectly and an arrow pierces the Cyclops' eye, blinding it! The giant comes falls to its hands and knees and begins groping after the two heroes in a blind panic. The adventure continues. . .

Notes

How does the game emotionally involve the player?

- "Buddy movie" stories following the adventures of various pairings of heroes
- Vivid, believable recreation of mythic Greece (rather than over-the-top fantasy)
- RPG structure immerses player as they work to 'power up' their heroes
- Strong non-linear interconnections between the stories ("Mythological Pulp Fiction")
- Later quests relate to the relationships between the heroes

How does the game function as wish-fulfillment?

- Player engages in larger-than-life heroics
- Epic quest format
- Player is immersed in famous mythology

How does the game appeal to the hardcore gamer?

- Multi-level controls allows hardcore players to perfect 'advanced' combat techniques (earning greater rewards in terms of character advancement by using combos to 'upgrade' power ups)
- RPG-style format popular with hardcore
- "Fantasy" settings popular with hardcore
- Constant unlocking of materials (new heroes, then mythic items) forms addictive motivating factor

How does the game appeal to the casual gamer?

- Easy controls allows the player to "button-mash" and still progress
- RPG format allows less-expert players to "level up" to tackle tougher quests
- Immersive mechanics (very little displayed as HUD overlays) builds atmosphere
- Quasi-historical setting provides easy identification with game world

Market notes

- Greek monsters are the most recognizable mythic creatures in the West and are perennially popular (especially amongst young males)
- *Shin Sangoku Musou* (*Dynasty Warriors* in the West) series succeeded incredibly in the Japanese market (top five sales positions) by drawing on an identifiable mythology—the Three Kingdoms. (This Three Kingdoms setting is extremely famous and popular in Japan and China). *Gods & Monsters* presents a Westernized version of this approach, using a recognizable Western mythology as the basis for the game.
- Multi-character progression (through reuse of materials in new story contexts) creates longer play window for hardcore players, resulting in longer shelf life and greater capacity to cross over into the casual audience.

Genres

Genre is a French word that means "type" or "class" of things. Another way to look at movie structure is to see repetitive characteristics in movies that have similar stories and plots. These recognizable conventions of plot and setting are useful shorthand descriptions that most of us use to describe something we saw. We say that it was a western, a horror film, a suspense thriller, or a romantic comedy in order to convey a certain type of entertainment experience—one that we have had before and recognize. We cannot describe all of the patterns, and anyway, genres can be mixed. We would risk sounding like Polonius describing to Hamlet the acting range of the players coming to Elsinore: "pastoral-comical, historical-pastoral (tragical-historical, tragical-comical-historical-pastoral)" (2.2. lines 392).

Westerns

This genre began with published stories of the outlaws and other colorful characters of the frontier and the American West. It is the American version of the pirate and outlaw tale of European fiction. In many ways the western recapitulates the story of Robin Hood. Robin Hood could be the archetypal story of the good guy wronged, who has to live beyond the law, whereas the bad guy, the Sheriff of Nottingham, is the law. Maid Marian is the love interest. The good king Richard Coeur-de-Lion is away at the crusades while his bad brother John usurps the throne. Robin, a dis-possessed nobleman, robs from the rich and gives to the poor. You could be forgiven for thinking that this piece of English history was invented by a Hollywood scriptwriter. No wonder this story has been made into a film a dozen times, most recently by Kevin Costner in 1991. Its storyline serves the western.

No sooner had motion picture been invented than the theme of the western furnished rich material, starting with *The Great Train Robbery* (1903) and retelling the story of characters such as Jesse James, Billy the Kid, and Wyatt Earp. Wyatt Earp, his two brothers, and Doc Holiday confront the Clinton gang in the famous Gunfight at the O.K. Corral, which has been made into film several times. The classic *My Darling Clementine* (1946), directed by John Ford, stands out among them. But the best Doc Holiday is played by Val Kilmer in *Tombstone* (1993). Some of my favorites are *Winchester 73* (1950), *The Gunfighter* (1950), and *High Noon* (1953). The Clint Eastwood series of westerns beginning with the spaghetti westerns of Sergio Leone is a newer reworking of the genre, but without the realism. A television masterpiece in this genre is the miniseries *Lonesome Dove* (1989), adapted from Larry McMurtry's western novel. The western has declined in importance over the years. Clint Eastwood has a consistent record of acting in and directing westerns from the days of his role in the television series *Rawhide* through spaghetti westerns, *The Outlaw Josey Wales* (1976), and his award-winning *Unforgiven* (1992).

Romantic Comedies

Romantic comedy often deals with social issues about love, money, class, and society. The essential element is an attraction usually between a man and a woman who either start out by detesting one another or by loving one another and then have to overcome amusing obstacles.

A classic romantic comedy, which required strong male and female leads, is *The Philadelphia Story* (1940). The hostile banter between the male and female leads is in inverse proportion to the warmth of the union with which it will finish. *Sleepless in Seattle* (1993) is a popular romantic comedy that errs on the sentimental side. *Liar, Liar* (1997) has a great comic premise. What if a little boy's wish as he blows out his birthday candles, that his divorced father would stop lying, were to come true? It leads to endless complications and hilarious scenes in which Jim Carrey says exactly what he thinks to everyone he meets. His son's wish eventually brings the father and mother back together in a second chance at repairing the American marriage.

Another brilliant comic premise lies behind *The Bachelor* (1999). A man is going to inherit $100 million on the condition that he is married by his 30th birthday. Guess what! Tomorrow is his 30th birthday and his

girlfriend has just turned him down on a botched marriage proposal. In desperation, he now frantically starts contacting all his ex-girlfriends with a proposal. They all turn him down. Each refusal heightens the tension and incites the audience's interest to a fever pitch. We won't reveal how it ends, but you can recognize a brilliant comic premise in this plot. *High Fidelity* (2000) is a quirky, music-oriented romance about breaking up and reuniting; the main character talks to the camera, using a cinematic version of the theatrical aside. *My Big Fat Greek Wedding* (2002) was a low-budget sleeper that became a box office success because of the ethnic conflict that the heroine has to break out of the confines of expected gender role and then get her non-Greek fiancé to be accepted by her extended Greek family. *Something's Gotta Give* (2003) takes the genre into senior territory and the taming of the womanizing confirmed bachelor. The TV series *Sex and the City* (1998), a serial romance without the comedy and an homage to the chick flick, became a movie 10 years later.

A new style off-beat romantic comedy for the second decade of the twenty-first century might be *Silver Linings Playbook* (2012), which collected an Academy Awards for Jennifer Lawrence in the female lead. Love is the by-product of other trials and tribulations.

There is also a kind of ironic antiromantic comedy that has more social realism or more character realism in which love and marriage are not the be-all and end-all. *Lost in Translation* (2003) explores emptiness and alienation. Woody Allen's script *Vicky Christina Barcelona* (2008) explores cultural contrasts between the European and American idea of love and marriage. Two recent European films about love and loss illustrate the adult alternative to Hollywood romantic comedy. *The Edge of Love* (2008) explores the destructive marriage of a brilliant womanizing drunkard who happens to be one of England's great modern poets—Dylan Thomas. *Il y'a Longtemps Que Je T'aime* (I've Loved You So Long, 2008) explores the rehabilitation of a woman after coming out of prison on parole for murder as she remakes the relationships with her sister and her family.

Horror Movies

This genre has origins in folk literature and fairy tales that children learn. It has a literary pedigree in the classic gothic novel *Frankenstein* (1818) by Mary Shelley. Then there is the vampire legend, which was fixed in its literary form by John Polidori in *The Vampyre* while holed up in a Swiss castle with Lord Byron and Percy and Mary Shelley in 1816, and in Bram Stoker's *Dracula* (1897). *Nosferatu* (1922) began the long career of Dracula and vampire stories in the movies. Seventy years later, Frances Ford Coppola's vampire movie title reflects the original, *Bram Stoker's Dracula* (1992). *Interview with the Vampire* (1994), adapted from the Anne Rice novel of the same name, created a mainstream hit with the tag line: "Drink from me and live forever." Teenage vampire movies include *The Lost Boys* (1987) and *Twilight* (2008) and its sequels. Vampires have populated the movies in endless variations and then broke into television with *Buffy, the Vampire Slayer*.

In the American tradition, we have the macabre tales of Edgar Allan Poe. The horror movie genre now has its own traditions that are almost stronger than any literary tradition. Many of its effects used to depend on lighting, but nowadays depend on computer-generated special effects. Whether it is psychological horror like Hitchcock's *Psycho* (1960) or supernatural horror films such as *Dracula* (many versions) or *The Exorcist* (1973), there is always a strong element of suspense and shock created by playing on the audience's fear of the supernatural and violent threats to normal existence.

Zombie movies have come from B-movie low budget horror films to mainstream television in *The Walking Dead* in 2012 and the movie *World War Z* (2013).

Road Movies

The road movie involves a journey that is both literal and figurative at the same time. It could be a journey of search or a journey of escape. These have ancient pedigree. The original road movie archetype is probably Homer's *Odyssey* or *Jason and the Argonauts*, which was remade in May 2000 as a television miniseries. In these cases, the three-act structure is not always necessary. The structure becomes episodic. A seminal road movie is *Easy Rider* (1969), which is a journey across American culture and counterculture of the late 1960s accompanied by a chorus of rock-and-roll anthems. It is also a buddy movie. *Thelma and Louise* (1991) is road movie with girls as buddies. *Mad Max* (1979) mutates the genre into a futuristic fantasy world. An original family road movie, *Little Miss Sunshine* (2006) reminds us how often this genre, as with *Easy Rider,* becomes a lens for examining American culture (the child beauty contest) and American landscapes. The screenplay by Michael Arndt won the Oscar for Best Original Screenplay in 2007.

Science Fiction

H.G. Wells wrote a science fiction novel called *War of the Worlds,* which was produced as a radio play in a documentary fashion by Orson Welles so convincingly that people began to flee New York and New Jersey believing that a Martian invasion was actually taking place. Then it was made into a movie in 1953, and it still stands up

well for its special effects. Steven Spielberg remade the movie in 2005. The genre of science fiction was relegated to B movies until Stanley Kubrick's *2001: A Space Odyssey* (1970) broke out into the big-time box office. *Star Trek* established the genre on television and spawned eleven movie offshoots with the most recent in 2009. The six-part epic *Star Wars* has since firmly claimed top box office status for science fiction, together with classics such as Spielberg's *Close Encounters of the Third Kind* (1977) and *E.T.* (1982).

There are many subgenre variations, but the basic plot is recognizable. Aliens invade the earth either as a single threat, as in *The Thing* (1956), or as a race, as in *Invasion of the Body Snatchers* (1956). We usually cannot tell who is human and who is alien. By the time we get to *Men in Black* (1997), we have combined the science fiction movie with the buddy movie and comedy. *The Day the Earth Stood Still* (2008) is a remake of a 1951 classic of science fiction that explores the hypothesis that we are not alone in this universe and that superior beings or more powerful beings with greater knowledge than we have exist, which provokes an examination of what is human. The most recent exploration of that theme can be found in *District 9* (2009), in which aliens stranded on earth with a broken-down spacecraft are herded into ghettos. A film like *Alien* (1979) combines science fiction, horror, and suspense. Almost a generation later, this subgenre is still going strong in a movie like *Species* (1995). In 2009, James Cameron extended the range and story matter of the genre with 3-D and special effects in *Avatar*.

War Movies

This genre hardly needs definition. These movies describe the sweep and confusion of war and the way it impacts the lives of individuals and civilian populations. Most war movies are ambivalent about war. The conflict between realism and myth animates the genre. They can be divided between those that celebrate heroism, nationalism, and victory, and those that show suffering and futility. *D-Day: The Sixth of June* (1956), *The Guns of Navarone* (1961), *The Longest Day* (1962), *Tora, Tora, Tora* (1970), and *Midway* (1976) try for the historical sweep. The First World War movie classic, *All Quiet on the Western Front* (1930), is an antiwar movie as much as a war movie. *The Deer Hunter* (1978), stemming out of the Vietnam War, is a modern antiwar movie, as is *Apocalypse Now* (1979). *M*A*S*H* (1970), later turned into a television series, is an ironic view of the Korean war from a behind-the-lines medical unit. *Saving Private Ryan* (1998) tries to have it both ways by combining extreme realism with a sentimental, patriotic storyline. Now the enemy is terrorism and terrorists, intensified after the terrorist attack on the World Trade Center, which turns the genre into a type of mission film, such as *Black Hawk Down* (2001). Elite units of the military are pitted against an anonymous but racially and culturally identified enemy. *Behind Enemy Lines* (2001) is set in the Balkans theater; *Rescue Dawn* (2006) revisits the Vietnam era. A counter trend critical film, *Rendition* (2007), challenges the extremes of antiterrorist illegal policies. The British-made reenacted documentary *Battle for Haditha* (2007) dispassionately reveals the how war crimes happen in Iraq. Recent films examine the personal consequences on individuals serving in Iraq: *The Hurt Locker* (2009), and in Afghanistan, *Brothers* (2009). World War II is continuously revisited and reexamined in film. The true story of Nazi officers who tried to assassinate Hitler is chronicled in *Valkyrie* (2008). *Defiance* (2008) tells the true story of Jews who escaped roundup by Russian collaborators with the Nazis, became partisans in the forests of Belorussia, and survived the war.

Buddy Movies

The beginning of the buddy movie was *The Defiant Ones* (1958), in which Tony Curtis and Sidney Poitier escape from a chain gang while still shackled together. The buddy theme is very much a part of *Butch Cassidy and the Sundance Kid* (1969), although it is also a western. The relationship between the two lead characters is in one way what the movie is about. *The Odd Couple* (1968), originally a Broadway play by Neil Simon, with the classic pairing of Jack Lemmon and Walter Matthau, became a movie and then a TV series. Buddy movies, because they are about character and relationship, lend themselves to low-budget originals like *Swingers* (1996), a portrait of the American male mating quest. Although the buddy movie is about male bonding and is a classic "guy thing," a female variant is *Thelma and Louise* (1991). *Wild Hogs* (2007) is a comedy variant of the biker and buddy movie.

Crime Movies

This is broad category that has several subgenres that have identifiable themes. From the early days of movies, crime has been a major subject matter of motion pictures. The chronicling of prohibition, Chicago mobsters, and legendary figures of crime like Al Capone and Dillinger and led to films such as *Little Caesar* (1930), *The Public Enemy* (1931), and *Scarface* (1932; remade in 1983) and introduced what has become a recognizable genre. Its latest version is *Public Enemies* (2009).

Private Eye (Film Noir)

Humphrey Bogart as Sam Spade in *The Maltese Falcon* (1941) and Philip Marlowe in *The Big Sleep* (1946) is everybody's idea of the private eye. Bogart established the style of the private eye as a tough loner and outsider. Again, a popular literary tradition (detective fiction) is the source. Dashiell Hammett and Raymond Chandler were detective fiction writers who also wrote Hollywood scripts, later followed by Mickey Spillane. A hallmark of the genre is the voice-over narration in the first person by the main character, and the wise guy dialogue. *Chinatown* (1974) is a dark variant. A spoof version of the genre is *Dead Men Don't Wear Plaid* (1982), which incorporates footage from all the classics of the genre.

Murder Mysteries

Body Heat (1981), written as an original screenplay and directed by Lawrence Kasdan, is a small masterpiece with a cunning plot and excellent performances. In the literary tradition, Sir Arthur Conan Doyle's *Sherlock Holmes* and Agatha Christie's *Hercule Poirot* laid the foundations of the genre, which also blends into the detective story or private eye movie. Typically, the plot is very involved and the audience cannot guess who the culprit is until all is revealed at the very end. Detective series have proliferated on television. An elegant variation on the theme, which involves a scathing exposé of the hypocrisy of British class values at the time of World War I, is the understated, brilliant *Gosford Park* (2001), directed by one of the world's great directors, Robert Altman. *Basic Instinct* (1992) is a murder mystery that is almost a film noir but the protagonist is a police detective rather than a private eye.

Gang Movies

Movies about criminal organizations and gangs are numerous. The one movie that rises to the level of art is Francis Ford Coppola's Godfather trilogy beginning with The Godfather in 1972. The mafia has become so much a part of American culture that we almost accept them as an alternate route to success in America. The TV series *The Sopranos* normalizes the life of crime as the family next door, with the mafia boss getting psychotherapy to adjust to his lifestyle. *The Outsiders* (1983), *Heat* (1995), *Snatch* (2000), *Carlito's Way* (1993), and *Pulp Fiction* (1994) provide various takes on the struggle of characters to survive and escape a life of crime. The summer of 2009 saw the release of *Public Enemies* in which the Feds go after the notorious gangsters John Dillinger, Baby Face Nelson, and Pretty Boy Floyd, remaking and updating the subject matter of the 1930s and 1940s.

Undercover Cops

Serpico (1973), an early example of the undercover copy genre, deals with the true-life story of corruption in the police force and the ostracizing of the honest cop. *LA Confidential* (1997) explores corruption in the LAPD. Ethical conflicts and dangerous undercover work give us *The Untouchables* (1987), *Donnie Brasco* (1997), and *The Departed* (2006).

Disaster Movies

Airport (1970), *Towering Inferno* (1974), *Virus* (1995), *Volcano* (1997), *Armageddon* (1998)—disaster movies favor one-word titles. The city, the country, the world (choose one) is threatened by a natural force that transforms someone into a hero as he orchestrates the struggle to save the world in clipped and tense dialogue. It is interesting to compare *The Day After Tomorrow* (2004) with the real tsunami of December in that year, which killed hundreds of thousands of people in the Indian Ocean basin. *Outbreak* (1995) is about another type of environmental disaster—deadly viruses. Disaster movies really explore those forces that human beings cannot control and reminds us of the insignificance of humans in the larger scheme of things. Invisible infections become enemies that for millennia have terrified all civilizations. The Black Death of medieval Europe, the plague, AIDS, and the Ebola virus strike fear into the hearts of us all. A futuristic elaboration of the same premise gave rise to *28 Days Later* (2002). **Useful lists** can found on the web.

Martial Arts

The martial arts movie is really about a theme. The theme crops up in other genres and probably began with the samurai movies of the great Japanese director Akira Kurosawa. A great example is his movie about a young man learning judo in *Sugata Sanshiro* (1943). *The Seven Samurai* (1954), also by Kurosawa, was adapted into a western in the United States, *The Magnificent Seven* (1960), produced by and starring Yul Brynner. The Hong Kong movie

industry developed the kung fu genre, which focused on the set piece dueling of good and bad guys. It has come to depend on a single actor/martial arts practitioner, the model being Bruce Lee. Other actor/martial artists have movies built around them, including Jackie Chan, Chuck Norris, and Steven Segal. The television series *Kung Fu* (1972–1975) introduced David Carradine and the martial arts to a wider public. The fighting style has now invaded many other types of movies; James Bond movies, police stories, and action-adventure movies incorporate it, not to mention television series such as *Walker, Texas Ranger,* and *Martial Law.* We find more serious exploration of martial arts in *The Rebel* (2006) and *The Last Samurai* (2003), which explores the end of the samurai tradition in nineteenth-century Japan's transition to the modern era. *Kill Bill Vol. 1 and Vol. 2* (2003, 2004) brought David Carradine back in a major martial arts story of revenge among a gang of assassins.

Epics

Ben Hur (1959), *Spartacus* (1960), *Cleopatra* (1963), and *Gladiator* (2000) have led to more sword and sandal renditions of ancient history such as *Troy* (2004), based on the mother of all epics, Homer's *Iliad,* and *Alexander* (2004). These films usually involve historical settings and historical characters whose lives affected millions or who are affected by great historical events. The plot usually involves battles, armies, and national destinies. They are, therefore, always big-budget entertainment spectaculars with costumes, large casts, and remote outdoor locations. They are difficult to write and difficult to produce. Nevertheless, new epics have come to the screen in recent years. The film *300* (2006) tells the story of the Spartan resistance to the Persian invasion of Greece at Thermopylae. *Beowulf* (2007), innovative in its use of the 3-D process, visualized the singular Anglo-Saxon epic poem again (another film of the same story was produced in 2005) about a hero who overcomes the monster Grendel and his mother. So it could be classified as a monster story as well.

Action-Adventure

Raiders of the Lost Ark (1981), *Indiana Jones and the Temple of Doom* (1984), *Romancing the Stone* (1984), *Indiana Jones and the Last Crusade* (1989), and *Indiana Jones and the Kingdom of the Crystal Skull* (2008), with a final appearance of Harrison Ford, are some of the recent examples of a genre that probably originates from literary works like H. Rider Haggard's *King Solomon's Mines,* which was made into movies in 1937 and 1950 with excellent results each time. Then there is Tarzan from the novels of Edgar Rice Burroughs, which spawned an endless number of Hollywood movies and was remade lovingly by Hugh Hudson as *Greystoke: The Legend of Tarzan, Lord of the Apes* (1984). These are all stories of fantasy and fiction tenuously connected to reality. Recent examples are *National Treasure* (2004) and *The Mummy* (1999), itself a remake, that are now turning into multiple sequel franchises.

Monster Movies

Mary Shelley's novel *Frankenstein* (1818) is the great ancestor of all monster movies. Monster movies always involve some creature, either man-made or a mutant human. There is *Dr. Jekyll and Mr. Hyde,* which involves again the theme of the mad scientist whose knowledge leads to unpredictable and frightening results. It becomes a kind of parable about the fear of knowledge as power, leading to unintended consequences when man interferes with nature. The genre reached network television in *Beauty and the Beast* (1987), with a story about a cultivated lion-man, who lives in a subterranean society of outcasts, and his love relationship with a beautiful New York district attorney. It presents interesting parables about sexuality and innocence.

Herman Melville's classic American novel *Moby Dick* chronicles Captain Ahab's vengeful pursuit of the White Whale. *Jaws* (1975) really borrows this premise and turns the whale into a great white shark. Following its success, the premise was reworked with alligators, piranhas, squids, and many more; the list includes films such as *Piranha* (1978), *Alligator* (1980), and *Lake Placid* (1999). The monster always has to have a personality and a motive to save its young or get back at its antagonist, the character in the title role. *King Kong* (1933) was remade twice, in 1975 and again in 2005. *Cloverfield* (2008) introduces a huge unknown monster who, instead of climbing the Empire State Building like King Kong, proceeds to wreck Manhattan. You wonder why this fascination with mythical and fantastical monsters endures. It has to be the survival of primal fear in some limbic part of our brains that has always been aroused by monsters in fairy tales and folk legend.

Biography

The Hollywood rag *Variety* refers to them as *biopics.* The genre hardly needs explanation. Certain lives of real people have either historical importance or a story in them of triumph over adversity or achievement in sports or the arts. The story has to involve something out of the ordinary. We can usually identify with the character who will be played by a major actor. In the old days, we had something as straightforward as James Stewart in

The Glenn Miller Story (1953) about the great jazz clarinetist. Most recently, Jamie Foxx played Ray Charles in *Ray* (2004). George C. Scott played General Patton in *Patton* (1970). *La Vie en Rose* (2007), an award-winning French film, told the story of the famous French singer, Edith Piaf, with a stunning Academy Award–winning performance by Marion Cotillard.

Satire

American Psycho (2000), adapted from a novel by Brett Easton Ellis, although crossed with the horror movie theme of a psychotic serial killer, is really a social satire and an attack on male culture and attitudes. *Cannibal Women in the Avocado Jungle of Death* (1988), one of my favorite bad movies, is a camped-up satire on contemporary gender issues starring Bill Maher, later the star of *Politically Incorrect* (abandoned by ABC in 2001 after Maher's politically incorrect remarks about the terrorist attack on the World Trade Center) and the late-night television show *Real Time* on HBO. A satire of the private eye film noir movie is *Dead Men Don't Wear Plaid* (1987), in which Humphrey Bogart appears by virtue of clever intercutting of classic film footage.

Cross Genre

Many excellent movies cannot be classified in a single genre but are hybrids that combine more than one type of genre. For instance, *The Mummy* (1999) is a combination of action-adventure, monster, and horror. Some writers and directors manage to create their own genres. Ironic observation and even comic moments can be introduced into the midst of serious and brutal crime. The Coen brothers film *Fargo* (1996) is a good example; it is a story of state troopers who are trying to solve a crime of kidnapping and murder that is combined with wry social observation of both the main and peripheral characters. It is almost the cinematic equivalent of the omniscient narration of the novel. The more recent Coen brothers film *Burn After Reading* (2008) combines comedy, satire, and suspense. *The Cooler* (2003), a beautifully made and acted film, initially appears to be about the mob and Las Vegas but turns out to be a moving love story as well as an antiheroic exposure of all the characters' behaviors. It defies classification. There are many more. The Woody Allen film *Manhattan* (1979) presents a certain type of character, references to movies and relationships, therapists, and so on. Allen's movies almost constitute a genre in themselves. Charlie Chaplin was perhaps the first to create a unique character and recognizable genre of his own.

Bibliography

General Bibliography

Atkinson, C. "Verizon Chief: Hulu Will Be Over in Two Years." *Broadcasting & Cable*. November 20, 2009.

Burkitt, L. "Commercials On the Go." *Forbes.com*. July 14, 2009.

Carr, N. "The Price of Free." *New York Times*. November 15, 2009.

"Cellphone-only Homes Are Increasing." *Boston Globe*. December 18, 2008.

Dickson, G. "FLO TV Makes Retail Push." *Broadcasting & Cable*. November 14, 2009.

Dickson, G. "Mobile DTV Standard Approved." *Broadcasting & Cable*. October 16, 2009.

Gates, B. *Business @ the Speed of Thought*. New York: Penguin Books, 1999.

Guthrie, M. "What's Webisode Worth." *Broadcasting & Cable*. November 24, 2007.

Holmes, E. "Mobile, DVR Video Log Fastest Growth." *Wall Street Journal*. February 23, 2009.

Jessell, H.A. "Mobile TV's New Free Market Economy." *TVNEWSDAY, 5,* March 13, 2009.

O'Brien, K.J. "Ericsson Reports 61% Decline in Profit." *New York Times*. July 25, 2009.

Reitmeier, G. "A Bigger-Picture Perspective on the Small Screen and ATSC Mobile Broadcasting," A White Paper from NBC Universal, unpublished.

Toffler, A. *Future Shock*. New York: Bantam Books, 1991.

"Top Level Radio Posse Pushes Cellular FM." *Radio Business Report*. November 11, 2009.

General Textbooks on Writing

Hilliard, R.L. *Writing for Television, Radio and New Media*. 9th ed. Belmont, CA: Cengage Learning, 2007.

Kauffman, T. *The Script as Blueprint: Content and Form Working Together, Writing for Radio, TV, Film and Video*. New York: McGraw-Hill, 1997.

Mayeux, P.E. *Writing for the Electronic Media*. 2nd ed. Madison, WI: Brown & Benchmark, 1994.

Rubenstein, P., and Maloney, M. *Writing for the Media: Film, Television, Video, and Radio*. 2nd ed. Englewood Cliffs, NJ: Prentice-Hall, 1988.

Ryan, M., and Tankard, J.W., Jr. *Writing for Print and Digital Media*. New York: McGraw-Hill, 2005.

Yopp, J.J. *Reaching Audiences: A Guide to Media Writing*. Boston: Allyn & Bacon, 2009.

Reference, History, and Criticism

Bluestone, G. "Bartleby: The Tale, the Film." In *Bartleby, the Scrivener: The Melville Annual*, edited by H.P. Vincent. Kent, OH: The Kent State University Press, 1966.

Bowser, E. "The Transformation of Cinema 1907–1915." In *History of the American Cinema: Vol. 2.*, edited by C. Harpole. New York: Charles Scribner's Sons, 1990.

Brownlow, K. *The Parade's Gone By*. New York: Alfred A. Knopf, 1969.

Budd, M., and Kirsch, M.H., eds. *Rethinking Disney: Private Control, Public Dimensions*. Middletown, CT: Wesleyan University Press, 2005.

Campbell, J. *The Hero with a Thousand Faces*. New York: Pantheon Books, 1949.

Campbell, J., and M. Bill. *The Power of Myth*. New York: Doubleday, 1988.

Chomsky, N., and E.S. Herman. *Manufacturing Consent: The Political Economy of the Mass* Media. New York: Pantheon Books, 1988.

Connelly, R.B. *The Motion Picture Guide, Silent Film 1910–1936*. Chicago: Cinebooks, 1986.

Elsaesser, T., and A. Barker, eds. *Early Cinema: Space, Frame, Narrative*. London: BFI Publishing, 1990.

Fox, B. *Documentary Media: History, Theory, Practice*. Boston: Allyn & Bacon, 2009.

Harpole, C., ed. *Cinema: Vol. 1*. New York: Charles Scribner's Sons, 1990.

King Hanson, P., ed. *The American Film Institute Catalog of Motion Pictures Produced in the United States 1911–1920.* Berkeley: University of California Press, 1988.

Masser, C. "The Emergence of Cinema: The American Screen to 1907." In *History of the American Cinema: Vol. 2,* edited C. Harpole. New York: Charles Scribner's Sons, 1990.

Packard, V. *The Hidden Persuaders.* New York: David McKay Company, 1960.

Perrault, C. *Histoires et contes du temps passé, avec des moralités. Contes de ma mère l'Oye.* Paris: Gallimard, 1967.

Schrader, P., and K. Jackson, eds. *Schrader on Schrader & Other Writings.* Directors on Directors Series. London: Faber & Faber, 1992.

Vogler, C. *The Writer's Journey: Mythic Structure for Writers.* Studio City, CA: M. Wiese Productions, 1992.

Early Script Writing Manuals

Ball, E.H. *Photoplay Scenarios: How to Write and Sell Them.* New York: Hearst's International Library Company, 1917.

Beck, L.J. *The Scenario Writers Guide.* Brooklyn: Henry Harris, 1915.

Bertsch, M. *How to Write for Moving Pictures: A Manual of Instruction and Information.* New York: Duran, 1917.

Bradley, W.K. *Inside Secrets of Photoplay Writing.* New York: Funk & Wagnalls, 1926.

Esenwein, J.B., and A. Leeds. *Writing the Photoplay.* Springfield, MA: The Home Correspondence School, 1913.

Farquarson, J. *Picture Plays and How to Write Them.* London: Hodder & Stoughton, 1916.

Fine, R. *Hollywood and the Profession of Authorship, 1929–1940.* Ann Arbor, MI: UMI Research Press, 1985.

Gaudreault, A. "Detours in Film Narrative: The Development of Cross-cutting." In *Early Cinema: Space, Frame, Narrative,* edited by T. Elsaesser and A. Barker. London: BFI Publishing, 1990.

Palmer, F., and E. Howard. *Photoplay Plot Encyclopedia: An Analysis of the Use in Photoplays of the Thirty-Six Dramatic Situations and Their Subdivisions.* Los Angeles, CA: Palmer Photoplay Corporation, 1920.

Parsons, L.O. *How to Write for the "Movies."* Chicago: A. C. McClurg & Company, 1915.

Patterson, F.T. *Cinema Craftsmanship: A Book for Photo Playwrights.* 2nd ed. New York: Harcourt, Brace & Company, 1921.

Film and Television

Armer, A.A. *Writing the Screenplay: TV and Film.* 2nd ed. Belmont, CA: Wadsworth, 1993.

Bluestone, G. *Novels into Film.* Los Angeles: University of California Press, 1961.

Blum, R.A. *Television and Screen Writing: From Concept to Contract.* 3rd ed. Boston: Focal Press, 1995.

Dancyger, K., and J. Rush. *Alternative Scriptwriting; Successfully Breaking the Rules.* 5th ed. Burlington, VT: Focal Press, 2006.

Elbert, L.T., ed. *Why We Write: Personal Statements and Photographic Portraits of 25 Top Screenwriters.* Los Angeles: Silman-James Press, 1999.

Goldman, W. *Adventures in the Screen Trade.* New York: Warner Books, 1983.

Gotham Writers' Workshop. *Writing Movies: The Practical Guide to Creating Stellar Screenplays the Way to Write for Television.* London: Hamish Hamilton, 1981.

Hamp, B. *Making Documentary Films and Reality Videos.* New York: Henry Holt & Company, 1997.

Koch, J., Kosberg, R., and Meureur, T., Pitching Hollywood: How to Sell Your TV and Movie Ideas. Sanger, CA: Quill Driver Books/Word Dancer Press, 2004.

Portnoy, K. *Screen Adaptation: A Scriptwriting Handbook.* 2nd ed. Burlington, VT: Focal Press, 1998.

Rouveral, J. *Writing for the Soaps.* Cincinnati, OH: Writer's Digest Books, 1984.

Schwartz, M.E. *How to Write a Screenplay.* 2nd ed. New York: Continuum, 2007.

Swain, D.V. *Film Scriptwriting: A Practical Manual.* Burlington, VT: Focal Press, 1982.

Taylor, T. *The Big Deal: Hollywood's Million Dollar Spec Script Market.* New York: William Morrow, 1999.

Thompson, K. *Storytelling in the New Hollywood: Understanding Classical Narrative Technique.* Cambridge, MA: Harvard University Press, 1999.

Trottier, D. *The Screenwriter's Bible: A Complete Guide to Writing, Formatting, and Selling Your Script.* 5th ed. Los Angeles: Silman-James Press, 2010.

Vale, E. *Vale's Technique of Screen and Television Writing.* Burlington, VT: Focal Press, 1998.

Whiteside, R. *The Screen Writing Life: The Dream, the Job, and the Reality.* New York: Berkeley Boulevard Books, 1998.

Screenplays, Stories, and Novels

Arndt, M. *Little Miss Sunshine: The Shooting Script.* New Market Shooting Scripts Series, 2007.

Barnett, M., and J. Alison. *Casablanca.* The Script Shop, www.hollywoodscriptshop.com/index.html, 1942.

Campion, J. *The Piano Player.* The Script Shop, www.hollywoodscriptshop.com/index.html, 1993.

Ephron, N. *When Harry Met Sally.* www.dailyscript.com, 1989.

Friedmann, A. *Bartleby,* unpublished script. New York: Museum of Modern Art.
Goldman, W. *Butch Cassidy and the Sundance Kid in Adventures in the Screen Trade.* New York: Warner Books, 1983.
Hecht, B. *A Farewell to Arms.* The Script Shop, www.scriptshop.com, 1957.
Hemingway, E. *A Farewell to Arms.* New York: Charles Scribner's Sons, 1962.
Melville, H. 1853. "Bartleby, the Scrivener: A Story of Wall Street." *Putnam's Magazine* (Nov-Dec, 1853).
Melville, H. "Bartleby, the Scrivener." In *Selected Writings of Herman Melville.* The Modern Library. New York: Random House, 1952.
Niccol, A., and W. Peter. *The Truman Show: The Shooting Script.* www.dailyscript.com, 1998.
Payne, A., and T. Jim. *Sideways: The Shooting Script.* www.imsdb.com/scripts/Sideways.html, 2003.
Schrader, P. *Taxi Driver.* London: Faber and Faber, 1990.
Sorkin, A. *The West Wing Script Book.* New York: New Market Press, 2002.
Stern, P. *Van Dorn, It's a Wonderful Life, Penguin Studio Edition.* Penguin: New York, 1996.
Vincent, H.P., ed. *Bartleby, the Scrivener: The Melville Annual.* Kent, OH: The Kent State University Press, 1966.
Welland, C. *Chariots of Fire,* The Script Shop, www.scriptshop.com, 1980.
Welles, O., and H.J. Manckiewicz. *Citizen Kane.* 1946.

Broadcast Writing

Carroll, V.M. *Writing News for Television: Style and Format.* Iowa City: Iowa State University Press, 1997.
Orlik, P.B. *Broadcast Cable Copywriting.* Boston: Allyn & Bacon, 1998.
Wulfemeyer, K.T. *Beginning Broadcast Newswriting: A Self-Instructional Learning Experience.* 3rd ed. Iowa City: Iowa State University Press, 1993.
Wulfemeyer, K.T. *Radio-TV Newswriting: A Workbook.* Iowa City: Iowa State University Press, 1995.

Corporate and Training

DiZazzo, R. *Corporate Media Production.* Boston: Focal Press, 2000.
DiZazzo, R. *Corporate Scriptwriting: A Professional's Guide.* Boston: Focal Press, 1992.
Matrazzo, D. *The Corporate Scriptwriting Book.* Philadelphia: Media Concepts Press, 1980.
Van Nostran, W.J. *The Scriptwriter's Handbook: Corporate and Educational Media Writing.* Boston: Focal Press, 1996.
Van Nostran, W.J. *The Scriptwriter's Workbook: A Media Writer's Companion.* Boston: Focal Press, 1996.
Van Nostran, W.J. *The Media Writer's Guide, Writing for Business and Education.* Boston: Focal Press, 1999.

Interactive Multimedia

Elin, L. *Designing and developing multimedia.* Boston: Allyn & Bacon, 2001.
Garrand, T. *Writing for Multimedia and the Web.* 2nd ed. Burlington, VT: Focal Press, 2001.
Gross, P. *Director 7 and Lingo Authorized.* Berkeley, CA: Macromedia Press, 1991.
IGDA's Guide to Writing for Games. Game Writers' Special Interest Group. 2003. www.igda.org/writing/index.html
Iuppa, N.V. *Designing Interactive Digital Media.* Burlington, VT: Focal Press, 1998.
Maciuba-Koppel, D. *The Web Writer's Guide: Tips and Tools.* Burlington, VT: Focal Press, 2002.
Miller, C.H. *Digital Storytelling, A Creator's Guide to Interactive Entertainment.* Burlington, VT: Focal Press, 2004.
Siegel, D. *Creating Killer Web Sites.* Indianapolis, IN: Hayden Books, 1996.
Thurlow, C., L. Laura, and T. Alice. *Computer Mediated Communication: Social Interaction and the Internet.* London: Sage Publications, 2004.
Varchal, D. J. *The Multimedia Scriptwriting Workshop.* San Francisco: Subex, 1996.
Wimberly, D., and J. Samsel. *Interactive Writer's Handbook.* 2nd ed. San Francisco: Carronade Group, 1996.

Radio-TV Newswriting

McCullough, V.C. *Writing News for Television, Style and Format.* Iowa City: Iowa State University Press, 1997.
Wulfemeyer, K.T. *Radio-TV Newswriting, A Workbook.* Iowa City: Iowa State University Press, 1993.

Articles, Journals, Blogs, Websites, Papers, and Newspapers

Andrews, Nellie, "CBS' 'Hawaii Five-0' Lets Viewers Choose Episode Ending in Real Time." www.deadline.com. January 3, 2013.
Ayala, D. "Google's Nexus One Specs Leaked." *PC World.* December 16, 2009. www.pcworld.com/article/184778/googles_nexus_one_specs_leaked.html.
Barnes, Brooks. "'Fast & Furious' Stresses Social Side of Fandom." *New York Times.* February 17, 2013.
Barnes, Brooks. "Solving Equation of a Hit Film Script, With Data." *New York Times.* May 5, 2013.

Bray, Hiawatha. "Hub to Get Early Look at Next-level Web Link to Test High-speed 4G Cellular Network." *Boston Globe*. August 13, 2009.

Bray, Hiawatha. "Mobile TV—Not a Lot to See Here." *Boston Globe*. January 16, 2013.

Brink, Julie. "Game-Based Learning for the Corporate World." *TrainingMag.com*. May 7, 2012.

Burr, Ty. "Truthiness and Consequences." *Boston Globe*. February 23, 2013.

Carr, David. "Shunning the Safe, FX Indulges Its Dark Side." *New York Times*. February 3, 2013.

Chmielewski, Dawn C. "Study: Majority of Consumers Watch TV and Surf Web Simultaneously." *L.A. Times*. January 28, 2013.

Corriea, Alexa Ray. "US Military Looking for Better Video Game Training Technology." *Polygon.com*. January 18, 2013.

Crupi, Anthony. "Lazarus: NBC Broke Even on Olympics: Long-term Impact of London Games Yet to Be Determined." *Adweek*. September 6, 2012.

Dickson, G. "ION, OMVC Organize DTV Showcase in D.C." *Broadcasting & Cable*, July 22, 2009.

"Fox Gets Serious about Second-screen Apps." 2013. www.forbes.com/sites/roberthof/2013/02/26/fox-gets-serious-about-second-screen-apps/

Heldenfels, Rich. "Hawaii 5–0" Lets Viewers Choose Episode Ending." *Akron Beacon Journal Online*. January 3, 2013.

Hof, Robert. "Fox Gets Serious About Second-Screen Apps." *Forbes*. February 26, 2013.

Jana, Reena. "On the Job Video Gaming." *Bloomberg Newsweek*. March 26, 2006.

Jessell, Harry A. "ABC Floats TV Everywhere Plan to Affiliates." *TVNewsCheck*. February 26, 2013.

Jessell, Harry A. "Networks Should Energize Mobile DTV Push." *TVNewsCheck*. January 4, 2013.

Kaufman, Leslie. "New Publisher Authors Trust: Themselves." *New York Times*. April 16, 2013.

Kosner, Anthony Wing. "The New TV Apps Will Be Social, and a Whole Lot More." *Forbes*. August 9, 2012.

Kozin, Allan. "MoMA Adds Video Games to Its Collection." *New York Times*. November 29, 2012.

Perez, M. "BlockBuster Bringing Movies To Motorola Phones." Information Week. www.informationweek.com/story/showArticle.jhtml?articleID219400486.

Mandese, Joe. "Nielsen: TV Usage Of 'TV' Continues to Erode, Mobile Is Fastest-Growing Segment." *OnlineMediaDaily*. November 13, 2012.

Marcucci, C. "40% of Americans Use Tablets, Smartphones while Watching TV." *RBR.comTVBR.com*. November 13, 2012.

Meyer, N. "The Situation Comedy Script Format: Its Evolution from Radio Comedy and the Traditional Screenplay," unpublished paper. Broadcast Education Association Panel. 2000.

Miller, Claire. "Tech Predictions for 2013: It's All About Mobile." *New York Times*. February 18, 2013.

Miller, Liz Shannon. "Hey, Twitter, *Hawaii Five-0* Wants You to Pick the Killer." *Gigaom*. January 13, 2013.

MocoNewsNet. January 8, 2009.

O'Leary, Amy. "Jenna Marbles, the Woman with 1 Billion Clicks." *New York Times*. April 12, 2013.

Pfanner, Eric. "Music Industry Sales Rise, and Digital Revenue Gets the Credit." *New York Times*. February 26, 2013.

Rahn, Cornelius, and Jonathan Browning. "TV Makers Join Forces Against Smartphone Giants." *New York Times*. September 5, 2012.

Ravindran, Vijay. "Is This What the Future of TV Looks Like?" *Washington Post*. March 8, 2013.

Reed, David P. "The Law of the Pack." *Harvard Business Review* (February 2001).

Sanger, Steve. "US TV Viewing Time Rises To Highest Ever." June 16, 2011. www.worldtvpc.com/blog/report-shows-younger-viewers-increasingly-watch-tv-mobile-devices/.

Sanger, Steve. "YouTube Reveal Quadruple Viewing Figures For Mobile Platforms, Online Media Daily." *OnLine Media Daily*. October 12, 2012.

Sang-Hun, Choe. "Samsung Advances Toward 5G Networks." *New York Times*. May 13, 2013.

Second Screen Society. www.2ndscreensociety.com/wp-content/uploads/2013/02/Overview-of-the-2nd-Screen-Society-2013.pdf.

Sharma, Amol. "Nielsen Gets Digital to Track Online TV Viewers." *Wall Street Journal*. April 30, 2013.

Stanton, Russ. "Second Screen Revolutionizing the Television Experience." 2012. www.tcs.com/.

Steinberg, Scott. "Video Games Are Tomorrow's Answer To Executive Training." *fastcompan.com*. March 14, 2012. www.fastcompany.com Web 1824740/video-games-are-tomorrows-answer-executive-training.

Stelter, Brian. "Niagara Falls Tightrope Walk Is a Ratings Bonanza for ABC." *New York Times*. June 16, 2012.

Stelter, Brian. "Nielsen Adjusts Its Ratings to Add Web-Linked TVs." *New York Times*. February 21, 2013.

Stelter, Brian. "Don't Touch That Remote: TV Pilots Turn to Net, Not Networks." *New York Times*. March 3, 2013.

Stelter, Brian. "ABC to Live-Stream Its Shows via App." *New York Times*. May 12, 2013.

Substance Abuse: The Nation's Number One Health Problem. Princeton, NJ: Institute for Health Policy, Brandeis University for the Robert Wood Johnson Foundation, October 1993.

"2011 Sales, Demographic and Usage Data, Essential Facts about the Computer and Video Game Industry." Entertainment Software Association. www.theesa.com/facts/pdfs/ESA_EF_2011.pdf.

Vega, Tanzina. "The New Algorithm of Web Marketing." *New York Times*. November 15, 2012.

Wallenstein, Andrew, and A.J. Marechal. "Social Reality Show to Skip TV, Play Entirely on Media." *Variety*. April 25, 2013.

Winslow, George. "NBC Lays Out Final Digital Plans for Olympics." *Broadcasting & Cable*. July 24, 2012.

Scriptwriting Software

www.CeltX.com provides free formatting software.

Final Draft, Final Draft, Inc., 1600 Ventura Boulevard, Suite 800, Encino, CA 91436. www.final- draft.com.

Inspiration, Inspiration Software, Inc., 7412 SW Beaverton Hillsdale Highway, Suite 102, Portland, OR 97225–2167. www.inspiration.com.

Movie Magic Screenwriter, Movie Magic Dramatica, Screenplay Systems Inc., 150 E. Olive Avenue, Suite 203, Burbank, CA 91502. www.screenplay.com.

Movie Master, Movie Master Hollywood Cinema Software, 12A Chestnut Street, Ridgewood, NJ, 07450, e-mail: MMsupport@aol.com.

Scriptware, Cinovation Inc., 1750 30th Street, Suite 360, Boulder CO 80301–1005. www.scriptware.com.

Scriptwerx, Parnassus Software, 1923 Lyans Drive, La Canada, CA 91011. www.originalvision.com.

StoryLinePro, Truby's Writers Studio, 1737 Midvale Avenue, Los Angeles, CA 90024.

StoryVision, 171 Pier Avenue, Suite 204, Santa Monica, CA 90405, e-mail: storyvisn@aol.com.

Glossary

(Note: Glossary entries which are also Key Terms are in *italics*)

Academy of Motion Picture Arts and Sciences This renowned industry organization, recognizing the need for some kind of format for screenplays when sound came into motion picture, began to standardize the screenplay format, which has led to the modern-day master scene script.

Act A term borrowed from the theater to signify a key story point in motion picture narrative.

Action The events and choices whose consequences impact characters and constitute the storyline; the fundamental component of visual narration in visual media.

Actuality A way to refer to real events as in news or directly observed reality as opposed to a description of reality.

Adaptation Using a source that is a fully developed story in fiction or drama and reconceiving it for a motion picture medium.

ADDIE model A five-phase process for instructional design: analysis, design, development, implementation, and evaluation.

Advanced Television Systems Committee (ATSC) The official body of the broadcast industry that has determined the signal standard for all broadcasters to use known as Mobile DTV.

Advertising on the Internet Changes the game from linear to interactive responses and uses contextual targeting a click mapping.

Agents Individuals or companies that represent talent of all kinds including writers. They negotiate fees and, if good, become a clearinghouse for a lot of jobs and put packages together.

Algorithm Computer code that determines the steps in a calculation to make decisions or organize information from data.

Analytic steps The critical thinking about a communication problem that can be summarized as six steps in the form of a question and answer that lead to the creative concept.

Angle of acceptance A term that describes how wide or narrow a given lens frames the scene in front of it.

Antagonist Derived from the Greek word *agon,* meaning "action," *antagonist* refers to the character who is the adversary or opponent of the protagonist.

Apps An abbreviation for applications or software written to run on a given operating system.

Archetype An essential idea or character or image that lies behind many different variations of it.

Archives Another term for libraries of still and moving picture images for which rights are sold for use in a program, although some archives—such as those of the Library of Congress—are in the public domain.

Aristotle Aristotle was the BC fourth-century author of *The Poetics,* which defines literary modes of communication.

Aristotle's Rhetoric A work of literary and communication analysis that explains how persuasion works on the recipient of written and oral argument.

Artificial intelligence A behavior programmed in to an avatar, object, robot, or character that enables it to make choices.

Assets Media elements that are created independently and imported into a multimedia environment.

Asynchronous A term signifying events not happening at the same time, typically in connection with online learning delivery, where sender and receiver communicate at separate intervals.

Audience The receiver of a one-way communication whose response determines the success of dramatic and media writing.

Audience as a character One of the principal persuasive strategies.

Audio writing Writing to designate a series of sounds, whether speech, music, or sound effects, that tell or help to tell a story.

Authoring software Software that enables the writing of code that can program interactivity and create an interface for the user.

Avatar The character that you control in the game or that you create in a multiplayer game.

Axiom A given that is a logical foundation to an argument, in this case, that no communication is necessary unless there is a problem of knowledge or understanding on the part of a potential audience.

B2B Business-to-business.

Background The farthest part of a camera frame along the optical axis of the lens.

Background research and investigation The process that sometimes precedes the concept and certainly the treatment of both corporate and entertainment scripts.

Backstory Refers to the life and background of a character that does not appear in the film or TV episode but that explains who the person is and why he or she is that way. Backstory is usually written up for a series or video game bible.

Bandwidth Describes the size of the data stream in bits or the measure of the speed of a network connection.

Banner ads A type of online advertising that appears on a web page as a banner-shaped box, either still or animated.

Banners *See* Banner ads.

BCU (Big Close-Up) or ECU (Extreme Close-Up) A big close-up or extreme close-up frames the head so that the top of the frame clips the forehead or hairline and the bottom of the frame clips the neck.

Beat A scriptwriting term written in caps to indicate a wait or a pause in the delivery of dialogue. It implies a reaction or when some business intervenes between lines of dialogue.

Beat sheet A scriptwriting term associated with television writing for series, which often substitutes for a treatment and outlines the numbered scenes or sequences for an episode.

Behavioral objective One of three types of objective that engenders actual change in action or behavior as a result of media communication.

Bible The *series bible* or *video game bible* refers to a substantial compilation of backstories and includes explanation of the setting, world, characters, and story background for the benefit of all writers and creative talent involved in the production of a TV series or video game.

Billboards A form of visual medium that often incorporates visual metaphor and meta-writing.

Blogs A contraction of web logs or websites maintained by one person who writes and collects links to other sites concerning a given topic.

Brainstorming A well-recognized process of free associative thinking that takes place at the beginning of the creative process.

Branching A basic schematic for organizing hierarchical relationships.

Branded content A relatively new idea of entertainment conceived around a product or a brand so that advertising is integrated into storylines and content; separate from product placement, which is the incorporation of specific brands as props.

Business theater A live presentation of product, corporate policy, or annual results with prescribed speech and multimedia modules to motivate personnel, usually in a special, sometimes exotic location.

Camera angles Are always in written in uppercase in scripts.

Camera directions A repertoire of camera angles that refer to the size of the frame around the human figure.

Camera lens The image-forming optical device that makes film and video.

Camera movements A repertoire of displacements of the camera platform in all the different possible axes of movement.

Camera plot A diagram of camera positions and moves for a given scene in relation to the action.

Capture audience attention Involves an essential strategic device to hold the audience.

Case history A story of someone's experience that illustrates the issue or idea that is the subject of a video.

Character The fundamental element of drama and story that an audience relates to.

Character as victim A comic device that makes a spectacle out of a character's mishap or misfortune.

Character Generator (CG) The electronic text-composing device that is the most downstream device in a television switcher before program. In video postproduction, a character generator is now integrated with desktop editors. See *titles*.

Character names Are always written in all uppercase in scripts.

Children, babies, and animals One of the principal persuasive strategies.

Circle A paradigm for representing graphically which interactive elements can relate so that all elements are equal, as any part of the circumference of a circle is equivalent to any other part.

Clear title As with a physical property, clear titles in intellectual property have no lien or encumberment.

Click mapping Software that tracks and analyzes a user's clicks and interaction with a web page for better targeting of signage and commercial messages.

Closed questions An interview question that forces the respondent into one of two responses as with legal cross-examination.

Cloud computing A recent development in information technology (Web 2.0) in which data, software, games, and personal consumer content are stored on a partition in a remote server that provides the service either as a commercial service or part of a digital application, such as email, a music locker, or a media store like iTunes.

Clusters Another paradigm for linked islands of information.

Comedy The outcome of conflict that is hilarious or, as Aristotle says, a situation in which people appear to be worse than they are in real life.

Commentary See Voice-overs/voice-over commentary.

Common denominator of a production The script becomes the unifying reference point for all production decisions.

Common law A British tradition of law made by precedent and tradition.

Communication objective An identified outcome to any media communication that can be stated and expressed before commencing the scripting process.

Communication problem The essential need or lack of knowledge or understanding that must be identified before any meaningful analytic or creative thinking can occur.

Communication strategy A choice of persuasive device, story, or image that addresses the psychographic of the audience and disarms resistance or lack of receptivity to a given message or objective.

Computer graphic imaging (CGI) Images created and rendered as pixels that are not produced by light forming an image through a lens onto focal plane.

Concept The first formal document you create in the scriptwriting process is called a *concept*. It is also sometimes called an *outline*. Whatever you call it, its function is the same, namely, to set down in writing the key ideas and vision of the program. This document is written in conventional prose. There is no special format for it. It does not cover all the plot or content; nor does it include dialogue or voice narration. It is primarily an idea in a nutshell from which the script in all its detail will grow.

Conflict The essential element of the premise for any drama or comedy.

Content The articulated matter that carries the story or the message that the audience sees and hears.

Copy platform An advertising term that is an agency formula that approximates the seven-step process of developing a script concept.

Copyright A right of ownership established by registering a work with the Library of Congress.

Copywriting and **scriptwriting** These functions overlap but are not identical in that scriptwriters are not necessarily copywriters and copywriters in ad agencies are not necessarily scriptwriters.

Copywriting for the web A new form of writing, thinking, and visualizing.

Cost benefit An analytic concept that relates cost for any communication exercise to the theoretical money-saving benefit accruing from it with the idea that the demonstrable value of the benefit should exceed the cost.

Cover A director must shoot the same scene from several different camera setups so that action and dialogue are repeated, or covered, in different camera angles in order for the editor to cut between them and create continuity from shot to shot within a scene. Without such cover, a scene cannot be edited.

Cover-up A comic device in which one character tries to cover-up some fact or action of his own or another character's that thereby increases comic tension and the anticipation by the audience that the truth must come and there will be consequences.

Crane A crane shot is made by raising or lowering a camera platform with a crane or boom, or, at great expense, a helicopter-mounted camera. In a low-budget production, a smaller-scale crane effect can be done by bending and straightening the knees while handholding the camera.

Creative concept The key idea or seed from which a script grows; also a form of meta-writing.

Creative visual idea The basis of a script is usually some visual idea or story idea that plays out in some action that can be visualized.

Cross-cutting A form of storytelling in visual media in which by cutting between two sequences two simultaneous events can be tied together.

Cross-platform Usually means something that can work in Windows or Mac OS but can also mean applications that are operational across other kinds of platforms or operational software.

Crowdsourcing A phenomenon of the digital networked world that allows anyone to input views, information, and ideas that determine program preferences or the participation of large groups in social communication, fundraising, political action.

CU (Close-Up) A close-up frames the head and shoulders, leaving headroom above the head. A close-up is a way to frame the face or to highlight detail of inanimate objects.

Cut-scenes Live or computer-generated video clips, usually not interactive; interludes between stages that furnish additional information, such as story elements, tips, tricks, or secrets.

Day/night The third piece of production information in a scene heading that has implications for lighting.

Decorum A term derived from classical rhetorical theory that the style of speech, diction, and vocabulary should match the person or setting.

Demographics The definition of an audience with respect to age, income, education, gender, race, and other key characteristics.

Dénouement A French word meaning, literally, "unknotting," which refers to the resolution of the basic conflict that drives a story.

Depth of field The nearest point of focus to the farthest point of focus in any given shot. This is a function of the focal length of the lens, the f-stop setting, and the shutter speed, usually fixed in film at a 1/48th of a second and in video at 1/30th of a second. Shutter angles can be varied on professional cameras to a small degree that changes exposure.

Design document A commonplace term that refers to the meta-writing or conceptual writing behind interactive media.

Deus ex machina A Latin phrase that means "the god outside the mechanism," found in Aristotle's *Poetics* to explain a weak dramatic device; undermines true tragic drama because it is arbitrary and not connected to human action or choice.

Dialogue Lines written for characters that are acted by talent.

Dialogue cards Written dialogue seen on screen as text to be read by the audience and a beginning to the need for a script to put words in the mouths of characters.

Dialogue engine A series of dialogue lines for each character in a game that are prerecorded and play in response to player choice at various points in the game, especially role playing games.

Digital signage A generic term that refers to all forms of inserting messages into web pages or any digital media.

Disguise Deception of one character by another through physical disguise or false identity.

Dissolve/mix In film production, anything other than a cut has to be created in the optical printer from A- and B-roll offsets. The editor marks up the film so that the lab technician can move the printer from the outgoing shot on the A-roll to the incoming shot on the B-roll. In video, the mix is made with a fader bar that diminishes input from one video source as a second is added. In the middle of a dissolve, when 50 percent of the printer light or video source comes from each picture, a temporary effect called a *superimposition* occurs. This effect is now created digitally within nonlinear editors.

Documentary A factual narrative form of film and television. *Biographical documentary* The story of a life, usually historical. *Dramatized documentary* A factual narrative but resorting to recreated or enacted scenes to imagine what a historical character or event might have been like. *Expedition documentary* A filmed record of a journey of discovery anthropological or geographical. *Expository documentary* A filmed essay that explains something such as science documentaries. *Historical documentary* A factual narrative about people or events in the past. *Investigative documentary* A probing exploration of the truth of an issue usually a political or social. *Objective documentary* An exposition of fact without an editorial or other point-of-view. *Point-of-view documentary* A factual narrative with an editorial point-of-view, or a personal advocacy about an issue. *Science documentary* An specific type of expository documentary that attempts to explain a scientific theory or hypothesis. *Travel documentary* A record of peoples and places that introduces countries and cities to an audience usually with an on-camera presenter. *Wildlife documentary* A record of natural habitat and fauna that investigates the lives and behaviour of animals and the ecosystem in which they live.

Dolly A dolly shot is similar to a tracking shot in that the camera platform moves, but it moves toward or away from the subject so that the frame size gets larger or smaller.

Double-barrelled questions Two questions that are usually linked and sometimes leads to one answer getting lost.

Double take Like many comic devices, the double take is a compact with the audience. The character takes an extra long time to react to a put down or before delivering a reply. Although it can be an acting technique, it is also very much a comic effect that can be written into a script. It needs the right line or situation with an indication in the script. You do this by writing PAUSE, BEAT, or DOUBLE TAKE.

Dramatic irony A dramatic device in which the audience knows more than one of the characters.

Dramatization A technique that explains concepts, policy, or actions in a corporate context by means of dramatic scenarios with character and dialogue.

Dual-column format This refers to a script layout in which all action is described in the left-hand column and all audio is described in the right-hand column.

Dub Used as both a noun and a verb, the term refers to the copying of an electronic signal, both audio and video or either by itself, from one source to a new tape, disk, or new location on a tape or disk.

DVE (Digital Video Effect) Transitions between shots have become so numerous because of the advent of DVEs in computer-based editors and mixers that it would be impossible to list the dozens of patterns and effects. Once again, this is the province of postproduction unless you have a strong reason to incorporate a specific visual effect into your script.

Thomas Edison Thomas Edison is credited with improving the movie camera and inventing 35-mm film, although simultaneous development of the movie camera and projector by the Lumière brothers in Paris moderates that claim.

Educational documentary A form of linear moving picture narrative that is dedicated to imparting knowledge or understanding of a specific subject matter or specific ideas, usually of an academic nature.

Emotion (pathos) One of the modes of persuasion in Aristotle's *Poetics*.

Engine The application that powers a game. One primary engine (the graphics engine) and several smaller engines power AI and sound. People refer to the whole product as the engine.

Establishing shot This shot establishes the setting and the dramatic components of the scene.

Ethical values (ethos) One of the modes of persuasion in Aristotle's *Poetics*.

Ethos, an appeal to ethical values Part of Aristotle's classic analysis of the way persuasion works.

EXT. (Exterior) This is the standard abbreviation for an exterior (or outside) setting used in the slug line of a script.

Fade in Almost all audio events are faded in and faded out to avoid the snap cut to music or effects at full level. This also permits us to use music cues that do not necessarily correspond to the beginning and end of a piece.

Fade in from black All programs begin with this effect, which is simply a mix from black to picture. Sometimes you might write in this effect to mark a break in time or sections of a program.

Fade out This is the audio cue that most people forget to use. They fade in music or effects and then forget to indicate where the audio event ends. The fade out eases out the sound so that an abrupt cut off or stop does not shock the ear or draw attention to itself. Many commercial recordings of popular music are faded out at the end.

Fade out to black All programs end with this effect that is a mix from picture to black, the opposite of the fade in from black. Logically, these two fade effects go in pairs.

Fade under Fading an audio event such as music under is necessary when you want the event to continue but not compete with a new event that will mix from another track—typically dialogue or commentary. These decisions are largely made by audio mixers and editors. Nevertheless, you should know these terms for the rare occasion when you need to lock in a specific audio idea in your script.

Fear One of the key emotions evoked by tragedy in the *Poetics* of Aristotle.

Federal Communications Commission (FCC) language codes The Federal Communications Commission, the federal agency that regulates broadcasting over public airwaves, bleep-censures a list of seven unacceptable four-letter words and also can fine stations that broadcast them.

Final-draft This is the final document that incorporates all the revisions and input of the client or producer and all the improvements and finishing touches that a writer gives to the writing job even when not explicitly asked for. A scriptwriter, like all writers, looks at his work with a critical eye and seeks constant improvement. This document should mark the end of the writer's task and the completion of any contractual arrangement.

First-draft screenplay See first-draft script.

First-draft script This is the initial attempt to transpose the content of the treatment into a screenplay or script format appropriate to the medium. This is the cross-over from prose writing to script writing in which all the special conventions of camera and scene description are used. The layout of the page serves the special job of communicating action, camera angles, and audio to a production team. It is the idea of the program formulated as a blueprint for production. The producer, the client, and the director get their first chance to read a total account for every scene from beginning to end.

First person In video games, means you see the action through the eyes of your avatar.

First-person plural The preferred pronoun "we" is inclusive and puts the client and the writer on the same team, as it were, working together to solve a problem.

First-person singular A fatal error of media writing because it interposes a personal self between the idea and the client who is paying for it and makes criticism awkward and harder for the client to bring forward.

Fixed media Interactive media that is burned onto a disk and then manufactured.

Flashback/flash forward These terms refer to a narrative device that both writers and editors use to manage the relationship of different moments of time in a dramatic story.

Flat fee Compensation by a fixed amount irrespective of time or effort spent.

Flight simulator Simulates the action of flying an aircraft. Realistic controls make the flying itself the point of the game.

Flowchart A diagrammatic representation of interactivity by lines and symbols.

Focus group A selected group representative of the demographic of the target audience.

Follow up questions A question that is improvised in response to the answer to a previous question to dig deeper or clarify the response.

Foreground The near part of a camera frame along the optical axis of the lens.

Format The special layout of the page and conventions of upper and lowercase that govern a script page.

Formative evaluation An investigative test of potential audience response before production or other communication exercises.

4:3 academy ratio The standard format and screen ratio for movies and television at the time television was invented.

Frame The borders of the images or picture, which corresponds to the area seen in a viewfinder.

Frames A border placed around an element of a web page such as a text block.

Friedmann's first law of media communication The effectiveness of a message varies in inverse proportion to the size and breadth of its audience.

Friedmann's second law of media communication The simplicity of the message must be in inverse proportion to the size of the audience. The larger the audience, the greater the need to simplify the content to reach the lowest common denominator of any given audience.

Functionality A concept of web design that emphasizes function and purpose in design.

Funnel A technique of questioning and interviewing that moves from the general to the particular.

Funnel technique An arrangement of questions that starts with broad general questions and progresses to specific, sometimes closed questions.

Gag A comic device involving physical or verbal play that gets a laugh. See Running gag.

Game bible The written story background that includes a description of characters and their powers and weapons.

Genre A type of plot or dramatic idea that is recognizable as similar to others and belonging to a class.

GIF or JPEG Two of many still picture codecs that computers and web pages still recognize.

Graphics Media content created by artwork or computer-generated images that are not photographically recorded and illuminated images of the real world.

D.W. Griffith An early pioneer of moving picture art for the Biograph Company who extended the vocabulary of visual narrative.

HDTV 16:9 The high definition television wide screen ratio that replaced the academy screen ratio.

Hero An essential dramatic character whose destiny, choices, and actions determine the story.

Hierarchical A term that refers to an organization structure that has levels that increase or decrease in choice depending whether you are moving up or down the hierarchy.

High angle A high angle means camera lens is pointed down to an object or a person.

High-concept film A Hollywood term that refers to big-budget, spectacular films usually notable for expensive special effects, star actors, and complex action scenes.

High-level design Refers to a comprehensive description of the content, style, and look of interactive media such as a video game, a website, or a CD-ROM.

Hook A situation or action that captures the immediate interest of an audience.

Hopefully A fatal adverb to use to qualify any written or oral pitch of an idea because it indicates the lack of conviction on the part of the author or presenter of any given idea.

How-to videos A common use of video to explain a process, job, or task, usually by demonstration so that the viewer can imitate and achieve the same result.

HTML Short for *hyper text markup language*, HTML is the universal open architecture code on which all websites are based.

Hub with satellites Another paradigm for the graphic representation of interactive elements.

Hubris A Greek word meaning "pride" or "self-delusion" or the "overconfidence that precedes misfortune."

HUD (heads-up display) A heads-up display is used most in first-person games. The heads-up display, like a fight deck or a dashboard, presents information on the screen, such as the life meter, level, weapons, ammunition, map, and so on.

Humor A key ingredient or device of many corporate, training, and other media communications; one of the principal persuasive strategies.

Hyperlink An object, text, or area of a web page that has an embedded link to another web page.

Hypertext Text in an interactive medium in which a link to another part of the text or another website URL is embedded and activated by mouse click.

Hypothetical questions A question that is based on a supposition that may or may not be true or a conditional premise.

Indemnity A warranty by the seller that the provenance of any piece of property is good in title and clear of liens.

Index cards A common technique of outlining the scenes of a program or script either with cards or virtual cards in scriptwriting programs that can be shuffled and rearranged.

Infomercial An extended form of advertising presented in the guise of programming.

Informational objective One of three types of objective that delivers knowledge, fact, or understanding to an audience that did not know.

Instructional design Techniques of developing systems to communicate knowledge efficiently and effectively in any medium, often called instructional technology, educational technology, curriculum design, and instructional systems design.

Instructional Systems Design (ISD) A generic shorthand for training and instructional design systems.

INT. (Interior) This is the standard abbreviation for an interior (or inside) setting used in the slug line of a script.

Intellectual property The legal notion that an idea or created work enjoys a status parallel to that of physical property.

Interactive design A term that refers to the need to think through the sitemap or interactive navigation through which a user will engage with the medium.

Interactive multimedia A generic term that refers to digital content and navigation with a required user choice and input for both fixed and online media.

Interactive television Allows real-time interaction with screen content on equipped TV sets that are also connected to the Internet.

Interviewing Recording the responses of people to questions, prepared or impromptu, that are then edited either as sync shots or voice only for inclusion in a video.

Inverted funnel An arrangement of questions that starts with closed questions and fans out to broader lines of questioning.

Inverted pyramid The classic formula for writing news stories filed by wire services in which the lead goes first and the least important details are presented at the end.

Isometric View A view of a video game and its action from an angle instead of directly from above or directly from the side.

Job In training terms, refers to the overall job of work that has to be accomplished.

Key moment The essential part of a story reality that makes up a scene.

Laugh line A term that refers to a type of dialogue line that is designed to get a laugh on its own and is not necessarily essential to the plot or storyline but often is typical of the character.

Leading questions Questions that have an element of trickery in that they are designed to trap the interviewee in revealing information, such as the notorious "when did you stop beating your wife" questions.

Learning Management Systems (LMS) A generic term for software that manages training and learning content and delivery in an educational or corporate environment.

Library music Library music is sold by needle time for specific synchronization rights for designated territories and is generally recorded without fades so that the audio mixer of a program can make the decisions about the length of fades. This music is recorded in convenient lengths of 30 and 60 seconds, as well as longer pieces with variations on the same basic theme so that the piece can be reprised at different moments on the sound track. Also, small music bridges and riffs and teasers are available off the shelf for editors and audio mixers to use.

Linear A program that is structured as a straight-line progression from beginning to end, like music, movies, and television.

Lingo The scripting language that Adobe Director uses to program interactivity.

Location research A specialized business of finding places and settings in which to shoot that correspond to the designated setting in the scene headings of a script.

Logline A logline is a short sentence or even a phrase that rests on the premise of a film and captures its essential idea.

Logos, an appeal to reason and argument Part of Aristotle's classic analysis of the way persuasion works.

Low angle A low angle means pointing the camera lens up to a subject whether an object or a person.

Low-concept film A Hollywood term that refers to stories that are about people and human nature with few special effects or action sequences that can be produced on a low budget with actors rather than stars.

LS (long shot) A long shot should include the whole human figure from head to foot so that this figure or figures are featured rather than the background.

Louis Lumière Louis Lumière invented a motion picture camera, which also served as a projector, in 1895.

Marked-up script A production script that uses vertical lines to show how much each shot and each take covers of the action and the dialogue in a master scene script. It records the camera slate information and shows where the shot begins and ends in relation to the script content. It reveals graphically how much cover material has been recorded for each scene. This enables the director to evaluate whether enough covering angles have been shot. In postproduction, it enables the editor to know what shots may be suitable for a rough cut.

Master scene script The standard form of the screenplay for feature film is sometimes referred to by this name because each scene is usually the description of an action from which a master shot will come.

Master shot This is a camera shot that captures the whole scene and its dialogue in one single shot or take. The standard practice of directors is to shoot a master and then cover it with other angles of the same action and dialogue.

Meta-writing The author's term used throughout the book to mean visual and conceptual thinking that underlies visual writing and that may not be explicit expressed in a program.

Metonymy A figure of speech that substitutes an attribute or a part of something or associated word to stand for the whole, such as "the White House" meaning the government of the United States.

Minidramas One of the principal persuasive strategies.

Miniscript The author's term for small scripts that define various assets such as video clips, voice-over, and graphics.

Miniseries A three- or six-part extended story that plays on television and is longer than a movie.

Minisode The author's term to describe an episode in the condensed storytelling format on mobile media platforms.

Mistaken identity Confusion of identity, usually comic, that produces plot complications and misunderstandings for other characters.

MMORPGs (Massively Multiplayer Online Role-Playing Games), MMP, or MMO (Massively Multiplayer Online) Online games that allows players to interact with a large number of other players in a real-time virtual environment.

Mobile media A generic term that refers to wide spectrum connectivity on newer, faster networks and WiFi.

Mobile TV A short-hand term that refers to a new signal for over-the-air network broadcast channels to be relayed to mobile devices if they have the requisite chipset.

Mobisode A term trademarked by Fox to denote a very short unit of a new serial narrative for mobile media.

Montage A montage is an assembly of shots that have no intrinsic continuity and no necessary relation to one another other than their function in the montage created by the editor. The term comes from the French *monter,* meaning "to edit."

MOOCs (Massive open online courses) Not-for-credit university courses available online to anyone, pioneered by MIT, Harvard, and other major institutions.

Morphing This refers to a computer-generated effect that makes one shape or object metamorphose into, or transform into, another object unlike the first. For example, a human face changes into an animal face.

Motivational objective One of three types of objective that induces an emotional response in the audience and so changes attitude and receptivity.

MS (medium shot) A medium shot allows headroom at the top of frame and puts the bottom of frame either above or below the waist. Keeping the hands in is one way to visualize the shot. It is definitely well above the knees.

MUD (multiuser domain) A website that hosts multiple players logged on to play one another. An example is a chat room for text-based games.

Multimedia time continuum The essential problem of scriptwriting, which is to describe visual and audio that happen as an integral continuous experience for an audience but can only be described by alternating representation of one after the other in words.

Multipoint-to-multipoint communication A form of communication that allows all parties connected to the network to communicate to all other points.

Music A music track is created independently of production. Music videos begin with a defined sound track. Other programs have music added in postproduction to fit dialogue, sound effects, and mood. The writer does not usually pick music nor decide where music is necessary. The exception is where the music is integral to the idea, or in a short script such as a PSA in which detailed conception might include ideas for music. If you do write in music cues, there is a correct way to do it.

Music bed A continuous piece of music that is mixed under other sound or is audio coloration of a visual sequence.

Music bridge A short piece of music that indicates a dramatic transition.

Music cues A vocabulary of descriptive terms that indicate how and when a musical event on a sound track occurs.

Music sting A very short and emphatic musical sound that underlines a dramatic moment.

Narrative argument A form of presenting content by means of a logical progression or exposition, usually without resorting to techniques or devices that entertain.

Narrative design A term that describes the imagining and the writing of characters, story, and world in a video game.

Narrative tense The present tense is the convention of screenwriting in contrast to narrative fiction, which can adopt a past or present tense.

Navigation Refers to the way in which a user can travel around a website or choose interactive hyperlinks to discover the in-depth layers of a site, CD-ROM, or DVD.

Navigational design Refers to the way interactivity is communicated to the user by intuitive visual ideas.

Nielson A company that collects audience data and sells it to broadcasters.

Nodes A point on an interactive path that requires choice to proceed.

Nonlinear Program content that has a beginning at some entry point or home page but no necessary end or order or play because it is determined by the user.

Omniscient narrator A novelistic device that is virtually impossible to replicate in a motion picture.

Omniscient or third-person narrator A narrative device or convention that is unique to prose fiction, although there is a kind of equivalent in an objective camera but never the exact equivalent of an author who can reveal the thoughts of multiple characters.

On-camera anchor A presenter who speaks to the camera and looks at the audience through the lens to narrate program content; this technique familiar from the television idiom of news and other factual programming.

One-liners Similar to laugh lines, these dialogue lines are written for a character to get a laugh.

Open Mobile Video Coalition The name of a cooperative body of TV broadcasters at first seeking to define the engineering standard for the mobile video signal and second to strategize how to penetrate the mobile eco-system with broadcast TV content.

Open questions A general invitation to the interviewee to determine the direction of discussion.

Outline A common technique of laying out the spine of a story or the sequence of scenes for a program or script.

Over-the-shoulder This shot, as the name implies, frames two figures so that one is partially in frame quarter-back view at one side while the other is featured three-quarter front view. This shot is usually matched to a reverse angle of the same figures so that the values are reversed.

Pace The rate at which a story and scenes unfold based on the length of scenes.

Pan (panorama) The most common movement of the camera. A pan can move from left to right, or vice versa, hence, sweeping across a scene to give a panoramic view. The most common use of this camera movement is to follow action while the camera platform remains stationary.

Parallel paths Another paradigm for graphic representation of interactive elements that charts movement that can hop from one path to the other.

Pari passu A Latin legal term meaning "at an equal rate."

Pathos, an appeal to emotion Part of Aristotle's classic analysis of the way persuasion works.

Per minute of finished program A practice of charging a sum per finished minute of program.

Percentage of the gross Gross revenue is all the money received by the distributor of a film.

Photoplays A term from the early days of the film industry that refers to what we now call a screenplay.

Picture libraries Commercial collections of images that are sold for use in programs and print media by license for specific rights.

Picture research A specialized activity that involves finding still and moving picture images of subject matter or people that is usually historical within archive collections in the commercial and public domain.

Picture researchers Specialized researchers that know the different specialized collections and how to find pictures and video/film clips.

Piecework Work paid for by the unit or piece.

Pitch/pitching Pitching is talking, not writing. It is the verbal communicating and selling of ideas in the media industries. You have to talk your ideas as well as write them down. To make a living as a writer, you often have to sell your ideas in meetings. The good pitch should capture the essential idea in a nutshell and tease listeners so that they are motivated to read what you have written.

Pity One of the emotions that is engendered in audience by tragedy contemplating the fate of the tragic hero as defined by Aristotle in *The Poetics*.

Platform The type of system a game is played on, such as PlayStation 3, Xbox 360, Nintendo DS, Nintendo Wii, etc.

Platform game Involves jumping on platforms of various sizes and jumping on enemies to destroy them.

Play-within-a-play A clever dramatic device that encases one play inside another, the famous example being the play Hamlet puts on to trap Claudius. The irony is that we are watching play put on within a play. There is a parallel idea in movies that are about making a movie in which the characters exist in both. The same irony enriches the movie equivalent of the play-within-a-play.

Plot The sequence of events that simulate the dynamics of circumstance, destiny, and choice involving one or more characters.

Point of view A narrative voice that can be injected into the narration of a story so that one character is the lens through which the audience sees a world, which in a moving picture medium can influence the visual point of view established by the camera.

Portal A gateway to enter the World Wide Web.

Postproduction Refers to all the activities that follow shooting such as editing, postsyncing, music recording, titling, and mastering that lead to a completed program or show print.

Premise This term refers to a compact statement of the essential idea of a movie or program. It embodies the essential conflict or dilemma that will drive the plot and the characters.

Preproduction This refers to all the activities before shooting that turn a script into a production. During this stage, scripts are broken down, scheduled, budgeted, crewed-up, and cast.

Pre-roll ads A form of advertising for digital media both fixed, internet and mobile that forces the viewer to watch advertising before any content can be played or accessed.

Present tense A universal convention of media writing which is more convincing because it implies we are seeing it now as if it already existed. Writing in the future tense, a common error of beginners, implies doubt because what is in the future does not exist.

Primary target audience The most important segment of any audience demographic, the primary target audience corresponds metaphorically to the bull's-eye of a target.

Problem A fundamental dilemma faced by a main character that is essential to the premise of a story and which must be resolved before the story ends.

Process An understanding that scriptwriting evolves through stages and changes from prose to a unique format.

Producer's net The money paid by the distributor to the producer minus a lot of distribution costs as well as a fat commission.

Product integration A term that refers to a new form of mobile media entertainment that is paid for by a commercial sponsor in which the product is built into the story and script for the program.

Product placement A term that describes a long-standing film production strategy of extracting money from the manufacturers of props that are in the film. Which soft drink is shown in the scene or what brand of sunglasses the character wears has no bearing on the plot and therefore placement can be sold to the highest bidder.

Protagonist A protagonist is the main character whose actions and choices determine the story (e.g., Hamlet, the main character in Shakespeare's play *Hamlet*).

PSA The acronym stands for public service announcement, which is like a TV commercial that communicates a message on behalf of a nonprofit organization or government agency with a message intended for the public good; broadcasters play PSAs to fulfill service obligations under their FCC licenses.

Psychographics The definition of the mental, emotional, and psychological frame of mind of an audience that helps identify its receptivity or hostility or neutrality toward a given media message.

Public domain A legal term referring to intellectual property rights that have expired or have no known authorship such as folk tales and fairy tales.

Public policy problem The large-scale issue that uses media as one technique, usually a PSA, to reach and influence various publics.

Putdown An essential device of comedy in which a character is insulted by another character in a way that engages the audience in the humor.

Rack focus Racking focus, also known as pulling focus, refers to a deliberate change of focus executed by twisting the focus ring on the barrel of a lens. This technique is typically used to shift attention from one character to another when they are speaking and the depth-of-field is insufficient to hold both in focus at the same time. It is commonly used in television drama and movies.

Random access Data that are immediately accessible in any part at any time because of their digital nature.

Realism A literal representation of reality.

Realistic Representing the world we know in a way that makes it convincing, sometimes by artifice.

Reason (logos) One of the modes of persuasion in Aristotle's *Poetics*.

Reportage A term borrowed from French that refers to reporting about events from where they take place.

Resolution A necessary solving of the problem that is at the root of the story or its main character to bring the story to a close.

Reversals A key device of storytelling that presents the main character with forces or events that set him back from his goal or objective, sometimes called a setback.

Reverse angle A reverse angle is one of a typical pairing of two matched shots with converging eyelines. They can be medium shots, close-ups, or over-the-shoulder shots and are shot from two separate camera setups.

Revision An inevitable part of all writing but especially scriptwriting for which contracts usually specify a certain amount of revision.

Role of writer Can be combined with producer or director but is usually an independent role preceding production.

RPG (role-playing game) A role-playing game is a genre of game for both PCs and consoles in which the player develops intelligence and skills by collecting points and solving puzzles.

Running gag A running gag depends on repetition. It keeps running. The audience knows the premise of the gag, so that each new exploitation of the gag gets a rise from the previous one. You keep going back to the same premise to work it from another angle. This device enriches a lot of comedy.

Scenario An early term of the silent movie industry to designate an outline dramatic idea, what might now be called a treatment.

Scene The scene is the basic unit of visual narrative for the screenplay. It has unity of time and place. A new scene begins when either time or place changes.

Scene heading Another name for a slug line.

Scene outline This term refers to a way a writer might compose a visual narrative by listing scenes rather than writing a treatment.

SCORM Sharable Content Object Reference Model, or a set of technical standards for e-learning Software products.

Scratch commentary A commentary that is a rough draft written and recorded to use for assembling a documentary and understanding the relationship between the available footage and the verbal narrative.

Screenplay A screenplay or script is the translation of the treatment into a visual blueprint for production laying end to end the particular scenes employing the specific descriptive language of the medium to describe what is to be seen on the screen and heard on the sound track. This means the action and its background and each new character in the scene must be delineated. Every word of dialogue intended to be spoken must be written down. Every scene must be described.

Script A script is the final document that details the scenes that make up the narrative of a film or program. It describes action and provides the dialogue to be spoken and is laid out in a format according to the convention of the medium. master scene script or screenplay is appropriate to film, and a dual column format is appropriate to documentary or corporate programs.

Script breakdown This is an analysis of the elements of a script by reference to location, cast, props, costumes, and so on that enables the producer to find the most efficient order for shooting the script in a shooting schedule.

Script format A specific way of arranging the description of an image or shot and its corresponding sound on the page together with scene information.

Scripting language A computer language that is a meta-language or coding language that creates a sublanguage or set of commands for other users who do not have access to the scripting language (e.g., Windows, Visual Basic, or Lingo).

Scriptlets The author's term for short miniscripts for PSAs and TV commercials.

Scriptwriting The term that embodies all the visual thinking and writing down in specific format of the narrative.

Scriptwriting software Computer programs, such as Movie Magic Screenwriter and Final Draft, that are specialized word processors that format the script page according to industry standards by keystrokes.

Search Engine Optimization (SEO) A term that refers to increasingly sophisticated techniques of putting key words and phrases into the meta tags of web pages so that search engines will rank that page higher in the search algorithm of the web crawler relative to other competing or similar sites.

Search engines Web crawlers that read tags and metatags in the HTML of web pages to list search results.

Second screen A term that refers to the phenomenon enabled by mobile media platforms and their social media in which audiences watch a second screen while watching a program and interact with an app created for the program or communicate through social media networks to their friends what they are watching and what they think. This is an important part of television and cable distribution that enables more accurate monitoring of audiences, which can translate into advertising dollars.

Secondary target audience A desirable audience that may or may not be affected by the communication and would be a bonus but for whom the message cannot be altered.

Segue to This term means to cross-fade two audio events. It is the audio equivalent of the video mix. You do not need to write this into the audio side of a script every time you use a mix to transition. It is understood by all involved that one goes with the other.

Self-assessment questions Questions that invite self-evaluation.

Sequence This term refers to a coherent section of visual narrative that might be composed of several scenes or several shots in the case of a long scene.

Sequence of images The basic narrative concept of storytelling in motion picture.

Serials Multiepisode narratives in which each episode is a continuation of the previous episode.

Series bible The book of characters, backstories, and locations on which a TV series is based, built up by writers over time.

Series editor The head writer of a series, either the original writer or someone who takes over from the original writer.

Service-for-hire A term that describes the temporary nonemployee relationship between a writer or service provider and client, also known as work-for-hire, which specifies the transfer of copyright from the creator or service provider to the client.

Setbacks Another way of expressing the idea of a reversal in fortune for the main character that raises the stakes and the challenge and thus gets the audience to sympathize with the character.

Setup This refers to the placement of a camera in a specific place and with a specific focal length lens to shoot a shot.

Seven-step method The method of asking and answering six questions analytically before writing a creative concept.

Sexual innuendo One of the principal persuasive strategies.

SFX (Sound Effects) Instead of describing a thunderstorm and the sound of thunder at length, it is sufficient to write, "SFX thunder." In postproduction, whoever assumes responsibility for the audio tracks will pull a stock effect from a bank of effects on a CD-ROM or audiotape. A sound effect is any sound other than speech or music.

Shock One of the principal persuasive strategies.

Shooter A game in which the object is to kill an enemy with a weapon that fires bullets or rays while avoiding being shot by the adversaries. Such games are usually constructed in a 3-D environment, assume a first-person perspective, and are referred to as FPS or "first-person shooters."

Shooting script A writer builds a screenplay out of scenes, which is its fundamental building block. the director has to compose a scene out of shots. This means a director has to create a shooting script out of a screenplay. The director has both the right and the responsibility to break down the scene into camera setups or shots that will cover the action of the scene.

Shot A shot describes the way a lens produces an image. It frames the subject in the viewfinder and is usually defined in two dimensions by how much or little of the human figure is included in the frame. It also has

a third dimension that is defined by the foreground and background in the frame. How much of this third dimension is in focus depends on the depth of field. See also *pull focus/rack focus*. The shot is the basic unit of narrative for the camera and for the director who shoots the movie. A shot can also be defined as the smallest unit of uninterrupted live action in the finished program.

Shot list This list consists of the shots that are revealed by a script breakdown. It can be a list of shots that a director visualizes to shoot a scene, or it can be a way for a writer to compose a sequence or outline a scene.

Show-and-tell A traditional and literal approach to training or video exposition that avoids visual metaphor.

Show print A print or dub from an edit master that embodies the finished program as it will be distributed.

Sidebars A box that is set off from the main content that contains auxiliary or parallel data as in this book or in web pages that need to offer multiple navigational options.

Simulation games Games that recreate an environment, such as flying an airplane, or simulate an environment in which realistic problems have to be solved.

Sitcom A standard abbreviation of situation comedy that is now a word in its own right.

Slapstick Physical comedy routines that were developed in vaudeville, evolved in early silent films, and continue to this day.

Slug line A standardized scene heading in a script consisting of three specific pieces of information crucial to production personnel who need to know whether the scene is interior or exterior, what the location is, and whether the action happens at night or in the daytime.

"Snackable" media A current term that likens media consumption on mobile platforms to food snacks.

Soaps This term is an abbreviation of the term soap opera, which was the popular term for radio and later television series playing in the daytime to a housewife audience sponsored by major detergent companies. It has come to mean a certain type of predictable domestic drama with romance and intrigue.

Sound cues A series of indicators of how audio events will be recorded, played, or edited on a sound track and how they will begin and end.

Sound effect An effect recorded wild for laying up on a mutlitrack mix, whether during production or taken from a sound archive or prior recordings.

Special effects One of the principal persuasive strategies.

Specialized kind of writing Scriptwriting in the history of writing is a new and specialized kind of writing.

"Spec" script A script for an established series that is not commissioned but written by a new writer who hopes to get a commission from a series editor or head writer.

Stage directions Taken from drama scripts and referring to directions for emotion or performance put in parentheses after a character's name.

Statute Law created by a legislative body and signed into law.

Sticky Web terminology that describes the quality of a website that keeps you on it by virtue of its navigational design and content.

Storyboard An artist's rendition of key frames of action in a script, somewhat like a comic strip.

Story engines Writing software based on story theory that generates plot, subplot, characters, and scenes given a certain premise by the user.

Storyline A throughline or story arc that threads through the events of the narrative.

Storymapping A term that can be compared to storyboard. It refers to a visual mapping of a sequence of thought that could explain an industrial process, a management decision process, or interactivity for a video game.

Story of a day A chronological narrative of the events in a 24-hour period of a person or an enterprise that explains the relation of parts to the whole or detail in the context of complex stories.

Strategies Ways of overcoming audience resistance to a message or its content.

Subject matter experts (SMEs) People with specialized knowledge inside or outside corporate client organizations that scriptwriters consult for essential background.

Subplot A part of a story that reinforces or builds complexity into the main plot and is often necessary to its resolution.

Subtext A term used by cultural critics to refer to unintended or indirect meaning that has an effect on an audience and may well either support or challenge cultural stereotypes.

Summative evaluation A verification of results obtained by measuring audience response to a finished piece of media communication.

Superimposition A superimposition (or SUPER as an instruction) is simply the mix or dissolve mixed into the midprinter light or midfader position and then out. Beginners often go to unnecessary lengths to describe the way titles superimpose on picture or a background. A sentence can be reduced to *SUPER TITLES over black*, *SUPER TITLES over LS of street*, or *SUPER name under CU of face*.

Survey of strategies These are humor; suspense; shock; minidramas; use of children, babies and animals; testimonials; sexual innuendo; and involvement of the audience as a character.

Suspense One of the principal persuasive strategies.

Sync Action and sound that produced at the same moment in time and recorded as such, particularly dialogue that requires lip sync.

Synchronous Events or media elements that occur at the same time and in the same time interval.

Tag line A phrase or sentence that invites you into the world of the movie and is usually part of the publicity for launching and selling the film (e.g., *Alien*'s "In space, nobody can hear you scream").

Take This refers to the discrete recording or filming of a shot from a given setup. More than one take may be shot from the same setup in order to correct technical or performance errors.

Target audience The identified group of people who are on the receiving end of any media communication.

Task A subset of a given job that involves specific actions or routines or skills.

Teaser An introduction to an episode that contains a dramatic premise, sometimes functioning as a hook.

Technical writer Someone who is capable of clear exposition of scientific or technical information and methods in a logical way, including writing user manuals.

Testimonials Real and fake; one of the principal persuasive strategies.

Third dimension Any interactive text has a relational dimension to other text or web pages through hyperlinks.

Third person An omniscient point of view in a video game that lets you see the character you are controlling in contrast to first person.

Three-act structure The classic dramatic or story structure that seems to correspond to the pattern of audience response that makes stories work.

Three-stage process The classic developmental sequence in the writing process starting with a concept, which is then elaborated into a treatment, which is then translated into a script or screenplay.

Throughline A scriptwriting term that refers to the comprehensible story thread discernible in the events or actions of the character or plot.

Tilt Tilt is a movement of the camera platform to angle up or angle down in a continuous movement along a vertical axis. It is useful for following movement. Panning and tilting are often combined in one movement to follow motion in three dimensions.

Titles A title is created either in a character generator or as part of computer graphic imaging. It is part of postproduction and needs to be identified by another slug line separate from a shot or a scene. You can indicate this by a simple slug: TITLE or CG.

Title cards The technique of representing the speech of characters in silent movies by interspersing text in full frame between cinematographic action shots.

Track A track refers to a continuous movement of the camera platform in one direction, usually alongside an action or moving figure. This is accomplished by putting the camera on a dolly that runs on tracks or by handholding the camera while walking alongside the action. This enables the camera to make a shot that maintains a constant frame around a moving object or person. The camera platform can also be mounted on a vehicle or any other moving object.

Tragedy Conflict or choice that results in self-destruction or an outcome that induces pity and awe in the audience.

Trailers Quick summaries with key moments edited together to suggest the promise of an episode to come.

Transitions A repertoire of changes from shot to shot, namely CUT, FADE TO, DISSOLVE, or WIPE.

Treatment After the concept comes the treatment. Both these terms are universally used and understood. A writer must know what they are and how to write them. Writing the treatment involves expanding the concept to reveal the complete structure of the program with the basic content or storyline arranged in the order that will prevail in the final script. All characters and principal scenes should be introduced. Although this document is still written in normal prose, it frequently introduces key moments of voice narration or dramatic dialogue.

Tunnel technique As opposed to funnel and inverted funnel, the tunnel technique does not go from general to particular or vice versa, but it continues in a series of questions that does not try to move the interviewee in a certain direction.

Two-shot Although this is not an abbreviation, it is a common term that describes two people in close-up or medium shot. The widescreen format of the movie screen and the new HDTV television format make good use of this frame.

Verbal comedy Comedy reliant on dialogue repartee, wit, or verbal humor.

Vertical dimension A term that refers to navigation in interactive media as a dimension in addition to the two dimensions of any given page.

Video news release A form of public relations presenting a story in the guise of news.

Video strips The author's term for short bursts of serial narrative for mobile platforms.

Viral A metaphor that likens crowd communication across networks to behaving as a virus infecting and multiplying when a given website gathers a huge audience that intercommunicates about it.

Virtual space A cyberspace that does not exist in physical reality but is accessible as a graphic world by one or more users.

Visual gags A comedy routine that involves physical action, not dialogue.

Visual metaphor Like literary metaphor, an image that allows an intensification of meaning by transference of qualities of one object to another.

Visual narrative A term emphasised in this book to underline the importance of storytelling through action and images in visual media in contrast say to storytelling in a novel.

Visual seduction The use of the visual properties of a camera shot or sequence that by means of color, form, and composition enchant or captivate the viewer.

Visual writing An essential characteristic of writing for visual media that means narrating through action and what the camera sees rather than by what people say.

VLS (very long shot) There is no precise definition about what is very long other than that it should include the whole human figure, the whole action, and a good view of the background.

Voice commentary An important component of the PSA or ad that requires special attention.

Voice narration A recorded commentary that is usually a voice confined to the sound track but can sometimes be the sync narrative of someone who appears on camera as presenter or interviewee.

Voice-overs/voice-over commentary A recorded commentary that is dubbed over the picture without the speaker appearing in the shot or in the program.

Vox pops From the Latin *vox populi,* a shorthand phrase that refers to random interviews of the man-on-the-street to find out the views and opinions of a cross section of the population.

Walled garden A metaphor that refers to the standard business model of legacy media companies that own intellectual property and want to charge the viewer for use of access to the "garden" of content which has only one entrance or turn style, e.g., a movie theatre.

Wall-to-wall commentary The author's term for relentless voice-over narrative that starts with first frame and never stops, exhausting the viewer and propping up inadequate visual content.

Web 2.0 The next evolutionary phase of the World Wide Web—version 2.0.

Webisodes A term that has come to mean a series produced for the web and not for television or cable. However, television and cable series sometimes add a second screen storyline that is unique to the web.

What the camera sees The basis for all screenwriting because there is nothing else.

Wheel A paradigm for representing graphically how interactive elements relate.

Wheel with spokes A variant of the circle with segments.

Where the action is taking place The second piece of production information in a scene heading that the writer must determine.

Which medium? A key question to ask about any concept to verify whether it will truly work in its chosen medium by exploiting the unique characteristics of that medium.

Wide angle This term is somewhat loose. It generally means a long shot, or an establishing shot that shows the whole scene.

Widescreen 2:85 to 1 The standard widescreen ratio.

WiMax Worldwide Interoperability for Microwave Access is a telecommunications technology that provides wireless transmission of data using a variety of transmission modes, from point-to-multipoint links to portable and fully mobile Internet access.

Wipe A wipe is the effect of an incoming image pushing off the outgoing image. A wipe is more commonly a video effect. Every mixer has a number of standard wipe patterns. The most obvious are a horizontal and a vertical wipe in which the two images are separated by a line. The other basic patterns are circle wipes and rectangle wipes in which the incoming image grows from a point in the middle of the outgoing picture as an expanding shape. A scriptwriter should think carefully before writing in such detailed transitions. Leave it to the director and editor in postproduction.

Work-made-for-hire Work commissioned and paid for by the acquirer.

World building Conceptual writing of the nature of the game environment, real or imagined.

Write for the voice Writing spoken dialogue or commentary that must work when read aloud by a voice artist or commentator.

Writers Guild of America The trade union of film and television writers, which bargains with the movie and television producers.

Writers Guild of Great Britain The British equivalent of the American guilds.

Writing for audio Writing to designate a series of sounds, whether speech, music, or sound effects, that tell or help to tell a story.

Writing in one medium for another Represents the fundamental paradox of scriptwriting because the writing is a blueprint for something that is not words.

Zoom A zoom is an optical effect created by changing the focal length during a shot in a specially designed lens that has a variable focal length. The effect makes the frame larger or smaller like a dolly shot. The important difference is that a dolly shot maintains the focal length and depth of field throughout, and the camera moves nearer or farther away. The zoom uses an optical effect without moving the camera to change from a wide angle lens to a telephoto lens so that it appears to the viewer that the subject is closer or farther away.

Index

Page numbers in italics refer to topics in tables and figures. Where figures or tables are on the page or inclusive pages of the topic the page numbers have not been repeated.